TATLIN'S TOWER

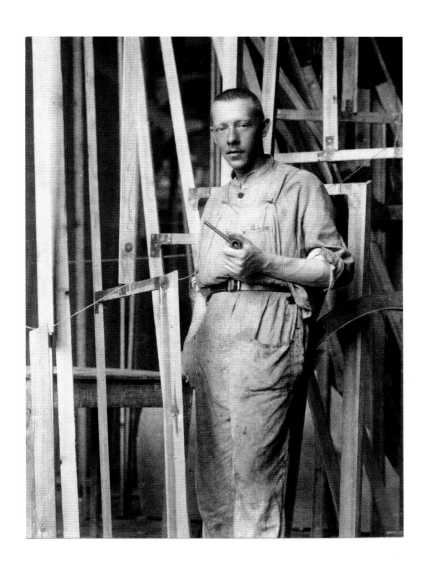

Н. ПУНИН

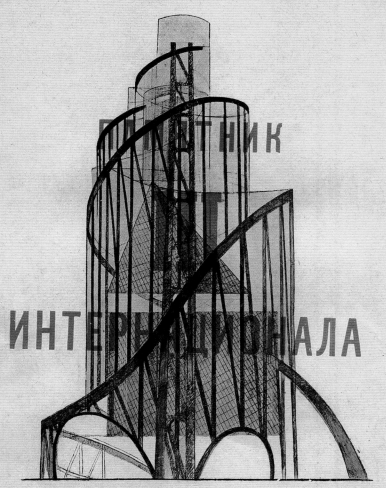

Проект худ. В. Е. ТАТЛИНА

ПЕТЕРБУРГ

Издание Отдела Изобразительных Искусств Н. К. П.

1920 г.

Tatlin's Tower

Monument to Revolution

Norbert Lynton

Yale University Press
New Haven and London

Published with the support of the Henry Moore Foundation and the Elephant Trust

Designed by Catherine Bowe
Printed in China

Library of Congress Cataloging-in-Publication Data
Lynton, Norbert.
 Tatlin's Tower : monument to revolution / by Norbert Lynton.
 p. cm.
 Includes bibliographical references and index.
 ISBN 978-0-300-11130-9 (alk. paper)
 1. Tatlin, Vladimir Evgrafovich, 1885-1953. Monument to the Third International. 2. Tatlin, Vladimir Evgrafovich, 1885-1953--Criticism and interpretation. I. Title.
 N6999.T38L96 2009
 720.947'09041--dc22
 2008022163

Half-title page: Photograph of Vladimir Tatlin, taken by Nikolai Punin, c.1920. N. Punin Archive, St Petersburg

Frontispiece: Vladimir Tatlin, Design for the Monument to the Third International, 1919–20 published on the cover of Nikolai Punin's book, *The Monument to the Third International*, Petrograd, 1920. N. Punin Archive, St Petersburg. The Russian text on the image reads 'N. Punin, The Monument to the III International, project of V. Tatlin, published by the Department of Visual Arts of Narkompros [People's Commissariat], 1920.'

Contents

Note on Transliteration

Russian names are spelled here following the system set out in the Cambridge Companion to Russian Studies. This system provides a reasonable idea of pronunciation. The 'Hard' and 'Soft' signs (silent letters) are not indicated here. The vowels —*yu* and —*ya* are indicated as here as —*iu* (as in Liubov) and —*ia* (as in Natalia), for this is now more familiar to the general reader. Adjectival endings —*iy* and —*yy* have been simplified to —*y*.

Monarchs after Peter the Great are given their English equivalent names, hence Alexander (not Aleksandr), and the spelling Alexandra, Alexei and so on is followed throughout.

Where names have a recognized Westernized form (Chagall, for example), these have been retained.

The city of St Petersburg (familiarly just Petersburg) became Petrograd on 1 September 1914 to make it sound less Germanic, and Leningrad after the death of Lenin (21 January 1924), until post-Soviet times when it resumed its original name. References here employ the name in use at the time under discussion.

Preface

Norbert Lynton completed this book shortly before his death in October 2007. He left a complete draft. The subject of Tatlin and Russian revolutionary art had engaged his thought for more than thirty years. That he should finish the book in the last months of his life shows its importance for him.

An intelligent critic, exhibition organizer and art historian, Norbert Lynton was the heir to a European intellectual tradition of enquiry into matters of history, culture and art, based upon close observation and wide scholarship. This gave him breadth of reference and access to literary, cultural and philosophical history. Here the work of Vladimir Tatlin is set within a context of Russian radical thought and twentieth-century revolutionary events.

It has been my privilege to edit this book. I have remained aware of Norbert Lynton's own voice, and have sought to maintain its integrity. The text is not strictly chronological, though it begins with Tatlin's early years and ends with his posthumous rehabilitation in Russia. Tatlin's Tower is at the heart of the discussion, and is examined in various contexts of thought and practice, to reveal its meaning and significance in revolutionary Russia and later to a wider world.

Norbert Lynton was meticulous in his acknowledgement of published and archival sources. He persisted in scholarly discussion of his subject with those who knew him. I am most aware of his discussions with Professor Robin Milner-Gulland, Lutz Becker, with myself, but many others were involved. Robin Milner-Gulland in particular brought his wide-ranging and intellectually adventurous awareness of Russian culture and history to the project. He has been an invaluable source of knowledge and interpretation, firstly to Norbert Lynton, and secondly to me in my editorial activities.

Karen Wraith has magnificently managed the whole project throughout its evolution in all its inevitably intricate adjustments of text, plates and notes. Norbert Lynton was also advised and given substantial assistance by Natalia Murray in the search for photographs from Russian museums, as well as new sources of information. I know — and I think that they know — how appreciative Norbert Lynton was in his final efforts to complete the book. He would also want to express his appreciation to Sally Salvesen for making his project a physical reality through Yale University Press.

We are in turn grateful to Sylvia Lynton, and to Norbert's sons and executors for their confidence in our determination to realize his plan.

John Milner, 2009

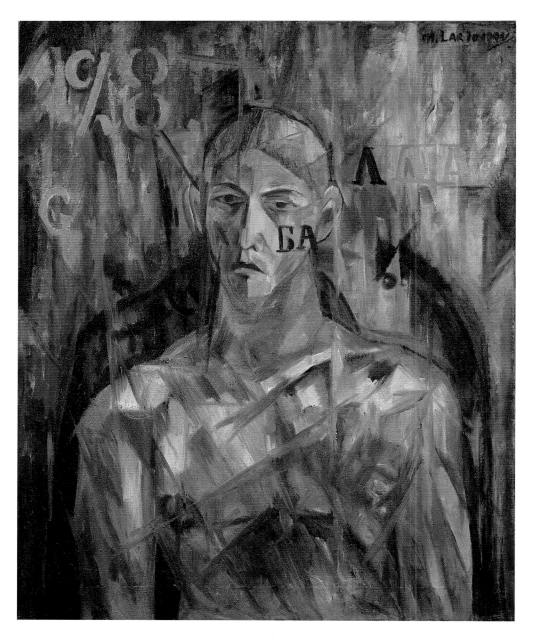

1. Mikhail Larionov, *Portrait of Vladimir Tatlin*, 1911, oil on canvas, 90 x 72 cm. Musee Nationale d'Art Moderne, Paris

Introducing Tatlin

Aspects of Tatlin's early life and work are relevant to the argument of this study, which centres on the meaning of his project for a Monument to the Third International, often referred to as Tatlin's Tower. However, this investigation does not propose a full account of the artist's life. In any case, even now, after years of research and publications during which much has been clarified, the information available remains sparse.[1]

Like other artists, perhaps especially those living in the first decades of the twentieth century and in Russia, Tatlin was guarded and sometimes contradictory when providing details of his life, particularly about the dates at which he did certain things. There is, however, no evidence that he ever wanted to pre-date his work to prove himself a pioneer in everything he undertook, as some of his contemporaries did. The political situation of the 1920s and after did not encourage full and objective disclosure. This or that work or aim had to be emphasized or repressed according to the climate of the moment, not least if, like Tatlin, one was for a while working close to the centre of power. The art historian Anatoly Strigalev has recently stated that much of the information we have about Tatlin's early life is incorrect and that the artist 'was inclined to mystification'.[2]

Circumstantial evidence is essential to this study of the Tower and of his other great project, that for the man-powered flying apparatus, *Letatlin*. The context of ideas and expectations within which he worked is as important as his directly and indirectly declared ambitions. The personal drive and the cultural environment are inseparable. No phase in modern art history has demanded from artists a closer involvement in the ideological demands of their time, shifting though these were. An aspirational and highly intelligent artist like Tatlin needed both to influence these demands and to respond to them. Misreading the signs became increasingly dangerous as the years passed and the State took direct control of what artists, of any specialization, could be allowed to do and to be.

Vladimir Tatlin was born in Moscow on 16 December 1885 (28 December by the Western calendar), the youngest child of Evgraf Nikiforovich Tatlin and Nadezhda Nikolaevna Tatlina, née Bart. The Tatlins were descended from a family of Dutch shipbuilders, Van Tatling, brought to Russia by Peter the Great in the early eighteenth century. Vladimir was one of three children, a girl and two boys one of whom committed suicide in childhood. We are told that Vladimir was beaten by his father, perhaps because he did not do well at school.

His mother was a poetess of some reputation; she died in or about 1889. Vladimir treasured her memory and honoured her achievements.[3] His father remarried when Vladimir was about ten years old. The boy appears to have resented his step-mother's presence. Evgraf Tatlin meanwhile became a respected railway engineer, having studied at the Practical Technical Institute in Petersburg. He was sent to the USA in 1892 and his report on the shift-work system used on American locomotives was published in 1892 and reprinted in 1896. In it he gave warm praise to the American appetite for experiment and innovation.[4]

The young Vladimir drew busily, irritating his father by devoting so much time to this unacademic pursuit. In 1890 the family moved to Kharkov, where his father managed a wool-processing factory. Kharkov, in the eastern Ukraine, was a major industrial city and intellectual centre, known for its revolutionary inclinations. For three years Tatlin attended secondary school there. Drawing classes at the school were given by an elderly artist, Bespertsy, presumably in a traditional manner to prepare students for teaching. An exhibition of folk art and handicrafts, shown in Kharkov in 1898, may well have impressed the young Tatlin by showing a wide range of work without implying levels of value: fine art alongside utilitarian objects — stoves, chairs, crockery, etc. — to which he himself would give his attention in the 1920s. The year 1898 also saw the publication of a book on flying dirigible machines, written by K. Danilevsky whom his father knew in Kharkov. He was part of a circle of people interested in science and technology.[5] This may have seeded Tatlin's ambition to contribute to the history of flight, subsequently given additional impulse by the enthusiasm of the poet Velimir Khlebnikov (who noted Tatlin's interest in flying in 1912) and of the poet-aviator Vasili Kamensky. Some of Danilevsky's theories are reflected in Tatlin's later work on his own flying apparatus.

At fourteen or fifteen Tatlin ran away from home. He got himself to Odessa where he enrolled as a cadet sailor on a cargo and passenger ship that took him around Black Sea ports and to Istanbul. He then went to Moscow and took a variety of occasional jobs, among them that of assistant scene-builder and painter. He was in touch with his family and may have visited them during the summer of 1901 or 1902. In September 1902 he was accepted, after examination, into the general department of Moscow's chief art school, the Moscow College of Painting, Sculpture and Architecture. The following April he was expelled from the college on the grounds of insufficient work and uncivil behaviour, as were several of his fellow students. Russian students were generally watched over for signs of rebelliousness and anti-authoritarian attitudes. Tatlin needed medical treatment for anaemia, but his father's request that Vladimir be readmitted to the college was refused, and the young Tatlin returned to Kharkov to live in the family house, until his father paid for him to spend time in a sanatorium.[6]

Evgraf died in February 1904. Tatlin, aged eighteen, again turned to the sea. He registered that summer as a cadet in the Marine College of Odessa, and sailed from August until October on the training ship 'Grand Duchess Maria Nikolaevna', obtaining a certificate to that effect. Subsequently he served on other ships. In 1905 the art schools of Moscow and Petersburg were closed because of the troubles following that January's Petersburg massacre, when the royal guards fired on a peaceful procession bringing a petition to the tsar. Tatlin moved to Penza, south-east of Moscow, and was admitted to its art school. One of his teachers was Alexei Afanasev who directed the school during 1905–9 before being dismissed for being too liberal. Tatlin remembered him with respect. Himself under police supervision as one of a group of student-activists, he completed the course in April 1910,

and gained his diploma as teacher of drawing and calligraphy. He appears to have spent vacations making contact with informal art circles in Moscow and in Petersburg, mostly of artists not much older than himself. He may have spent some time back at the Moscow College during 1909–10, and was certainly studying there in 1911 when he got to know a fellow painting student, Alexander Vesnin, two years older than himself. Tatlin also served as an apprentice in the workshop of a Moscow icon painter.

During his Penza years, encouraged by Afanasev, Tatlin studied church fresco paintings and built up a collection of images of religious paintings, Russian and Italian (Giotto, Cimabue, Masaccio, Piero della Francesca), as well as some German 'primitives'. He kept many or all of these throughout his life: they were linear tracings from photographs, presumably done by himself, a foretaste of a process he would use when designing for the theatre. Penza Art School is said to have enabled Tatlin to study examples of modern Western art, presumably in reproductions. School records state that he worked well on painting, drawing and anatomical study, but not on history of art and perspective.[7] He became friendly with a Penza family, Tsege, who were interested in modern art and were part of an intellectual circle. With their help, Tatlin exhibited twice in 1908 in Penza: his work was considered 'outstandingly innovative'. He meanwhile became a member of the school's student council. Its sessions were soon forbidden by the local government but continued secretly, on account of which Tatlin was again under police observation from 1909 until he left Penza in 1911. As Strigalev writes, Tatlin had 'moved back and forth from being a captain's boy on a ship, a sailor, an icon painter's assistant, and a prop maker at the Solodovnikov Opera — with occasional courses at art schools.'[8] He was quite poor, earning bits of money where he could and often going hungry.

He exhibited more regularly in 1910–11, when he was invited to send paintings, watercolours and drawings to the well-known 'International Izdebsky Salon', displayed in Odessa and Kiev. If he visited the exhibition he will have seen in it a substantial selection of new art from the West, mainly French but also Italian and German, as well as current Russian work that may well have been new to him, such as Vasily Kandinsky's *Improvizations*, painted in Munich, and Alexandra Exter's first ventures into the newest Parisian avant-garde idiom, cubism. Exter was spending part of each year in Paris, from 1909 until war began in 1914, and was well-known to Pablo Picasso and Guillaume Apollinaire's circle. Back in Russia, she was a major source of up-to-date information of what was happening in Paris.[9]

When Tatlin showed in three exhibitions put on by the Petersburg group Union of Youth he was also exhibiting from Odessa in the South, in Moscow, and in Petersburg in the North. He was rapidly meeting a wide range of painters. Kazimir Malevich (1878–1935) was one of his fellow exhibitors. Both became members of the Union, and they exhibited together repeatedly during the next five years. The Union of Youth had been formed in 1909 and had begun its exhibition programme in 1910. Like other groups formed at this time, it emphasized its openness to anything forward-looking and anti-traditional without representing a specific movement.[10] Around 1912–13 Tatlin sketched a little formal portrait of Malevich, an oval, cameo-like image in which the older man's head and hat are central, and his clothes and setting are indicated in a semi-cubist, essentially rhythmic manner.[11]

By 1908 or 1909 Tatlin had made the acquaintance of the painter Mikhail Larionov, who, only four years his senior, was already prominent among the avant-garde as a painter and a busy organizer of exhibitions and other art events. Thanks to this connection, Tatlin

showed in the third 'Salon of the Golden Fleece' in Moscow from late December 1909 to January 1910. In December 1910 Tatlin contributed to the first 'Jack of Diamonds' exhibition, organized by Larionov in Moscow, and in February 1911 to the second 'International Izdebsky Salon'. Tatlin had moved back to Moscow in 1911, living first with an uncle, then finding accommodation close to the home of Larionov and his partner Natalia Goncharova. Larionov and he travelled and painted together that summer, during which he also went on two sea voyages out of Odessa into the eastern Mediterranean. During that summer of 1911, possibly with Larionov, he visited the Burliuk brothers at Chernyanka, near Kherson, the town and port on the Dnieper close to where it enters the Black Sea. David, Vladimir and Nikolai Burliuk were painters and poets, and — especially David, the eldest, born in 1882 — prominent radicals in the art world of the time. In June 1911 David Burliuk sent Tatlin a friendly letter of invitation and instructions for reaching the Burliuk's home. On his way there, Tatlin will have seen water-towers and new lighthouses by the sea and these stayed in his mind.[12]

David and Vladimir Burliuk had both studied art in Odessa, Munich and Paris. David also spent part of 1902–3 at the academy in Munich, where he made the acquaintance of Kandinsky, already a prominent figure in Munich through his teaching and organizing of art groups. In 1912 Burliuk was again in Germany. He contributed to the *Blaue Reiter Almanac* edited by Kandinsky and Franz Marc, and to the exhibitions of new art they presented. To him, as to them, modern art was an international venture that, rejecting academic priorities derived from classical and Renaissance traditions, could again feature national and regional characteristics, taking inspiration from folk art and from primitive art forms wherever they could be found, but determined by the artist's individual spirit. Larionov had first visited the Burliuk brothers in 1910 and may have drawn their attention to Russian or Slav primitivism. Thus the Burliuks, like Kandinsky and Marc, were alert to the anti-academic and pre-academic modes of child art, folk art and prehistoric art, which offered freedoms alternative to those they had found in German expressionism and in the fauvism, and then the cubism, of Paris. Chernyanka was at the heart of the region once populated by Scythians, ancient Greeks who called it Hylaea. The Burliuks adopted the name Hylaea for the loose association of artists and writers that formed around them there, but also met and collaborated in Moscow, bringing the region's ancient past, historical and mythical, to bear on recent innovations. In Paris the appetite for primitivism fed primarily on exotic, often African or Oceanic tribal art forms. In Russia it was supported by rich resources of a local, regional and partly Asiatic sort, with new information on the vast country's traditional arts and crafts made available through the research of archaeologists, many of them artists, and through the *World of Art* journal in which material of this sort was published alongside contemporary Russian and Western art.

Hylaea was to be the first group in what soon became Russian futurism, bringing to that movement a characteristic Russian rootedness in aspects of the rural past. Italian futurism, launched by Filippo Tommaso Marinetti as a literary avant-garde movement in 1909, and extending into painting the following year (and into sculpture, with Umberto Boccioni, in 1912), was essentially urban and modern and would have no truck with such *passéisme*. Prominent among members of Hylaea were the poet, artist and airman, Vasili Kamensky; the poet Khlebnikov who had visited the Burliuks in 1910; Elena Guro, art-school trained but a writer, and the wife of Mikhail Matiushin, composer, painter and theoretician, a leading figure in the Union

of Youth art society of Petersburg; and the poets Vladimir Mayakovsky and Alexei Kruchenykh, both former art students. By 1912, through exhibiting and contributing to futurist publications, and through personal friendships, Tatlin was clearly associated with Russian futurists.

During the early part of 1912 Tatlin was especially close to Larionov, exhibiting as part of his Donkey's Tail group within the third Union of Youth exhibition in Petersburg (January–February 1912) and in the Donkey's Tail exhibition in Moscow (March–April 1912) where he showed fifty-two items while Larionov showed forty-three and Goncharova fifty-four. That year he contributed drawings to one of the new breed of futurist publications, *Worldbackwards*, a small, roughly assembled booklet presenting texts by poets Kruchenykh and Khlebnikov and illustrations by Natalia Goncharova, Larionov and others. In 1913 he made drawings for another such booklet, *Service-Book of the Three*, with texts by Khlebnikov, Mayakovsky, David Burliuk and Nikolai Burliuk, and illustrations by the three Burliuks, Mayakovsky and himself. These futurist books and booklets, which had begun in 1910, in Petersburg, with the unillustrated *A Trap for Judges*, edited by Matiushin and others, were compilations of anti-conventional poetry and usually images, presented in intentionally eccentric forms. Thus they contrasted sharply both with traditional poetry and *belles-lettres* publications, and with the sophisticated products of symbolist literature and art. To bourgeois tastes, the futurist booklets were ill-mannered drivel. To their admirers they were invitations to adventure into wild, unlimited expression, including overt irrationalism and serious or playful innovation in written and visual language. To the futurists, logically and conventionally organized verbal discourse was bourgeois and too hidebound.[13]

The year 1912 saw also the end of Tatlin's friendship with Larionov. Larionov's restlessness and claims to leadership must have made him as wearying as inspiring a comrade. He saw his artist friends as followers, and expected them to behave as such. Tatlin had not wholly adopted Larionov's embrace of new Western idioms or his sudden preference for Slav traditions and rough primitivism, nor would he adopt the new idiom, rayism, that Larionov delivered and promoted in 1913. Rayism set out to picture the dynamic play of linear elements representing rays of light, sometimes linked to recognizable motifs but often appearing to be without figurative reference, even though the emphasis on rays implies a visual experience. Making such rays prominent recalls the Italian futurists' exploitation of lines of force (*linee forze*). In this sense, Larionov's rayism can be seen as a contribution to international futurism. Moreover, with its emphasis on the appearance and actions of light, it recalls impressionist painting, including Larionov's own. Tatlin continued to organize, and partly to appear in, exhibitions of a primitivist sort — now distancing himself from the modernism of Paris as well as the conventional art of Russia by being emphatically non-Western. Dominated by Larionov's and Goncharova's paintings, these exhibitions included icons, children's art, painted shop signs and *lubki* (singular *lubok*: traditional block-printed and often hand-coloured broadsheets produced for the unschooled public since the seventeenth century). Many of these were from Tatlin's own collection.[14]

Tatlin now moved into another flat and studio. He lived there in a very simple manner, though we are told that, exceptionally for this date, he had a telephone.[15] He found a new artistic circle forming around himself. His studio became a collective place of work for his artist friends and a place for informal teaching and discussions, with Tatlin tacitly seen as the leading figure among them. Among the regulars in what was nicknamed 'the Tower'[16] were Alexander and Viktor Vesnin, former art students but later well known as architects,

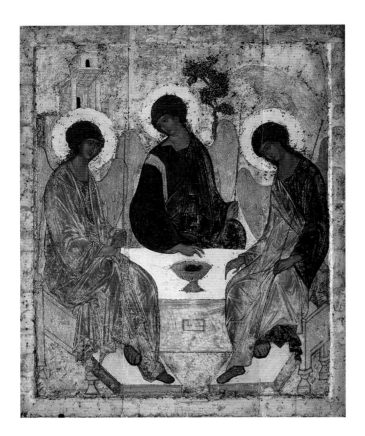

2. Andrei Rublev, *Holy Trinity*, 1422–7, icon on panel, 142 x 114 cm. Tretyakov Gallery, Moscow

and the painters Lyubov Popova, Nadezhda Udaltsova and Vera Pestel. Malevich was an occasional visitor. Tatlin's relationship with him, not unfriendly at this stage, was to turn into open rivalry as Malevich became more of a leader and sought to build up a following for an art wholly different in principle and direction from Tatlin's. It is said that Tatlin, like Malevich, could be secretive about his work and somewhat withdrawn socially, though an admired speaker and reciter. His intimate circle seems to have been both close and relaxed, sharing ideas and joining in experimental work, notably in trying to make sense of the cubism some of them had sought out in Paris.

Cubism proposed not a defined style or method but a range of possibilities. For some artists, from 1911 on when it became known in Paris as a new movement with a name, but also in other countries, cubism was a way of adding surface stylization of a modern flavour to traditional representations. Examples of the work of Pablo Picasso and of Georges Braque, who initiated cubist painting and sculpture in 1909–12, could be seen in Russian exhibitions and collections, but the work of the wider circle of cubists was more easily assimilated and adapted. Thus young artists in Moscow and Petersburg could have first-hand knowledge of cubism from visits to Paris, local exhibitions and Moscow collections and, at second-hand, from publications and from other artists who returned from Paris with illustrations of new art as well as gossip. When Italian futurism added its idioms and subjects to the mixture, it became possible to take a range of positions vis-à-vis the Western avant-garde.

3. Vladimir Tatlin, *Composition-Analysis*, 1913, pencil, gouache and watercolour on paper, 49 x 33 cm. Collection A.A. Kapitsa, Moscow

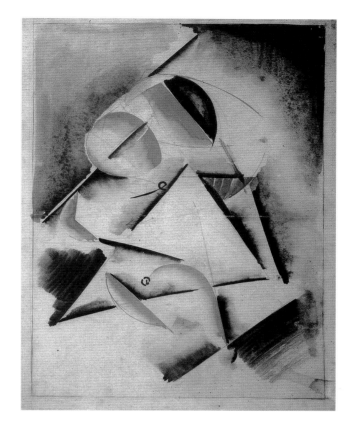

Tatlin's professional interest in new Western art contended with his engagement with traditional Russian religious painting, especially icons (fig. 2). He studied and practised the old art under a professional icon painter, though it is not clear exactly where or when. As Strigalev suggests, Tatlin was perhaps consciously looking for an alternative path to those opened by cubism.[17] The critic and art historian Nikolai Punin (1888–1953) would later assert that Tatlin owed more to icons than to the work of Picasso.[18] During his Penza years, Tatlin had visited Novgorod to copy ecclesiastical murals and study the imagery and techniques of the city's icons.[19] He extended this interest to Western religious paintings. His *Composition-Analysis*, dated 1913 and described as a 'sketch', is evidently an analytical study of a Renaissance *Madonna and Child* of around 1500 (fig. 3). Leonardo da Vinci and Cranach are both adduced as possible painters of the original, but none of the comparative examples offered quite fits Tatlin's analysis. This is not in itself significant; there are many Italian paintings of this type and date, one of which may have been in Tatlin's mind, though Zhadova inclines to a Cranach. The important point is that he was looking for the main structural functioning of images he admired.[20] He pursued this in his independent paintings and drawings of the period. Moreover, his analytical approach announces one of Tatlin's two strengths, often found working together: an urge to look deeply into the functioning of things, including images and materials, and a complementary approach which is visionary and holistic.

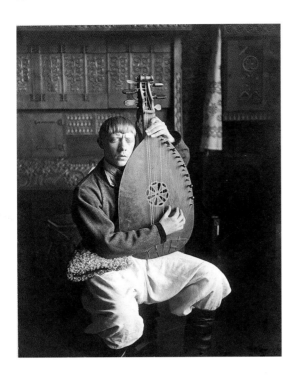

4. Vladimir Tatlin at the Russian Exhibition of Folk Art, Berlin 1914. Collection Russian State Archive of Literature and Art (RGALI), Moscow

Another aspect of Tatlin's activities must be mentioned at this stage; it is referred to by many of his contemporaries. The artist who, we are told, carried poetry in his head and was praised for the vigour and sensitivity with which he could recite it, including long poems by his friend Khlebnikov, was also passionate about folk music and the instruments it called for. He carved and constructed a number of such traditional instruments himself, and is said to have played them well, singing folk songs to his own accompaniment. In 1914 he was invited to join a band of musicians going to Berlin to perform at a Russian folk art exhibition in the well-known Wertheim store. Dressed like a peasant, and sporting a suitable haircut, he performed as a blind musician, accompanying his singing on a large bandura or *domra*, a multi-stringed instrument of the lute family (fig. 4).

Tatlin owned and played a number of banduras over the years, and is thought to have made some of them. Photographs show him playing them around 1910, in Berlin in 1914, and then also in the 1940s. The instruments vary in form. One of them, in the Glinka Museum for Music in Moscow, was probably made by Tatlin. From 1913 or 1914 on, the investigation and full exploitation of materials was his central concern as artist. In view of this, it is interesting to note that the Glinka Museum's bandura is made from several kinds of wood including maple and pine, and metals including brass, with plastic bridges raising the strings above the body of the instrument. The bandura is associated with Ukrainian folk music. Wandering singers had accompanied themselves on it when singing religious and secular verse, but by 1900 there remained very few performers on this largely forgotten instrument. Tatlin seems to have discovered it in his youth, learnt its use and the music associated with it, and never abandoned it. He could also accompany himself on a guitar or a harmonium.[21]

Early paintings, drawings and stage designs

The young Tatlin displayed characteristics that would be significant for his adult life and work. He valued freedom as well as committed, ongoing study. Running away from home at fourteen or fifteen and then being excluded from his art school, probably for political reasons, imply self-direction and independence, as does his returning to sea in the midst of his art studies. Becoming a seaman means acquiring essential skills, accepting discipline and working collaboratively, often under pressure. Going to sea may well have seemed the opposite to going to art school, and in some respects it must have been. On the other hand, art schools at a time of anti-academic initiatives — especially the Moscow College of Painting, Sculpture and Architecture where Larionov and Goncharova studied during 1898–1908, Malevich in 1904–5 and Mayakovsky in 1911–14 — could be lively places stirred by contradictory impulses, especially after the 1905 Petersburg massacre and the major strikes that followed it.[1]

Tatlin demonstrated an early inclination to work with others while determining his own path. Having worked in an icon workshop and among a group of painters of theatre sets, he attracted other artists to his studio. His work for futurist publications and designing for the theatre meant engaging with other professionals, writers, theatre directors and craftsmen. After the October Revolution, as we shall see, he regarded working with a collective as the correct programme for the new society, but this recognition came easily to him. The study and practice of icon painting had also implied commitment to an impersonal discipline as opposed to a desire for self-expression. His study of Old Master paintings, together with his study of Russian ecclesiastical art, sharpened his sense of the role of forms and divisions in two-dimensional art. He was both focused and peripatetic in his development as an artist.

Nothing in Tatlin's studio work promises a move into three-dimensional art, except that some of his paintings, of 1911 and after, have in them elements that can be read as three-dimensional accents, and of course his stage designs were partly for realization in three dimensions. The first of these designs are emphatically flat in character, even heraldic, yet we should imagine his costumed figures moving in front of his symbolical and decorative backdrops. His stage designs for *A Life for the Tsar*, in 1913–14, become emphatically

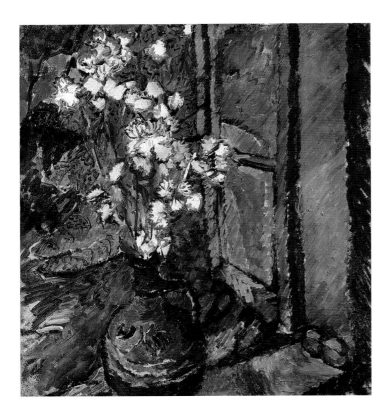

5. Vladimir Tatlin, *Carnations*, 1908, oil on canvas, 73.5 x 66.6 cm. State Russian Museum, St Petersburg

6. Vladimir Tatlin, *Still Life* (*Flowers*), 1912, oil on canvas, 71.5 x 71.5 cm. State Russian Museum, St Petersburg

7. Vladimir Tatlin, *Sailor* (*Self-Portrait*), 1911, tempera on canvas, 71.5 x 71.5 cm. State Russian Museum, St Petersburg

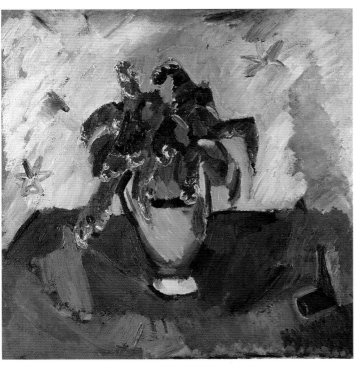

three-dimensional, even sculptural in the case of the village scene, though he still presents his costume designs like cardboard figures for a toy stage. Nonetheless, here, as with the later designs for *The Flying Dutchman*, we are made conscious of space and of movement in that space.

His paintings of around 1910 are mostly flower still lifes in oil on canvas, modest in size (figs 5, 6). They are confident works, with brushmarks often laid side-by-side in a constructive manner that suggests some knowledge of Van Gogh but does not adopt his way of enhancing colour by juxtaposing complementaries. The settings are as firmly noted as the motifs, so that there is little sense of foreground and background. For his self-portrait as a sailor, dated 1911, Tatlin used tempera like an icon painter in flat patches of colour, especially for the face, and juxtaposed brushstrokes for the clothes (fig. 7).[2] He used longer, graphic strokes to indicate the sketchy figures of two other sailors appearing on either side of his head, read as further back on account of their scale and lack of definition. The colour here is concentrated and muted: blues and greys for much of the image, with hints of pink, and his face and neck in flat, unmodulated ochre. The implied drawing is bold and concise. The form of the fine head and powerful neck is suggested partly by gaps left in the paint, so that the white canvas becomes part of his design. The composition has in it echoes of traditional icon painting, most obviously the head itself and the smaller figures in the margin. The square format and the central head with its emphatic arcs together hint at the most significant of all Orthodox icons, the legendary image of *The Saviour Not Made with Hands*.[3]

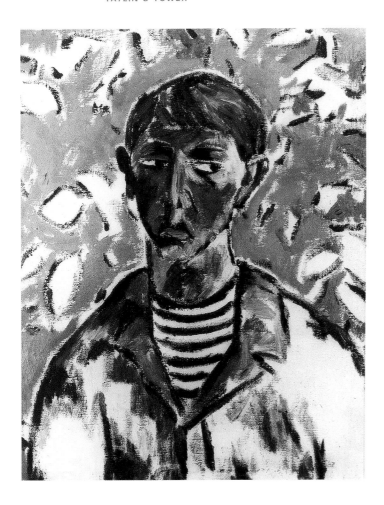

8. Mikhail Larionov, *Portrait of Tatlin in Seaman's Blouse*, 1908, oil on canvas, 76.8 x 59.1 cm. Jay Cantor, Los Angeles, California

9. Vladimir Tatlin, *Fishmonger*, 1911, oil on canvas, 76 x 98 cm. Tretyakov Gallery, Moscow

Larionov made two portraits of Tatlin. One, painted around 1908 and now in California, presents an image, sketched with the brush, of the young man's head and shoulders against a background of flowered wallpaper (fig. 8). Tatlin is shown frontally but looking sharply, nervously, to our right.[4] The second, larger portrait shows Tatlin's head and shoulders, but he is now naked, tougher, adult (fig. 1). Tatlin's head is in much the same position, but now the eyes are looking at us. His features have become sharper, the expression is more determined. Contrasts of tone and colour assert the forms of the face; the athletic body, in ochres and green, is more generalized. Everywhere emphatic brushstrokes break up the otherwise flat composition; they could well have been added in 1913 as demonstrations of rayism.[5] This would suggest that Larionov made this portrait in 1911 or 1912 and then reworked it in 1913, updating it stylistically. By this time his friendly relationship with Tatlin had ended, and it must have been at this later date that the figure '28' and the letters 'G' (roman style) and 'BA LDA' (Cyrillic) were added. Tatlin was twenty-eight in December 1913; the letter 'G' might stand for *god* (at age of). 'BA' is inscribed over the sitter's left cheek; 'LDA' further to the right, as though floating in front of the background. Together they spell 'blockhead'.[6]

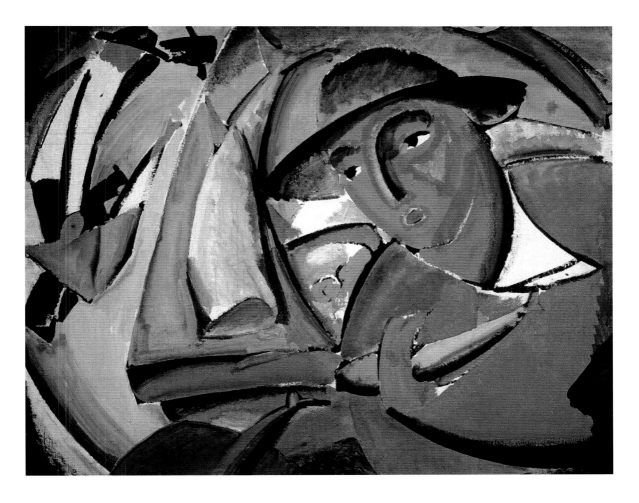

Tatlin's *Fishmonger*, 1911 (fig. 9), is both loosely painted and firmly constructed, like his self-portrait. Its firmly constructed image is proposed by powerful arcs which suggest space while confirming the picture surface. The fishmonger's counter sweeps up and into space behind him, but then returns in the top right corner to show it is really a form lying flat on the canvas. His head and hat imply three dimensions: the ovoid head, its plasticity enhanced by the curve establishing the left eyebrow and nose in one sweep, seems to penetrate the tilted disk that is the brim of his hat and is sensed as a plane set at a right angle to the face. Tatlin exhibited these two paintings in early 1912: *Fishmonger* together with his 1911 designs for a Moscow production of *Tsar Maximilian* in Petersburg during January–February, and *Fishmonger* again together with the self-portrait and several other paintings and drawings in the 'Donkey's Tail' exhibition in Moscow in March–April. His break with Larionov occurred that autumn.[7]

Tatlin's interest in the formal priorities of Russian religious painting, and perhaps of Persian and even Chinese calligraphic painting, at a time when cubism and cubo-futurism tended to dominate modernist tendencies in Russia, needs attention: Tatlin's innovatory

10. Lyubov Popova, *Female Model*, c.1913, pencil on paper, 26.5 x 20.5 cm. Irkutsk Regional Art Museum

11. Vladimir Tatlin, *Standing Nude*, 1912–14, pencil on paper, 33 x 22 cm. Thomas P. Whitney Collection, Washington, Connecticut

12. Vladimir Tatlin, *Male Nude, Rear View*, 1913, pencil on paper, 42 x 26 cm. Collection of D.V. Sarab'ianov, Moscow

work of 1913 and after stems mainly from this dual impulse. The life drawings of male and female models made in the 'Tower' studio, principally by Popova, Alexander Vesnin and Tatlin himself, shed some light on this. The question of naturalistic drawing *versus* cubist analysis and simplifications was central to them. At times they shared sheets of paper, perhaps to comment on each others' work, and the authorship of particular drawings is not always certain, nor their exact dates.[8] Looking through them makes it clear that the wish to show the human body in cubist terms was strong and enduring in the work of Popova and Vesnin, but rarely prominent in Tatlin's. They sought occasions for finding straight lines, preferably at right angles to each other, with which to set out the figures' structure — in Popova's drawings also circles that can indicate breasts and the major joints, sometimes with a strong volumetric emphasis reminiscent of Léger — and impose a mechanistic reading that echoes aspects of cubism (fig. 10). By contrast, Tatlin increasingly simplified the lines with which he noted the figures' main elements and eliminated any suggestion of solidity or weight (fig. 11). In 1910 he still drew figures in a manner that would have been recognized by the academies. By 1913 he was drawing them in long, often delicate lines,

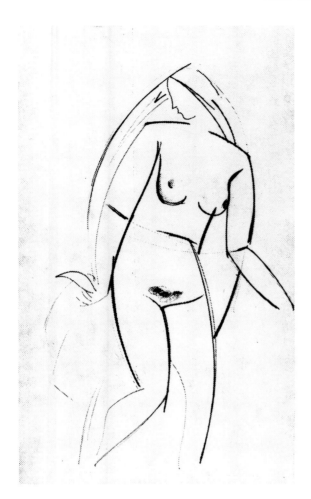

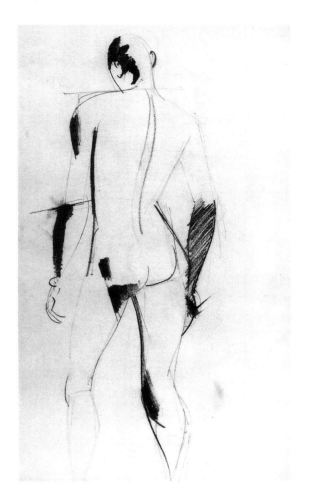

adding a more emphatic stroke here and there, so that the result is a rhythmic pattern of lines (fig. 12). In both cases the observed object is transformed to become a pictorial image. His friends were adopting a new conception of the human being as an inhabitant of an urban and technological world.[9] Tatlin, without suggesting a particular time or environment, simplified his lines to demonstrate his essentially graphic art, echoing the grace of Persian miniatures and Oriental calligraphy, as well as the more austere lines Rublev and other notable Russian icon painters had used centuries earlier.

When Tatlin contributed to two futurist booklets, in 1912–13, he made free-hand sketches that fit their rough-and-ready presentation. The first of these was a humorous sketch to go with a short Khlebnikov poem in *Worldbackwards* (fig. 13). It shows a fierce duel between two fez-wearing men. It looks childlike but results from a considered process of reduction, with curved lines providing essential information about the figures and their actions. For *The Service-Book of the Three* (Moscow 1913), Tatlin drew an image for Mayakovsky's poem 'Signboards' (fig. 14). It too is sketchy, hinting at rather than describing its contents: a knife and a fork stuck into a large fish on a little oval table and, separate from these as though in

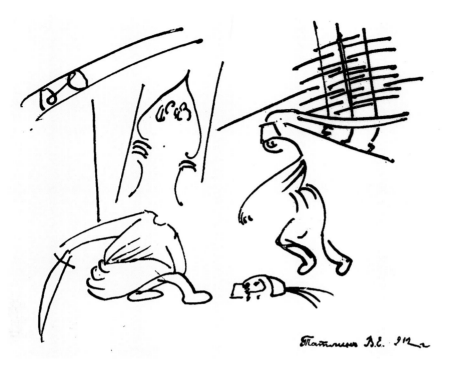

13. Vladimir Tatlin, illustration to a poem by Velimir Khlebnikov in *Worldbackwards*, 1912, lithograph, 18.6 x 15 cm

14. Vladimir Tatlin, illustration to a poem by Vladimir Mayakovsky in *Service Book of the Three*, 1913, lithograph, 21 x 17.6 cm

15. Vladimir Tatlin, illustration from *Service Book of the Three*, 1913, lithograph, 21 x 17.6 cm

another space, an almost cubic box with lettering on it. The shapes of the fish and the table invite curved lines; otherwise the sketch consists mainly of scribbled areas of black. A second Tatlin drawing in this booklet is a skilful, summary sketch of the head of Vladimir Burliuk. A third Tatlin drawing accompanies a poem by Burliuk. It shows the figure of a house painter, probably on his way home from work, a long-handled whitewashing brush over his shoulder and a pail dangling from it (fig. 15). There is some shading in this image, but mostly it is a structure of arcs that depicts the man and his enveloping clothes, jacket, trousers and boots. Comparing the 1912 illustration with this one of 1913, which looks sketchy but is a more refined work, clarifies the distinction between curved lines suggesting and exaggerating an action, as a caricature might, and Tatlin's arcs that can convey the pose of a figure and, with or without added shading, endow it with physical reality.[10]

Work on the costumes and sets for *Tsar Maximilian* during 1911 had prepared Tatlin for these choices. Russian artists took a keen interest in drama and in theatrical design, and theatre companies frequently involved artists in their productions. Drama played a more incisive role in Russian debates than in the West. Generally, throughout Europe, production and stage design were being reconsidered as key elements in delivering a play's message, especially after Wagner's creation of a new kind of opera house at Bayreuth (which opened in 1876 and began its annual Wagner festivals in 1882). In the 1890s came Adolphe Appia's rejection of the naturalism that had guided Wagner's productions in favour of settings made suggestive, sometimes symbolical and often psychodynamic, by simple divisions of the stage and by subtle lighting and colour. Naturalism combined with psychological realism had been the basis of Stanislavsky's productions at the Moscow Art Theatre from 1898 on.

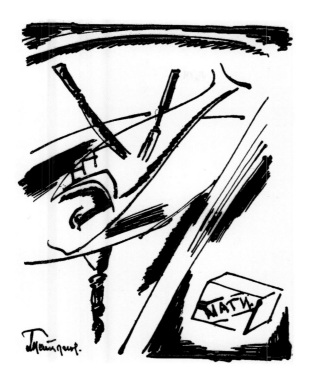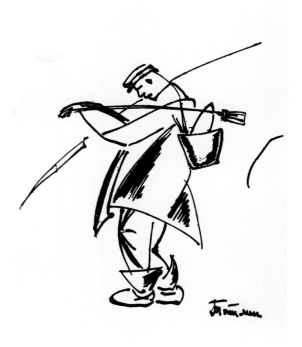

His aim was to make the theatre what Tolstoy had written it could be: 'the most powerful pulpit of our time'. Rather than serving art as art, Stanislavsky asserted, the theatre 'must … be the teacher of society'.[11] The symbolist theatre associated with Maurice Maeterlinck, Edward Gordon Craig and in Russia outstandingly with Vsevolod Meyerhold's productions from 1906 on, countered this by bringing in minimalist and often anti-naturalistic ways of suggesting dramatic and emotional situations rather than illustrating them. A key source for this, and at times the basis for new drama, was the Russian heritage of national epics and folk legends, and the illustrations associated with publications of these, often by artists distancing themselves from academic conventions.

Tsar Maximilian and his Disobedient Son Adolf was based on a popular Russian play of the late eighteenth century — a farcical as well as fairy-tale re-telling of the fatal conflict between Peter the Great and his son Alexei. It exists in several versions. It was staged in Moscow in November 1911 using Tatlin's sets and costumes. His contribution could not be overlooked:

> The decisive rhythmic qualities in particular stressed the action of a scene, its distinct character or mood, yet were clearly artificial and in evidence as painted and designed works in themselves.[12]

His designs for the backdrop for 'Maximilian's Tent' and for 'Maximilian's Throne' take us into the realm of folk art (fig. 16). They have something of *The World of Art*'s elegance, but there is more in them of Ivan Bilibin's admired illustrations of folk tales, mostly published

during 1900–10, and his theatre designs for Diaghilev, Meyerhold and other directors during 1908–14, than of the earthier primitivism found in Larionov and Goncharova's paintings of 1908 and after. Diaghilev's embrace of this folk-based primitivism, in a glamorized manner, became patent in 1914 with Goncharova's designs for *Le Coq d'Or*, and in 1915 with Larionov's designs for *Le Soleil de Nuit*. So Tatlin was pointing in the direction Diaghilev's designers would develop further and export to the West. His costume designs are full of fun and, usually, bright colours. His stage sets are in bright colours too, and arranged more or less symmetrically, bringing together decorative items, such as flowers and shrubs, heraldic cockerels and soldiers with halberds, pictured as flat forms and using the irrational scales familiar in folk-tale imagery. Some of the characters so vividly sketched by Tatlin exhibit the structural arcs he was finding, or was about to find, in his studies of nude figures (figs 17, 18).

These arcs dominate his next stage work, a large group of designs and models he made in 1913–14 for Mikhail Glinka's *A Life for the Tsar* of 1836, considered the first national Russian opera and one that uses folk music and dance. Its patriotism and theme of self-sacrifice for the greater good made it an apt message-bearing entertainment after the revolutions of 1917, when it became known by its peasant hero, reverting to the title Glinka

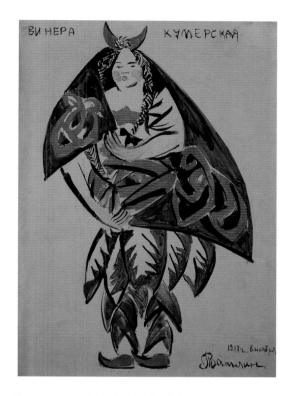
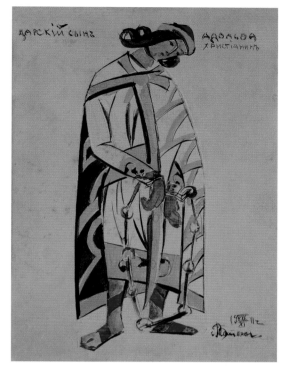

Facing page: 16. Vladimir Tatlin, 'Maximilian's Throne', set design for *Tsar Maximilian*, 1901, pencil and watercolour on coloured paper, 49.5 x 55.5 cm. State Russian Museum, St Petersburg

17, 18. Vladimir Tatlin, 'Venice from Kumer' and 'Tsar's Son', costume designs for *Tsar Maximilian*, 1911, pencil and gouache on paper, 23 x 17 cm. N. Punin Archive, St Petersburg

had intended for it, *Ivan Susanin*. Tatlin's designs demonstrate his populist reading of the opera. The peasants are its heroes; the boyars and the soldiers of several sorts are mocked, by means of subtle variations of idiom. Tatlin's sets and costumes speak the language of arcs almost throughout, curved lines answering curves, curves repeating, curves converging and separating. This is most evident in the pure line drawings he used in developing these designs. He tested his ideas in quick sketches but as the designs became critical he would often trace them in line alone as flat, controlled linear structures, without shadows or other suggestions of mass or space. Even where some overlapping of forms is implied we do not sense recession. What we do sense is regularity and intelligent construction. The peasant girls' costumes were drawn mostly with ruler and compasses.[13] Firmly drawn arcs certainly dominate the linear construction representing 'A Peasant Girl'; some of its freehand lines look as though they are confirming indications given by compasses. 'A Soldier of the Imperial Guard' exaggerates the idiom, swinging the marching figure through a rising curve, emphasized by the placing of touches of ochre and black gouache to add a hint of satire. The assertive straight lines and curved blade of the halberd make the man look even more ridiculous. Tatlin would use much the same simplified lines when drawing his designs for everyday clothing a decade later.

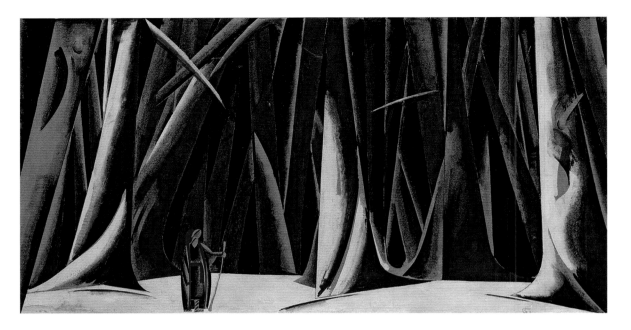

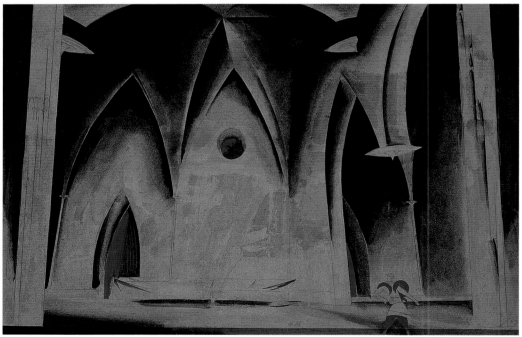

19. Vladimir Tatlin, 'The Forest', stage design for *A Life for the Tsar* by Mikhail Glinka, 1913, distemper on card, 54.4 x 95.5 cm. Tretyakov Gallery, Moscow

20. Vladimir Tatlin, 'Polish Ball', stage design for *A Life for the Tsar* by Mikhail Glinka, 1913, lacquer, ink, pencil, distemper and watercolour on card, 55.4 x 93.2 cm. Tretyakov Gallery, Moscow

The same elements were used even more strikingly for the scenery. 'The Forest' is all rising lines (fig 19). The hall of the castle for the 'Polish Ball' is less dense but uses much the same lines, straight and curved, to suggest a Gothic interior that leans over the actors like the sets built for German expressionist films in 1919–20 (fig. 20). The set for 'The Village of Domino' is almost all straight lines, many of them horizontal, to suggest buildings and then also floating shapes that are at first clustered to suggest a background of fields, but then become independent, non-descriptive forms. The watercolour in which Tatlin represented this scene is mostly in browns, greens and black. The buildings of the village are in light and dark browns; part of the ground and the backdrop are black; and the straight-edged three- and four-sided planes that are part of the backdrop, or hover in front of it, are in soft, smudged greens over cream. If they were indeed intended to hover between the village and the backdrop, they may represent Tatlin's first projected work in real space. The summary forms that make up the village would establish a first plane. Between this and the background Tatlin may have intended to suspend these boards or stretched-canvas forms, themselves appearing to be tilted in space. Figures indicate the substantial size of all these elements.

The chastity and precision of the lines Tatlin used in these drawings remind us of John Flaxman's creation of neoclassicism's graphic idiom in entirely linear illustrations of time-honoured texts, published in the 1790s and of great influence throughout Western art. Tatlin repeated his designs with charcoal shading added to exactly the same lines, and then also with colour, presumably via rubbings taken from his traced working drawings to retain their economy and firmness. He was working for himself, without a production in view, but the opera was popular and had recently, in 1911, been made into a film. Almost all the dated drawings are of 1913. He exhibited them, together with models of the proposed set, in three exhibitions opening in 1913–14, two of them 'World of Art' exhibitions in Petersburg and in Moscow, one of them an exhibition of Moscow artists at the end of 1914. Critics took opposing views of this work, some of them responding very positively to what they saw as an original fusion of modernism and the Russian theatrical tradition. One writer saw the designs as a major artistic effort in the cubist manner and refreshingly new; another called them 'the most interesting designs in the theatre in the last few years' that should certainly be realized on somebody's stage.[14]

During 1915–18 — that is, the war years and the first post-Revolution months when he found himself employed by Lunacharsky's Ministry of Education — Tatlin worked with great seriousness on another uncommissioned project: the set and costumes for Wagner's *The Flying Dutchman*.[15] Presumably he was captivated by the opera's power as well as his own experiences as a seaman. The costume drawings show the same long arcs used for *A Life for the Tsar* and some of them are in unshadowed line only. The sketches and more developed drawings he made for the set are almost exclusively in straight lines set at many angles, close to the horizontal and also rising sharply, none of them quite horizontal or vertical. In this way he suggests a mighty sailing ship in a parlous state: the masts should not be at such odd angles to each other, the sails, where visible, have been furled to escape the storm, the decks and rigging seem to be giving way, while a dark but luminous blue indicates nature's presence as sea and sky. Tatlin pictured this scene in an oil painting measuring 87 by 156 centimetres, in light and dark browns and greys as well as this blue (fig. 21). Its overlapping planes and many angles may suggest some influence

21. Vladimir Tatlin, 'Ship's Deck', stage design for Richard Wagner's opera, *The Flying Dutchman*, oil on canvas, 87 x 156 cm. Bakhrushin Museum

from cubism, but perhaps it would be better to think here of the liberties Parisian cubism brought into pictorial construction rather than of any particular cubist example. More importantly, this painting, although admirable, can only broadly indicate Tatlin's intentions: the stage set would be a constructed array of planes and ropes, wires and canvas, situated in real space.[16]

Tatlin's stage designs up until *The Flying Dutchman* show him responding creatively to the specific context of the theatre and the opera house, its essential purpose being to deliver a significant discourse, grave or humorous, to a wide public. The format invites their attention; the designs support and satisfy it, enriching the experience by underlining and driving home the production's message and leaving a memorable imprint of it. Tatlin achieved this through a process of analysis as much as through his sympathy with the dramatic character and particular concerns of each piece. *Tsar Maximilian* and *A Life for the Tsar* led him to concentrate on old-Russian themes, and a formal language that had recently been explored by archaeologists and by artists and designers with a particular interest in formalized idioms. This formal language took Tatlin not only far away from realism but also past cubism and other modernist idioms that were drawing other Russian artists into forms of internationalism. In his designs for *Tsar Maximilian*, with its broadly entertaining script, Tatlin was showing himself to be one of the new artists who engaged with Russian folk traditions as an essential, invigorating resource. In making his designs for *A Life for the Tsar*, serious in content but also essentially optimistic, he was continuing in this vein to give reality to the all-embracing Russianness of Glinka's opera. To achieve the dynamism and patterns involved in this, he structured his designs more and more in linear terms, using many more long arcs now than straight lines. In the case of Wagner's opera *The Flying Dutchman* he engaged with a Western work based on a relatively simple plot rooted in Romantic mysticism, ending with the death both of the protagonist and of the woman whose love should

save him from needing to sail the seas for all eternity. The subject had special meaning for the experienced sailor. It must have had additional poignancy in the context of European war. Tatlin's costume designs for it are still primarily set down in long arcs, but the stage is rendered in dramatic clusters of straight lines, against which the moving curves of the performers would have been doubly expressive.

We find the same analytical process in two paintings of female nudes, both made in 1913, a climax to his pursuit of life-drawing. *Nude 1* was shown that year, in Moscow in February/March and in Petersburg in April, in two Knave of Diamonds exhibitions. Tatlin's willingness to show with this group is evidence of his detachment from Larionov and closer engagement with the Burliuk circle of painters and poets, including Khlebnikov.[17] Through the group he became aware, at first hand, of some of the more important Parisian painters, notably Robert Delaunay,[18] as well as the Munich Blaue Reiter group centred on Kandinsky and Marc for whom Delaunay had become an important model. In their different ways, all these artists were asserting the work of art's independence from the visual world as normally described, and the superiority of painterly expression over realistic subject matter and factual accuracy. Milner quotes part of Olga Rozanova's incisive article 'The Bases of the New Creation and the Reasons Why it is Misunderstood', printed in the March 1913 issue of the *Union of Youth* journal, which Tatlin would have received as a member of the association. Rozanova argued that modern art was being liberated 'from the alien traits of Literature, Society, and everyday life', and that painting now called for a 'constructive reworking' (*konstruktivnaia pererabotka*), revealing the essential nature and demands of painting.[19]

The Russian term 'constructivism' (*konstruktivizm*) did not come into use until 1921. But 'construction', 'constructive' and 'constructivity' (a Russian concept) were in use before then, for two-dimensional as well as three-dimensional art.[20] Paul Cézanne had spoken of 'constructions after nature', and insisted both on nature as artists' essential source and on the concrete character of the result, unmediated by literary considerations that could lead art to lose contact with the intense experience of the world, which was always the basis of Cézanne's work.

Nikolai Punin wrote later that Tatlin, in his earliest paintings, consciously followed Cézanne's example, but that subsequently 'the influence of the Russian icon on Tatlin is undoubtedly greater than the influence on him of Cézanne or Picasso'.[21] All three were available to him: about twenty-six Cézannes in the collections of Ivan Morozov and Sergei Shchukin, also Picassos in both collections, and icons everywhere, collected as art since the 1890s and in daily secular and ecclesiastical use as sacred devotional objects. Another understanding of Cézanne and of what was becoming known as post-impressionism was on offer through the Matisse paintings acquired by Shchukin from 1908 on, particularly the large *Dance* and *Music* canvases of 1910. Matisse came to Moscow in 1911 to install them on Shchukin's staircase after they had been shown, and mocked, in Paris. He also rehung the smaller Matisses in his friend's collection, making one of Shchukin's reception rooms a Matisse gallery. Moreover, he expressed publicly his admiration for Russian icons, asserting their importance as a base for modern art. Matisse's *Notes of a Painter*, published in France in 1908, had been translated and published in Russian the year after. Its essential message is that, though art springs from the artist's engagement with the visible world, it delivers his intuitive grasp on it through bold departures from naturalistic representation in order to embody and transmit his experience: 'I want to reach that state of condensation

of sensations which makes a painting'.[22] (Malevich's emphasis, in late 1915, on the role of sensation in suprematism may be an echo of this.)

In an essay of 1918 Punin would define 'painterly materialism', with which he credited all the progressive ('leftist') painters around him, as exploring 'a self-contained and constructive system of forms and marks', adding that this was a broad category of art, 'particularly applicable to that from Cézanne until today'.[23] In 1920–21 Punin wrote about Tatlin in the essay he entitled, presumably with his friend's agreement, 'Tatlin (Against Cubism)'. Exaggerating a little, he stated in it that when Tatlin was beginning to paint 'Cézanne was reigning supreme', and the young man emulated him 'as best he could' whilst also trying to go beyond him. The cooperative analytical study that went into life drawing in Tatlin's studio reflected also the syncretic figure work of cubism's 'father', Cézanne. His geometric method, which called for attention to cones, spheres and cylinders as forms underlying those of nature, was promulgated in France, and was known in Russia. The curves structuring Tatlin's drawings are not those of geometrical forms, yet they too can be found in Cézanne as well as in the flat painting that came out of Gauguin, well represented in the great Moscow collections. They are prominent also in the pre-cubist Picassos of 1907–8 owned by Shchukin, and have heroic presence in Matisse's large canvases *Dance* and *Music*. In gentler forms, they dominate some traditional icon paintings, most obviously Andrei Rublev's Old Testament *Trinity* (fig. 2) which shows the three archangels as a polyphonic arrangement of long curves. Rublev's icon, newly revealed after cleaning in 1903, was the subject of an early book by Punin, who noted its echoes in Tatlin's figure drawing. Punin had studied law, history and then art history, was part of the new Russian art department in the Russian Museum when it was formed in 1913 and from this time on worked multifariously, before and after the Revolution, as teacher, writer and organizer of art institutions and cultural pressure groups.[24]

Tatlin's two paintings of nudes of 1913 demonstrate his grasp of the issues confronting painting at that time. The two figures are posed in a traditional manner, inherited from the broad nineteenth-century stream of figure studies without narrative or symbolical functions: they are seated and inactive. Tatlin explores in them principles of painting which Rozanova had indicated in 1912–13, so much so that one is tempted to assume some productive dialogue between the two artists. *Nude 1* (fig. 22) is subtitled 'Composition based on a female nude': we are not to see it as the direct study, but as a painting developed from a study. It is a very powerful work, a vertical canvas 143 centimetres high: the woman is well over life-size. She is firmly abstracted in terms one could call iconic if Tatlin's use of great arcs for her outline as well as for forms within it did not give the figure an emphatically three-dimensional character by non-naturalistic means. The arcs are read as shadows as well as lines establishing forms, partly because they are in fact painted as such, their darkness tapering away into the body, and partly because they appear also in the red material of the model's seat and in the blue cloth hanging behind her. Yet there is no sense of directional lighting: if these dark forms are shadows, they fall arbitrarily and are both cancelled and enhanced by strong white arcs on the model's body. The result is that the figure can be seen as both firmly three-dimensional and as flat. In fact, the lines seen within the figure, which can be almost imperceptible threads of white (e.g. for her left elbow) and black arcs (as for her left wrist, where an arc is combined with a white edge), deliver the turning form of a joint in the minimal, non-three-dimensional way introduced by Matisse

into his post-fauve paintings of 1908. The painting gives no hint of the cubism that Tatlin's friends had seized on.

The other nude, *Nude 2* (fig. 23), was never exhibited in his lifetime, which may suggest that it was a particularly significant work for Tatlin but perhaps also one that might counteract the public image he wanted to establish. In surface area it is not much smaller than *Nude 1*, but the canvas here is oblong, a little over one metre high. The woman sits on a box that, in spite of the perspective indicated by its short sides, gives little sense of a solid object. The figure, too, is almost without weight or volume; the question of how large she would be in real life does not arise. She seems in-turned, meditative and remote from the viewer, a contrast with the more challenging presence of *Nude 1*. The red cloth falling behind the figure in *Nude 2* is gently modulated in tone and hue. The long arcs we find in it are understated versions of those in *Nude 1*, so that the whole picture is unassertive, silent, a rhythmic arrangement of areas of three colours, again without any possible connection to cubism. Margit Rowell, contrasting Tatlin's paintings of this time with Malevich's figure paintings, sees Malevich's as 'assemblages of separate and discrete planes, whereas Tatlin's no matter how schematized, retain a fluid continuity'.[25]

What Rozanova called 'the internal demands of the painting' dominate here, almost cancelling out the representation of a living being. In these two paintings, particularly, we see that Tatlin was prioritizing 'rhythm and proportions, an underlying geometry and *faktura*, the handling of these materials'.[26] In 'Tatlin (Against Cubism)', Punin spelled this out:

> Colour understood as material inevitably led to work on materials in general. His professional consciousness found such material first of all in the surface intended to be the painted surface.[27]

Presumably at Tatlin's instigation, Punin was here announcing an analytical and constructive painting process that the artist would soon after pursue in reliefs. Paint and the flat canvas are material elements by means of which the painter asserts the reality of his pictures, only indirectly related to the reality of the motif. That motif too can become something like a material component. We non-artists bring all sorts of notions to the idea of life-drawing. For artists who work for many hours, day after day and often over years, in order to draw or paint the figure in a way that satisfies them, the model becomes another part of the 'material' to which Punin refers. In earlier paragraphs, Punin attacked the aestheticism and individualism that ruled even the most advanced art of Paris, and contrasted it with Tatlin's acute 'eye', looking more deeply into the essential roots of art. Before turning to 'colour understood as material' Punin had asserted that traditional Russian painting, before the time of Peter the Great, 'had worked with pigment as a painting material' and that icon painting was 'powerful and healthy'. Thus what could have been read as an adaptation of Maurice Denis's famous statement of 1890, that a painting is 'essentially a flat surface covered with colours arranged in a certain order', becomes an emphasis on the material process. In 1913 Tatlin would produce the slogan: 'Let us place the eye under the control of touch'. By 1922 he had developed a further slogan: 'Through the discovery of material to the new object'.[28]

These two paintings mark a turning point in Tatlin's attitude to the functions in art of seeing *versus* inventing and of designing *versus* constructing. Inevitably the paintings have

22. Vladimir Tatlin, *Female Model* (*Nude 1: Composition based on a female nude*), 1913, oil on canvas, 143 x 108 cm. Tretyakov Gallery, Moscow

23. Vladimir Tatlin, *Female Model* (*Nude 2*), 1913, oil on canvas, 104.5 x 130.5 cm. State Russian Museum, St Petersburg

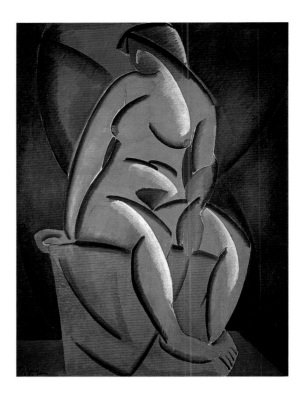

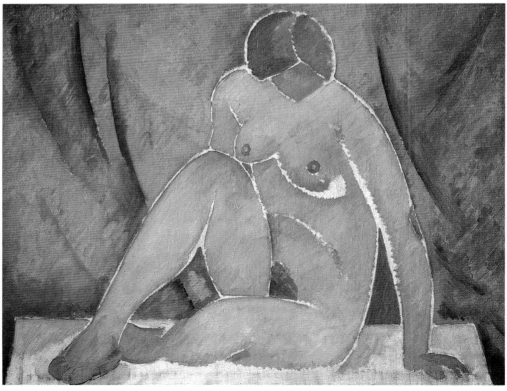

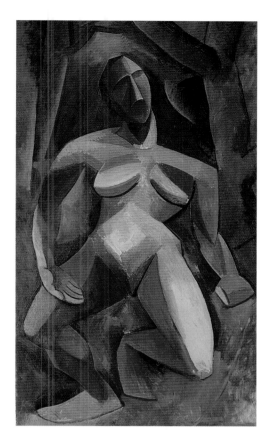

24. Pablo Picasso, *Dryad*, 1908, oil on canvas, 185 x 108 cm. The State Hermitage Museum, St Petersburg

25. Henri Matisse, *Dance*, 1910, oil on canvas, 260 x 391. Archives Henri Matisse

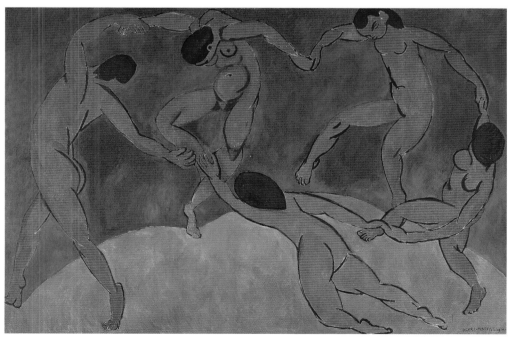

much in common. They are similar in size and start from the same motif. In the case of *Nude 1*, Tatlin simplifies the form and limits his pictorial means so as, first, to assert the physicality of the subject as a volumetric figure with strength and potential energy, and second, to counter this impression and deliver a two-dimensional image. This calls for sophisticated controls and balances. So does foreshortening and projection of parts of the body: volume is offered but is everywhere negated. Meanwhile forms are elided, the powerful marks that act as outlines serve more to connect parts of the body than to identify them. Dark arcs in the red cloth and the background hanging dramatize what would otherwise be passive areas of colour. This differentiates *Nude 1* quite sharply from Malevich's figure paintings of 1912–13, before he turned to his much less descriptive cubo-futuristic style of 1913–14. Malevich dramatically represented his figures of peasants engaged in various activities. He designed them in terms of curved, mostly conical surfaces, emphasized by bright colours and contrasting tones that persuade us of their three-dimensionality, though the lighting implied by the tones is contradictory. So here too volume is stated and negated, though the sense of boldly curving forms remains dominant and the figures appear to be assemblages of such forms rather than organic wholes.

A few similar arcs can be seen in the red cloth which is the background of *Nude 2*. We see in perspective the sides of the box she sits on. There is a hint of shadow right and left of the base, and the dark arcs in the backcloth, combined with lighter tones, do suggest three-dimensionality as revealed by light. But none offers more than a hint of space, while the figure itself is almost entirely flat. Her pose however is emphatically three-dimensional. Her left knee and her right foot should project towards us, as should her head, so sharply inclined towards us that we cannot see her face. But then the information Tatlin provides for any aspect of this woman is so slight that we are tempted to endow the sitter with great delicacy just as we endow the sitter of *Nude 1* with vigour. The right arm of *Nude 2* disappears from sight almost at once. Her left arm is seen in its entirety but as one unmodulated band of ochre with a little dark patch where we would expect an elbow. The torso, though not slight, is left without any weight or force because it is represented as almost a continuous surface. When we question what marks there are by way of internal divisions (as opposed to outlines), we find a crease that could mark the waist, and something we could call shadows under her breast though these are the primed, unpainted canvas. Not only is the figure posed in a remarkably compact manner without appearing forced; she occupies almost no space without quite becoming a flat emblem.

The differences between *Nude 1* and *Nude 2* can be summarized by saying that the former stems from Picasso and the latter from Matisse. The pre-cubist Picasso represented in Moscow by his 1908 *Dryad* (fig. 24); the post-fauve Matisse so brilliantly represented in Moscow by *Dance* (fig. 25) and *Music*, and by smaller canvases. In Tatlin's two paintings, as in these from Paris, pictorial means are displayed openly to demonstrate their force and functions. A few colours, little modulated by tonal variation; a few kinds of brushstroke; forms boldly simplified. Economy rules, without jettisoning poetic expression.

What we cannot find in Tatlin's work is any clear debt to futurism. The illustrations he made for those futurist booklets in 1912 and 1913 are evidence that he was involved with the futurists who edited and contributed to them — Kruchenykh and Khlebnikov, who wrote texts, and co-illustrators Goncharova and Larionov for *Worldbackwards*; the writers Khlebnikov, Mayakovsky and Nikolai Burliuk, and as co-illustrators all three Burliuk brothers

and Mayakovsky for *The Service Book of the Three* — but whether these illustrations are in themselves essentially futurist is questionable and Tatlin's paintings show no signs of futurism. It is not entirely clear what, in Russian futurism, these signs would be. Italian futurism announced themes and methods of a quite specific sort, mechanical energy, human energies as displayed in urban life and insurrection or, combining with machines, in war, as well as the complex of ordinary experience as our minds assemble countless and contrary impressions before sorting them according to our needs. Marinetti's first manifesto gave priority to cars and trains as dramatic extensions of man's power; it was not difficult to celebrate them in words. The first manifesto of the futurist painters addressed the complexity of experience, but it took time for their art to find ways of delivering this convincingly, drawing on symbolism and divisionism and then also on cubism. Khlebnikov said that Russian futurist writers should learn from visual artists. But then many of the writers in Russian futurism had been trained as painters — notably Kruchenykh, the Burliuks, Mayakovsky, Matiushin and Guro — and at this time the avant-garde in any of the arts felt a special kinship as they sought ways to liberate their various art-forms from inherited laws.

These Russians seem to have learnt from the Italian futurists the value of publicizing their work and their theories by means of events and actions of various anti-conventional sorts. Their words, music and visual art would outrage bourgeois society only if contact was made with it, and so they needed to draw attention to themselves. One way was to present performances in various public places — in Italy often theatres, in Russia more often clubs and cafés — in which manifestos could be proclaimed, poems recited, occasionally works of art exhibited but, above all, controversy could be stirred up and furious exchanges could take place between performers and the audience who had come to be shocked. Some of the Russian futurists' activities seem innocuous today, as when some of them walked along the major streets and boulevards of Moscow wearing unsuitable clothing, with signs and symbols painted on their faces and wooden spoons in their buttonholes. David Burliuk sported a top hat and a lorgnon. Mayakovsky suddenly required his mother to make him a shirt-like tunic from thick cotton printed with broad yellow and black stripes. This became a brand image for him, and the police tried to prevent his wearing it in public because it signalled a riotous evening.[29]

This attention-seeking affected the reception of their work. The research of such men as Khlebnikov and Kruchenykh into the roots and origins of language and syntax, Kruchenykh's insistence on taking language into the realm he named *zaum*, beyond sense, the abuse or omission of punctuation in their publications, the value put on primitive texts and images of all sorts — all such ventures could be received as mere nonsense but were serious and productive professional undertakings. The difficulties experienced even by willing audiences at, for example, performances of the Matiushin/Kruchenykh/Khlebnikov/Malevich opera *Victory over the Sun* in December 1913, or in May 1923 at Tatlin's physically structured presentation of Khlebnikov's long dramatic text *Zangezi* (a 'supertale' as Khlebnikov called it), were patent and could not be removed; only time and familiarity would build bridges. Tatlin was willing to lecture on his work, and occasionally to join in public discussions, but he did not parade as a futurist or otherwise impose himself on the public.

Before the Russian futurists adopted the Italian term for their movement, Khlebnikov had proposed a new word, *budetlyanin*, in its place, meaning 'man of the future'. It never

became the movement's name, but Khlebnikov went on using it for himself, presumably because it asserted an open-minded approach to, and expectation of, new things in a new world, and because it detached him from the Italians' vehement rejection of everything from the past. Tatlin probably shared his friend's views on this. Also, unlike Malevich, Tatlin did not adopt *zaum* methods and aims for any of his work. He was not interested in creating riddles, though, like Khlebnikov, he knew that serious works of art did not have to be easy to understand. Russian futurism being a broad movement, without stated principles other than that of refreshing the arts in preparation for that new world, Tatlin could work with the futurists without being a futurist. Humour could play a part in his art, most obviously in his early stage designs, but he did not offer himself as a performer except when he recited poetry (mostly Khlebnikov's) or sang old folk songs and accompanied himself on his home-made bandura. These were private events for his friends, except when he sang and played folk songs in 1914 at the Russian crafts exhibition in Berlin, as part of his plan to reach Paris.

Paris was becoming the first choice of artists drawn by the anti-academic innovations offered there, and Russian collectors were among the boldest and the most reliable collectors of Parisian avant-garde art, especially from the 1890s on, when Gauguin and his followers were prominent among their choices. Some of these collections were open to visitors. In addition, exhibitions were organized by artists' associations, and included recent and new French art in their exhibitions. The Paris critic Henri Mercereau wrote regularly for the Moscow art journal *The Golden Fleece* during 1907–10 about Paris's avant-garde work, and he arranged for examples to be shown in Moscow's international exhibitions. These were sometimes challenged by Russian-only exhibitions, asserting that the artists of Russia had nothing to learn from the West and could renew their art by drawing on Russian and Slav resources. Awareness of new work in Paris was matched by a new consciousness of Russia's own rich, non-academic traditions. During the same years Germany's new capital, Berlin, attracted Russian travellers as the city chosen by many Russians for extended residence abroad or for permanent emigration. In any case, the road to Berlin could lead on to Paris.

The painter Alexandra Exter had studios in Paris from 1908 on. She went to Paris every year and returned home with information and images representing new trends. Cubism became known in Russia very soon after it was launched in Paris. The Italian futurists' milestone exhibition, first shown in Paris in February 1912, toured as far east as Berlin, Vienna and Bratislava. Russian artists less affluent than Exter made occasional visits to Paris, sometimes via Berlin. In these ways, an international interest already opened by the *World of Art* during 1899–1904 was widened and sharpened by the activities of a new generation of artists, curators and collectors. Matisse's visit to Moscow in 1911 is a symbolic moment in this story: the leading avant-garde painter of Paris not only brought two large and unprecedented works to Moscow but also praised the virtues of Russian icon painting. This easy to-and-fro of people, art and art news had to end when war closed the frontiers at the beginning of August 1914.

Tatlin's colleague Popova went to Paris in November 1912, together with her friends, the painters Udaltsova and Pestel. They stayed for about a year, returning to Moscow in the winter of 1913 when Popova and Udaltsova began working regularly in Tatlin's studio.[30] No doubt they reported on what they had seen and done in Paris. At Exter's suggestion, they had attached themselves to the Académie La Palette where instruction was offered by two

of the new cubists, Henri Le Fauconnier and Jean Metzinger. They visited Alexander Archipenko and Ossip Zadkine. They are likely to have seen Boccioni's first exhibition of futurist sculpture in June 1913. They probably knew the Russian sculptor Vladimir Baranoff-Rossiné (known in Paris as Rossiné), and may have seen the work he was preparing to exhibit in the spring of 1914. They would surely have encouraged Tatlin to visit Paris.

Tatlin lacked the necessary funds to travel, but this problem was solved in 1914 when he was asked to go to Berlin in the role of a folk musician. Tatlin negotiated firmly with its organizers, demanding fewer hours of daily performance in the exhibition and better pay. Clearly he was not intending to spend the greater part of every day as a musician; he will have known of Berlin's importance as a centre for international contemporary art. Moreover, money earned there would finance a trip to Paris, though the brevity of his stay there implies limited funds. There may have been an additional impulse behind his visit and its timing: that he sensed, and perhaps was beginning to pursue, a new direction in his work, and wanted to check out what was being done in the West that might be relevant to him. That he was able to put on an exhibition of his new pictorial reliefs so soon after returning home suggests that he had started on them before his departure.

Tatlin was in Paris for just one week in early April 1914 (Western calendar). His desire to see Picasso's studio was stimulated by seeing illustrations of some of his three-dimensional work, notably the mixed media assemblage *Still Life with Guitar and Bottle* (1912), among the illustrations used by Apollinaire in an article in the 15 November 1913 issue of *Les Soirées de Paris*. (This journal, edited by a Russian who called himself Serge Ferat, was well-known in Russia.) Having introduced extraneous materials such as paper and oil cloth into his paintings during 1912, Picasso was experimenting with three-dimensional compositions made of various non-art materials, found and/or shaped by himself, to suggest a still life and, in one extreme instance, a partly three-dimensional life-size figure strumming a real guitar. These works exist only in reproduction. For the still-life he had used wood, cardboard, paper and string to make a relief, loosely pinning it to a wall. Braque is known to have made, and destroyed, paper sculptures as studies for paintings in 1911–12. Picasso made a deep paper construction resembling a guitar in late 1912 (not illustrated in Apollinaire's article). Braque, presumably early in 1914, made a three-dimensional still life of a bottle, a glass and other objects, using newspaper and cardboard, set into a corner of his studio on a sloping triangular base. This too is now known only from a photograph. Its base suggested a table supporting the still-life group, and slanted steeply to exaggerate the amount of space occupied by the work. Yet this composition did firmly occupy real space, however delicate and impermanent its components, and it is misleading to refer to it as a relief. It was much closer to the physical reality of objects than the Picasso assemblage of 1912 which combined paraphrase, in its guitar, with emblematic representation in the bottle motif. We do not know whether Tatlin visited Braque or saw any of the paper sculptures Braque made in and after 1911. The newspaper Braque used in this corner piece was of 18 February 1914.[31]

We can only guess what else Tatlin may have done in Paris during his short visit, in addition to visiting Picasso. No doubt he spent his time well. He will have needed advice and guidance in planning the best use of his time. He will have contacted some of the other Eastern European artists in Paris. One of them, Jacques Lipchitz, took him to Picasso. Lipchitz was a sculptor, six years younger than Tatlin (who was twenty-eight in 1914), and

came from Lithuania, then a province of Russia. Tatlin must have wanted to know what innovations were being prepared in three-dimensional art by artists other than Picasso, and would have gone to other Eastern European sculptors working in Paris, Archipenko, Baranoff-Rossiné and Zadkine. He may have gone to the Galerie La Boëtie to see what remained of Boccioni's sculptures.[32] For many reasons, social as well as professional, he is likely to have attended one of the Russian soirées at the house of Robert and Sonia Delaunay. Sonia was Ukrainian by birth.[33] Tatlin will almost certainly have been aware of the special importance Kandinsky, Marc and others of the Blaue Reiter circle attached to Robert Delaunay's work. We can assume that he had seen the *Blaue Reiter Almanac*, edited by Kandinsky and Marc and published in Munich in 1912, and noted the honour it paid to Delaunay in words and images. If, as seems likely, he visited the 1914 Salon des Indépendants, he would have seen there sculptures and pictorial constructions by Archipenko as well as an astonishing Baranoff-Rossiné sculpture assembled out of partly-painted wood, cardboard and crushed eggshells — a free-standing compilation the height of a woman and vaguely figurative, but entitled *Symphony No.1* — among many other contemporary exhibits of widely varying quality and interest. He would also have seen there Robert Delaunay's *Homage to Blériot* (1913–14), a celebration of mechanical flight, displaying a prominent propeller and many disks and rings of colour suggesting power and motion, Blériot's biplane in the sky and, below it, the Eiffel Tower and the ferris wheel. There were also new paintings by a fellow Russian living in Paris: Marc Chagall. Apollinaire was especially enthusiastic about Archipenko's and Baranoff-Rossiné's exhibits in his reviews of the 1914 Indépendants.

In 1928 Tatlin answered a brief questionnaire about his life and work. After the question 'Have you been abroad and where?' he wrote:

> In Paris at Le Fauconnier, Metzinger and Picasso (1913–1914). I have been in Germany, Egypt, Syria, Turkey, Greece and Italian colonies in Africa.[34]

In his summary 'Autobiography', dated 1929, he again referred to the visit to Paris:

> In 1913 I went to Paris, where I continued perfecting my work in private studios. Two months before the beginning of the war I returned to Moscow and continued working and exhibiting at exhibitions.[35]

Recent research by Strigalev has established the true dates of Tatlin's visit to the West. He was in Berlin for the opening of the Russian Folk Art exhibition on 14 February 1914. The exhibition closed on 19 March. On 7 or 8 April he was in Paris, returning to Russia on or about 14 April (1 April in Russia).[36] We are left wondering whether his later statements were intended to imply a much longer visit to Paris than he actually managed. Le Fauconnier and Metzinger ran the Académie La Palette where Popova and Udaltsova studied in 1912–13. Tatlin may have spent some hours there; he may also have contacted those two cubists outside the Académie.[37] Léger was another painter developing a personal form of cubism then marked by strong contrasts of form and colour and adventuring into abstraction. During 1913–14 he taught intermittently at an open studio, the Académie Wassilieff run by the Russian artist, Maria Vasilieva, attractive to Russian visitors and nicknamed the Académie Russe. Tatlin does not mention Léger but must have been aware of his work, not least

26. The Great Wheel and the Eiffel Tower, Paris, as shown on a postcard of c.1900. Private collection

from its partial echo in Malevich's paintings of around 1912.

There are conflicting accounts of Tatlin's contact with Picasso, some of them implying repeated visits. According to one, Picasso saw Tatlin playing his bandura on a street corner and invited him to his studio. Another suggests that Tatlin did not admit to being an artist lest Picasso should keep him out of the studio — as Tatlin himself might have done with a visiting colleague. Another has it that he offered to stay and work for Picasso as a cleaner (or studio assistant) and that Picasso, in rejecting the offer, gave Tatlin tubes of paint in compensation. The sculptor Jacques Lipchitz claims to have taken Tatlin to Picasso's studio but does not mention any offer or dissimulation, nor additional visits.

Archipenko, Baranoff-Rossiné, Zadkine and Chagall were long-term Paris residents; Exter, Ivan Puni and his wife Ksenia Boguslavskaya were there for at least part of 1914. If Tatlin failed to make independent contact with any of them, he was likely to encounter most of them at the Delaunays'. Commercial galleries, such as Ambroise Vollard's and Daniel-Henry Kahnweiler's could show him the work of Cézanne, Picasso, Braque, Gris and Léger. And of course, there was Paris itself, Paris in the spring, with the Eiffel Tower on the Champ de Mars and, a little way beyond it to the south-west, the contrasting silhouette and motion of Paris's great ferris wheel (fig. 26). Both were extremely popular: the great vertical feature built for the 1889 Paris International Exposition and the wheel that rotated for people's amusement and the owners' profit, erected for the 1900 Exposition. The tower, three hundred metres high and named in honour of its designer, had no function other than to be proudly visible and offer access to viewing platforms, cafés and restaurants. Fiercely disliked by some when it was under construction and when it was new, it was welcomed by most Parisians and was soon accepted as a permanent feature of the cityscape and as the city's, even the country's, international emblem.

Little is said about what Tatlin may have done in Berlin, apart from his appearances as a musician at the Russian exhibition. The new dates tell us that he was in Berlin for seven to eight weeks altogether. His duties as a musician left him some free time and he stayed on for eighteen or nineteen days after the exhibition closed. At that time Berlin was the best centre anywhere for seeing avant-garde art. This was primarily because of the number of progressive art associations and galleries established there, most notably the gallery opened in 1912 by Herwarth Walden. It was one of his several cultural/promotional activities under the name *Der Sturm* (meaning storm, tumult, assault), possibly chosen because it echoed the

Sturm und Drang (*Drang* meaning urgency, impulse) of the German Romantics whose ambitions were of particular interest to radical artists of the early twentieth century. Nationalism and racism vied openly with internationalism in art, and Walden's exhibitions resolutely presented the newest art to be found within and beyond Germany's frontiers, not only in Paris. Among the artists who showed at the gallery Der Sturm in 1913 were Delaunay, Paul Klee, Marc and the Italian futurists whose work attracted especially lively controversy in Germany. Later that year Walden staged his 'First German Autumn Salon' (adapting the title of Paris's annual *Salon d'Automne*). This showed 366 works by 90 artists from 14 countries, among them a large group of paintings by the Delaunays, as well as a number of Sonia's recent applied art productions, including her bound copy of the long poem Blaise Cendrars had addressed to Christ in 1912, *Pâques à New York*; its end papers were boldly collaged rectangles of coloured paper that may well have caught Klee's attention. Robert Delaunay came to Berlin for its opening in September, together with Cendrars and with Apollinaire who lectured in the gallery on Orphism, the name he had bestowed on the recent work of Robert Delaunay, Léger and others because of the visual lyricism they achieved by means of their colour and forms. Russians shown in that historic exhibition included David and Vladimir Burliuk, Larionov and Goncharova, Georgii Yakulov, Kandinsky and Alexei Yavlensky (Jawlensky). Whenever possible, Walden acquired some of the exhibits for himself or retained them in stock for potential purchasers. In January–February 1913 Robert Delaunay had had a one-man show at the gallery Der Sturm, which included his large and dynamic picture *The Cardiff Team* (1912–13) in which rugby-football players leap up for the ball. Chagall sent works to the gallery Der Sturm in March 1914 for an exhibition he shared there with Alfred Kubin in April, and came in person that June/July for a one-man show at the gallery, his first anywhere. Future Commissar Lunacharsky attended the private view. From Berlin, Chagall went home to Vitebsk and found himself trapped there when the frontiers closed in August. During March 1914 Archipenko too had a major show at Walden's gallery. Russia attracted Walden's attention more and more, until he emigrated there in 1932, to die nine years later in one of Stalin's prison-camps.

Back in Moscow, Tatlin may well have felt that he had rejoined an art world that was marking time. Perhaps he sensed that it was time for someone to take a lead. He opened his studio for five days beginning on 10 May, three weeks after his return, in order to show his new 'painterly reliefs'. In 1914 he referred to them also as 'synthetic-static composi-tions'. They demonstrated a dramatic, unforeseeable step in his development. That December he sent one of them — probably *Bottle* — to an exhibition put on for the bene-fit of those wounded or killed in the war that Germany had declared against Russia on 1 August. This item caused such a scandal that it was removed from the show. Later it was reinstated, presumably after fierce disputes.[38]

War sharpened suspicions and sensibilities. Those who objected to Tatlin's relief may well have thought it un-Russian and therefore anti-Russian. France was in fact Russia's ally, as England was too — the enemies were Germany and the Austro-Hungarian Empire — but anything with a foreign flavour was now suspect.

Constructivism

In 1921, when he was preparing notes for Punin's *Tatlin (Against Cubism)*, the artist quoted his own slogan, 'Let us place the eye under the control of touch', and ascribed it to 1913. He also listed a number of his reliefs and counter-reliefs in terms of the materials used in them, and dated this group of works 1913–19. Punin used this list but added two works which he also illustrated in his book, a relief and a painting he called *Board No.1*. Even so, it is a very short list, implying years of relative inactivity.[1] Tatlin's work as head of Lunacharsky's art section in Moscow took him away from his studio a great deal during 1918–19, and 1919–20 would be devoted mainly to designing, making and exhibiting the large model of his Tower. In any case, his output was limited by the nature of his work. He could not produce thirty-nine new works — now in three dimensions and made largely from found materials — in nine months, which is about how long it seems to have taken Malevich to complete his comprehensive first exhibition of suprematist paintings between the spring and December of 1915.[2]

Tatlin presented his studio show, the 'First Exhibition of Painterly Reliefs', for five days in May 1914. There was no catalogue or published list, so we cannot be sure how many pieces he showed or which they were.[3] Even so, it seems unlikely that he could have made the entire exhibition since his return from Berlin and Paris, nor did he need to if we accept that the essential impulse to making reliefs came from reproductions he saw of Picasso's *Still Life with Guitar and Bottle* (fig. 27) and other assemblages in November 1913.[4]

The relief we call *Bottle*, known to us from just one photograph, is thought to have been Tatlin's first work of the 'Painterly Relief' type (fig. 28). 'Pictorial relief' catches better Tatlin's intended meaning: a work that, like a picture, is made on a vertical support, yet does not depend on painting techniques and projects into real space. When he subtitled some of these new works 'synthetic-static composition' he may have wanted to emphasize their composite nature and to distinguish them from futurist works which, in Russia too, could incorporate symbols of motion and even movable parts.[5] His friend and colleague Vera Pestel commented that Tatlin returned from Paris 'with the counter reliefs in his head'.[6] If this can be taken literally, he was thinking already of the second stage of his work in reliefs, after the pictorial first phase. Again, this suggests that the 'painterly reliefs' had been begun before he went to Paris.

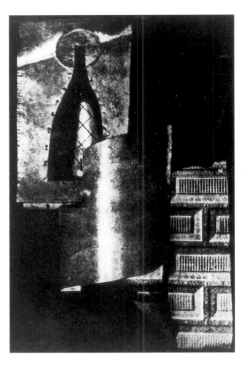

27. Pablo Picasso, *Still Life with Guitar and Bottle*, mixed media assemblage as illustrated in *Soirées de Paris*, no.18, 15 November 1913

28. Vladimir Tatlin, *Bottle*, painterly relief, c.1913, tinfoil, wallpaper, string on board. Lost

The key differences between Picasso's illustrated *Still Life with Guitar and Bottle* and Tatlin's response to it lie in their use of illusion and reality. The guitar in Picasso's assemblage is an allusion. Made mainly of cardboard and wire, it offers enough references to what guitars look like for us to enjoy the visual pun. All representation in art depends on our willingness to join in make-believe. The guitar images Picasso used in his cubist paintings prepare us to recognize guitars in his assemblages. We know that even the most guitar-like of these is not a guitar. The same applies to his other props: bottles, glasses, even figures. To the right of his fabricated guitar in the *Still Life*, Picasso placed an image of a bottle criss-crossed with diagonal lines. This may well have been, or been taken from, a tin stencil used to mark crates containing fragile goods. Another joke perhaps, this ephemeral assemblage was worse than fragile: it was disposable. Picasso would also have enjoyed the fact that the stencil gave a negative image, an absence, and thus extended the way presences and absences were equally persuasive in his cubist paintings. Dark paper or cloth pinned up to the left of the guitar hints at a background other than that of the wall itself. A once-folded, now unfolded, piece of paper, projecting forward below the guitar, suggesting a small table, pretends to support the still life physically though it can do so only visually. An essential difference between this Picasso and Tatlin's *Bottle* and other pictorial reliefs, is that the Picasso was merely pinned to the wall and therefore temporary whereas Tatlin's pictorial reliefs were intended to be discrete objects that would last. Even his later corner reliefs and increasingly free-hanging constructions are

made so that it is clear how they are to be held in space. They can be taken down and set up again.[7] Their forms and dispositions are largely determined by the materials available to the artist. Picasso's reliefs and assemblages do not originate in a response to materials. He sometimes saw, in particular objects or matter, an opportunity for creating a punning image, but he is not guided by the nature of the material.

Tatlin's *Bottle* may be his response to seeing the Picasso reproductions, and may have bred the urge to go and check what Picasso had been doing since. We do not know of any comment Tatlin made then or later about what he saw in Picasso's studio. It is unlikely that anything there will have added further impulses to his venture into pictorial reliefs and constructed art.[8] The visit may even have distanced the Russian artist from the Spaniard. These first Picasso assemblages are playful; the large one, in which a two-dimensional image of a figure reaches out to hold a real guitar, is a clumsy joke. Tatlin's reliefs are grave, adventurous in method and spirit but endowed with significance and not intended to amuse anyone. On 7 November 1922 Punin wrote in his diary: 'Picasso and Tatlin. What the French toy with, we make into a tragedy'.[9]

Picasso's assemblage came out of his use of collage on paper or canvas. Braque appears to have been the first to have used stuck-on pieces of paper (*papiers collés*), incorporating pieces of printed paper resembling wood panelling in pictures of 1912, providing visual support for still lifes or for a man's head drawn firmly in charcoal. Picasso picked up the idea and ran with it. Braque had learned early on how to imitate wood grain in paint and used a decorator's comb to achieve this effect in a painting of 1911–12. Soon he was substituting areas of painted wood grain for attached pieces of paper looking like wood, thus offering a teasing double-take to an art world that was becoming familiar with his use of wood-substitute. During the winter of 1912–13 Picasso made several pictures in which printed papers of various sorts play major roles: mostly sections of newsprint, chosen partly for their wording, including puns made by using parts of the paper's title, images cut from trade catalogues, pieces of coloured paper, patterned wallpaper, etcetera. Soon he went beyond using only paper elements, and so the term 'collage' (*colle* is French for glue) came into use. At the same time, Braque began to use pieces of newsprint and coloured papers as more central elements in his compositions, on canvas as well as on paper. In 1912 he had made little sculptures out of paper; they were flimsy and have not survived. In February 1914, or soon after, he made the still-life sculpture showing a bottle, glasses, etcetera. (discussed in chapter 2) out of paper, fitting it into a corner of his studio.

Generally, Braque presented harmonious compositions whatever they were made of. Picasso's temporary assemblages of 1913 looked alarmingly off-hand and discordant, as did, increasingly, some of the heads and still lifes he made in mixed media. Also introduced elements such as pieces of newspaper could indicate a *terminus post quem* but nothing more certain about the whole work. Far from providing the uplifting experiences academic priorities demanded, art could now no longer be trusted to be sensible. Tatlin evidently did not want to engage in ambiguities of this sort, playful or otherwise. They may have fallen outside his understanding of what art can be or should do.

Collage introduced new opportunities. The identity of an applied piece of newspaper, Picasso's oil cloth resembling chair caning, or sheet music, survives its shaping. Newspaper cut to the form of a bottle suggests a bottle without ceasing to be newspaper. Subject and material remain distinct. For Tatlin, material and subject are inseparable, the former

proposing the latter. His constructions declare the materials used in creating them, without excluding the possibility of other levels of content.

Bottle was made of tin, string and wall paper and a glass fragment, all deployed on, or set into, a wooden board. He cut the shape of a bottle out of a sheet of tin, and used what remained as part of his composition. He impressed into it a circle which projects slightly to make a little halo around the top of the bottle shape but may have been intended only to refer, as in some Picassos, to the roundness of bottles when seen in plan, as against the elevation given by the negative shape. Here too the bottle itself is absent. String neatly threaded through holes punched into the tin makes a criss-cross pattern over a recess, rather like the lines of Picasso's stencil. Tatlin fixed his small rectangle of tin over a hollow he carved into his board. In that we glimpse a curved piece of glass, presumably part of a bottle. A larger piece of tin, curled cylindrically and fixed in the centre of the composition so as to curve out boldly and catch the light, again reminds us of a bottle's roundness, while also echoing the taste for firmly painted curved planes in paintings such as Léger's and in Malevich's echoing of them in his work of 1912–13. In Tatlin's relief, this three-dimensionality is a material fact, not an illusion created by painted tones. Fact, too, is the collaged bit of wallpaper in its bottom right-hand corner. The photograph shows that one corner of the paper was left to curl upwards, reminding viewers that it is nothing more than a scrap of decorators' commonplace material, printed to show a pattern of recessed tiles or bricks. It is a flat piece of reality that delivers an illusion of three-dimensionality; we are to know this illusion for what it is.

The image in *Bottle* is its only direct link to Picasso's ephemeral still life. Where Picasso's was playful and implied sleight of hand, Tatlin's presented something like an argument. It is possible that *Bottle* was made as a riposte to a rayist painting Larionov had made towards the end of 1912 when it was shown in 'The World of Art' exhibition in Moscow, and then in Petrograd and Kiev. Larionov's painting, *Glass*, is now in the collection of the Guggenheim Museum in New York. In his 1913 book on the work of Goncharova and Larionov, Eli Eganbyuri wrote of it in terms proposed to him by its painter: it was made to show glass 'as a universal condition of glass with all its manifestations and properties . . . the sum of all the sensations obtainable from glass', including its 'brittleness [and] ability to make sounds'.[10] This associates the painting with Italian futurism's ambition to capture a sum of sensations in a composite image, but the painting echoes impressionism's focus on purely visual responses. It is almost a jungle of rising brushstrokes representing rays, among which we discern lines indicating a vertical bottle and a loose cluster of tumblers among other, less identifiable objects.

Tatlin's reliefs emphasize a reliance on combining found materials, requiring distinct kinds of handling but not displaying subjective, expressive 'touch'. Tatlin's new work delivers in three-dimensional terms the quality Russians call *faktura*, and usually associated with the informative as well as the affective use of texture and contrast in paint.[11] His use of a bottle as his relief's most evident motif echoes the bottles prominent in Picasso's and Braque's still-life compositions, but does not, as those do, imply relaxation and conviviality. Here Tatlin's contrast of forms and tones, of degrees and kinds of legibility and apparent or actual presence, are tactics within a strategic debate on the question of art and reality. Such a debate may have stemmed from Gleizes and Metzinger's attempt to give cubism a theoretical basis in their *Du Cubisme*, promoting cubism as a fundamental form of 'realism'. In *Bottle*, Tatlin is questioning contradictory manifestations of reality, relying on 'succinctness'

in reconciling 'elements made of differing materials'. There is no contemporary account of the meaning of Tatlin's reliefs. It seems clear that in them he was investigating alternative realities available to art, as it abandons its inherited role of mimesis and engages more directly with the everyday world by using its materials and often its forms to declare the thought and constructive process that makes them into art.

Tatlin was breaking new ground, whatever encouragement he received from Picasso and Braque. His process was analytical where theirs was accumulative. His images originate in his materials; theirs serve depiction even when they question its functioning. For Tatlin, material and *faktura* lead to construction.[12] Moreover, by cutting into the base board of his *Bottle* relief, Tatlin challenged the principle of a picture being a more or less flat object, bearing marks that suggest a three-dimensional scene or, in some periods, form a decorative two-dimensional image. Picasso and Braque worked both with and against the plane of their supports, emphasizing it here, contradicting it there, and generally making it unreliable. In cutting a niche into his board and also building outwards from it, Tatlin was taking the radical step of enlisting the support as an active constituent, one real component among others. The straight-on photograph which is our only image of *Bottle* emphasizes its pictorial character. Approaching the object itself would have made its spatial complexity more apparent. Tatlin's disruption of the physical picture plane may well have been its most challenging aspect at the time, and deeply disturbing.

In addition, collage invited a new attitude to composition: the process serving it and the result. Artists now turned themselves into builders, dropping the brush and mahlstick of academic painting. A collage is visibly put together out of this and that. We observe the additive and sequential process, signalling three-dimensionality even where only millimetres of depth were involved. The process becomes a major part of the message. Picasso's mixed-media assemblage *Still Life with Guitar and Bottle* was evidently some centimetres deep in some parts and flat against the wall in others. Its three-dimensionality as well as its general unseriousness, denying art all its fine-artness even more gruffly than pictorial cubism had done, must have struck Tatlin and other Russians at that time as a disruptive act more extreme than anything Russian futurism had allowed itself.

A Russian viewer of *Bottle* would have been struck by another aspect. Tatlin made no secret of the fact that his reliefs were at least partly inspired by the covers on many Russian icons. Icons were often given a metal cover, the *oklad*, mostly of silver, sometimes enriched with precious stones. Icon covers allow glimpses of the head or heads of their subjects, say the Madonna and Child, through openings fitting their outlines. Tatlin said that these covers 'led him to drill his boards, [and] mount metal rings on them'.[13] Tatlin's bottle is a negative form but the piece of glass that glints from inside the recess proposes the reality of bottles. The cylindrically projecting piece of tin in the centre of the relief, where an icon might show a saint framed by scenes from his life, asserts physical presence in space and thus one kind of reality, while the patch of wallpaper invites us to recognize an illusory reality. Academic painting was concerned, most of all, with persuading the viewer to believe in the reality of what was represented. In icon painting, the desired reality lies beyond the image but may be approached through it. In no case did Tatlin wish to mock the high seriousness of icons, nor their status in Russian life. There is plenty of evidence of his positive attitude to religion even though he does not appear to have adhered to any faith.

Most of Tatlin's reliefs are lost; we do not even have photographs of all of them. The condition of those that survive suggests reconstruction and incompleteness. Considering the most convincing of these, we soon find ourselves looking for significance beyond that of noting their constituents and their visual character. It becomes likely that all these three-dimensional works had conceptual implications not indicated in their titles. He classified them in terms of their material constituents. It is we who attach titles, such as *Bottle* or *Glass*, for the sake of easy reference.

Painterly Relief, Collation of Materials, probably of 1914, is known from three photographs. Tatlin exhibited it twice in March 1915. Stylistically it suggests an early place in the series. Milner, who dates it 1914, names it *Glass* (fig. 29).[14] Tatlin may have been countering Larionov's visual complexity by asserting the commonplace reality of a glass. In the relief *Glass* refers to the topmost element attached to the ground within its crude box frame: half a tumbler wired to a metal channel. Other materials used in this relief are iron for the triangular plane that projects, plaster, tar or asphalt, and wood (not only in the frame and support, but also the roughly trimmed panel below the iron triangle). Nothing within the frame is quite vertical or horizontal. The main upright element rises through the triangle to slant to the right; the dark strip of what may be asphalt slants equally to the left where it meets the plaster. These and the other deviations from the orthogonals detach the construction visually from its support, affording it a frailty that a more classical arrangement would have prevented. The photographs demonstrate Tatlin's desire to declare his material components and the way he arranged them to make this new object. In the context of cubism and Picasso's constructed pieces, *Glass* may be seen as a paraphrase for a musical instrument, a balalaika perhaps.[15]

A *Blue Counter-Relief*, found recently, is also ascribed to 1914 (fig. 30).[16] Its materials include various pieces of wood, part of an iron grill, leather, screws and glue and lime wash colours. There is no frame. Two rough planks form the rectangular support; the line between them gives the piece a central vertical axis. To them are fixed the metal grill fragment on the left and, centrally, a piece of leather on which Tatlin mounted several pieces of wood of diverse surfaces, colours and shapes. Two laths, probably square-sectioned, lie together at the centre of the relief; one, in dark wood, continues downwards and is close to other pieces of wood similar in tone; the other rises up and in this context suggests a mast. Two flat shapes, stained a weathered pale green, are fixed either side of this mast and suggest sails. The piece of wood closest to us is semicircular, and suggests the hull of a ship rocked by waves. Apparently, it was in the following year that Tatlin began to work on his designs for *The Flying Dutchman*. Again, the forms of the construction avoid echoing the orthogonals of the support. This example makes one wonder about colour in other Tatlin reliefs: how much there was of it, what roles it played visually and whether it contributed significantly to the meaning of each piece.

A *Synthetic-static Composition*, known to us thanks to a reproduced photograph, was bought by the artist Ivan Puni (later Jean Pougny) in 1915, possibly from the 'Tramway V' exhibition (fig. 31). It was shown in March 1915.[17] Nothing in it appears to allude to anything outside it. Its elements are arranged on a frameless rectangular board, acknowledging each other in echoing vertical and horizontal lines, and also in lines tilted away from these. Their directions are picked up by the main component, a finely fashioned piece of wood with a brass fitment. This was probably part of a lightweight easel, the ledge that could be raised and lowered to support a small board or canvas. Here it is a rising form, spanning the full

Clockwise from top left:

29. Vladimir Tatlin, *Glass*, painterly relief, collation of materials, c.1913–14, iron, plaster, glass, asphalt. Lost

30. Vladimir Tatlin, *Blue Counter-Relief*, 1914, mixed media on wood, 79.5 x 44 x 7.3 cm. Private collection

31. Vladimir Tatlin, untitled painterly relief (*Synthetic-static Composition*), 1913–14, mixed media collage on wood. Formerly collection of Ivan Puni, now lost

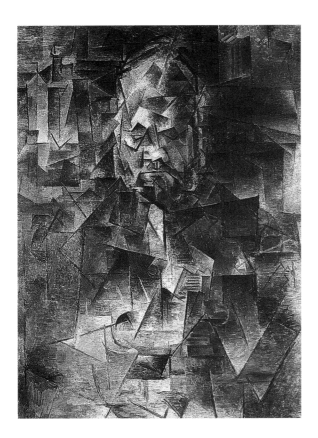

32. Pablo Picasso, *Portrait of Vollard*, 1910, oil on canvas, 92 x 65 cm. Pushkin State Museum of Fine Arts, Moscow

height of the board. The sloping line which is the bottom edge of the central piece of paper continues in the top of a small cardboard box, the sort of box made to hold pieces of charcoal. Above it, in the upper left-hand quarter, is another piece of paper or card, visibly nailed to the board. On it is a motif consisting of a vertical line and a sloping line, rising to the right, making a freehand 'T', and a neatly drawn arc, linking the right end of the upper line to its longer partner in a shape perhaps suggestive of a stylized eye. Tatlin found this motif in Picasso's *Portrait of Vollard* (fig. 32), painted in 1910 and brought to Moscow by Morozov in 1912 or 1913.[18] The painting has the same motif in reverse. Tatlin may have traced it from a photograph; there can be no doubt that he intended a quotation. The motif asks to be read as a key to the code of portions of Picasso's painting. Tatlin may have wanted it to refer to analytical cubism and thus to Western painting at its most advanced. The entire Tatlin relief may be thought to bid farewell to drawing and painting, or at least to the art associated with easels.

Tatlin's repeated use of a major axis slanting away from the vertical became his trademark. It is prominent in his reliefs and then in his 'counter reliefs' of 1914–15. Rather than repeat the orthogonals of the normal support, they suggest free, anti-authoritarian action. An impulse to exploit the device of a dominant non-vertical form may have come from one of Boccioni's sculptures: the *Fusion of Head and Window* of 1912. Here a length of real window mullion supports the woman's head and provides an emphatic off-vertical axis. Tatlin is more or less certain to have seen in *Soirées de Paris* another Picasso assemblage, *Bottle and Guitar*. Made of wood, pasted paper and a plasticine ball, this was difficult to read as a still life. The bottle is on the left and is made mainly of newspaper. Wood and larger pieces of paper form something one might well not consider a guitar if the title did not propose it. Its main features are the dark ball combined with a pointed cone coming forward towards us, piercing through and supporting a long wooden L-shape, rather like a home-made T-square. This slants away from us and from right to left as it rises.[19] Tatlin may also have been interested in a Wyndham Lewis drawing: *Portrait of an English Woman* was reproduced in 1915 to accompany an article on 'The English Futurists' in the Petrograd journal *The Archer*.[20] It showed hard geometrical forms set in mostly rectangular relationships on, or close to, an axis rising steeply to the left. It looks neither cubist nor futurist, but implies a construction of blocks and slabs.

If the ascribed dates are correct, Tatlin's constructions ceased to be 'pictorial' by the end of 1914. Generally, they ceased having in them elements that signalled their original functions. An interesting exception to this was what Tatlin termed a 'central counter-relief', meaning a relief not set into a corner but held in front of a flat surface by means of bent rods. A curved plane of wood projected forward and maintained a vertical axis; this was part of a broken palette. The rest of the palette, set at right angles to this and parallel to the wall, can be recognized by the S-curve that would give the painter's hand access to the thumb-hole. This hole, however, was almost wholly obscured by a small T-square. Tatlin may have been saying that the T-square, in other words measurement and exactness, was now replacing the subjective act of painting.

A particularly interesting account of Tatlin's work, as seen in the Moscow 'Exhibition of Paintings of the Year 1915', which opened in March, and in the '0.10' exhibition that opened in Petrograd in December, was given by the sculptor, art historian and critic Sergei Isakov. His article, 'On the Counter-Reliefs of Tatlin', was published that December in the Petrograd *New Journal for Everyone* (*Novy zhurnal dlya vsekh*, which also produced Tatlin's leaflet for the exhibition). Isakov begins by setting the art of the past against the art of modern times, before homing in on Tatlin's recent work. He defends this against all charges of affectation and desire for notoriety. 'Tatlin's works are so simple in appearance, so obviously constructive and so far removed from any attempt to produce a sensation' that they must come from a 'serious, thought-consuming effort to resolve an extraordinarily difficult problem: *material* and *tension*.' This leads Isakov to make an important distinction between the pictorial reliefs whose 'centre of gravity was in the material', and the corner counter-reliefs where 'it is "tension" and "strain" that are in the foreground'. This emphasis may well have come from Tatlin. No other commentator stressed the role of dynamics in Tatlin's newest work, yet this is clearly a major aspect of how it differs from the pictorial reliefs and from all other art produced at this time. Isakov insists that the material emphasis of these sculptures should not be seen as implying idolization of the machine. Enslavement to the machine had 'forced the whole of mankind to plunge into streams of fraternal blood'. Tatlin, with all his knowledge of materials and industrial reality but an overriding concern with artistic ideals, works to help mankind 'find the means and the strength to cast off the humiliating yoke of the machine'.[21]

Tatlin had not ceased painting altogether. His friends were making constructions in the form of paintings: Popova and Vesnin in particular. Among them now was Alexander Rodchenko (1891–1956), six years Tatlin's junior. He had studied in Kazan and Petrograd, moved to Moscow in 1915 and soon got to know Tatlin and his circle. Rodchenko was making radically experimental drawings and paintings, analyzing his means in a manner suggestive of Tatlin's approach but going on to make paintings that paraphrased cosmic events under the influence of suprematism. Tatlin is known to have painted two panels in 1916–17.[22] One is titled *Board No. 1* and has been given the subtitle *Staro-Basman* by Strigalev (fig. 33); the other one is known by the inscription on it, 'Month [of] May' (fig. 34). *Board No. 1* was exhibited in 1924; *Board No. 2* (as I shall call it) not until 1977, in the Berlin exhibition 'Tendencies of the Twenties', where it was dated 1916.[23] Tatlin chose the title *Board No. 1* with care. The Russian word *doska* means many things, from plank or board to table, notice board or icon. It was painted on vertical boards, together making a support measuring 100 by 57 centimetres, a format familiar in icon painting. The pale ivory ground, too, is

33. Vladimir Tatlin, *Board No.1* (*Staro-Basman*), 1916–17, tempera and gilt on board, 105 x 57 cm. Tretyakov Gallery, Moscow

34. Vladimir Tatlin, *Board No.2* (*Month of May*), 1916–17, mixed media on board, 52 x 39 cm. National Galerie, Berlin

characteristic of many icons. On this he has carefully arranged a number of more or less rectangular forms in different colours and textures, including one, partly edged in white, that suggests a transparent plane; the words 'Staro-Basman' are neatly inscribed on this in white. In the centre we can also make out the figure '33' in black. Staro-Basmannanya Street, House no. 33 was Tatlin's address from the autumn of 1915 until he moved to Petrograd in 1919. The composition is derived from Picasso's synthetic cubist paintings of about 1914–15 in which many overlapping planes deliver a figurative image that feels flat even though it is formed of successive strata. *Board No.1* asserts verticality but does not serve it directly. The edges of some of its planes dissolve, and on the left is a long curved form in black that continues, with an intermission, almost to the top edge. Other forms, too, suffer intermission near the top, where suddenly we see the ivory ground instead of a continuing rectangle. A rectangle in pale orange, a large element were we able to see all of it, lies behind several other forms including the transparent plane, but dissolves into loose brushwork as it stretches downwards. The composition gives a first impression of neatness and concision, but turns out to be complex and not entirely stable, with its several visual

44

35. View of Malevich's display of suprematist paintings at the '0.10' exhibition, Petrograd, 1915, showing the *Black Square* hung across the corner of the room like an icon

effects (colour, tone, firmness against softness, etcetera), including the use of gold paint. As a whole it surprises the viewer with its delicacy. In this exploration of *faktura* Tatlin seems to be demonstrating the versatility of paint as well as a kind of pictorial architecture, so that our eyes travel from the immaterial pale orange form that fades away to the transparent plane which is hardly there at all. Most important, this is not a picture of anything; it is a composition representing nothing but itself. Perhaps we should think of it as a signboard for Tatlin's studio, a modern painter's contribution to a folk tradition.

What I am calling *Board No. 2*, inscribed 'Month [of] May', is much smaller and not a regular shape but a board measuring 52 × 39 centimetres with three of its corners trimmed off. Tatlin may have found it in this form. Certainly it is not new and its lower portion looks worn. Again, he has painted onto it assembled planes, mostly rectangular and some with curved edges, and again there is a transparent plane, suggesting glass, clearly shown on the left but only hinted at on the right. That the word 'May' is inscribed on a red plane may be symbolical: red is the colour of revolution and May Day is the Socialist spring festival. The unpainted support has a dark tone, and many of the painted forms are in dark hues, so that this bright red stands out. Its form is also the sharpest in the group; it points upwards and in doing so reiterates a slanting form to the right, a few degrees off the vertical, and is echoed in several other forms in the composition. There is no painted vertical. Its general character brings it close to some of Tatlin's pictorial reliefs, particularly those constructed on irregular supports. It is also close to being an icon. The colours Tatlin used here are all iconic, and so is the prominence he allowed to the wood grain of the support.[24]

They were probably painted after the opening of '0.10 — The Last Futurist Exhibition' in Petrograd at which Malevich first displayed his suprematist pictures (fig. 35). The exhibition, intended to celebrate the avant-garde work of Tatlin and Malevich and their associates, nearly did not take place because Tatlin found these Malevich works amateurish. Only Ivan Puni, organizer of '0.10' and a particular friend of Malevich's, had been allowed to see his new

paintings before they were taken to the Dobychina Gallery and hung in time for the private view on 19 December. The exhibition was saved by letting Tatlin and his friends show in a space clearly distinguished from that allotted to Malevich and his. Tatlin signalled this separation, and presumably his view of suprematism, by putting up a notice for his own section announcing 'Exhibition of Professional Artists'. There is much more to be said about the exhibition: the point here is that Tatlin, who had certainly been willing to exhibit alongside Malevich previously and may indeed, as Malevich claimed, have learned something about cubism from his older colleague (who never visited Paris), needed to dissociate himself from Malevich's new work and its implications. Tatlin did not explain this, apart from that word 'professional'. He must have thought Malevich's new work regressive. Malevich published and republished an elaborate theoretical statement for the exhibition, entitled *From Cubism and Futurism to Suprematism, To the New Realism of Painting, To Absolute Creation*.[25] Tatlin produced only a two-page leaflet, giving factual information about his work and illustrating two pictorial reliefs — that owned by Puni and another owned by Exter — as well as two 'corner counter reliefs' dated 1914–15, both shown in the Petrograd exhibition 'Tramway V' in March.

For the moment I want to stay with that word 'professional' and consider Tatlin's two 'boards' in the light of suprematism and Malevich's phrase 'the new realism'. Malevich's text rejects all representational and all functional art: his new work 'approaches creation as an end in itself and domination over the forms of nature'. He implies that the realism it offers is that inherent in the work itself, both its visual character and its material constituents — a definition of realism he shared with other Russian avant-garde artists developing their ideas under the impact of both cubism and futurism:

> Creation is present in pictures only where there is form which borrows nothing already created in nature, but arises out of the painted masses without repeating and without altering the primary forms of the objects of nature.[26]

The painting to which Malevich gave especial prominence in the exhibition, and presented in his writings as the seed from which suprematism grew, was the *Black Square*. He displayed it like an icon, hanging it across the 'beautiful corner' of the room allotted to suprematism — the corner diagonally to one's right, looking from the entrance, traditionally reserved to a family's main icon or icons when the location was a home, but used also in public buildings. It was convincing to be told that this amazingly minimal image was the starting point, especially since one of his backdrop designs for *Victory over the Sun*, drawn in 1913, could be regarded as a step towards it. Malevich was to imply, in writings and in producing paintings that reinforced the point, that suprematism developed from the single black square, sitting squarely in the centre of a white square ground, to the circle and the cross, also in black on white, and thence to multiple forms and to the use of colour, both displayed in increasingly complex ways that would imply both space and movement through space. The first *Black Square* was painted very crudely. Earlier and subsequent paintings, including later variants of it, were executed quite neatly.

It is now clear that the painting in the Tretyakov Gallery in Moscow, the original *Black Square* displayed in '0.10', could not be Malevich's first, ground-breaking suprematist picture. The black paint of the square has developed serious cracks (a sign of hurried work) through which a more elaborate, possibly suprematist composition can be glimpsed, with

multiple forms and colours.[27] What was presented as a logical development — from the intensity of a concentrated image to multiform compositions using several colours, a variety of forms and relationships of scale — now appears to have been less programmatic. Their white grounds suggest infinity, but it is the multiple forms hovering in that emptiness, and at times appearing to move through it, which permit the visionary cosmology the painter claimed as his new subject. He prided himself on breaking through the limitations of the physical cosmos, in order to reach further cosmic dimensions and spiritual realms. He spoke of the *Black Square* as establishing a 'zero' in art, a strong but empty position which accords with the interest in anarchism he shared with other avant-gardists in wartime Russia.[28] Soon he was arguing that his art demonstrated not merely a clearing of art's decks of all traditional limitations, but the opening up of a new world.[29] Physical exploration of this world, by space travel, would follow before long. It must have struck his contemporaries that Malevich had rejected visual riches and intellectual ambiguities in order to start again with the most basic images. Suprematism could be mysterious and other-worldly, but it brought with it an assertive visual clarity where fragmentation, irony and the futurist principle of *zaum* (beyond sense) had reigned.

Tatlin does not seem to have shown any interest in the transcendentalist speculations of Theosophy and the other spiritualist endeavours that had stimulated Malevich, including mystical (as opposed to mathematical) interpretations of the Fourth Dimension and other much discussed ideas in the area of spiritual development such as those offered in Richard M. Bucke's *Cosmic Consciousness*, first published in 1901.[30] Nor did he share Malevich's faith in painting's ability to unveil the cosmos.[31] Punin would later write that the two artists

shared a peculiar destiny. When it all began I don't know, but as far as I remember they were always dividing the world between them: the earth, the heavens and interplanetary space, establishing their own sphere of influence at every point. Usually Tatlin would assign himself the earth and would try to shove Malevich off into the heavens because of his non-objectivity. Malevich, who did not reject the planets, would not surrender the earth since he considered it, justifiably, to be also a planet and [that it] could also be non-objective.[32]

Their work reveals another division or difference, instinctual at first perhaps, but becoming conscious as the two artists became aware of their opposition. When Malevich's art did not picture 'the heavens', it focused on the countryside and peasants. A few early paintings, and later reworkings of them, are townscapes, mostly showing figures on a tree-lined boulevard. What hints he gives of urban life occur in his least representational pre-suprematist pictures, the sub-cubist alogical works which feel urban even when the subject is an interior, as in *Lady in a Tram*, or *Lady at a Poster Column*. He announces an urban situation but confirms it only in one or two details, for example, a tram ticket. The well-known painting that specifies a place, *An Englishman in Moscow*, assembles emblematic objects without conveying the city. The early work of Tatlin includes a few pictures that can be called landscapes, such as *Summer* and *Twilight* in the Moscow Central State Archives, and he spent some summer months of 1909–10 at Larionov's house in Tiraspol painting landscapes alongside his friend. Many of his early pictures, oils and watercolours, have been lost to sight and may no longer exist. We are told that he destroyed some of his work in the 1920s. The

Strigalev and Harten catalogue mentions one or two possible landscapes among the lost works, including a picture probably of Turkey. Tatlin may have made many sketches and paintings of marine subjects, land as seen from a ship or seaside pictures of land and sea.[33] Like most progressive painters of his time, Tatlin used personal versions of impressionism while looking for a more distinct and radical idiom. From about 1910 on, landscape does not exist as a subject for him. Like Mayakovsky and most of the futurists, he focused on the man-made world and its future.

There were more specific points on which Tatlin would have disagreed with Malevich, including the increasingly dismissive attitude Malevich expressed *vis-à-vis* older Russian artists and European artists up to Cézanne. In short, the two artists had different priorities and different ways of promoting them. Both were seen as out-and-out radicals by most Russian critics at the time.[34] Benois's mockery of Malevich's 'icon' in the '0.10' exhibition, published in a Petrograd newspaper on 9 January 1916, is a telling instance of how Russian radical art was seen by its enemies. Malevich's swingeing but unfocused reply of May 1916, in the form of an open letter which no one was willing to publish, is translated in Troels Andersen's first collection of Malevich texts.[35]

Whereas '0.10' served as Malevich's opportunity to go public with his newborn and newly named art, Tatlin's reliefs were already known to his circle and to anyone who had visited exhibitions of new art in Moscow and Petrograd during 1914–15. In fact, they were to some degree echoed in '0.10' by the presence there of reliefs made by artists on both sides of the division, including Popova in Tatlin's camp and Rozanova and Ivan Kliun in Malevich's. This implies that reliefs had recently been recognized as a progressive form. The artists involved did not need to conform to any one idiom or definition. Nothing could be less suprematist than Kliun's relief of a *Cubist Woman at her Toilet*. It owes almost everything to reliefs Archipenko had made in Paris in 1912–13 and showed in a 1914 exhibition that travelled from Paris to Hagen, Berlin and Rome, and included work by Rozanova and Exter. Membership of either camp seems to have been largely a matter of friendship. Puni did not yet adopt suprematism. The artists showing in the space allocated to Malevich's faction were represented by work that was broadly cubo-futurist. The show's title, we recall, included the words 'Last Futurist Exhibition'; we do not know how that phrase was agreed nor, indeed, to what end '0.10' was added to it. Ten past midnight? Some months earlier Malevich had been planning an art magazine with the title *Zero*, meaning, as he wrote to Matiushin in May, that 'zero' would be the state of art cleansed of all old conventions, 'while we ourselves will go beyond zero'.[36] Popova, who showed in Tatlin's section, in 1916 joined the 'Supremus' group that formed around Malevich after the exhibition, without breaking her connection with Tatlin. Rodchenko did not exhibit until March 1916 when he showed ten ruler-and-compass ink drawings at the 'Store' exhibition in Moscow, which Tatlin organized and in which he showed his corner reliefs while Malevich was represented only by paintings of 1913–14. In 1916 Rodchenko was a follower both of Tatlin and suprematism.[37] But the possibility of such mobility or bracketing was not predictable amid the open antagonism of December 1915, and Malevich's withholding, or Tatlin's exclusion, of all suprematist work from The Store exhibition in March 1916.

In ceasing to be 'pictorial', Tatlin's constructions detached themselves finally from Picasso's constructions and assemblages. We should not let hindsight turn Tatlin's 'counter reliefs' and 'corner counter-reliefs' into logical extensions of his 'pictorial reliefs'. These

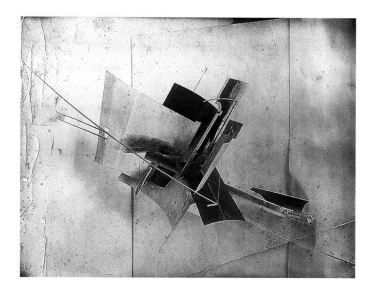

36. Martyn Chalk, reconstruction of Vladimir Tatlin's *Corner Counter-Relief*, 1914–15, iron, aluminium, paint, 78.2 x 152.4 x 76.2 cm. Annely Juda Fine Art, London

reliefs had succeeded each other in a great variety of form and expression, and there is no evidence that he was running out of ideas for them. Since he worked largely with found materials, engaging with their particular character, shapes and scale, his creative process centred on responses to them, not on preconceptions. The new constructions are discrete inventions. Moreover, one 'counter-relief', known by its constituents, *Selection of Materials: Zinc, Palisander, Pine*, has been dated 1916 and 1917, which means it was made after some of Tatlin's more obviously non-pictorial constructions.[38] A striking aspect of this work is the handsome piece of palisander which is its support, the product of fine carpentry, rounded at top and bottom, with four brass-lined recesses let into it close to its four corners. It may well have been the base of a navigational device or of some other instrument for seeing or measuring. The other wood, fir, is not visible but may be the board to which this palisander form is pinned. The pieces of metal Tatlin arranged on it come out into space, asserting their volumetric character (not unlike the curved piece of tin in *Bottle*) and their sharp edges. The major axis is stated by the right side of the largest curving zinc plane, which slants upwards right to left and continues well beyond the top of the board. There is a hint, here too, of a mast and sails, but also perhaps of a space-travelling craft. The forms and character of the various pieces of metal Tatlin used, though clear in themselves, contrast dramatically with that finely wrought palisander support.

For our purposes, two of Tatlin's counter-reliefs are especially important. One is the relatively well-known *Corner Counter-Relief*, supported by metal rods fixed to two walls forming a corner and by a less visible wire or string attached to the ceiling (fig. 36). The other is another *Corner Counter-Relief* consisting of clustered planes of metal hovering, so to speak, in mid-air but held in place by wire and cord rigging, kept taut by means of a pulley and fixed to a wall on the left and to the floor on the right (fig. 37). Both are dated 1914–15 and are now lost or survive only in part, but have been plausibly resurrected in reconstructions made in 1979–81 by Martyn Chalk. Thanks to the rigging that holds the clustered metal planes in space, the second piece has unmistakable echoes of seafaring. It is an early instance of what we now call installation art. Both works involved intelligently conjoined metal elements that do not hide their distinct identities.

The earlier *Corner Counter-Relief*, floating on rods, consists of curved and straight planes forming a cruciform but slanting arrangement. Nothing in it is vertical or horizontal; the entire cluster seems to incline towards us and to the right. One especially striking element rises out of this cluster and is picked out by (pre-existing?) paint along one edge. To anyone familiar with icons, the arrangement readily suggests an icon hung in a corner — possibly

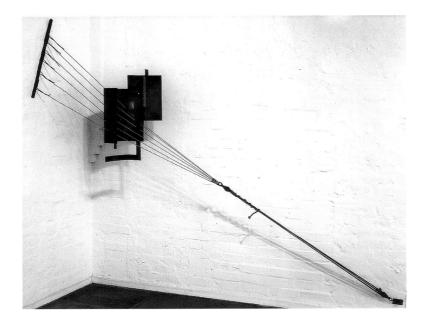

37. Martyn Chalk, Reconstruction of Vladimir Tatlin's *Corner Counter-Relief*, 1915, reconstructed 1980–1, iron, wood, steel, wire, cord, pulleys, etc., 225 x 232 x 82 cm. Annely Juda Fine Art, London (a repaired version of Tatlin's original is in the Russian Museum, St Petersburg)

38. Naum Gabo, *Head in a Corner Niche*, 1916/17, phosphor bronze version, 1954/64, 62.2 x 48.9 cm. Collection Berlinische Galerie; original celluloid version, Museum of Modern Art, New York

Russian Orthodoxy's most popular icon, of the Madonna offering herself as the caring mediator between mankind and God and inclining her head towards us. This suggestion may seem far-fetched, yet we recall Tatlin's study of traditional icon painting and also of Western Madonna paintings of around 1500, as well as his general interest in church and folk art. He was fully aware of the honour paid to icons in his time, even by non-believers.

Tatlin was not of course alone in having this interest. A particularly telling instance is that of Naum Gabo (born Neemia Pevsner in 1890), who was to bring Constructive art to the West after leaving Russia in 1922. Gabo's father owned a successful iron works in Bryansk, supplying railway and other industries in Russia. The Pevsners were Jews but did not follow Jewish religious practices. The three Pevsner brothers were brought up as Christians; their nanny, devoutly Russian Orthodox, shared their bedroom. Gabo later stated that 'in our nursery on the wall opposite me hung an icon and in nanny's corner another icon and a lamp that was always lit . . . we went to bed and slept at night and woke in the morning with its image . . .'; the icons 'certainly made the most decisive impression on me. I still think and feel that in the icons there were beginnings of my education in painting'.[39]

In about 1916–17 Gabo conceived what is known as *Constructed Head No. 3* and also as *Head in a Corner Niche* (fig. 38). The Museum of Modern Art's version of it was made in 1917–20 of celluloid and metal; another, made in 1920–22 of brass covered with enamel, may still exist in Russia.[40] The essentially modern, austere head, inclines to the viewer exactly as does the painted head of the Madonna in many a Russian icon. Hammer and Lodder illustrate an icon of *The Virgin Eleusa* for comparison, showing the Madonna and Child, their heads pressed lovingly together but with her eyes looking out at us. They also quote a letter of 1925 from Antoine Pevsner to his brother, referring to this sculpture as 'the Madonna'.[41]

Thus the '0.10' exhibition contained two major works presented as icons, Tatlin's and Malevich's. Rough, handwritten notices pinned to the walls of Malevich's room announced

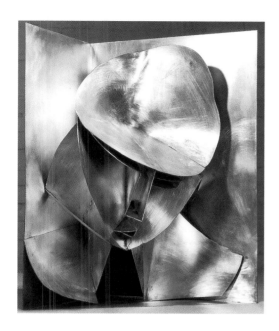

suprematism, and there were numbered lists and little numbers below most of the exhibits.[42] A much-reproduced photograph of the room shows the greater part of two walls, that facing the entrance and that to the right. In the angle between the two, the 'beautiful corner', Malevich showed his *Black Square*. His hanging generally has the rushed and amateurish look familiar from other Russian exhibitions of the time, but here each picture is allowed its space and it was perhaps determined systematically[43] — except, it seems, for the *Black Square*. This was surely given its significant position at the last moment, possibly transferred from the wall to the left where there would have been more room for it. It almost touches the cornice and the painting to its right, as well as the tall painting below it to the left. No other exhibits touch or nearly touch. It seems probable that Malevich moved his picture after seeing Tatlin's iconic *Corner Counter-Relief* in order to trump it as an icon. This may be what caused Tatlin and Malevich to fall out at the exhibition; they are said to have come to blows.

But in distinguishing his section from Malevich's with the word 'professional', Tatlin was making a more general point. His own work was realistic in the sense of using real materials, almost every piece recycled from the real world and creating significance through the manner of assembly. Malevich's suprematist paintings were all painted shapes on a painted ground. He claimed a post-futurist dynamism of colour and form for them, but the dynamics they deliver depend on our reading of relative sizes and locations as referring to space and motion, as in traditional art, rather than on confronting what is there in material fact. They are representations of an imagined world. They are in that sense illusionistic: they represent something that is imagined as existing elsewhere by pictorial means matching neither the physical constitution nor the size of the subject, and indeed leaving us uninformed as to what is being represented. It could be said that they are closer to icons than are Tatlin's constructions, icons being images through contemplation of which we gain access to another world. Worshippers do not pray *to* icons but *through* them, the icon's function being to raise our spiritual state and serve as a channel for transcendental communication. Tatlin's use of iconic forms did not invite a pious response but was intended to hold the viewer's attention to works self-evidently constructed of earthly, material, facts.

*

As the war progressed disastrously, revolution stirred in Russia. The February Revolution of 1917 brought with it a lessening of many official controls, including an end to censorship

and to the legal restrictions that had burdened the lives of Jews and Old Believers. With that came also a lot of disruption, including strikes in the cities and soldiers deserting. Some individuals, such as Gorky, saw the February Revolution as the end of civil order, especially in the capital. Others rejoiced. Tatlin, like Mayakovsky, might say that revolution had been prepared in his art and Khlebnikov had even predicted it. Tatlin found himself much involved in the groupings and meetings that followed quickly on the heels of February, as were Punin and others close to him. The different arts met and spoke together as indeed other artists had done previously under the aegis of the World of Art group and its journal, but now with a greater appetite for reform and innovation, and with open emphasis on left ideologies.

After the October Revolution, also of 1917, which brought in a government likely to impinge on these new freedoms, Lenin appointed his old colleague Anatoly Lunacharsky (1875–1933), dramatist and critic, to the post of People's Commissar for Enlightenment.[44] In other words he became head of the Ministry of Education, referred to by the acronym Narkompros. In February 1918 Moscow reverted to being the capital city of Russia, instead of Petrograd, liable to attacks from the North and the West. (About the same time, Russia adopted the European calendar and imposed spelling reforms.) It took some months to transfer all the ministries and other government institutions to the old city. Lunacharsky remained in Petrograd until early 1919 but meanwhile set up a parallel office in Moscow. In April 1918 he appointed Tatlin head of its art department, IZO; the painter David Shterenberg (1881–1948), who in 1917 had returned from a long period in Paris, was put in charge of IZO in Petrograd. Though less of a radical than Tatlin, Malevich and the other avant-gardists in either city, Shterenberg proved an effective cultural manager. Malevich served under Tatlin in the Moscow IZO, Punin under Shterenberg in Petrograd. Both IZOs were involved in the reformation of art education, notably the establishment of the Free State Studios which replaced the Academy School and other art colleges in Petrograd and Moscow. These were to undergo further reforms and re-namings. Malevich and Tatlin were deeply involved in their aims and courses, with Tatlin teaching the 'Culture of Materials' first in Moscow and then, from 1919 on, in Petrograd. Other bodies were rapidly set up, to protect Russia's artistic inheritance, to develop existing museums and art galleries, as private collections became public, to initiate the world's first museum of contemporary art in Petrograd while disseminating examples of contemporary art around the country, and so on. Tatlin was involved in this work. In March 1918 he had written a letter to the newspaper *Anarchy* calling for fellow artists to 'embark on the path of anarchy'.

An anarchist treatise by Peter Kropotkin, *Mutual Aid: A Factor of Evolution* (1902), appears to have made a particularly fruitful impact on Russia's progressive artists by associating the rejection of all forms of authority with the peaceable co-operation traditionally practised in Russian peasant communities. In these, Kropotkin claimed, mutuality ruled instead of individualism and conflict: 'in the ethical progress of man, mutual support — not mutual struggle — has had the leading part'. Thus for human beings mutual aid replaced the struggle for survival demonstrated by the animal world, and further human evolution would be powered by it.[45] Tatlin clearly absorbed such ideas, whether directly from Kropotkin or by other routes, and they surface in his later discussion of the role of the creative individual in mass society. Futurist artists, he wrote on that occasion, had been too willing to work for a narrow section of society, in, for example, the Café Pittoresque, where Tatlin had collaborated with Yakulov, Udaltsova, Rodchenko and others to provide the new décor for a

revamped Moscow café. More fundamental changes were needed if art should contribute to reforming society. 'I am waiting for well-equipped artistic depots where the artist's psychic machinery can be repaired as necessary'.[46] Tatlin's work in IZO was largely to this end. In October 1918 the Moscow State Free Art Workshops (Svomas) would open, replacing both the Institute of Painting, Sculpture and Architecture and the Stroganov Art School. It would take some time for new programmes to be drawn up and put into effect, especially if they required new kinds of equipment. In Petrograd Svomas took the place of the Academy, closed in April 1917 (though later the name 'Academy' was reinstated). Changes in programmes and organization led to Svomas in both cities becoming Vkhutemas (Higher State Art Technical Studios) in 1920, and Vkhutein (Higher State Technical Institute) in 1926.

Mayakovsky was calling for developments of much the same, basic sort. Disappointed by the Bolsheviks' generally conservative view of the arts, he, David Burliuk and Kamensky opened the short-lived Poets' Café in Moscow in November 1917. From there they launched the *Futurist Newspaper* in which futurism was associated with Socialist anarchism and all the 'depots and sheds of human genius', including libraries and theatres, were considered abolished. What was needed now, Mayakovsky wrote, was the 'third, bloodless but nonetheless cruel revolution, the revolution of the psyche', in which the proletarians would join the artists.[47] By April 1918, anarchism in its political form was under attack from the new government. The Poets' Café was forced to close; the secret police did not intend to distinguish between theoretical and active political anarchism. Communism and anarchism both foresaw the withering away of the State. Anarchism demanded its immediate end, but Lenin insisted there would have to be a revolutionary government in place to prepare for its own demise. To artists such as Tatlin and Malevich, anarchism meant freedom from government and class domination of the arts. Tatlin maintained that artists were inhibited by preconceptions of what could be done, by 'obsolete values' inherited from the pre-revolutionary world. Overhauling their psychic machinery would enable them to handle their unprecedented freedom. Mayakovsky's call for the proletariat and artists to join in a 'revolution of the psyche' was broader and more problematic. The constructivists would take this a step further, justifying their abandoning of art for industrial production as the effective way to change life for everybody.

One of Tatlin's most pressing and difficult tasks in Moscow was to realize, under Narkompros, Lenin's ambitious project for 'monumental propaganda', announced through the official press on 14 April 1918 as 'The Removal of Monuments Erected in Honour of the Tsars and their Servants and the Production of Projects for Monuments to the Russian Socialist Revolution'.[48] Lunacharsky recalled that Lenin, in discussing this project with him, had referred him to Tommaso Campanella's utopian vision of *The City of the Sun*, first published in 1623 in Latin as *Civitas solis*. Campanella was a radical thinker but also a theologian and a monk who spent much of his life in prison, at times under torture, for leading a popular uprising in the south of Italy and for expressing views on religion and science the Church of Rome could not tolerate. In *The City of the Sun* he foresaw a communistic city-state, a 'philosophic community' governed by reason and the laws of nature and following a universal religion. All its citizens, the Solarians, are equal, men and women. They receive the same ongoing education and have equal duties, work for the common good and are careful not to end up with surplus production. Four hours' work a day is reckoned to see to that. Scientific and technological progress is rapid. Medicine, hygiene and dietetics are

studied with care, and the mechanical arts are learned and developed to the benefit of all. For example, the Solarians are able to fly individually. Their circular city is laid out in seven concentric streets, named after the seven planets, flanked by buildings whose walls bear paintings, sculptures, showcases and didactic diagrams, chosen to educate everybody in matters of State, morality and science. Health is stressed, and maintained partly through field sports. Birth control makes for offspring, well endowed both physically and mentally, who live to about 170 years. They worship the sun and their elected prince is called Sun. At the city's centre, reached by radial streets, is its chief temple, not a walled building but an open and transparent one, mostly of columns.[49]

Lenin wanted the towns and cities of Russia to be studded with works of art celebrating Socialism and giving it historical validation; those that were three-dimensional would also serve as podiums from which the masses could be addressed. This would contribute to persuading the people of the promises of Communism and the Bolshevik leadership, while implanting names and references, language even, which would identify the new State. Tsarist statues and symbols were removed at first with punitive zeal in an unplanned manner, and Lunacharsky feared that destruction would spread to buildings and other sites associated with the Court. New works of art should replace the old, or be introduced independently, or on occasion be fashioned out of what already existed. The majority of these new works would be statues or busts memorializing ancient and modern forerunners of Socialism, from Spartacus and Thomas More to Henri de Saint-Simon, Alexander Herzen, Chernyshevsky, Georgi Plekhanov, Mikhail Bakunin, and, above all, Marx and Engels.[50]

Tatlin was to see to the erecting of such monuments in Moscow. He reported to Lunacharsky on 18 June 1918 on the problems and opportunities created by the programme. Lenin wanted quick results but, Tatlin wrote, haste must not endanger quality lest the State be 'the initiator of bad taste'. Therefore as many young sculptors as possible should be involved in the scheme, and the populace invited to comment on the results. There should be neither juries nor prizes, just financial support for artists while engaged on this work. Proposed monuments should be erected in ephemeral materials (plaster, cement, wood), and executed in permanent materials (bronze, marble, granite), only after public approval. All this should, and could, be made to happen quite quickly, 'by about the end of September' 1918.[51] In July the Council of People's Commissars, in effect Lenin, called for 'energetic' fulfilment of the decree of April. In May or June Tatlin had made proposals which were echoed, in a report to Lenin and the Council, by the sculptor Sergei Konenkov, a member of Moscow's IZO. Their chief points were that speed must not be at the expense of quality, that young artists should be drawn into the programme and that these, particularly, would need money for their time and materials. The Council approved, and told Narkompros to make the necessary arrangements.

Lenin wanted lots of monuments, especially for Moscow. He was not concerned about artistic quality and did not look for innovation. The names would justify the images. The original decree issued on 13 April called for the provision of new monuments in time for May Day, three weeks away. Lenin was disappointed by the inaction that ensued, and complained to Lunacharsky about it. This led to money being set aside to launch the programme, and artists receiving any of it were warned that results would be expected by the autumn, in time for the first anniversary of the October Revolution. In late September or early October Tatlin wrote to Lunacharsky, stressing that the new monuments should be 'free

39. Vladimir Lenin speaks at the opening of a provisional monument to Marx and Engels, by Sergei Mezentsev, in Voskresenskaya square, Moscow, on 7 November 1918. Quote on shroud reads: 'The revolution is a whirlwind which sweeps away all who stand against it'. Museum of the Revolution USSR, Moscow

creations in a socialist state', and that artists should work 'not only on monuments to prominent figures but also on monuments to the Russian Revolution, monuments to a relationship between the State and art which has not existed until now'. In an article 'About Monuments', published in *Art of the Commune* on 9 March 1919, Punin argued that figurative monuments would not change the environment in any significant way. Post-revolutionary monuments should demonstrate 'a synthesis of the different types of art' and employ the geometrical forms modernity called for.

In 1918 Russia had few professional sculptors of note, and these were likely to be conservative in their outlook.[52] Tatlin recognized the need for a new generation of sculptors, capable of expressing the aspirations of the new society. No doubt he hoped to encourage bold young talents. He certainly did not want artists to miss out on opportunities of working for the general public. That public, meanwhile, needed occasions for developing the judgment Soviet cultural ambition called for. The history of Russian sculpture had been too meagre to allow for criticism of any weight to develop.

A large crowd gathered on the first anniversary of October to hear Lenin speak at the unveiling of a Marx and Engels monument in the newly named Revolution Square in Moscow, formerly Resurrection Square (fig. 39). (To associate the Revolution with Christ's Resurrection was a typical Soviet appeal to religious values.) The stepped rectangular base of the statue was still shrouded with cloth to which a temporary inscription had been affixed, but above the upper block stood the two men in bronze, shown realistically from their hips up, wearing their beards and suits (a handkerchief peeps from Engels' breast pocket), looking in the same direction and leaving no doubt which was the main aspect of the freestanding monument. The Moscow public neither liked nor disliked it but embraced it through humour: surely these two were their old friends Saints Boris and Gleb, sharing a bath.[53]

Among other monuments for Moscow completed in 1918 is Sergei Konenkov's large memorial to those who fell fighting 'for peace and fraternity' during the October Revolution, a low relief, made of cast and painted concrete tiles, set into the Kremlin wall.[54] On Leninskaya Sloboda, a mighty half-figure on top of a massive cube and cylinder base represented Jean-Paul Marat. Among sculptures erected in 1919 was the Soviet Constitution Obelisk in Soviet Square, designed by D.P. Osipov and enriched by the addition of a large, lively, almost Baroque female figure of Liberty. This was the work of Nikolai Andreev, who also made a massive head of

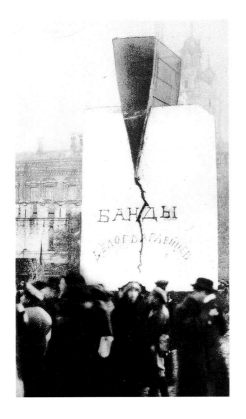

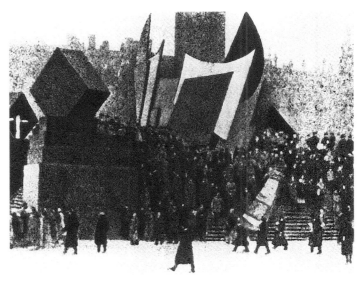

40. Nikolai Kolli's Red Wedge Monument, November 1918, Revolution Square, Moscow, c.12 m high. The slogan on it reads: 'Bands of White Guardists'

41. Natan Altman, transformation of the base of Alexander Column, St Petersburg, for November 1918, showing spectators and procession

Georges Danton, set up in Revolution Square in 1919. In 1922 his two figures of Herzen and Herzen's friend Nikolai Ogarev were set up outside the old Moscow University.

In Petrograd, Alexander Matveev's full-length figure of Marx was erected in 1918 outside the Smolny Institute, the site of the Soviet government until its move to Moscow. A dramatic bust of Ferdinand Lassalle was set up on a base of stacked white stone blocks on Nevsky Prospekt. The year 1919 saw the erection of a fiercely futuristic bust of the Russian revolutionary Sofia Perovskaya, made by the Italian sculptor Italo Griselli. A bust of Alexander Radishchev, set up in 1918 outside the Winter Palace, probably in plaster, looks curiously Rococo in this context.

There were also a few non-figurative, symbolical projects most of which never saw the light of day. One was N. Dokuchaev's stone memorial to Liberty and the Soviet Constitution, designed in 1918. Nikolai Kolli designed a monument for Revolution Square in Moscow, and it was ready for the 1918 anniversary of October (fig. 40). It comprised a large white block of stone on top of a darker rectangular base. The white block, taller than a cube, tapers slightly as it rises, while a red wedge seems to have been driven into it from above. As executed, the monument is taller than Kolli's sketch suggests; about twelve metres high. Words inscribed on the block say 'Bands of White Guardists'; the red wedge is the conquering Red Army. This, in Kolli's drawing a geometrical form, becomes an axe head in the actual monument.[55] In 1919 Malevich's colleague, El Lissitzky (1890–1947), designed a famous poster in which a large red triangle pushes its sharp point into a white circle and words say 'Beat the Whites with the Red Wedge'.

A memorable example of the new idiom being applied to a public event is Natan Altman's transformation of Petersburg's Palace Square, on the city side of the Winter Palace, renamed Uritsky Square for the 1918 anniversary of the Revolution. The Alexander Column, an enormous granite shaft surpassing the memorial columns of other cities, had been brought from quarries on Lake Ladoga, erected with impressive engineering skill in 1829, and topped with a grandiose Baroque angel holding a cross. The square had been a grand parade ground for the military, but in 1905 it was also the site of that grave misuse of tsarist power, the Bloody Sunday massacre. Altman could not hide the column but dramatized its immediate setting with timber platforms and tilted cubes, and surrounded its lower part with large planes, presumably also of wood, some flat, some curved (fig. 41). These planes were painted red, orange and yellow, symbolizing flames licking at the symbol of imperial rule. This remains one of the best-remembered instances of what Russians were then still calling futurism.[56]

For Tatlin 1918 was an extremely busy year. There were local difficulties about producing the first wave of monuments. It had been hoped that about fifty monuments would be up in Moscow in time for the first anniversary of October. This seemed to be accepted by Tatlin's long memorandum of 18 June to the Council of People's Commissars. In September Tatlin wrote to Lunacharsky that about thirty monuments might be realized, and indeed postcards were published showing designs for thirty monuments. He stressed that these monuments to 'outstanding individuals' would 'at the same time [be] monuments to the Russian Revolution'. Meanwhile he formed and chaired a joint commission, consisting of IZO and the Moscow Soviet, to cope with disputes that had arisen between the national and the city boards and to see to the erection of those thirty. It is clear that some proposals were found unsuitable, and perhaps others were never developed to the point of realization. In any case, Moscow saw no more than seventeen statues and busts erected during 1918–19.[57]

Tatlin was also involved in discussions about both the projected Museum of Contemporary Art, continuing for years while definitions were argued over, as well as the development of the old, pre-October, museums.[58] His report on the Museum of Artistic Culture, written in the summer of 1918, sets out how such a museum should be organized for Moscow: for example, IZO would choose the artists to be approached, and the artists would choose their 'best works' for inclusion. It also refers to the other museums. He proposed that works coming into these from private collections should have the collector's name shown on them. He did not wish their pioneering spirit to be forgotten.

Peace came at long last. After long negotiations, both led and cunningly delayed by Leon Trotsky, who was hoping that Socialist revolutions in the West would weaken his country's enemies, Russia accepted the punitive peace measures imposed by Germany in the Treaty of Brest-Litovsk on 3 March 1918, ceding vast areas that had been under the tsar's rule in 1914. Russia was bankrupt and industrially a ruin. Seizure of banks and much Church property, and the nationalization of almost everything, made for a kind of hollow security under controls so strict that they weakened efforts to revitalize production. Then came years of Civil War, with Western powers and a Japanese force collaborating with disaffected Russians gathered into a White Army in order to end the Soviet regime. Their triumph was expected with every day. Detachments from Britain and France, sent in to support the failing Russia, stayed to help the gathering elements of the Russian White (that is, anti-Bolshevik) Army, while more troops from the West landed and the British navy did what

damage it could to the Soviet State. Moreover, liberated prisoners of war, most notably the Czechs, formed counter-revolutionary forces inside Russia. We know that Communist revolutions in German and other Central European cities would turn out to be short-lived and had the effect of strengthening conservative and military rule in their countries, but this was not evident in 1919 during the period of the Russo-Polish War when Socialist uprising, if not full-scale revolutions, were expected in cities across Western and Central Europe where newspapers meanwhile promised Bolshevism's early demise in Russia. Endless meetings at Versailles, dominated by President Wilson of the USA and by the prime ministers of Britain and France, Lloyd George and Clemenceau, discussed the creation of a band of anti-Communist states, stretching from a Finland freed of Russian rule to the newly concocted Yugoslavia, as a *cordon sanitaire* against Bolshevism. Churchill pressed for an all-out war against a Soviet Russia that had proved its barbarism when the imprisoned former Tsar Nicholas II and his family were murdered in July 1918.

Yet the Red Army, hastily formed and exhorted by Trotsky, won successive victories over the White Army and its allies in spite of awesome difficulties. By 1921 the Civil War was over, but Russia found herself in an even more parlous state, with famine a continuous threat and recurring fact, especially in urban areas. In March 1921 Lenin announced his New Economic Policy (NEP), in effect a dilution of Communist principles. Some internal trade and private commerce was now permitted and reformed state banks became active partners in raising the country's economic profile. The beneficial effects of NEP were slow to become apparent, but entrepreneurs emerged on all sides to benefit from this relaxation.[59]

Peace offered an opportunity to re-establish cultural communications. One instance of this was Lunacharsky's plan, developed in 1919, to launch a journal intended for foreign as well as Russian readership and to be called, simply, *International Art*. He himself, as well as Tatlin, Khlebnikov, Malevich, Shterenberg, Pavel Kuznetsov and Sofia Dymshits-Tolstaya (a painter who worked with Tatlin on IZO in Moscow and in Petrograd in 1919–20), drafted articles for it, but the journal never appeared. Tatlin's intended contribution, 'The Initiative [of the] Individual in the Creativity of the Collective', is a stern, impersonal statement of the mutual needs of inventive artists and the close-knit society Socialism will build. 'The initiative individual collects the *energy* of the collective, directed towards knowledge and invention. . . . A revolution strengthens the impulse to invention.' The individual invents, but 'invention is always the working out of impulses and desires of the collective and not of the individual'. He quotes Khlebnikov on this: 'If we take the principle of multiplication, then a positive singular multiplied by a thousand makes the entire thousand positive.'[60] This 'organic connection' is true for society, and provides Tatlin with a principle that places the focused creative individual at the service of his people while receiving his core impulse from them. He was not alone in asserting these principles. They had a long development in Europe.[61]

What was called a 'philosophy of collectivism' had been announced and developed by Lunacharsky, Bogdanov, Maxim Gorky and others as early as 1904–9, contrasting their Marxist view of society's dynamic, especially in regard to creative work, with that of the bourgeoisie and its vaunted individualism. Mayakovsky's epic poem '150,000,000', of 1919–20, identifies its ostensibly anonymous author with all those millions and names them 'Ivan'. In the first issue of *Lef*, in March 1923, Mayakovsky explained that it was necessary now 'to dissolve with joy the little "we" of art into the huge "we" of communism'. Punin promoted

the ideal of collectivism in direct association with Tatlin's work in his detailed account of Tatlin's own monument when the large model went on show in Petrograd in late 1920.[62]

By that time news of Tatlin's project was reaching the West, most noticeably Central Europe where revolutionary political movements were closely associated with avant-garde art. The first comprehensive survey of the arts in Soviet Russia was Konstantin Umanskij's book, *New Art in Russia*, published in Potsdam and Munich in 1920. Umanskij, a young Russian art historian who had studied in Vienna, had reported on the subject in two articles in German journals of 1919 and early 1920. The first, in *Das Kunstblatt*, speaks generally of new developments and illustrates one Tatlin relief. The second is a two-part article on 'Tatlinism, or Machine Art', published in successive issues of *Der Ararat*. Umanskij here promotes Tatlin's proto-constructivist art in machine terms: 'Art is dead — long live the art of the machine with its construction and logic, its rhythm, its components, its material, its meta-physical spirit — the art of the counter-relief.' He emphasizes the range of materials used in this art, demonstrating a 'triumph of the intellectual and the material' and 'the quintes-sence of present-day reality.' The second part gives a remarkably detailed yet still unspe-cific account of Tatlin's projected monument. Paraphrasing an account Tatlin had himself written in 1919 for the Moscow journal *Art*, Umanskij speaks of a monument in the form of a 'living machine', functional as well as monumental, providing a radio and telegraph station, cinemas, an exhibition gallery, etcetera.[63]

Umanskij's book is a remarkably full account of what was happening in Russian art, cham-pioning the new in forthright terms and contrasting it with the old art of imitation, whether of nature or of styles borrowed from the West. Russian art of the last few years shows that

the young have successfully carried through their struggle [against older generations and traditions]. . . . As we shall see, their complete success is at hand. An artist beginning to live socially as an actively functioning member of society, organically linked into his time, stepping down from the heights of Parnassus into the depths of life, proclaiming his rights [while] inviting viewers to an intense co-experiencing of his creative work, thus finding a true use for his artistic ideals — are these not positive symptoms of an incipient renaissance in art?[64]

A long appendix adds up-to-date information under several heads: lists of the main painters, sculptors, applied artists and state designers; of the leading Russian artists' associations and their members; of the various groups from which the Art Workers Trades Union and the All-Russia Union of Painters were formed; of museums and collections of new art in Moscow and Petrograd; of newly opened museums including the Winter Palace; of new art schools in Moscow and Petrograd; of significant exhibitions shown in 1919; of new monu-ments erected in 1918–19; of recent drama and opera productions; of leading Russian art critics, writers and composers; of Narkompros's boards and offices dealing with art, art education, architecture and the art heritage; and finally, of books and periodicals, including illustrated books and albums of prints. This Baedeker-like section of the book, as accurate as it could be (the text is dated 'February 1920'), must have been welcome in Berlin, where the ending of war, the creation of a new republic and the sense that a new, co-operative world of culture was being born, created keen interest in the Russian experience. The pres-ence in Berlin of countless Russians gave all this information added vividness.

Umanskij's report ended with a plea for a collaborative effort by Russian and German artists to convene a First International Congress of Creative Artists. Its optimistic vision must have appealed to many left-minded German artists. Tatlin is listed in Umanskij's appendix as a painter, yet presented in the main text as the most radical and far-sighted of Russian artists, going far beyond painting. Umanskij refers with scorn to earlier movements, such as that of the Wanderers and The World of Art:[65] visual realism and sophisticated styles are now out of date. They have been pushed aside by various sorts of expression, including the primitivism that derives from folk art and the personal psychic primitivism pursued by such painters as Chagall. Dilettantism always threatens, but in this situation the 'Tatlin Group' is not content merely to add new words to an inherited language:

> Painting as such — so says Tatlinism — is dead. . . . Altogether, a critical view is taken of the need to create 'paintings', 'works of art', just to amuse the lay public, and to be rejected by it. And so there develops, in 1915, that Tatlin 'machine art' the origins of which are to be found in Picasso's and Braque's experiments of 1913. . . . This does not disdain material of any sort as unworthy of art. Wood, glass, paper, tin, iron, screws, nails, electrical fittings, splinters of glass to condition planes, the potential mobility of elements of a work, etc. All this is declared to be justified means for the new art, and its new grammar and aesthetic demand from the artist more extensive preparation in skills and technical knowledge, and a close bond to its mighty ally, the sovereign machine. . . .
>
> As we have indicated, Tatlinism is not an autochthonous Russian trend; its beginnings lie in the French initiative. Yet we understand that this machine art, particularly in the Russia of today, seems in complete unison with the mindset of the time.[66]

A famous photograph, taken in Berlin at the Great International Dada Fair of May 1920, shows the Dadaists George Grosz and John Heartfield holding a large card, taken down from the gallery wall, printed with the slogan, 'Art is Dead — Long Live Tatlin's Machine Art'. They will have read about Tatlin, but had not yet seen any of his work. To us it is obvious that the constructions he made mostly of found materials have little to do with machines or with the Dada spirit, which was ironic and mocking and sharply political. Tatlin did not need to make political points: he and his colleagues felt their work represented the new political life of their country. Dadaists used found materials more to mock bourgeois culture, even when it took avant-garde forms, than in pursuit of any ideal of building a new culture through the intelligent exploration of materials.

The years 1919–20 saw the development of Russo-German cultural contacts, but the art involved tended to be of the more conservative sort, associated with symbolism and the World of Art group. Soviet foreign policy was concerned with establishing advantageous trade links with Germany. In March 1921 Kandinsky, well known in both countries, proposed that an exhibition of recent Russian art, including a selection of work from the new art schools, should be shown in Germany. The Socialist art critic Adolf Behne (born in 1885, like Tatlin) had trained in architecture and then art history, and was one of the founders of the Novembergruppe, close to Bruno Taut and Walter Gropius. He received this proposal in Berlin and communicated it to Gropius, director of the new Bauhaus in Weimar since 1919, who responded enthusiastically. There developed an official exchange between Lunacharsky's

ministry and the German government, more specifically between the German Foreign Office and Umanskij who now represented IZO in Germany. Political strife in Germany led to shelving the matter until the autumn when Lunacharsky raised it with the German representative in Moscow at the 1921 October celebrations. The proposal was accepted under various conditions. Lenin supported it for its propaganda value, assured by Lunacharsky that its costs would be met from sales of Russian ceramics included in the exhibition. In early 1922 Punin, Shterenberg and Lunacharsky were planning its art section. Even then the project nearly failed, until the Treaty of Rapallo in April 1922 pledged full economic and cultural co-operation between Germany and Russia. For both countries this marked a return to the world's cultural stage, and generated a special relationship between them from which the project benefited. The Van Diemen Gallery in Berlin was chosen to receive a large exhibition of recent Russian art entitled, promisingly, 'The First Russian Art Exhibition'. The exhibits started arriving that August. All hints of political propaganda were minimized by announcing that proceeds from the exhibition would go to famine relief in Russia. Both sides, in any case, wanted a sober exhibition, showing continuities as well as innovation and countering the impression that the new Russia was without culture. There were worries among younger Russian artists that their work would be overshadowed by the more accessible works of their predecessors. Russian exhibitions shown in Paris and London in 1921 had focused on painters of The World of Art and on Russian crafts, and were thus anti-modernist in character and appeal.[67]

'The First Russian Art Exhibition' opened on 15 October 1922, and was intended to tour Germany. Although it was received with interest by critics and well visited by the public in Berlin, the tour did not eventuate. Lissitzky had been sent to Berlin to see to its realization, and it may be through his quick alliance with Theo van Doesburg, painter and founder of the Dutch *De Stijl* journal and its associated movement in art and design (Mondrian, Rietveld, etcetera), that key figures in Holland were made aware of the exhibition and persuaded to receive it. It had a second showing at Amsterdam's municipal gallery, the Stedelijk, in 1923. Lissitzky, charming and hyperactive, would stay in Germany until 1924, working on several fronts to promote the new art, until he collapsed with tuberculosis and went into a Swiss hospital, where he continued to work as best he could. Lissitzky's activities in Central Europe will be outlined in chapter 8.

Tatlin's three-dimensional work was represented in the Berlin exhibition by one striking 'counter-relief' which has since disappeared. This was the first appearance of any of his work outside Russia.[68] The selection also included two Tatlin pictures, a painting listed as *Sailor*, presumably his self-portrait of 1911, and a stage design, *Forest*, probably the painting he made to show one of the scenes he designed in 1914 for the opera *A Life for the Tsar*. Gabo assisted with the exhibition in Berlin and showed several constructions, including the *Constructed Head (Head in a Corner Niche)*. Rodchenko, Georgii and Vladimir Stenberg and other members of the first constructivist group, were well represented. Shterenberg's foreword to the exhibition catalogue, while mentioning the work of less radical groups, emphasized the role of the Revolution in opening 'new avenues for Russia's creative forces', most obviously by bringing artists out of their studios to realize their ideas in public art forms. 'They were no longer content with the canvas', these artists of 'the leftist groups' who represent 'every type of experimental development that has led to the revolution in art.' The introduction to the catalogue gives prominence first to suprematism and then to the work of Tatlin whose works 'constitute a stage in the transition to production

art'. Rodchenko, the Stenbergs and others are presented as artists moving towards pro-ductivism. 'The display of Tatlin's most celebrated work Monument to the Third International, in Moscow may be regarded as the first step in this direction.'[69] Seeing so new and radical a development as constructivism, and its announced goal of productivism, promoted in an official national display, was wholly unprecedented.

It must have seemed strange, in a Germany riven by political confrontation and fierce cultural enmities, to see an up to date exhibition of art brought from a major country and representing recent developments there without implying deep divisions. Some critics responded optimistically, finding in it a path into the future; others saw in the work done since the Revolution the negation of honoured cultural values. On 1 March 1919 the Dresden 'paper for new art' entitled *Menschen* (Mankind) published on its front page a brief 'Address of the progressive artists of Russia to their German colleagues', signed by Shterenberg and dated 30 November 1918. In it he asserted that the new Russian State supported the newest developments, and that these aimed 'at collective creative work which will go beyond narrow nationalism in order to serve international interaction'. In turning to their German colleagues, the Russian artists hoped for an exchange of cultural news, and proposed a congress of German and Russian artists, leading on to a world conference. Meanwhile there should be exhibitions, publications, theatrical productions and concerts demonstrating an exchange of both people's artistic product.[70]

Reviewing 'The First Russian Show', Behne stressed its constructivist message:

The question is no longer whether the suprematist image is better or more beautiful than the impressionist image; rather the question is whether the image as such can continue to supply us with an accepted, fruitful area of work. The image itself is in crisis — not because a couple of painters thought this up but because the modern individual has experienced changes in intellectual structure that alienate one from the image. The image is an aesthetic matter whereas what the radical artists of all nations want is to lend immediate form to reality itself. . . . Soviet Russia was the first to recognize the possibilities inherent in this great new goal and give it free rein.[71]

It is astonishing to find so firm a focus on the promise of constructivism in a review of an exhibition in which this emerging movement was represented by just a few examples, mostly drawn from the constructivists' Moscow display of May 1921. These exhibits, in addition to Gabo's, will easily have overshadowed Tatlin's one relief and two earlier pictures, thus working against the German image of Tatlin as the machine artist announcing the death of old concepts of art. Lissitzky would not have given constructivism such undivided attention. Presumably Behne had information from the Moscow art world, perhaps from Rodchenko himself; László Moholy-Nagy, whom Behne knew well, was in touch with Rodchenko. Soviet officialdom would not have wanted, or been able at this early stage, to promote constructivism as today's achievement or tomorrow's goal.

Monument to Revolution

In December 1914 Tatlin had responded to a newspaper's enquiry whether or not a new artists' society should be organized 'on new principles'. His answer was positive. He had long hoped for a broad association which would end 'the present most unhappy artistic reality', by establishing 'new conditions of artistic life by uniting artists of all directions into a harmonious family, bound together by mutual respect'. At the time, over forty percent of artists were denied all access to exhibitions; this created 'resentment and impatience'. Those who were rejected were often thought 'irreconcilable', yet it is precisely they who would be 'the first to stretch out their hands in reconciliation'.[1]

Tatlin knew about exclusion. While his stage designs were exhibited repeatedly during 1913–15, his paintings could appear only in avant-garde shows. In May 1914 he used his studio to display his first pictorial reliefs. When he was invited to contribute to the 'Moscow Artists in Aid of Victims of the War' exhibition at the end of 1914, it was his designs for *A Life for the Tsar* that were wanted and there was trouble, as we have seen, when he hung one relief alongside them. In 1915 he was able to show seven reliefs in Petrograd at 'Tramway V. The First Futurist Exhibition', organized by the avant-garde painter Ivan Puni. The term 'futurist', never quite defined, announced that this display was devoted to unconventional, culturally 'left', art. In the same year, a Moscow exhibition on the theme of 'Mementoes of the Russian Theatre' included nineteen Tatlin designs for *Tsar Maximilian*, lent by one collector. That March another Moscow exhibition, 'Exhibitions of Paintings of the Year 1915', was accompanied by a catalogue which pointedly excluded all of Tatlin's exhibits, presumably reliefs, and all Malevich's, presumably pre-suprematist paintings, as well as those of Mayakovsky and Alexei Morgunov, both using cubo-futurist idioms to produce images of an irrational, 'alogist', sort. We know their work was shown because reviews referred to it. That December, the exhibition '0.10. The Last Futurist Exhibition', shown in a Petrograd gallery, consisted entirely of avant-garde works by Tatlin, Malevich and their associates.[2]

After the February 1917 Revolution Tatlin helped organize a 'left bloc' of artists in Petrograd. Delegated to represent them in Moscow, where he went in April, he joined others to found the Artists' Union and was promptly put in charge of its 'Left Federation'. About this time he worked with Yakulov, Rodchenko and others on the decor of the Café Pittoresque in Moscow where what would become known as constructivist methods and means were

tested on light fittings and ornamentation. After the October Revolution, the Artists' Union delegated Tatlin to the art section of the Moscow Soviet, and Khlebnikov invited him to join his visionary 'Government of the Presidents of the Terrestrial Globe'. By April 1918, Tatlin was heading the Moscow art department of Lunacharsky's ministry, IZO, and was occupied almost exclusively on organizational and theoretical work.

Tatlin found himself in a dramatically new situation. Known for some years as one of the artists intent on upsetting cultural conventions, he had been chosen by Lunacharsky to hold that key position. Presumably Lunacharsky knew enough about the artist, and Tatlin knew Lunacharsky well enough, for them to sense they could work together. This mattered profoundly at a time when Lunacharsky knew himself to be in a difficult position, between Lenin and the people around Lenin who spurned all artistic innovation, and the Russian avant-garde who knew that he inclined to traditional art even if his tolerance appeared to be wider. Avant-gardists feared they might lose the freedoms brought in by the February Revolution. Almost everyone in the arts expected some form of interference from the Bolshevik regime, and was reluctant to recognize in Lunacharsky a minister intent on respect and reconciliation.

Tatlin suddenly became the key figure in a complex programme of construction and reforms initiated for the democratization of Russian culture and education. He was now concerned with controlling what demolition there should be of tsarist monuments and determining what should be preserved even though it represented the past, and with protecting Russia's architectural and artistic heritage against depredation. At the same time, he was charged with realizing urgently Lenin's scheme for monumental propaganda. By the end of 1918 he was also playing leading roles in reforming art museums, in helping to find an international platform for Russia's new art and in contributing to the structural reform and re-programming of the Moscow and Petrograd art schools.

He did not exhibit during 1917–20 (except for one, possibly old, drawing included in a Tiflis exhibition of art by Moscow futurists). In 1919 he donated a representative range of works to the new museums, including an early painting of flowers, the painting *Fishmonger* of 1911, a drawing or painting of a female nude, a 1915 pictorial relief and his *Board No.1*.[3] He may still have been working on his designs for *The Flying Dutchman*, though exactly when he pursued this personal project and whether he ever completed it is not certain.[4] If indeed he was developing it during his first year of working for the new government, it may have reminded him that his essential role was that of the creative artist, not the bureaucrat. It is striking how often his drawings for the stage focus on the ship's main mast, slanting as it well might when seen close up from below, but slanting also to express the ship's battle with the storm. One senses in it something like a self-image.

A brief visit to Petrograd early in 1919 to set up and lead a workshop for 'Volume, Construction and Colour', soon renamed 'Material, Space and Construction' to distinguish it from painting workshops, was followed by Tatlin's move to Petrograd that summer. He stayed until 1925. There had been mention in the press in January 1919 that he was working on a monument to the Revolution. The project had backing from the ministry, and by the end of the year there had been an official statement that he was developing designs for what was now to be called the Monument to the Third International.[5]

In March 1919 the ministry's art journal *Art of the Commune* (*Iskusstvo kommuny*) published an article by Punin about Tatlin's project 'for a monument to the great Russian

Revolution'.[6] Either Tatlin's ideas were still far from settled or he was being secretive. Punin is firm in his evaluation of his friend's abilities and about the originality of his evolving concept – Tatlin is 'the great master whose spirit is the most assured and the most alert of our day' – but vague about its form. It is time, Punin writes, 'to finish for ever with human images; the ideal monument must respond to the widespread call for that synthesis, observed nowadays, of the particular forms of art'. The monument will be, in its ensemble, 'one unified form which is at the same time architectural, sculptural and painterly'.[7] It will be as large as possible in the context of our cities, and will employ the simple forms associated with modernity: 'cube, cylinder, sphere, cone, arcs, spherical surfaces, their sections, etc.' The spaces provided by these will be adaptable to many uses, including propaganda meetings, gymnasia and lecture rooms, but will not serve for anything requiring stillness and permanence, such as libraries and museums. The whole should demonstrate mobility above all else: 'the monument will be a locus of concentrated movement'. Punin stresses the role of cars and motorcycles as elements in Tatlin's concept; there will need to be a garage from which 'standardized motorcycles and automobiles . . . a fleet of vehicles' will distribute 'appeals, proclamations and publications'. Individuals will be transported up and down mechanically, with electricity powering lifts as well as heating. Projection onto large external screens will make it possible to show films when it is dark. Searchlights will project slogans onto the night sky, using coloured lettering. There will be centres for artistic work, and perhaps a canteen. A radio station of global reach will be incorporated, as well as telephone and telegraphic equipment. Punin wonders whether such a monument can be realized in the present situation, 'but I believe that it can be done if we really want it'. Most important, this monument will also be a necessary, functioning building.

We probably hear the artist's voice in Punin's words about 'concentrated movement'. Tatlin 'is tired of creating busts and statues of heroes'.[8] Punin emphasized the concept's origin in Tatlin's reliefs, notably the one associated with Khlebnikov's 'Martian Trumpet'. Tatlin may have wanted this mentioned, but Punin knew Khlebnikov well and may have been pressed to make this point by the poet. Apart from that, he could say little more than that the proposed monument would be a complex, constructed thing of uncertain form, 'but surely this will come very close to the simplest forms being developed in recent years'. He did not say Tatlin's building would be a tower, only that lifts would be needed. He referred to a giant screen affixed to 'one of the monument's wings', so he may have understood Tatlin to be working on a more or less horizontal scheme. Whatever form it finally took, it would not be another celebration of anybody. Marx had been disinclined to heroicize individuals in the face of what he saw as historical necessity. Closer to home, Alexander Bogdanov (1873–1928), describing a serene Communist State in his *Red Star*, wrote about sculpture as practised there and seen by the Russian visitor, Leonid. Leonid was struck by the assured naturalism of the figure sculpture, but even more by the 'functional perfection' of all areas of design, from architecture to furniture and utensils. As for monuments on Mars:

In pre-socialist times the Martians erected monuments to their great people. Now they dedicate them only to important events, such as the first attempt to reach Earth, which ended in the death of the explorers, the eradication of a fatal epidemic, or the discovery of the process of decomposing and synthesizing chemical elements.[9]

We can only guess at Tatlin's path towards the solution he arrived at, but there are impulses and real and legendary works likely to have served him as guides and prototypes. A monument commemorating a great event would traditionally, in Russia, call for a church, sometimes a church shaped like a spire or a tall tent, but whenever possible a large assembly of forms like those of St Basil in Moscow's Red Square or the more compact great Church of the Saviour which was built in central Moscow as a memorial to Napoleon's defeat in 1812. This was (and is again) the largest church in Russia. Commissioned by Nicholas I, it was designed by the architect Konstantin Ton, and built during 1839–83, in 'an ineffectual attempt to graft Byzantine detail onto a classical form', part archaeology and part neoclassicism.[10] A massive cube topped by a large dome and four smaller cupolas, it is overbearing and lugubrious, Moscow's tallest building after the Great Kremlin Belfry. Stalin had it blown up in 1934 to make room for a Palace of Soviets. The international competition for that involved Le Corbusier and other eminent western architects but nothing came of it, and the site was turned into a vast open-air heated swimming pool. This has now been replaced by a second Church of the Saviour, a copy of the first.

There had been an earlier proposal for a great church to commemorate 1812. This was the work of Alexander Vitberg (1787–1855), who was a painting student at the Academy when, on 26 December 1812, Tsar Alexander I proclaimed his intention to build in Moscow 'a church in the name of Christ the Saviour' to commemorate the defeat of the French. The proposed site was the Sparrow Hills from which Napoleon first looked down upon the capital city that seemed to lie defenceless before him. Young Vitberg was enthused by this challenging prospect with its at once national and religious significance, and turned himself into an architect to compete for the commission. This and what followed has been recorded in a long and thoroughly researched article by F. Vitberg, grandson of the painter-architect, 'Alexander Vitberg and his Project for a Church in Moscow', published in the journal *Former Times* (*Starye gody*) in February 1912.[11] The writer was working in an age when Russian belief in God and trust in a benevolent tsar had diminished markedly in the towns, even if the vast majority of Russians still placed their faith and hopes in both. He emphasized the old belief in Russia's mission to lead the world in matters of faith and the conviction that Napoleon's defeat in Russia was God's work. The tsar's proclamation, he stressed, was made following a decision 'to undertake Russia's destined mission of freeing Europe'. The memorial church would be built in Moscow and would maintain forever 'remembrance of the exemplary labours, loyalty to and love of Faith and Fatherland, to which the Russian nation devoted itself in this difficult time, and to mark the occasion of Our gratitude to the Providence that saved Russia from the threat of death.' F. Vitberg adds:

The proclamation was an expression of the general feeling prevailing everywhere. Everyone maintained that it was necessary not merely to immortalize the memory of individual persons and events, but also to build a monument that would express the general, major meaning of what happened.

Designs were invited from Russian and foreign architects. In 1816 the tsar himself examined twenty selected projects, choosing the one that best 'expressed his inner feelings.'

Alexander Vitberg, baptised 'Karl', had been born in Petersburg in 1787. A rising young painter of history paintings of both the allegorical and the narrative sorts, he was appointed an

42. Alexander Vitberg, project for Moscow's Cathedral of Christ the Saviour, 1817

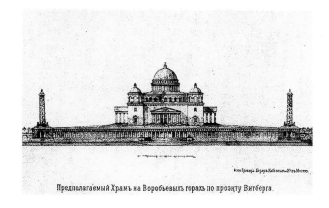

Предполагаемый Храмъ на Воробьевыхъ горахъ по проэкту Витберга.

assistant teacher in the Academy. The tsar's proclamation excited him as a creative opportunity and focused his religious beliefs. The church was to be dedicated to Christ the Saviour. He thought this 'a new idea. Until now Christianity built its churches in celebration of this or that saint, but here is a concept that is all-embracing'. The whole church would be 'a Christian text'. Therefore it should be ecumenical, not conforming only to Orthodox usage. Man is a temple, composed of three parts: body, soul and spirit. The church too must be triple, yet cohere as one church. Trinities 'exist everywhere, in God, in nature, even in thought. In the life of the Saviour we find three periods . . .[.] The Incarnation of Christ, . . . the Transfiguration, . . . and the Resurrection.' The whole church being dedicated to the entirety of Christ, 'it is a pressing need to express the three churches as moments of Christ's life.'

Each stratum of the triple church would have its form: rectangle, cross and circle. The lowest of these, the rectangular 'bodily church' presses against the earth. Three of its sides would be within the hillside; it would be entered and lit from its fourth side, facing east, the light diminishing towards the 'rich catacomb' commemorating those who died for the fatherland in 1812.

The church 'of the soul' sits above it and is visible from all sides. In plan a Greek cross, it symbolizes 'the union of body and spirit [which] is the union of man with God'. Over the altar will be a painting of the Transfiguration, and the light in this upper church will come mainly from that.

The uppermost church 'of the divine spirit' is circular in plan, 'expressing infinity'. Here the Resurrection is pictured over the altar, and the whole interior is brightly lit, 'as much as the architecture permits'. The dome over the circular church will be flooded with light, artificial as well as natural, to suggest the open sky.

The elevation shows a symmetrical structure, conceived in classical terms. The lowest church is solidly neoclassical: thirty-two heavy Doric columns and their massive entablature screen it, and extend beyond it right and left to ring two circular pavilions, each supporting a tall column like Trajan's Column in Rome, with ramps winding up, to a platform above which stands a large Angel of Victory.[12] The overall height would be 234 metres. Internally and externally there is an invitation to ascend.[13]

The tsar chose Vitberg's design (fig. 42). Later Vitberg was found guilty of misappropriating funds and exiled to Vyatka in 1827. If Tatlin did not read this article when it appeared in 1912, he is likely to have studied it when he began to ponder his own project. But social activists too may have inspired him. Alexander Herzen founded the first anti-tsarist Russian press in Europe, thereby laying the foundation of revolutionary agitation in his country.[14] The failed revolutions that took place in several western countries in 1848 – Herzen witnessed

the February Revolution in Paris, partly negated by a counter-revolution there that June, but kept himself informed also about revolutions and uprisings elsewhere – convinced him that Russia alone was capable of establishing Socialism. His fortnightly journal, *Kolokol* (*The Bell*) (1857–67), written and printed mostly in London, was smuggled into Russia and widely read, even at court. Most of his autobiography, *My Past and Thoughts*, written in London during 1852–5, was published in Russia in 1913 as two of seven volumes of his collected writings.

Though baptised in the Orthodox faith, Herzen was not religious by inclination or practice. This did not prevent him, or any other Russian, from responding positively to Vitberg's mysticism. Herzen knew the role that religion played in Russian society at all levels. The name *Kolokol* he gave to his resonant journal, arguing for reform and revolution, has evident church associations and was chosen to appeal to this shared mentality. Travellers approaching Moscow across the almost endless steppes knew they were getting close when, before glimpsing the city, they could hear the bells of Moscow's many churches. As they got closer their view would be dominated by the hundreds of gilt onion domes of those churches and, the highest of them all, that of the tower of Ivan in the Kremlin.

Herzen was not alone in stressing the social and historical importance of a religion he himself did not adhere to. There were many thinking doubters and apostates among the Russian intelligentsia; among the thinking believers there were many who understood the others' position. One of the most telling moments in Russian literature, showing how the call of traditional piety could override humanistic convictions even in the most progressive spirit, occurs in Tolstoy's *Anna Karenina*. Levin, a free-thinking, consciously modern young man who attempts to share the life of the peasants on his estate, working with them and hoping to raise their awareness – almost a self-portrait of the author – is deeply troubled by the first lying-in of his young and beloved wife. What can he, so eager to be active on everyone's behalf, whose loving has brought her to this, possibly do for Kitty as she cries out in labour? He rushes into the house, seizes the 'best icon', and hangs it over her head so that its power might protect her.

The centrality of icons to Russian daily life is often mentioned. It is difficult for Westerners to appreciate how true this was even for those who doubted or turned their backs on religion. A Great Schism of the seventeenth century forced reforms onto the Russian Orthodox Church. This created division between those who accepted reform and the many Old Believers who refused to do so. Old Believers were dissenters, and, being against the Church, they were also against civilian authority once Peter the Great had combined the two powers. In spite of acts of persecution and repression that continued up to 1905, the dissenters thrived as secluded communities and increasingly also as families wielding industrial and commercial power. It is said that around 1900 there were twenty million Old Believers in Russia. Several of the cultural patrons of around 1900 were Old Believers, and their support for innovation in the arts and for archaeological research into pre-Petrine Slav and Russian arts and crafts, often went with their willingness to finance revolutionary activities. Old-Believer icons were still being produced professionally when Tatlin became an apprentice icon painter.

By contrast there were also highbrow cultural movements in Russia from 1893 on, especially in Petersburg where Dimitry Merezhkovsky and his wife Zinaida Gippius were its initiators and critical *animateurs* until they emigrated to Paris in 1919. These symbolists were committed to mystical-religious beliefs and enquiries. The Religious-Philosophical Society of Petersburg, which they helped form, met from 1901 on to discuss

spiritual questions and the deeper realities lying behind contemporary life and its dissatis-factions, but was closed by the authorities in 1903. The writings of the admired mystical philosopher Vladimir Soloviev (1853–1900) provided the Society with material for analysis and debate: 'the absolutely right and the absolutely desirable relation of each to all and of all to each . . . is called the kingdom of God'. He found this unity expressed and sometimes realized in art when it worked to regenerate mankind. Using words that seem prophetic of developments in the 1920s, Soloviev wrote that the purpose of art was 'life-building'; artists are capable of disclosing the universal harmony which will not become available to all until after the events of the Apocalypse.[15] Viacheslav Ivanov (1866–1949) became the leading theoretician of Russian symbolism. From 1905 on, his 'Wednesdays' – gatherings in the large bay-windowed room of his top-floor Petersburg apartment, nicknamed the Tower – attracted intellectuals and artists of all sorts to discuss philosophy and mysticism and the purposes of art. Ivanov himself developed a coherent aesthetic which was of deep and lasting influence.[16]

It is well known that Russian intellectuals were much engaged with the function and the teachings of religion before the Revolution, especially after the grave events of 1905.[17] What is less familiar is the continuation of this interest and concern after the Revolution. Lunacharsky's part in this was of especial importance. He had worked with Lenin to prepare for revolution during the early years of the century, when he also developed ideas he had long had on the role of religion in relation to Socialism. Religion for him was the man-centred faith the German philosopher Ludwig Feuerbach had written about, influencing Marx. Early Christianity had been a proletarian movement characterized by a 'beautiful sense of brotherhood' and a collective spirit which individualism, encouraged particularly in Protestantism, had gradually eroded. Lunacharsky's two-volume treatise *Religion and Socialism*, published in 1908 and 1911, argued that Socialism was a new religion, a religion of the Third Testament, and that the Russian people, deeply attached to Orthodoxy, would need to have Communism delivered to them in religious terms if they were to embrace it.[18] Lenin mocked this man-dominated version of religion as 'god-building', and as against the 'god-seeking' of Soloviev and other mystical thinkers,[19] yet it was the subject of lectures Lunacharsky gave in 1918 to political-education instructors employed by his ministry in Petrograd. In these he portrayed Christ as one of the earliest 'founders of utopian social-ism'.[20] Maxim Gorky (1868–1936) was of working-class origin, orphaned at seven and entirely self-taught as a writer who soon fell foul of the Russian authorities. In exile, he was close to Lenin and to Lunacharsky, with whom he trained would-be revolutionaries at the political school they set up in his house on Capri. In 1909 he too wrote in *Confession* of a fusion of Marxism and Christianity as a religion which the general public would understand and adopt. After the Revolution Lenin publicly honoured him as a true worker-writer. Yet Gorky was distressed by the Soviet State's dictatorial actions, and in 1921 he went west again, returning briefly in 1928 and permanently in 1931.

Thus, at the working-class level as among intellectuals, it was possible for Lunacharsky and others to preach 'a religion of social democracy' which was atheistic but expressed itself in terms of religious conviction and warmth.[21] Meanwhile, intellectuals who went to the peasants to preach Socialism, adopting the habit of the Populists of the 1870s, saw their world as a religious utopia, 'a kingdom of freedom and fraternity'. The Bolsheviks needed to find a language that would address a peasantry unaccustomed to the more

openly political terms heard in the cities. They used religious references and imagery to implant their messages. Socialism was Christ's work; Lenin, especially after a bullet failed to kill him, was seen as 'a Christ-like figure . . . blessed by miraculous powers'.[22]

Proletkult (PLK) was devised by Bogdanov[23], who had also taught at the Capri school, bringing to his promotion of Communism wide-ranging energies and talents as a philosopher and sociologist, economist and physician. After retiring from public cultural work because of Lenin's opposition to PLK in 1921, Bogdanov returned to academic philosophy and then to research in haematology. He died performing on himself an experimental blood-transfusion. He too was a 'god-builder'. He saw mankind divided since prehistoric times into those who organize and those who execute, into decision-makers and labourers. A basic task of the new society would be to end that duality by developing every Russian's creative abilities and enabling people to express their own culture and organize themselves. The arts were all-important in developing creativity and awareness in a spirit of conviviality. In an essay published in 1918, he stated that 'Art organizes social experiences by means of live images not only in the sphere of knowledge but also the sphere of feelings and aspirations'. His science-fiction novel, *Red Star*, first published in Petersburg in 1908 in a series of utopian books which included Thomas More's and Tommaso Campanella's, was reissued in large editions in 1918 and 1922 and staged by PLK Theatre in 1920. It describes a benign Socialist society flourishing on Mars, as experienced by Leonid who was taken to the red planet during 1905, against the background of the massacre in Petersburg and the strikes and near-revolutions that followed it.[24]

Before the October Revolution, in the summer of 1917, Bogdanov had begun to set up PLK as a network of workers' cultural study centres. Often called studios,[25] PLK centres grew rapidly outside government control, though with encouragement from Lunacharsky. Bogdanov strove to establish harmony and union where others spoke of class struggle and cultural opposition. His tastes, like Lunacharsky's, inclined him to recommend continuity and the classics while some around him, like the admired and ambitious worker-poet Alexei Gastev, writing in the PLK's journal *Proletarian Culture*, demanded a close embrace by proletarian art of 'the stunning revolution of artistic methods'. In 1920, in the same organ, Bogdanov encouraged PLK artists to adopt the avant-garde's new methods – 'photography, stereography, cinematography, spectral colours, recording etc.'[26] Though the cultural product of PLK remained modest – positive achievements included cabaret and theatrical performances on topical issues – the new class of worker-poets was enlarged and empowered to exhort their fellows to have faith in the new system.[27] Cultural work, PLK insisted, was as important as industrial work, and it was proper to accept the help of the 'revolutionary-socialist' intelligentsia even if they were bourgeois in origin. Collective work would remove class barriers. In any case, no aspect of the cultural inheritance should be dismissed or destroyed but all should be weighed in the light of working-class priorities and developed through 'critical reworking'.

An independent proletarian university was set up in Moscow in 1919, to Bogdanov's great satisfaction, but in 1920 it was merged with a Central School of Soviet Work and thus placed under the control of Lunacharsky's ministry. Lenin's antagonism to PLK had been declared at the All-Russian Congress on Extra-Mural Education of May 1919 in an unscheduled speech after Bogdanov had reported on PLK's work. Lenin declared 'merciless hostility . . . towards all intellectualist concoctions, towards all "proletarian cultures".' His vehemence indicated the weight people gave to Bogdanov's teaching. It reminds us that,

in spite of Lenin's pre-eminence, the Soviet government did not exercise full control during Lenin's lifetime but had to allow open dissent on all issues not directly contrary to its political premise. In 1922 Lenin insisted that Lunacharsky's ministry should assume direct control of PLK. Before that, up to half a million working-class people, male and female, had been studying at about three hundred PLK centres throughout Russia, issuing their own books and journals.[28]

Alexei Gastev (1882–1942) was one of the best, and best-known, proletarian poets of Tatlin's time. A metal-worker, he had been writing and publishing poetry since 1904. A fellow poet named him the 'Ovid of engineers, miners and metal workers'.[29] For him, progress would come from a cultural fusion of Russia with America. He saw machines as symbolic and practical forces transforming society into a powerful unity. In 1917 he wrote of the revolutionary worker as one growing 'into a mythic giant, reaching the height of smokestacks as iron blood flows into his veins'.[30] In his enthusiastic rhetoric, collectivism becomes close to enslavement to the machine, with each worker's life synchronized with the needs of industrial production. After PLK became an organ of government, Gastev wrote little poetry but as founder and director of the Central Institute of Labour he promoted Taylorism,[31] especially in Russia where America was seen as demonstrating the benefits of energetic enterprise in a republican society unfettered by the restraints of nostalgia. Lenin had first seen Taylorism as Capitalist abuse of the worker but changed his mind in the face of Russia's sluggish industrial life. Bogdanov considered it destructive of the workers' self-respect and contrary to the Marxist vision of working-class development to full social and cultural awareness as individuals within a strong community. He wrote articles critical of Taylor's system from 1913 on and did not adjust his opinion in the light of Russia's economic needs.[32]

In spite of Lenin's open antagonism, Bogdanov was widely respected among the leading figures of the time for his outgoing energy and his commitment to the working class as the foundation of the new society. His theory of organization was adopted by the constructivists in 1922 as part of their argument for abandoning art for industrial production. A statement issued by PLK during its brief independent existence defined its task as being to revolutionize labour, fusing the artist and the worker, life-style and feelings. PLK also insisted on collectivism, and universalism; thus, a movement initiated in Russia as a class development would grow into an international culture. The year 1920 saw the organization of an International Bureau of PLK. Lunacharsky chaired its executive committee which included elected members from all the major Western European countries. It was assumed that a common language, most probably English, would counteract national divisions.

*

The Russian tradition of memorializing great events by building commemorative churches, and the vision of technological advance to the point where it guides society without divine governance, are both directly relevant to Tatlin's monument. His designs and models for it have often been presented as a utopian technological vision. More will need to be said about these two strands and their meeting in Tatlin's Tower, but the mind-set of the period in which it was being conceived clearly made its contribution.

Wars and the immediate aftermath of wars are times for fantasy, architectural and otherwise. When all economic power goes into the war effort, there can be few opportunities

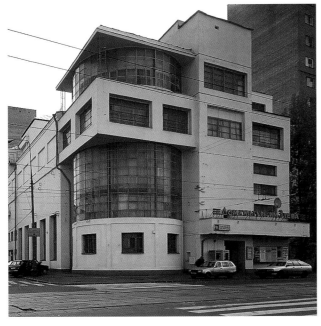

43. Walter Gropius, Administrative Building, Werkbund Exhibition, Cologne, 1914

44. Ilya Golosov, Zuyev Workers' Club, Moscow

for significant building. The ruins left by war may call for reconstruction but, though ideas for this may well be put forward, the work itself is likely to be delayed by shortages of every kind and, once it can be undertaken, limited for economy and speed. 'Paper architecture', as it is sometimes called, thrives under these conditions, and also in periods of open social dissent. The years before the French Revolution of 1789 and its aftermath saw French architects, notably Étienne-Louis Boullée and Claude Nicolas Ledoux,[33] transforming the classical tradition into a language of monumental symbolism both in designs that stayed on paper and in executed buildings – an *architecture parlante* as it was to be called subsequently, a 'speaking architecture' addressing itself to a wide public which would readily respond to their symbols and expressive force. The centenary of the French Revolution was celebrated by the great Paris Exposition of 1889 and the Eiffel Tower. The achievements of the French Revolution and its immediate and later consequences, of which Napoleon's invasion had to be a key component, were carefully studied by Russian revolutionaries and by the tsar's government. References to French political thought of that epoch were common in Russian writings and debates, and continued beyond the Revolution. There were also close parallels in Germany.

Germany witnessed dramatic developments in architectural design in the pre-1914 years, and immediately after the emperor's abdication and the armistice of November 1918. That month a forward-looking group of architects and artists was formed in Berlin as the Working Council for the Arts (*Arbeitsrat für Kunst*[34]), as well as the Berlin Novembergruppe with artist members from all over the country and with architects such as Walter Gropius and Bruno Taut prominent in its committees. The Novembergruppe proposed radical reforms for the production and consumption of art, including the brave proposal, never actually adopted, that art should be exhibited anonymously so that an artist's standing should not condition viewers' responses to individual

45. Bruno Taut (with
Franz Hoffmann), Glass
House, Werkbund
Exhibition, Cologne, 1914

works. In April 1919 the group presented an 'Exhibition for Unknown Architects', consisting of designs for imaginary buildings. In a pamphlet published on this occasion, Gropius described architecture as 'the crystalline expression of the noblest of men, of their ardour, their humanity and their religion'.[35] Similar words could be read elsewhere, representing the aspirations of the moment.

Gropius and Taut, and many others around them, believed that architecture could lead to the formation of an international brotherhood bound by spiritual ties, instead of material goals and rivalry. In his book of 1919, *Die Stadtkrohne* (The City's Crown), Taut put forward ideas for major community buildings in terms of clustered crystalline forms, reaching up into the heavens. Communities would be organic growths; public buildings would be 'organisms . . . expressing the human community'. Taut formed a circle of like-minded men who corresponded with him as *Die gläserne Kette* (The Glass Chain): glass brought transparency and implied total sincerity. With their help, from 1920 to 1922, he published a journal entitled *Frühlicht* (Dawn), arguing enthusiastically for an architecture made quasi-immaterial by its use of glass and steel, transparent but also giving light, and illustrated by means of fantastical drawings.[36]

This vision was demonstrated publicly in two buildings erected for the 1914 Cologne Werkbund exhibition. Gropius contributed a Factory Administration Building (Fagus-Werk) (fig. 43) with spiral staircases at both ends rising in glass and steel cylinders (to be echoed in Ilya Golosov's Zuyev Workers' Club (fig. 44), Moscow, in 1927), its dematerialized forms making internal movement visible. Taut caught even more attention with a glass and steel pavilion, circular in plan and rising in two stories from a concrete base (fig. 45). In elevation it was cylindrical below and acorn-shaped above, with a faceted, diagonally latticed, almost Gothic glass dome rising to a point. Inside, the combination of coloured glass and a waterfall

46. Alexander Rodchenko, design for a street kiosk, 1919, gouache and ink on paper, 51.5 x 34.5 cm. Private collection

made this building a temple in praise of light. Taut's pavilion served no other purpose than to demonstrate itself.[37] Similar impulses came from the Netherlands before 1914 and a grandiose 'Pantheon of Mankind' was proposed there by H.P. Berlage in 1915.[38]

Comparable developments flourished in Russia. Gigantism was a noticeable tendency; another was the piling up of stereometric solids without concern for structural limitations. Vladimir Krinsky and Nikolai Ladovsky were leading figures in this and, though it seems extremist to our eyes, it was not marginal on the post-Revolution scene. In 1919 those two and a few other like-minded architects, as well as one sculptor, formed a commission under IZO to pursue a research work separate from that of IZO's architecture department which was led by a convinced classicist. The sculptor was Boris Korolev (1884–1963) who had travelled in the West before the war and was responsible for the shortlived monument to Bakunin in 1918.[39] This group researched 'questions bearing on the Synthesis of Sculpture and Architecture', and was known as Sinskulptarkh. They hoped to find a new architectural language that owed nothing to classicism. Towards the end of 1919 they were joined by Rodchenko and Varvara Stepanova, and by Alexander Shevchenko (earlier associated with Larionov's primitivism and rayism), all then thought of as painters, so that Sinskulptarkh became Zhivskulptarkh by inserting *Zhiv* from *Zhivopis* painting and its aim being the synthesis of painting, sculpture and architecture. Punin's first account of Tatlin's project, published in March 1919, may well have stimulated this appetite for design concepts embracing elements of all the visual arts.

Their 'experimental designs' were graphic representations, rarely developed as plans, elevations and sections. One of the tasks they set themselves in 1919 was, significantly, to design a 'Temple of Communion Between Nations'. The results were bold but entirely impractical, proposing alarmingly unbalanced compositions of solid masses, each quite original but conceivable only as paper architecture. Calling themselves now the rationalists, and joined by the sculptor-painter Alexei Babichev (1887–1963), they ran a foundation course in

free formal invention in the new art workshops, intended to liberate students from all pre-conceptions of what is permissible and feasible, and implant in them a formal language of communicative abstract form. Babichev was prominent also in the theoretical work of Inkhuk, the Institute of Artistic Culture, including its debates about composition and construction. His work for Lenin's programme included statues as well as non-figurative monuments.[40]

Rodchenko's architectural work of 1919–20, done under the aegis of Zhivskulptarkh, in many respects stands apart from this search for monumental expression. He developed several designs for kiosks – light structures to stand on streets for commercial and agita-tional purposes – including a newspaper kiosk known in three variants, exhibited during 1919 and 1920 and published in the journal *Kino-Fot* (cinema photography) in 1922 (fig. 46). This kiosk comprised a relatively solid hut at street level, for storage and to provide a counter, the roof of which could serve as a platform for speakers. From this would rise a mast-like spire to which various planes are attached to display posters and slogans, and, above them, a three-faced clock. Rodchenko gave the designs transparency, planes, sharp corners and odd angles. In 1920 he made designs for a 'House of Soviets' for the centre of Moscow. This important new project called for a clearly anti-traditional form. Rodchenko found this by adapting his kiosk concept to the scale and practical functions of a major gov-ernment building.[41] In each design a relatively solid architectural unit of several stories would be its base. Contrasting with this, a mast, strengthened by cables and lattice girders, would rise to three or four times the height of the base. Connected to it by lifts, this mast would serve to display a clock, slogans and probably loudspeakers. Other Rodchenko designs vary greatly in their forms, some continuing the research begun in connection with kiosks, but also one introducing a new concept. This proposed two solid tower blocks linked two-thirds up by a weighty horizontal unit, like the bar across the letter H, supported by rods or cables coming down to it from the upper portions of the vertical blocks. What unites these efforts is the desire to initiate architectural design of a new sort, at once functional and visibly innovatory. They all proposed expressive as well as functional extension by going upwards, without building on more city space. They appeared in exhibitions during 1919–22 and many of them were published in the periodicals of those years.[42]

*

This activity and the aspirations propelling it on were part of the context of Tatlin's work on the Tower. They show a hunger for innovation, and at times seem to respond to news of his Tower project even before essential information about it became available towards the end of 1920. Tatlin found himself in competition with a return to historical classicism as well as with this anti-historical, semi-playful, often blatantly unrealistic experimentation.

Malevich's architectural projects, for example, in drawings and plaster and/or wood mod-els, embarked on after 1921, were exploratory works rather than designs intended for realization. Some propose earth-bound buildings, among them the 'Pilot's House' seen in a drawing in the Stedelijk Museum, Amsterdam: a long, low building, mostly symmetrical about its long axis, and drawn in perspective as though looking down at its front. Seen like this it resembles an aeroplane.[43]

Contacts between Russian and German artists were established after the war, especially between those with generally Socialist or progressive views of society.[44] Already in 1918

Lunacharsky's Petrograd and Moscow IZO committees had approached the newly formed Berlin Workers' Council and Novembergruppe to establish information links and to exchange personnel and work. In 1920 he sent representatives of PLK to the West, among them probably the young Umanskij who spoke good German. Many writers, artists and musicians began to move between Russia and Berlin, and many Russians came to Berlin to stay. The Treaty of Rapallo, April 1922, gave new opportunities for Russo-German interaction by re-establishing full diplomatic relations between the two countries and pledging economic co-operation. This ended the relative isolation in which war and its aftermath had left them.

Cultural co-operation between Moscow/Petrograd and Berlin developed rapidly from 1922 on, most noticeably in music, theatre, film and photography, but also in architecture and the visual arts, including news of radical developments in art education. Here Russian initiatives certainly led the way and German institutions such as Gropius's Bauhaus followed. The Bauhaus opened in 1919 but needed to be reformed and reorientated during 1922–3. The appointment there of Vassily Kandinsky, early in 1922, was part of the story; even more important was the appointment of the young László Moholy-Nagy. Born in 1895 in Hungary and self-taught as an artist, Moholy witnessed the rise and fall of an Hungarian Soviet state, left his country to work in Vienna and then, in 1920, moved to Berlin where he got to know the Dada activists and also, from late 1921 on, El Lissitzky. By the time he joined the Bauhaus in 1923, he was patently a Lissitzky disciple, in his own work and in his teaching and the world-view it expressed.

The Russian art exhibition shown in Berlin in late 1922 and Amsterdam in 1923 was followed, in 1924, by the 'First General German Art Exhibition' in Moscow's Central Historical Museum. It comprised about five hundred exhibits representing German art since 1900, mostly works on paper to minimize transport costs. It had many thousands of visitors and was well received by critics. Though it ranged widely in subject-matter and style, it included recent work both by artists associated with the 'New Objectivity' (*Neue Sachlichkeit*) tendency and by artists and architects working at the Bauhaus. It coincided with the open development of opposed tendencies in Russian art and design, when the socially-orientated realism of the Association of Artists of Revolutionary Russia (AKhRR) emerged in opposition to non-figurative art and constructivism.

For Germany, as for Russia, America offered a model of opportunity and headlong modernization though its priorities were patently Capitalist. A Berlin cabaret song of about 1923 celebrates the new Russian theatre ('Let's make Russian theatre, just like Tairov's!'), but goes on to say that 'the Russian way is already entirely New York' (*Russisch ist schon ganz New York*). Enthusiasm for Whitman's exuberant poems was almost as widespread in Germany as in Russia, and joined to that was the growing popularity both of detective stories on the American model and of science-fiction in which the future tended to resemble the New York of skyscrapers, not of brownstone houses. Edward Bellamy's American 'tale of social felicity', *Looking Backwards*, first published in 1888, was widely read and discussed in Europe as well as in America. It described a Socialist society through the eyes of a rich, nineteenth-century Bostonian who had fallen into hypnotic sleep to awake in the year 2000. Universal education and the organization of economic and social matters had replaced conflict and inequality. Christian ideals had been accepted so firmly that religion itself was no longer needed. Art had become part of the daily life of the community and served these ideals.[45] In England H.G. Wells began publishing his famous science-fiction

novels in 1895, and soon moved on to write studies of society that envisaged a better future. In 1906 he visited the USA. In January 1914 he visited Russia. His writings were well-known there already, a collected Russian edition having come out in 1909. He spent some time with Gorky, whom he had met in New York. Gorky was his host in Petrograd when he went to Russia again for fifteen days during September/October 1920. They had endless conversations, and Gorky arranged for him to meet Lenin in Moscow. Lenin appears to have lectured Wells on the need to electrify industry throughout Russia. Wells came away impressed, and wrote *Russia in the Shadows* before the end of the year. Lenin thought him a philistine.

It is difficult today to see the disparate utopias proposed to mankind up to the 1920s as having a common purpose. In Russia their distinctness had become apparent as their specific aims were debated; their underlying unanimity could be taken for granted. One of the visions on offer was metaphysical, and focused on mankind's spiritual life. The other was materialistic and social, and focused on developments in industry and the material demands of modern life. Both foresaw social equality established in a world of general amity. Once mankind's inherent kinship was realized militarism could cease, releasing vast resources, mental and material, for constructive purposes. The two visions were fused in the thought of a reclusive but amazingly erudite and prophetic librarian, working from 1868 at the Rumiantsev Museum in Moscow, Nikolai Fedorov (1828–1903). Fedorov wanted to announce and defend specific practical programmes, reflecting God's wishes for humanity and the powers that nature offered, as yet utilized only by primitive means, such as coal mining, but available on global, even cosmic scales as developments in science and technology demonstrated every day. Most of his writings were published posthumously in 1908 and 1913 as *The Philosophy of the Common Task*, but Fedorov had long before that established his remarkable influence on prominent Russian thinkers.[46]

Fedorov drew on many aspects of science to form his visionary prescriptions for humanity's 'common task'.[47] He planned to control weather and to derive electrical power from the atmosphere. The magnetic energy of our own planet and other celestial bodies would enable Earth to explore the universe. Those who studied his complex project argued that it provides the fullest and the most profound answer to the question that modern mankind confronts as it advances along the path of controlling and altering life: what is to done?[48] Mayakovsky's vast optimism about the future relied partly on his reading of Fedorov. Viktor Shklovsky, the futurist man of letters, who worked alongside Mayakovsky on the journal *Lef*, hesitated to associate Mayakovsky with Fedorov and all that 'mystical nonsense about the resurrection of the dead'. Yet a little way further down the same page he quotes lines from his hero's great poem of 1923 about love and life, 'About That!'[49]:

I'll shout
 from this
 the page of today:
Don't turn the pages!
 Resurrect![50]

Elsewhere in the same poem, Mayakovsky associates immortality with the liberation of human powers associated with the promise of electrical energy:

> Immune to decay and dissolution
> there rises above the passages of the centuries
> casting light in all directions
> the laboratory of human resurrections.

<div align="center">*</div>

Specific points in Fedorov's wide-ranging thought come close to Tatlin's. We cannot assert a direct connection, but need not see Tatlin detached from ideas and expectations many around him shared and debated. Malevich's art and writings echo Fedorov's vision of a cosmos open to exploration, as well as his disdain for all art that serves lust and materialistic values. Konstantin Melnikov, one of the most adventurous and profound architects of the age, free-thinking in many respects although devoutly Russian Orthodox, was much concerned with thoughts of death and the question of the prolongation of life. Under Fedorov's influence he developed his architectural projects to embody and signal thoughts about rejuvenation and rebirth. For many Russians the Revolution itself was a first step towards the ultimate revolution which the overcoming of death would bring. Time would show that this second step was not imminent, yet the Five Year Plan and the Cultural Revolution of 1928 raised the same Fedorovian expectations.[51]

Tatlin spoke in early 1919 to Punin about his monument: 'As unity of architecture, painting and sculpture, the temple represents the Earth, which returns its dead, and Heaven . . . which is being populated by resurrected generations.' An epoch of human collaboration will come with the advance of science and of social understanding, and hence also major technological discoveries, especially in the area of 'celestial mechanics, celestial physics and other celestial sciences', so that:

> a sturdy structure could be erected – a Temple of the Worlds – which would exist without props or supports, and which would move in infinite space. Such a temple would emancipate all the world from bondage to gravity and from subservience to the blind forces of gravitation, transforming thereby these worlds into a tool for the expression of the mutual feelings and of mutual love of all the generations of mankind.

Mankind must become 'sky-mechanics and sky-physicists'; Earth will become a spaceship and mankind its crew. Meanwhile, it takes effort to maintain the vertical posture which is mankind's expression of will and morality.[52]

Bogdanov's 'science of organization' incorporated major aspects of Fedorov's thought and was particularly influential in the early 1920s. A telling instance of a younger man inspired by both Fedorov and Bogdanov was the writer Andrey Platonov (1889–1951). Of working-class origin, Platonov became an electrical engineer. In 1920 he was sent from Voronezh to Moscow to attend the first all-Russian convention of the Association of Proletarian Writers. Debate there centred on Bogdanov's vision of a new proletarian culture and on his Fedorovian belief in the omnipotence of a mankind working in full mutuality. Platonov's first published piece of writing is a pamphlet on *Electrification* (Voronezh 1921), promising that electrification, apart from bringing immediate practical benefits, would in

47. Gustav Klucis, *The Electrification of the Entire Country*, 1920, black and white photomontage, 20.1 x 25.2 cm. G. Costakis Archive (Inv.no A230a), State Museum of Contemporary Art – Costakis Collection, Thessaloniki

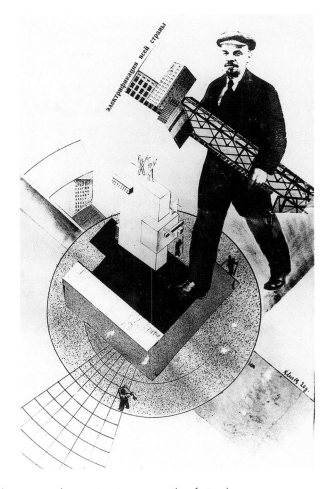

changing the nature of work change also the nature of humanity, welding workers into a spiritual and practical community:

> Electrification is the 'revolution' in technology and has the same significance as the revolution of October, 1917. Only through electrification can one understand the importance of the October revolution.

Platonov goes on, in this pamphlet and in his poems, to elaborate visions of mankind's wholesale command over nature on Earth and in the cosmos: 'The same strength is in us which burns up the sun'. Platonov's remarkable fiction is charged with Fedorov's ideas.

It is clear that the State's most self-evidently utilitarian ventures were at this time as imbued with spiritual aspirations as was its ideology, even though Lenin himself resisted the spiritualization of matters he considered best governed by rationality. Gustav Klucis's well-known poster, *The Electrification of the Entire Country* (1920) (fig. 47), shows Lenin striding purposefully towards us, carrying a structure, mostly of steel girders, onto and across a global area which has on it notional architecture in a Malevich or Unovis mode. It can be read both for its signals referring to bold activity in a new and blatantly modern context and for its utopian vision of harmony: the march of Communism promises technological empowerment to all. Klucis had previously made a photomontage entitled *The Dynamic City*, with similar architectural elements and a global disk, and with a few figures so placed as to counter pictorial norms of 'top' and 'bottom' and thus also of notions of gravity.[53]

This aspirational energy informed Tatlin's work and thought. If he did not express it fully in words, his repeated insistence on collaborative creation embodies it: individualism and competition bring death; collectivism and unanimity bring harmonious life without end. This is patent in Khlebnikov's writings, and sometimes also in Mayakovsky's. It is vital in Lissitzky, five years younger than Tatlin and Khlebnikov, though Lissitzky, partly through his training and partly through his important activity within the art and design worlds of Central Europe, learned to express it in more technical, and thus more internationally acceptable, terms.[54]

. . . the recognition of the potential holiness of matter, the unity and sacredness of the entire creation, and man's call to participate in the divine plan for its ultimate transfiguration. These ideas are grouped under the name of Hagia Sophia, Holy Wisdom, the vision of which has never faded out in the long evolution of Russian Christianity.[55]

Even the coming of Lenin's New Economic Policy, during 1921–2, did not block this vision, though there is some lowering of the temperature in which it was expressed. The immortalization of Lenin's image and body after his death in 24 January 1924 reflects it, and Stalin was to find in it ways of promoting his own importance and even his concept of 'Communism in one country'.

Punin's suggestion that Tatlin's Tower, especially when seen in profile, suggests a human figure makes one wonder whether it could not be an image of Fedorov's prehistoric man, raising himself from the ground. In other respects, the proposed position of the Tower and the direction of its spine[56] suggest that one of its functions was to serve as the emblematic control-module of the spaceship earth as it ventures forth on cosmic exploration. These points will be discussed in the next chapter; here they are raised merely to locate Tatlin, too, among those responsive to Fedorov's exultant concept of the 'common task'.

Tatlin is likely to have responded to Fedorov's paragraphs on the meaning of buildings in a section of his writings headed 'Art as it should be, how it was and what it has become'. Art has been limited to 'the creation of dead semblances' and, in churches, symbolical representations of the universe. It should be 'the actual creation of the past and of the universe'. The Russian church is already 'a projection of the world as it should be'. The images inside Russian churches unite to give 'a picture of all history beginning with Adam, . . . then the forefathers . . . the Forerunner, Christ, the apostles and so on to the end of time'. These join with the clergy and congregation in worship.[57]

Concept and design of the Tower

I

At some point, Tatlin decided that his monument to the Revolution would have to be a tower. Perhaps he knew this already when Punin, in his article of early 1919, wrote it would comprise a 'united form', not a cluster of forms with discrete identities, as in Vitberg's design, nor an historicist exercise like Ton's massive Church of the Saviour in Moscow. The new monument would be a proudly innovative addition to the long history of towers ranging from Babel to Eiffel.

In Russia, the tower known as 'Ivan the Great', or the Great Kremlin Belfry,[1] dominates the silhouette of the Kremlin, Moscow's citadel, standing on hills that rise to 400 metres. Its lower parts were built to the orders of Ivan III during 1505–8. Boris Godunov added the upper third in 1600, so that its golden onion dome, reaching about 82 metres, would soar above the clustered domes of the fifteenth-, sixteenth- and seventeenth-century cathedrals close to it. Providing the highest vantage point in the Kremlin, it also served as the city's watch-tower. At ground level, it houses a chapel dedicated to St John Climacus (St John of the Ladder). The Sukharev Tower of 1692–1701 — a tall three-storey edifice in an idiom known as 'Moscow Baroque' but suggesting influence from Northern Renaissance buildings along the Baltic coast — was a gateway on Moscow's main highway going north. It was 'built like a lighthouse or a ship', and housed a navigational school and Russia's first astronomical observatory. Its dominant feature was an octagonal tower ending in a short spire. Until the Church of the Saviour was built, the Sukharev Tower was the second tallest building in Moscow after the Great Kremlin Belfry. It was demolished in 1934.[2]

The focal point of Petersburg on the other hand is the Admiralty, a partly neoclassical edifice designed by a Russian architect, Andreyan Zakharov, and built in 1823 to replace a modest building begun by Peter the Great. Its tower is topped by a fine gilt spire — known as 'the needle' — rising to about 73 metres. It stands out amid the ordained horizontality of old Petersburg. Three avenues radiate from it, of which the Nevsky Prospekt is the longest and busiest. Across the River Neva, further east and north, roughly opposite the Winter Palace, stand the eighteenth-century Cathedral and Fortress of Saints Peter and Paul, built to keep out the Swedes but soon used as the 'Russian Bastille' to hold generations of

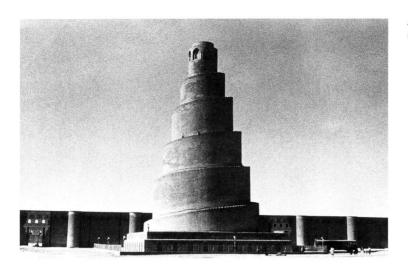

48. El Malwiyya
mosque, Samarra, Iraq

prisoners. The church dates mainly from 1750 and has a tower: its gilt spire rises to about 123 metres. Tall as that is, it does not diminish the focal role of the Admiralty's golden needle. St Isaac's Cathedral, Petersburg's largest church, was built in 1819–58 a little to the south of the Admiralty. Designed by the Frenchman Ricard de Montferrand, it is a massive classical building of granite and marble on a Greek cross plan, topped by a large, semispherical dome which, with its lantern, reaches about 102 metres.

Russian churches do not normally aspire to great height. Their onion domes, unlike the domes of classical architecture, seem charged to reach higher than they do in physical fact. They are normally part of the church proper though some bell towers were built to be freestanding, such as the Great Kremlin Belfry. The sixteenth-century Church of St Basil in Moscow's Red Square has a multitude of domes, large and small, as well as pyramidal caps over its seventeenth-century porches. It was built by Ivan IV ('the Terrible') to commemorate his capture of Kazan after a long struggle during 1552–3. It is popularly known by the name of Russia's favourite native saint who installed himself beside it: Basil, the Holy Fool. Holy Fools were wandering men, homeless and poor as the rags they wore attested, known as men of God and admired as at once truth tellers and 'fools for the sake of Christ'[3] by the populace. In a land where tsar and patriarch, State and Church, became so closely united, these seemingly powerless but independent men were held in deep affection by the peasants on whose support their lives depended. According to James Billington, Ivan's 'campaign against the Tatars at Kazan . . . was a kind of religious procession, a re-enactment of the storming of Jericho'.[4] The church he commissioned was dedicated to Our Lady of the Veil (*Pokrov*); it was later by popular usage that it acquired the name St Basil's. Tall and colourful enough to catch attention, it is experienced as a pyramidal composition.[5]

Tatlin on his travels may have seen the El Malwiyya Mosque at Samarra (fig. 48), a masonry tower in the form of a spiral. He could also have seen the great Ibn Tulun mosque, with its spiral minaret, in Cairo. Khlebnikov is likely to have interested him in Babylonian precedents, and so might the artist Georgii Yakulov, born in Georgia in 1884. Yakulov travelled in the Far East before 1905 and in Western Europe in 1910, and spent the summer of 1913

49. Athanasius Kircher, the Tower of Babel, engraving, as illustrated in Kircher, *Turris Babel*, Amsterdam, 1679. Private collection

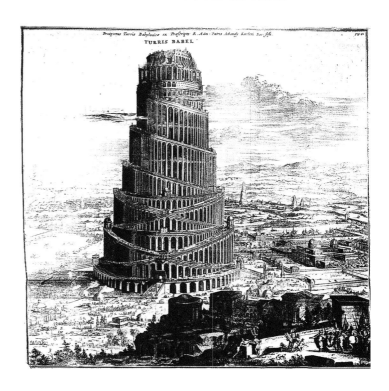

in Paris as a guest of the Delaunays. Returning to Russia, he tried to have the Delaunays invited to show in Moscow. Sonia Delaunay was in touch also with other Russian artists and intellectuals, such as Mayakovsky and Alexander Smirnov who lectured on the art of the Delaunays at The Stray Dog café in Petersburg in December 1913.[6] Yakulov worked and exhibited alongside Tatlin in Moscow before and after the Revolution. In 1923 Yakulov, together with the architect Shchukov, designed the spiralling Monument to the Twenty-Six Commissars of Baku, combining aspects of Tatlin's Tower with architectural fantasy in what should have been a work of solid masonry reaching high above the Baku skyline.[7]

The most obvious Middle Eastern precedent for Tatlin's Tower is the Tower of Babel built to the orders of King Nimrod, 'a mighty one in the earth' when 'the whole earth was of one language, and of one speech . . . a tower, whose top may reach unto heaven'. This was intended as a challenge to God's authority, an act of rebellion that should make Nimrod and his people renowned. But God prevented it: 'Therefore is the name of it called Babel; because the Lord did there confound the language of all the earth: and from thence did the Lord scatter them abroad upon the face of all the earth.'[8] Thus the Tower of Babel was both the ante-type and the antitype of the Monument to the Third International: global Communism, achieved through Comintern's efforts directed from the headquarters housed in it, would reunite mankind politically and allegorically — in time also linguistically — in one shared language and endeavour. Tatlin's friend, the poet Khlebnikov strove all his life to identify the basic components of human language by studying the functions, meanings and visual equivalents of particular sounds across the several ancient and modern languages to which he had access.

Many images of the Tower of Babel were available. They normally took the form of a vast ziggurat, circular in plan. The best known today are those in Brueghel's paintings, but there are others in such books as Athanasius Kircher's *Turris Babel*, published in Amsterdam in 1679 (fig. 49). Kircher was a searcher akin to Khlebnikov and the last of the great Renaissance polymaths, working before science separated from theology and alchemy. He investigated the origins and early histories of everything, from numbers and languages to music, philosophy and the plague. His *Ars Magna Sciendi* ('The Great Art of Knowing'; Amsterdam 1669) is a systematic presentation of all forms of knowledge overseen, as its frontispiece shows,

50. Martin van Heemskerck, *Colossus of Rhodes*, 1570, engraving. Witt Collection, Courtauld Institute, London

51. Boris Kustodiev, *The Bolshevik*, 1920, oil on canvas, 101 x 141 cm. Tretyakov Gallery, Moscow

by the eye of God and borne by Sophia, Divine Wisdom. Having written about the Deluge, Noah's Ark and the origins of languages in *Arca Noë* (Amsterdam 1675), Kircher turned to the Tower of Babel and its context of ancient civilizations and languages. He claimed that Nimrod, Noah's great-grandson, wanted the tower built in case God should decide on another Deluge, and calculated that it could not have been realized. Livius Creyl's representation of the Tower of Babel in Kircher's book delivers a tall structure, unfinished but rising confidently from its circular base, way beyond the skyline of nearby palaces and ziggurats. Two equal spirals criss-cross it symmetrically to provide broad ascending roads, until, about halfway up the tower, they become one spiral, rising more steeply. In the background of Kircher's illustration stands a ziggurat resembling the mosque at Samarra.[9]

Turris Babel discusses also other 'Wonders of the Ancient World', including the pyramid of Cheops, the hanging gardens of Babylon and the Colossus of Rhodes (fig. 50). A memorable engraving shows this vast male figure bestriding the entrance to a large, circular harbour. He holds a sceptre in his right hand; his left hand, outstretched, holds a flaming lamp. So the statue functions as a lighthouse as well as symbolizing and defending the island's commerce and power. For Milner, Tatlin's Tower would have been a Wonder of the Modern World, challenging those of the ancients, specifically the pyramids, the Colossus of Rhodes and the Pharos or lighthouse at Alexandria.

St Petersburg/Petrograd has a port. A stroll westward from the Admiralty or from the Academy brings us to the busy modern harbour with all its traffic and technologically advanced equipment. T.M. Shapiro, who helped Tatlin build the model of the Tower, spoke of their awareness of that scene:

Walks along the banks of the Neva with its forest of cranes and girders were for us an inexhaustible source of inspiration. The view of moving openwork constructions against a background of swiftly flowing clouds revealed to us the poetry of metal.

Tatlin's workshop was in the mosaic studio of the old Imperial Academy. It was here that he and his assistants built the model of the Tower and displayed it first, in a classical edifice, on the embankment of Vasilievsky Island opposite the Admiralty.

Shapiro confirmed that the two great arches from which the Tower rises were intended to straddle the Neva at the heart of Petrograd. 'This strengthens the case for its interpretation as a special kind of striding figure', Milner adds, pointing to Kustodiev's 1920 painting, *The Bolshevik* (fig. 51). Kustodiev shows the gigantic figure of a worker, carrying a red flag and marching determinedly out of the industrial section of Vasilievsky Island into the centre of the city, accompanied by a swarm of tiny figures: a poetic image of the way the October Revolution had come over Palace Bridge to the Winter Palace. In Bely's novel *Petersburg* a senator dreads an imminent uprising in the city, coming out of Vasilievsky Island where factories and university buildings concentrate a dangerous mix of workers and students.

Tatlin's Tower, signalling Communist evangelism to the whole world, would also be a giant lighthouse for Petrograd, emulating the Pharos of Alexandria. A sixteenth-century drawing represents this as a cylindrical, spiralling ziggurat, tall and massive, rising from a rocky island connected to the city by a long causeway.[10] The actual Pharos was built in the third century BC on a square platform in three tall, diminishing sections: square, octagonal and cylindrical, rising to a total height of about 140 metres. The Roman Tower of Hercules at La Coruña was built in imitation of Alexandria's Pharos and looks onto the Atlantic from the northernmost point of north-west Spain. It rises from a platform as a tall square-

sectioned building containing a ramp, and has above it two much smaller octagonal sections and a nineteenth-century lantern, reaching much the same height as the Pharos.[11]

The immediate model for Tatlin's Tower was Eiffel's, designed by the engineer to commemorate the French Revolution of 1789 and to advertise the 1889 Paris International Exposition (fig. 52). This was on the Champ de Mars, the old parade ground between the classical buildings of the Ecole Militaire and the River Seine which had served as the site of Maximilien Robespierre's celebration of 'Worship of the Supreme Being' around a raised altar called 'the Sublime Mountain'. Eiffel's tower would entertain visitors by offering them viewing platforms, cafes and restaurants. It had no other practical functions. Many of Paris's intellectuals and taste-makers hated it, in prospect and in fact, comforting themselves with the thought that it was a temporary structure that would disappear with the exhibition. Eminent figures of the Paris arts community had protested against its erection already in 1887, decrying it as 'useless and monstrous'; the city's fine buildings would be dwarfed by this structure resembling 'a gigantic black factory chimney'. The public, they claimed, already scorned it and rightly called it the Tower of Babel.[12] The poet Jules Laforgue supported the project with the slogan 'Place aux Jeunes!' (Make Way for the Young!) and promised that it would become beautiful. That it was so was noted by André Antoine, director of the controversial Théâtre Libre, in 1889: 'There are days when . . . the Tower takes on an admirable lightness and elegance.' He was certain that everyone would come to admire 'this first realization of the aesthetic of iron'. Some responded to its anthropomorphic character, as when the engineer was caricatured in the guise of his own design. In the event, Paris and France love it and have kept it. After 1903, at Eiffel's suggestion and expense, it was equipped to send military radio messages over great distances; from 1911 it also radioed time signals, using Greenwich Mean Time. From 1918 it housed France's first civil radio station.[13] From around 1910 the tower served also as a marker for newfangled flying machines to race around.

At three hundred metres, the Eiffel Tower was the tallest building in the world. It still is surprisingly tall, in itself and as seen in its flat terrain. A little way to the south of it stood another fine engineering structure, a play-thing without a commemorative role, the ferris wheel built for the 1900 Exposition and known as La Grande Roue. We see the two structures together, the mobile and the stabile, in photographs of the time and in paintings such as those Delaunay and Chagall made around 1912. The two constructions complemented each other: the static, vertical feature (a male form, but a feminine presence as *La Tour Eiffel*), and the slowly rotating wheel, both erected for pleasure and profit. One could also, and still can, combine a view of the Eiffel Tower with that of another commemorative monument, a small version of the Statue of Liberty, standing beside the Seine near the Pont de l'Alma. New York's Statue of Liberty, properly *Liberty Enlightening the World*, was the French Republic's gift to the American Republic, in celebration of the centenary of its birth in 1776. Frédéric Bartholdi designed its surface; Eiffel provided the internal iron framework. She stands, a female Colossus, on Liberty Island, at the entrance to New York's harbour, a flaming torch in her hand. The small version by the Seine commemorates this fraternal gift. Tatlin will certainly have seen the Eiffel Tower and the Grande Roue when he was in Paris. He may also have taken in the small Statue of Liberty, perhaps looking across the Seine from the right bank. He will have known of them in any case: the symmetrical vertical engineering structure celebrating revolution, the slowly revolving wheel offering popular entertainment, and the female figure of Liberty, the vast one in New York if not the small one in Paris.[14]

52. Eiffel Tower, Paris

53. Robert Delaunay, *Red Eiffel Tower* (*La Tour Rouge*), 1911–12, oil on canvas, 125 x 90.3 cm. Solomon R. Guggenheim Museum, New York (Solomon R. Guggenheim Founding Collection 46.1036)

In 1909–12 Robert Delaunay had painted a series of Eiffel Tower pictures (fig. 53). The poet Blaise Cendrars relates how he and his friend Delaunay would stalk *la Tour*, peering at her from all angles, near and far. In the paintings the tower becomes something like a Baroque saint, a vivid, spirited thing, with clouds clustering around its head like *putti*, and little and large houses and sometimes curtains framing and echoing its dramatic presence. Delaunay's work was included in both the Blaue Reiter exhibitions in Munich (the second was in February 1912) and was represented in the *Blaue Reiter Almanac* by three large reproductions and an article on his work by a German art historian, Erwin von Busse.[15]

The *Blaue Reiter Almanac* was well known in Russia from the moment it was distributed in the summer of 1912. It reproduces Russian folk art as well as modern art, and texts were invited from Russian writers — on primitivism in modern Russian art by David Burliuk, on Skryabin, on 'free music' (involving quarter and eighth tones), and so forth. Kandinsky's own art and words dominate the book. He wanted to be considered part of the Russian art world and achieved this through correspondence with and visits to his native country, as well as by contributing to exhibitions in Russia and writing for Russian journals. From the

midst of modernity, the almanac trumpeted the timeless continuity of artistic creation as an expression of humanity's need to transcend earthly existence. Like the best Russian futurists, Kandinsky took a position that looked back as much as forwards; it was the academic and materialistic recent past that he was working against in his art, his writing and his promotional work. Though his views differed in important respects from Tolstoy's, he too thought that art should operate on a spiritual plane and that authenticity was the product of inner necessity honestly attended to.

This spiritual aspiration was demonstrated in the almanac's wide range of illustrations. Some showed work by the editors and the contemporaries they esteemed. They ignored all classicism, ancient or Renaissance, and its extension in academic art. The name *Der Blaue Reiter* (the blue horseman), will have warned readers that its views were rooted in symbolism. In Russia the name echoed that of a pioneering group of artists which formed in Moscow in 1907 and in the same year held an exhibition of paintings that were often dreamlike. This group was called The Blue Rose.[16] Moreover, the almanac ignored the convention whereby folk art, tribal art, exotic art and above all child art were not considered fine art. In this the editors were of the same mind as Larionov.[17] Several illustrations were paired, inviting comparison. For example: the recumbent stone figure of a German knight, from a tomb in Frankfurt Cathedral, is shown opposite a bronze figure of a Benin warrior. Between pages 32 and 33 are reproduced, on the left page, Delaunay's *Eiffel Tower* and, on the right, a supposed *St John the Baptist* by El Greco. This showed a tall, flame-like figure, characteristic of El Greco's mature work, silhouetted below against a distant landscape and above, from his long thighs upwards, against a sky in which billowing clouds frame and celebrate the saint. Both paintings were in Köhler's collection. The monochrome illustrations reveal surprising similarities. The tower and the saint are both emphatically central and vertical, and are displayed as tremulous visionary presences, though one pictures a famous piece of engineering while the other represents a man charged, long ago, with announcing God's arrival on earth to redeem mankind.

Paris had originated another relevant tower project, the proposal of a world-famous artist eager to serve progressive social purposes. In 1898 the question arose what kind of monument should grace the 1900 Paris Exposition Universelle, extending from the Champ de Mars across the river and as far as the Place de la Concorde. The idea was to erect a monument to all human labour, physical, mental, artistic, etcetera. Rodin, then at the height of his fame, was asked whether he would contribute to it and was so enthusiastic that he took command of the project and immediately began to work on a model. The monument would be a masonry tower, 130 metres high, combining features of the campanile at Pisa with the spiralling reliefs of Trajan's Column. It would be more significant than the Eiffel Tower which, Rodin said, for all its size, 'has no meaning'. At the top, two female winged figures, 'benedictions', would crown the edifice and commend its message (fig. 54).

The scheme was too elaborate to be realized for the exposition, but by that time Rodin's plaster model had been reproduced in the first book on his work, by Léon Maillard, published in 1899. The story did not end there. The peace conference of 1907 in The Hague, which promised to render all wars unnecessary, called for a visible sign. It looked as though Rodin's tower might be realized there or, failing that, somewhere in France. There was much enthusiasm for this 'first monument of a new age'. The money was available;

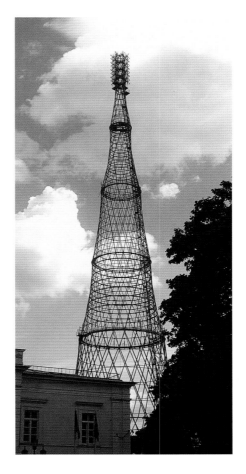

54. Auguste Rodin, Monument to Labour, 1893–4, plaster maquette, 90 cm high. Rodin Museum, Paris

55. Vladimir Shchukov, Radio Tower, Moscow

committees were formed. After some months the idea was dropped, for no evident reason. The writer Ricciotto Canudo, having spoken up for it in the journal *Censure* in August 1907, celebrated the project at greater length in his own journal *Montjoie!* in 1913. The idea of erecting an 'Apotheosis of Work', as Paris's fine arts inspector described it, a monument to life outside the Garden of Eden, was not easily discarded.[18]

Hindsight makes it difficult to imagine a Tatlin Monument to the Revolution built of solid materials. Yet stone or bronze were the norm for sculpture; brick or stone — in Petersburg often brick, or even wood, stuccoed to look like stone — were the norm for architecture, with iron sometimes concealed within structures to reinforce them or displayed ornamentally in the spirit of Russia's modern style. It is possible to imagine Tatlin thinking of wood. Russia has a fine tradition of log churches and other wooden buildings, and this tradition was associated with the *plotniki* — the honoured fraternity of roaming carpenters of great skill and utility, but also of assertive independence and thus associated with radicalism.[19] As

a former sailor with a lifelong passion for ships, and as a maker of traditional musical instruments, Tatlin knew wood intimately. But his father was an engineer, and engineering had already achieved its progressive image. Russia had exciting engineering structures to show. In Moscow, for example, the store we know as GUM, the State Universal Store, was built during 1889–93 by the architect Alexander Pomerantsev in massive masonry. Internally it has three-storey shopping arcades roofed by metal and glass tunnel vaults and domes designed by the engineer Vladimir Shchukov. Light bridges linking the walkways on the first and second floors are in reinforced concrete: the first use of this system in Russia. Shchukov was already known for other engineering contributions to architecture as well as for developing structures of a new kind for erection as towers. Possibly they were larger versions of the steel skeleton masts erected on Russian battleships before 1914, using a similar lattice structure.[20] The best-known by Shchukov is a radio tower standing in Moscow, completed in 1922 (fig. 55); it was being constructed off-site when Tatlin was finalizing his own tower project. Smaller towers of similar design, lighthouses as well as radio transmitters, had already proved the value of Shchukov's innovation. The Moscow tower is 153 metres high, an exceptional height in the city, but Shukhov had intended one more than 350 metres high, consisting of ten sections. As built, five diminishing hyperboloid sections form a light and elegant steel structure that functions to this day. Its erection required neither scaffolding nor cranes, each section being hoisted up within the completed lower section.[21] Two Shchukov lighthouses were built in 1911 between Odessa and the Burliuk's home; Tatlin may well have known of these.

None the less, the exclusive use of metal and glass for a great building, let alone a monument, was unprecedented in Russia, which is one of the reasons why Tatlin's Tower attracted such sharp reactions when its model was exhibited in 1920–21. Mayakovsky declared it 'the first monument without a beard': it owed nothing to the historicist idioms of nineteenth-century design. Perhaps Mayakovsky was also referring to Peter the Great's symbolic act of compelling his courtiers and civil servants to shave off the beards that Orthodoxy had required until then. It seemed that the Monument to the Third International was shrugging off all debts to tradition. Yet, of course, the architectural use of iron and glass has its history too, and one to which Russians gave special symbolical value.

London's Crystal Palace was erected in Hyde Park in 1850–51 to house the first Great Exhibition in an empire's capital. Many eminent people in Britain argued passionately against the exhibition and against this building; all sorts of disasters would stem from both, not least from the mingling of the world's races, drawn to London for the event. The event and the building turned out to be an outstanding success, and from that success grew the taste for similar large, often international, exhibitions in the leading cities of Europe and America. In 1853–4 the Crystal Palace was reconstructed, at twice its original great size, on Sydenham Hill in South London. Its displays, and also the formal and informal gardens laid out around it, were presented as a 'living encyclopedia' as well as the site for musical and other festivals, and it drew many visitors. A fire destroyed it in 1936.

The heroine of Chernyshevsky's *What Is To Be Done?* has a dream about how perfect life will be when good sense prevails. The author has already set the tone for this in many ways, principally by offering us Vera Pavlovna and her two successive husbands as model 'New People' who live by the light of reason and refuse to be trapped by conventions. They are not superior, the author insists; it is just that we are all inferior.

Come up from your caves, my friends, ascend! It is not so difficult . . .[.] Try it: development! development! Observe, think, read those who tell you of the pure enjoyment of life, of the possible goodness and happiness of man.

Vera foresees that happiness. She dreams of a vast building, standing among perfect corn-fields and orchards. It is of a new kind of architecture, made of glass and iron: 'there is just a hint of it in the palace which now stands on Sydenham Hill'. In her dream, this serves as the shell case of another building, with enormous windows, inside which everything is novel and perfect, including furniture made of a new metal called aluminium. Many people live here. Vera sees them working in the fields and orchards, singing as they harvest with the help of machinery; their work done, they come inside to join in a splendid dinner, an everyday event. 'The closer you bring the future,' Vera is told by her guide, 'the brighter, richer and happier your life will be. Strive for it, work for it, bring it nearer and do everything you can to bring it into the present.'[22]

Chernyshevsky's message was that of the Enlightenment, reinforced by early nineteenth-century social thinkers such as Charles Fourier: let reason be your guide and all will be well. Harmony and contentment, mankind's natural lot, requires only the shedding of superstitions and the oppressive systems these generate. All we need is rational egotism. The influence of his book was remarkable. Lenin praised it, seeing in Chernyshevsky an important herald of Bolshevism. Its optimism was difficult to resist for generations living in a sharply divided world. An article in Dostoevsky's journal *Epoch* in 1864 reviewed the book at length and with high praise. In the same year Dostoevsky wrote a short novel, *Notes from Underground*, publishing it in the same journal. Its first part is a passionate reaction to all notions of human perfectability. The voice is that of a dismissed former civil servant, a nobody who is trying to survive in spirit as well as body amid the glamour and seductions of Petersburg. To him, reason is a false guide. Look beneath the surface of existence and you soon learn that 2 plus 2 equals 4 is 'an intolerable thing'. People tell him that the perfect world is coming, 'all complete and also calculated with mathematical accuracy', and that 'the Crystal Palace will arise'. But shall we be able to bear it? Man has an appetite for 'construction and the laying out of roads', but is also 'passionately disposed to destruction and chaos'. As for 'the palace of crystal', one wouldn't even 'be able to stick out one's tongue at it'. Does he want to stick his tongue out, then? 'On the contrary, I would let my tongue be cut off out of sheer gratitude if things could be so arranged that I myself would lose all desire to put it out.' Meanwhile we should admit that suffering exists, as much as the longing for happiness.[23] In an article of 1873, Dostoevsky expanded on his attitude to Chernyshevsky, whom he admired as a man but found impossible to agree with on important issues.[24]

In this way a potent utopian symbol can attract hope and faith, but also derision.[25] In the first decades of the twentieth century, glass architecture was valued for its connotations of enlightenment and a new age, both rational and transcendental. But it depended on industrial support. It was not only Tatlin's iron and glass monument that could not be built. In its wake came other designs, such as the Vesnin brothers' projected Palace of Labour, a vast building designed in 1922–3. The initial design for this was the work of Tatlin's friend Alexander Vesnin. He also made the first drawings for another competition, for the Leningrad Pravda newspaper offices in Moscow, in 1924. This was a brilliantly pared-down concept to fit a tiny site, calling for glass and a metal frame and little else, and providing for a range of

communication methods, including loudspeakers and the projection of news and slogans onto a movable screen, as well as a prominent digital clock. Attached to the side of this glass box would have been a *paternoster* lift — itself a glass box — to be entered and left as it moved up and down.[26] In the same year Alexander and Viktor Vesnin devised a collapsible aeroplane hangar, kept erect by steel posts and tensed cables. None of these admired projects was executed.[27]

*

Part of a seventeenth-century mural showing the Tower of Babel in the vault of the Voskresenskii Cathedral at Tutaev (formerly Romanov-Borisoglebsk) is sometimes adduced as another possible model for Tatlin. We see the tower under construction, with workmen around its foot and on scaffolding higher up, adding stones to a slender and already tall structure. The surface of the painting being curved, from most viewpoints the tower itself appears curved and leaning. It shows a spiral ascent similar to that of Samarra, though in the opposite direction. Tatlin, with his interest in church art, is likely to have known of it, and may even have seen it at first-hand.[28]

An impulse of another sort came from closer at hand. Lunacharsky finished writing his play *Faust and the City* in 1916 and published it in 1918. His first essay in literary criticism had been an article of 1902 on 'The Russian Faust', and he returned to this theme in an article of 1903. Shortly before his death in 1933 he told Gorky he was working on a book on Faust. This ongoing interest stemmed from his admiration for Goethe's famous drama, itself developed over years from a cluster of folk legends, and Lunacharsky's interest in the theme of the creative, restless genius *vis-à-vis* the calls of democracy. He outlined his dramatic plot in 1906. In 1908 he wrote a first version of the play; the 1916 version involved substantial cuts and changes. His purpose was philosophical as well as dramatic. How can the genius, driven by subjective urges as well as by his understanding of the world, relate to the masses, and they to him? He had discussed this with Gorky when they worked together in the West. He wrestled with Nietzsche's presentation of the Superman as a modern Faust. He ends by pointing to the proletariat as the source of the genius's power, and thus reconciles the intelligentsia to collectivism. 'Learning from genius, the people is learning from itself.' The genius draws on a great common inheritance, and serves to focus the people's collective thought. They need him; he owes everything to them. Bogdanov and Gorky had debated this concept with Lunacharsky long before the Revolution. Tatlin would express similar thoughts in the essay he wrote in 1919.[29]

In the play, Faust commissions a great Florentine artist, Dellabella, to design a monumental tower: 'He is a great and wonderful man. He can do — everything!' In short, a Leonardo. Dellabella brings his drawings: the tower will be tall, circular in plan above a square base and topped by a lofty dome that will rise far above any other building in the city. In the dome is a rose window with a stained-glass image of the heroic godhead 'bestowing upon us light, motion and order'.[30]

As Commissar of Enlightenment Lunacharsky commended plays and films as potent means of shaping public opinion and aspirations. His *Faust and the City* was staged in Petrograd in 1920. The text published in 1916 has a frontispiece, by Sergei Chekhonin,[31] showing a vast tower and a heroic male figure, a Superman. Lunacharsky's *Oliver Cromwell*,

written in 1919, is a more historical treatment of a similar theme, this time a bourgeois hero working for the masses. It was published in 1920 and staged in Moscow in 1921. He left unfinished a trilogy of plays about Campanella, two parts of which were published in 1921. These met with criticism for presenting a priest as a revolutionary, yet here again Lunacharsky was examining the relationship of the creative individual with the world around him. In 1918–19 he had scripted Soviet agitational films in collaboration with their producers. Altogether it is estimated that he wrote about fifty plays and film scripts, and two thousand articles, many of them on literary themes.

During 1918 the new Commissar gave lectures in Petrograd as part of the training of Soviet political education instructors, in which he promoted the faith of god-building, of mankind as the new divinity. Convinced that religion was the most elevated expression of human consciousness, and that Socialism was the only possible religion for modern society, he saw no conflict between religious idealism and positive political and social programmes. Himself a Jew, he considered Karl Marx to be one of Judaism's greatest gifts to mankind; others he named were Isaiah, Christ, St Paul and Spinoza. Marx's challenge to his followers to change the world called for a religious response. 'Religion is enthusiasm', Lunacharsky wrote, adding Marx's words that 'without enthusiasm it is not given to people to create anything great.'[32] Christ was one of the 'founders of utopian socialism'. The lectures were published in 1923 as a pamphlet, *An Introduction to the History of Religion*.[33]

Lunacharsky's position in the young Soviet State was a difficult one. The differences that obtruded between him and Lenin were many and fundamental, whereas Bogdanov, never part of the Soviet government, and Lunacharsky were close allies. Lunacharsky started from a deep love of the arts and his belief in their ability to advance human society, whereas for Lenin they were dangerous distractions. Lunacharsky could not see objective criteria on which rules for the arts could rest. Artists must be free to open up new areas of human consciousness. They should aim to teach others, at all levels, to read art adequately.

Shortly after being appointed Commissar, Lunacharsky called for 'representatives of the literary and artistic intelligentsia' of Petrograd to meet him for a discussion in the Smolny Institute which the Bolsheviks had made their headquarters. Only a handful turned up: the artists Kuzma Petrov-Vodkin and Natan Altman, the writers Mayakovsky and Blok, and Meyerhold the actor and theatre director.[34] They declared themselves willing to work with the new government. People in the arts were generally suspicious of the Bolshevik take-over, which threatened doctrinaire control after the broad freedoms gained by the February Revolution.[35] But Mayakovsky welcomed the Revolution as the political corollary of the cultural work he and his friends had been pursuing in the arts, and Blok, apparently remote from politics, had a deep sympathy with the flow of change and the expectation of a world revolution which older symbolists could not share.[36] Lunacharsky, who knew personally many of the people he had invited to discuss the future, was to remember with gratitude those who did come. He needed committed individuals to work with him, and so he gave the futurists (as they still tended to be called, without differentiation) what looked like official support though they did not fit his personal tastes. Lenin was to berate him for doing so. For a time, futurism appeared to become Russia's official idiom in the arts, not least because the government's art paper in Petrograd, *Art of the Commune* (nineteen issues, December 1918 to April 1919), and its Moscow partner, *Art* (*Iskusstvo*; eight issues, January–December 1919), were largely written by Mayakovsky and his friends, including Osip Brik, Punin and Altman.[37]

Lunacharsky insisted that these avant-gardists should not see themselves as the government's chosen cultural party. (They, for their part, did not want to be seen as the government's employees.) His support, he stressed, would go to a wide range of Russian artists. Above all, Russia's art heritage had to be protected against vandalism, even the vandalism in the name of progress that Mayakovsky was preaching in his headstrong way.

The reactionary wave which, led by AKhRR, first formed in May 1922, fought to re-establish realistic art as the norm and politically correct portraits and genre scenes as the proper way to engage with the Revolution, appalled Lunacharsky. It was not art's business, he insisted, to illustrate the political present or to promote as reality idealistic scenes of social harmony not yet achieved. The re-emergence of realism as a force in Russian art followed Lenin's partial retreat from the full Communist programme in his New Economic Policies in 1921.[38] Lunacharsky feared a return to bourgeois values, and a threat to the development of a discrete working class culture as envisaged by PLK. At this point, too, some of the most progressive artists, such as Rodchenko, began to press for a commitment to utilitarian design and production. Thus regression into illustrational realism coincided with its opposite, an at least temporary abandonment of studio pursuits for the sake of economic stabilization, and it was to this that Lunacharsky gave his support. He was doubtful that artists were ready for total engagement with industrial processes, yet he was one of the first to welcome their desire to work on prototypes for factory production of utilitarian objects. Tatlin, on the basis of his work on materials, organized classes to prepare for work of this purposeful sort and himself made significant original designs.[39]

Lunacharsky was Tatlin's boss. The Tower project could not have been developed without Narkompros's direct support, nor, for that matter, the flying apparatus *Letatlin* on which Tatlin worked from the mid-1920s on and most intensely during 1929–32. This indicates the high regard he was held in within the ministry, for Lunacharsky resigned from it towards the end of 1928.

II

Commissioned by Lunacharsky to develop his monument to the Revolution, Tatlin moved to Petrograd in the summer of 1919. It is almost certain that the Tower was intended for that city and not, as has sometimes been said, for Moscow.[40] Lenin had moved the capital back to Moscow in February 1918, but Petrograd was proud to have been the Revolution's birthplace. And it was still Russia's 'window on the West',[41] with the vast extent of the Russian Empire, European and Asian, spread out behind it. In the spring of 1919 Grigorii Zinoviev, close to Lenin, had prophesied that 'in a year the whole of Europe will be Communist'.[42] Both cities were affected by the Revolution, Zamyatin wrote in 1933: 'And indeed, the victorious Revolution has become the fashion, and what true woman will not hasten to dress according to fashion? Petrograd accepted the new without such haste, with masculine composure, with greater circumspection.' Petrograd remains adult, he added, whereas there is now a new Moscow, aged sixteen, alongside the six-hundred-year-old city. Moreover, central Petrograd has no room for anything new; only the outskirts can take new buildings.[43]

There are many reasons why Tatlin's Tower should straddle the Neva, a combination of colossus and bridge. The Revolution had come across the Neva from Vasilievsky Island over Palace Bridge, linking the industrial and academic world of the island to the centre of the city. There is a world tradition that temples of all sorts gain power from being located on or close to major waterways. The Parade Ground, up-river from the Winter Palace, may also have been considered as a site for the Tower, though the Neva is impossibly wide here. This open space, much used for military parades in the days of the tsar, is Petrograd's equivalent to the Champ de Mars in Paris where the Eiffel Tower stands, but much smaller and less impressive.

Tatlin's project must have been well advanced by the time he settled in Petrograd. Punin's first account of it, published in March 1919 in the ministry's newspaper, gave evidence of his intentions, remaining vague on several points but asserting others. The commission and the move to Petrograd imply a moment of decision. This appears to have been taken before March, and was followed by the commission's specifying a monument in the form of a useful building. Later in the year its title became *Monument to the Third International*. We can only guess at the processes by which Tatlin developed his first intimations into a presentable design. How did he arrive at and set down in communicable form so unprecedented and complex a structure? We know of only two drawings. Clearly his dissatisfaction with the Monumental Propaganda programme had produced the urge to invent a technically advanced monument that could express the Revolution's grandeur. Once this thought had taken root it probably obsessed him. In the middle of 1920 he was ready to make the result public through drawings and, by November, to exhibit its large model in his Petrograd workshop.

The Civil War reached a critical stage during 1919. White forces pushed towards Moscow from the south. The Finns, having snatched independence from Russia, were preparing to invade their former masters from the north. In the newly independent Estonia, General Yudenich was trying to build up an army of Whites, Estonians and others, with a view to taking Petrograd from the west. The city was under grave threat. Lenin sent Stalin to defend it. He countered a British attack on Petrograd's naval bastion on the island of Kronstadt, close to the mouth of the Neva, and returned to Moscow in triumph that June. But his oppressive measures had damaged the Bolshevik cause in Petrograd. Moreover, Yudenich had not yet launched his attack. That came at the end of September. Supported by Finnish troops, and with a British naval squadron blockading Petrograd after demolishing much of the Russian fleet, Yudenich advanced to the Pulkovo Heights, just to its south, on 20 October. Meanwhile, Petrograd's inhabitants were close to starvation — so much so that Yudenich had to plan for the supplies the city would need when the Whites took over.

Trotsky rushed north from Moscow overnight on 16–17 October. With determination and unequalled skills as organizer and orator, he prepared Petrograd for Yudenich's attack. Lenin had considered letting the city fall. Trotsky, convinced that this should not happen, built up a spirited force of soldiers, workers and students. Punin, back from a visit to Moscow, appears to have been exhilarated by the danger, writing in his diary that, while Moscow was full of life, food and bustle, 'we — Petrograd, like a revolutionary fort — are alone, heroic, deserted, starving. Great city!'[44]

At the time the outcome was wholly uncertain. Both advances, General Denikin's on Moscow from the south and Yudenich's on Petrograd from the north-west, were repulsed during October. In fact, the Whites' defeat at these points, combined with Admiral Kolchak's retreat eastwards from the Volga earlier that summer, spelled the end of White hopes of

toppling the Soviet State. The war changed direction. The year 1920 saw Red armies pushing north towards Archangel and south towards Odessa and Sebastopol on the Black Sea, and Baku on the Caspian.

Lenin set up the Third International in March 1919. A shorter name sometimes used for Tatlin's Tower is *Monument to Comintern*, the abbreviated name of the office established in Moscow in March 1919 to promote Communism internationally. We must not forget this dual function, as a monument and as the Comintern's headquarters. What Tatlin may at first have thought of as an extension, though a bold one, of his work as artist, had become a project for a great governmental building. No such building had ever existed, a statement about collective power and about the unity of mankind as well as a functioning complex. Milner-Gulland aptly describes it as 'a monument to something in the future, intended to serve as the headquarters of the thing commemorated'.[45]

The model Tatlin and his group of assistants built in 1920 was about five metres high above its circular base. It was exhibited in Tatlin's studio of 'Materials, Volume and Construction' that November–December and was then taken down, transported to Moscow and reconstructed in the House of Unions where it was displayed during December 1920–January 1921 as part of an official exhibition to coincide with the eighth Soviet Congress. Alongside the model in Petrograd, pinned to the wall, were two large drawings. One shows the 'front', with the Tower appearing to rise vertically (fig. 56); this was used for the cover of Punin's 1920 pamphlet.[46] The other drawing, also reproduced in the pamphlet, shows the 'side' with the spine on the right, rising at about 65 degrees from the horizontal (fig. 57). Tatlin drew them in strict elevational mode, but the 'side' elevation is set against a lightly sketched background of city buildings, with tall factory chimneys prominent right and left, to suggest the monument's scale.

Tatlin's 'studio collective' or 'creative collective' — himself, Tevel Shapiro, Pavel Vinogradov, I. Meyerzon, Dymshits-Tolstaya and occasionally others, including Punin — built the model out of laths and broader strips of wood, tin and paper, nails and glue.[47] Angle brackets were cut from the tin. The units hanging within the Tower's skeleton were given paper sides ruled with black lines to indicate glass panes and their metal framing. The deep circular base under the model made it possible for someone to sit inside it, cranking a handle which made the units rotate — presumably all together. Tatlin's intentions for this motion were more complex, as we know from Punin's second and longer essay on the monument, written in July 1920 and published in December for the model's display in Moscow. In his diary, Punin tells of how he helped with the model for a while on 17 July: 'This evening I was building the "monument" with Tatlin. We worked on fixing the struts'. He obviously had a cheerful time, working and eating with the team. His entry ends: 'I really want the monument to be finished as soon as possible'.[48]

Punin's essay starts by emphasizing that this will be 'a new type of monumental art combining a purely artistic form with a utilitarian one'. It will demonstrate an 'organic synthesis of architecture, sculpture and painting'. Three 'large halls' of different forms will be supported by it. He uses letters to identify them: (A), a cube rotating once a year, is for 'legislative purposes', i.e. conferences, congresses etc.; (B), housing administrative offices, is pyramidal and rotates once a month; (C), cylindrical, will rotate once a day and accommodate the information services, i.e. publishing, telegraphs, projectors, everything needed 'for disseminating information to the world proletariat'. All are double-glazed for temperature control, 'like a thermos'. Electric lifts, fitting the revolution of the units, will connect

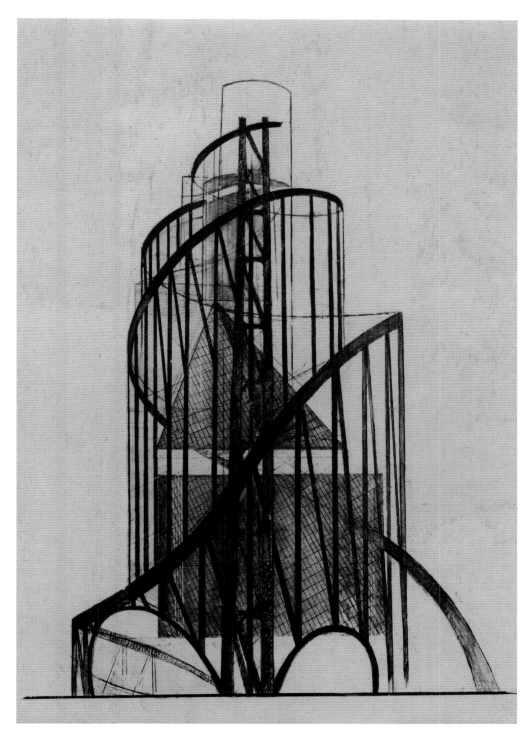

56. Vladimir Tatlin, Monument to the Third International, 'front' elevation, drawing, published in the book
The Monument to the Third International by Nikolai Punin, 1920. N. Punin Archive, St Petersburg

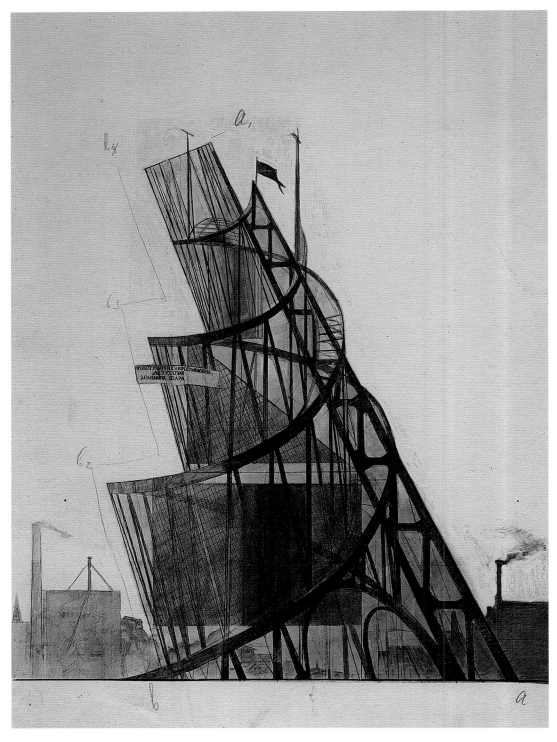

57. Vladimir Tatlin, Monument to the Third International, 'side' elevation, drawing, published in *The Monument to the Third International* by Nikolai Punin, 1920. N. Punin Archive, St Petersburg

them with each other and with the ground. There follow paragraphs emphasizing the need for a new kind of monument to replace the classical tradition of 'torsos and heads of heroes and gods': these 'do not correspond to the modern understanding of history'. 'Who will express the mental and emotional tension of the collective thousand?' A new monument has to share in the life of the city by being both 'indispensable and dynamic'. A new type of artist is called for, one 'who has not been crippled by the feudal-bourgeois Renaissance tradition', and has worked with 'the three units of contemporary plastic consciousness: material, construction and volume'. In Tatlin's invention we have the answer to the ideologists' search for 'the classical content of socialist culture'. 'The most complex problem of culture is being resolved before our very eyes: a utilitarian form becomes a pure artistic form. . . . We declare the present project to be the first work of revolutionary art that we can send — and we do so — to Europe.'

Punin then considers the Tower's formal language and commends it: the rising straight line of the great girder and the movement of the two spirals. The whole is 'like a steel snake held together . . . so as to rise above the ground'. The spirals are the most 'dynamic lines the world knows of . . .[.] A spiral is the best manifestation of our spirit'. 'These two most primitive materials', glass and iron, that 'owe their birth to fire', are 'the elements of contemporary art'. 'We have here an ideal, live and classic manifestation of the international union of the workers of the globe in a pure and creative form.'

Zhadova stresses Punin's intimacy with Tatlin and Tatlin's circle, as well as his eminence in Petrograd. She considers his essay art criticism of a new kind since it is 'written in a publicist manner' and as an ' "agitational pamphlet" for new art'. In 1922 Lissitzky and Ilya Ehrenburg published a shortened trilingual version of the text in the first issue of their Berlin journal *Veshch-Objet-Gegenstand*. Lissitzky (using the pseudonym 'Uden') added a brief note, reporting on how the model was shown in Moscow. There Tatlin and two assistants stood 'and explained the purpose and meaning of the towering monument to delegates from Siberia, Turkestan, the Crimea and the Ukraine'. Responses to the model varied from enthusiasm to puzzlement, and official ones tended to be negative.[49]

The model does not exactly correspond to Tatlin's drawings: the design was still developing (fig. 58). The relationship of the two great arches at ground (river) level to the struts rising from them seen in the photographs of the model differs from that shown in the drawings. What we might call the seven steps incorporated in the girder which is the building's spine, the horizontal joists, in the model are at regularly diminishing intervals. The profile drawing shows a double interval after the first four, counting upwards. In some respects the model makes clear what the drawings show only if we look for it. For example, both spirals end without clear terminal points, one appearing to touch one of two vertical poles (supports for telegraph wires etcetera), while the other continues a little way beyond the girder. In effect, they do not end. The Tower itself appears to be endless, unlike the Eiffel Tower. Like the Eiffel Tower, it springs out of the ground without a base. (Vitberg's triple church would have appeared to grow out of the slope of the Sparrow Hills.) When clouds cover the city, as they often do, Tatlin's Tower would seem to disappear into the sky.

Also, the Tower we see in the model (fig. 59) does not quite fit Punin's description. The third of the units, or 'halls', he described under (C) is topped by a semi-spherical element he leaves unmentioned. It is very close to the top of the cylindrical unit though probably not attached to it and not on the same axis, but it was generally regarded as making one unit with

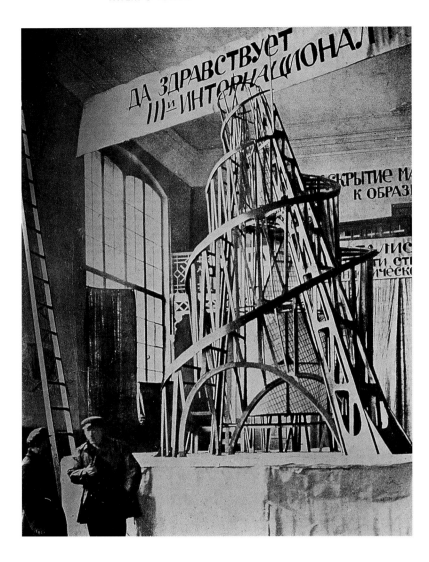

58. Model of the Monument to the Third International at an exhibition in Moscow, 1920, with Tatlin in the foreground holding a pipe, illustration from Ivan Puni's book, *Tatlin* (*Protiv kubizma*), 1921. Private collection

59. Model of the Monument to the Third International, at an exhibition in Petersburg, 1920, wood, cardboard, wire, metal, oil paper, c.500 cm tall

the cylinder. The middle, administrative unit, (B), is an irregular tetrahedron, a four-sided pyramid lying on one side, its longest face uppermost. This unit, alone, would change its silhouette as it turned. The lowest and largest unit, (A), the great 'hall', described by Punin as a cube and often referred to as a cube in others' accounts, has become in the model a wide cylinder. This change may represent an aesthetic choice, although a cylindrical form can occupy more volume than a cube within the Tower's circular structure. It may be that Tatlin decided that the very gradual, once-a-year turning of a cube, with its emphatic corners, would be less effective than the barely-perceptible rotating of a large cylinder. He may also have hesitated to give such prominence to a right-angled form. All the units necessarily had to turn clockwise. In this way the inclined black lines of the glazing bars would suggest a rising action, most noticeable in the topmost, once-a-day unit which would seem to screw its way into the sky, within the embrace of an iron skeleton which itself looks as though it is

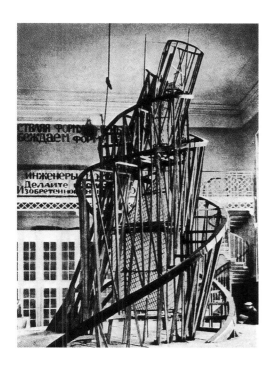

reluctant to end. The Tower would perform like a vast clock, telling cosmic time.[50]

One of its most remarkable features, as drawn and in the model, is the way the top section of the Tower comes close to being a discrete unit, an open structure of rising struts tilted to fit the general thrust of the Tower. In this way it resembles a tele-scope of the sort William Herschel erected in 1788, its great metal tube raised and lowered above a revolving base, supported by a timber structure. The massive derrick required to raise the granite Alexander col-umn in Palace Square, in 1829, offers a similar contrast between the core object and the supporting frame, in this instance temporary. We cannot be certain that Tatlin knew of these. Milner points out that in both cases their mechanical function and operation is clear, whereas in Tatlin's model they are not explicit. Either exam-ple may have led Tatlin to conceive his Tower as stereometric units within a linear skeleton. The fact that the Tower's apparent inclination from the vertical was intended to make it point at the Pole Star gives additional weight to this reference to an astronomical instru-ment.[51] What Tatlin's Tower does not show, in the drawings or in the model, is how the units within the structure would be supported or turned, entered and left.

If these discrepancies, between Punin's account, the drawings and the model, show that the design had not been finalized, we are left to wonder how it reached this point. It is one thing to have a vision of a great tower which might serve as a celebratory image and func-tion as a utilitarian building, and it is merely natural that the artist would consider many pro-totypes; it is another to arrive at a design capable of presentation in model form. Presumably Tatlin began with sketches, setting down a variety of ideas. At some stage he must have felt the need to test his ideas in three dimensions. That would have involved making maquettes, the first perhaps in hand-moulded clay, to hold what was becoming a complex structure that needed studying from many angles. Perhaps he made some small models in wood. Once the concept had become clear, the question arose how to make architectural drawings of a building in which hardly anything is rectilinear, vertical or horizontal and no aspect is a façade. The elevations he drew were done in terms of a wooden model, not in terms of iron or steel. He will have known as well as anybody that the economic and industrial situation of Russia could not immediately realize so ambitious an undertaking. He will also have known that large-scale engineering would call for professional input from engineers. He was too familiar with materials to have expected his design to be executed as presented. The model could only be an indication, a large three-dimensional drawing.

If the Tower were to straddle the Neva, it is not clear where precisely it might stand. Some commentators have tried to calculate its span from Tatlin's drawings to determine

where it could fit. This may well have been a question Tatlin left open until the realization of the Tower was under discussion. Many issues relating to it as a new element in the image and functioning of Petrograd would need considering, besides obvious technical questions. Punin, and we with him, should surely have known Tatlin's intentions on such points had they been settled. It seems likely that the Tower would have been sited to link the eastern end of Vasilievsky Island, on the right bank of the Neva, to the Winter Palace on the left bank or, quite close to that, a little further south-west where it would link the University Embankment on the right bank to the Admiralty on the left. In either case it would be an additional bridge, linking two significant areas. This end of Vasilievsky Island is occupied by the old Exchange (now the Navy Museum), a splendid neoclassical building designed by the French architect Thomas de Thomon to echo the Temple of Poseidon at Paestum — an example of the Doric Order at a relatively primitive, austere stage — and built during 1805–16. Thomon intended to develop its immediate surroundings 'as a monumental setting for civic and commercial ceremonies with granite quays, ramps, and rostral columns for lighthouses with seated figures of marine deities at their feet'.[52] Rostral columns have the prows of ancient galleys, represented in sculpture, projecting from them. Two such columns were built and stand there still, adding to the hieratic dignity of the open 'square' with its semi-circular end looking east towards the Cathedral and Fortress of Saints Peter and Paul as well as south to the Winter Palace and the Admiralty. Nearby are other major buildings of the eighteenth and nineteenth centuries, including, to the west of the Exchange, the row of twelve colleges which in 1819 had become Petersburg's University and, a little further, the Academy of Fine Arts. Its landing stage is marked by two powerful Egyptian sphinxes, brought there from Thebes in 1832. Further west, along the quay is what is known as the End of Carnival Square, on a small island. Beyond that is the harbour.

Those who have, since the 1960s, made reconstructions of the Tower as represented in the model have usually been able to derive their designs from old photographs of it, from Tatlin's drawings, and sometimes from more detailed drawings kept by Shapiro.[53] Eiffel published a detailed description of his tower in 1900, including in it a history of towers. The Eiffel Tower Tatlin saw in 1914 has many features that are echoed in his own, notably the large arches between Eiffel's four 'legs', inclined at about sixty degrees from the horizontal, and the great number of struts, etcetera. Eiffel was a great and experienced engineer. 'Tatlin', writes Milner, 'in wishing his tower to go higher than Eiffel's tower, was approaching the problem with more optimism than experience.'[54] And, I would add, he was intending to create a significant sign: the Tower of Petrograd would have symbolic meaning to support its work of promoting Communism to all mankind. The poet's son was in close collaboration with the engineer's.

This was not spelled out at the time and the design drew criticism from some quarters. In June 1919 Viktor Shklovsky, the literary critic and theorist close to Khlebnikov and to Mayakovsky, had expressed his doubts about

the intention to erect monuments to the Russian Revolution. It seems the Revolution hasn't died yet. It's somehow strange to build a monument to something still alive and developing.[55]

When Tatlin's model was on display it drew from Shklovsky this warm comment:

The word in poetry is not only a word, it attracts dozens, indeed thousands, of associations. The work of art is thick with them, as is the air of Petersburg of snow.

The painter, or the maker of counter-reliefs, is not free to bar the way to this blizzard of associations, leading through the canvas of the painting or out through the rods of the iron spiral. These works have their own semantics.

. . .

The monument is made of iron, glass and revolution.

Ilya Ehrenburg's account, in *E pur se muove*, was entirely enthusiastic, but he reckoned the model 'struck if anything terror and evoked ridicule. The majority of Communists greatly preferred Marx's plaster beard'. He wondered whether it could ever become the monument it should be: where would the courage come from, and the materials? He reported on 'A Design by Tatlin' in the third, Spring 1922, issue of Bruno Taut's journal *Frühlicht*. It is the first monument for modern times, he wrote, not only in Russia. Statues of individuals, the human figure naked or clothed, are 'mammoths' and have no place in the modern city. Tatlin's monument is utilitarian and 'has the same practical beauty as has a crane or an industrial bridge': it is not a governmental palace but a monument conceived in terms of work. The glass units inside it, two cylinders and a pyramid, turning at various speeds and having various purposes, are surrounded by a spiral (*sic*) that soars upwards. 'Unfortunately this is only a model, and it is hard to say when its realization might be managed.'[56]

Lunacharsky called Tatlin 'one of our most important artists' but could not like the model, presumably because of its unclassical asymmetry and thrust, perhaps also because of its conscious violation of the city of Petrograd. Trotsky may not have visited the model. He half-praised Tatlin's design. Eiffel's tower has no purpose, he wrote; 'it is not a building but an exercise'. 'That Tatlin . . . has excluded the national styles, allegorical sculpture, stucco-work, ornamentation, decoration and all sorts of nonsense — in this he is unreservedly right.' But why a rotating cube (*sic*), a pyramid and a cylinder, all of glass? Is not the whole thing untimely? How could anyone propose so new and demanding a building, technically and formally and therefore also economically, when we were just 'beginning to repair the pavements a little, to relay the sewage pipes', etcetera. The time would come when Soviet Russia would be able to take up 'the problem of gigantic construction that will suitably express the monumental spirit of our epoch'. By then Tatlin would have had time to revise his project. In any case, need a cylindrical meeting hall rotate? Trotsky was attracted by the idea of a vast tower built by emphatically modern means, but unwilling to consider any symbolical content. According to Strigalev, 'an expert committee of architects and engineers' advised in December 1919 that 'modern technology fully allows for the possibility of constructing such a building'. A. Sidorov, a critic reviewing Punin's pamphlet about the Tower, presumably after seeing the model, complained about the 'unnecessary aesthetization of the machine'. 'The technical beauty of the machine . . . does not require any artist-repairman.' In fact, Punin made no mention of machines and aesthetics. Also, 'The entire construction is inclined, and instead of a struggle toward the sky, it gives an impression of *collapse*.'[57] In fact the construction does not incline.

The circular plan of the Tower, its springing out of the ground rather than being built on visible foundations, its spirals and the rotating units, together deliver a message that evidently made a striking, to many a shocking, addition to the history of Russian monumental

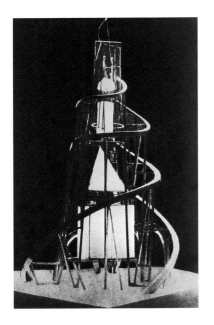

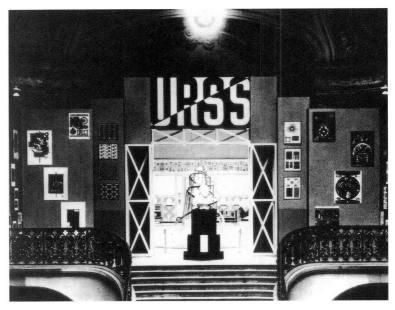

60. Monument to the Third International: photo of the model in the Paris International Exhibition of Decorative and Industrial Arts, 1925, as reproduced in its catalogue

61. Photo of part of the Soviet section of Paris International Exhibition of Decorative and Industrial Arts, 1925, showing model of Vladimir Tatlin's Monument to the Third International behind the bust of Vladimir Lenin at the top of the grand staircase

architecture. Christian churches, in the West and in the Orthodox East, are orientated whenever possible: they look towards the rising sun and are entered normally through the west end. Tatlin's Tower, rising above the churches of Petrograd, accepts no orientation other than that (using the word loosely) towards the Pole Star. It signals a new era.

Malevich was in no mood to welcome Tatlin's project. The Supremus group he had formed in 1916 had failed to produce their intended journal. He had said he would supply it with articles, and then said he would not, or only later. Worse, the group of his followers was breaking up by mid-1917. On 22 November Udaltsova wrote in her diary that these former allies had broken with suprematism in a callous manner: 'Malevich suddenly went crazy, and we quarrelled; if the journal comes out, and we get back what we put into it, fine, but if the money is gone, horrible . . .' Malevich had been thinking of calling it *Zero*, but *Supremus* would reiterate what 'suprematism' implied, his move from an anarchistic view of art to an entirely positive one. Yet the tone of an article he wrote in 1920 is wholly anarchistic, attacking everything in swingeing terms except for the 'banner of red Unovis'. Writing before Tatlin's model went on display, he referred disparagingly to 'Tatlin [who] wants to receive sums for the invention of a utilitarian monument not offering any new meaning'.[58] In 1922, the theorist Boris Arvatov, close to Rodchenko and to Tatlin, responded to another Malevich text, *God Is Not Overthrown* (published that year in Vitebsk), in an article arguing that in abstract art, as previously in representational art, there were two opposed directions, locked in battle:

One is Expressionism, i.e. art of subjective and emotional-anarchic forms, proceeding from Vincent van Gogh (Wassily Kandinsky, Paul Klee, Oskar Kokoschka). The other is Constructivism, i.e. the art of making things, proceeding from Paul Cézanne (Vladimir Tatlin, Alexander Rodchenko, Vladimir and Georgii Stenberg). . . . Suprematism is nothing other than Expressionism, only not emotional but intellectual.[59]

In spite of all the critical comments, the model of Tatlin's Tower made a deep and lasting impression. It was 'the first Russian project to express industrial-technological design not only literally but also figuratively, thus satisfying Russia's psychological need for a symbol of national progress and technological achievement. . . . Tatlin enlisted advanced technology to create a structure imbued with symbolic meaning'.[60]

A new model was commissioned for Paris, where the 1925 'International Exposition of Modern Decorative and Industrial Arts' was to signal peace and a return to civilized priorities (fig. 60). Even so, Germany was not invited to contribute; neither, for other reasons, was America. But Russia was, in spite of the fact that the organizers prioritized the comfort and entertainment of the rich and fashionable, by means of interiors mingling modern with archaic styles or playing with tribal imagery to create an amusing bathroom or study. Le Corbusier's Pavilion for *L'Esprit Nouveau*, the design journal he edited and largely wrote, was despised as non-architecture since it seemed to lack any style. It was, in fact, a section of one of the residential towers he proposed erecting in Paris in his visionary scheme for a city of sky-scrapers set in parkland. Accorded a blatantly marginal site in the exhibition, behind the Grand Palais, it was surrounded by a high fence while the exhibition was being formed lest its presence should endanger the preparations. Removing this fence at the last moment revealed to a readily scandalized public an example of what was already being mocked in the conservative West as Bolshevik design. The De Stijl group, formed in Holland during the war but by now thoroughly international in its membership and activities, was excluded, as was the Bauhaus, directed by Gropius and since 1922–3 radically modernized under the influence of Van Doesburg and his Russian ally Lissitzky. Political pressures made the Weimar Bauhaus close in 1925. Its rebirth the following year, in Dessau, was not foreseeable.

But there was a Soviet pavilion as well as an additional display in the Grand Palais. The pavilion was the work of one of Russia's most inventive architects, Konstantin Melnikov (1890–1974). It was built primarily of timber, on a rhomboidal plan bisected diagonally by a pair of open-air stairs. Whereas Le Corbusier's and other avant-garde architects' designs started from the classical formal base of the rectangle, Melnikov's pavilion spoke through more dramatic forms, inside and out, to form 'a masterly propaganda instrument'.[61] Rodchenko created for the exhibition a Workers' Club, an interior that contrasted powerfully as a concept as well as visually with almost all the rest of the exhibition, including even the interior of Le Corbusier's *Pavillon de l'Esprit Nouveau* with its space, Thonet chairs and Léger paintings.[62]

Rodchenko had been chosen for this work at the suggestion of Mayakovsky.[63] He was also charged with curating and installing the entire Soviet display. Many of the exhibits had to be works on paper — designs, posters, photographs, etcetera — though Rodchenko included prototypes for industrial production of utilitarian objects developed by his own students. This display was reached via a grand staircase at the head of which a white bust of Lenin greeted the visitor (fig. 61). Immediately behind it, as the exhibition's centrepiece, was

the new model of Tatlin's Tower.[64] About four metres high on its square base, it was a simplified version of the large model. With many fewer struts but otherwise retaining its features — the two spirals, the four units hanging inside the skeleton (the semi-sphere now clearly separated from the cylinder beneath it) — the model was more elegant as well as more legible, and possibly closer to what engineering in iron or steel would permit.

The Soviet contribution to the Paris exposition attracted a great deal of notice; much of it, especially in the architectural press, was respectful, even envious. Many commentators saw in the Russian exhibits evidence of the optimistic spirit of the young State. For some, Soviet Russia was becoming a promised land, so that Le Corbusier and others responded eagerly to calls for proposals for the Palace of the Soviets and other major building projects and even, in a few cases, emigrated to Russia. Conversely, Rodchenko made friends during his three months in Paris. He arrived at the end of March and had little time in which to prepare the Russian displays, and little money with which to complement the sparse materials he had been able to bring with him. His work done, he engaged with Paris and what it had to offer, often wishing he could buy things to bring back home. French art, as seen in that year's Salon des Indépendants, shocked him with its 'mediocrity and insignificance! The French, evidently, have nothing more to say. After Picasso, Léger and Braque there is emptiness, there is nothing else'. He left at the end of June. When the exhibition closed, his Workers' Club was presented to the French Communist Party.

Tatlin's books, Khlebnikov and festivals

I

In October 1925 Tatlin left Ginkhuk and Leningrad because of unspecified 'dramatic, unre-solvable conflicts'. He went to Kiev, to teach 'formal-technological disciplines' in the Theatre, Film and Photography department of the city's Art Institute. He remained there until the late summer of 1927, by which time he had been made a professor. He also worked in a ceramics workshop and formed a relationship with M.P. Kholodnaya, a ceramicist and sculpt-ress. When Mayakovsky visited Kiev, Tatlin collaborated with him on poetry recitals. During these months he began his research into the anatomy and flight of birds. In the summer of 1927 he applied to the Moscow Higher Artistic and Technical Institute (Vkhutein) for a teaching post and was welcomed into the department of Wood and Metalwork where Rodchenko and Lissitzky were teaching. He moved to Moscow with Kholodnaya and their son, into accommodation on the school premises.[1]

In her undated and unpublished *Reminiscences of Tatlin*, Anna Begicheva recalls that his bookshelves in Kiev held

> everything that Khlebnikov had published; one volume of Gogol and [one of] Pushkin, two volumes of Blok, collections of poems by Mayakovsky and Whitman, Dostoevsky's *The Idiot*, stories by Leskov, and Lenin's *Philosophical Notebooks*. On the wall there was a death mask of Leonardo and the head of his 'Angel in Plaster'.[2]

This is a significant list. Tatlin's interest in Leonardo will be discussed below. The 'Angel in Plaster' may refer to a relief version of the head the young Leonardo contributed to Andrea del Verrocchio's *Baptism of Christ* (about 1476). Tatlin's admiration for Mayakovsky is well known and will be commented on further. Whitman's collection of poems, *Leaves of Grass*, existed in at least two Russian translations and was a great favourite among progressives in Russia, before and after the Revolution. There are many lines in the poems that sing the faith in the future of mankind that sounds also from Tatlin's Tower and the work of several

of Tatlin's contemporaries. Khlebnikov and Mayakovsky were profoundly influenced by Whitman's free rhythmical verse and firm voice, but did not share Whitman's solipsistic embrace of the world. Alexander Pushkin and Nikolai Gogol are great heroes of Russian literature; both wrote major works on the theme of Petersburg. Gogol lived in Rome during most of 1836–48, the friend and champion of Alexander Ivanov when the painter was pursuing his *magnum opus*, a great painting of the *Revelation of the Messiah*. Of this, too, more below.

Nikolai Leskov (1831–1895) was a writer, principally of short stories, who lived and worked in Kiev as a young man, travelled all over Russia on behalf of an Anglo-Russian company, collected local sayings and tales, and in writing his stories often echoed regional idioms. Later he explored Eastern Europe, reporting what he saw and thought for a Petersburg newspaper, and went also to Paris and the Louvre. Before becoming known as a writer, Leskov had been commissioned by the government to report on the education provided in Old Believer schools. Arguments supporting closure were looked for, but he reported on the positive qualities he found in them, and on the limitations imposed by poor resourcing. He recommended that their situation should be eased, and that any plans for assimilating them to those run by the State should be achieved gradually and with sensitivity to their virtues. His report was valued by liberal opinion and dismissed by the conservatives. He was enthusiastic about Tolstoy's radical programme for the education of the young. Always alert to art and its reception, and insisting on the social and moral force of all the arts, he was one of the first to write about the artistic merits of old icon painting, regarding them as evidence of Russia's profound spirituality. He was especially interested in Old Believer piety and in the icons to which much of this was directed. He was acquainted with an Old Believer icon painter in Petersburg who restored old icons and painted new ones in the pre-Schism manner.

Leskov's fiction began to appear in 1863, the year of Chernyshevsky's novel, which he reviewed with praise. A short novel, *The Islanders*, is critical of official art theory but also of the nihilist critics' denial of art's social value. One of his most admired stories, 'The Sealed Angel', tells of the determination of Old Believers to recapture a cherished icon which officialdom had confiscated and 'sealed' by covering it with wax. He wrote about the icon in specialist terms not then in general use, and is eloquent about its spiritual dimension. The unsealing of it, with which the story ends, feels like a miraculous event. 'The Sentry' is one of Leskov's more urban tales. A drunk man is attempting to cross the ice of the Neva in the dark, about the time of the January 'Blessing of the Waters' ritual. He was likely to fall into the 'Jordan hole' cut for the ritual (see chapter 7) and be drawn under the ice. Lost and floundering, he was shouting for help. A sentry on the embankment, on oath never to leave his post, decided he would risk punishment to save the man's life. The crux of the story is not this brave act but the complex mental processes of, and actions done and left undone by, his immediate superior officer and by this officer's commanding officer, to protect themselves against their own regulations. The story assumes everyone's familiarity with the 'Jordan hole'.[3]

Tatlin made personal contact with the writers of his own generation quite early on. The great swell of interest in Slav and Russian antiquities and folk traditions had served both the Wanderers and the symbolists in the last decades of the nineteenth century. Moreover, there was a growing awareness of new developments in Western art — notably the work

of Gauguin and, among his followers, especially Maurice Denis, both well represented in the collections of Morozov and Shchukin. In addition Wagner's ideal of the *Gesamtkunstwerk*, the work that would bring all the arts into fruitful union, was often spoken of and attempted, mostly on the stage. The activities of the World of Art group — artists, writers and impresarios such as Diaghilev — and its influential journal, embraced a wide range of Western and Russian idioms yet clearly distanced itself from anything that could be seen as either academicism or polemical realism. But the *World of Art* journal addressed a cosmopolitan and leisured class requiring culture to enhance civilized existence. Other Russian journals reported on and reproduced current work in all the arts but showed an increasing concern for the social utility of what they represented. Tolstoy's swingeing criticism in *What Is Art?* (1898), denouncing work done by blinkered specialists for the pleasure of a small sector of society, could not easily be accepted. Yet such was his rhetorical power that we find echoes of his analysis reflected in the work or texts of those who could not share his principles.[4]

After the October Revolution such issues could be confronted openly, and even then there was fundamental disagreement between those who, like Lenin, assumed that any valid new art had to be rooted in past achievements even if these were now labelled 'bourgeois', and those who looked for a new culture originated by the workers and rooted in working-class life. This led to Bogdanov's programme for the development of proletarian culture, Proletkult, in preparation for the dictatorship of the proletariat promised by Communism. Here the investment in hard-won excellence was replaced by faith in everyone's innate ability. Unfettered by high-art conventions, the workers were well placed to give artistic expression to their experience even if this would, in the first place, come directly out of their solidarity and daily labour.[5] In time their new art would find its own excellence out of communal activity, akin to that of folk art but now reflecting urban and industrial realities. Lunacharsky shared Bogdanov's faith, though his preference was for the classical tradition. A convinced Marxist, he knew that the world had to be changed, and so he supported radicalism even when it offended his taste.[6]

As a Communist Lunacharsky knew that the working class should be the arts' primary public, and that new work in the arts would need to deny control of the cultural product to the bourgeoisie. In this spirit Lunacharsky supported Russian futurism despite Lenin's complaints against it. Calling for an end to art's alienation from reality, the poet Blok in his essay 'The Art of the Future' (1907), asked for attention to shift from method to content. The new art must be rooted in a new, essentially religious, view of the world. He wrote several other essays and poems on the position of the Russian intelligentsia *vis-à-vis* the political and social crises of the time.[7]

Among the writers on Tatlin's shelves, it was Mayakovsky's achievements especially that are difficult to summarize in relation to Tatlin's, except in relation to early works. Born in 1893, the son of a forester in Georgia, Vladimir Mayakovsky quickly became a public figure thanks partly to his outstanding physical presence and the powerful voice with which he overcame his shyness. Before he was fifteen he became a member of the Bolshevik party and soon found himself under police supervision. But for his youth and uncertain health he might well have been imprisoned or exiled in 1908. That autumn he entered the Stroganov School of Industrial Arts in Moscow. In 1909 he was found guilty of operating an illegal press. His mother got him released into her custody because he was still a minor. He

studied in the Stroganov School of Painting, and engaged, in defiance of school regulations, in public debates about art. David Burliuk, seven years his senior, became a fellow student in 1911 after studying in Odessa, Munich and Paris. Hearing fragments of a Mayakovsky poem, he pronounced his new friend 'a genius', took to introducing him as 'the famous poet Mayakovsky' and trusted the young man to prove him right. David Burliuk's brothers, Vladimir and Nikolai, were artists too, though Nikolai became more prominent as a writer. Together they formed the Hylaea literary group, the first unit of Russian futurism.

David Burliuk was outgoing and active, an *animateur* of new Russian art and writing, and, from 1912 on, the instigator of some of the futurist booklets through which this work became known. *A Slap in the Face of Public Taste*, published that December, included a manifesto signed by Burliuk, Kruchenykh, Mayakovsky and Khlebnikov, inveighing against the established heroes of Russian literature from Pushkin to Tolstoy and mocking contemporaries including Gorky and Blok: 'We look down on their nothingness from the heights of skyscrapers.' They advocated new ways of writing, spurning established syntax and promising to use 'arbitrary and derivative words'. They presented themselves as seriously radical, opening up new areas of meaning and expression. As a painter David Burliuk was associated with Larionov's primitivism. He reprinted four of Kandinsky's prose poems in *A Slap . . .* , but Kandinsky disliked the unruly company he found himself in and ended all connections with the Burliuk circle. Two poems by Mayakovsky, in the same booklet, revealed his already 'thunderous voice', exceptional in what was, apart from that manifesto, a fairly peaceful collection. Khlebnikov was represented in it with eight poems, including a poem of sounds without literal or semantic meaning. Burliuk provided essays on cubism as a new kind of painting and on 'faktura', pointing to the handling of paints as found in Cézanne and Monet. Khlebnikov wrote about neologism and gave some examples, and the book ends with his prophecy, derived from numerical patterns he had discovered in history, that an empire would fall in 1917.

Burliuk was also involved in the publication of two dramas in booklet form. The first was the futurist opera *Victory over the Sun*, written by Kruchenykh and given a prologue by Khlebnikov, composed by Matiushin and designed by Malevich during the summer of 1913. This was published shortly after the opera was performed twice in Petersburg, on 2 and 4 December. On the same stage, on 3 and 5 December, Mayakovsky performed his play *Vladimir Mayakovsky (A Tragedy)*, sponsored by the Petersburg artists' association, the Union of Youth. Iosif Shkolnik and Pavel Filonov designed the sets and costumes.[8] Its text appeared early the following year, with illustrations by David and Vladimir Burliuk.

Mayakovsky's play can be seen as the first public performance of his own poems. Egocentric but not self-glorifying, he appeared in it like the victim-hero of a Greek tragedy or a modern Hamlet. Mayakovsky himself produced and directed his tragedy. In the first act he wore his own identifying clothes, including a yellow waistcoat with wide black stripes. In the second, in a scene set in a future post-revolutionary city, he was dignified by a toga and a laurel wreath. People bring their pains to him in the form of tears, which he collects into a bag on his back in order to 'bear their suffering'. Here and elsewhere in this view of humanity's plight, he hints at Christ's mission to mankind. His next major poem, *A Cloud in Trousers* (1915) should have been called *The Thirteenth Apostle* but for the censor's objection. In it he explains that his poetry 'is a personal Golgotha, a crucifixion', 'And there wasn't a one / who / didn't shout / "Crucify him! / Crucify him!".'

In July 1915 Mayakovsky declaimed *A Cloud . . .* in the Petrograd apartment of Osip and Lily Brik. He had been courting Lily's younger sister Elsa and she had brought him to the Briks. Both the Briks fell in love with the poem and the poet fell in love with Lily. He dedicated the poem to her; Osip financed its publication. The Briks and Mayakovsky embarked on a triangular relationship which endured until the poet's death.[9]

Mayakovsky was one of those who welcomed the October Revolution. It would bring a 'revolution of the spirit' and clear away the rags of the past. He foresaw a close alliance between the futurists and the new State: the clean sweep they looked for proved them to be the working proletariat of culture. His poems in IZO's weekly journal *Art of the Commune* were blunt calls to man the barricades against the past of Raphael and Pushkin. When the old values have been burnt off and art is once again a public service ('The streets are our brushes, / the squares our palettes'),[10] the poet and the technician will be working together to everyone's benefit, heart and mind. Malevich, Shklovsky and Brik were among those who wrote for *Art of the Commune*. Lenin distrusted them all as cultural hooligans, and in December 1918 Lunacharsky had to protest against Mayakovsky's call for attacks on old monuments and on museums. In April 1919 the journal was discontinued, and the futurists lost their ministry-financed pulpit.

Mayakovsky soon found other ways of coming before the public. *Mystery-Bouffe*, not unlike a mystery play but also a combination of carnival and blaspheming cabaret, was staged in 1918 on the first anniversary of the October Revolution. Meyerhold directed it in close collaboration with the author. Malevich made the designs but, perhaps because there was little time for preparing the production, there was internal friction, some of which focused on Malevich's contribution.[11] The drama presents a parodic reading of the Bible: *Mystery-Bouffe* opens on earth where, during a second deluge, two groups, the clean and the unclean, crowd onto the Ark. The unclean are the workers, who throw the others over-board — clean politicians and Capitalists — and escort them to hell. The unclean then enter the promised land, only to find it unbearably boring. They return to earth, to be their own masters amid the real promises of Communism.[12] Lunacharsky, who saw the theatre as the most powerful means of addressing the public, later praised Mayakovsky for his skilful way of adapting futurism 'to the placard and mass meeting period of our Revolution'. 'For the first time', Lunacharsky wrote, '. . . we had a play which was completely identical with all the feelings of the times'. Bely was at the first performance and wrote in his diary that it was 'a day not to be forgotten'.[13] In 1921 Meyerhold staged a second version of *Mystery-Bouffe* in Moscow for the delegates to the Third Congress of Comintern, brought up to date by new blasphemies and jokes as well as new exhortations. He insisted that this kind of drama lived by its topicality.[14] Both versions make frequent reference to religion. 'Mayakovsky-Christ' (as Brown identifies him) is present, but he is now more prophet than god-like, promising a glorious city of transparent factories and skyscrapers and offering all the best things under the sign of the hammer and the sickle, together with the traditional Russian welcome of bread and salt. The Crystal Palace is invoked as utopia, and the city buzzes with trains, trams and cars under the light of an approving sun.

Mayakovsky spent much of 1919–21 creating agitprop posters for the Russian Telegraph Agency (ROSTA). He drew over six hundred of them and helped to multiply them by means of stencils. Most of these posters pressed home one particular point by means of a telling image and a line or two line of text. 'Verse jingles', E.J. Brown calls them aptly, but they

embodied quotations from the classics as well as echoes of folk songs. Those were hard years — the years also of Tatlin's Tower — with the White armies advancing and then falling back, and with dreadful shortages. The work was as proletarian as Mayakovsky with his visual acuity and agile literary mind could make it. He was excited by the process: news arriving was instantly rendered as outgoing messages; governmental decrees were quickly disseminated. 'It meant Red Army soldiers looking at posters before a battle and going to fight not with a prayer but a slogan on their lips.'[15] The ROSTA windows — the posters were often displayed in shop windows which would otherwise have been empty and mute — exhorted all good Russians to put their best feet forward to defend the Revolution and destroy Capitalism.

From 1923 to 1925 Mayakovsky wrote advertising jingles for the Moscow Food Stores, Mosselprom. The stores required sharp graphic images on advertisements and packaging, created by Rodchenko, and brusque texts, rhythmical and sometimes rhyming. The places, organs and objects they recommended vary from toffees and baby's dummies (pacifiers), to cigarettes and galoshes. Commentators tend to apologize for this descent into the marketplace. The critic Yury Tynyanov in 1929 corrected his own earlier feeling that Mayakovsky was here ' "wasting" his talent by immersing himself in *byt*' (the Russian word for everyday material existence), insisting instead that he was actually renewing poetic language and versification. Brown, on the other hand, sees in this advertising no advance on his work for ROSTA. We find here not the experiencing poet but the 'brilliant non-poet'. Those were the years when emerging constructivism called Russian art away from artistic radicalism into production of the real things that would serve *byt*. Lunacharsky had drawn attention to this need, and then Mayakovsky, Brik and others gave it their support, in the journal *Lef* which they founded and edited from 1923 to 1925, and before that in speeches and other articles. Rodchenko, the essential instigator of constructivism, designed the layout of *Lef* and contributed articles and illustrations to it.

Rodchenko called himself Tatlin's disciple,[16] but he was more than that. Born in 1891, he emerged from the provinces a committed pioneer in search of an outlet and an idiom. He studied art in Kazan (where he met Varvara Stepanova who became his wife) and in Petersburg, and arrived in Moscow in 1915, attaching himself to Tatlin and, soon after, also to Malevich. He made minimalist drawings in ink with rulers and compasses that suggest Tatlin's analytical approach. He also made paintings of cosmic forms and spaces, connecting with suprematism by representing a visionary cosmos but going beyond suprematism in exploring colour, tone and texture, that is, the essential nature of his means and their interaction as *faktura*. From this he turned to exploring the constructional possibilities of particular materials in three dimensions, as in his 'White Non-Objective Sculptures' of 1918. These were made from white cardboard, cut and slotted together.

Rodchenko was the most inventive as well as most ambitious of the artists associated with Tatlin and Malevich, capable of moving purposefully between different programmes. In 1921 he and Stepanova contributed to Inkhuk's debates at which composition and construction were discussed as opposed concepts. Associated with them was Alexei Gan whose *Constructivism* was published in the last months of 1922 to challenge all traditional art. They organized the First Working Group of Constructivists as a faction within IZO's Institute of Artistic Culture (Inkhuk), set up in Moscow at Kandinsky's suggestion in March 1920. Kandinsky had initiated an analytical investigation of the means available to art and their psychological effect. He wanted parallel studies of the other arts, notably music, to see

how their components and structures operated and to what extent their effects echoed those occasioned by visual art. He had outlined this programme in *On the Spiritual in Art*, published in Munich in December 1911. It stems from investigations begun in the 1890s by philosophers and designers in Munich. A body such as Inkhuk would be able to pursue them systematically and conclusively. Rodchenko and his associates judged Kandinsky's programme elitist and regressive.[17] They wanted a project that would be objective and concerned with the future, not with examining the past. Their aim was to study the organization of materials and the value and contribution of this organization to life itself. Kandinsky left Inkhuk in January 1921.

The theoretical initiative for much of this, including Mayakovsky's 'anti-poetry',[18] seems to have come from Brik. Already in December 1918, in *Art of the Commune*, Brik showed how avant-garde artists could develop their modern experience and ideals to Soviet ends. He referred to the guild system of the past, which saw no distinction between artist and craftsman in responding to social and material needs. In modern terms, artists must participate in the industrial life of their country. In 1919 he published an article, 'The Artist and the Community', in which he told artists to demonstrate 'their right to existence . . . [by undertaking] fully definable, socially useful work'. What he meant by this he spelled out in terms echoing Dimitri Pisarev's in the 1860s. Brik wrote:

> A shoemaker makes shoes, a carpenter — tables. And what does an artist do? He does not do anything; he 'creates'. Unclear and suspicious.[19]

Artists not seeking a justifiable social role are to his mind parasites. So when Lunacharsky needed to reprimand the futurists for thinking themselves the official cultural force of the Soviet State, and Lenin restated his total incomprehension of avant-garde art movements ('I do not experience any joy from them'), Brik was telling artists to go beyond the dictates and judgements of personal taste and prove their worth in the world of industrial production.

In June or July 1918 Lunacharsky invited Brik and Mayakovsky to join the Petrograd IZO where Shterenberg, Malevich, Punin, Altman and Chagall represented visual art. As IZO's journal *Art of the Commune* was edited by Mayakovsky and Brik, their ideas and preferences became public as official opinion at a time when diverse, contradictory hopes for cultural life in Russia vied for priority.

Lunacharsky's article, 'Theses of the Art Section of Narkompros and the Central Committee of the Union of Art Workers Concerning Basic Policy in the Field of Art', was written with Yuvenal Slavinsky, a Bolshevik musician who was president of the Union of Art Workers, founded the previous year. It was published in Moscow's drama journal, *Theatre Herald* (*Vestnik teatra*), on 30 November 1920 (when Tatlin's Tower was on display in Petrograd). Lunacharsky encouraged the programmes of PLK but wanted to leave the wider arts situation open to left and right ideas, to innovation but also to conserving and studying the European and Russian cultural heritage. The time had not yet come for government to put its weight behind one direction or another, but it should 'render every assistance to the new searches in art'. Meanwhile 'all fields of art must be utilized in order to elevate and illustrate clearly our political and revolutionary agitational/propaganda work', in daily activities and also on the special occasions provided by national festivals, etcetera. Here Lunacharsky almost quoted Tolstoy's *What Is Art?*, though the famous writer's negative

account of bourgeois culture must have shocked him. He was echoing one of Tolstoy's favourite terms when he wrote that 'art is a powerful means of infecting those around us with ideas, feelings, and moods'.[20]

Mayakovsky's *About That*, written between December 1922 and February 1923, echoes Fedorov's promise that the past exists all around us and awaits reconstruction. The poet attacks Soviet philistinism, condemning the present and the recent past but not the longer past in which rural society and communication are rooted. The theme of a violent end, by suicide or by crucifixion, recurs prominently. Writing with subtlety and sometimes vehemence about misery and isolation seems to have helped Mayakovsky to recover. It was immediately after the publication of the poem, in *Lef* and as a book, as well as Brik's warm advocacy of directing creative abilities to the needs of everyday society, that Mayakovsky embarked on his advertising jingles.[21]

One of Rodchenko's photomontages for *About That* invites our attention. Its central motif is the poet himself, standing with his arms spread out (it is not clear from the image alone whether he is being crucified or about to fly) on top of an elongated version of the Kremlin's Great Tower of Ivan. A vast car tyre stands beside the tower; behind it flies an up to date biplane. Both these loaded motifs are close to the tower and the man, and between the three of them they suggest a response to Tatlin's Tower as well as awareness of Delaunay's pre-1914 paintings in which aeroplanes, the Eiffel Tower and the Paris ferris wheel celebrate modernity. Rodchenko's compilation adheres closely to Mayakovsky's complaints about being beaten and crucified by the world.

Rodchenko was becoming Russia's most persuasive photographer, producing potent images as well as aesthetically thrilling ones. Moholy-Nagy may well have learnt aspects of photography from him. The Russian film-makers, notably Dziga Vertov and Sergei Eisenstein, took montage as the essential method of making films real, persuasive and memorable. Rodchenko worked with Vertov on the film journal *Kino-fot* during 1922–3, and designed posters, tickets and texts for Vertov's films. His advertising for Eisenstein's *The Battleship Potemkin* (1925) moved the combining of photographic images with lettering and tone onto a new level of intensity.[22] *Lef*, wishing to guide all the arts, gave prominent attention to theatre and to film. Eisenstein, then working for the Moscow PLK studio on new methods for the theatre and including film in his insistently audience-orientated productions, wrote about these at some length in *Lef* no.3 (1923). His methods were essentially constructivist:

From minute fragments taken from reality the artist created a new world, an artistic vision precisely calculated to induce the recipient of art to an active transformation of his own life and the life of his society.

The same issue of *Lef* published Vertov's key manifesto 'The Cinemen. A Coup', outlining his concept of film-making in visually emphatic and discontinuous terms, similar to those used by Gan in *Constructivism*. The 'camera-eye' (*kino-glaz*, the phrase he would use for his film series as an alternative for *kino-pravda*, 'cinema-truth') can capture a reality beyond the reach of any individual's eye. The film-maker should become a 'cinema-engineer' and give his camera unprecedented freedom to capture scenes which, through montage, would confront the audience with a new reality, charged with the visual energy that was the essential dynamic of film.[23]

The first issue of *Lef* opened with an editorial, signed by the editorial board,[24] and headed 'What does *Lef* struggle for?' It stresses the futurists' welcome to Communism, passing over the difficulties they had had with it since 1917. It lists three works as first instances of the new art the Revolution demanded, *Mystery-Bouffe*, Kamensky's poem *Stenka Razin* and Tatlin's Monument to the Third International.

An aspect of *Lef*'s teaching that may not have coincided with Tatlin's views was its insistence on a Marxist theoretical base: Arvatov wrote in 1923 that '*Lef* is the only, or almost the only, journal in search of the methods of the Marxist approach to art.'[25] We have no direct statement of Tatlin's attitude to Marxism, or indeed to any specific theories as opposed to intelligent and persistent enquiry. We do know of Mayakovsky's and Shklovsky's enthusiasm for his Tower, and of Rodchenko's admiration for the 'Father of Constructivism'.

A generation older than Mayakovsky, Vsevolod Meyerhold (1874–1940), actor and director, was to share many of the younger man's convictions.[26] It was war and the revolutions of 1917 that changed his priorities. He staged Maeterlinck, Wagner and Ibsen through war and revolution.

Meyerhold developed non-illusionist stage space and choreographed acting, without sets or footlights to intervene between the performance and the audience. Meyerhold presented the actor as a trained worker using words, gestures and bodily movements, to effect real experience.

After 1917, Meyerhold used a bare stage, the bare-faced actors and performances mingling *commedia del' arte* and circus elements, acrobatics and rhythmic ensembles. In 1920 Lunacharsky invited him to head the new Theatre Department of his ministry, which he ran energetically while also directing important new productions — outstanding among them Emile Verhaeren's *The Dawn* (1920), the second staging of Mayakovsky's *Mystery-Bouffe* (1921) and Fernand Crommelynck's *The Magnanimous Cuckold* (1922). The report on a lecture Meyerhold gave in June 1922, on 'The Actor of the Future and Biomechanics', included the following:

> In art our constant concern is the organization of raw material. Constructivism has forced the artist to become both artist and engineer. Art should be based on scientific principles; the entire creative act should be a conscious process. The art of the actor consists in organizing his material; that is, in his capacity to utilize correctly his body's means of expression.

During a debate on the staging of *The Dawn*, in November 1920, Meyerhold had already spoken bluntly of the need to abandon rich and illusionistic décor:

> For us, 'decorative' settings have no meanings; 'decoration' is for the Secessionists and restaurants in Vienna and Munich; spare us 'The World of Art', 'Rococo' and the painstaking detail of museum exhibits . . .
>
> We have only to talk to the latest followers of Picasso and Tatlin to know at once that we are dealing with kindred spirits . . .[.] We are building just as they are building . . .[.] For us the art of manufacturing is more important than any tediously pretty patterns and colours. What do we want with pleasing pictorial effects?

What the *modern* spectator wants is the placard, the juxtaposition of the surfaces and shapes of *tangible materials*![27]

There is no evidence of friendship between Meyerhold and Tatlin, but they regarded each other with interest and respect. In the summer of 1917 Meyerhold asked Tatlin to collaborate with him on a film, *The Spector's Charm*, based on a novel by Fyodor Sologub. Tatlin appears to have been unwilling to fit in with the director's expectations of how the design should work, and the film was never completed. When Meyerhold undertook the production of *The Dawn*, for Moscow's celebrations of the third anniversary of the Revolution, he asked Tatlin to design it. In the event, this was done by a younger designer who had studied art under Petrov-Vodkin and stage design with Meyerhold. Vladimir Dmitriev's stage, which crossed the orchestra pit to lose the boundary between stage space and audience space, clearly echoed Tatlin's work and Meyerhold's in its 'juxtaposition of the surfaces and shapes of *tangible* materials', that was 'conceived as an adjustable construction of diverse materials assembled like a great relief'.[28] Admission was free; the theatre was unheated and almost derelict. News from the Civil War and revolutionary songs interrupted the action, reminding the public of parallels with Verhaeren's play of 1898, about how a Capitalist war was turned into an international workers' uprising. In the public debate that followed, Mayakovsky praised the production, but Lenin's wife Nadezhda Krupskaya raised objections to it in *Pravda*, making Meyerhold adjust the text. In *Vestnik teatra* (Herald of Theatre) Lunacharsky made a guarded comment:

> I am prepared to entrust Comrade Meyerhold with the destruction of the old and bad and the creation of the new and good. But I am not prepared to entrust him with the preservation of the old and good, the vital and strong, which must be allowed to develop in its own way in a revolutionary atmosphere.[29]

Tatlin could not design *The Dawn*: he was building his model of the Tower in Petrograd. He declined again in 1921, when Meyerhold wanted to engage him for the new *Mystery-Bouffe* to be performed on May Day. Tatlin would have been working with Mayakovsky as well as Meyerhold. The invitation presumably came some months earlier, perhaps during the two showings of the Tower model and all the meetings and talks, and the taking down, transporting and setting up they involved. Later, Meyerhold wanted to use Tatlin for a production of Pushkin's *Boris Godunov*, with music by Sergei Prokofiev. In fact, from 1925 on Tatlin was increasingly busy in the theatre, working on productions for Moscow, Leningrad, Kiev and elsewhere. *Boris Godunov* was intended to open Meyerhold's new theatre in central Moscow in 1938, and to be followed by a production of *Hamlet*, with designs by Picasso. Instead, following a change of personalities in the government and attacks on his work in *Pravda*, Meyerhold's company was liquidated and work on the theatre was halted. He was invited to explain himself, that is, to confess publicly to the sins he stood accused of, but did not do so with sufficient obsequiousness. In June 1939 he was arrested. After torture and trials he was shot on 2 February 1940, one of the countless victims of the State to which he had given his enthusiastic support.

Khlebnikov had died in 1922. *Lef* accorded him the unique honour of presenting him as a forerunner and printing a selection of his poetry as exemplary poetic art and

political writing, offering views of the future of mankind. *Lef* no.1 included 'Memoirs of Khlebnikov', written by Dmitry Petrovsky, a member of the LEF group and the poet's friend. In 1916 Petrovsky and Tatlin had gone with Khlebnikov to Tsarytsyn where Khlebnikov lectured on 'Iron Wings', referring to Tatlin's reliefs, and Petrovsky recited it.[30] Tatlin's production of Khlebnikov's 'supertale' *Zangezi*, in 1923, was to be his most public act of homage to his friend and also the only production handled in its entirety by the artist, from conceiving the project to realizing it via close study of the text, visualizing and designing the structures and props it called for, rehearsing the students who were to be the actors and himself carrying the major role. His involvement with Khlebnikov, man and poet, and Khlebnikov's role in Tatlin's thought and work demands special consideration.

II

Velimir Khlebnikov (1885–1922) is known to history as a poet. He was that, and much more. His studies and speculations embraced many aspects of the past and the present in order to prepare the future that should be born out of the age of radical change in which he participated. His interest, his passion, was global. His investigation of languages and cultures, past and present, seemed limitless.

He was born among Kalmyk Buddhists at Malye Derbety, near the lower Volga and the Caspian Sea, in the only house standing among nomads' tents. 'Planet Earth', he wrote later, had always been his home. The son of a local administrator with a keen interest in the natural sciences, especially ornithology, young Khlebnikov too studied ornithology and, already in his teens, published scientific papers as well as poems about birds. At Kazan University he studied mathematics and natural sciences, including Nikolai Lobachevsky's post-Euclidean geometry which had brought fame to the university in the nineteenth century. In 1904 the Russo-Japanese war broke out and the Russian Empire found itself humbled by the destruction of her navy. This led Khlebnikov to embark on analytical studies of historical time, in search of mathematical laws of periodicity which, he believed, must underlie great events.[31]

The year 1908 saw the first publication of a Khlebnikov poem, in Kamensky's proto-futurist journal *Spring*. The same year he wrote the first fully-fledged distinctive poem, 'Incantation by Laughter'. It brought him fame among the avant-garde when it was published in one of the first of the many futurist booklets produced from 1910 on: *The Impressionists' Studio*, published that year in Petersburg and edited and illustrated by the artist, physician and exhibition organizer Nikolai Kulbin. The poem is a verbal construction. The word *smekh* (laugh) is both its material and theme. Using Russian's many prefixes and suffixes, Khlebnikov created a sequence of neologisms in which the shape, sound and sense of the word are altered without it losing its core meaning. Rhythmic and other oratorical devices give the ten-line poem an incantatory character. When recited, it still moves Russians to laughter. It is often called abstract since it is without narrative or description, yet it is directly related to human experience.[32] About this time Khlebnikov wrote his first play, *The Little Devil*, subtitled *A Petersburg Joke on the Birth of Apollo*, described as chaotic in structure and a high-spirited melange of mythical beings and ordinary creatures.[33] It was not performed, but probably led to his involvement in *Victory over the Sun* in 1913.

Khlebnikov's grasp on Slavonic languages' wide treasury of words, ancient and modern, religious and secular, high and low, brought with it an acute awareness of time. He was convinced that the modern poet, like the shaman, can communicate deep truths about the world's future. A poet refreshes language by inventing and manipulating words and forms, and he refreshes our sense of history and cultures by embracing them all as one great present. Religions and languages give him a multi-dimensional view of mankind in time and space. Khlebnikov analyzes languages to find their underlying unity and to prepare for a return to the Ur-language mankind shared before Babel.[34] He dusts the abuse of centuries from everyday speech to uncover the original, magical or mystical, functions of words, a futurism that rests on explorations of the past. Often a visitor to Moscow and Petersburg, bringing work for his friends to use or not use, Khlebnikov wandered restlessly throughout Russia and as far as Persia, a modern instance of the saintly nomad of popular tradition, the Holy Fool.[35] In 1922, ill and a pauper, he was taken in by the graphic artist and inventor Pyotr Miturich, but refused all medical care. Partly paralyzed and smelling of death (which soon came, on 28 June 1922), he asked for flowers.

In 1908 Khlebnikov had enrolled at university in Petersburg to read biology and Sanskrit, and then Slavic Studies. He was invited to attend Viacheslav Ivanov's weekly literary meetings although exceptionally young for that company. Through Kamensky he met Matiushin, painter and composer, and Matiushin's wife Elena Guro, painter and poet. They published the futurist booklet *A Trap for Judges* in 1910, which included a prose poem by Khlebnikov and illustrations by Vladimir Burliuk. He met all the Burliuk brothers soon after and became a member of their circle. In 1912 Tatlin made a sketchy illustration for a short poem by Khlebnikov — the first instance of a collaboration that was to continue beyond the poet's death.

The critic and theorist Shklovsky compared Khlebnikov with Christ. Punin wrote that 'he was the trunk of the century, and we grew from it like branches'. The critic and novelist, Tynyanov, like Shklovsky close to LEF, called him 'the Lobachevsky of the word'. The linguistic and literary scholar Roman Jakobson published a study of Khlebnikov's work in 1921. *Lef* included his poems in its first issue in 1923 and announced the publication of his collected works. The poet Osip Mandelshtam wrote the same year that

Khlebnikov does not know what contemporaneousness is. He is a citizen of all history, of all systems of language and poetry. He is a sort of 'idiotic' Einstein, not knowing which is closer — a railway bridge or *The Lay of Igor's Campaign* [an Old Russian historical epic]. Khlebnikov's poetry is idiotic in the true, Greek, unoffending meaning of the word . . . Khlebnikov did not write simply verses or poems but a large all-Russian prayer book from which those who are not indolent will draw for centuries.

The futurists around him knew him to be a genius, needing a hero to promote and not really understanding his work or cast of mind, and called him their 'Leonardo'.

He called himself a *plotnik* rebuilding the house of the world to bring positive human energies to the fore in place of the rifts and repressions that dominate history. He calculated that his birth-year accorded significance in itself, linking him by mathematical fate to great thinkers of the past, 'Amenhotep IV — Euclid — Sankara [the Indian philosopher] — Khlebnikov'. He also saw himself as linked to Pythagoras in his preoccupation with numbers and with reincarnation, and to Stenka Razin, the charismatic leader of a seventeenth-

century popular rebellion against the tsar, calling himself 'a Razin with the banner of Lobachevsky'. Both were to him revolutionaries of outstanding importance. But 'Razin' is also *nizar* backwards, the inhabitant of the lower reaches of a river, like himself in boyhood. The Volga links them all, and if Lobachevsky was working on the frontiers of reason, looking westward, Razin points to the east, to the instinctive call for freedom. Razin marched north to meet the forces of the tsar; Khlebnikov walked south, into Persia, a 'Razin in reverse'. *Razin* (1920–21) is a four-hundred line poem, each line of which is a palindrome.[36]

Hearing of his death, Tatlin wrote to Miturich that Khlebnikov had been 'the biggest thing that ever happened to us'. After breaking with Larionov, Tatlin engaged fully with Khlebnikov's developing theories about language and poetry as well as with his inventive verbal presentation of them, and sought material means of giving them artistic form in three and four dimensions. His admiration for Khlebnikov must have had a strong admixture of love for the man and for his stance in the world. It may have been powered by memories of the poet who was his own mother and whom Tatlin never really knew. Daniil Danin, one of Tatlin's students, wrote from close knowledge and observation of him:

> If Tatlin loved one of his contemporaries with an inexhaustible and unreserved love, it can only have been Khlebnikov. Mayakovsky remained for him a kind, magnanimous, brilliant friend, but Khlebnikov was his passion. Only *his* poems did Tatlin preserve in his memory. Only of *him* did Tatlin speak with reverence. He considered it the greatest fortune to have met him.
>
> . . .
>
> Tatlin carried Khlebnikov inside himself with the devotion of an evangelist.[37]

Khlebnikov's interest in and friendship with Tatlin originated in the writer's conviction that modern art had important lessons for poetry, a conviction backed by his keen visual awareness and talent as a draughtsman. One bond linking poets like Khlebnikov and Kruchenykh (who had studied art in Odessa and Moscow) with artists was their concern with *faktura*, the manipulation of the raw materials of each art (words, paint, colour, texture, collage, the elements used for constructions) as an inventive and craft-like process delivering not only surface qualities but also meaning. Painting, in post-impressionism and symbolism, had liberated itself from its inherited commitment to imitating the visible world or adapting aspects of it to convey visions in its terms. Soon in painting and sculpture subject-matter would no longer provide even the first immediate sign of meaning. Another bond linking Khlebnikov and Tatlin was the fact that they were born in the same year. The poet who located himself in human history by means of dates will have seen deep significance in this.

In May 1916 Khlebnikov wrote a poem about Tatlin, a concentrated work of eleven lines and thirty-five words, dense with references and word-play. It was probably conceived when the poet and the artist met in Tsaritsyn in May 1916, and spent some weeks there together with the younger futurist poet Petrovsky. Possibly to raise funds, they presented an evening of readings under the title 'Iron Wings'. Tatlin may have exhibited there a construction with that name. What is certain is that Khlebnikov had seen Tatlin's three-dimensional work in at least two exhibitions during 1915–16 and that the poem is, as Milner-Gulland writes, an 'ecstatic' response to it. Tatlin owned the autograph original: according to Danin he kept it 'religiously or like a conspirator'. When the scholar Nikolai

Khardzhiev, a friend of the poet, was preparing the 1940 collection of Khlebnikov's unpublished writings, Tatlin had his young friend Smirnov type a copy of the original before passing it on. It has since been lost and versions published subsequently cannot be checked against it. Only the first three lines are unchallengeable because they were quoted in Kornely Zelinsky's 1932 article on *Letatlin*. It is possible that Khlebnikov's manuscript was unclear enough to invite guesses.

Milner presents his translation and a Russian text; Zhadova prints, in Russian and in English, the version published in 1940. Milner-Gulland offers a close study of the poem's structure and meaning in 'Khlebnikov, Tatlin and Khlebnikov's Poem to Tatlin', together with a new translation, 'as literal as comprehensibility permits', of the standard text.[38] The opening lines,

> Tatlin, secret-seer of blades
> And stern bard of the screw
> From the detachment of suncatchers

refer to Tatlin's experiences as sailor and as futurist. There follow oblique references to his working with metal: 'an iron horseshoe', and 'tin objects touched by [his] brush'. In an article of 1919–20, Khlebnikov was to celebrate Tatlin in sonorous, indeed musical terms:

> Before you is the futurist with his balalaika. On it, fixed to its strings, there trembles the phantom of humanity. And the futurist plays: and it seems to me that the enmity of nations can be replaced by the enchantment of strings.

Milner-Gulland notes that the musical scale implied here 'at one end agitates heaven, while at the other it is concealed in heartbeats'. In Tatlin's Tower we have a tensed structure of metal — almost a musical instrument worth comparing with Mayakovsky's poem 'Backbone Flute' with its anthropomorphic account of the instrument — combined with a prominent material that may be thought of as the opposite of iron or steel but, like them, is born out of heat, the glass of the units which give the monument its *raison-d'être*. The structure of the poem — three three-line sentences, each with its particular theme, followed by a two-line peroration, with 'dead' as the keystone word at the poem's centre and a reference to 'life' in the last line — is reflected in aspects of the Tower. Tatlin may well have found the poem's construction compelling. Milner-Gulland's account of Khlebnikov emphasizes his insistence on meaning. He wanted to be understood, but not 'like a street sign': understanding rewards the attentive reader. Milner-Gulland also points out that the word *vint*, in the second line of his poem, here translated as 'screw', can mean also 'spiral' as in spiral staircase.

Zhadova stresses 'the spiritual affinity between Khlebnikov and Tatlin' and notes that Khlebnikov's Tatlin poem uses images common to them. Both were 'sun-snarers', responding to their generation's use of the sun as a symbolic motif. They shared Fedorov's conviction that the cosmos awaited mankind's coming. Both were open to 'mystery' visions. Zhadova quotes the composer Artur Lurié's comment that Tatlin had 'the same creative spontaneity, freshness of perception and sharpness of imagination in the sphere of plastic forms and lines as Khlebnikov did in the sphere of words.'[39] She also suggests that Tatlin's reliefs may have stimulated Khlebnikov's interest in architecture. In 1914–15 Khlebnikov wrote an essay entitled 'We and Houses' in which he proposed thirteen new types of dwelling, giving

them distinct names such as 'bridge house', 'underwater palace' and 'house on wheels'. He sketched some of them, illustrating varieties of residential skyscrapers as well as smaller units. He proposed that a home might be a unit, not unlike a container but framed in glass, and that such units might be transported from place to place as its owners needed to relocate, and slotted into pre-existing gridded structures for support and services. All of Khlebnikov's architectural inventions are distinguished by transparency and by adapting nature's growth patterns. Subsequently he pushed these ideas further, envisaging very tall structures amid light and air. Lifts are everywhere; horizontal movement of people and of units is by means of flight. Weightlessness, like transparency, is the goal, and he expects cities to exist in free space, inhabited by flying individuals with floating homes. His visions harmonize with Fedorov's prophecy of a whole universe inhabited by mankind.[40]

By 1916 Khlebnikov was calling Tatlin 'the builder', using the archaic term *Zodchiy*. This may reflect conversations they had on the future of architecture, or just that the poet sensed the artist's instinctive drive towards constructing. It was in 1916 that Khlebnikov gathered together many of his hopes for the future in the proclamation *The Trumpet of the Martians*. It foresaw 'air-sailing' (flight) and 'spark-speech' (radio) as the two legs on which mankind would soon be standing; it spoke of his 'dwellings made of glass' that might be moved at will and inserted into towers; it asked for radio to provide education and scientific news to everyone, and for the inherited concept of space, as in three-dimensional design, to be replaced by the concept of time, the fourth dimension. He foresaw great screens delivering information throughout the world.

For all his engagement with mathematics and technology, Khlebnikov proceeded by means of symbol and analogy, sieving the past for nuggets of timeless meaning and the present for scientific fact. In a pamphlet of 1912 he pointed to the people as the essential source of literary creativity, with folklore and old legends as the live basis of Russian culture. In 1913 he had insisted on including poems by a thirteen-year-old girl in the second *Trap for Judges* booklet, and in 1920 he joined a Proletkult conference and praised the industrial poetry of Gastev. But he did not insist that poetry had to be easy to follow. It was through the cleansing of words, removing their conventionalized sense in order to reach their old roots that lasting significance could be achieved.[41] Yet his self-image is a modern and constructive one: he called himself, says the critic Tynyanov, 'a railway engineer of artistic language.'[42]

The close mutual regard of the poet and the artist is illustrated by Tatlin's response to Khlebnikov's long poem *Ladomir*. Written in 1920, its title refers to *lad*, 'harmony' in Old Russian and related to the name of the Old Slavic goddess of love, Lada, and *mir* which means both peace and world or universe. The poem is about destroying the old world and entering a new one, and uses socio-political ideas where other writers, especially Russians, had preferred to deal with spiritual themes, often in apocalyptic terms. Tatlin was sent the manuscript to comment on before publication, but asked his friend to come and read the work to him in his studio. He then responded in writing, filling the manuscript's margins with words of praise, but also commenting on some passages with a boldness that shows the two men's mutual regard. Tatlin wishes Khlebnikov had mentioned the Tower in two places. He suggests an alteration, substituting for Khlebnikov's 'letting the space of Lobachevsky / Fly from the banners of night-time Nevsky' the words 'the spaces of Lobachevsky, Tatlin, Uspenski / Fly from the banners of the Third International'. He thinks also that Khlebnikov might have mentioned the Tower in the lines 'Let Lobachevsky's level curves / Adorn the

cities. Like an arc over the toiling neck / Of world wide labour.' All this implies that Khlebnikov was informed about the Tower before the model was unveiled in December 1920. That Khlebnikov should want Tatlin's comments on a major work — the last before his final composition, *Zangezi* (1922) — helps one to understand Tatlin's urge to make *Zangezi* into a stage work in homage to his deceased friend. The invitation to comment on *Ladomir* suggests that their relationship might also be studied to assess the artist's influence on the poet.[43]

The tower is one of the favourite images used by this insistent visualizer. Khlebnikov writes that his mathematical formulas resemble 'a street of towers disappearing into the distance'. He speaks of towers as strong points for himself to besiege: 'the tower of the crowd' symbolizing a governing 'benefactor' for all mankind; 'the tower of the word', the universal language, the language of magic; 'the tower of time', referring to the Fedorovian dream of a cosmos in human control. In *Zangezi* he presents himself as both the builder and besieger of towers.[44] In 1921, during his joyful wanderings in Persia in spite of physical weakness, offering himself to Persia as 'a Russian prophet', Khlebnikov looks up, beholds a tower and is struck by its likeness to the Mother of God, a caring tower that 'puts bandages on wounds'.[45]

Fascinated as he was with towers and the promises of technology, Khlebnikov did not worship machines. He was interested in the new, and ready to speculate on its potential. He did not foresee a world governed by Taylorist priorities. His early poem *Crane* rests on the word's double-meaning, in Russian as in English, as bird and as a tall metal structure for moving heavy weights. The harbour of Petersburg was rich in such constructions. In the poem, the cranes that have been flying over Petersburg become the quayside towers and suggest that the city revolts against mankind. It was Khlebnikov who led the rebellion against the Italian futurist Marinetti when he came to Russia. Italian futurism made a fetish of modern engines of speed and noise: racing cars, aeroplanes, railways. (In this sense, Malevich's well-known 'futurist' painting, *The Knife-Grinder*, 1912, in the Yale University Art Gallery, opposes the ethos of the Italian futurists: not for them this celebratory image of the humble man, earning his pennies by soliciting piece-work in streets and courtyards.) Khlebnikov could not countenance Marinetti's facile denunciations of the past, of museums and of women. Mayakovsky had already stated, in a lecture of November 1913, that he considered the Italian futurists ruffians. Marinetti arrived in Moscow on 26 January 1914, preceded by his and his associates' manifestos, expecting to be celebrated as the leader of all modern-minded men. He stayed about three weeks. The press followed him around, eager to quote him and report on his performances. Though some commentators respected Marinetti as the leader of international futurism, others found him shallow as well as blind to what the Russians themselves were developing. He lectured three times in Moscow and twice in Petersburg, where Khlebnikov and Benedikt Livshits distributed leaflets attacking the visitor and those who placed 'the noble neck of Asia under the yoke of Europe'. Marinetti, who knew little of Khlebnikov's work and understood less, dismissed it as archaism.[46]

*

Even before futurism emerged, Russian artistic life was theatricalizing itself. From the turn of the century some artists presented themselves as performers, like those in cabarets and circuses, and their works as fantasy akin to *commedia dell' arte* and masquerades.

They looked increasingly not to the conventional theatre but to folk and puppet theatre as vehicles for their material, and hoped to startle their audiences with satire and grotesques. Blok's and Meyerhold's staging of *The Puppet Show* caused a gratifying scandal in 1906. Mayakovsky, the Burliuks and others would collaborate on performances and street demonstrations for which they would dress unconventionally and paint symbols on their faces. During 1910–15 Meyerhold put on performances at literary cafés which a critic described as 'a motley combination of mockery and gravity' — a description that makes one think of Hugo Ball and his friends performing at the Cabaret Voltaire in Zurich in 1916–17.[47] There, he and Jean Arp had both known and admired Kandinsky, and that is how pictures and poems by Kandinsky came to feature in Zurich's Dada evenings.[48]

Khlebnikov's play *Oshibka smerti* (Death's Error), written in 1915, was directly influenced by the forms and tone of folk theatre, mocking both conventional theatre and religion. He was never dismissive of religion, yet here he parodied the Last Supper and the death of Christ. Some of his fellow futurists were willing to attack religion, as when Kruchenykh made what he called 'a linguistic experiment' which turns out to be the vowel sequence of the Lord's Prayer; Lönnqvist considers this an example of the '*parodia sacra* of carnival'.[49]

Until the late 1920s, the pattern of Russian life did not change so much as did the labels and themes officialdom attached to events. Religious practices continued, in spite of Bolshevik attacks on the Church's property, institutions and manpower. Lenin warned his colleagues against being too openly anti-clerical; there was a period of spasmodic tolerance and intolerance. There were even signs of a spiritual renaissance. In 1918 Petrograd's Orthodox Theological Academy was closed by the State, but in 1920 writers and academics were able to open the Theological Institute in Moscow. The Free Philosophical Association (Volfila) had been founded in 1918 by Blok, Bely and other writers, by Petrov-Vodkin the painter, and by Meyerhold. Several members of Mikhail Bakhtin's circle were involved in it. He himself would later lecture for Volfila on theology. In 1923 Volfila summarized its aims as the need to question all 'the dogmatic trumpeting forth of definite, absolutely unambiguous answers and approaches', by 'strengthening habits of critical thought and acute self-analysis'. The Voskresenie (Resurrection) group, founded in 1917 by A.A. Meier who had worked for the revolutionary underground, included former members of the Religious Philosophical Society and was not limited to believing Christians. 'But all members . . . put Christ at the centre of their life and thought'. Generally they believed in Socialism; two of them were Communists holding fast to religion. Meier, a convinced Marxist, wanted to show how religion and revolution could co-exist harmoniously. With his close colleague K.A. Polovtseva, Meier issued statements entitled 'The Revolution and Christ', which pre-echo Blok's vision, in *The Twelve*, of Christ at the head of a band of Red Guards. One of the most prominent members of the group, George Fedotov, saw its task as finding a spiritual basis for Socialism: 'we must save socialist truth with spiritual truth'. Such aims survived the increasingly open enmity of the State to religious forms and expression, even the 1922 expulsion from Russia of several prominent thinkers with roots in religion and Socialism, including Berdyaev. In 1924 it was still possible for the defenders of religion to organize a series of debates with other intellectuals in the House of Scholars just outside Petrograd. Bakhtin was associated with these groups. It was not until 1926 that the promising engagement of Communism with Christ was broken off.[50]

Carnival thrives in a religious context. Much of Russian futurism reaches out to both. A carnivalesque intention is patent in the street events and decorations to which artists gave so much attention in the first post-Revolution years. These often involved removing, covering up or otherwise subverting the symbolic and figurative images still representing the tsarist empire: this must have felt like mischievous behaviour. To the many whose Orthodox faith continued to be the basis of life, it must have seemed impious to see images of Marx and other heroes, and symbolic objects such as large globes with blunt slogans, borne in procession on festival days where once icons were carried, but such displays did not stop one going home to piety and one's beloved icons.

Officialdom prescribed the two national festivals, May Day and the anniversary of the October Revolution, partly to counter the plenitude of religious festivals. May Day would distract from Christ's Resurrection at Easter, the climax of the religious calendar. Local and national government worked to get the best results from this secularization of festivals by producing funds and suggesting programmes in their search for the best balance of entertainment and indoctrination. There were always stylistic issues: old art or 'futurist' art, or something in between. There were questions of content: Soviet achievements that could be celebrated in the streets and Soviet leaders whose images might lend them a saintly aura, as against lampoons of Capitalism and of the West's political leaders whose parading and maltreatment in effigy would amuse everyone, or clowns and other circus folk doing their routines in the streets. Floats, parading workers or soldiers passing between rows of organized schoolchildren, symbolical figures among them or as painted images, lots of red flags and red paint — different forms and methods were proposed, tried and reported on. The menu kept changing with circumstances, the experience gained from previous festivals and the finance available.

In 1918 Lunacharsky's diary noted his response to the first Soviet May Day in Petrograd: lots of decorations, some of which could be criticized, but notice the enthusiasm 'young artists' brought to their creation. That night there were searchlights and fireworks: 'I went to the Neva and was met by a truly magical fairytale! . . . a symphony of fire and darkness.' The State had backed it, yet 'If this festival had only been official, it would have produced nothing but coldness and emptiness. . . . But is it not intoxicating to think that the State, until recently our worst enemy, now belongs to us . . . ?' We know that 'Communism in one country' came to replace the optimistic vision of global Communism, so that Lunacharsky's optimism can now seem pretentious, but these were honest reflections. Because of everyone's willing effort, he ends, 'we can say that this festival of labour has never been so beautiful.'[51]

Tatlin led a team devising a firework display, together with dramatic lighting from searchlights and signal flares, centring on Red Square: 'a firework display greater than any seen in Moscow or in Western Europe'. Lunacharsky had scripted the first Soviet agitational film; it had its première that day.[52] For this festival in Petrograd, Petrov-Vodkin painted Stenka Razin and his supporters on a fifteen-metre canvas, while Altman transformed Palace Square with painted images hanging on the facades all around it, a cluster of trees occupying part of it, and with his rostrum of cubic solids and curving planes at the foot of the Alexander Column as a setting for an elaborate and dramatic pageant.[53] There were ships and fireworks until midnight on and over the Neva. Aeroplanes circled overhead. Yet reports were mixed: bad weather and material shortages were a handicap, and the use of

conflicting kinds of art implied discord. Some of the work ignored its city setting, some enhanced it, and some seemed to be fighting it with its view of the future. Some commentators asked why daily life could not be transformed into a constantly cheerful festival.

In April 1919, IZO was instructed to supervise the planning of festivals.[54] In Moscow, May Day 1919 did bring cheerful events, including a clown, other circus acts and packed theatres. Petrograd the same day had marches and speeches, and floats symbolizing the old and the new world, including another huge globe inscribed 'Internationale'. Moscow confronted the economic crisis, giving prominence to 'an arch of factory labour, an obelisk of agricultural labour, arches and obelisks of trade unions', designed by themselves. In 1920 Moscow instituted a *subbotnik* for May Day, a day of cheerful but unpaid labour demonstrating workers' loyalty to the State. The only 'entertainment' on offer that day was an open-air performance of Sophocles's *Oedipus Rex* before a mass audience. The institution of *subbotniki* and also *voskresniki* (Saturday and Sunday voluntary workdays) spread, and with it the idea of awarding medals to outstanding workers.[55] That year, Petrograd witnessed all sorts of cabaret and clowns, but here too there was symbolical emphasis on work, with Palace Square and the Field of Mars tidied up beyond actual need while, in Moscow, Lenin himself helped to clear accumulated rubbish from the Kremlin's courtyards. There was some new sense in this: workers were showing that they were free to choose to work; the songs heard were songs 'of workers, not slaves', as Khlebnikov wrote in his poem 'Labour Holiday'. May Day 1919 in Petrograd had been celebrated with a mass *Pageant of the Third International*, demonstrating everyone's readiness to fight in defence of the Revolution and issuing a challenge to its enemies even while Yudenich's forces were massing not far from the city.[56] The 1920 Petrograd anniversary of October (Tatlin's model of the Tower was being readied for display) re-enacted the Storming of the Winter Palace, a major piece of street theatre involving mass action and a vast audience. The theatre director Nikolai Evreinov planned and conducted it. Annenkov was chief designer of the various structures it demanded. It felt intensely realistic yet improved on what had happened in 1917.[57]

The year 1921 brought in the New Economic Policy with which Lenin hoped to reverse his country's decline. By diminishing wartime controls exercised by the State over industrial production, banking and business, NEP would create 'the new beginnings of everyday life' while also 'reconstructing our real surroundings', and here the emerging constructivists could find encouragement for their programme of transforming life itself. Some committed Communists sought to oppose NEP, but improvements in living conditions in the cities were soon noticed, breeding hope for more. All economic interaction with other countries, Lenin argued, depended on some such easing of the domestic situation. But he used the same congress to end all vocal opposition to the government's reforms: the one-party State should have a one-opinion people to work with. June 1922 saw the return of tsarist-style censorship in the establishment of Glavlit. In the autumn there followed a dramatic return to imposing exile as a means of controlling individuals and groups. A large number of intellectuals and other leading figures in Russian philosophy and economic theory were invited to leave the country with their families or risk a worse fate in Siberia. Most of those who went abroad went to Berlin in the first instance, in many cases retaining Soviet citizenship.

In Moscow, the 1923 anniversary of October brought the Proletkult *Symphony in A*, performed by factory hooters, sirens and 'central heating pipes'. Cannons, machine-guns,

etcetera, provided the percussion, and Russia's favourite revolutionary songs, the 'Marseillaise', the 'Internationale' and the 'Varshavianka' were performed, as well as '[Chopin's] funeral march'.[58] Special thanks were due to the Union of Metalworkers. Baku and Nizhny Novgorod had presented similar performances earlier; others would follow, in Petrograd and elsewhere.

In *Theatre Herald*, in April/May 1920, Lunacharsky had again asked what festivals should offer and whom they should involve. 'Democracy presupposes the free life of the masses.' There was all that goodness and energy to be tapped into if only people were given the right opportunities. Like Bogdanov, he knew that organization was always a necessary first step. The masses must be organized to sing and dance and 'perform some extensive gymnastic manoeuvres', drawing in the unorganized others. In this way, 'one can say: the whole people manifests its soul to itself'. But entertainment is not enough, and the masses are not yet ready to create for themselves anything more substantial than 'a lively noise and the coming and going of festively dressed people'. Next May Day the major centres should present 'some central action, such as an elevated symbolic ceremony . . . satirical or ceremonial'. There should also be indoor events, such as revolutionary cabaret, and outdoors all sorts of speeches and performances with political point. 'It would be good if it is imbued with uncontrollable, uninhibited laughter, etc.'[59]

That February a subsection of the Theatrical Department of Lunacharsky's ministry — the Section of Mass Performances and Spectacles — had discussed and published new proposals for Moscow's May Day. Their tone was quite different. The only name on the document is that of Alexei Gan, a member of the department since 1918 and now working with Rodchenko on defining constructivism as a step towards productivism.[60] He rejected the previously voiced intention to use ancient myth as an overriding theme for the coming festival. No, Greek myths are 'alien to the proletarian masses', as are 'Biblical myths or Christian rites', or 'alien cults' including 'the festivities of the French Revolution', often invoked before. This time 'the content of the festivities is to be the history of the three Internationals . . . in theatrical form', using the whole city and its outskirts. Its ultimate aim would be to visualize 'the Communist city of the future', and this would be staged outside the city on 'a field of the International supplied with a wireless station and an aerodrome'.[61] Mobile patrols would initiate mass participation in all parts of the city. The First and Second International would be dealt with at the heart of Moscow, calling for another huge globe; the 'field of the International', on its outskirts, would witness 'the emergence of the Third and the transition to a socialist system'. Various means would force the crowds into energetic participation, accustoming them to 'collective action and mass theatre'. This was easily the sternest proposal for any festival recorded during the first post-Revolution years. It sees the population in terms of columns and blocks, to be led from place to place for political indoctrination. The text admits that 'the very nucleus of the festivities has not yet been found', meaning how to bring people into 'a harmonious, general participation that is both theatrically fine and fascinating for the performers'. 'The collective genius of the proletariat must overcome these difficulties.'[62]

The contrast between this dictatorial proposal and Lunacharsky's vision of purposeful gaiety is clear. Neither was quite achievable. Gan's plan was not followed, though it was taken seriously enough to be published. Instead there was the *subbotnik* May Day and *Oedipus Rex* performed around midnight, perhaps to please the minister. Petrograd had more fun

that day: lots of theatrical and musical offerings, Gluck's *The May Queen*, *Hippolytus*, *Petrushka*, fanfares, a balalaika group and hardly any political indoctrination at all, unless it was the pantomime signifying 'slave labour, transforming into joyous construction', staged on a tramcar in several locations. But on 21 July Petrograd celebrated the Second Congress of the Third International with a spectacle entitled 'Towards a World Commune' in and around the noble portico of the Stock Exchange. It outlined the history of the revolutionary movement in Europe 'from the First to the Third International' in what sound like Gan-ish terms. 'We saw nothing but a dramatization of dull prose,' said a report. Later that year, in November 1920, while Petrograd thrilled to the Storming of the Winter Palace and could see and discuss Tatlin's Tower model, Moscow had a relatively quiet time. There was much talk of decorating streets and squares, but also of material shortages. The cinemas stayed open longer and additional cinema screens were set up on the streets.[63]

Khlebnikov's career as poet began with laughter, and a personification of Laughter was prominent in the posthumous presentation of *Zangezi*. His search for the deepest cultural roots led him into myth, mysticism and shamanism as work equal to mathematics and philosophy. He connected everything with everything in a spirit of joyous truthfulness, outshining every established faith. His friendship with Tatlin suggests that his enthusiasm carried his friend beyond the professional limits he might have set himself. Tatlin's parentage and his experience as a sailor, as well as his passion for, and skill in, folk music, in addition to his many-sided activities as artist, will have helped him to respond to Khlebnikov's universalism.

There was also the point that Tatlin and Khlebnikov, born the same year, were twinned by destiny. I have referred to the poet's insistence on seeing key historical figures as his precursors as well as guides. No doubt Tatlin was encouraged to speculate along the same lines, by his friend's example as well as by the symbolists' vision of humanity on the brink of a great spiritual advance stimulated by profound engagement with the greatest thinkers of the past — as spelled out, for example, by Richard Bucke in *Cosmic Consciousness*. Like Malevich and others, Tatlin looked back to Cézanne as a cardinal figure in the history of painting and to the tradition of icon painting as a major *point d'appui*, but among artist-inventors he must have seen himself as heir of Leonardo da Vinci and of Daedalus. Khlebnikov said Tatlin was Leonardo reborn.[64]

Both were on Russian minds. Leonardo's fame had grown dramatically in the later nineteenth century, both on account of the mysterious qualities that symbolists found in his art, and through the publication and discussion of his notebooks and drawings. These demonstrated what Giorgio Vasari's sixteenth-century account of the artist could only indicate: his unparalleled creative curiosity before nature's forms and processes, from human anatomy to geology and the flow of water; his urge to find connections between natural phenomena and between these and man's work; and his tireless inventing of things of use, including of course his efforts to create a machine enabling individual human flight. The 1880s and succeeding decades saw the publication of Leonardo's drawings and writings in richly illustrated editions, followed by scholarly studies of the man and his work. One of the most admired of these was that of Georges Séailles, *Léonard de Vinci, l'artiste et le savant*, published in Paris in 1892.[65] Merezhkovsky and his wife Hippius travelled in Italy in 1896 to research Leonardo's life at first hand. Merezhkovsky wanted Leonardo as the hero of the second volume of his trilogy *Christ and Antichrist*, between books telling of Julian the

Apostate and of Peter the Great and his son Alexei. The Leonardo volume was published serially in 1898–9 and as a book in 1901. A luxurious, richly illustrated Russian life of Leonardo came out in 1900, written by A.L. Volynsky whom Merezhkovsky had expected to undertake the publication of his book but who preferred to produce his own. Merezhkovsky's trilogy had substantial international success, especially the Leonardo book which has been translated many times.[66]

Tatlin's generation was fascinated by Leonardo the inventor.[67] Leonardo's double spiral staircase in the chateau of Chambord may have encouraged Tatlin to think of a double spiral for his Tower, but Leonardo's spirals are symmetrical and connected (like those on the lower part of Kircher's image of the Tower of Babel). Single spirals are frequent in Leonardo's drawings of nature and of mechanical inventions. Kulbin lectured in 1908 on 'Free Art as the Basis of Life' and published the text soon after. In 1912 he gave a similar lecture as part of a debate organized by the Knave of Diamonds. In it, Kulbin argued that 'the real theory of art' was to be found not in modern aesthetics but in 'the Good Book and in the thoughts of Leonardo da Vinci, Shakespeare, Goethe and other literati great and small'.[68] In May 1922 Viktor Pertsov, a member of Moscow PLK and normally writing about Russian poetry, published an article 'At the Junction of Art and Production'. He was interested in the debates leading to constructivism and productivism, perhaps because of his membership of Gastev's Central Institute of Labour. Pertsov's article starts from the fact that everyone now realizes that art can be linked to production. But he rejects the equation 'art = production'. Art should not be abolished nor artistic energies repressed. The past has demonstrated that the best work comes out of 'the combination of technological/mathematical abilities and artistic flair and talent. The historical example of their brilliant combination in Leonardo da Vinci is particularly striking to our age, more than any other.' The artist's and the engineer's education should both prepare for this combination.[69]

Boris Arvatov had studied science and mathematics, became a member of Proletkult and in 1923 was a founder of LEF. He was intent on finding for art a practical as well as ideological base. In 1920 he wrote about Leonardo in an article in the journal *Forge*. In 1921 he was a member of the Inkhuk committee, alongside Brik and Rodchenko, which formulated a programme to replace that of Kandinsky's. In 1922 a book, *From Depiction to Constructivism*, was announced; it would have contributions by Tatlin, Rodchenko, Brik, Arvatov and others, but it was never published. In 1923 Arvatov's book *Art and Class* associated constructivism and the death, he claimed, of easel painting, with the emergence of 'a technological intelligentsia'. Modern painting has moved on from imitation to abstraction of two sorts: expressionism, 'the path of extreme idealistic individualism', stemming from van Gogh and now associated with Kandinsky, Klee and Kokoschka, and its opposite, 'Constructivism (Cézanne — Picasso — Tatlin)'. He names Tatlin again as a 'constructor' intent on developing new training methods for this fusion of art and engineering. In January 1922 he had published in *Art Herald* (*Vestnik iskusstv*), Moscow's official arts journal, an article on 'The Proletariat and Leftist Art'. Its theme is that proletarian art, 'of which so far there is no trace', will necessarily be wholly distinct from bourgeois art with its 'fetishism of aesthetic self-sufficiency': it will be 'bound indissolubly with life'. Leftist art had prepared the way: 'Beginning with Cézanne and Picasso and ending, via Carrà [the Italian futurist painter], with Tatlin', modern artists have cleared 'the fields of old art and have ploughed them ready for the proletarian sowing'. The proletariat may find modern art strange, yet it is 'the historical

62. Photo of simplified Tower model, May Day 1925 procession, Leningrad. Collection of the State Archive for Film, Photo and Telephone Documents, St Petersburg

bridge which the working class must cross to reach the shore of its own art'. It is striking that Tatlin is the only Russian artist Arvatov named in his book; in an earlier article he had named Tatlin, Rodchenko and the Stenbergs as key figures in the constructivist tendency within abstract art.[70]

The cover of that issue of *Art Herald* includes a graphic motif. It is of Daedalus, a powerful figure shown in profile against a black ground, kneeling or flying, with mighty wings and carrying a blazing torch. References to Daedalus are rare in Russian writing or art. As in the West, Icarus is habitually invoked, an image of ambition and failure.[71] Khlebnikov knew his Daedalus, the legendary artist and inventor of ancient times whose name suggests 'artful works', and among whose achievements were the hollow cow into which Pasiphaë climbed to mate with the bull of Crete and thus generate the Minotaur, as well as the labyrinth within which the Minotaur lived and the thread that Ariadne gave to Theseus when he entered it to slay the man-beast. Daedalus invented the basic tools of carpentry, including the axe and the saw. He invented the mast and yards of ships. He was skilled in working metal.

He made many sculptures of wood, also figures that had open eyes and moved, as well as furniture, fortresses and temples. It was to escape from Crete and the wrath of Minos, and to fly to Sicily, that Daedalus fashioned wings for himself and his son. Khlebnikov, we are told, fulfilled the myth of Daedalus.[72] The correspondences between Daedalus and Tatlin are many, not least the combination in both men, as in Leonardo, of artist and inventor, image-maker and engineer, and the refusal to limit one's work and public standing to any one medium and form. To see Tatlin as a Daedalus for a new age is fair; to think him conscious of this is speculative. There can be no doubt that he knew of Leonardo and drew on his work.

Tatlin conceived his Tower as a monument to the Revolution. Its adjusted name, Monument to the Third International, makes good sense in view of the date of the model's display and the monument's intended function as the headquarters of Comintern. But Tatlin's symbolic idea was broader: a welcome to and a public sign of the opening of a new epoch. The Tower resembles a helter-skelter, set up on many a fairground for people to climb up internally in order to come sliding down an external spiral. Its vast form, at the heart of Petrograd, would counter the city's authoritarian character (fig. 62).

From November to March or April, the Neva is frozen solid. The breaking up of that ice is the audible harbinger of spring, but until then its broad and solid surface serves as a thoroughfare, a marketplace and a fairground for everyone, without the class associations borne by different districts and sections of the city. Among the traditional amusements provided on the ice were tall timber open-work towers. Sleighs were pulled up the steep side in order to shoot down the slope on the other side, drawn by gravity down the iced-over surface, and continuing for some distance over the ice of the river itself. And at Epiphany the Neva was the locus for the Blessing of the Waters.[73]

It is not possible to think of Tatlin's Tower without imagining cars and motorcycles going up and down its two spirals, and also lifts, presumably connected to its mighty spine, travelling up and down. We recall Punin's emphasis in 1919 on motion as a key feature of the project. This is a vision wholly distinct from that of the traditional government building of brick or stone, enclosed, guarded, secretive. In a post-Revolution manner some would call post-modern, Tatlin's building is transparent, displaying its activities. In the dark months, and whenever the nights are dark, it would be ablaze with internal lights and projected images and texts. It would contribute greatly to combining politics with pleasure, to the government's need to imprint new ways of thinking and to associate these with the fulfilling life promised by the new age. Public festivals, we have seen, were planned, experienced and then reported on in terms of this dual function, propaganda and carnival.

Tatlin, the least studio-bound artist of his generation, bore within himself a similar duality. He wanted to make great art at a time when the focus switched from the elitist world of exclusive specialization, which Tolstoy ridiculed so effectively, to an art addressing everyone. The Eiffel Tower was created to remind the world of a great national revolution and to serve as an object of pleasure, transcending its immediate task of advertising a festival of commerce. The ferris wheel, to the south of the tower around which intrepid aeronauts raced their machines, emphasized and enlarged its mission. The Russian tradition of building churches to commemorate cardinal events, as opposed to sculptural memorials, was also in effect an act of sharing with the people: monuments stand apart; churches invite engagement. The Church was intimately joined to the State from Peter the Great's time on, yet churches were and remain home territory to all levels of society. The Russian convention of not sitting or kneeling in church but of standing and moving about during services in order to address this or that icon, is egalitarian and non-prescriptive in a manner not known in Western Christianity. Tatlin conceived and developed his Tower as a popular and culturally resonant object, as well as a politically significant and useful one.

Humour, as Lunacharsky kept reminding himself, would have to be part of anything offered to hold the people's interest and convert them to the living faith of Communism. When John Bowlt contributed an essay he entitled 'Tatlin and His Anti-Table' to the 1989 symposium held in Düsseldorf,[74] he started from the recollections of an artist friend, Vladimir Milashevsky, who visited Tatlin and his team in his Petrograd workshop where the Tower model was in construction and sat down with them for food and conversation. Bowlt proposed that we should see Tatlin not as the sober, positivist, proto-constructivist of conventional art history but as 'in many ways a Dadaist or, more exactly, an Absurdist'. Milashevsky saw the circular base of the model as a sort of pulpit. 'We sat with our backs to the tower, so that each of us looked outwards — radially — from the model, fixing our gaze on the walls of the studio'. To speak with anyone other than the next person

required complicated contortions from both parties. 'One might say now that this was an anti-table, something contrary to the usual table at which people have been chatting for centuries, looking at each other one on one.' This base, familiar from photographs of the finished model, would have been much too high for sitting on or eating at: its top was breast-high for Tatlin and neck- or shoulders-high for most people. Photographs of the team working on the model suggest that there was no base at that earlier stage. So either Milashevsky was using an unclear memory to invent an interesting situation or the model had a much shallower base before the one known to us. This seems unlikely. Apart from hiding the cranking mechanism that could make the hanging units turn, Tatlin evidently wanted to make visitors look up at the model and thus get some sense of its potentially dramatic presence. Bowlt linked this recollection to the impossible objects and projects Tatlin gave his career to: the 'unbuildable Tower', 'a suit that was not worn, a chair that was not sat in, and an airplane that was not flown', all of them 'absurd — although not nonsensical'.

In the later 1920s, this attitude would associate Tatlin with a literary movement known as Oberiu (pseudo-acronym for Association of Real Art) which existed from 1927 until 1930 and devoted itself to absurdist, anti-rational poetry, drama and prose. It would also echo aspects of early futurism and the buffoonery that interferes with the messages of the famous futurist opera of 1913, *Victory over the Sun*. These writers, especially Daniil Kharms, were true heirs of Khlebnikov. Malevich's trans-rational paintings of 1913–14 were referred by him and by others as *zaum* art. Switching to suprematism in 1915 was a *volte-face* for which we have no explanation other than the new situation created by war and the self-reliance invited by cultural isolation from the West. But there must also be some significance in the fact that Malevich, in reworking several of his pre-suprematist paintings in the late 1920s, did not do this for any of the *zaum* compositions. Perhaps he wanted to distance himself from those riddling paintings-with-collage, patently influenced by Paris, and to emphasize his image as a Russian, or East European, priestly artist.

One of the founders of Oberiu was the writer Daniil Kharms (1905–1942). Tatlin illustrated the ten episodes of Kharms's story *Firstly and Secondly*, published in 1929. This wholly inconsequential and fantastical story became a popular children's book. It relates how two boys meet a very tall man (Tatlin himself, in the pictures) with whom they go travelling. On the way they encounter a very little, cross-featured man (the illustrations hint at Malevich), who goes with them, at times borne on the tall man's shoulders. The illustrations are semi-naturalistic. The absurdity of the two boys associating with a tiny man and a very tall one is enhanced by emphasis on the various modes of conveyance they use — dog, donkey, car, boat, elephant and the tall man, who carries them all at one point and, at another, pulls the boat containing the others, including the donkey (but not the elephant and the dog who join the company later), through shallow waters while the car dangles from a staff over his shoulder. But this is gently mitigated by hints of the world about them, primarily through telegraph poles and wires and, in one scene, a hotel's iron bedsteads that are laughably too small for the tall man who has to sleep on the floor. Efficiently shaded forms convey most of this, with telegraph wires and the beds providing some linear emphases. The illustrations may remind us of Tatlin's early stage designs, especially those of 1913–14 done for the Glinka opera, in which no figure is allowed any gravity and the guards are satirized in their chorus-line grandeur. Much the same degree of naturalism, with

shading to give his forms volume and solidity, shows also in Tatlin's late stage designs but usually without self-evident humorous intent.

In 1927 Kharms published his theory of 'the Absurdist conception of life as a complex of interrelatioships whose only legitimate meaning is the so-called fifth meaning'. Kharms defined the five meanings of every object in this way: the first four are 'the graphic meaning' (the geometric meaning), the 'utilitarian meaning' reflecting its purpose, its 'emotional influence' and its 'aesthetic influence'. 'The fifth meaning is determined by the very fact of the existence of the object . . . and serves the object itself. [It] is the free will of the object. . . . Such an object is "SOARING". . . . Not only objects but also gestures and actions can be soaring.'[75]

Bowlt proposes that we should see Tatlin as an absurdist, classifiable with the *oberiuty* but *avant la lettre* because this disposition is seen already in his reliefs as well as in the many things that occupied him but never really happened. (Bowlt suggests that Tatlin did not expect to realize them and that his reliefs, etcetera, were not intended to survive.) This seems to exclude the possibility that he could also work practically and exercise 'a positivist mentality'. Need one exclude the other? To see Tatlin as a 'master of reason' is an extreme option not usually taken and certainly not called for by the man himself. The artist in him tended to the builder (as Khlebnikov named him); the builder in him always tended to the poet and to the 'blizzard of associations' referred to by Shklovsky. His refusal to be seen as the Father of Constructivism stems from his insistence on art's essential role even in approaching utilitarian design (this will be discussed further in chapter 9). Bowlt's account certainly deepens our awareness of Tatlin's anti-rational faculty, and accords it a guiding role. Indeed what else could have led the artist from drawing, painting and stage design, into making pictorial and then un-pictorial reliefs, and on to conceiving and developing his almost outrageous idea for a vast modern monument? Even his study and teaching of the culture of materials must have been rooted in an instinctive identification which he could develop in practical terms and communicate in teaching. Khlebnikov's short poem 'Tatlin' unambiguously presents him as a 'visionary' or 'secret-seer', and a 'bard', offering us a 'mystery vision' through his 'clairvoyant' work. This was in 1916, when his great projects lay entirely in the future.

Form of the figure

I

The writer Viktor Shklovsky wrote, in his 1921 article: 'The Monument is made of glass, iron and Revolution'. How can materials translate an event into a monument? How can it deliver its meaning? One approaches it, he implies, as one would a poem. 'The word in poetry is not just a word: it produces dozens and thousands of associations. A literary work is permeated with them as Petersburg's air is permeated with snow in a blizzard.' Tatlin's Tower brings with it a 'blizzard of associations', and was intended to do so. The artist was not able to 'confine the movement . . . between the supports of an iron spiral within this blizzard of associations'. Instead, 'it seems to me that Tatlin incorporated the Soviet of People's Commissars into his monument as a new artistic material and used it together with ROSTA for the sake of artistic form'. He also wrote, thinking of the famous equestrian monument to Peter the Great, situated close to where the Tower would stand, that

> It is the first time that iron has reared like a horse and is now searching for its creative formula.
>
> In this age of building cranes beautiful as the wisest Martians, iron had the right to go berserk and remind people that ever since the time of Ovid our epoch has gratuitously adopted the name of 'iron age' without producing any iron art.[1]

The Soviet of People's Commissars was the highest governing council of the new Russia. ROSTA, the Russian Telegraph Agency, was its information and propaganda agency, for which Mayakovsky and others worked so devotedly during the crisis years of 1919–21.[2] Later Mayakovsky looked back on this work as a major contribution to the revolutionary struggle during its most difficult years. He went on to contrast the indulgence with which lyric poets could pursue their sweet verbal music with his and his associates' urgent task. In 1919 he had written, and in April 1920 had seen published, his propagandistic but also amusing poem *150,000,000*, addressed anonymously to the people of the Soviet State. They are 'the creator of this poem / . . . no one is the author', and he invited 'anyone at all to add to it and improve it' — like folk material which would change over time and from

place to place. The poem's theme is a duel, between David, here 'Ivan', and, as Goliath, the supposedly all-powerful President Wilson and his gang. Lenin thought it silly, and berated Lunacharsky for permitting a print-run of five thousand copies. Tatlin's Tower, worked on ardently during 1919–20, addressed itself directly to the same 150,000,000, but was intended also to be a signal to the whole world.

Shklovsky implies that Tatlin's work on the Tower combined the ideals and ambitions of the new Soviet State with Russia's folkloristic and pugnacious instincts. Moscow having become the Soviet capital in 1918, Trotsky needed to argue with Lenin for the defence of Peter the Great's city and the Revolution's birthplace. The Whites, as Orlando Figes put it, had only one idea: 'to put the clock back to the "happy days" before 1917'.[3] But peasants and workers did not want a return to tsarism; they would defend the Revolution without being altogether certain what it offered. In November 1919, Petrograd, Moscow and other centres could celebrate the second anniversary of the Revolution with some relief and optimism.

The model Tatlin and his team began constructing in the summer of 1919 is more than a three-dimensional and larger version of his drawn elevations. Of course, the drawings and the model coincide in many respects. We cannot tell when the drawings were made. They may have been new when Punin used one for the cover of his booklet about the monument and the other as an illustration inside it, in which case they were made while the model was in construction, not as finite blueprints for it. Whatever the role of these and other possible drawings connected with the Tower model may have been, Tatlin was thinking primarily of the model he had to build of banal materials, as the necessary next step in making his concept known to the government and to Russia at large. Certainly these two well-known drawings were made for display, as their size (more than 10 feet, or 320 centimetres, high) and their neatness suggests.[4]

What everyone commented on when they saw the model and/or read Punin's new account of it was the monument's intended size, its asymmetry, and its commanding spiral or spirals.[5] They all knew that the real Tower would be a thing of iron and glass, and that it would incorporate and allow for movement of several sorts. No one remarked that it would be the first great government building that would be transparent. The glass box Vesnin proposed in 1923–4 as the Moscow offices of the newspaper *Leningrad Pravda*, was evidently conceived as the Tower's offspring.[6]

People saw in the great girder rising at an angle to the vertical the Tower's main structural element, everything else being much slighter in the drawings and in the model. The entire skeleton repudiated the age-old tradition of trabeated architecture: to see that great column not vertical but slanting disconcerted many and thrilled others. Many recalled *a* spiral. Those who saw two spirals thought of them as equal and parallel, which they are not. Almost everyone remarked on the units hanging within the iron skeleton and their intended rotation at different speeds. Shklovsky even pointed out that their motion would be barely perceptible. He, like others, referred to three geometrical bodies, not four, but it is easy to see the upper cylinder and the hemisphere above it as one unit, and I shall suggest that the number three proposed itself because of its historical and symbolical resonance.

In fact, each of these aspects can be associated with symbolic values, traditional ones and others specific to Tatlin's context. The concept of a tower reaching into the sky inescapably echoes that of the Tower of Babel. As suggested before, Tatlin will have seen his Tower as a rejoinder to Nimrod's. Comintern would make good the disintegration of human relations

occasioned then. Punin's pamphlet ended with a hint in this direction when he wrote that Tatlin's Tower would be 'an ideal, live and classic manifestation of the international union of the workers of the globe'.[7] Khlebnikov thought of towers as carriers of ideas as well as real and potential architecture; the ziggurats of the Near East were and are towers; the Russian tradition of memorializing major events called for churches topped by onion domes pointing towards heaven; Moscow's tallest tower was the Great Kremlin Belfry, rising above a chapel dedicated to St John Climacus. Petersburg did not possess a tower of any size or distinction but had two tall, gleaming spires (the Admiralty and the Cathedral of the Fortress of Saints Peter and Paul) and the high dome of St Isaac's Cathedral. Shklovsky wrote that the Tower would be twice as high as St Isaac's; four times as high would have been more exact.

The spiral is a dynamic form: 'the classical form of dynamics', as Punin wrote in his pamphlet. The Renaissance expressed its view of the world through the triangle and the pyramid. 'A spiral is the ideal expression of liberation; with its heel pressed into the soil it escapes the ground and becomes a sign, as it were, of the liberation of [everything] animal, earth-bound and reptile.' A natural form associated with growth, the spiral has a long history as a symbol in many cultures. It is often a symbol of power, as well as a connection between the circumference of a circle and its centre and thus a line linking the one to the many. Milner quotes Hegel: 'From the point of view of the human actors, history is a union of irony and tragedy; from the point of the whole it is a cyclic or spiral advance.' He comments:

> A dialectical view of history as a process of evolution has replaced the contemplation of events, isolated in time and space. . . . [The Tower] was a social alembic: the evolution of human history was to be determined here, and corporate will condensed, purified and transformed into the energy of action.[8]

Friedrich Engels saw both historical and natural evolution as a 'spiral of development'. Lenin saw education as a spiral growth calling for urgent attention if it was to attain essential social and political aims, in the first place that of establishing literacy. The rising spiral is often used in Russian texts in association with revolutions and with the positive developments that should follow from them, just as, throughout humanity, ascending a mountain is associated as much with spiritual growth as with physical achievement. But did Tatlin opt for two spirals for traffic reasons? It could make sense to have two one-way approach roads. Leonardo had two spirals criss-crossing in his staircase at the heart of the chateau of Chambord.[9] The staff identifying Mercury as the heavenly messenger, the caduceus, is entwined by two symmetrical serpents. His statue, complete with caduceus, stands on top of Petersburg's Exchange on Vasilievsky Island, silhouetted against the sky.

The Tower's asymmetry was seen by some as precipitous and perilous. In fact, no part of the Tower strays beyond its base plan: it *appears* to lean and, with its great intended height, confronts and affronts imperial Petersburg. City regulations controlled building heights, relating them to status and location; no secular building should be higher than the Winter Palace. Thus this city, built in classical styles derived primarily from French and Italian as well as German and Dutch examples, never failed to remind inhabitants and visitors that it is a foreign thing imposed on Russia. Peter required stone buildings, though timber houses persisted for a long time. The nobles whose attendance he demanded were to import stone for their houses and palaces from far away — or at least pretend that stone

was used by faking it with inscribed stucco. Remembering Versailles, Peter called for three radial boulevards which here would focus not on the ruler's bedroom but on the Admiralty. Their straight lines ignore the rivers and canals they cross, along which many of the new dwellings were aligned. Large groups of buildings, and buildings around squares, tended to be given a uniform style and thus speak of control as well as harmony. Trees, occasional gardens and parks relax this imperiousness.

Many Russians admired Petersburg, though Moscow was always held in special affection as the more truly Russian city. Its informality and gradual development, most obviously its many Russian or Slav-style churches and its Kremlin, spoke of deep roots in the past. Petersburg, built to show that Russia was a force in modern Europe by a tsar ready to force modern ways on his people, was associated with westernization but also, in the time of symbolism, with spiritual enquiry and debate in the face of rampant materialism and hypocrisy. As a sudden creation and then a government centre situated on the western edge of the vast European and Asian empire, Petersburg had to be an artificial growth, affirming the ruler's power but, some asserted, permitting only an unnatural form of life. Dostoevsky hated Petersburg. Blok loved and hated it, and noted the disparity of numbers between men, many of them working for the government far from their families, and women. He called Petersburg 'a gigantic brothel', and meant it literally as well as more broadly. Herzen in 1842 set Petersburg, with its intense pursuit of money and status, against Moscow's more relaxed, at times even liberal, ways and values. Comparing church-going patterns in the two cities, and finding that attendance in Petersburg was regular only among the simpler folk and among the Germans attending their Protestant church, as against the true piety of Moscow's inhabitants, he added: 'All this holiness is guarded by the Kremlin walls; the walls of Peter and Paul fortress guard prison cells and the Mint.' A year later he wrote:

> The life of Petersburg is wholly in the present: it has nothing to remember but Peter I; here the past was manufactured in the course of a century, and having no past it has no future either; any autumn it can expect the squall that will finally wreck it.

The Neva was liable to flood, even after its granite embankments were built, but it was not only thoughts of a natural catastrophe that led the writer Mikhail Lermontov in the 1830s to make watercolour sketches showing a submerged Petersburg, with just the top of Alexander's tall new column in Palace Square emerging from the waters. He was half-seriously foreseeing the destruction of a cursed city. Others took a wholly positive reading. The great critic Vissarion Belinsky, forerunner of the radical critics of the 1860s, in 1845 claimed that Petersburg represented Russia's 'new hope, the fair future'. Gogol's anti-Romantic story 'Nevsky Prospect' opens with 'There is nothing finer than Nevsky Prospekt', and ends on 'Do not believe this Nevsky . . . the devil himself lights the lamps only so as to show everything not as it is'.[10]

Petersburg's Bloody Sunday of 1905 was followed by strikes in the city — reminding everyone how heavily industrialized it had become — as well as echoes of those strikes elsewhere. That day's ill-starred procession consisted mainly of workers from Petersburg's outer ring, many of them from Vasilievsky Island. From this island one crosses into central Petersburg over one of two bridges, and closing those two bridges would always be the first move when unrest called for special controls.[11] One of the slogans suspended beside

the Tower model when shown in Petrograd reads: 'The engineers who build bridges calculate our invented new forms'.

Bely's great novel *Petersburg*, published serially in 1913–14 and as a book in 1916, takes the pulse of the city in 1905: a capital with a fine cultural life threatened by social unrest. Its main characters are Apollon Apollonovich Ableukhov and his son Nikolai. The young man, a student involved with revolutionaries, is given a time bomb with which to assassinate a high government official. The chosen victim is his father, Apollon, the son of Apollo. The bomb will explode in twenty-four hours. What happens during those hours is the narrative of the novel, but its context is the contrast between the threat of terrorist action as an expression of rebellion and the authority of Petersburg. The central parts of the city are regulated by means of straight lines that pattern its flat terrain. From the islands, across the Neva, come dangerous, shadowy figures, individuals and also columns of them carrying red flags, their arrival threatening the city's order. Apollon, 'of venerable stock: he had Adam as his ancestor', is a Privy Councillor who lives in a fine house by the Neva with plenty of servants. He is dedicated to his status and to the rather vague work it requires from him. He is extremely conscious of time, and also of his son's dilatory ways. His home is his personal zone of authority; the world outside is much less secure. Across the Neva is 'many-chimneyed' Vasilievsky Island. He 'did not like the islands: the population there was industrial and coarse . . .[.] The islands must be crushed!' Simple geometric forms and symmetry soothe the senator's nerves. Straight lines and squares reassure him, as do the cubes of houses and of the carriage in which he rides to and from work along the straight line of Nevsky Prospekt. 'Oh, you lines!' exclaims the author; 'In you has remained the memory of Petrine Petersburg.' The straight streets 'possess one indubitable quality: they transform passersby into shadows', but now these are sensed as hostile apparitions. His home is rectangular spaces formed by walls, ceilings and parquet floors. Over the grand piano hangs a copy of J.-L. David's imposing portrait of Napoleon. In the study is a 'handsome bust of — it stands to reason — Kant'.[12]

Tatlin's Dionysiac monument was to tower over this Apollonian city.[13] It would have been the ideal place for it: the headquarters intended to control and propagate the new faith erected in 'Russia's window on the West'. Tatlin's eighth Wonder of the World, outdoing France's monument to the French Revolution not only in size and form but also as a functional building, would trump the old order by refuting its formal idiom. It would re-state Russia's old messianic mission to the world. Bely's senator wanted the entire planet bound by linear prospects and cubic houses. Tatlin wanted his anti-rectilinear structure to serve as the command module of the planet Earth as Milner has noted, ready to venture forth on cosmic voyages foreseen by Fedorov.

*

The units or bodies turning within the iron skeleton were, from the top, a hemisphere above a cylinder; a tetrahedron; and a relatively squat cylinder echoing in its diameter the diagonal of the cube previously planned. The pyramid lies on one side so that its largest triangular face is exposed as a sloping face whereas one might have expected this to be its base. It is the only unit whose silhouette would change as it rotates. The others present continuous surfaces. Rotating at distinct speeds, they are linked by the sloping grid pattern of the glazing bars, which is the same on each unit and ignores differences in size. Punin's report

of 1920, which Tatlin must have helped to compile, speaks of only three units, 'three large glass halls . . . located one above the other and their different shapes are in harmony with one another.'[14] Were the pyramid placed with its largest side as its base, we should be more tempted to read the stack of units as consisting of perfect forms in the Platonic sense, perfect products of the compass and the ruler, demonstrating the work of reason. To turn one form on what we think of as its side would deny that prejudice. Tatlin may also have felt that a pyramid placed symmetrically above the big cylinder, its apex pointing upwards, would divide the stack into two halves. The fact that the hemisphere at the top is not axially aligned to the cylinder below it implies a subtle visual balancing of every part.

All these forms have traditional symbolic connotations, including that jettisoned cube. That would have been the most earthy, material form; it would represent stability. The cube is associated with thrones and authority, and may have been reconsidered as being against the spirit of the Tower, as well as against the idea of rotation. The pyramid, too, is associated with the earth and permanence, but that is the four-sided pyramid above a square base. Here all the sides are triangular, and the three that rise upwards express aspiration and represent fire. Whatever angle Tatlin's tetrahedron is seen at, it is ternary. In the absence of the cube, it is the only form that speaks of a number. The number three is associated with fusing unity with duality, and thus of creation and of growth as well as spiritual synthesis. We see threes everywhere, in the physical world and in our religious or mystical speculations — most poignantly, for Christians, in the concept of the Trinity, three aspects of divinity in one, echoed, as Vitberg pointed out, in the threefold nature of man. In Orthodox Christian thought, the universe itself presents three 'levels of being': the heavenly world of divine being, the paradisiacal world lost to us through the Fall of Man, and the level of human existence and the opportunity of 'deification' given to mankind by the Holy Spirit through Christ and the New Testament. Orthodox churches echoed these three levels in their architectural form and iconographical system: on the lowest levels there are images of saints, important sustainers of the redeemed world; the upper parts of walls, the pendentives, etcetera, image the life of Christ and the 'regaining' of the 'heavenly Jerusalem'; the dome and highest vaults carry images of the divine world.[15] Vitberg's project was for three great churches in one. I suspect that those who saw three units in Tatlin's model wanted to see three for the sake of that familiar symbolism.

The inclined beam of the Tower's spine resembles a ladder with seven rungs and as such recalls St John Climacus's *Ladder of Perfection*. The number seven is rich in symbolic meanings and practical applications, from the number of notes within an octave to (by some accounts) the number of distinct colours seen in a rainbow. There were seven established planets, each with its corresponding pagan deity. There are seven virtues and seven vices. Seven is the number of angles in a form combining the square with the triangle. In his short story *Ka* (written 1915, published 1916), Khlebnikov wrote that 'Ka studied how to play on 7 strings'.[16] Ladders lead up and down, in myths and legends. Genesis tells of Jacob's success in usurping Esau's birthright, and of his escaping Esau's revenge. On his journey he dreamed of a ladder connecting heaven and earth, of angels ascending and descending, and of God at the top, confirming the blessing Jacob had won from his father; this is represented in many icons. Similarly, the angel with whom Jacob wrestled throughout one night, and whom he survived in spite of the other's superior might, departed blessing him for 'thou hast striven with God and with men, and hast prevailed'. Thus the beam, man-made

from earthly materials and raised up at the correct angle for pointing at the Pole Star — an extension of the earth's polar axis — is a potent image of achieved power and unity: Jacob is renamed Israel by his benign opponent, and his descendants are the Israelites. 'Israel' means 'let God rule'.[17] To 'god-builders' such as Lunacharsky and Gorky this would mean 'let conscious mankind rule'. In the familiar photograph of the model in Petrograd, with Tatlin standing close to it, a tall ladder is seen behind him, leaning against the wall and echoing the model's spine. The ladder is also associated with the world-axis linking and stabilizing the cosmos. Milner had the interesting idea of visualizing the Tower as a structure rooted in our planet by the spirals and the spine that lack termination at either end, so that we see them emerging out of the ground and not quite ending among the clouds. His diagram shows the Tower's roots in our planet but also sets the planet and the Tower against a map of the cosmos. In this way, the planet is shown as the vehicle that Fedorov envisaged exploring the cosmos and the Tower resembles the rocket of which Tsiolkovsky, whom Tatlin admired, wrote in *Beyond the Planet Earth*, the science-fiction novel published serially in 1918 in a popular journal and as a book in 1920.[18]

This reminds us that the Tower was not intended to address only its immediate location. Like the Tower of Babel, it represents global aspirations. It was intended to be both symbolic and functional in realizing the vision it bodies forth, charged now with the might of collaborative, technically advanced, spiritually alert humanity. Punin wrote:

> We emphasize that only the fulfilment of the power of the many-millioned proletarian consciousness could hurl into the world the idea of this monument and this form. It must be built by the muscles of that power . . .[19]

II

In his 1920 pamphlet *The Monument of the Third International*, Punin regretted the hold the Graeco-Roman figurative tradition still had on monumental art. The government has no choice in the matter, he wrote, having to employ artists formed before the Revolution. But such monuments

> present a double opposition to our times. They cultivate individual heroism and distort history; torsos and heads of heroes and gods do not correspond to the modern understanding of history . . . at best they express the character, feelings and thoughts of the hero, but who will express the mental and emotional tension of the collective thousand?

His subtitle for the essay is 'A project of the Artist V.E. Tatlin'. He calls him 'the best artist of the Russia of workers and peasants' and his project 'an international event in the world of art'. Here, 'a utilitarian form becomes a pure artistic form', reaching 'beyond the representation of man as an individual'.[20]

Punin's assertion of 'the collective thousand' has its historical roots in the Bolshevik philosophy of collectivism developed mainly by Lunacharsky, Bogdanov and Gorky from 1904

63. Auguste Rodin, *St John the Baptist Preaching*, 1877–80, bronze. Private collection

64. Raymond Duchamp-Villon, *Torso of a Young Man*, 1910, terracotta, 57.8 x 31.8 x 41.9 cm. Bequest of Clara G. Binswanger, 1993.247, The Art Institute of Chicago

65. Umberto Boccioni, *Unique Forms of Continuity in Space*, 1913, bronze, 111.2 x 88.5 x 40 cm. Collection of The Museum of Modern Art, New York. Acquired through the Lillie P. Bliss Bequest

on. Russian futurism asserted it. 'We' sounds imperiously from the manifesto printed in the 1912 futurist booklet *A Slap in the Face of Public Taste*: 'We stand fast on the rock of the word . . .'. After the Revolution, 'collectivism' and 'collective' became key words in cultural debate. The first issue of *Proletarian Culture*, July 1918, includes an essay by Bogdanov on the path proletarian poetry should follow. Its natural theme would be not the personal 'I' but 'comradeship'. Its generative centre would be the 'real, most basic creator of this poetry — the collective' instead of the ' "I" of the poet' associated with bourgeois and especially with symbolist writing. This attitude was received as official PLK policy, and is amplified in Mayakovsky's poem of 1919–20, *150,000,000*, in which 'the unified Ivan' stands for the masses and feels with and sings 'the millions'. At the same time, Zamyatin was writing his dystopian novel mocking that optimism; he called it *We*.[21] The 'theses' Tatlin drafted for an article intended to be his contribution to the journal *International Art* in 1919 defined the role of 'The Initiative Individual in the Creativity of the Collective'. This individual works in response to the 'impulses and desires of the collective'; he is the link between 'the invention and the creativity of the collective'; he is 'the refraction point of the collective's creativity', and realizes its ideas. Tatlin finds proof of the 'complete organic connection of the individual with the collective' in Khlebnikov's theory of numbers. But, he adds, it takes a revolution to repair the centuries-old divorce between the artist and the collective.[22]

Milner observed that the Tower, with 'its thoroughly three-dimensional coherence', is sensed as having 'a front, sides and back'.[23] He saw in this the suggestion of a figure and more particularly, thanks to the big arches rising on both sides, one 'recalling the ancient sculptural tradition of the striding figure revived by Rodin and more recently by Umberto Boccioni'.[24] Rodin's famous *St John the Baptist Preaching* (fig. 63), shown at the Paris Salon of 1880 as a larger-than-life bronze, seems to stride towards us and gestures forcefully with both arms, expressing urgency and conviction in every part. Noticed from the first as a dramatic image of this biblical hero, the sculpture was soon seen as one of the masterpieces of a sculptor who was being recognized as a modern genius. It became even better known when Rodin made a new version of the figure without head and arms yet amazingly powerful, known as the *Walking Man*. A cast of it was shown in Rome in 1911 and remained in the city until 1923, standing accessibly in the courtyard of the Palazzo Farnese. Duchamp-Villon's *Torso of a Young Man* (fig. 64), a bronze of 1910, has the figure stride forward

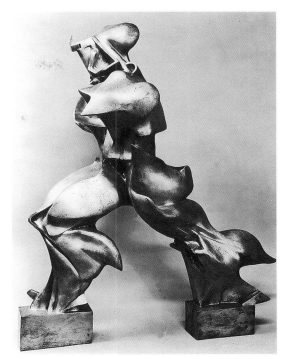

vigorously, its two legs widely separated above the pedestal; it was shown in New York in 1913 and in Prague in 1914, and it is possible that Tatlin saw a terracotta version of it in Paris in 1914.[25] Boccioni's abstracted figure, *Unique Forms of Continuity in Space* (1912–13) (fig. 65), one of the sculptures that survived his shows in Paris and Rome, turns human anatomy into flaring shapes suggesting muscles, and emphasizes dynamic action by giving the widely-separated legs separate blocks as bases.[26] All these sculptures pay their respects to the classical tradition. Thus Milner's associating of the figurative Tower with the ancient Colossus of Rhodes is reinforced: a male figure bestriding the entrance to a great harbour and tall enough for ships to sail easily between his legs.[27]

The image of a depersonalized but epic hero, incorporating echoes of Nietzsche's promethean superman and references to Lenin, the essential leader, is frequent in prole-tarian literature. It is in Gastev's famous poem 'We Grow Out Of Iron', written in 1914, pub-lished in 1917. Mikhail Gerasimov's image of a 'giant worker striding across villages and seas, holding aloft a factory smokestack as a beacon', in his poem 'Zavodskaia truba' (Factory trumpet/chimney), published in July 1918, had become an iconic presence in art by 1920.[28] Kustodiev's 1920 painting *The Bolshevik* represents a gigantic striding figure. During 1918–20 Chagall had used a striding, or leaping, male figure to similar effect.[29]

Another epic image must be introduced here as an influence on Tatlin in determining the form and symbolism of his Tower. A major event in the history of Russian painting was the creation and display of Alexander Ivanov's painting *Christ's First Appearance Before the People* (fig. 66). Ivanov's father was a respected history painter and professor at the Academy in Petersburg. His son (1806–58) studied under him from an early age and graduated in 1829.

66. Alexander Ivanov,
*Christ's First Appearance
Before the People*, 1855.
Replica of the painting,
1837–57, oil on canvas,
172 x 247 cm. Tretyakov
Gallery, Moscow

A scholarship took him via Germany and Austria to Italy. He settled in Rome, where Gogol became his public champion. They were convinced that the arts should work for human progress. Ivanov was both humble, knowing that such an aim called for total dedication and openness to the best influences available, and ambitious in feeling that he could meet its challenge. After twenty years or so of unceasing labour he began to doubt his ability to succeed, but he never lost his conviction that it was his duty to change the world, and in the 1850s he began to pursue an even more grandiose vision.

The result of Ivanov's first project was a vast painting. In Western art its theme is usually referred to as the Baptism of Christ: we are familiar with images of St John the Baptist pouring, or offering to pour, a little water over the head of the adult Christ standing by or in the River Jordan. Sometimes angels are the only witnesses, as in Verocchio's picture of about 1476, for which the young Leonardo supplied the angel seen in the left foreground. Sometimes other humans are present, some who have come to be baptised and others who are observers, as related in the Bible, but Western representations tend to show the event as a private moment. Ivanov, basing himself on the elevated style of Raphael and Poussin, but influenced also by the German Nazarene painters whom he knew in Rome, decided on both a many-figured painting and a landscape setting that would enhance the painting's message. The Nazarenes offered visual as well as moral veracity through carefully rendered naturalistic details. Like them, Ivanov found himself drawn to the Renaissance of the *quattrocento* as well as to the more grandiose art of the High Renaissance. For all his pursuit of correctness, of light and forms in the landscape, of physical differentiation between the several ethnic and social types of the attendant figures he brought into his composition, he sought a high degree of simplification. History painting has always been a form of visual theatre, the painter's task being to present a known and important truth by staging its most telling, most persuasive moment in a manner that reveals its meaning and

enlarges on it. Unlike most noted history painters of his time — such as the Russian painter Karl Briullov, whose large painting of *The Last Day of Pompeii* (1830–33; State Russian Museum, Petersburg) was made and exhibited in Rome to great acclaim and then much admired in Russia, notwithstanding its hollow dramatics — Ivanov studied also the work of the precursors of the Renaissance, most notably Giotto, at a time when these were still generally seen as 'primitives', apparently handicapped by their ignorance of classical models.

Ivanov called his 540 by 750 centimetre picture *The Revelation of the Messiah*. It is now commonly called *Christ's First Appearance Before the People*. In the Orthodox Church's calendar this event is celebrated on 6 January as the Epiphany. In the West, on the same day and using the same term (meaning the manifestation of a superhuman being), Christians celebrate the visit of the Magi to the stable in Bethlehem. Orthodoxy celebrates it as the moment when the adult Son of God comes forward to be baptised by John and commence his mission to mankind. The Western Church celebrates the Incarnation; the Eastern Church celebrates the Messiah's role as the world's Saviour as the Son of Man. In 1847 Ivanov wrote that the Slavic people would bring in a Golden Age when 'mankind will live in complete peace, when wars will cease and eternal peace will be established'.

He made about 250 studies on the way to producing his mural-like picture, studies of details, of colours and objects, of heads and figures, of the landscape setting, and of the whole composition. He also made separate paintings that seem preparatory to this *magnum opus*, such as *Christ's Appearance to Mary Magdalen* (1834–5), a severe composition showing little more than the two figures set into the foreground of a pictorial space. Also large at 242 by 321 centimetres but only half the area of the other, it reflects neoclassicism as well as the severer side of Roman Baroque painting (Guido Reni as well as Poussin). Neoclassical sculpture was primarily a Roman achievement, at the hands of the great Italian artist Antonio Canova, who died in 1822, and the Dane, Bertel Thorvaldsen, who worked in Rome from 1797 until 1838 and then again in 1841–2. Thorvaldsen befriended Ivanov.

Much of the action in *The Revelation of the Messiah* is in the foreground. The Baptist stands there, just to the left of centre. He is seen in profile, facing right and stepping forward as he raises both his hands.[30] His large figure dominates the scene. His gesture implies his words, drawing attention to the much smaller figure appearing in the middle distance, a mute, gesture-less Christ, clearly silhouetted against the desert and the lifting mist, yet not immediately present to the viewer.[31] This isolated figure impresses with its silence and modesty. His isolation will end, but not until after he has spent forty days and nights in the desert, following his baptism. Time plays a significant part in the story and the painting, including the time of day and the season. Ivanov shows Christ modestly initiating the mission that, apparently ending in failure, climaxes in mankind's redemption through his death and the glorification of divine power at the Resurrection celebrated at Easter, the most honoured festival in the Orthodox calendar.

The painting's size, and the care Ivanov expended on it, demonstrate the importance he saw in its subject and his desire to deliver its message to everyone. His picture represents a turning point for all humanity. So it had to be realistic. Light, the landscape setting, humanity crowding forward in all its diversity, believers and doubters, all had to be shown convincingly as of this world. The sky does not open; we do not see the dove of the Holy Ghost descending; no voice speaks from heaven. Ivanov secularized his religious subject, sacrificing some of its traditional appeal by omitting the glamour supernatural powers would have lent it.

Ivanov had much encouragement from artists and others in Rome, and managed, with some difficulty, to get the painting to Petersburg in 1858. His reception there was an anti-climax. The picture was shown in the Winter Palace for just five days and then moved to the Academy, against the painter's wishes. The tsar and other important people saw it. Some praised it; others considered it an abject failure. After an interval, Ivanov was awarded a decoration and a mean purchase price, and some additional money for the sketches and studies he had made for it. But he had died a few hours before the news reached him, from cholera. There had been talk of his being honoured with a professorship at the Academy, which he did not want. The funeral service was held in the Academy church, which he would have thought an insult, so opposed was he to the routines still being taught there.

Ivan Kramskoy, the leading figure among the student rebels who left the Academy five years later and would soon become the nucleus of the Wanderers, greatly admired Ivanov's work.[32] An article of 1858 praised Ivanov's fusion of classicism with Christianity, presenting him as 'the son of the first centuries of Christianity . . . with a simple and direct understanding of the teaching of the Gospels . . . Ivanov is a true son of Russia, and also of our time . . . Russia has inspired in him the pure, so to speak, infantile faith of the first centuries of Christianity.' Nikolai Ogarev, Herzen's lifelong friend and associate, wrote an obituary of Ivanov in which he claimed that Socialism came to guide the painter's thought and actions more than religion. Ivanov's example should prove to younger artists that it was their duty to dedicate their art to denouncing injustice and inertia. After the Europe-wide disturbances of 1848, with unsuccessful revolutions in several cities in the West, and then also Russia's defeat in the Crimean War of 1855, the 1850s found many Russians gripped 'by a mood of profound disillusionment, by a distrust of the very idea of progress, of the possibility of peaceful attainment of liberty and equality by means of persuasion or indeed any civilised means open to men of liberal convictions'.[33] There were repeated demands for more militant action but also a marked lack of spirit for it. The critic Alexei Khomyakov in 1858 commended Ivanov for working his way through what Italy had to offer and then focusing on his own central idea, thus reflecting 'the national Russian spirit, illuminated by the Orthodox faith'. He saw *The Revelation of the Messiah* as one of the few great paintings of all time, on the same plane as the *Sistine Madonna* which many Russians admired as Raphael's masterpiece and visited in Dresden on their westward travels. Chernyshevsky honoured Ivanov for his deep desire to improve the world and for the commitment he brought to that task. Ilya Repin, who had studied under Kramskoy, became one of the best-known artists associated with the Wanderers, and brought avant-garde Paris methods (such as those of Degas) to Russian subjects before becoming a professor at the Academy and then its director in 1898–9. He acclaimed Ivanov's visionary painting as 'a work of pure genius, the most truly Russian of all Russian pictures'. The artistic and literary journal, *Zolotoe Runo* (the Golden Fleece), devoted issues 11–12, 1906, to Ivanov's work and ideals, especially to this great painting. Punin, who had made a special study of the *Sistine Madonna* for his doctorate, called Ivanov's painting 'the first modern picture'.

Ivanov's second great project, pursued from about 1845 on, proposed the building of ecumenical shrines, embracing all faiths as expressed in different cultures and religions, from polytheism to monotheism. He studied Byzantine as well as other non-Renaissance art, including old icons and ecclesiastical paintings, in search of idioms and images for large murals which would be of all time and for every part of the world. These would go into

'Temples of Humanity' to be built all around the world. Visitors would be able to read on their walls the story of all mankind and learn to 'cultivate their own spiritual consciousness'.[34]

Ivanov's figure of the Baptist echoes, in its stance and gestures, the overall form and inclination of Tatlin's Tower. To check this, reverse the figure and impose it on Tatlin's drawing of the west elevation, or, leaving St John as Ivanov painted him, reverse Tatlin's drawing. The similarity may be coincidental. But the painting was famous in Tatlin's time and it was available to everyone in Moscow's Tretyakov Gallery, which still displays it together with many of the Wanderer paintings Lenin and his friends admired for their social and historical messages.

III

The 1920 Congress of the Third International, held in Moscow's Kremlin, ended on 29 July. Its conclusion was marked by a great demonstration organized by Trotsky. A tribune was built against the Kremlin's wall, facing onto Red Square, from which the Soviet leaders and eminent visitors could watch a parade and be saluted by it. This continued for five hours, involving many civilian categories as well as military detachments: Komsomol (Russian Boy Scouts), Caucasian tribesmen on horses and in native dress, athletes in swimming trunks, workers of several sorts, many of them carrying gold-lettered placards. Buildings around the Red Square were hung with banners. The whole of Moscow, almost all Russia, seemed eager to convince the world that the Revolution was here to stay. James von Geldern describes the event and goes on to define what he calls the 'myth of origin' of the Revolution:

> A myth that distilled the Revolution to a single moment. It was the instant of
> transition: the moment when history began and from which the future unfolded.
> Marx and ideology were irrelevant to this center of revolutionary history; it was the
> storming of the Winter Palace . . .

A re-enactment, in Palace Square, of that historical and mythical event was Petrograd's main offering for the 1920 anniversary of October. The display of Tatlin's model of the Tower opened in the old Imperial Academy the following day, proposing to signal Communism's life and energy by means of a vast, new, composite edifice from which the campaign for world brotherhood would be launched, initiating the new age.[35]

St John the Baptist is a cardinal figure in Christian thought. An angel announced to Zacharias that he and his wife Elisabeth, cousin to the Virgin Mary and barren to that day, would have a son. Filled with the Holy Spirit, he would prepare the world for the coming of Jesus Christ. John grew up mostly in the wilderness beside the Dead Sea and by the River Jordan, where he preached a new dispensation and offered baptism to those who wished to prepare themselves for it. Multitudes came to him, and also Christ, whose shoe-latchet John knew himself unworthy to loosen, and who nevertheless asked John to baptise him too, thus publicly initiating his mission to the human race. Later, after denouncing Herod for incest with his brother's wife Herodias, John was imprisoned and beheaded, thanks both to Herodias's hatred of him and to Herod's lust for her daughter Salome. John's preaching, Christ's coming to him and praise of him, and this dramatic end (soon followed by the

destruction of Herod's army), made him one of the most admired saints, the greatest of the prophets and the immediate herald of Christ and the new age of the Second Testament.

The Orthodox Church refers to John as the Forerunner and accords him higher status and greater visibility than does the Western Church. On the iconostasis, the wall of icons that in Russian churches screens the sanctum of the chancel from the public area, his image is always next to that of Christ and of the Mother of God in the 'Deisis' (intercession) grouping: Christ in the centre, Mary to his right, John to his left. Christ said, 'Among those born of women there is not a greater prophet' (Luke 7: 28). If John's personal feast day is 24 June,[36] his role as the Forerunner is most richly and popularly celebrated on 6 January as the Epiphany.

The ritual performed on that day, known as the Blessing of the Waters, centred on the local river, whose water would be blessed by the chief priests and thus become the water of the River Jordan, with holy and health-giving qualities. All Russian rivers are normally frozen over in January. In the Russian capital, Moscow or Petersburg, the ceremony would centre on the Moskva and the Neva, at the foot of the Kremlin and just outside the Winter Palace respectively. It had the additional glamour of being attended by the tsar, his family and courtiers, and by large detachments of the imperial army, and performed by many priests and church dignitaries led by the primate of the Russian Church, the Patriarch. During the nineteenth century it was decided that the ladies of the court might stay inside the Winter Palace and observe the service from its windows.[37] Men standing outdoors bare-headed throughout the service were still at risk; deaths from exposure were not uncommon. In Petersburg, the ceremony would usually be launched from the Palace Embankment. On occasion an alternative site was used, a few steps south-west along the embankment where a short channel linking the much smaller River Moika opens into the Neva. Sometimes a temporary temple was built on the embankment, with icons of the Baptist and, on one occasion, a statue of St John standing on its dome. More often such temporary structures would be erected on the ice itself, and the 'Jordan hole' was cut through the ice inside it.

The Epiphany service of the Orthodox Church — properly the service for the Theophany, when God manifested himself to the world — begins the previous day, 5 January, with psalms, prayers and readings known as 'the Royal Hours', from which the following excerpt is taken:

the Forerunner and Baptist, the prophet honoured above all the prophets . . .

For the Father in a loud voice bore clear witness to His Son; the Spirit in the form of a dove came down from the sky; while the Son bent His immaculate head before the Forerunner, and by receiving baptism He delivered us from bondage . . .

The service of 6 January, the Blessing of the Waters, includes the following lines:

Today Paradise has been opened to men and the Sun of Righteousness shines down upon us . . .[.] Today we have been released from our ancient lamentation, and as the new Israel we have found salvation. Today we have been delivered from darkness and illuminated with the light of the knowledge of God. Today the blinding mist of the world is dispersed by the Epiphany of our God. Today the whole creation shines with light from on high. Today error is laid low and the Coming of the Master has made for us a way of salvation . . .[.] Today earth and sea share the joy of the world, and the world is filled with gladness . . .

The service for the next day, 'The Synaxis of the Honoured and Glorious Prophet, Fore-runner, and Baptist John', addresses itself repeatedly to the saint ('O wise John the Fore-runner', etcetera), stressing his humility before Christ. Matins that day praises John repeatedly:

Thou hast come as the voice of the Word, and as the morning star hast thou risen, O Forerunner, plainly announcing the approach of the Sun of Righteousness . . .[.] We acknowledge thee to be the seal of the prophets, the mediator between the Old and the New Testament: and we proclaim thee Baptist and Forerunner of the Saviour Christ.[38]

Detailed accounts of the Blessing of the Waters are infrequent, perhaps because it was a familiar event celebrated all over the country. However, the following report is unusually full:

In St Petersburg on the ice of the Neva an open temple, painted and gilded, supported by pillars, surmounted by a golden cross and embellished with icons of John the Baptist, was erected. Inside, the temple was decorated with crosses and holy books and in the middle of the sacred enclosure a hole was cut in the ice and called the Jordan. . . .
 After a liturgy held in the Court Chapel, the bishops and archimandrites issued from the Winter Palace in their richest habits, sewn with pearls and glistening with gold, and with lighted tapers proceeded to the Jordan singing anthems. In splendid attire, the Imperial family and the court followed, and while the service was being performed, all the troops in the city were drawn up in an enormous ring on the ice of the Neva, with their standards waving and artillery planted ready to fire. After many prayers, the priest blessed the water with his uplifted hands three times and consecrated it by immersing a holy cross in the water three times, while cannons reverberated in solemn cadence. After the ceremony, mothers hastened to dip their children in the opening in the ice to bless them, and people flocked to draw water, for it was believed that the water so consecrated remained for years as fresh as when drawn from the river and had the power to cure the sick of their diseases.[39]

William Richardson, in Petersburg during 1768–72 as tutor to the British Ambassador's family, saw a domed pavilion on eight pillars erected for Epiphany where the River Moika enters the Neva. The approach to it from the palace was carpeted with red cloth and fenced with fir branches. On top of the pavilion stood a gilded figure of the Baptist; inside it the white dove of the Holy Spirit hovered over the Jordan hole.[40]

The ceremonies witnessed in the capital cities were the most elaborate.[41] Elsewhere they were performed on a more modest scale but with equal ceremony. They could not con-tinue after the October Revolution, though local saints' days were in many places and for some time celebrated more or less as before. The Bolsheviks' animosity to all religions could not erase the piety of the Russian people, though propaganda and education were designed to wean new generations of this attachment. Lenin, Lunacharsky and other lead-ing figures in the government agreed that no forced eradication of religious faith and prac-tices was achievable or even desirable. Keen discussions about the role of religion in the new State followed 1917, more incisive than had been possible under the tsar.

It was probably Nikolai Berdyaev who had persuaded the authorities to permit the Religious-Philosophical Society to hold its meetings in Petersburg at the start of the century, though these were always watched over by the censor's office and did on occasion attract official reprimands and threats of closure. Berdyaev (1874–1948) had studied economics and become a convinced Marxist, but gradually replaced that belief with a deep faith in God and a desire to lead the Russian intelligentsia back to the Church and to religious values. Exiled to Vologda for expressing views critical of Russia, he met Lunacharsky there and joined him in public debates about religion and Socialism, until the police moved Lunacharsky into almost total isolation further north. Each of them impressed the other, and this must be why Berdyaev was able to become professor of philosophy at Moscow University in 1920 and establish a Free Academy of Spiritual Culture which endured until he left Russia for the West in 1922. He was one of a number of eminent people either exiled within Russia or ordered to leave the country for a range of official reasons, not including the unstated one that they were, or might one day be, opposed to the Bolshevik Revolution.[42]

One of Berdyaev's most resonant gifts to Russian thought was his response to the teaching of the twelfth-century monk and mystic, Joachim of Fiore. Joachim distinguished between the Old Testament past, the age of God the Father and the rule of Law, and the New Testament present, the age of the Son and of Grace.[43] He announced the coming of a Third Age, an age of universal religion under the guidance of the Holy Spirit. (It was for this epoch that Alexander Ivanov prepared his global temples.) Berdyaev spoke of Joachim's 'prophetic hope of a new world-epoch of Christianity . . . an epoch of love and an epoch of the spirit', and saw this hope as driving the dynamic achievements of the early Renaissance. He named the three ages the Age of the Law, the Age of Redemption and the Age of Creativity. His *The Meaning of the Creative Act*, written in 1913–14, was published in 1916: 'If his earlier works had not attracted much attention, this one resounded through the entire Russian intellectual world.'[44]

Thoughts of a coming Third Age harmonized with the old conviction that Orthodox Russia was the Third Rome, destined to bring the message of salvation to the whole world. Dostoevsky restated this conviction in ringing terms. Berdyaev called Lenin 'a typical Russian' exhibiting typical Russian traits, including 'simplicity, wholeness, boorishness, dislike of embellishment and rhetoric, thought of a practical kind, a disposition to nihilist cynicism on moral grounds', but saw him also as an imperialist and his Third International as a secular response to the promise of the Third Rome.

> The old Russian autocratic monarchy was rooted in the religious beliefs of the people; it recognized itself and justified itself as a theocracy; as a consecrated Tsardom. The new Russian State is also autocratic; it is also rooted in the beliefs of the people, the new faith of the working class and peasant masses; it also recognizes itself as a consecrated state, as an inverted theocracy. . . . Something has happened which Marx and the Western Marxists could not have foreseen, and that is a sort of identification of the two messianisms, the messianism of the Russian people and the messianism of the proletariat.[45]

Lenin rejected Dostoevsky's books because of their negative view of the world and the writer's equation of Socialism with global Christianity. Lenin himself, especially after being

wounded in an unsuccessful assassination attempt in 1918, was thought to have miraculous powers and to be Christ-like in his readiness to yield his life for the public good.[46]

Alexander Blok's understanding of Russia and revolution was similar. Not a religious man, he put his faith in the Bolshevik Revolution as expressing the ideals and energies of the Russian people and as a step towards the 'World Revolution, at the head of which stands Russia'. He wrote these words to his wife, Lyuba, shortly before the Revolution, expressing his faith in its ability to cure Russia of 'a 300-year-old sickness'. In March he had written to his mother: 'Almost anything might happen and the moment . . . is a perilous one, but all is overcome by the awareness that a miracle has taken place, and, therefore, we may expect more miracles.' There is really nothing to fear: 'freedom has an extraordinary majesty'. This response set him apart from most of his friends and associates, though they had welcomed literature's deliverance from censorship thanks to the February Revolution. A few days before the Bolshevik coup, Zinaida Gippius, the writer Merezhkovsky's wife, had invited Blok to join them and others in an anti-Bolshevik statement to the press, and was surprised to hear him refuse. 'I suppose you are not with the Bolsheviks by any chance, are you?' she asked, thinking it an absurd question. 'And here is what Blok answered (he was very straightforward, never told lies): "Yes, if you put it that way, I am more with the Bolsheviks".' [47]

The immediate aftermath of the Revolution in Petrograd, still Russia's capital, was social and physical chaos amid exceptionally heavy snow-storms, extreme shortages of food and of fuel, and amid violence and robberies, often committed by marauding soldiers and sailors as well as by workers left with nothing to do when factories and shops closed.[48] In early January 1918, with gunfire sounding from the streets, the Germans threatening to overrun the city and a German aeroplane dropping leaflets on Petrograd to say so, Blok resisted the gloomy, end-of-everything voices he heard around him. 'Russia is doomed to live through torments, humiliations, divisions, but she will emerge from these humiliations renewed and — in a new way — great'. A few days later: 'The music of the intelligentsia is the same as the music of the Bolsheviks. / . . . The intelligentsia's bitterness against the Bolsheviks is all on the surface . . .[.] Reconciliation will come, a musical reconciliation.' The purpose of revolution is 'to *remake* everything. To organize things so that everything should be new; so that our false, filthy, boring hideous life should become a just, pure, merry, beautiful life'. By 'music' he meant the flow of history, the heartbeat and the energy of humanity. In his article 'The Intelligentsia and the Revolution', which shocked many of his friends when it was published on 19 January, he told them to be silent 'if you can't hear the music'. For decades the intelligentsia had attacked the values of imperial Russia and now, when the remaking had begun, could they do nothing but tremble and mourn the past? Blok had been one of the handful who came to Lunacharsky's meeting with writers, artists and theatre people at the Smolny Institute in November 1917.[49]

On 8 January 1918, Blok began, and during the night of 27–8 January finished, his poem *The Twelve*, writing it in about four days with many other things occupying his time between those dates. He thought also of writing a play about Christ ushering in a new age, inspired partly by reading Ernest Renan's account of the human Christ, *The Life of Jesus* (1863). *The Twelve* had been gestating within him. It was born in two bursts of labour, and immediately afterwards he felt, as he noted, '*Today — I am a genius*'. On 29–30 January he wrote another poem, *The Scythians*, in vehement support of the Soviet announcement that Russia could not accept Germany's harsh peace terms. Beware, you in the West; we

are in large part Asian and may yet beat you down unless you join us in the 'joyous broth-erhood' to which our 'barbarian lute' invites you. *The Scythians* was published in Moscow on 7 February. On the same day the Soviet government declared itself willing to accept Germany's peace terms. No one knew what would follow. Would the government quickly move to Moscow? Would German forces sweep unopposed into Petrograd? On 5 March *The Twelve* was published in the newspaper *Znamya Truda* (Banner of Labour) and Germany signed the peace treaty. Everything now felt new and different. For a moment Blok was enchanted by a vision of Russia as a tiny country, 'a waifish wooden church in the midst of a drunken and debauched market-place'.[50]

In April 1918 *The Twelve* and *The Scythians* were published together in the periodical *Nash Put* (Our Way), and *The Twelve* also separately, as a pamphlet. In November 1918 the publisher Alkonost brought out *The Twelve* in a large-format edition of three hundred copies, accompanied by twenty-four drawings by Yuri Annenkov. Some of these are full-page, some smaller, sharing the page with Blok's words. Blok had had meetings with the publisher about the drawings, and on 12 August wrote a letter to the artist that is at once admiring and critical. Annenkov, who revered Blok, thought it 'a marvellous letter'.[51] The poem, printed and reprinted but also read aloud on several occasions — sometimes by Blok's actress wife — met with a mixed response from his friends and the wider public. Some of his colleagues, Gippius among them, attacked it; many writers and the younger part of the audiences were enthusiastic. Some commentators objected to Blok's invoking Christ at the end of the poem, and complained that this association was left unexplained. Yet no one seems to have been wholly surprised by it, and a priest made respectful use of *The Twelve* for his sermon. Blok wrote in his diary on 10 March:

> If in Russia there was a true priesthood and not just a class of morally dull people of ecclesiastical calling, they would long since have 'taken into account' the fact that 'Christ is with the Red Guards'. It is hardly possible to dispute this truth, self-evident for people who have read the Gospels and thought about them.[52]

Many Orthodox priests felt this to be true.

Bely wrote a letter from Moscow in which he spoke admiringly of *The Scythians* and of the 'valiance and courage' he found in his friend's present writings. 'Be wise: combine valiance with discretion.' Blok wrote back in April, thanking him for his support and for the warning. January and February had found him experiencing 'frequent fits of physical trembling . . .[.] Now I am feeling better [yet there lingers] a kind of lost feeling of total exposure.'[53]

According to Molok, *The Twelve* 'stepped beyond the bounds of literature and became the folklore of the revolutionary street'. The poem was displayed on walls and hoardings, the long poem as printed in *Znamya Truda* or lines from it, enlarged, coloured and put up like posters. Few can have been unaware of it.[54] The scholar and critic R.V. Ivanov-Razumnik, who called for an end to symbolism and recognition of Russia's traditionally realistic con-ception of the world, welcomed *The Twelve* as a poem 'about the eternal universal truth of the Revolution'. He saw the Revolution as a sequel to the revolution initiated by Christ. Christ had brought 'inner freedom'; now, in the wake of October, 'the world must have *external* freedom'. Russia was uniquely placed to bring this about by virtue of her spiritu-ality and her ability to embrace the world's cultural values.[55]

The Twelve is a poem of three hundred lines in twelve numbered sections. It is a symphonic work, with contrasting motifs used structurally as well as for their inherent value, taken from diverse and theoretically incompatible sources. Blok had learned from Viacheslav Ivanov to progress 'from and through visible reality to the more real reality'. He found aspects of his poem mysterious himself, and was interested in others' interpretations of it.[56] Topical and even realistic, it is also heavy with quotations, near-quotations and symbols that give it a much wider and deeper relevance than its surface subject implies.

It offers an account, without beginning or end, of a file of Red Guards patrolling Petrograd in January 1918, during a stormy night and amid driven snow. Individual figures are glimpsed out of doors, some of them familiar from Blok's earlier writings. The patrol stumbles along behind its red flag, its mood and reactions echoing Russian popular songs and dances of the time, some of them aggressive/destructive, others celebrating revolution. They are a ruffianly lot. When a friend of theirs passes by in a sleigh with a girl by his side, they shoot at him yet it is she that falls into the snow, a bullet through her head (fig. 67). She was only Katka, a prostitute, yet Petya, one of the soldiers, loved her and bewails her death. The others tell him not to fuss. Petya responds, switching from misery and pain to violence and anger. His 'cyclone of wrath and sorrow' is interleaved with a sudden prayer ('Receive into Thy rest, O Lord, the soul of this thine handmaiden', from the *Dies irae*) and 'the sweet strains of a sentimental ballad' about the silent city. They notice a bourgeois watching them, a cringing dog at his heels: the Old World. The snow-storm worsens; they are almost blinded by it and follow the red flag nervously, shooting into the shadows. Yet they also urge each other to 'Keep in step with the revolution!', and so it is that the last verse has them proceeding, 'with sovereign tread', behind an immaterial figure, invisible in the blizzard, crowned with white roses: Jesus Christ.[57]

Blok uses the Old Believer spelling 'Isus', having hesitated over it and then insisting on it. It refers the reader to pre-Schism Russia, the old Holy Rus, to Blok's mind the 'ancient, unwesternized, uncivilized — and therefore *vital* Rus' of three centuries earlier. Russian orthography had been modernized in 1917 and its use was mandatory. Blok had to apply to Lunacharsky for permission to use the old spelling, and got it. Lunacharsky's commentaries on the poem raised the question whether Blok might not have placed Lenin at the head of his patrol, and assumed that he could not do that in spite of his pronounced respect for the Soviet leader. Many were shocked to find the poem ending on the image of those ruffians as the Apostles following Christ. Blok told Annenkov in August 1918 that, notwithstanding all the criticism, 'essentially, I do not renounce [the Christ of *The Twelve*]'.

The use of biblical language was characteristic both of symbolism and of literature in the first Soviet years. Anna Akhmatova, the widely admired poet and a friend of Blok's (and the future wife of Punin), had written about the war wounding Russia's 'holy body', identifying it with the body of Christ.[58] Goncharova's suite of lithographs, *Mystical Images of War*, made in 1914, includes an image of three flying angels and two aeroplanes, creating an ambiguous dialogue: are they safeguarding or restraining those large machines and their tiny pilots? In any case, they inhabit the same sky, caught up in the same war. Bely's prose and poems, too, are full of religious references and symbolism. But for Blok this symbolism, and indeed his direct quotations from religious texts as well as his adopting the Old Believer Christ, demonstrate his conviction that Russia was the appointed healer of the world. His nationalism was international in its purposes. Like Berdyaev, and also like Ivanov-Razumnik to whom he was

67. Yuri Annenkov, 'Katya dead',
illustration from Alexander Blok's *The
Twelve*, 1918

68. Yuri Annenkov, crossed lines at
end of Alexander Blok's *The Twelve*,
1918, representing Christ

especially close in the winter of 1917–18, he recognized that the concept of the Third Rome had been given reality by the creation of the Third International. Blok had written earlier that the coming Golden Age would usher in a 'New Petersburg city, coming out of heaven' — to which Sergei Hackel adds: 'a latter day New Jerusalem'. None of these concepts and expectations is unique to Blok. It is the intensity with which they sound from *The Twelve*, from its inglorious context, that gives them their force and memorability. Blok wrote:

> The revolution, like a fierce tornado, like a snow-storm, invariably brings with it the new and unexpected . . .[.] The deafening and awe-inspiring roar which issues from it . . . invariably *concerns that which is great* . . .[.] 'Peace and brotherhood of nations' — this is the sign beneath which the revolution is taking place . . .[.] This is the music which he that hath ears must hear.[59]

Despite the general failure of his associates to respond wholeheartedly to the Revolution, Blok believed that reconciliation was on the way. 'Don't be afraid . . .[.] The Demon once ordered Socrates to hearken to the spirit of music. With all your body, with all your heart, with all your mind — hearken to the revolution.' These words come from an article he wrote in mid-January 1918 in answer to the question, 'Can the intelligentsia co-operate with the Bolsheviks?'; it was published in *Znamya Truda* on 19 January. Many of his friends found it 'unforgiveable'. In fact it echoed views he had expressed a decade earlier.[60]

White is the colour of freedom; black is the Old World cur that follows the patrol into the last verse. Christ is crowned with white roses, a white spectre shrouded in snow. How to represent Him graphically was a point of discussion between Blok and Annenkov. In the end they agreed on an abstract image, a few vertical and horizontal lines sketching a Cross

(fig. 68). In 1920, sick and thinking of death, Blok asked that his grave should be marked by nothing more than a simple white Cross. He died on 7 August 1921, aged forty, and was buried in this manner, only to be re-interred beneath black marble in Volkovo cemetery among other literary figures — a mark of respect wholly against his wishes.[61] His death, from hunger and lack of medical care, was laid by many at the door of the new regime.

The other image Blok needed Annenkov to reconsider was that of Katya. The drawing Annenkov had done was 'splendid . . . [but] it is not Katya at all. Katya is a healthy, fat-faced, passionate, snub-nosed Russian lass; fresh, simple and kind — swears like a trooper, weeps over novels and kisses with abandon . . .'. Annenkov's final drawing of her has all that — a chubby earth-goddess-in-a-bar, and it is shocking to see her dead on the ground two pages later. Katya is left 'as carrion' in Blok's poem. In a draft, a few days earlier, Blok had the soldiers raising their world-wide conflagration 'out of love for Katya'. He proposed to Annenkov that the cover of the Alconost edition of *The Twelve* should combine an image of Christ amid snow and Katya dead on the ground: Christ and she are the poem's 'most distinctive characters'. But then she asks to be associated with Mary, Mother of God, not least by way of the traditional Dormition icons, representing the dead Virgin surrounded by the Apostles and with Christ above them 'in radiant robes'. Peter, like Petka, is 'the most prominent mourner' among them. Blok frequently saw Madonnas in the women of Petersburg. Petrov-Vodkin, whom he had considered a possible illustrator of *The Twelve*, in 1920 painted *Petrograd 1918*, in which a secular Madonna-and-Child group, seen on a balcony in the foreground, hovers over the post-revolutionary city. In the winter of 1920 Blok admitted to a friend that Christ's sudden appearance there took him by surprise. 'Why Christ? Is it really Christ? But the more I looked into it, the clearer I saw Christ. And then, for my own benefit, I made a note: Unfortunately, Christ.'[62]

Blok's thoughts about the Revolution encapsulated in *The Twelve* were received during the twelve months or so following the October Revolution, the time when Tatlin, as overseer of the erection of monuments to revolutionary forerunners, began to think of a monument to Revolution. Blok's poem may have encouraged Tatlin to incorporate religious material. Lunacharsky too had wanted to offer Socialism as a new, humane religion. Tatlin may have sought an equivalent to the Blessing of the Waters. Blok began writing his poem two days after the Blessing of the Waters did *not* take place for the first time in centuries.

Art historians have imagined Tatlin asking himself what form such a monument should take, and what significance it might have. How would it present itself as relevant to a people habituated to symbolism not only in the nationally significant objects put before them but also in their daily life? Blok and Tatlin were of much the same generation. It was the younger part of the audiences listening to readings of *The Twelve* that responded with reliable enthusiasm. We noted in chapter 6 that Tatlin had 'two volumes of Blok' by him when he worked in Kiev during 1925–7. We cannot assert that Tatlin took a special interest in *The Twelve*, but we cannot imagine him unaware of it. Its fragmented, often colloquial *faktura* gives it a futurist energy. It illustrates the Russian desire to communicate through symbolism and quotations drawn from a wide range of sources, often popular, folkloristic, or religious. Public festivals mingled too sacred and profane elements, after the Revolution in Russia's cities. These began with May Day 1918, when the poem was making its first impact.

An additional impulse may have come from the *Blaue Reiter Almanac*. We can assume that Tatlin was aware of Kandinsky, the Russian scholar who had moved to Munich in 1896

to become a painter, and who retained close contact with the Russian art world until 1914 when he returned to Moscow. His treatise *On the Spiritual in Art*, published in Munich in January 1912, had been delivered as a lecture, read by Nikolai Kulbin, at the Second All-Russian Congress of Artists which met in Petersburg during 29–31 December, 1911.[63] This text was published in October 1914 as part of the proceedings of the Congress. In February 1912 Kulbin presented Kandinsky's thesis at a public debate of the Jack of Diamonds group in Moscow. It was thus one of many essays and reviews Kandinsky published in Russia between 1889 and 1923. Several Russian artists came to Munich before 1914 and were in touch with Kandinsky there. These included the painter and art historian Igor Grabar whose multi-volume *History of Russian Art* (1910 and after, edited and in large part written by him) included the first systematic study of Russian icon painting, and Tatlin's friend David Burliuk who studied at the Munich Academy during 1902–3 and was in Munich again in 1912 when he showed work in a Blaue Reiter exhibition.

There are substantial differences of content and style between the Russian *On the Spiritual in Art* and the book first published in Munich and soon translated into several languages, but they agree on a necessary stage in art's development to a transcendental level, with colour as a major expressive and, by analogy, musical element. John Bowlt, who has translated the Russian text, stresses that it often employs 'a rhetorical, even biblical tone'. Kandinsky was a symbolist by generation and inclination. His developing theories about art were especially close to Bely's thought that art might well choose the path of 'objectlessness [whereby] the method of creation becomes an *object of itself*'. In his influential book on symbolism (1911), Bely stated that 'art has no inherent meaning apart from a religious one'. Tolstoy's *What Is Art?* required art to communicate religious thought in ways that would reach the masses. Meanwhile, art travelled between Russia and Munich. Kandinsky showed with the Jack of Diamonds group in 1910 and 1912. He invited the Burliuks, Larionov and Goncharova to show in the exhibitions presented in Munich by 'the editors of *Der Blaue Reiter*'. He also made sure modern Russian art and Russian folk art, as well as new Russian music, were well represented in the book, which gave prominence to significant texts by and reproductions of Kandinsky's work, and of paintings by David and Vladimir Burliuk and Goncharova. All these, together with reproductions of *lubki*, gave Russia a major presence, matched only by that of new art from France (Robert Delaunay, Henri Rousseau, Matisse, Picasso) and by examples from Kandinsky's collection of Bavarian folk art in the form of under-glass paintings, mostly of religious subjects.

The most striking fact about the *Almanac*'s illustrations is the almost total exclusion of classical art, ancient or Renaissance. The exceptions are what is said to be a 'Greek painting', a dancing figure freely drawn, probably taken from a late-antique original, and a painting considered the work of El Greco. I discussed this El Greco, probably the work of assistants, and the Delaunay Eiffel Tower painting with which it is paired in the Almanac in chapter 6 (fig. 69). What needs stressing here is the way the images of the Eiffel Tower and of St John the Baptist echo each other's forms and expression. Neither in pre-1914 Paris nor in Spain at the start of the seventeenth century were such expressions of enthusiasm to be found outside the work of those two studios or workshops.

The *Blaue Reiter Almanac* was well known in Russia. The work of the Delaunays did not attract significant attention in Paris, though Apollinaire spoke up for them around 1912. Generous displays of their work in two 1913 Sturm exhibitions made Berlin the art centre

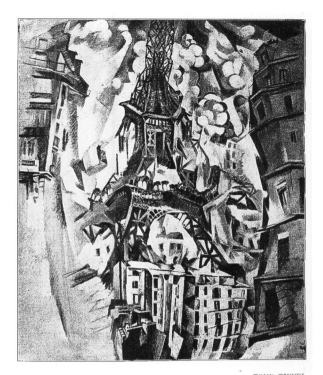

R. DELAUNAY TOUR EIFFEL EL GRECO ST. JOHANNES

69. *Blaue Reiter Almanac*, two images from a spread showing Robert Delaunay, *Eiffel Tower* and 'El Greco', *St John the Baptist*

best informed about them and will have added to the interest Robert's work attracted in Russian art circles. It is possible that Tatlin, in Berlin in the early months of 1914, saw some Delaunays at Walden's gallery. The Guggenheim Museum's *Red Tower* of 1911–12 could well have been one of them, perhaps also Köhler's picture. These are the most concentrated and iconic paintings of the series, unmistakably triumphant images.

Tatlin had seen the real Eiffel Tower in Paris. Memories of the Eiffel Tower will have helped Tatlin to think of a monument that would be dramatically out of scale with its surroundings, and its silhouette may have suggested that the Russian tower should have a more assertive presence by being asymmetrical. The existence of a small Statue of Liberty nearby may have lodged the idea of giving a figurative cast to his monument; he will have known of New York's Statue of Liberty. The Delaunay series of paintings will have encouraged him to see his Tower as a dynamic object countermanding the authoritarian order of Petrograd. The paired illustrations in the *Blaue Reiter Almanac* may well have seeded in him the idea of fusing the concept of the Forerunner, announcing a new dispensation for all mankind, with that of a dynamic tower memorializing the Revolution and embodying its promise. In any case, planning a monument for that site at the heart of Petrograd must have raised thoughts of the great ceremony of the Blessing of the Waters. Perhaps he wanted to make some reparation for the cancellation of that popular rite.

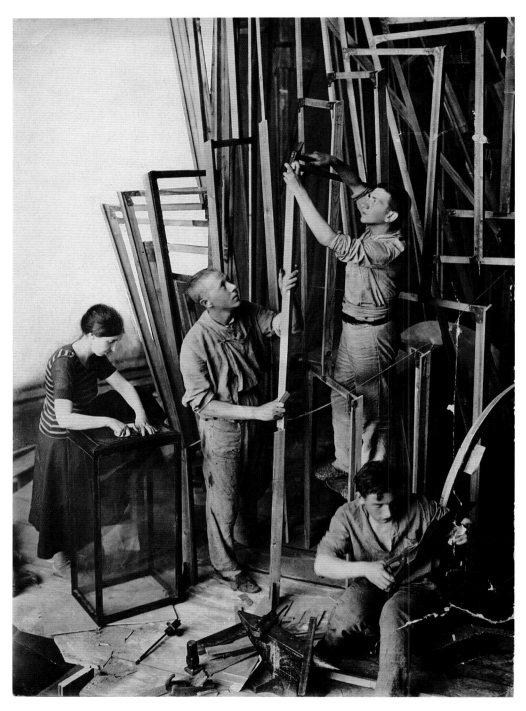

70. Vladimir Tatlin and assistants (S. Dymshits-Tolstaya, I. Meerzon, T. Shapiro) working on the Tower model, 1920. N. Punin Archive, St Petersburg

'Constructivists in inverted commas'

The year 1921 saw the emergence of constructivism as a programme and a ginger group out of the avant-garde cluster still referred to as futurism, and Tatlin's adoption as the 'Father of Constructivism'. His work with everyday materials and their construction and display in real space, his teaching of the study and use of materials in the post-Revolution workshops, now followed by exhibiting, in Petrograd and Moscow, his monumental but also functional Tower, made him the obvious forerunner of what was promoted as a new movement, dedicated to closing the gaps between art and society's pressing needs and between art and the proletariat. In fact, Tatlin found himself at odds with his supposed offspring. He could not echo the belligerence with which they distinguished their highly specific aims from those of other artists nor, most of all, their rejection of art.

The story of constructivism in Russia needs outlining here in order to clarify Tatlin's position. Considering its brief career and the small number of activists directly concerned in it, constructivism left a deep impression in Russia and had some impact on Eastern Europe, notably Poland and Hungary. One of the reasons for this is that a philosophical basis for a move away from art as a special, elevated concern to art as the product of close involvement in daily life, had been laid by Russian literary and cultural critics in the 1860s. This had never been lost sight of, and influenced Tatlin as well as the constructivists, giving what must have seemed a sharp re-directing of avant-garde work in Russia a shared tradition. The new group's invective against art convinced Tatlin that he did not wish to be associated with them, though some of his teaching and production in the workshops was parallel to theirs. He had no desire to deny the artist within himself or within anyone else. It was as an artist that he had conceived and developed his Tower, and then worked on utilitarian projects for clothing, stoves, etcetera, as well as on the apparatus for man-powered flight, *Letatlin*. Those pursuits made it clear to him that artists, as artists, had valuable insights and skills to offer to the industrial world.

*

The 1 January 1921 issue of a bulletin, published for the Eighth Congress of the Soviets in Moscow while the Tower model was on show there, included a statement entitled 'The

Work Before Us'. Tatlin was named as its author in the contents list, but three other names followed his at the end of the piece: T. Shapiro, I. Meyerzon and P. Vinogradov, his chief assistants on the Tower model. The first paragraphs were clearly Tatlin's, a personal report. Only at the end does the article become more general and prognostic.

'The Work Before Us' associates the artistic direction it represents with the Revolution itself. What happened in 1917, 'from the social point of view had already been achieved in our art in 1914, when we established "material, volume and construction" as our principle'. Linking this principle directly with Communism was new. The futurists claimed they had prepared minds for radical change in their efforts to free the arts from the individualism, the decorative or entertaining purposes and the historicism that had screened the expression of contemporary issues. But Tatlin claimed a more specific and essential identity for his work with the new faith. His 1915 exhibition of reliefs and counter-reliefs, he wrote, consisted of 'laboratory models made of real materials', presumably a reference to the 'Tramway V' show in Petrograd. (The constructivists quickly adopted the word 'laboratory' for their exploratory work.) This provided the basis for creating new forms from materials such as iron and glass, the materials of a modern classicism which in their clarity warrant comparison with the marble of ancient times. Fusing 'artistic forms with utilitarian goals' became a possibility, and Tatlin's Tower project exemplifies this. The last sentence reads: 'The results of this work are models which lead to further discoveries in our work of creating a new world, which call on all producers to control the forms which surround us in our new life.'[1]

This exhortation suggests an early contribution to the debate about constructivism and productivism. Art's duty, after the Revolution, is to engage with the daily life of ordinary people — *byt* in Russian — abandon all claims to superior status and adapt Marx's charge to philosophy: art's task, too, is to change the world. Tatlin's work in three dimensions with a variety of materials and, above all, his controversial proposal for a vast monument of metal and glass that would also serve as a building of world importance, were referred to again and again as initiating a new role for artistic invention, even by individuals now eager to define and promote the next step. During 1921 this debate became the key issue pursued in Inkhuk, the Institute of Painterly Culture founded in Moscow in May 1920. As critic Alexei Gan would write in his book *Constructivism* (published at the end of 1922), 'We should not reflect, depict and interpret reality but should build practically and express the planned objectives of the new active working class, the proletariat'.[2] 'The Work Before Us' does not, as Gan does *fortissimo*, proclaim the end of art. The article's reference to ancient classicism is respectful; Gan would have framed it in abuse. Tatlin never denied the past. In this he represented also the position of Lunacharsky, who in 1920 had dismissed Gan from his position as head of Mass Presentations and Spectacles in the Theatre Section of Narkompros because of his extremism.

In 1917 Tatlin had established his Materials, Volume and Construction studio within the Petrograd Free State Art Studios, and in 1920 his students' work formed part of a Studios exhibition, but none of this meant that he had ceased being an artist. Also in 1919 he had drafted the article defining the role of 'The Initiative Individual in the Creativity of the Collective': the inventive artist receives impulses from the collective, but remains a key figure who must give, and needs to receive, without constraints.[3] But living and working mainly in Petrograd, Tatlin is believed to have attended few of these Inkhuk debates in Moscow. It may be that he would have found them naive in their attempts to distinguish

categorically between 'composition' and 'construction', the former associated with aesthetic (academic, bourgeois, The World of Art) priorities, the latter with materialistic (Marxist, proletarian, real-world) objectives. He lectured on his Tower in Moscow under the auspices of the Vkhutemas in December 1920.

Tatlin's example and teaching called for a reconsideration of artists' involvement in and contribution to the Soviet world. Constructivism required artists to abandon studio pursuits in order to function as artist-engineers. Russia's industrial backwardness was patent to all. Lenin's institution of NEP at a Party Congress in March 1921 was intended to remedy that. The Civil War had demonstrated the power of unquestioning discipline, but famine raged in the cities in 1921 and 1922 while agriculture slumped, partly owing to compulsory grain requisitioning which led many peasants to produce less or to pretend to do so. This too was ended by NEP, in the hope of erasing the antagonism that had developed between workers and peasants, between the hammer and the sickle. At the Third Congress of the Communist International, in June/July 1922, Lenin emphasized the need for large-scale industry, powered by great machines. He restated this in writing to the trade unions in September 1922, by which time it had become clear that while light industrial production, of household objects and agricultural tools, was developing well, the heavier branches of industry were slow to become fully active.

The Congress of March 1921 instructed the Communist Party to play a greater role in determining culture. This actually led to a reduction in the part played by avant-garde artists in IZO. It cut State patronage while inviting private enterprise into the arts. The year 1922 witnessed the more or less systematic exiling of leading members of the intelligentsia. Some were sent to Siberia. Others left Russia for the West, often for Berlin in the first place. Many hoped that their emigration would be temporary. The pull of the mother country was felt by them all. Lenin drew up the original lists, intending to rid Russia of all actual and potential counter-revolutionaries. These 'excelled at the academic and journalistic professions which had recently enjoyed a renaissance . . .[.] They included cultural critics and religious thinkers', pre-eminent among them Berdyaev. More than sixty such individuals were expelled, mostly with their immediate families, while the Russian Orthodox Church was made to turn itself into a compliant, unresisting partner of the State as what was called 'The Living Church'.[4]

The art world split into openly conflicting groups. Where there had been some hope of advancing on a broad front — still implied by the survey presented in the First Russian Exhibition of 1922–3 — there now developed sharp divisions and exclusive claims of validity. The First Working Group of Constructivists' emergence coincided with the birth of NEP. In March 1921 a small discussion group within Inkhuk, consisting of Rodchenko, Stepanova and Gan, became an officially-recognized faction within the arts. They enrolled the Stenberg brothers, Konstantin Medunetsky and Karl Ioganson as additional members. The year 1922 saw the formation of AKhRR which soon swelled into a large and busy group of artists offering to devote their work to celebrating Soviet life in realistic art. Krupskaya, Lenin's wife and always the futurists' enemy, gave the realists her support as head of Lunacharsky's Political Education Committee. Including former students of the avant-garde workshops of Moscow and Petrograd, they accused constructivism of fetishizing the machine. Even the emphasis on technical and material values in art, the exploration of *faktura* as well as the internal logic, was now denounced by artists intent on delivering images to be valued for their social messages in conventional terms.[5] In these circumstances, it must have appeared sensible, as well as

forward-looking, for artists unwilling to surrender their position to seek a clear role and a base in industry. On the way to this they turned to non-studio methods and processes to develop new forms of socially effective work, by shouldering such tasks as designing advertisements and packaging (Rodchenko with Mayakovsky), posters (especially the Stenberg brothers), as well as bec-oming photographers for books, magazines and exhibitions (Rodchenko and Lissitzky), and making films (notably Vertov and Eisenstein). But it seems that Tatlin never used a camera.

Avant-garde practice always involved questioning inherited methods. Like Tatlin, the constructivists saw Russia's professional engineers locked into outdated practices and attitudes. Closing the traditional gap between art and labour must have been seen as an essential contribution to Communist hopes of unifying life. The constructivists polemicized, they exhibited objects demonstrating their stated principles, they worked with students to develop prototypes for utilitarian products and hoped to influence industrial production methods. Their new work, not offering metaphors for the world but engaging directly with its needs, would demand new kinds of research leading to utilitarian, economically justifiable products. At a session of Inkhuk on 24 November 1921, Brik reported that the institution was no longer associated with Lunacharsky's ministry but had been put under the control of the Supreme Council of the National Economy, and announced its commitment to 'production art as an absolute value and constructivism as its only form of expression'. 'Building socialism' — the cliché of the day — called for the development of a modern industrial society, founded on the scientific principles on which Communist society should be based. There followed a wide-ranging campaign to link Inkhuk to organizations dealing with industrial problems, including trade unions and PLK, to which Nikolai Tarabukin and Tatlin contributed.[6]

A programme drawn up by the First Working Group of Constructivists in 1921 exists in various versions: one unpublished, one printed in the Autumn 1922 issue of the Moscow journal *Hermitage* (*Ermitazh*), and another published in Hungarian the same year in Vienna.[7] They make much the same points in heavily didactic terms to show their determination to define their place in a State apparently retreating from basic Communist principles. I quote parts of one very long sentence:

> It is necessary to . . . master . . . the philosophy and theory of scientific communism, to realise the practice of Soviet construction, determine the place which the intellectual productivist of constructivist constructions must occupy in communist life . . . to define concretely the meaning of 'intellectual production'; . . . to elucidate the position of work in its historical perspective . . . : before the Revolution — slave work, at present — the liberation of work, and after the final victory of the proletariat — the possibility of exultant work.[8]

*

Such assertions had roots in the radical critics of the 1860s, challenging the arts to assume their proper social task, including Chernyshevsky, Dobrolyubov and Pisarev. Chernyshevsky (1828–1889) insisted that the basis of the arts must be 'respect for real life', and that imitations of reality will always be inferior to reality itself. 'A real apple is more beautiful than a painted one', and more vivid to us. Art has no room for sophisticated imaginings or style

(his own writing is plain to a fault). On occasion, the arts may go beyond reality. An element of subjectivity and an awareness of potentialities may add significance to realistic art in order to shape mankind's destiny. Analysis of the historical present and concern for the future situates artists beside the daily shapers of reality, the engineer, the shoemaker and the journalist, except that the artist is best placed to lead the public to a higher understanding of life. This is the 'commitment' that Chernyshevsky demanded and portrayed through the narrative of his novel, *What Is to Be Done?* (1864), which made a powerful impression on readers over the next half century and beyond.

Dobrolyubov died young (in 1861, aged twenty-five), a fervent Socialist. He shared the Enlightenment's faith in progress towards rationality and in science's mastery over nature, and declined all authority and convention.[9] Pisarev too died young (in 1868, aged twenty-eight), after a sickly childhood. A mental crisis in 1859 turned him against religion as he discovered in himself the urge to analyze and criticize the world: its assumptions, lethargy and false values, especially the dishonesty guiding political and social life from the tsar down. For Pisarev, as for Tolstoy later, the arts stood between mankind and the better future offered by scientific developments. He himself 'would rather be a Russian shoemaker than a Russian Raphael'.

In many respects Tolstoy's *What Is Art?* (1898) reinforced these doctrines, though he wrote from a position opposed to that of the radical critics. His onslaught on the arts' artificiality and elitism, in the name of peasant simplicity and of uninstitutionalized Christianity, was seen by many as an old man's aberration. The function of art was to influence people — he called this 'infection' — easy to comprehend and religious in purpose. Beauty is not necessary: 'People will come to understand the meaning of art only when they cease to consider that the aim of that activity is beauty, that is to say, pleasure.' Art should be 'a means of union among men . . . indispensable for the life and progress towards well-being of individuals and of humanity'. For a man to be able to make true art requires that 'he should stand on the level of the highest life-conceptions of his time, that he should experience feeling, and have desire and capacity to transmit it, and that he should moreover have a talent for some one of the forms of art'. Sincerity is essential: 'the artist should be impelled by an inner need to express his feeling'. Art's function being to transmit 'the highest religious perceptions of our times', it follows that the 'art of the future . . . will not be a development of present-day art, but will arise on quite other and new foundations having nothing in common with those by which our present art of the upper classes is guided.' Later, Tolstoy would argue that achieving the full 'physical and spiritual construction of man' could be possible only 'on the basis of Socialism. . . . To produce a new, "improved version" of man — that is the future task of Communism'.[10]

*

This inheritance gave the constructivists a familiar base in Russian thought. But they hoped to align their programme with progressive political theory, and for this they reached back to Marx and Engels and beyond. The *Communist Manifesto* of 1848 had foreseen a 'combination of education with industrial production'. At the Congress of the First International, in 1864, Marx had called for 'the general principles of all processes of production' to be taught in schools, and for the young to be initiated 'into the practical use and handling of

the elementary instruments of all trades'. The schooling Marx and Engels recommended would produce 'fully developed human beings'. Industry needed workers with varied skills, not 'crippled by life-long repetition of one and the same trivial operation, and thus reduced to the mere fragment of a man'. Lenin's early resistance to the introduction of American Taylorism, which called for industrial workers trained to repeat one task in a process of serial production, reflected Marx's concern for 'fully developed human beings', but he surrendered this position in the face of Russia's acute economic needs and Gastev's advocacy of Taylor's system. Lunacharsky too was opposed to anything that might turn workers into cogs in a machine. Inaugurating the State Free Studios in October 1918, he said that 'To link art with life — this is the task of the new art', without implying any link with industrial production, but he also announced that 'labour, pedagogical as well as productive labour, will be made the basis of teaching'. For the younger children this meant work mostly within the school kitchen, garden and workshops. For those over thirteen it involved time in factories and on farms. These plans were widely propagated, though the country's vast size and low level of literacy, together with teacher resistance to reform, delayed their realization. In 1920, combating proposals to make vocational training dominant in schools because of the extreme scarcity of skilled workers, Lunacharsky wrote that Russia's present needs should not be allowed to contaminate Socialist ideals:

> We, as socialists who defended the rights of the worker's identity against the factors which tried to stifle it under capitalism, cannot help protesting when we see that the new Communist factory is showing, in these respects, the same tendency.

There were Marxists who unhesitatingly give priority to meeting present-day economic difficulties, he added, but there were also Marxists 'who, in spite of everything, cannot let this hard time trample the flowers of our first hopes of the proletariat and proletarian youth, their first chance of many-sided human development'.[11]

Krupskaya, directing the academic council within Lunacharsky's ministry from 1921 on, sought ways of integrating his principles by developing educational programmes in which they fused with existing disciplines. Every lesson would have social relevance and a basis in the daily experience, and would be studied under a triple rubric: nature, society and labour. Though programmes would call for developing skills in language and mathematics, the emphasis throughout would be on activity: 'observations and independent work with materials' and 'excursions' linked to 'laboratory and labour methods'.[12]

Constructivism was aligned to pedagogic thought of this kind and therefore looked to government for support. By 1922, when Gan wrote *Constructivism*, Lenin was recommending that a book on *The Organizational Science of Labour and Production and the Taylorian System*, by O.A. Ermansky, should be used as a standard textbook in all trade union schools and secondary schools. Lunacharsky had to approve this, in spite of his opposition to Taylorism. For artists eager to fuse with the proletariat, Marx's vision of polytechnical schooling and Taylor's close analysis of production opened up vistas of classless work in the service of the new State.[13]

Alexei Gastev appealed for inventiveness in industry through an ad-hocism he associated with Robinson Crusoe's efforts to construct his island life on the basis of whatever was available. He balanced this romantic image with a harsher one in the name of 'mechanized

collectivism', which would allow no room for the expressive functions others thought inalienably human. This collectivism would manifest itself in processes and products that are 'devoid of expression, of a soul, of lyricism, of emotion'. Artists would thus assert their kinship with the proletariat, and spurn the 'applied art' tradition which decorated products to meet bourgeois demands.[14]

Above all else, Gastev offered an image and a name, engineer, associating it with that of social reformer. He insisted, in 1919, that to understand proletarian culture 'it is not enough to be a writer, a lawyer or a politician': one must be 'an engineer, an experienced social constructor' in touch with the 'most exact molecular analysis of the new production which has brought today's proletariat into being'. The full 'emancipation of proletarian psychology' would have to be achieved in the 'gigantic new laboratories' which are developing the 'metallurgy of the New World, the automobile and aeroplane factories of America and Europe'. It is the proletariat of the metal-working industries (wrote this former secretary of the union of metalworkers) that best understands the new structure of production, and forms 'the leading rank of the proletariat'. Meanwhile, proletarian culture will be qualified by the need for 'methodical, ever more exact work', which will find expression in a proletarian art characterized by '*a wholesale revolution of aesthetic norms*'.

Gastev and the emerging constructivists were impatient with Lunacharsky's policy of pluralism in the arts, set out in the 1920 'Theses',[15] though constructivists could find in them an indication that their path and that of the proletariat might merge. In 1922 Arvatov published an article headed 'The Proletariat and Leftist Art', in which he identified 'leftist art' with the path opened up by 'Cézanne and Picasso and ending, by way of Carrà [the Italian futurist painter] with Tatlin'. Their work leads to abstraction and an art exploring the essence of materials. 'They, and only they, advocated the idea of constructivism. . . . Is it not thanks to them that we understand now that form is not a starting point, but a result?' This points the proletariat's way into the factories. There they will need to take the next step, 'to fuse the manager and the producer' and thus shape the industrial process itself.[16]

*

On the day 'The Work Before Us' was published, with the Tower model on display nearby, Rodchenko offered the 'clearest and earliest formulation of the Constructivist position' to a meeting at Inkhuk.[17] The development of new artistic forms must come from technological and industrial considerations, untrammelled by aesthetics and taste. He spoke again on 21 January, identifying construction with fulfilling utilitarian needs, but going on to insist also on its inherent formal and material economy, excluding every extraneous element.[18] Six days later, Kandinsky announced he was leaving the institute. Rodchenko, thirty years old, formed a new Inkhuk praesidium, became its chairman and brought onto it the critic Brik and the sculptor Babichev. He was also prominent in Inkhuk's debates about composition and construction. Brik and Mayakovsky had become his guides and spokesmen. Like them, he respected Tatlin for his pioneering role in leading art from picture-making and stage design to the prioritization of materials. During the week of 14–20 March, he presented a report on Inkhuk's new aims, and joined in the discussions that ensued.

Constructivism's principles were neither readily grasped nor shared by Rodchenko's colleagues in Inkhuk. There was wide disagreement when paintings were scrutinized to

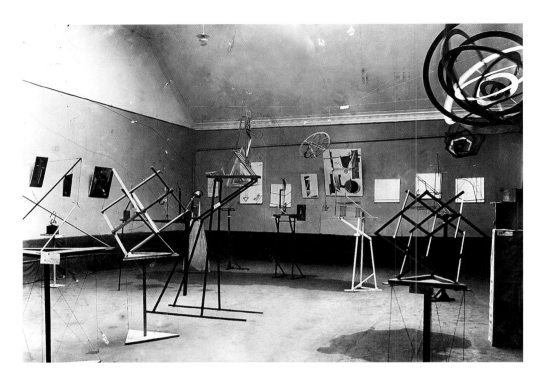

71. View of Constructivist section of the Obmokhu exhibition, Moscow, May 1921

determine whether they demonstrated composition or construction. This uncertainty was shown even among those closest to Rodchenko, including Stepanova though she could hold a firm constructivist line in the debate.[19] Rodchenko's paintings tended to be credited with incorporating elements of construction, but none was found in, for example, Malevich's suprematist paintings which were judged to be mere compositions. It took time for agreed principles to emerge. Rodchenko insisted that his own most advanced painting demonstrated 'aspiration towards construction', professing that 'in my works there is not yet pure construction, instead there is constructive composition'.

Something closer to agreement emerged when discussion centred on the metal structures made by the Stenberg brothers, Vladimir (1899–1982) and Georgii (1900–1933), and by Konstantin Medunetsky (1899–1936).[20] These, together with standing constructions by Ioganson and with Rodchenko's hanging constructions, were shown in Moscow's Society of Young Artists (Obmokhu) exhibition of May 1921 (fig. 71), just two months after Lenin's initiation of NEP. Medunetsky's free-standing welded sculptures combined forms in different metals, which suggests they should be classified as compositions determined by aesthetics, yet they were called constructions. Only the Stenbergs' structures, using industrial metal and glass, and exhibited on plinths that were themselves essays in construction, combining wooden struts with tensed cables, suggest a deeper interest in Tatlin's work. Yet, in making analogies with utilitarian engineering, they are essentially symbolic and cannot fully demonstrate constructivist principles. Among Rodchenko's works before 1921, only the linear com-

positions of 1920, made exclusively with compass and ruler and without evident symbolism (mostly in pen and ink on paper; a few with brushes and paint but without any appeal to the expressive values of *faktura*), suggest the material-based investigative methods of Tatlin.

The new works Rodchenko showed in May 1921 were spatial constructions. Jigsawed concentrically out of sheets of plywood, each an explicit geometrical form — square, circle, triangle, hexagon and ellipse — they consisted of the same form repeated several times and reducing steadily in all-over size while maintaining the same width in every band. Opened out to become spatial, with the smaller forms tethered by wire or string to the largest, and painted silver to simulate metal, they hung from wires strung across the room, turning gently. They could be stored flat once the wire or string was removed.

This display of constructed sculpture was said to show constructivism in its 'laboratory' phase. The exhibits were to be seen as steps towards constructivism's goal of socially-programmed, functional work. In 1922 Rodchenko referred to his hanging constructions as representing the 'experimental transition of painting through Constructivist art and spatial forms towards industrial productions', intended to guide 'the future constructor of industry' by demonstrating the role of calculation as opposed to chance and intuition. None of these constructions revealed utilitarian functions.

Here the opposition between the constructivists and their adopted 'father' became acute. Tatlin had demonstrated that he stood for the conscious use of real-life, non-art materials and methods. He would guide and join his students making prototypes for industrial production, but he refused to see the creative process reduced to exclusively rational operations. Instinct and intuition, denied any role by Brik and the constructivists, remained essential to him. Malevich and his Unovis group also insisted on the role of intuition. Lissitzky, in an essay written in 1920 on his *Proun* work (the acronym means 'for the new art'), and published in an altered form in *De Stijl* magazine in June 1922, had insisted that his images go beyond what engineers attempt: 'It is the power of Proun to create goals. In this lies the freedom of the artist vis-à-vis science'.[21]

Rodchenko called his hanging constructions *Spatial Construction* and *Spatial Object*. Another series, of the same time, was of standing assemblages of modest lengths of unpainted, often rough, wood, simply nailed together. These too he called *Spatial Construction*; they too were experimental and function-less. In many cases their components were modular. Neither series was determined by the material used. Rodchenko had used the word 'construction' (*konstruktsiya*) already for his linear compositions of 1920 and for the kiosks he designed the same year: *proiekty-konstruktsii*. Examples of these were shown in the 'Nineteenth State Exhibition' in Moscow in October 1920; they too did not stem from the nature of their materials. In the catalogue of the 'Tenth State Exhibition: Non-Objective Creation and Suprematism', shown in Moscow in 1919, Popova had foreshadowed constructivist principles without using the new term. Where she wrote (in Bowlt's translation) 'Construction in painting — the sum of the energy of its parts', she uses the word *postroenie* which refers to a wide range of form-giving, building, erecting, structuring. Where Rozanova in 1913 had taken an advanced position in her essay on 'The Bases of the New Creation' by echoing Uspensky and recommending 'the Intuitive Principle', Popova in 1919 shunned individualism and used only impersonal terms. Yet Rozanova had written of *konstruktivnaya pererabotka*, constructive processing, 'the most important thing in art'. *Konstruktsiya* was used increasingly during 1920 to distinguish certain works from others

described as *postroenie*. By 1921 the word *veshch* too (object, thing, but also prophecy) had acquired polemical force by detaching art from its special status, asserting each work's existence as a physical entity justified by the logic of the processes invested in it.[22] Brik was associated with highlighting the object in order to marginalize the work of art, but in the second issue of *Lef* (1923) another member of its editorial board, Nikolai Chuzhak, attacked Brik for his concept of the object as referring only to material things and excluding any mental component, ideal or meaning in it.[23]

Only the six constructions shown in May 1921 by Karl Ioganson (born c.1890) matched the logic of Rodchenko's exhibits. Ioganson sought to demonstrate constructivism's essential process. Made of equal lengths of standard square-sectioned wood or of metal rods, they were set on triangular bases, and held a small number of elements in space by means of connecting wire or string. Some outline a cube and repeat its axes, but a cube set on one corner, so that transparency and dynamics countermand the stability a resting cube would signal. Others use acute and obtuse angles and start from three points on the pedestal. Where the elements operate separately, without the overlaps (in one case, joints) required by the cross form, they are tensed by wire or string whose role is as essential as that of the rods: two materials in complementary roles effecting an economical result. One recalls Isakov's recognition, in 1915, of the role of 'tension' and 'strain' in Tatlin's counter-reliefs.

Ioganson agreed that a constructivist work must be visually clear and transparent, without expressive input and purged of all inessential elements. He went on to pursue constructivism's larger role in society, going beyond basic productivism. Calling himself a *konstruktor* (which implies 'engineer') and claiming working class origins, he was from 1923 until 1926 engaged as metal cutter in a Moscow steel works. He soon assumed a quasi-managerial position, examined the production process in terms of technology and manpower, helped enlarge and reallocate the premises, and fostered Communism among the workers and in the works' public image. Output increased dramatically. He ignored Marxist hopes of raising factory workers' understanding of and participation in the social as well as industrial functions of their labour. Concerning himself from the start with the means of production, he ended up, in effect, as a government representative. Such a career was the true and natural path for a constructivist-productivist.[24]

At least one of his wooden constructions of 1920–21 was adjustable, introducing the possibility of change through manipulation and reducing the artist's role to that of initiator.[25] Seen by itself, the work of Medunetsky and of the Stenbergs would have appeared diverse in vision and method. Rodchenko's and Ioganson's exhibits were the most principled, and thus the most memorable, objects in the exhibition. Just as Ioganson's constructions recall Rodchenko's linear works on paper, so also one of the Stenberg works, an insistently linear construction stretching upwards and outwards from a small triangular base, resembles a particular *Spatial Construction* Rodchenko drew and made in 1921, both numbered 14 in his series.[26]

The Stenbergs and Medunetsky produced a little catalogue for an exhibition of their work in the Stenbergs' studio in January 1922, heading it 'Constructivists' and adding a brief introduction which linked constructivism to factory production and the end of art:

Every man, born on this earth and before returning to its bosom, should take the shortest road leading to the factory where the compact organism of the world is created.

This road is called CONSTRUCTIVISM.

. . .

Weighing THE FACTS on the scales of an honest rapport between earth's inhabitants, the Constructivists declare art and its priests to be outlaws.[27]

Gan's book, published at the end of 1922, lambasts 'the priest-hireling . . . who might become an aesthetic depicter and produce a lot of palliative forms of the intellectual-material culture of Communism'. Did he consider Tatlin a 'priest-hireling', allied to Lunacharsky's god-building campaigns? The Constructivists' denunciation of representational artists smacks of Lenin's obsession, climaxing in 1922, with ridding the new Russia of idealists of every kind: they were all parasites, trading in bourgeois values that are now worse than useless. Ioganson had already pronounced against 'Tatlinism'. He expressed strict views on constructivism in a paper he gave at Inkhuk on 9 March 1922, entitled 'From the Construction to Technology and Invention', distinguishing between artistic constructions and constructions arising from 'building and technical' considerations and intended to be 'important and useful'. What he called 'Tatlinism' was merely an 'accidental operating with materials'. He too wanted an end to art: 'From painting to sculpture, from sculpture to construction, from construction to technology and invention — such is my path and such is and will be the final aim of every revolutionary artist'.[28]

Yet Rodchenko said Tatlin was his master. Lodder calls Rodchenko 'Tatlin's most immediate follower'.[29] As a painter Rodchenko had allied himself for a time to suprematism. He made paintings that adopted Malevich's cosmic themes but used them minimally in, for example, the eight black-on-black paintings he produced as a riposte to the five white-on-white paintings Malevich had made in 1918–19. The two series confronted each other in the 'Tenth State Exhibition: Non-Objective Creation and Suprematism' Rodchenko arranged in Moscow in April 1919. He was openly challenging the work of the older man whose high standing the exhibition had been framed to demonstrate. That month a list of artists whose work should be acquired for the forthcoming Museum of Pictorial Culture began with Malevich's name. Later that year, he was honoured by a retrospective exhibition at the Sixteenth State Exhibition, 'K.S. Malevich, Impressionism to Suprematism', showing 153 works. In the event, 1919 marked the brief climax of Malevich's fame and visibility. Already in the 9 February 1919 issue of *Art of the Commune* Punin published an open letter questioning the value of suprematism in the face of Tatlin's creativity:

What was Suprematism? Without doubt, it was a creative invention, but merely a pictorial one. . . . Tatlin defined Suprematism simply as a sum of the mistakes of the past . . . Suprematism has sucked all the painting out of world art history. It made this painting abstract, taking away its flesh and substance, its *reason d'être*: that is why Suprematism is not the great art.

I consider Tatlin the only creative force, capable of shifting art out of the trenches the old art dug for itself. Where does his power come from? From his simplicity and absolutely pure and harmonious/organic working. . . . He is a master from head to toe, from the most involuntary reflex to his most conscious act. Incredible, absolutely unmatched skill.

Soon, Punin added, the 'old world' will collapse, 'when only drawing masters will still be talking about Suprematism, when finally all paintings will be removed to the museum'.

Brik, after seeing the April exhibition, declared that 'because of Rodchenko, Malevich was finally passé'. Stepanova had written in her diary that Rodchenko had made that exhibition a compromise by including suprematism: 'It would have been better to exclude it and exhibit only non-objective art.'[30] She too now saw suprematism as a form of representational painting. Before the end of the year, Malevich accepted Chagall's invitation to move to Vitebsk to teach at the art school set up there by Lunacharsky and directed by Chagall. Soon he built up there a strong faction of his own disciples under the acronym Unovis (Champions of the New Art) and ousted Chagall. But Vitebsk was neither Moscow nor Petrograd. In March 1921, Rodchenko's Inkhuk lecture on constructivism attacked both suprematism, as an art merely 'filling empty spaces in an individualist manner', and Tatlin's counter-compositions: 'When [an artist] selects such materials as are at hand or fills empty space with decorations, it is composition and therefore reactionary.'

El Lissitzky (1890–1941) knew more about what he called 'science' than those around him. He had studied engineering and architecture in Darmstadt, and had travelled widely in Western Europe to bring himself up to date in art and design, before returning to Moscow at the outbreak of war to complete his art studies and work in an architect's office. He was employed by IZO and designed the first Soviet flag, first displayed on May Day 1918. Chagall appointed him to his staff. Lissitzky presumably knew of suprematism before Malevich arrived in Vitebsk in 1919. Soon he was the older man's chief disciple and champion, using the suprematist idiom in combination with minimal words, for the well-known black-and-red-on-white poster of 1919, *Beat the Whites with Red Wedge*. In his essay of 1920, published by *De Stijl* in 1922, Lissitzky asserts the necessity of art. For all the attacks on 'A.', meaning art, it continues to be 'an invention of our spirit, a complex whole combining the rational with the imaginary, the physical with the mathematical, $\sqrt{1}$ and the $\sqrt{-1}$ '.[31]

Lissitzky saw suprematism as an invitation to invent and explore forms, with and without spatial implications and possible utilitarian application, in graphic works and paintings he called *Proun*. The first Prouns were made in 1919; they continued until about 1923 when he built a *Proun Room* for an exhibition in Berlin. In 1920–22 he had created a book for children, *The Story of Two Squares*, a parable of revolutionary change delivered via geometrical images and dispersed lettering, joined in unconventional but self-explanatory layouts. In 1923 he invented a new form of, and style for, a book of Mayakovsky's poems, *For the Voice*. Both of these were remarkable innovations, drawing a line under traditional methods of printing for reading and looking, close to film experience in the first case, close to hearing 'the voice' in the second. Perhaps Lissitzky's Jewish origin and first works made it easy for him to question Western traditions of organizing visual and verbal material for the pages of a book; in fact the two adjectives need to be fused to suggest his way of delivering it. The results are strikingly modern and efficient, making a quick impact but also inviting imaginative input from the reader.

His *Proun Room* offered a different kind of experience. It is a cubic space, three meters in each direction, just white on the outside and white also inside but here articulated, on all six sides, by Proun forms, both flat and three-dimensional and made of paint or of painted and unpainted wood. The effect is visionary, extra-terrestrial — as proposed in his two-dimensional Prouns, but here made intensely persuasive because of its cell structure, mute

on the outside, inside bedecked with significant forms, inexplicit in themselves but redolent of space and movement. It is a secular sacred place. Nothing about it hints at any possible utilitarian application; if it is a contribution to the reform of *byt*, it does so in an uplifting, quasi-religious manner that could complement daily life by offering a contrast to it. In moving on from two-dimensional Proun images to three-dimensional ones, in a context that stressed their three-dimensionality by having them project into a clearly limited box space, Lissitzky was partly repeating Tatlin's journey from pictorial reliefs to emphatically spatial ones.

Lissitzky described his Prouns generically as an 'interchange station between art and architecture', and indeed they hover engagingly between being pictorial inventions of forms placed into slightly unreal spatial relationships and isometric projects for buildings or towns. It is not always clear how the Proun paintings are to be hung; there is a suggestion that seeing them different ways up would reveal them more completely. His later career, back in Russia, involved him in a wide range of design work, notably exhibition design and architecture, but during the early 1920s, while in Germany, he was seen primarily as a pioneering artist and polemicist supporting both suprematism and constructivism, but without insisting on the political or reform basis of such work.

Lissitzky moved to Moscow in 1921 to teach architecture at the Vkhutemas until, late that year, was sent to Berlin to work on the 'First Russian Art Exhibition' which opened on 15 October 1922. (He returned to his teaching at the Vkhutemas in 1925, and in 1927 adopted, for the cover of a book surveying his workshop's architectural designs, an image he had created in Germany as a kind of self-portrait, with and without his own face showing through the composition.[32] This was based on a photograph he had taken of his open right hand with a pair of compasses loosely held between his fingers: human competence and care together with precise technical procedures. One feels that Tatlin would have approved.)

In 1921 Germany was the only major country to have diplomatic and commercial relations with Soviet Russia. Berlin, capital city of the Germany formed in 1871, had become the main centre for Russian émigrés as well as a cultural centre attracting Russian avant-garde writers and artists as visitors. Among these was Ilya Ehrenburg, a Russian journalist, with whom Lissitzky collaborated on a new trilingual journal entitled *Veshch/Gegenstand/Objet*, published in a double issue for March/April 1922 and a single issue for May 1922.[33] The choice of title and some of the contents indicate that *Veshch* was to represent the Russian radical art and theory to the Western world. It reprinted part of Punin's 1920 essay on 'Tatlin's Tower'. Reports and articles by 'Ulen', in other words, Lissitzky himself, gave prominence to Tatlin, to Gabo and Antoine Pevsner on account of their exhibition and manifesto of 1920 (to be discussed below), to Unovis and to Obmokhu. *Veshch* no.1/2 included a well-known photograph of the Constructivists' room in the Obmokhu exhibition. Exclaiming that 'one of the most glorious revolutions has taken place in the former Russian Academy', 'Ulen' wrote that these 'are the fields of battle for the rallying cries "Art into Life" (not outside it) and "Art is One with Production"'. Yet Lissitzky distanced himself from doctrinaire constructivism. The journal's title, he wrote, is intended to show that 'to us, art means nothing other than the creation of new objects'. Having ceased to centre on representing the visible world, art now assumes a wider domain:

Naturally it is our opinion that useful objects produced in our factories — aeroplanes, perhaps, or automobiles — are also the products of true art; but we do not wish to

see artistic creation restricted to these useful objects alone . . . [. Our journal] regards poetry, plastic form and drama, as essential 'objects'.[34]

In a lecture he gave in Berlin that year, he contrasted the attitudes of Unovis and of the new constructivist group. 'Unovis distinguished between the concept of functionality, aimed at the creation of new forms, and the question of direct serviceableness', whereas 'Some members of the Obmokhu group . . . went as far as a complete disavowal of art in their urge to be inventors, [and] devoted their energies to pure technology'.[35] Lissitzky was still in Moscow when the exhibition '5 × 5 = 25' opened there in September 1921 (see below). We know he attended Tarabukin's Inkhuk lecture, 'The Last Picture Has Been Painted', in October and the debate that ensued.

Lissitzky was clearly not prepared to delimit art's freedom, and represented suprematism and Unovis in this light. *Veshch*, as Lodder points out, was also intended to inform Russia about Western developments. It published words from and about Picasso, Léger, Le Corbusier, Van Doesburg and others, including the Berlin Dadaists. It reported also on the International Congress of Left Artists, held in Düsseldorf in May 1922, at which Lissitzky, Van Doesburg and Hans Richter together failed to persuade a diverse assembly of artists to agree to an association not merely of good will and commercial advantage but committed to defined goals. Lissitzky, Van Doesburg and Richter protested jointly against the Congress's refusal to debate what the term 'Progressive Artists' should mean, 'on the grounds that the way people tackle the problems of art is an entirely personal matter'. This proved the continuing 'tyranny of the subjective'; what was needed was clear organization and systematization of art not rooted in personal expression. They called themselves the International Faction of Constructivists, and abandoned the Congress after they had made their statement and the young Werner Graeff had spoken firmly in their support.[36] Lissitzky does not appear to have called himself a constructivist except on this occasion.

Graeff, a Bauhaus student during 1921–2, soon became a disciple of Van Doesburg. Other Bauhaus students took the same option, allying themselves to Van Doesburg and Lissitzky, and to artists associated with the Dada groups of Zurich and Berlin such as Arp, Richter and the independent Hanover Dadaist, Schwitters, for an International Congress of Constructivists and Dadaists held in Weimar in September 1922. We have noted the interest Berlin Dadaists showed in Tatlin as the initiator of 'machine art'.[37]

Tatlin's lecture on the Tower, on 14 December 1920, had been followed by a discussion to which Brik and Mayakovsky contributed, whereas Gabo attacked the Tower as 'a medieval idea . . . [like] the Tower of Babel', new only in its incorporation of moving parts, and certain never to be realized. Gabo admired Tatlin, but his own training in science and engineering, and his rather different conception of art in Russian society after 1917, led him to develop independent principles and priorities. In and about 1921 he designed projects for a 'Monument for an Observatory', a radio station and a 'Power Station for the Electrification of Russia' that were certainly responses to Tatlin's Tower. Many years later, in America, he would criticize these as utopian: 'During the famine, the horrible civil war, the frost and all that, we were living on our fantasies', he explained in 1969. 'The plumb-line in our hand, eyes as precise as rulers, in a spirit as taut as a compass . . . we construct our work as the universe constructs its own, as the engineer constructs his bridges, as the mathematician his formula of the orbits.' Artificial colour will be replaced by the hue and

72. Naum Gabo, *Square Relief*, 1937 (base 1950s), perspex on enamelled anodised aluminium base, 44.5 x 44.5 x c.16.5 cm. Private Collection

tone of the materials used, line will establish direction and rhythm, and space takes over from mass as sculpture's essential element.[38] All this implies the influence of Tatlin's pictorial and corner reliefs, but expresses cosmic analogies that may have been stimulated by Malevich, while asserting an informed allegiance with engineering.

Apparently Tatlin did not reply to Gabo's attack, though Gabo's own projects could be criticized in similar terms. Tatlin knew better than anyone that, to become the vast structure he envisaged, his Tower would have to be reworked in terms of the materials and techniques available in consultation with engineers and builders. He was fully aware of all the shortages and economic limitations of the time. The display of constructions by Rodchenko and his friends in May 1921 was in part a response to the exhibition by Gabo and others nine months earlier. None of their exhibits was utilitarian, unlike Tatlin's Tower project. An article published in the journal *Hermitage* in 1922 reported on the birth and ideas of the First Working Group of Constructivists in terms that echo Gan's — for example, '. . . art which, by getting involved with real and energetic social reconstruction, seeks forms of artistic work that have a precise social purpose' — though it ends on an independent journalistic note: 'Constructivism has become fashionable'.[39]

Presumably the writer meant the subject 'constructivism', not constructivist work. The autumn of 1921 had seen in Inkhuk a two-part exhibition, consisting of paintings and graphics by Rodchenko, Stepanova, Popova, Vesnin and Exter. Its unconventional title was '5 × 5 = 25': five works each by five artists. The exhibits were changed between the first showing, which opened on 18 September, and the second, consisting of drawings only, from 6 October on. Rodchenko included three paintings of the same size and format (24 1/2 × 20 3/4 inches, 62.5 × 52.7 centimetres[40]), each covered evenly with one primary colour: red, yellow and blue. Khan-Magomedov comments that 'only with these works did he reach the end of his researches in the field of pictorial representation and shift his interest towards the construction of real objects'.[41] Others have written similarly, though of course such paintings do not necessarily spell the end of anything. Tatlin produced an all-over *Pink Painting* during 1922, possibly as a riposte to Rodchenko's polemical act. Stepanova's statement in the catalogue was clear:

Composition is a contemplative attitude of the artist to his work.
Technology and industry have confronted art with the problem of CONSTRUCTION

as an active principle and not as contemplative invention. The 'sacred' value of a work of art as a unique object has vanished.[42]

The exhibits showed the artists at their most minimal. Each of them provided a brief statement or implied one in titling their work, defining his or her personal position in the Inkhuk debates. Popova wrote: 'All the experiments shown here are pictorial and must be considered only as a series of preparatory experiments for concrete material constructions,' which is almost to say 'Do not enjoy these images as art'. Exter wrote: 'The works exhibited here are part of a general plan of experiments with colour . . . [including] the transition [to] a colour construction based on the laws of colour itself.' Rodchenko, the leading force behind the exhibition, listed five works (*Line* 1920, *Square*, *Pure Yellow*, *Pure Red* and *Pure Blue*, all 1921), and summarized his progression from the *Black on Black* paintings of 1918 via his 1920 drawings showing 'LINE' as an element of construction: 'In this exhibition the three primary colours are first shown by me.'

Stepanova typed the texts of twenty-five little catalogues on a tired machine that needed a new ribbon. Each had a hand-painted or drawn cover, and included original graphic works by the exhibitors. Stepanova's poster for a debate about the exhibition, to be held on 25 September, was blatantly hand-made. It listed the artists as well as Kruchenykh and Ivan Aksenov as speakers, and made a point of naming the exhibition twice in red, but also writing *iskusstva* (art) in black capitals and then crossing it out, twice, in red.[43] Milner characterizes the event as 'an act both of nihilism and positive integrity'. It appears to have focused talk and action in Inkhuk. On 24 November Brik again demanded an end to easel painting and the switch to utilitarian work for industry, and Gan's book of 1922, *Constructivism*, would demonstrate how one could work within industry on assembling type and graphic devices, and giving these new expressive functions.

The constructivist group were distancing themselves from Tatlin. Above all, they wished to be seen to be working towards utilitarian results. On 8 December 1921 Medunetsky denounced Tatlin's Tower as utopian whereas he and his colleagues 'talk of real things, and we have never talked of anything else. We took iron, wire, and nothing else'. Tatlin had questioned their understanding of materials: the group 'does not feel material but simply copies it'. An Inkhuk debate on 26 December followed a lecture on 'Constructive Work' as displayed in the Obmokhu exhibition in May, given by the Hungarian art critic Alfred Kemeny. In it he called Tatlin the 'father of Constructivism' and a 'pioneer of Constructivism connected with the practical tasks of the material forms of life'. But the constructivists, he said, were going further in their experimental work which he saw as 'agitation for the life of the future and for communism'. He praised them for succeeding where Tatlin said they failed: 'Their constructions are material in the truest sense of the word and they emerge from the inner nature of the material used.' Brik expressed similar views, distinguishing between Tatlin and the constructivists. He considered the constructivists' work agitational — presumably meaning it laid down a direction to what should follow — and praised their attitude to materials as a step towards working for industry. Vladimir Stenberg stressed that their work was not merely agitational but demonstrated practical ways of using materials.

Tatlin agreed that it was important for artists to turn to creating utilitarian objects. He saw this as a broad, collective programme, the work of many outgoing individuals including existing designers. However, he argued against jettisoning all artistic experience. Georgii

Stenberg and others suggested there were still basic issues to be confronted. How, lacking a solid theoretical base and practical experience, could they work for mass production? The architect Ladovsky told the constructivists that they were still artists, for all their words against art and aesthetics, and too talented to end up in production. Students would be more likely to manage that switch. Babichev maintained that the difference between Tatlin's work and that of the constructivists lay in their use of forms, not in any demonstration of utilitarian functions: the objects they had shown in the Obmokhu exhibition confirm their 'mechanical aestheticism', not the rejection of aestheticism.[44]

Brik, Rodchenko and those closest to them believed that constructivist work should be welcomed by the new society as a model activity. Marx had believed passionately in the need to break down the barriers of specialization. Tolstoy had called for it. Once labour was organized efficiently and fairly, with the profit motive no longer dominant, there would be no reason why the factory worker or the coal miner should not also be an artist. That of course was part of Bogdanov's vision of Socialist life in *Red Star* and the basis of his PLK campaign. The constructivists' vision of artists becoming artist-engineers working for factory production was similar, though it implied surrendering their status as artists. They did not imply that industrial workers would become artists. It was precisely at the end of 1920 that, preparing 'The Work Before Us', Tatlin and his assistants had associated research into materials with 'discoveries serving the creation of a new world' and designing prototypes with 'the forms of the new life around us'. 'Art into life' was one of Tatlin's repeated slogans.[45]

A few months after the publication of Gabo's 'Realistic Manifesto', a 'Programme of the Productivist Group' had appeared over the names of Rodchenko and Stepanova. It is not clear when exactly productivism became the group's express goal. Lodder has highlighted steps towards it. In November 1918, during a debate whether art was 'A Temple or a Factory', Punin had asserted that proletarian culture would demand a new kind of art: 'not a sacred temple for lazy contemplation, but work, a factory, producing artistic objects for everyone'. Brik had written in *Art of the Commune*, 7 December 1918, that art was a form of production; 'a real object is the aim of all true creativity'. Like Punin, Brik at this stage left the art *versus* work for industry issue poised ambiguously. It was Lunacharsky who took what may have seemed the decisive step. In a speech of August 1919 the minister had asserted that 'If we are really going towards socialism, we must give production more importance than pure art . . .[.] There is no doubt that production art is closer to human life than is pure art'.[46] He set up an Art and Industry Commission to investigate how art might be used to raise the level of manufactured goods, but he did not want to set art aside. He was asking for little more than co-operation between artists and industry, even though his words imply art on two levels, pure art and something 'closer to life', which sounds like bourgeois art and working class art. Shterenberg, as head of IZO in Petrograd, committed his department to 'art's penetration into industrial production'. Again, it is likely that he and his minister were thinking that artists should be able to influence industrial production and thus earn their place in a world disrupted by economic and social strains, not that art should cease.

Punin was among the first to call unambiguously for an end to subjective art and a determined focus on materials. In February 1919, in *Art of the Commune*, he had praised suprematism's role in designing posters and other displays 'all over Moscow', yet had also announced the end of suprematism 'in creative terms'; it was, after all, 'an invention strictly confined to painting'. The work Malevich and his Vitebsk students did subsequently may well

have been in answer to this relegation. They produced two-dimensional suprematist images but also applied that idiom to the decoration of vehicles, streets and squares for May Day and October celebrations, built three-dimensional projects that could be prototypes for architecture and space stations, and subsequently also shaped and decorated in suprematist terms household objects such as teapots, cups and saucers. This did not satisfy Punin, who was convinced that Tatlin held the key to progress with his continuing investigation of materials. He wrote in his diary, during this time of famine, that Tatlin 'was essential, like bread'.[47]

In February 1922 Medunetsky and the Stenbergs lectured on 'constructivism' at Inkhuk. The text is not preserved, but Lodder lists the theses it was to present. Their wording, perhaps because of its brevity, has a new sharpness. The first line is: 'Constructivism as economy — space'. The second is: 'utility — the logic of everyday life'. When they turn to constructivism's immediate tasks they become less specific. First: 'The first laboratory works and their agitational significance'. Second: 'The abstract solution of the basic problems of Constructivism'. A few lines further down: 'The communistic expression of material and spatial structures'. How these problems were to be dealt with, and how the structures would yield 'communistic expression', may have been addressed in the lecture.[48]

Altogether, the rapid adoption of the term constructivism for other art forms and purposes calls for distinctions to be made between constructivism proper, in other words, reflecting the group's stated principles, and a constructivist idiom that could be adapted to a wide range of tasks but remains a stylistic option. In this latter category I would include the work Popova and Stepanova did for Meyerhold's stage in 1921–3 — Popova's kinetic apparatus for *The Magnanimous Cuckold*, Stepanova's constructed gadgets and props for *The Death of Tarelkin*, variously used during the largely comic performances, and Popova's bold, gantry-like structure for Meyerhold's *Earth in Turmoil* — as well as the timber stage construction suggesting the hubbub of life in a modern metropolis, which Vesnin made in 1923 for Tairov's production of *The Man who was Thursday* (a dramatized version of G.K. Chesterton's novel of 1908). All these combined suggestions of a mechanized world and of human beings using it as well as being used by it. For *The Earth in Turmoil*, Popova

> sought to eliminate all risk of aesthetic blandishment by resorting to purely utilitarian objects: cars, lorries, motor cycles, machine-guns, field telephones, a threshing machine, a field kitchen, a model aeroplane — only what was required by the dramatic events. The one exception was a stark red wooden model of a gantry-crane, built only because a real crane proved too heavy for the stage floor to bear. The sole sources of light were huge front-of-house searchlights. The costumes of the soldiers were authentic and the actors wore no make-up.[49]

In other words, her work here was an assemblage of real-life objects, made to achieve the character of a documentary. This highlights the essentially symbolical role of her earlier apparatus for *Cuckold*, a Belgian farce as against the serious agitational action of *The Earth*. *Cuckold* made full use of the formalized movement, biomechanics, in which Meyerhold schooled his actors, whereas action in *The Earth* was essentially realistic. Biomechanics was the opposite of traditional acting: not a pretended surrender of the individual performer's personality to assume someone else's, not a cast of persuasive actors conveying illusions of character and relationships to a public asked to 'suspend disbelief', but a troupe

of performers trained in codified routines of expression and circus-like or acrobatic actions whose very impersonality and generalization would entertain a broad public.[50]

These stage constructions were set up on otherwise undisguised stages and could be re-used in other places, including the open air. In early 1921 Vesnin and Popova had collaborated on models and an all-over design as their *Project for a theatricalized military parade for the Congress of the Third International, entitled 'The End of Capital'*. This was to be directed by Meyerhold and performed on Moscow's Khodynsky Field that May Day. It would involve thousands of soldiers and civilians, trains, tanks, artillery, motorcycles, airships and aeroplanes with searchlights, gymnasts and military bands. Work began in April but the event was cancelled at short notice for lack of funds. Vesnin's and Popova's models of the two symbolical cities, the 'Capitalist Citadel' and the 'City of the Future', represented for the former a close huddle of solid buildings, patently defensive, and, for the latter, an open cluster of mostly transparent engineering structures, partly kineticized by large turning wheels. Both made prominent use of cables to tense their structures but also to represent telecommunication. Airships would hover over the scene, tethered by cables across which would be slung slogans greeting the Third International in several languages. In some respects this scheme foreshadowed Popova's compact apparatus for *Cuckold* of the following year. In others it prepared the ground for her staging of *The Earth in Turmoil* in 1923.

Alexander Vesnin's model for *The Man who was Thursday* was shown in Paris and Berlin in 1923, before the first performance. It proposed a particularly complex apparatus, including towers with lifts, movable platforms, a sloping conveyor-belt and large wheels, transparently built in timber to represent modern city life in diagrammatic terms. Lissitzky considered that it adopted the principles demonstrated in Tatlin's Tower. The set provided a multi-functional but essentially naturalistic setting; the actors wore normal city clothes, and Moscow's critics were enthusiastic. The Vesnin brothers produced other pioneering designs in 1924–5, notably one for an aeroplane hangar, a light structure held in place by external cables. Here the term constructivist could well apply. Other designs and realized buildings suggest a mix of functionalism with symbolical references that amount to a constructivist style. A telling example of this was the Vesnins' design for Moscow's telegraph offices: a rectangular concrete-framed block incorporating large areas of glass and topped by a commanding cube with a clock-face on each side and, towering over that, a steel mast supporting a complex of cables, not unlike the rigging of a great sailing ship.[51]

Launching constructivism had not changed the world. Futurism itself, still the term used for anti-traditional art and design, was beset by the commercial priorities flourishing under NEP as well as by reactionary tendencies within art. In January 1923 Mayakovsky and Brik founded the Left Front of the Arts, LEF, to promote 'left' ideas and energies. From 1923 until 1925 they published the journal, *Lef*. One of its recurring themes was that the arts should and already do play a significant utilitarian role in Soviet society, and that therefore leftist art warranted official support in spite of Lenin's antagonism and Lunacharsky's reluctance to go beyond tolerating it as part of a range of theories and activities. Mayakovsky was *Lef*'s official editor; his friend Brik was its active leader. Both asserted their commitment to Communist ideology and used the journal to demonstrate the union of utilitarian work in the arts with the new Communist life. Seven issues of *Lef* appeared but financial support for it declined, and thus also the number of copies printed, from five thousand in 1923 to two thousand in 1924. Not all copies were sold.

The constructivists became contributors to *Lef*. Rodchenko was its designer, and his work and sometimes that of his fellow constructivists was illustrated and discussed in its pages. In the first issue, in March 1923, Brik defined what a constructivist must be and do, and introduced Rodchenko as an exemplar: 'Rodchenko has become a Constructivist and production artist. Not just in name, but in practice.' Others merely use the word 'construction' as an alternative for 'composition' and keep on painting 'mystical insights' or 'little cockerels and flowers'; if they go near real objects it is only to decorate their surfaces. They serve bourgeois values, but a consumer is emerging 'who does not need pictures and ornaments, and who is not afraid of iron and steel. This consumer is the proletariat. With the victory of the proletariat will come the victory of Constructivism'. In the sixth issue of *Lef* (1924), Brik wrote again about the need for artists to stop producing easel paintings for the leisured few; posters and printed textiles would give them better employment. When Mayakovsky, early in 1925, listed the main participants and allies of *Lef*, he emphasized the role of writers as developers of new, often condensed, syntax, and, turning to non-literary fields, mentioned Eisenstein, then still a theatre director, and Vertov, the experimental filmmaker, but made no mention of the constructivists. Trotsky, discussing futurism in his book *Literature and Revolution* (1924), like Mayakovsky thought mainly of writers but saw no role for verbal experimentation in real life: they had not yet 'mastered the elements of the Communist point of view', and thus *Lef* had nothing practical to offer. Lunacharsky, in a speech of 9 February 1925, dismissed LEF, and especially Mayakovsky, as 'stuck in the bourgeois camp'. The Soviet government's 'Resolution on Literature', issued that June, stated that LEF did not represent Communism and was of little use except perhaps in the field of agitational texts and images. Thanks to a diplomatic response to this from Brik, and to Mayakovsky's rejection of 'Americanism' in an article he sent from New York that October, LEF was given government backing for a journal to be called *New Lef*. The first issue appeared in December 1926; the last in December 1928, by which time Mayakovsky, Brik and Rodchenko had dissociated themselves from it. *New Lef*'s concern was now almost exclusively with literature. Its message was that writing should be entirely factual and 'relevant'. Photography and documentary film would be its visual complement.[52]

Lunacharsky had replied to Brik's challenging article of 1923 in his introduction to a collection of the plays of the German dramatist Georg Kaiser, published that year. Beware of 'mimicry of the machine', Lunacharsky says to the constructivists, including Tatlin whose Tower 'mimics the machine'. One can sympathize with the impatience this symbolist poet and playwright felt at the sight and sound of Tatlin's tilting model, its units turning as someone hidden in its base cranked them noisily. Gan's aggressive book may have sharpened Lunacharsky's view of constructivism: art was being led into slavery. Technology's power to command man would have to be overcome by developing man's awareness of his own much greater innate powers if mankind were ever to be free and whole.[53]

The year of *Veshch*, 1922, saw Lissitzky and Ehrenburg collaborating again.[54] Lissitzky prepared illustrations for his friend's *Six Tales with Easy Endings*, published that year in Berlin. In them he combined Proun shapes and space with collage, the latter often presenting a naturalistic image. This applies, for example, to the illustration of a footballer, the photographed figure facing into the page to head a ball or disk.[55] The illustration *Tatlin at Work on the Monument to the Third International* combines photomontage with drawing and watercolour (fig. 73). The figure of Tatlin was drawn in pencil after the well-known photograph

73. El Lissitzky, *Tatlin at Work on the Monument to the Third International*, 1922, gouache and collage on paper, inscribed top left 'El Lissitzky', 29.2 x 22.9 cm. Michael Estorick Collection, London

showing him and his assistants building the Tower model: Tatlin holds a lath while Shapiro fixes a metal bracket to its top. Lissitzky's isolated Tatlin stands on a wooden stool drawn axonometrically (Lissitzky's normal practice for showing three-dimensional elements in Proun compositions, instead of traditional perspective with its diminishing measurements). He looks upwards, as in the photograph, but from his near eye springs a pair of protractors with which he measures the heavens; they are set at the sixty-five-degree angle at which the spine of the Tower rises.[56] He is backed and flanked by Proun forms, mostly planes set into non-perspectival space. A dark plane behind him, like a blackboard, has white lines inscribed on it, including a plus sign and minuses and half a circle, which, continued in the protractors, haloes Tatlin's head. Some of the planes on the right look slotted together to support a sloping cylindrical form. This could be a version of the topmost section of Tatlin's Tower, but is closer to the Herschel telescope which may have influenced Tatlin's design.[57]

Lissitzky represents Tatlin as a modern Ptolemy, or at least a modern image of a natural philosopher as pictured in the late Middle Ages and the Renaissance. Signs inscribed in the panel on the right include mathematical symbols and constructions: a spiral, the sign for infinity, drawn over a plus-or-minus root 5 figure leading to a firm zero, and so on. These associate Tatlin with the new mathematics Khlebnikov had studied as the key to his

investigation of history.[58] A major symbolical image in Lissitzky's illustration is that of a woman's head, part of a photograph collaged in at the top so as to float horizontally, distinct from the world below both by its position and its scale. A curving line gives it a partial halo; a patch of red renders it more mysterious and suggests that the head is about to ascend and disappear. The woman's face is frontal and clear, and the one eye visible to us is large, like the eyes of major figures in Byzantine art. Moreover, her lips are sealed by a white patch: she is silent. She represents Sophia, the feminine principle invoked by theologians and philosophers as representing Divine Wisdom, and precious to the symbolist generation. Lissitzky presents us with a 'Tatlin at Work' who is a practical earthling and a thinker alert to advanced mathematics in relation to physics and to the transcendental idealism with which man confronts eternity.

Tatlin was very important to Lissitzky. This is clear from his writings, notably his influential book, *Russia: The Reconstruction of Architecture in the Soviet Union*, written in 1929 and published in translation the following year in Vienna as the first of a series on 'New World Architecture'. Discussing relationships between the arts in Russia, Lissitzky gives pride of place to Tatlin's focus on materials and their exploration for artistic as well as utilitarian ends. That his designs for the Monument to the Third International still lack full development via technological expertise, Lissitzky argues, proves the concept's rightness: Tatlin was creating a 'synthesis between the "technical" and the "artistic"'. Moreover, in adopting a form known to ancient architecture, and encouraged by Khlebnikov's enthusiasm for lofty buildings, Tatlin transcended it in his efforts to dematerialize volumes and let interior and exterior merge. An earlier sign of Lissitzky's interest in Tatlin is found in his teaching in Vitebsk, notably in the Lenin Tribune designed by his student Ilya Chashnik in 1920. Lissitzky published this design in the book, *The Isms of Art* (*Kunstismen*), worked on while he was hospitalized in Switzerland. Arp collaborated with him; it was published in 1924.[59] In a few words (in German, French and English) and a dramatic sequence of images, it traced the major steps taken by modern art, design and related activities such as abstract film, reading backwards from 1924 to 1914. On page 9 is the Lenin Tribune, ascribed to 'Atelier Lissitzky 1920' but developed for publication by some simplification of its forms and an added photograph of Lenin addressing a crowd. Its basic concept was that of a collapsible structure, for erection as needed. A black cube supports a slanting open-work steel beam echoing that of Tatlin's Tower. Platforms slotted into this beam may presumably be fixed in various positions. On page 3 there are two images, one of Tatlin's counter-relief *Selection of Materials: Zinc, Palisander, Pine* of 1916, and a larger portion of the photograph Lissitzky used for drawing *Tatlin at Work*.

That page is headed 'Constructivism'. Introductory pages of *The Isms of Art* offer definitions and descriptions of named movements. Here is what is said about constructivism on page xi in the English-language column:

These artists look at the world through the prisma of technic. They don't want to give an illusion by the means of colours on canvas, but work directly in iron, wood, glass, a.o. The shortsighteds see therein only the machine. Constructivism proves that the limits between mathematics and art, between a work of art and a technical invention are not to be fixed.[60]

74. El Lissitzky, *Architecture Vkhutemas. Work of the Architecture Faculty of Vkhutemas*, 1920–27. Cover with letterpress typographic design and photographic illustration on front, and letterpress typographic designs on back and spine, 1927, page: 24.3 x 16 cm. Museum of Modern Art, New York

Lissitzky is said to have brought with him to Berlin the 'Programme of the First Working Group of Constructivists' and photographs of their work. Gan mentioned in *Constructivism* that Ehrenburg had taken to the West photographs of their work and notes about it. So the editors of *Veshch* were in a position to promote constructivism yet did not really do so. The 'First Russian Art Exhibition' was wide-ranging and did not present constructivism as its culmination. The West was given 'a picture of Constructivism which was eminently more accessible and digestible to them than the actual rigorously anti-aesthetic, politically and socially utilitarian Russian movement', as Lodder suggests. Gan complained that the West was being offered constructivism as just another new art trend and kept ignorant of its productivist aim. He specifically blamed Lissitzky and Ehrenburg for this, saying that they 'cannot tear themselves away from art'.[61]

Lissitzky's suite of lithographs, *The Plastic Formation of the Electro-Mechanical Spectacle 'Victory over the Sun'*, conceived around 1920 and prepared in watercolours during 1922, was published in Hanover in 1923. The portfolio has a block 'F' on its front which divides, as it is opened, into a vertical rectangle and two horizontal rectangles of different lengths: the familiar letter-sign is analyzed before our eyes into its constituent forms. 'F' stands for *Figurinen* (puppets), the largest word on the title page. Lissitzky's puppets occupy nine of his lithographs and have various names, such as 'Gravediggers', 'Announcer' (with megaphone), 'Globetrotter' (the English word; the image suggests a figure in an aeroplane) and 'The New Man' (fig. 76). This one warrants special attention here. The image of that ideal being, inherited from Chernyshevsky and others, is at once an abstract compilation and a figure spreading its arms and striding gigantically. Its double head sports a black and a red star, each five-pointed in the Communist manner, while its chest bears a large red square, the most prominent element in the design. The whole figure is super-energetic and resilient, as though fashioned of the finest steel. It reappears, smaller and slightly adjusted, in the suite's first lithograph, representing 'Part of the Show Machinery' (fig. 75), and is there accompanied by more obviously varied versions of 'Announcer', 'Gravediggers' and 'Globetrotter'. They inhabit a construction that hints at the laths and spirals of Tatlin's Tower. An introductory text refers to this as 'rib-construction, so that the bodies circulating in the play will not be masked'. Lissitzky was imagining a performance involving a light structure which would serve as an open-air 'stage on a square', permit movement in all directions and display its 'machinery'. He implies that such a structure could be used also for other

75. El Lissitzky, *The Electro-Mechanical Spectacle Victory over the Sun*, 1923, lithogaph: *Part of the Show Machinery as Title Page*, 46.4 x 36.8 cm (image) / 53.3 x 45.7 cm (sheet). Philadelphia Museum of Art: Gift of Dr. George J. Roth

76. El Lissitzky, *The Electro-Mechanical Spectacle Victory over the Sun*, 1923, lithogaph: *New Man from 'Victory over the Sun'*, 38.1 x 26.7 cm. Philadelphia Museum of Art: Gift of Dr. George J. Roth

performances. Here, he admits, he is using an existing script, but he has brought it from the 1913 context of Malevich, Kruchenykh and Matiushin's collaboration into the new world of Prouns via Tatlin's example.[62] Tatlin and Lissitzky were not to be personally acquainted until 1927 when they quickly became 'good friends'.[63]

Gan's *Constructivism* delivered the movement's ambitions in belligerent terms, and may have limited its success by doing so. His second sentence announces in capital letters that he and his associates were taking over the task the Russian futurists had set themselves a decade earlier. He repeats a statement of 1921: 'Long live / the Communist expression / of material / construction.' The 'proletarian revolution' has liberated art; 'a new chronology begins with October 25, 1917.' Repeatedly Gan associates constructivism with Marxism: 'It indissolubly unites the ideological with the formal.' Pursuing research and practice in 'intellectual and material production', constructivism embraces a second objective 'in establishing scientific bases for approaches to the organization and consolidation of mass labour processes', etcetera. 'The Constructivist joins the proletarian order for the struggle with the past, for the conquest of the future.'[64]

Others' talk and writings about art and constructivism may have made Gan feel that a firm voice was urgently needed. Nikolai Tarabukin's *From the Easel to the Machine*, written in 1922 and published by PLK in 1923, traces a linear development of modern art from impressionism via abstraction to constructivism.[65] The title of his book is polemical, outlining the progression he hoped to see realized. Tatlin's counter-reliefs, he wrote, achieve

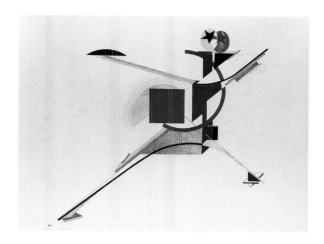

realistischeskaya konstruktivnost, realistic constructiveness, when they detach themselves from the wall, occupy real space and offer themselves to diverse viewpoints. He pointed to the red one of Rodchenko's three monochrome paintings of 1921 as especially significant, designating it 'the last painting'. Unlike Malevich's suprematist canvases, the Rodchenkos are 'destitute of all content', and for this reason should be acquired by the Tretyakov Museum to join the paintings of others — he names Larionov and Tatlin — as noteworthy stages in the evolution of Russian art. Rodchenko's monochrome painting proclaims the end of realistic representation in art, but Tarabukin reckoned that even this was still a piece of representation: every painting, even Rodchenko's 'stupid, blind, dumb wall', has to be an image of something. Paintings are of use only to the museums. Today, 'the old Pegasus is dead . . . replaced by the automobile of Ford'.[66] The way forward is to reject pictorial art altogether and to create 'a genuinely real object'. Once he has a firm foundation in technology, the 'artist-productivist' can reform life through the objects he initiates. This does not mean embarking on socio-economic structures; these 'are not art's concern'. At present art and production are still far apart, and it may not be possible for artists, with their professional versatility, to focus on the priorities of machine production. Tarabukin sees potential tragedy in this mismatch, but ends on a positive note. We may yet see 'art breaking the chains of the museums and launching itself triumphantly into life'. He has no doubt that 'For the worker in production, the process of production itself . . . becomes the goal of his activity.'[67] We cannot tell whether he was influencing Ioganson or echoing him in writing this.

*

It was obviously difficult to agree on the present and prospective roles of constructivism. Whatever was said about its contribution to society had to be speculative, an expression of faith. The debate had begun with the showing of Tatlin's model for the Tower. Everyone knew that Tatlin had come to that from his exploratory work on pictorial reliefs, corner reliefs and the formal clusters he suspended in open space, and thus that the Tower concept was born out of wide-ranging investigations into materials. In 1919 he had founded his Petrograd workshop for Material, Space and Construction, remaining in charge until 1924 when the school was reorganized. He also ran a Department of Material Culture in the Petrograd version of Inkhuk, called Ginkhuk, and there, in 1923, he began to work with students on directly utilitarian projects, developing prototypes for mass production. But at no point did the Tower propose, or his teaching of Material Culture announce, a programme focused exclusively on the production of useful objects for everyday life.

Tatlin's organizing of product design work in Petrograd appears to have preceded that undertaken by Rodchenko and his students in the workshop for Metalworking (Metfak) in Moscow. Rodchenko had taken over Metfak at the start of 1922 but found it short of students, ill-equipped and handicapped by the old Stroganov School's focus on ecclesiastical and devotional metalwork. His hopes of producing new artist-engineers could initially be developed only in theoretical studies. On 12 February 1923 he produced his 'Provisional Syllabus of the Metfak', leading to diplomas to 'engineers-artists-constructors . . . capable of manufacturing objects for everyday use'. That March he added a syllabus for the 'minimum practical work for the academic year 1922–23', which would include basic studies in architecture and town planning. Meanwhile he himself was intensely busy on graphic work, regarding this as a form of productivism. During 1922–5 he designed a stream of book and magazine covers, trademarks, posters, advertisements, wrappers for food of various kinds and film titles. Much of this work involved close co-operation with printers, as well as with Vertov and Eisenstein as film-makers and with Mayakovsky who provided clever advertising jingles to go with Rodchenko's sharp designs. Results of his Metfak teaching in the form of prototypes for furniture and other household goods began to be realized during 1923–4, and it was in 1925 that he designed and saw to the installation of the Workers' Club at the Paris Exposition of Decorative Arts.

This was the first time that Soviet Russia contributed to a major international cultural display.[68] Lunacharsky worked wonders with limited funds and preparation time. Eleven architects, almost all of them avant-gardists, were asked to submit designs for a Soviet pavilion. A design by Konstantin Melnikov (1890–1974) was chosen. He had some of the elements his design called for prepared in Russia, and went to Paris to supervise their assembly. The Soviet display in the Grand Palais, curated by Rodchenko, centred on the new model of Tatlin's Tower and struck a utilitarian note amid all the chic goods and interiors of which the international exhibition largely consisted. Melnikov's pavilion attracted the greatest attention. Building it required co-operation from the Paris carpenters' association, *Les Charpentiers de Paris*, who were charged with erecting the timber framework brought in from Russia and filling it in with sheets of plywood and glass. Unprecedented at the time, this method has become common since.

Exhibition pavilions were expected to be folksy or palatial, and to deliver a national image. The Paris Exposition in fact found room for a number of modernist designs by Le Corbusier, Tony Garnier, Robert Mallet-Stevens and others, but these were overshadowed by voguish installations appealing to a well-to-do and fashionable clientele. Melnikov's pavilion was at once modern and modest in its requirements, but also exotic, particularly in its strange geometry, overcoming forever the impression of a glamorous, semi-Asian and timeless Russia given by Diaghilev's Russian Ballets productions. The pavilion's plan was rectangular but the building countered that form, slicing through it diagonally with broad open-air stairs leading up to a first-floor landing from opposite corners. The effect of this apparent division into two triangular halves — the ground floor areas connected beneath the landing from which one entered the first-floor areas — was to deprive it of almost all the right angles modern architecture generally depended on. A vertical tower stood close to the stairs, an open girder, triangular in section, rising well above the pavilion to announce the Soviet Republic's presence.

The result was both functional and a memorable image of the new Russia. Its latent symbolism links it to Melnikov's 1924 designs for Lenin's sarcophagus, for which the architect

proposed a stretched prismatic form in glass. Thus the Paris pavilion offered the public a version of the shrine proposed for the deceased but immortal leader. Its form owed much to Tatlin's insistent use of triangulation and the non-vertical rising line, as well as to the dynamic forms and lines explored by Lissitzky and others in the Unovis group. Ehrenburg reported Le Corbusier's comment that Melnikov's pavilion, just one among several small buildings and stands erected in the ground of the exhibition, including Le Corbusier's own Pavillon de l'Esprit Nouveau, was 'the only one . . . worth looking at'.[69] The presence of a fine new model of the Tower at the heart of the Grand Palais' Russian section must have surprised anyone aware of officialdom's negative response to the large model; here it was again, a smaller version greatly honoured by its placing. A Danish art historian encountered Melnikov in the exhibition and was given a quick tour of the pavilion and of the other Russian display, together with 'a rhapsodic introduction to the model of Tatlin's tower'. The Melnikov pavilion has traditionally been represented as a triumphant example of Russian constructivism, yet the constructivists' insistence on materialist theory and on not being artists repelled Melnikov. To him, architecture was a form of art, and art had to be concerned with the spiritual development of mankind, whereas constructivist design was, he wrote, 'soul-less'.[70]

Rodchenko's Workers' Club made almost as deep an impression. Organizing and, sometimes, creating new buildings as workers' clubs was one of the tasks trade unions set themselves in order to bring workers together for relaxation and the inculcation of revolutionary attitudes. In 1915 the City Council of Moscow had set up a People's House on the model of the *Maisons du Peuple* of France and Belgium as social, cultural and educational centres. Workers needed somewhere to meet in convivially and where drinking was not the prime occupation. Such People's Houses, and later Workers' Clubs, would encourage useful leisure activities. As with festivals, there was a danger that the clubs set up after the Revolution would put too much effort into indoctrination and too little into, as Trotsky wrote, 'healthy recreation and healthy laughter'. Some of Russia's best architects were engaged for these buildings. Mention has already been made of the Zuyev Club which Golosov designed in 1927. Melnikov made several designs for workers' clubs, some of which were realized though his designs often had to be modified to cope with shrinking budgets. He saw them as opportunities to advance 'all the highest aspirations of the intellectual life of man, of the human personality'. He wanted them to be buildings set '*against* the hostile city rather than *in* it', and gave them forms that distinguished them from their surroundings. His Rusakov Factory Club, built in Moscow in 1927–8, for all its aggressive exterior, is planned to serve diverse social purposes by means of six meeting halls which can become one great auditorium. The best ways of using these spaces, their acoustics and sight lines, the economics of the whole building including its remarkably low heat loss, were thought through and documented by the architect. What some have considered an over-dramatic display of modern formalism was in fact the product of functional design. Postcards made from Rodchenko's photographs of the Rusakov Club sold in their thousands. Melnikov resisted all efforts to develop a standard design, but gave each instance its individual character.[71]

The workers' club Rodchenko made for Paris had to be interior design and equipment only, not a complete building but an installation developed inside the Grand Palais to simulate a club interior. It demonstrated constructivist methods. Starting from project designs he developed with his students, it was a rectangular space furnished with a long table flanked by twelve chairs for reading and other activities, shelves and cases for papers,

pamphlets, posters and books, a Lenin corner (like an icon corner) with a photograph of the deceased leader, additional photographs and posters on the walls, a unit combining a speaker's platform with extendable screens, another unit combining a chess table with two armchairs, and so forth, all designed to be economical and of maximal utility. The furniture was made in Paris to designs Rodchenko had brought with him. He worried that the furniture would turn out to look too heavy, but was very happy with the result, including the colours. The floor may have been painted black. The colours he chose for the furniture were the same as those he used on the pavilion: white, red and grey.[72] There had been some worries in Russia that the club's 'essentiality' would be mocked in Paris. It was, by some visitors and commentators, but many others, especially those writing for the architectural press, admired it for itself and for the contrast it offered with all the fashionable and expensive displays. Even Le Corbusier's Pavillon de l'Esprit Nouveau could not match its simplicity and coherence. The furniture of Rodchenko's worker's club was presented to the French Communist Party when the exhibition closed and was soon lost sight of.[73]

Paris established Melnikov and Rodchenko as outstanding new designers on the international scene. Ehrenburg was in Paris and showed Rodchenko around. Mayakovsky stopped off in Paris on his way to America, spent some evenings with Rodchenko and introduced him to Léger. In June Melnikov and Rodchenko returned to Moscow and to teaching at the Vkhutemas. Melnikov continued to design remarkable buildings, including his own poetic and functional house of 1927. He refused to share any of the dogmatic positions promulgated by contemporary architects and theoreticians, insisting on architecture as a mode of personal expression. Rodchenko meanwhile developed an additional career as a pioneering photographer. He also produced outstanding designs for the theatre, notably in 1929 for Mayakovsky's play *The Bedbug*, directed by Meyerhold with music by Dmitri Shostakovich. In the 1930s he returned to painting while continuing to work also outside the studio.

Theorists of constructivism, such as Gan, spoke with a dogmatism its practitioners hesitated to adopt since it would be their task to produce the results heralded by the propaganda when the necessary working situation did not yet exist. There is no evidence that Russian industrialists were avid for the artists' input. In 1921, when Tatlin had approached the Novy Lessner factory in Petersburg with the proposal to set up a project laboratory, he had been told to apply to the draughtsmen's office and 'teach them to draw beautifully'.[74] Tatlin had by then had some contact with factories and so was perhaps better placed than most artists to work with industry, but managers hesitated to accept propositions of this kind. Nonetheless, in 1924 Tatlin reported positively on work done since 1922 in his Section for Material Culture within Ginkhuk. He, his colleagues and 'a small number of employees' together 'formed a group working on the analysis of [the] properties of heterogeneous materials and their artistic application to our new way of life in the USSR'. He specified prototypes for heating stoves and normative clothing, as well as the development of forty standard colours. But he also stressed that

The work is being carried out in the closest contact with those corrective measures provided by life itself, in that our employees have been working since January of this year in factories of the Leningrad Clothing Manufacturers and Low-Voltage Electrical Factories Trust, and are arranging contacts and joint work projects with the other trusts in Leningrad.

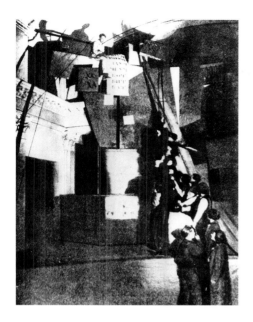

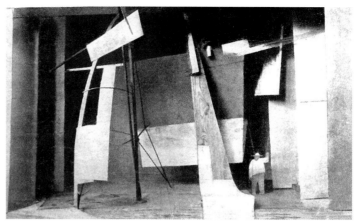

77, 78. Vladimir Tatlin, stage for production of *Zangezi*, Petrograd, 1923: photo of model, copied from 1923 publication, and first performance

Zhadova notes that Tatlin was the first artist to create such a research workshop, and that he saw its work as a continuation of that done in his Material, Volume and Construction workshop.[75] The 'employees' were his former students.

He had long argued that the artist, as an 'initiative individual', draws on the 'impulses and desires of the collective' in a Socialist society.[76] Already in 1914 he had called for a new 'Artistic Society', something like a 'harmonious family', which would enable artists to work in a co-operative spirit, without antagonism and partisanship.[77] He had established something like a small 'harmonious family' before 1914, his studio becoming a place for discussion and collaborative work for himself and a valued circle of friends. After October, and particularly as head of Moscow IZO, Tatlin worked towards this mutuality on a larger scale. As teacher, Tatlin worked with his students as much as he instructed them by word.

His friend and mentor Khlebnikov died in 1922, and Tatlin decided to stage the poet's 'supertale', *Zangezi*, in homage to him. This composite text, which Khlebnikov had only recently completed, could be enacted by declamation and by the use of speaking and mute individuals personifying attributes and qualities. Tatlin edited the script, invented the stage set, and designed the costumes and the action. He took his friend's part as Zangezi. Instead of professional actors, he asked students from the art workshops and other Petrograd institutes to work with him. Three performances were given on 11, 13 and 30 May 1923. Tatlin's original model for the stage, made of wood, cardboard, paper, metal rods and wires, celluloid, etcetera, does not survive but was recorded in a photograph (fig. 77). Another photograph shows a moment probably in the first performance on 11 May (fig. 78). A model of the *Zangezi* stage was sent to Venice for exhibition at the 1924 Biennale, which suggests official approval of the work.[78]

Tatlin was again responding to the poet's vision of a future world. That the production's main feature should be a tower — something between a ship's mast with sail and an initial

sketch for Tatlin's Tower — could merely reflect the artist's own repertory, but Khlebnikov frequently referred to towers as benign focal points as well as potent structures. Milner has pointed out that the vertical structure on the *Zangezi* stage, just to the left of centre-stage in the model, was erected close to the left corner of the Ginkhuk space, echoing Tatlin's corner constructions.[79] From what we know of the tone and references of Khlebnikov's poems and the material he gathered into *Zangezi*, it is tempting to assume that the performances — like the envisaged activities of Tatlin's Comintern Tower — will have been charged with strong folkloristic and carnival elements to reinforce and give access to the supertale's prophetic purposes.

A Tatlin article 'On *Zangezi*', published in *Life of Art* on 8 May 1923, referred to the entire event — the production, a lecture and an exhibition accompanying it — as 'the height of Khlebnikov's creative achievement'. Punin was to lecture on Khlebnikov's 'laws of time',[80] and a linguist would explain the poet's work of 'word-creation'. Khlebnikov's poems are deliberated constructions. Tatlin wrote: 'Parallel to the word structure I decided to introduce material construction. By this means the work of two people can be fused into one whole, in order to make Khlebnikov's creative work accessible to the masses.' Going on to describe the poet's use of sound, Tatlin quotes some lines from the poem in which Khlebnikov associates certain syllables with activities, including 'people's games', 'crowds around a fire', and both work and song.[81] The exhibition included a number of Tatlin's constructions to underline the unity of his work since 1914 and to associate those works too with Khlebnikov's ideas.[82]

Punin wrote a second article for the 22 May issue of the same journal, possibly echoing his lecture. It says some remarkable things about the supertale itself and about Tatlin's re-creation of it as a drama. He also mentions that many people attending the performances failed to understand *Zangezi*. He accepts that 'to comprehend and appreciate the unusual and the unfamiliar' is always difficult, but claims that Tatlin 'provided a simple and clever parallel to the linguistic material of the poem'. People are puzzled if they look for rational answers. On the other hand, Punin writes, 'Khlebnikov's poem can be understood only after perceiving its irrationalism', and he quotes just two lines from it:

> . . . I am singing and raving
> I am hopping and dancing on a cliff edge.

He adds: 'One is reminded of a comment by Pushkin: poetry should be a little crazy. Was not art fighting against its sworn enemy, rationalism, already in his time?' Tatlin's taste and judgment in finding material equivalents for Khlebnikov's verbal construction is unchallengeable: he is 'one of the most sensitive people we have so far as the theatre is concerned . . . [in him] the true living spirit of the theatre lives on . . . old like art itself and young at heart'. He has bypassed the bourgeois theatre's resources — professional actors, costumes, make-up, curtains, wings, elaborate lighting, etcetera — and prepared a commonplace situation with limited theatrical means. 'Tatlin's and Khlebnikov's day is still some way ahead.'[83]

Critics were for and against. Additional productions intended for Leningrad and Kiev did not take place, yet Leningrad's Oberiu group subsequently launched a form of theatre of the absurd derived from Tatlin's example. His formal concept for its staging recalls the Tower but in some ways also echoes his designs for *The Flying Dutchman*. Moreover, his stage for *Zangezi* found further development in work he did for the theatre in the 1930s and after,

notably for *Comedians of the Seventeenth Century*, produced in 1935.[84] Tatlin was following the new, primarily futurist, anti-illusionistic methods of Meyerhold and other avant-garde directors to engage audiences in active participation. In this spirit Tatlin conceived his production as 'a performance + lecture + exhibition of material constructions': his *Zangezi* was a multi-media event offering a broad artistic spectrum helping spectators to focus on a unique literary creation, at once epic and comic, as he had hoped the realized Tower would be.

Meanwhile he engaged on a task superficially opposite to that of delivering Khlebnikov's thought to the world. In 1922–3 he began to work on inventing or reforming the design of 'standard clothing' for men (cap, overcoat or jacket, trousers, shoes) and women,[85] a range of crockery, a bed 'of new construction' and five versions of a heating stove. In each case he was exploring new materials or processes with a view to economical manufacture and effective use.[86] Some of these designs were developed into prototypes and are essentially his own work; others he worked on with students and when such work was exhibited, as in 1923 at Ginkhuk, his students' names would appear alongside his own. A neat hand-written poster invited people to a lecture on 'Material Culture' Tatlin would give at Ginkhuk on 27 May.[87]

About that time Tatlin drew up a summary of what his department, originally called the Section for Research on the Construction of the Object, was offering:

1. New kinds of processing of materials.
2. New kinds of techniques for processing materials.
3. New kinds of construction of the object and its standardization.

As new objects resulted, the Section would give demonstrations and talks to explain them.[88]

Tatlin had always objected to 'isms', and Punin had expressed this in the titles he gave to articles in 1921 and 1923. It was in Tatlin's essay, 'Art into Technology!', reflecting on art's and architecture's relationship to technology, published in 1932 in the catalogue of the 'Exhibition by Honoured Art Worker V.E. Tatlin', that the artist directly attacked constructivism. The exhibition was primarily of *Letatlin*, his flying machine, but included representations of the Tower and of other works, alongside examples of his 'utilitarian objects'. In the essay he criticizes the narrow formal concepts limiting contemporary design, and argues for 'living, organic forms'. Working on these convinced him that 'the most aesthetic forms are indeed the most economical'. A note within the essay begins: 'The "Constructivists" in inverted commas', and soon after refers to ' "Constructivism" in inverted commas'. The constructivists, he asserts, inevitably 'turned into decorators or took up graphic art'. They had failed because they could not get beyond trying to link their capacities as artists to the needs of technology, while denying their artistic potential. They were fooling themselves when they called themselves 'artist-engineers'; his own specialization, he had written in 1923, was that of 'artist-constructor'.[89]

Meanwhile Tatlin had recreated his model of the Tower in a form that could be shipped to Paris for the Exposition of May 1925. It returned to Russia in 1926 and Tatlin offered it to the Russian Museum in Leningrad. It was exhibited but has disappeared since. Commissioned to make it at the end of December 1924, he worked on it with assistants in Ginkhuk, creating a smaller and in some respects clarified construction. Again we notice how his thinking is guided by practical considerations. The three-metres-high model would not need as many struts as the large one, so that the two spirals are more distinct and the

hanging units are seen more easily. Comparing photographs of the new model and the old suggests that the new one was more elegant, and raises the question whether, if constructed of steel as opposed to laths of wood, the great Tower could not indeed have had this grace.[90]

Another model of the Tower was displayed in Leningrad's 1925 May Day parade. This was a roughly simplified version, elliptical in plan to fit onto the back of a lorry, with thick struts supporting just one spiral, and no hint of the apparent inclination of the original model or of internal units and kinetic action. Built for strength and quick comprehension, it lacked the global and cosmic echoes, as well as the formal energies, the *élan*, of Tatlin's original. Since it was built by the assistants who had worked with Tatlin on the Paris model, we must assume that it had his approval.[91]

From late 1925 until the summer of 1927 Tatlin worked in Kiev. He then asked the rector of Moscow Vkhutein for a teaching post. He was warmly welcomed, given accommodation for his family in the Vkhutein building, and appointed to the Faculty for Wood and Metalwork (Dermetfak; previously Metfak, Faculty for Metalwork). Rodchenko and Lissitzky were his colleagues there. From 1930 on Tatlin taught also in the ceramic workshop. His subjects were 'Material Culture' and the creation of everyday objects. Some of his most remarkable achievements in this line date from the period from 1927, the years also when he turned from theoretical studies of flight to developing *Letatlin* as, he hoped, another everyday object.

Outstanding in his work on utilitarian products, credited to himself or at times credited to students working with him, are the Viennese Chair, the Sleigh, and the Babies' Bottles.[92] These last were white earthenware rounded objects not unlike a breast, to be sucked and, in time, held by the baby. Trays were designed and produced which could deliver ten such Bottles clipped onto them, or even thirty when three trays were joined together. They were evidently intended for large crèches.[93]

The Viennese Chair and the Sleigh were made of bent wood, that is, wood split along its grain, layered and glued, and bent permanently under steam pressure. This was the material and method employed from the 1840s on by the Viennese firm Thonet whose chairs, particularly, had become best-sellers around the world. Tatlin was drawn to the idea of using bent wood partly because steel was in very short supply in 1920s Russia, whereas wood was easily available and there were plenty of craftsmen experienced in its use. Also, wood is lighter than steel, and in conditions of extreme cold much safer to handle than metal. Thonet occasionally exploited the resilience of bent wood. Tatlin and his students made good use of it, reacting against the steel-tube furniture made in the West from 1925 on by designers such as Mart Stam and Marcel Breuer, who used the resilience of curved steel tubes in a few of their designs but otherwise saw them as rigid structures. Tatlin got his students not only to make it a characteristic function of bent-wood objects, but also wanted their organic nature to be revealed in their forms. We probably see his touch in the final version of the Babies' Bottles, remarkable for its refined and elegant form. Comparing reconstructions with the only known photograph of the Viennese Chair leads to similar conclusions. The London reconstruction of 1971–2 and the Russian one of 1986–7 were both made with a steel tube in the place of bent wood, resulting in heavy and rather clumsy objects where the original was light and graceful, and feels natural.[94] The Sleigh, also in bent wood, was made in two sizes and designs — the smaller rather more complicated than the more elegant larger version which may be Tatlin's. Both are now referred to as the Children's Sleigh. The

date is probably 1929 when the prototypes were illustrated in a Tatlin article on 'The Artist as Organizer of Everyday Life' in the Vkhutein journal. Tatlin here emphasizes the need for organic design to complement the human being who is to use the product.[95]

Tatlin reinforced these points in an article of the following year, 'The Problem of Correlating Man and the Object'. Tatlin foresees cybernetics: only close consideration of functions, in relation both to the user of any object and to the best materials and processes involved in creating it, will produce the objects called for by Socialist life. Imitation of Western designs, with their endemic class distinctions, will not serve. Russian industry needs artists' involvement if it is to rise to the new demands: 'It will be able to produce objects of high quality only when the artist-production worker takes a direct part in the organization of the object.' Artists have experience of a whole range of materials, their colours, strengths, textures, etcetera, and prove their alertness to new materials:

> Our way of life is built on healthy and natural principles and the Western object cannot satisfy us. We must look for completely different points of departure in the creation of our objects.
>
> Therefore I show such a great interest in organic form, as a point of departure for the creation of new objects.[96]

The article 'Art into Technology!', printed in his 1932 exhibition catalogue, makes some of the same points, but adds that using organic forms — still, according to Tatlin, at a primitive stage, especially where architecture is concerned — is something the artist is more likely to give his attention to than the engineer. Tatlin mentions his own progress in designing 'the architectural construction in honour of the Comintern' and a range of 'objects of everyday life', and now 'the flying machine . . . the most complicated form', intended to meet the need 'for man's mastery of space'. The artist's 'method of creation is qualitatively different from that of the engineer':

> I have come to the conclusion that an artist's approach to technology can and must pour new life into the outmoded methods which frequently ignore the tasks set by this period of reconstruction.[97]

It was here that he inserted his reference to 'the "Constructivists" in inverted commas'. By 1932 constructivism and productivism had become history. The authorities were relieved to see futurism countered by AKhRR, and gave this association increasing support during the later 1920s.[98] Other anti-modernist groups formed in the years following NEP, demonstrating their members' impatience with analytical methods and specifically with constructivism's rejection of artistic values and inspiration. In 1932 all groups were terminated by decree, and superseded by one Union of Artists charged with controlling artistic production.

As has been said already, some of the constructivists found vehicles for their energies and priorities in graphic design, photography and photomontage. Rodchenko was the outstanding example, while Stepanova gave much of her time to textile design as teacher, theoretician and practitioner. The Stenbergs produced a series of admired film posters, combining realistic photomontage with dramatic layout. Film itself, especially in the hands of Vertov and Eisenstein, had become an unexpectedly potent art form, adopting

constructivist methods for developing the raw material provided by the camera. Each film had to be constructed in the cutting room to fit its purpose. Photomontage was the essential link. Klucis (1895–1944), associated as a young artist with Malevich and Pevsner, claimed to have created the first Russian photomontage in 1919, combining blockish lettering and concentric rings with photographs of athletes to deliver an image of sport. That date has been questioned, but in 1920 he produced his well-known poster, *The Electrification of the Entire Country*, in which a photograph of Lenin, carrying a modern architectural structure composed of photographic fragments, strides onto a disk, an emblematic world. Klucis was delivering a Communist message through this new artform.[99]

The years 1920–21 had in fact seen the official role of Russia's avant-garde, still habitually referred to as 'futurists', more or less eliminated. In January 1921 Lunacharsky found it necessary to caution against letting the marginalization of the futurists turn into a 'witch hunt', but Brik could write later that 'the guardians of philistinism proved to be stronger and threw the "Futurists" out of all the commissariats.'[100] Russia's contribution to the 1924 Venice Biennale was the country's first appearance at that international art event since 1914, and the organizers hoped that Soviet Russia's new art would be prominent in it. A group of Malevich's suprematist paintings was sent, as well as one Tatlin relief (from the 'First Russian Art Exhibition' of 1922–3), and avant-garde paintings by Popova, Exter, Vesnin, Rodchenko, Stepanova and others. But they were not shown. More had been sent than could be accommodated, and this enabled the installation to present a conservative line while the catalogue continues to indicate a much more adventurous selection. The introduction to the catalogue emphasized that the Russian proletariat preferred art that was naturalistic and dealt comprehensibly with contemporary life.[101]

On 14 April 1930 Mayakovsky died by his own hand. It is said he committed suicide, though he was possibly playing Russian roulette. On 17 April his body went to be cremated, accompanied by a large procession. Tatlin designed the catafalque. Photographs of it are not very clear. It seems he partly clad a lorry in sheets of metal and built upon it an iron podium on which the draped coffin rested. That Tatlin should be given this role speaks not only of the two men's mutual regard but also of others' recognition of it.[102]

Why Tatlin did not want to be known as the Father of Constructivism is clear: the constructivists' view of how their work should develop and of their role in society was too narrow and he was distanced by their dogmatism. Why did they and bystanders see him as their Father? It is not easy today to imagine the impact the display of the Tower model made in Petrograd and Moscow. Punin's writings about it will have given weight to speculation of what Tatlin was preparing. The model, for all its physical limitations, exceeded positive expectations as well as misgivings. Old, familiar photographs of it still attract the attention of artists and historians. The very simplicity of the model, assembled and re-assembled bit by bit, made a telling contrast with his dream of a four-hundred-metre Tower.

Flight

I

Tatlin's ambition to create an apparatus for manpowered solo flight was noticed as early as 1912, when Khlebnikov remarked on it.[1] Tatlin may well have been thrilled in boyhood during 1898–1900, when Danilevsky presented in Kharkov what was called 'the first aircraft'; and he may have met the inventor personally.[2] Jyrki Siukonen, in a recent study of artists' contributions to the prospect and realization of human flight, pointed to a major impulse that almost certainly reached Tatlin.[3] In 1921 the Prix Peugeot was won in France by Gabriel Poulain with a man-powered flight of almost twelve metres. Poulain was a racing cyclist; Peugeot manufactured cars and bicycles. There had been other prizes for short flights and other attempts that started from the concept of a winged bicycle which would take off if pedalled hard enough and then continue flying by means of flapping wings with or without a propeller.[4] In 1909 an Englishman, William Cochrane, had won third prize with a design for a 'man-propelled monoplane with flexible wings and tail and two propellers, powered by a man on a bicycle'.[5]

Tatlin never doubted that his project should emulate bird and insect flight. The fact that bicycles were being produced in quantity suggested to him that industry could also produce a standardized flying apparatus. Man-powered flight became his main pursuit during his time in Kiev, from late 1925 until the summer of 1927. But already in 1923 he had spoken to Punin of how life would change once people could fly to and from work. They would no longer have to live close to their workplaces. In 1924 he talked more specifically about his concept of an organic flying frame, essentially different from the mechanical devices developed by scientists and engineers.[6]

Khlebnikov and Tatlin shared this vision. Khlebnikov had always had a keen interest in ornithology. His speculations about the architecture of the future centred on a range of semi-fantastic, semi-prophetic towers, with flying inhabitants and accommodation units transported by air. In 1928, as Tatlin's work on his flying machine moved towards its practical climax, two speculative proposals were published in Russia, for a *Flying City* by I. Iozevich and for a floating *City of the Future* by Georgii Krutikov, both assuming individual and group access to homes and other sites in mid-air.[7] By that time also, Ivan Leonidov (1902–1959)

had emerged as a radical innovator among Russia's most progressive architects with his schemes for the Lenin Institute of Librarianship (1927), for a Club of a New Social Type (1928) and his competition designs for a Monument to Christopher Columbus (1929) and a Palace of Culture (1930). These all included motorized aircraft and airfields, as well as masts for dirigibles, in association with steel-and-glass buildings. Leonidov 'had a great respect for Vladimir Tatlin — he very much liked his *Letatlin* flying machine', according to the architect's son.[8] Reporting on his 1932 interview with Tatlin, Kornely Zelinsky described his work as 'technical Khlebnikovism', an attempt to realize Khlebnikov's vision by design and manufacture. He claimed that this was an individualistic ambition, nothing to do with working for the community by communal means, though in fact Tatlin surrounded himself with assistants and with specialists of several sorts in pursuing it, and wanted to create an efficient apparatus for the benefit of all.[9]

The modern arts are full of the expectation and then the realization of mechanical flight, and often enthuse over the new dimension this would add to human experience. Moreover, around the start of the twentieth century, the arts exhibit a desire to break away from an inherited inclination to closed forms implying gravity and anchorage. Tatlin would have argued that mechanical flight, transporting human beings amid noisy mechanical efforts to overcome gravity, as well as pollution and the reliance on fuels that are expensive as well as difficult to obtain, emphasized our being earthbound and offered movement but no freedom, transport but no transports.[10]

Marinetti spoke of looking at things 'from a new point of view . . . I was able to break apart the old shackles of logic and the plumb lines of the ancient way of thinking'. Proust welcomed the aeroplane because it accustomed people to looking up, into the sky — encouragement perhaps not needed by ornithologists. Malevich, fascinated by aeroplanes, probably never flew in one but included summary images of them in his suprematist art, spoke of the Earth as seen from the air and made models of structures, *planiti*, for possible location in space. He saw flight as a step in the opening up of the cosmos he pictured in his suprematist art.[11] The notion of solo flight may seem to run counter to ideals of collective living, but the bicycle was leading people, especially urban workers, to form clubs and was associated with conviviality, and even with the spreading of Socialism. Individual flight could improve communal existence as well as answer the need for solitude. 'The air bicycle will relieve the town of transport, of noise and overcrowding, and will cleanse the air of petrol fumes'.[12]

Russia was one of the leading countries in researching, building and developing machines of flight: aeroplanes, including helicopters, and rockets. The names Tsiolkovsky and Igor Sikorski are prominent in that history, but Tsiolkovsky, particularly associated with research into rocketry, made immediate popular impact with his science-fiction novel, *Beyond the Planet Earth*, published serially in 1918 in the magazine *Nature and Man* and as a book in 1920.[13] There is reason to think that Tatlin met Tsiolkovsky, who was sceptical about man-powered flight but conceded that artistic intuition might succeed where 'the mere calculator' could not.[14] Official Russian interest in developing aeroplanes sharpened dramatically when Wilbur Wright brought his aeroplane to France in 1908 and when Louis Blériot achieved his celebrated flight across the Channel in 1909. Among the many notable Russians in Paris around 1908 was Lenin, writing his attack on the philosophy of positivism espoused by Bogdanov and others, between enjoying bicycle rides with his wife, touring the country-

side of the Île de France but also visiting local airfields and learning to appreciate different designs and the skills involved in operating them. He is said to have speculated on the role of aircraft in a revolution. Russian authorities thought of this too, and the police were ordered to supervise all flights. In the event, aircraft played no part in the revolutions of 1917.

From 1908 on, the Russian establishment worked hard to catch up with the pre-eminence achieved by the French. In 1909 the All-Russian Aero Club was granted imperial status to give additional force to its campaign to encourage training, exhibitions and public aviation displays, with an eye to the military use of aircraft. The year 1909 saw the first Russian flight, in an imported plane.[15]

Russian literature seized both on the realities of flight and on its spiritual implications and potential social role. Fedorov's vision of a world guided by brotherhood was fused with Nietzsche's exhortation to mankind to seize the powers available to it once the chains of superstition were sloughed off. Both Sologub and Bogdanov stirred readers with their tales of alternative states established in space. Sologub's trilogy *Legend in Becoming*, written in 1907–14, associated space travel with a spherical vehicle made of glass and steel. Bogdanov's *Red Star* was to be reached by egg-shaped space vehicles made of aluminium and glass and propelled by anti-matter. Khlebnikov's *The Crane*, part-published by the futurists in 1910 and complete in 1914, presents a nightmarish vision of a vast bird composed of city elements, including cranes and other machines, which turns itself into a vast aeroplane and causes a carnivalesque, partly Fedorovian, scene in which corpses are reborn.

Nietzsche's *Thus spake Zarathustra* was first published in Russian in 1898. The worker-writers of Russia seized on his words about the superman, 'an enemy of the spirit of gravity' who would 'one day teach men to fly', together with a host of literary and other influences. These ranged from symbolist dreams and metaphors to news of early aeronautics, from the very short experimental flights to the first extended flights such as Blériot's and, when Tatlin was pressing ahead with his work, to Charles Lindbergh's non-stop solo flight from New York to Paris in 1927. Many meanings could be attached to thoughts of flying: escaping physical limitations and the pressures and ugliness of urban life, which for workers could mean reconnecting with the countryside from which many of them stemmed. Wings might appear of themselves on the shoulders of workers engaged in the class struggle, as Gastev wrote in 1913 and his fellow Petrograd metalworkers could read in their trade union journal in 1914. Wings signified earthly powers serving the great social cause as well as spiritual liberation and a transcendental future for far-sighted individuals, and hence for the masses. Wings spelled an end to suffering and the opening of a new age. In poems by Platonov, published in 1922, they might be 'white wings' accompanying the procession to Golgotha, 'beyond which lay a new time when people themselves would fly, even to the stars and to the sun'.[16]

The Russian futurists often mentioned flight, as implying freedom of thought as well as extending human mobility. Many individuals of that generation associated themselves, in spirit and in aspiration, with the few active aviators they knew, and they honoured the historical forerunners of flight, especially Leonardo da Vinci. For centuries, men like Leonardo had striven to realize what everyone called 'the dream of Icarus',[17] the ancient promise of human flight that awaited fulfilment until the Wright brothers and their competitors achieved it and normalized it. Among these futurists was Vasily Kamensky (1884–1961), who hoped for fame as a writer but made his first career as a stunt pilot, acquiring a Blériot machine

and travelling around Europe to perform at aviation fairs, until he crashed close to railway lines during a display in May 1912. Malevich's drawing, *Simultaneous Death of a Man in an Aeroplane and at the Railway*, published in 1913, almost certainly refers to this event, as does the Kruchenykh/Matiushin/Malevich opera of 1913, *Victory over the Sun*.[18] Kamensky returned to Russia and during 1913–14 toured seventeen Russian cities with David Burliuk and Mayakovsky as, so to speak, a stunt futurist, puzzling and entertaining crowds in the streets and at poetry recitals. Advertised as the 'poet-aviator', he liked to parade the title of 'pilot-aviator of the Imperial All-Russian Aero Club'. In his lectures he presented flight as the ecstatic triumph *of* nature, not *over* nature, an organic step in evolution. His best-known contributions to the new writing are his 'ferro-concrete' poems in which letters, words and phrases are printed in a variety of typefaces arranged in plots divided by straight lines within the rectangle of the page. At once abstract and suggestive of meaning, his words and word groupings sometimes invite thoughts of travel in space. Some are entirely visual, others can be read to some degree.[19] He showed them in a 1914 Moscow exhibition arranged by Larionov. This included his assemblage *A Fall from an Aeroplane*. A heavy metal weight is suspended by a wire from a hook, and hangs an inch or so in front of a sheet of iron. On the floor is a red puddle, suggesting blood. A face has been painted on the weight, and the visitor is invited to make the weight hit the iron background and cause a thunderous noise — the thunder of joy that Kamensky felt at surviving the crash, according to Mayakovsky.[20] It is clear that flight, through flying displays with and without aerobatics, through poetry and science-fiction, and through daily news of innovations and mid-air dramas, was entertainment for the many who never expected to participate as pilots or passengers.

This new interest, popular as well as scientific, called for new words. In 1909 F. Kupchinsky proposed new terms for aspects of aviation in the Petersburg daily paper, *Novaya Rus* (New Russia), including *letatel* to mean pilot or aviator. The futurists naturally engaged in this too, notably Khlebnikov who published in the futurist booklet of 1912, *A Slap in the Face of Public Taste*, a column of neologisms incorporating the syllable *let*, signalling flight. In Paris, the same year, Apollinaire published 'Zone' in a collection of his poems with the same title, in which he presents Christ as a record-breaking aviator, flying higher than the others as he ascended into heaven.

Mayakovsky's poetry often sings of flight. Ever eager for travel, he used the best means available to him, cars, trains, steamers and also aeroplanes when possible in Western Europe. In June–October 1924 he flew to Mexico City and New York, Cleveland, Detroit, Chicago, Philadelphia and Pittsburgh, returning during November via Paris, Berlin and Riga. Younger than his colleagues, he presented an outgoing, pioneering image. Nature is not invoked in his writing, nor village life, nor landscape. He questioned the reality of peacocks and of roses:

> On the other hand, we find in his poems boulevards and squares . . . streetcars, bazaars, streetlights, the ribs of the roofs, the smoke of factories, tunnels, locomotives, automobiles, planes, bridges, trains and so forth.[21]

Even so, much of his best poetry is deeply lyrical: he 'was one of the supreme love-poets in the Russian language'.[22] The future Mayakovsky imagines in the epic poem *The Flying Proletarian* of 1925 is powered by electricity and keyboards, obviating physical labour; every-

one will have aeroplanes and streets will no longer be needed.[23] Even when he writes about the city, in 1913, Mayakovsky envisages a superior freedom: 'Like a graceful and light bird, man has torn himself from the earth and hovers in the clouds in his aeroplane'. And whereas in 1913 he challenges 'your poor old songs, capable only of making a man feel sentimental [when he should be] hard, brave, daring, the master of life and not its slave', in the end, withdrawing from *New Lef* in 1928 and dissociating himself from the ideas of his old friend Brik, he suddenly announces that 'I've granted Rembrandt an amnesty . . . we need poetry and song too, and not just newspapers'.[24] Khlebnikov travelled too, almost ceaselessly, disappearing for long periods as he wandered in Russia. He had no money and probably preferred to go on foot, a pilgrim in search of human diversity and common roots.

Tatlin did his major travelling in his youth and on ships, in the Black Sea and the Mediterranean. He presumably travelled within his country by train, and by train also to Berlin and Paris and back to Moscow, but he does not mention this. What he does remark on is sails and masts engaging with nature's forces. He marvels at the seagulls' ability to follow ships tirelessly, day after day, coping with strong winds as ships do but with less apparent effort. When the apparatus for 'aerial cycling' is ready, we shall 'have to learn to sail in it in the air, just as we learn to swim in water, ride a bicycle, etc.'[25] Many have commented on how his experience as a sailor shaped his life and career: his unusually economical lifestyle, with few possessions neatly stowed as they would have to be on a ship, and his obsession with masts and sails feeding directly into such work sequences as the sets and costumes he designed for *The Flying Dutchman*. Nicoletta Misler points out that the trees he drew and painted some years earlier for *Ivan Susanin* are like masts. They pre-echo the rising beam or spine of the Tower and reappear in the staging of *Zangezi* and Tatlin's later theatre designs. She writes that sails feature in Tatlin's work only rarely. I think they appear quite often, as themselves and metamorphosed into sculptural forms in his constructions and his stage sets, even into clothes — hinted at in the loose-shouldered sailors' blouses Tatlin liked to wear. And are not the wings of *Letatlin* activated sails?[26] The illustrations he drew for S. Sergel's book *On the Sailing Ships* in 1929 prove his knowledge of, indeed love of, such ships, their masts and sails, and ropes running over pulleys (fig. 79).[27]

Tatlin's reaction to aeroplanes was not that of the typical futurist, Russian or Italian:

> I want to give back to man the sensation of flight. We have been robbed of this by the aeroplane's mechanical flight. We cannot feel our bodies' motion in the air.[28]

Here too he was at one with Khlebnikov who, as a man of the future, was thrilled by the technological developments he foresaw or glimpsed the beginnings of, as against the machinery developed by nineteenth-century Capitalism. His imagination looked beyond the devices of the first machine age to immaterial, often invisible, forces such as electricity and broadcasting. 'Let air-sailing be one foot, and the gift of spark-speech the other foot of humanity,' he wrote in the proclamation 'The Trumpet of the Martians' in 1916, meaning flight and global radio and television. In *Zangezi* he associates flight with liberation and the arrival of spring. The first 'surface' or 'board' of *Zangezi* — meaning here something close to 'scene' — is that given to the birds: ten birds greet the rising sun with onomatopoeic exclamations. (The gods of all nations occupy the second 'surface'.) He saw attaining human flight as a necessary step towards the overcoming of death.[29] In a short poem

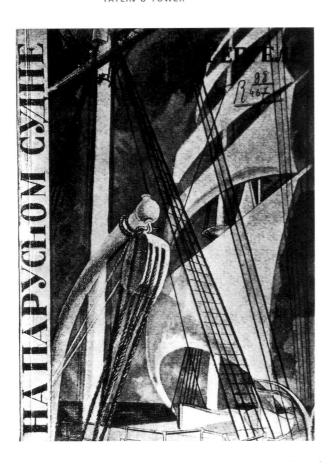

79. Vladimir Tatlin, cover of S. Sergel, *On the Sailing Ships*, 1929

'Liberty for All', published in the army newspaper *The Red Soldier*, he associated energetic flight with revolution: 'Like a whirlwind immortal, a whirlwind united, everyone follow freedom — there we go! People with the wing of a swan carry the banner of labour.'[30]

'Air-sailing' may well have come out of Khlebnikov's and Tatlin's conversations. Tatlin had started work on *Letatlin* before the end of 1924, the year in which Punin was especially moved by a conversation he had with Tatlin:

> It is difficult to convey the conversation, especially one that was so sharp and lively . . . Tatlin is charming — which is quite impossible to convey in a letter — and speaks with a beautiful, childlike and passionate intonation, sincere, always with a great thought of some kind — a miracle-child — a very tall man. . . .
>
> In passing, he spoke of the airplane, on which he appears to be working. [He criticized current inorganic design of planes and all the instrumentation they require; this means flying by science alone, out of touch with human sensations.] 'Why do they need to carry all their office stuff with them? . . . I will fly,' said Tatlin, 'in my own way, like I breathe, like I swim.'[31]

In Kiev Tatlin pursued research into the flight and anatomical structure of birds and insects, and he pressed this further when he moved to Moscow in 1927 and was teaching in Vkhutein. In 1929 he was funded by Lunacharsky's ministry to develop a workshop in the bell tower of Novodevichi Convent, the 'new monastery of the Virgin', founded in the sixteenth century in the south-western outskirts of the city but a museum since 1917. He was to engage former students of his as assistants. In 1931 Vkhutein was discontinued, and Tatlin was appointed professor at the Moscow Institute for Silicates and Building Materials which had replaced Vkhutein's Ceramic Faculty. That year he was awarded the title of Honoured Art Worker on the recommendation of Vkhutein's director. On 5 April 1932 a 'model' *Letatlin* — that is, the complete apparatus but without the silk that would cover its wings and much of the fuselage, screening the structure — was exhibited at the Moscow Writers' Club, and a literary evening was presented there in Tatlin's honour. During 15–30 May 1932 a Tatlin exhibition was shown at the State Museum of Fine Arts (the Pushkin Museum), consisting principally of three *Letatlin*s, of varying dimensions. The test-pilot Konstantin Artseulov, who, after a glittering

career as sportsman-pilot and flying instructor in the Red Army, had developed a special interest in gliding, wrote an article on Tatlin's apparatus, explaining its character and structural virtues, notably its elasticity. This was published as a pamphlet to accompany the exhibition, together with Tatlin's article 'Art into Technology!', and with other texts and two drawings for *Letatlin*.[32] The year 1932 also saw the publication of an essay on *Letatlin* which included 'something like a verbatim report' (according to its author, Isai Rakhtanov) of a speech Tatlin gave on 5 March. Birds don't fly by calculation:

> I was a sailor. Gulls flew behind our stern without getting tired. They flew three days and still didn't get tired. There was a storm, the wind reached an enormous force, but they didn't care, the worthy birds fly and don't get tired. . . .
> Birds are arranged more perfectly than aeroplanes. They're plastic in their construction, while aeroplanes are rigid. Birds have living, soft wings, while aeroplanes have dead, rigid ones.[33]

One of the individuals working with Tatlin in the Section for Material Culture in Ginkhuk during 1923–4 was Mariia Geintse. She was Tatlin's wife from 1921 to 1925, and they worked together after that period. A doctor and a surgeon, she was able to give scientific support to his research into the anatomy of birds and insects, including their microscopic structure. Tatlin also mentioned the well-known pilot and flying instructor A.V. Losev as a specialist consultant, and two former students, now 'colleagues': A.G. Sotnikov (who had worked on the Babies' Bottles prototype) and I.S. Pavilionov. Other former students were involved: A.V. Shepitsyn and A.E. Zelinsky. He and his team 'became the closest of friends'.[34]

In 'Art into Technology!', Tatlin wrote that the artist seeks 'new material relationships' when, as artist and not as engineer, he sets out to solve new design problems and thus lay the basis for further developments:

> Forms of complicated curvature require other plastic, material and constructive interrelationships — these can and must be mastered by the artist, whose method of creation is qualitatively different from that of the engineer.
> And so:
> 1. I chose the flying machine as an object for artistic construction because it is the most complicated dynamic material form which can enter into the daily lives of the Soviet masses as an object of widespread use.
> . . .
> 4. My apparatus is built on the principle of using living, organic forms. Observations of these forms led me to the conclusion that the most aesthetic forms are indeed the most economical. Work on the shaping of material in this direction is indeed art.[35]

We should note his solemnity on the subject of *Letatlin*. The name's construction is clear: *let*, flight; *letat*, to fly, overlapping with 'Tatlin'. The punning title signals his intimate identification with the work. We are told that none of the *Letatlin*s ever flew. We are also told that one of them flew a short distance, and elsewhere that one of them flew — we are not told how far or how long.[36] Early in 1932, Tatlin spoke to the doubting critic Zelinsky of the magnificent flight of birds, and added:

It is early to speak of the future of aerial cycling when the apparatus itself has not been tested. But in the spring we'll take tents and off we'll go, to try it on the hills. But besides this I should like to emphasize the aesthetic side of the matter. Here art is going into the service of technology.[37]

He and his friends made three *Letatlin*s, similar in appearance but with differences of detail, including their dimensions and weight and thus their support loads. The wing spans varied from 8 metres to '9–10 metres', their surface areas from 8 to 12 square metres, the weight of the machine from 32 to 36 kilograms.[38] No doubt these variations were thought crucial: finding the perfect ratio of carrying capacity to weight (apparatus + flyer) was the essential goal. Tatlin's recognition that the flyer should be recumbent, like a swimmer, and not hanging from the glider as did Otto Lilienthal, the ill-fated German pioneer of the 1890s of whom he was certainly aware,[39] presumably came early and may derive from Leonardo: it made for a much better aerodynamic form and enabled the individual to use his legs as well as his arms and thus to fly not a glider but, as Artseulov emphasized, an 'ornithopter: a flying machine with moving wings'.[40] Artseulov described the way the wings would be operated, which was to tilt and adjust their angle rather than to flap, supporting and directing the machine rather than propelling it. He went into some detail on its construction: the basket-like fuselage, the bent-wood wing spars with their 'high degree of resilience, the wing ribs, held in place by whalebone which moves without distorting'. He listed the materials employed: 'ash, linden, cane, cork, silk cord, Duralumin, steel rope, whalebone and even raw leather belt'; also ball-bearings for the major joints, and the silk covering. He said that attempts to fly *Letatlin* had so far achieved only '10m long jumps at the most'.

How close did Tatlin come to creating everyman's bicycle-for-flight?

When we are making as many *Letatlin*s as we now produce bentwood chairs, then children will have to learn to fly from about the age of eight. This age in humans roughly corresponds to two weeks in a bird's life. In all schools there will be flying lessons because by then it will be [as] necessary for a person to fly as it is now to walk.[41]

He was eager to stress the future normality of individual flight. It would be a commonplace activity; the necessary skill would easily be acquired and never forgotten. At the same time he believed his intensive work on *Letatlin*, combining scientific research and mathematical calculation with an artist's insights into nature and natural materials, would of itself benefit industry. Most of all, he wanted to emphasize that *Letatlin* was the work of an artist: 'I consider it aesthetically perfect . . . aesthetically complete', he told Zelinsky.[42]

Letatlin would be a magnificent sight. The wings, which clearly received the greatest attention, are entirely beautiful. They come close to some of Leonardo's designs for wings, but Leonardo never tested their efficacy.[43] Leonardo and Tatlin started from close observation of natural flight, to which Tatlin's team could add microscopic analysis. In 'Art into Technology!', Tatlin took pains to sketch his career path from 'the simplest forms to more complicated ones', rearranging chronology in order to make his point: he proceeded via 'clothes, objects of everyday life, up to the architectural construction in honour of the Comintern'. *Letatlin* is the climax of his post-Tower work. When he made the smaller model of his Tower for the Paris Expo in 1925, he was already working on it.

The symbolism inherent in *Letatlin* is self-evidently that which has always attached to the dream of individual human flying. In realizing mankind's age-old dream of moving through the air like a bird, *Letatlin* would invoke the winged deities of pagan times, notably Hermes/Mercury, swift messenger of the gods, and of the angels and archangels that were the courtiers and emissaries of the Judaeo-Christian god, and would accompany him at the Second Coming. The Tower would re-enact the Tower of Babel. Both of Tatlin's great artistic ventures belong to the long history of mankind as much as to modern times.

The noisy, polluting aircraft that were beginning to serve travellers, depriving them of the sensation of flying, were blatantly modern but only modern; their development was intimately linked to power and its application to war. Soviet military leaders were of course interested in Tatlin's machine — at the very least it might enable flyers to observe an enemy's defences and military dispositions. But they, and Soviet officialdom altogether, turned away from Tatlin during the 1930s. They came to see him as a visionary artist-inventor who had not achieved much in either role at the practical level. Tatlin's workshop in the tower of the former Novodevichi Convent closed in 1937. Lunacharsky had ceased to be Minister for Education in 1929, but Tatlin's standing and known activity enabled him to retain the ministry's support after the minister's departure. After 1937, Tatlin's public work was almost exclusively for the theatre, while he re-established his private career as painter and draughtsman. His paintings and graphic work, including his theatre designs and the models he made as blueprints for his stage sets, are of the highest quality and exhibit his particular sensibility for materials. They have not received the attention they deserve. Again, there is the thought that we are witnessing an artist in decline because he is neither sought out by the authorities nor working in open opposition to them. In fact, his stage work increased markedly during his last decades, even though some of it met with criticism. Moreover, in January 1953, just weeks before his death on 31 March, he contributed to a conference on non-rigid-wing flight at the Zhukovsky Air Academy.[44] He was still admired by many; his thinking, in which the visionary fused with the practical, the functional with the beautiful, was still valued. His ashes were given an honourable burial in the cemetery of Novodyevichi Monastery where Gogol, Chekhov and Mayakovsky lie, and Skryabin, Prokofiev and other leading artists and architects.

*

Did *Letatlin* also convey Christian symbolism? A flying apparatus is not site-specific; a bird-like apparatus speaks of flight to everyone, and although it might open up a cheering view of tomorrow, it does not directly address the future. Tatlin was developing an invention promising all sorts of use and expression but lacking the Tower's double function as monument and as government building. During the 1920s and early 1930s he was teaching what he was also developing in practical terms, and his own students could go on to form part of his working team. Yet it was a relatively discreet programme, silent, while his work on the Tower had been publicized by Punin. Did officials demand secrecy? The *Letatlin* exhibitions in April–May 1932 seem to have come as a surprise to almost everybody. It was impossible for the interested public of 1920–21 not to have sensed some of the references built into the Tower, most obviously that to the Tower of Babel, just as they must have seen that the proposed structure would offer a total contrast to the city and its culture. Many of

them shared expectations of space travel and were attached to Fedorov's prophecy of the Earth as tomorrow's cosmic voyager. The Tower's probable intended location, over the Jordan hole traditionally cut through the ice of the Neva each January, will have borne the message of the Third Dispensation, the Third Testament, and of the Forerunner's role of issuing in this joyful New Age. Mankind has always longed to be able to fly. *Letatlin* derives from nature's flying creatures. That would seem to cover it.

To prepare readers for what follows here I must introduce them to a book I recall reading in boyhood with some excitement and which used to be both popular and respected in Europe and America as well as in Russia: Merezhkovsky's book about Leonardo da Vinci. Merezhkovsky has already been mentioned as the leader, the instigator even, of Russian literary symbolism. His position was that of the Christian who, in the face of rationalism and positivism (Auguste Comte, Herbert Spencer, John Stuart Mill and Darwin), embraces his religious faith publicly in order to counter its erosion by philosophy and science. He embarked on a trilogy of historical novels in 1893, and worked on them for over twelve years. The trilogy's title is *Christ and Antichrist*. The individual novels tell of Julian the Apostate (1896) who, in the fourth century AD, used his power as Roman emperor to promote paganism and repress Christianity; of Leonardo (1901) and his life and work in Italy and France, as the finest artistic and intellectual flower of a Renaissance which Merezhkovsky still hoped Russia might somehow emulate; and of Peter the Great and the son, Alexei, he murdered (1905). Merezhkovsky's ambition was to reconcile ancient paganism's celebration of the body and of earthly life with Christian values. Of the three volumes, that about Leonardo has frequently been republished in many languages and with diverse titles. Even in Russia it exists under alternative titles, the artist's name, sometimes followed by *The Return of the Gods*, but also as *The Forerunner*, presenting Leonardo as the cardinal figure between two cultural epochs and as an echo of the Forerunner of Orthodox devotion. Owing to censorship, early printed texts of the book varied, and translated versions were often based on a French edition. I have by me an English translation by Bernard Guilbert Guerney, done (we are assured) from the complete, unbowdlerized Russian text, titled *The Romance of Leonardo da Vinci*, subtitled *The Gods Resurgent*, and published in New York by Random House in 1931. It is reasonable to assume that Tatlin knew the Leonardo volume.

It is a dense book, rich in major and minor characters and locations: from the Medicis' Florence to the Sforzas' Milan, to Rome and a succession of popes, to the village of Vinci and Francis I's Amboise. We meet high-minded humanism and the greed for antiquities, religious fundamentalism in the preaching and also in the persecution of Savonarola, philosophy coming up against superstition, and sex and violence next to courtly pomp and civic dignity. Amid all this, Leonardo is the wise witness, often silent, tall, soft-bearded and gentle of mien, a Christ-like man who smiles rather than laughs and is capable of sternness, but is above all busy: nature's forms and forces, war engines and fortresses, the long worked-on *Last Supper* in Milan and the great equestrian statue of Ludovico Sforza, never completed, drawings and paintings named and unnamed and, always, the flying machine as an ongoing project. From childhood on, Leonardo had been fascinated by wings. To give wings to mankind he studied those of insects and of birds, but wings meant to him not only a new power but also a new freedom which he associated with men 'becoming even as the gods'.[45] Assistants of varying character and abilities crowd around him. One of them, Astro (a short form of the name Merezhkovsky gave him, Zoroastro), against Leonardo's

wishes tests the unfinished apparatus, crashes it and is a partial cripple ever after. Talk, inside and outside the studio and workshop, touches on the flying machine as a central programme, condemned by some as witches' work, eagerly awaited by others. There is mention of a drawing made from a Greek icon of 'John the Winged Precursor . . . a man with gigantean wings'.[46]

In 1515 Francis I became King of France, and set out to reconquer Lombardy. He also wanted to collect Italian scholars and artists. Leonardo went from Rome to Pavia where Francis held court. For a celebratory banquet, the artist fashioned a mechanical lion which walked down the hall towards the king and reared up, opening its chest to spill out white lilies, the emblem of France, at Francis's feet. Leonardo accepted the king's invitation to come to France, and to live in a small chateau near Amboise on a good salary. Early in 1516 he arrived there with two servants and two assistants, including Astro. The last 'book' or section of Merezhkovsky's novel is entitled 'Death — The Winged Precursor'.

Leonardo, now in his mid-sixties, paints a mysterious picture of Bacchus. We are told it was stimulated by the *Bacchantes* of Euripides, where the effeminate beauty of this smiling, youthful god is emphasized and his teaching of joy through inebriation. But also that Leonardo was reading the Bible, the Song of Songs and, in the Gospels, Christ's words about the 'true vine', including, in John VII, 'If any man thirst, let him come unto me, and drink'. With *Bacchus* still unfinished, Leonardo begins a curiously similar picture. Here another seductively beautiful youth sits, smiling ambiguously. This one's loins are clad not in a doe's skin but in a garment of camel hair, and he holds not a thyrsus wreathed with vine leaves but a reed formed as a cross. He is St John the Forerunner.

Leonardo's last energies have gone into these paintings when Astro reminds him of the great unfinished project. Gravely ill and weak, Leonardo insists on getting out his notes and drawings for the flying machine. He is impatient with them and makes new calculations, finally crossing everything out and crumpling up the papers. Helped to his sick-bed, he will not leave it again. As he feels life ebbing, he asks for the priest . . . and we are left uncertain whether Leonardo, who had lived without religion, decided to accept the Last Rites out of conviction or to reassure those around him. At the last, a swallow he had found nearly dead, brought home, nursed and tamed, flies into his room from the workshop below, settles on Leonardo's hands for a few moments and then suddenly soars and flies out through an open window 'into the heavens, with a happy cry'.[47]

Merezhkovsky's last pages introduce a visitor from Russia, young Eutychus (Evtikhy), a clerk in the train of the Russian envoy to Rome, come to Amboise to learn the French king's plans but also to visit Leonardo in his chateau. The book now focuses on Eutychus. Leonardo has died. The young man, given access to the great man's workshop, stops before the painting of the Forerunner and at first mistakes it for the image of a woman. He realizes his error, seeing the cross and the camel-hair garment, but is haunted by the seductive power of the half-naked youth. Returning to his room at the end of the day, he sets to completing a painting of his own, an icon of the 'Winged Precursor' in the Orthodox tradition: a standing man, bearded and with 'the gaze of an eagle', his long emaciated limbs as light as a bird's, while from his shoulders spring two great wings, snow-white on the outside, gold on the inside. Eutychus needs only to finish their gilding. As he works, they remind him of the wings made by Daedalus and of what he had heard and seen of Leonardo's flying machine. But now also, between him and his icon there hovers the image

of 'the mysterious Youth-Virgin . . . pursuing him like a possession'. He tries to pray; he dares not attempt sleep. He turns to reading, yet again, the legend of *The White Hood*, which prophesies 'the coming grandeur of the Third Rome, of "Jerusalem, the New-begun City", of the ray of the rising sun striking the seventy cupolas of the universal Russian temple of Sophia of the Wisdom of God'.

At last he sleeps. In his dreams he sees St John at the head of a host of prophets and saints, but now with the face and long white beard of Leonardo. Beneath them, he sees Russia with her golden cupolas, her fields and rivers, all joining in celebration of Sophia. He wakes. It is early. The swans on the Loire are calling to each other and, as the sun appears, white pigeons fly up from a nearby dovecote. A ray penetrates Eutychus's room to fall on his icon, and he picks up a brush to complete it, inscribing on the scroll in the Baptist's hand the Bible's prophetic words, 'Behold, I will send My Angel, and he shall prepare the way before me . . .'

A people devoted to the Orthodox faith and to honouring St John the Baptist as the greatest of male saints — often represented as a winged figure like a great archangel — will not have been slow to sense that, with wings, they would themselves be like angels, like Forerunners opening up a better world. The vision of solo flight was on the brink of being realized, with men and women in their ornithopters perhaps drawn up to a starting height by powered aircraft, perhaps launching themselves from hills close to Moscow, in flatland Leningrad even flying from and around Tatlin's Tower. Rodin's *Tower of Labour* was to have been topped with two large winged figures as 'an allegory suggesting triumph'.[48] The upper parts of Delaunay's painted Eiffel Towers swarm with little rounded clouds like adoring putti. Today hang-gliding comes close to what Leonardo and Tatlin envisaged.

II

'I knew Tatlin', Shklovsky wrote in his 1977 memoirs:

> He resembled the sailors of the revolution — of sturdy build, huge hands, splendid singing voice — he played on instruments of his own making. With what passion and calm he looked forward to the future![49]

On 17 August 1926 Punin wrote to the poet Anna Akhmatova, presenting a more complex portrait of his friend:

> Tatlin came to see me, and we had a peaceful conversation; he was asking after you. I had started working in the Russian museum again, and want to open Tatlin's room there. What a light feeling one has when talking to Tatlin after Malevich: simple and direct thoughts; what a feeling for art. I especially like this sense of art when I meet it in people, and I have rarely met it in such a harmonious state as it exists in Tatlin. But his oddness hasn't lessened from the way it was. Imagine, he quarrelled with Taran; he had started a quarrel with him, and he tends to blame me for the fact that Malevich is going on a business trip. And yet he is a suffocated person, either

because the times strangle one, or because one just cannot invent without feeling strangled — I don't know. . . . But I love the tenderness of his gesture, his eyes and voice — he is one of the most charming people of our time.[50]

In his partial memoirs, 'Department No.5', written in the 1930s, Punin called Tatlin one of the *arbitri elegantarium* (judges of quality) in the 'epoch of industrial Cubism'. He was often at Tatlin's flat from 1916 on, and witnessed his friend's influence at that time and subsequently: 'Much of what, in the period of war communism, became the artistic/political policy of IZO Narkompros, came from Tatlin's major principles'.[51]

The painter Tatiana Litvinov was born in England in 1918 of an English mother, Ivy, and Maxim Litvinov, and now lives and works in Hove. Her father had been sent to London by the new Soviet State as an official representative (until Stalin removed him from his Foreign Affairs department). Tatiana knew Tatlin in the 1930s. Her mother, a writer interested in the arts, had formed a friendly relationship with Tatlin around 1931. Tatiana recalls that he gave Ivy a volume of Khlebnikov's poems. Mother and daughter enjoyed these greatly, partly for their oddity (Tatiana recites *Laughter* from memory) and the mind-expanding use of words and hints of meaning in many of them. As a teenager, Tatiana wondered whether she might not be a writer too or whether she should follow her liking for art. An early sight of Cézannes and Matisses from Shchukin's collection had left a deep impression, and she had got to know the artists Vladimir Favorski, famous as an illustrator and printmaker, and Favorski's former student Andrei Goncharov, both of whom encouraged her to study art. She and a girl friend meanwhile decided to get to know Tatlin. In 1934 they had seen, in a second-hand bookshop, a book that illustrated some of Tatlin's early stage designs, and were thrilled by them. They called at his apartment; he was out and so they left a note giving their first names and telephone numbers. He responded by asking them to come again, which they did, together and then, in time, Tatiana visited him by herself. Tatlin drew her in 1940, a young woman, seated in a wooden armchair, seen more or less frontally as she looks to her right, her head shown in three-quarters profile. There is another drawing of a young woman that could possibly be of her, done two or three years later. The earlier drawing is gentle, even tentative. The second is robust, with firm hatching to establish a rounded form.[52] Tatlin asked the Litvinovs to look after a *Letatlin* wing when he had to clear his workshop in the Novodyevichi Monastery. It hung for a while over Tatiana's bed, an imposing but benign presence: she says she felt 'sheltered' by it.

She remembers Tatlin as a strong and kind man, humorous at times but serious about his work. Exceptionally deft with his hands, he was working on stage sets, and at times she assisted him. When he spoke to her about work of this sort, or about painting, which she was studying formally with Goncharov, he would always emphasize the need to use the right materials with intimate knowledge, letting their character command the result, and particularly the importance of taking elaborate care of paint brushes. If she wanted to paint in gouache on wood, the panel had to be prepared in a particular manner he had learnt from icons. She says she wheedled him into going painting out of doors with her, from the mid-1930s on, but she did not know of the studio paintings he made then and later; no one did. Tatlin had always been secretive about his current work. After Germany's invasion of Russia in the summer of 1941, the Litvinovs left Moscow for Kuibishev on the Volga and Tatlin was evacuated to the Urals where he got some income from picturing sexual organs

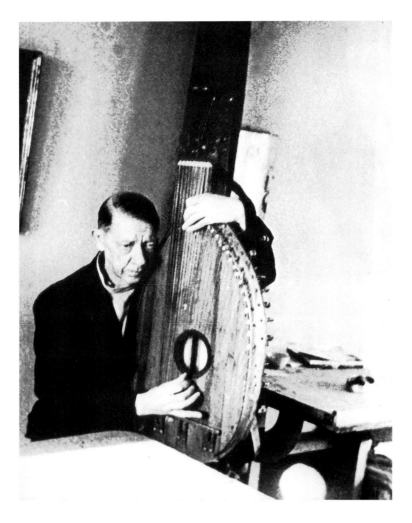

80. Vladimir Tatlin playing the bandura, 1940s. Private collection

81. Vladimir Tatlin, c.1912–13. Collection of the State Mayakovsky Museum, Moscow

82. Mosej Nappelbaum, photograph of Vladimir Tatlin, 1930s. Collection of Museum of Modern Art, Oxford

damaged by venereal disease, for display in the local clinic. He and Tatiana met again after the war, by which time she was married to a sculptor.

A photograph of the artist in the 1940s, playing the bandura, may show a disappointed man in his fifties or absorbed by music that is itself melancholy; perhaps both (fig. 80). Two world wars cost Russia dearly. Tatlin's own son had been killed in the second of them. There was the adventure of being prominent in the world of avant-garde art, and suddenly becoming a key figure in the reformation, management and teaching of art under a ministry of culture which encouraged him to conceive and develop the famous Tower and the flying apparatus he named *Letatlin*, and then the years of relative obscurity in a State now openly hostile to his priorities. The bandura he is playing is not the one he used in Berlin in 1914. A photograph of 1912–13 makes a striking contrast, showing him aged around twenty-six, a positive young man, intelligent and active (fig. 81). The features are those of the self-portrait called *Sailor*, except that here his eyes look sharper, his mouth and chin more determined. Another undated photograph shows him a few years older, in his early

thirties perhaps. One feels he is in friendly company though no one else is in the shot. He is dressed quite casually, has a long clay pipe in his mouth and is about to pack it with tobacco from an English 'Old Holborn' tin. Zhadova's frontispiece is a photograph she dates to the 1930s and which Milner also illustrates and dates 1934 (fig. 82). It shows a more mature version of the man in the preceding one: his determination is more pronounced because he looks directly at us (in other words, at the camera). There is a cigarette in his mouth; one guesses that he smokes a lot, even when working with his hands. These are very prominent, resting on his thighs for a moment. This man gets things done.[53]

In the photograph of Tatlin working with his assistants on the Tower model in 1920 — from which Lissitzky took his image of Tatlin at work — we may notice that he is somewhat older than they, but not distinguished from them otherwise. All the men are wearing working clothes, their sleeves rolled up. Tatlin's attention is not on the camera but on his interaction with Shapiro who is fixing a horizontal strut to the vertical one Tatlin is steadying — an action that must have been repeated many times in building the model. Our frontispiece is a photograph of Tatlin, possibly made the same day, showing him in front of the model. He is thirty-four, close to the age that many men see as the apex of their life-time, and looking 'forward to the future', to echo Shklovsky. He will reach the age of thirty-five while his model is on show in Petrograd. Malevich was thirty-five in 1913, the year, he claimed later, of suprematism's birth.

Photographed in 1923, between performances of *Zangezi* and among his friends (fig. 83), Tatlin looks positively boyish though there is also a touch of 'I am the captain of this ship' about him. They all look fairly young, and that includes Nikolai Punin, now in his mid-thirties and seated front left, wearing a hat and looking quite cosmopolitan. Nearly ten years later we see Tatlin holding, and looking up at, a skeleton wing made for *Letatlin*. He is in his Novodyevichi workshop. His face is inexpressive, peaceful, in shadow. His left hand holds the wing, and he gazes up at it, a remarkable creation more than twice his own height. He looked similarly peaceful, perhaps satisfied, when photographed standing in front of the completed Tower model in Petrograd in 1920.[54]

*

Hindsight makes it hard to see Tatlin's career path with the amazement it warrants. His mother's early death and the difficulties occasioned by his father's second marriage deprived him of a secure childhood and youth. Choosing to be a sailor distanced him from his father physically and professionally, and allowed him to earn money. But something else must have led him to make this choice. His periods at sea occupied years and were evidently important to him. We can only guess at skills developed in this occupation, and to what extent he was drawn by the experiences that travel — combining freedom with regulated employment — would offer. Meanwhile, the trained artist produced drawings and paintings, but soon combined this relatively individualistic work with stage design and occasional illustrations, requiring him to engage both with the themes and wishes of others and the demands of publication or performance. At about twenty-eight, he began making the pictorial reliefs which rapidly developed into a new art form that was all his own, using mostly found materials, a step towards the principles on which his further work and his teaching would rest. At first his stage designs were better received than his constructions. In 1917, before October, he became a leading figure in artists' unions in Petrograd and Moscow. In the same months he was approached by Meyerhold and Khlebnikov with proposals for collaboration. Khlebnikov's relationship with Tatlin was already deep. He had written his poem about Tatlin in May 1916. In 1923 Tatlin would produce Khlebnikov's 'supertale' *Zangezi* in homage to his recently deceased friend.

In 1918, as head of IZO in Moscow, struggling to realize Lenin's programme for monuments to Socialists and Socialism, Tatlin found himself obsessed with the need to invent a new type of monument, not honouring individuals but celebrating the Revolution itself. This, he soon determined, would have to be on a colossal scale, not just the largest building on earth, but, with its change of purpose and name in 1919, both a monument to October and the headquarters for the propagation of global Communism. It would enhance the authority of Petrograd while refuting the imperious message of the city's architecture. It would rise, a dynamic construction over the city's winding canals and the low-profile residences along them, painted in pretty colours, most of them built during the neoclassical period. Nonetheless, Petersburg/Petrograd was until 1918 the capital of a great empire, with imperial palaces along the Neva, the Admiralty as the focal point of grand avenues, and statues of its rulers as milestones in its short but dramatic history.

Tatlin's mental step from producing statues of the historical heroes of Socialism, and a few abstract monuments, to dedicating himself to the monument that would be his Tower,

83. Vladimir Tatlin with *Zangezi* team, 1923. Collection Russian State Archive of Literature and Art (RGALI), Moscow

is a more significant one than even enthusiastic commentators have noted. Statues present their subjects in the stillness of death. Lenin no doubt hoped that his programme would give them some semblance of living for the new society, and that it might even exaggerate their energy and passion, but stillness would haunt even them. Most of the sculpted images were more blatantly dead than old photographs for the very reason that the restrained naturalistic idiom inherited from nineteenth-century statuary never succeeded in conveying a living image. There is no hint that Tatlin thought even briefly of making propaganda statues himself. His imagination fastened on a monument that would celebrate the Revolution as a public miracle pointing into the future, full of light and movement, and even hinting at mankind's overcoming of death itself.

Yet a monument referring only to the future could be a cold and artificial creation. Tatlin wanted it to echo aspects of biblical history and Orthodox piety while hinting also at the possibility of cosmic exploration. From Babel via the Eiffel Tower to Tatlin's astounding concept: there is nothing in the history of art and architecture to equal it, though it stands beside Khlebnikov's intense exploration and development of writing. Both men bestride the world like colossi — not merely the Russian world. Tatlin's ambition, leaping from making his innovatory sculpture to working on this extraordinary project, reflects his ambition for art in the context of a new world more than any evident urge to self-aggrandizement.

There follows his attention to smaller, more immediately practical, everyday objects, including that second personal obsession, the flying apparatus that he worked on for most

of a decade and hoped to see produced as another everyday object. *Letatlin* too would be a kind of monument to the Revolution, to the physical and mental liberation it promised, and not a unique object in a particular location but everywhere. His prototypes for industrial production had convinced him of the superior virtue of organic design — of which contemporary engineers seemed unaware — and he associated this understanding with his particular nature as an artist-poet and not the impersonal artist-engineer the constructivists want him to be. Their desire to denounce all art and aesthetics in favour of strictly rational engineering made it necessary for him to dissociate himself from them.

One element is essential to both his great ventures: space. As Tatlin told a meeting of Inkhuk in 1921: 'I look upon the sky as concrete material.'[55] His constructions had at first played real and illusionary space against each other, extending the painter's attention to the space of the motif before him and the space-making effect of brushstrokes, colours and design, but he quickly abandoned illusionism to set his material elements into real space with increasing boldness, until some of them, notably the *Corner Counter-Relief* of 1914–15, a cluster of metal forms held in mid-air by cords and cables, delivered a new form of sculptural art which today would be called an installation. In his 1920 account of the Tower, Punin stressed that its form 'provided an escape from the earth along the tightest and speediest lines known; it is full of motion, aspiration, flight'.[56] Tatlin's Tower is made of space as much as of metal and glass. One could argue that its most evident component — as a model, but much more so as a structure four hundred metres high at the heart of Petrograd — is the space it penetrates without being divided from it. Space and the sky are preconditions for flight, and man-powered flight would turn them into a human domain. Both projects involve also movement and, therefore, time. In the Tower, time would be involved physically in the turning of the units and in the movement of vehicles and individuals. The entire structure expresses the modern desire to refute gravity, referred to in part I of this chapter. As Punin reported in his article on the Monument to the Third International of June 1920:

> The form [of the Tower] strives to overcome the materials and the force of gravity; . . . the form is searching for the way out along the most resilient and dynamic lines the world knows of — the spirals. They are full of movement, aspiration and speed . . .[57]

In 1931, mostly in recognition of his work in the art schools, Professor Tatlin was given the title of 'Honoured Art Worker'.[58] In January 1933, speaking at the Moscow Artists' Club, he said he intended to return to making 'architectonic constructions' and to stage design,[59] and there followed a long series of stage works, occasional illustrations and, for his private satisfaction, strong naturalistic paintings. When avant-garde artistic programmes and adventures were vetoed under Stalin, Tatlin could still find backing for his flying apparatus, presumably because a successful product would have military applications. Some critics at the time accused him of reneging on his true role as artist. His answer was to point to the beauty of what he was making and its source in study of nature's organic processes as evidence of his deep attachment to art. From this came his advocacy of an attitude to form and materials which would advance both art and design everywhere. Nonetheless, he insisted that *Letatlin* would fly.

Tatlin can never have been in doubt about the form his flying apparatus would take. It would have to be organic design, derived directly from nature. His awareness of the legend of Daedalus and his admiration for Leonardo will have given a humanist dimension to his observation of seagulls flying around and behind the ships he served on. The basic concept of *Letatlin* was given as he worked towards a more or less foreseeable goal, bird-like extensions big and strong and light enough to enable human beings to fly. The problems he was wrestling with were technical, and brought out aesthetic qualities in the process of solving them. In becoming bird-like, mankind would achieve an aspiration deep and timeless enough to seem inevitable, a physical development parallel to the development of consciousness others foretold. Khlebnikov, poet and ornithologist, could contribute to both aspects, the legend and the physiology. I believe that the wings of St John the Baptist, whose life was dedicated to introducing mankind to a new epoch, were also in Tatlin's mind. The winged Forerunner of the Orthodox Church was part of every Russian's mental store. People flying confidently would in some measure *be* the Baptist, but where St John was announcing the Second Age of the god-man, they would be enjoying the Third Age of mankind-as-god, of universal peace and infinite collaborative power in a manner foreseen by the ancients' dream of a Golden Age.

The Bible's Tower of Babel played a similar role when, impatient with the regressive character of the monuments Lenin's programme had called for, and the imaginative poverty of almost everything it promoted, Tatlin was seized with the urge to create his monument to the greatest moment in human history. The French Revolution had its national monument in the Eiffel Tower. The closest to an international monument promising brotherhood was America's Statue of Liberty, placed to welcome immigrants to the republic. Tatlin had this nineteenth-century figurative statue, almost a lighthouse, to start from, and perhaps some speculative images of the Colossus of Rhodes, the Pharos at Alexandria and the Tower of Babel, as well as Eiffel's steel tower close to the heart of Paris, still a relative newcomer when Tatlin visited it in 1914. Its mighty engineering image was well complemented by the engaging slightness of the ferris wheel rotating to its south. So, a tall abstract feature without any practical function, a tall motherly figure promising hospitality, and a vertical roundabout, like a vast bicycle wheel. As his desire formed to celebrate the Revolution in commensurate terms, Tatlin decided to harvest the ancient and the recent past in order to embrace both and outreach them all. The new world he was helping to initiate required him to question everything, even the assumption that towers had to be upright. No: angle this gigantic new building purposefully towards the Pole Star to indicate the next stage in human evolution. Both the Tower and *Letatlin* promised a new viewpoint, loosening mankind's bonds to Earth while implying new powers over it. But if *Letatlin* is self-evidently descended from Leonardo's attempt to develop a bird-like flying frame, and is thus a contribution to a long history, Tatlin's Tower, as he modelled it, is a personal innovation. It would be the first building to display its practical functions in a structure exposing also the logic of its material elements — wood and paper in the model, metal and glass in its potential realization.

We know Tatlin's respect for and intimate knowledge of materials: his springboard and his inspiration. It is not difficult to find in aspects of his reliefs and counter-reliefs the first signs of his thinking about the Tower, most obviously in his immediate emphasis on three-dimensional form coming out into real space, his use of metallic elements in relationships

that declare the way in which they are assembled, his reliance on rods, cables, etcetera, reaching out from his sculptural nuclei to suggest a cluster hovering in space: always the reaching out, the going beyond the apparent borders of his concept, to signal energy and aspirations and embrace space and time, in accord with his personality and the spirit of the new world whose birth he was witnessing and aiding. In the case of *Letatlin*, research and physical effort centred on finding and refining the most suitable materials. That study, and the long business of shaping and testing the materials he decided to enrol in this project, must have been almost the opposite of the labour required by his Tower. The immediate problem here was to build something that would carry his vision by means of the banal materials available to him. *Letatlin* called for not a model but successive attempts to realize the thing itself, in actual materials discovered through trial and error. The ornithopter's dimensions were dictated by those of human beings. Like the aeroplane designers of subsequent generations, he will have found the look of what he was making announcing its efficacy: he had no way of checking it by means of close calculations, nor did he have successful precursors to learn from.

Tatlin learned his distrust of 'isms' quite early. When he and his friends pursued non-academic life drawing as a discipline, cubism was the international magnet and fashion. Progressive artists looked for ways of interpreting the figure that could be seen as a response to cubism. Tatlin's were the drawings least touched by this vogue. They soon become lines on the surface of his paper, not treating it as a visual space within which three-dimensional forms might be displayed. His drawings became rhythmical and fluent, closer to the icon paintings of Rublev and his school than to anything to do with cubist fragmentation and re-assembly or with futurist attempts to capture the multiplicity of experience. Self-evidently modern, Tatlin's drawings are out of step with the march of modernism. After his very first known works, paintings done in an international idiom combining features of impressionism and of fauvism but exhibiting also a personal sensitivity to paint as a material, Tatlin's art rapidly became stylized in a manner that owes more to icons and to the folk art of shop signs than to any modernist 'ism'.

His interest in Picasso's still-life assemblages drew him to Paris. Aged twenty-eight, he may have sensed that he had come to a turning-point in his work. He did not return to Russia a cubist or any other 'ist'. Soon after his return, his display of 'Syntheso-Static Compositions' demonstrated a new view of art and new methods, but neither a style nor the realization of any stated theory. That December one of his reliefs, probably the one known as *Bottle*, caused a scandal. By then the First World War was in full flood and cultural interaction between Russia and the West had ceased. After *Bottle*, the pictorial reliefs do not refer to Parisian prototypes but develop independently, each one a discrete adventure, before reaching a degree of continuity with the counter-reliefs and corner reliefs of 1915. Punin's comment that 'the influence of the Russian icon on Tatlin is undoubtedly greater than the influence upon him of Cézanne or Picasso' could reflect a decision Tatlin took after making *Bottle*. (Malevich's decision, in 1915, to turn to the entirely un-Western vision of his suprematist paintings, may have sprung from a similar wish for dissociation.) After the war ended, reactionary tendencies became dominant in Paris and other Western centres, but not yet in Russia where the revolutions of 1917 enabled progressive individuals and groups to function openly, dominate the art scene for a time and aspire to influencing the shape and priorities of a new society.

The reliefs of 1913–16 take Tatlin from assembling pictorially a variety of common materials to constructing counter-reliefs in which clustered metal forms are sustained in space. The non-pictorial reliefs tend to centre on a knot of discrete but interlocking elements set at angles to each other to assert their three-dimensionality.[60] This method is essentially different from that developed by Gabo during 1916–17, which delivered the outlines of figures in the edges of his projecting planes which in themselves are passive.

An element Tatlin introduced after the *Bottle* relief is the off-vertical axis. Like the spiral, it is a line of energy. The off-vertical thrusting axis became, after the Revolution, a declaration of social optimism and energy in Tatlin's design and model for the Tower.

The Tower design that we know, from the drawings and from photographs of the large and small models, was developed in terms of the available materials. The man who placed so much emphasis on the study of materials cannot, at this stage, have been pretending to design in terms of iron. The differences we noticed between the drawings and the 1920 model imply that the design was never quite finalized. The *Letatlins* were works in progress, each a finished or nearly finished apparatus. The design process demanded by *Letatlin* was that of adapting nature's perfectly evolved design to human appropriation. The beauty of the result was patent; its utility awaited proof. Tatlin was here working towards a broadly foreseeable outcome. Only the fuselage needed inventing, and for this he devised a basket-like frame, light, strong and elastic, to support a figure and accept the wings.[61]

The Tower is wholly distinct as a design problem. The fact that Tatlin worked on the Tower mainly in Petrograd and on *Letatlin* mainly in Moscow may have made the two ventures more distinct to him than they are to us. What unites them is the intensity of his motivation. All mankind shall have wings. Petrograd, Russia, Earth shall have a super-tower from which to guide the human race into world comradeship and space exploration. Towers signify power, human power engaged in worship of a superior power or in offering a challenge to it. Depending on its functions, a tower can exalt but also isolate whoever commissioned or built it, as in the case of the tower built for Lunacharsky's Faust, but it can also bring people together to work collectively. The clarity and transparency of Tatlin's structure stressed this, as well as the information broadcast in several forms from its top unit, and the busy life demonstrated by the ascending and descending traffic on its spirals. As an additional bridge, the Tower will also have been a means of connecting, and the probability that it would have linked Vasilievsky Island, with its industrial and student population, to central Petrograd, with its courtly palaces, will have underlined the Revolution's message. The Tower and *Letatlin* would both be charged with the warmth of piety by invoking the historic Forerunner. They both 'failed', in the sense that neither project was fully realized. Any air bicycle proposed today would probably include a power pack; mankind may soon learn to harness subtler forces. Today, mighty businesses and would-be mighty governments raise taller and taller towers for prestige rather than utility, competing to make each of them more newsworthy than the last. Their motivation is their message: money = power = money. The motive that links Tatlin's two major pursuits is to help mankind across thresholds of superstition and doubt, and launch us all into the golden future promised by age-old dreams.

Though I have emphasized that the Tower drawings and models have to be seen as steps towards his Monument to the Third International, and that more would have had to be done in realizing the project, we have no reason to think that Tatlin intended to depart from his

basic ideas any further than engineering technology and capacity would require. What would the Tower have been, to Russia and to the world, had it been built more or less along the lines he established? Its unrealized image has continued to haunt artists, as has his outgoing spirit, so that there have been many references to him and it in the intervening years. Even today, there is a project to realize his Tower by means of global co-operation.[62]

The more we attempt to see Tatlin's Tower in the context of architectural history, the more remarkable an invention it becomes. Its particular fusing of architecture with engineering to create a monument is unique. The fantastic architecture pursued by others at that time tended to formal and expressive extremes that make Tatlin's design appear as sensible as it is grandiloquent.

News of Tatlin's Tower, from 1920 on, will have told the world that the new-born Soviet State was ushering in an age without nationalistic antagonism. In this context, Trotsky's recognition that Tatlin was 'undoubtedly right' in having 'excluded the national styles, allegorical sculpture, stucco-work, ornamentation, decoration and all sorts of nonsense', takes on additional force. Associating Tatlin's Tower with church architecture, however strange this may have seemed when initiated in chapter 4, is not unfounded. The Tower was intended to announce, promote and serve the new religion of Socialism.

Tatlin's Tower would easily outreach and outshine the gleaming but comparatively modest verticals rising in Petrograd from the Admiralty and the Cathedral of Saints Peter and Paul. A position close to the meeting of two streams was in many cultures thought to bring power to sacred buildings. In Petersburg the Great Neva and the Little Neva (*Bolshaia Neva* and *Malaia Neva*) part company at the east end of Vasilievsky Island, outside the Winter Palace, together making a vast plain of water or, for many months of each year, of ice.

It may be said that Tatlin's Tower would have been a demonstration of worldly might and optimism, standing where Russia and Asia face the West, a sign of power. Great buildings cannot but express the power that goes into their creation. But in this case, power and faith were one. The Tower's association with sacred architecture and its own embodied symbol of the Forerunner would tie it into the continuity of human aspirations, though its goal would not be to assure believers of a happy afterlife but to bring mankind to convivial existence in this world. Its open-work structure and the glass and metal fragility of the units hanging within it would propose not only openness of purpose but also peace. No large building was ever less concerned with defending itself — with the exception of its famous ancestor, the Crystal Palace.

Had Tatlin's Tower been built and served its purpose even temporarily, the story of modern architecture would be different. The model of 1920 could not make such a major contemporary impact: it was a transient thing, shown and then destroyed. The 1922 competition for a design for the *Chicago Tribune* offices illustrates this lack of influence. They all assumed that solid materials, mostly concrete over a steel frame, would be required.[63]

To an amazing degree, Tatlin's design was his personal invention. Had the Tower been built, more or less along the lines of the 1920 model, a 400-metre structure at the heart of Petrograd promoting the new faith through its internal activities and their external expression, as well as the implanted religious identification, it would have altered the path of modern architecture and just possibly modern politics. It might have been judged an off-beat creation for an unusual purpose and situation, but its existence could not have been ignored. Apart from propagating the new faith to the world, the real Tower would have

proposed to the profession and its clients the values of asymmetry and complexity, as well as openness, as against the closed geometrical rigour adopted in the 1920s and 1930s by the twentieth-century idiom that would soon be called the International Style.

In his first and last architectural endeavour, Tatlin fused ancient and modern concepts into a work that would appear to be primarily an engineering product. Its grandiloquence would take it far beyond Eiffel or any modern building. Looking for a possible comparison one would have to think of the Egyptian pyramids, though these are firmly grounded whereas Tatlin's Tower, standing over the Neva, would seem to lift. In any case, it would have risen much higher than any other human artefact, as indeed (Tatlin might have said) a monument to the Revolution and its promise to change the world should.

*

The influence of constructive methods on the arts has been fundamental: the recognition that art can be an opportunity to build an image, a book, a play, most obviously a film, from items of the world's data selected to persuade and/or to entertain, while demonstrating the creative force of individual artists/authors/directors and (it would have been argued by Tatlin's generation) the

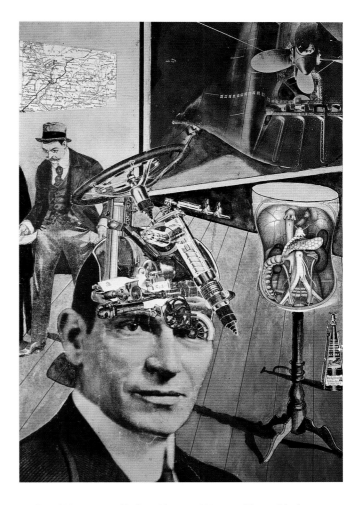

84. Raoul Hausmann, *Tatlin at Home*, 1920, 41 x 28 cm. Moderna Museet, Stockholm

collective they represent. Film had largely been the visual recording of stage performances. The move from this to constructing a sequence of purposefully selected rushes is dramatic and all-important,[64] soon finding its echo in posters and other forms of advertising. These developments date from the time of the Tower model's brief existence in 1920–21.

Before the First Russian Art Exhibition, shown in Berlin and Amsterdam in 1922–3, Tatlin's reputation in the West was that of the hard radical, denying all validity to the art of representation and announcing his machine-art. That is how Grosz and John Heartfield celebrated him during Berlin's great Dada exhibition in May 1920, before Punin's second essay on the Tower and its display. If accepted, Tatlin's machine-art would certainly spell the end of all the available 'isms', in particular expressionism which Dadaists mocked for having done nothing to prevent the war. Raoul Hausmann showed there his collage *Tatlin at Home* (fig. 84). Without attempting a likeness (Hausmann probably had no notion what Tatlin

looked like), he represents him as the ultra-modern man, concerned only with technology and computation. The background is occupied by a scarcely legible map of Pomerania in northern Germany, and by part of a large image that resembles a painting but makes much of a ship's screw propeller, and a figure of a man ruined by business or gambling and displaying his empty pockets. In the foreground, so close to us that we see only his head and shoulders, stands 'Tatlin', very much the Western city operator, looking out at us with his right eye. The left is partly screened by a wheel, while the upper part of his head, and the area above it, is occupied by a knot of machine parts, too intricate for us to recognize. This man thinks mechanically. He *is* a machine. Lissitzky was in Berlin. His own collaged image of Tatlin was created in 1922. It wholly refutes Hausmann's superficial reading, but it was not exhibited or published at the time. In 1924 Lissitzky would passionately condemn all machine worship in the arts.

The First Russian Exhibition could not override the Dadaists' view of Tatlin. The way Tatlin's one construction was displayed there, away from his two pictures but close to constructions by Gabo and Rodchenko, three by each of them, will have made it seem part of the constructivist movement. Studied by itself, it was an isolated, even eccentric contribution, essentially different in character from the Gabos or Rodchenkos, the former referring to figuration, the latter being mostly geometrical hanging constructions of 1921.[65] Tatlin's relief demonstrates no principle or definable method, but merely free artistic deployment of the materials at hand. German responses of the time confirm this. The constructivist aspect of the exhibition was noticed with interest, but Tatlin's construction was not commented on.

We are told that, after that exhibition transferred to Amsterdam in 1923, Tatlin's work was not seen outside Russia until 1967. This is not strictly true: three two-dimensional Tatlins were included in an exhibition of 'Contemporary Art of Soviet Russia', shown in New York in 1929 and probably toured to Detroit and Boston. It was not until the late 1960s that Tatlins were allowed out of Russia again, and then only just. In 1967 the Grand Palais in Paris showed 'Russian Art from the Scythians to the Present', which included three of his early theatre designs.[66]

It is very rare that any original work by Tatlin appears at auction or in the commercial galleries; when something does, it is likely to be a sketch, not always of convincing pedigree. George Costakis's extraordinary collection of, mostly, Russian avant-garde art, formed in Moscow after 1945 and before he left Russia in 1978, ceding part of it to the Tretyakov Museum, included more than fifty Maleviches but only twenty items representing Tatlin, including five paintings and drawings of the 1930s and 1940s, one relief, now in the Tretyakov, dated vaguely 'c.1914–17?' and probably incomplete, but also a wing-strut for *Letatlin* — an object of remarkable beauty, made of bent willow wood and cork.[67]

Yet Tatlin's name and generalized image have remained vivid and illustrious for artists and art historians, in Russia and even more so in the West. If detailed knowledge of his activities has been difficult to find, is it the whole Tatlin trajectory that has captivated us? His is an outstandingly romantic story of an art student and sailor, and then young practising artist, who remains wholly marginal to the Russian culture scene until he suddenly becomes one of the two or three most relied-upon artists in the new country, charged with urgent tasks of several sorts, yet adding to them the pursuit of a monumental structure that will represent the Revolution and Russia's mission to bring harmony to the world. That the Tower was never built, or even seriously considered by officialdom for construction,

adds to this story, as well as the dip in Tatlin's standing when he leaves Petrograd to work in Kiev for a while, soon returning to teach in Moscow and pursue his second obsession, *Letatlin*. It is difficult to imagine a world in which mass-produced *Letatlin*s are part of every-day life. We cannot be certain how close to that the project came. Here again, Tatlin's efforts approached success to end in, practically speaking, failure. (Tatlin's Daedalus here takes on aspects of Icarus without actually falling out of the sky.) Investing years on researching flight and the material structure with which mankind might be enabled to fly, he may well have come to think this project even more important to him than the Tower. The Tower would stand in Russia's second city, addressing the world. The ornithopter would be Russia's gift to all mankind, enlarging life to an extent difficult for us to imagine but pre-sumably more and more real to Tatlin as he worked on it during the 1920s and into the 1930s. While he was pursuing this second obsession Soviet attitudes to art and design changed drastically as the Communist Party, under Stalin, took control of the arts, demanding nightmarish, gimcrack versions of classicism for its significant architectural proj-ects and academic idealization for its portrayal of contemporary life. Tatlin, who must have been aware of this gradual demotion of creative activity, may well have thought that he was eluding it by devoting himself to a goal both utilitarian and life-enhancing.

After being honoured as an artist of national importance, Tatlin returned to busying him-self with stage design and privately to easel painting. Some of his stage work was com-missioned, some of it was personal ventures, as before. Some produced disagreement in the theatre, but many of his stage sets and costumes were praised and enjoyed by critics and the public.[68] His late paintings show him working only in oils. Here he was working entirely for himself, and in a more or less naturalistic manner. Sometimes he enshrines a visible motif in layers of paint and carefully worked surfaces, at times drawn into with the brush handle and including little touches with the palette knife. Here again the material used plays a considered, constructive role.

Tatlin's Tower has continued to interest generations of artists and art historians. This is due, I believe, not only to its originality and the problems that realizing it would raise, but also to its anthropomorphic suggestion and a hint of particular significance that increases as one stays with images of it. My argument that the Tower signals the dawning of a new age by symbolizing St John the Baptist, may never find documentary confirmation. I have here attempted to describe the context in which Tatlin lived and worked, in order to make the idea of the Tower having religious signification less arbitrary than it might seem at first, but also to give weight to the specific reference I have suggested for it. His need to invest historical and spiritual meaning in this project is evidence of the true ambition of perhaps the greatest of Russian artists, working to make art contribute directly to the prospect of humanity that was offered in his time.

<p style="text-align:center">*</p>

Larissa Zhadova, with the help of Z.P. Mellit who selected the drawings, curated a Tatlin exhibition shown in the Fadeev Writers' Hall in Moscow from 17 to 28 February 1977. It was felt that such an exhibition had long been wanted. In the Tatlin book she edited and partly wrote, published in Hungarian in 1984 and in English in 1988, but never in Russian, Zhadova provides some details about it.[69] About half the 108 exhibits were examples of his theatre

designs, from 1910 into the 1940s. There were photographs of drawings for the Tower, the 1920 and 1925 models and of his prototypes for industrial production, thirty-two paintings from 1909 on, drawings and book illustrations, a small 1975–6 reconstruction of the Tower model and one of the bent-wood chair. The exhibition also included a *Letatlin*, lent by the Zhukovsky Central State Air and Astronautical Museum.[70] Only one of Tatlin's reliefs was included; *Selection of Materials* of 1917, lent by the Tretyakov Gallery.[71]

This selection probably reflects the availability of Tatlin's work at the time: one relief, several paintings of various dates, mostly from the Tretyakov, theatre designs from there but also from the Bakhrushin Theatre Museum in Moscow and the Leningrad Museum of Theatrical History, and graphic works from the Central (now the Russian) State Archive of Literature and Art in Moscow. It does not indicate any political prohibitions or exclusions. Yet it is a poor representation of 'V.E. Tatlin, Honoured Art Worker of Russia'. The words the event occasioned add warmth and enthusiasm to the limited parade offered by the exhibition. From Begicheva's memoirs, for instance:

> Vladimir Evgrafovich was deprived of a deserved recognition in his own lifetime. But he had been working without rest in the name of the future until he breathed his last: 'I see my Motherland as a treasure-house of great traditions. My contribution is there too.'

And from a contemporary reflection by V.M. Goriaev, a major graphic artist who was himself honoured as a People's Artist of Russia:

> It is good that all the works have come together now and we can easily leap from them — from drawings and paintings to this marvellous central object, the Tower of the Third International. . . . He could do everything: he makes a bandora, he makes the Tower of the Third International — what an extraordinary range! One is taken from the past, the other from the future. And all that was done by one person — a dreamer and so very Russian in his appearance, in his generous nature, his love for everything Russian.

V.B. Elkonin, who had known the artist since 1928, wrote a long essay entitled 'What I Remember about Tatlin', touching on many aspects of his friend: his relative quietness on social occasions and reluctance to theorize, though he could make very effective speeches when they were needed, his 'unique musical gift' when playing and singing to the bandura, his ability to recite Khlebnikov's poems from memory, revealing their 'simplicity and clarity', his physical presence, more like a plumber than an artist ('He was thin and tall, his features were very large, as if carved with an axe'; one would soon 'realize that such an unprepossessing appearance belonged to a great artist'), but also how he was distrustful of other artists lest they steal his latest ideas. In an article of March 1977 in *Russian Literature*, 'On Eccentrics and Tatlin's Bandora', Ivan Rakhillo recalled the words of the writer Vsevolod Vishnevsky:

> 'One should not just write about this man,' Vishnevsky used to exclaim, 'one should shout about him, ring all the bells!'

Professor Strigalev reports that he approached the Union of Artists in Moscow with a proposal for a Tatlin exhibition to open on 25 December 1985 in celebration of the centenary of the artist's birth. The reply was positive but ungenerous. The Central House of Artists might be used for a one-evening Tatlin event, during which there could be talks about the artist and a display of documentary materials only. No originals, no models: the 1977 exhibition had cost too much for anything like that. Strigalev was encouraged to gather photographs and reproductions for that brief display, and brought together over two hundred items. They would go on for showing at a similar event in Penza after Moscow. Offers to speak about Tatlin and his work came in, and Strigalev arranged for the printing of a thousand invitation cards, though the House of Artists could not seat more than six hundred. As time passed, doubts and rumours of disapproval about the Tatlin evening surfaced. A senior member of the Union said he would certainly be unwell that day. Then the evening was cancelled. The first Strigalev knew of this was when he telephoned the Union on 24 December, to check an organizational detail. No explanation was given, nor any idea of where the veto had come from. Confusion reigned, mixed with fear. The cancellation must have been ordered from high up.

Some weeks later, having found a route by which this might be done, Strigalev wrote a letter to Mikhail Gorbachov, then a prominent member of Russia's Presidium of the Supreme Soviet, asking for the Tatlin celebration to be sanctioned. Rumours about this approach got around, and suddenly the permission he wanted arrived: the event should go ahead and a date was set for it (of no particular relevance to the subject): 18 May 1986. It happened; it was well attended: a success, as far as it went. It actually went further. Leningrad University presented a Tatlin conference. Early in 1987 Penza organized not only a Tatlin evening, using the material Strigalev had collected for Moscow, but added Tatlin originals borrowed from regional museums, a separate Tatlin conference and the re-staging of two scenes from Tatlin's dramatic presentation of *Zangezi*, with student actors as in 1923.[72]

The year 1990 saw a Tatlin room formed at the State Russian Museum in Leningrad; its contents included a reworked *Corner Counter Relief*, originally made in 1915, largely reconstructed in 1925 by the artist himself, and offered to the Museum together with his 1925 model of the Tower.[73] Tatlin's rehabilitation in Russia was well underway.[74]

Addendum

To the end of his life, Norbert Lynton sought to fathom the creative relationship of Tatlin and the visionary poet Khlebnikov. Both born late in 1885 in the southern Russian countryside, they met in 1912, if not before, when Tatlin illustrated 'Worldbackwards'. Khlebnikov was already well known (unlike Tatlin) — chiefly for his arresting neologisms and 'transsense language'. He was deeply interested in the visual arts, close not only to Tatlin, but also to Pavel Filonov and Tatlin's great rival Kazimir Malevich. When Khlebnikov died young in 1922, Tatlin put much time and energy into a memorial production of the poet's least stageable 'supertale' *Zangezi*. They had been together with the futurist poet Petrovsky in Tsaritsyn (Volgograd) in May 1916. Khlebnikov dedicated a short, strange poem to Tatlin, evoking his recent non-figurative constructions, calling him a 'secret seer', an animator of lifeless objects. Tatlin guarded the manuscript 'like a conspirator'. It seems then that they shared or developed architectural interests: these were exemplified by Khlebnikov's drawings of biologically-based skyscrapers and by the fact that his friends dubbed Tatlin 'Zodchiy', 'the Builder'. Tatlin's Tower project may have hatched in his mind then. Khlebnikov later proposed entrusting Tatlin with the construction of a 'chapel for manuscripts', an 'iron skull . . . for preserving our deeds and thoughts to prevent the mice of time from gnawing at them'.

Khlebnikov could offer Tatlin a 'biological' approach to structural form utterly at odds with Constructivism — manifest both in the Tower and Letatlin; also a concern with transcending human limitations, notably our subjection to Time. The Tower incorporates Time in its revolving chambers, and 'overcomes' it, as a monument to the future — the Third International. Khlebnikov's thoughts and calculations decoding time were published in his late 'Boards of Fate'. Khlebnikov's *Doska*, Russian for board, also signifying an 'icon', was adopted by Tatlin in 1916–17 for certain painted works postdating his non-figurative constructions. Khlebnikov's association of the eye with the sun and the speaking mouth may be reflected in Tatlin's Tower, seen as a sort of 'telescope' with an oculus at the top through which news could be broadcast to the world.

Khlebnikov perhaps had in mind Tatlin — expert maker and player of musical instruments — when he summed up his vision of harmony in a musical image: 'Before you is the futurian with his balalaika. On it, fixed to its strings, trembles the phantom of humanity. And the futurian plays: and it seems to him that the enmity of nations can be replaced by the magic of strings' — his scale at one end agitates heaven, at the other is embedded in human heartbeats.

R.R. Milner-Gulland, 2009

Notes

Chapter 1

1. My chief sources here are Milner 1983, Zhadova 1988, Milner 1993, and Strigalev and Harten 1993, though reference has been made to many other publications. See the Bibliography for full details.
2. See Strigalev 1996, and my chapter 9.
3. Milner 1983, p.7, quotes Tatlin's later words about her work: 'Her poems were published in the leading journals of the time. Her work was closest to Nikolai Nekrasov (1821–1878) and Viacheslav Polonsky (1819–1898). The meeting of my father with my mother happened at Polonsky's funeral where my mother was reading her verses on the death of the poet.' This suggests that Tatlin senior too had a positive regard for the person and/or the work of Polonsky. But Polonsky died some years after Tatlin's mother, and it may be that Tatlin, or whoever told him of his parents' first encounter, meant Nekrasov. Nekrasov was a fluent, busy writer who was also a publisher and edited the best-known intellectual journal of the 1850s and 1860s, the quarterly *The Contemporary* for which Chernyshevsky and Dobrolyubov wrote in the 1860s. Polonsky was a prolific writer of prose and poetry, whose verse was also published in *The Contemporary*. In his 'Autobiography' (written after 1927) Tatlin says that his mother was a member of the *Narodnaia Volia* (People's Will) movement, a militant party working to involve peasant communities in revolutionary action (see Zhadova 1988, pp.264–6).
4. See Strigalev in Zhadova 1988, p.14 for a quotation from Tatlin senior's book.
5. See Strigalev 1996, p.410.
6. Ibid., p.413.
7. Ibid., p.418.
8. See Strigalev in Zhadova 1988, p.14.
9. See Paris 1972 catalogue, pp.5–18.
10. See Howard 1992, especially pp.42–7.
11. This drawing is illustrated in Picasso Museum, Barcelona 1995 catalogue, p.104. See Zhadova 1988, pp.491–504 for a list of Tatlin's exhibitions. According to Strigalev, Tatlin worked for some months of 1911–12 in the Moscow studio of Alexei Morgunov (1884–1935), meeting there Valentin Serov (1865–1911), an internationally experienced and admired painter, whose memory Tatlin treasured. See Strigalev 1996, p.420, and Milner 1993, pp.378–80.
12. See Strigalev 1996, p.425.
13. For a close account of Russian futurist publications see Compton 1978 and 1992. Both attend to the contexts and connections of these publications and their creators, and thus deal not only with developments in Russian modernist literature and art but also with theatre and with architecture. The most interesting account of Russian futurism, focusing on its literary aspects, is still Markov 1969. See also A. Lawton and H. Eagle (eds), *Words in Revolution: Russian Futurist Manifestoes 1912–1928*, Washington DC, 2000, and John Milner, *A Slap in the Face: Futurists in Russia*, London, 2007.
14. In 1928, answering a brief questionnaire about his life and work, Tatlin wrote that the following artists had influenced him: Afanasev, best known for graphic work of an illustrational and often satirical sort, Picasso and Larionov.
15. Strigalev in Zhadova 1988, p.40, note 19.
16. This name may have been chosen to echo that given to the lofty Petersburg apartment of the symbolist writer and theorist Viacheslav Ivanov, where, from about 1905 on, groups of writers, musicians, etc., met on Wednesdays for formal presentations and for free discussions, among them the writers Andrei Bely and Alexander Blok, and, from 1908 on, Khlebnikov.
17. See Strigalev 1996, p.430.
18. In the first issue of *Russian Art*, 1923. See Lodder 1983, p.11 and p.269, note 28.
19. See especially V.I. Kostin in Zhadova 1988, p.67. According to Milner 1983, p.8, 'Tatlin's earliest paintings were probably icons and thoroughly traditional. He worked in an icon-painting studio near the Kremlin, delighting in the complex process involved.' This suggests that he worked there during or just after his studentship in Moscow in 1902–3, rather than when he returned to Moscow in 1911, and was close to Larionov who had a keen interest in Russian icons. If the later date is correct, his analytical work on Western Madonnas comes close to his time in the icon-painting studio. Milner summarizes the nature and tradition of icon painting and its importance to Tatlin and others: 'For Tatlin, as for Malevich and Goncharova, the icon provided a living and Russian alternative to Western traditions' (ibid., pp.24–7). Matisse's high praise for icon painting, when he visited Moscow in 1911, enhanced artists', collectors' and curators' interest in them, and the recent removal of darkened varnish

had revealed the brilliant colours of the originals: see S. Bauer, 'Round is Orange – Yellow is Triangular', in Thessaloniki 2005, p.445. A large exhibition of icons presented in Moscow in 1913 confirmed their value as art. In addition, the Old Believers' defence of the old canons of the art, as against the Westernized icon painting that developed from the late seventeenth century on, gave the subject a quasi-political, anti-authoritarian subtext. See Milner-Gulland 1997, pp.122–6. Some of the major patrons of modern art and of research into old high-art and folk-art traditions belonged to the new merchant class. Milner 1983 emphasizes the flatness of the traditional icon image – which thus meets the call for flat painting coming out of the Gauguin circle from about 1890, well represented in Ivan Morozov's and Sergei Shchukin's collections – but also the nature of the icon as a functional object, part of the real world: 'An icon was clearly an object to be used, transported, carried in processions and installed.' He also suggests that Tatlin may have been attracted by the multi-media composition of many icons (p.93).

20. See Zhadova 1988, plate 103, the comparative material in plates 99–102, and Zhadova's essay, '*Composition-Analysis, or a New Synthesis?*', pp.66–3. The medium is given in Zhadova's list of illustrations, p.505, where its dimensions are said to be 490 × 330 cm; presumably this should be 49 × 33 cm. Strigalev and Harten 1993 catalogues this work on paper (cat. 237, plate 64), and also mentions an oil painting of the same sort and possibly the same design, as shown by Tatlin in the Union of Youth exhibition, Petersburg, at the end of 1913, together with three ink drawings (cat. 235). Its dimensions are not stated, but it is interesting that Tatlin should have thought a study of this sort, an interpretation of a Madonna by an Old Master, warranted executing as a painting and exhibiting. Tatlin also made a *Compositional Analysis on the Theme of Rembrandt's Painting 'Staalmeesters'*. This is described as a drawing with collage, but nothing further is known of it (cat. 234).

21. Strigalev and Harten 1993, cat. 1308.

Chapter 2

1. Strikes played a major historical role in Russian politics. As industry grew, dependant on the manpower of peasants coming into the towns and on their first descendants, strikes developed in number and severity as the workers became better organized from about 1880 on. The so-called revolution of 9 January 1905, when the guards fired on a peaceful column of workers 'singing hymns and carrying icons and crosses, . . . more like a religious procession than a workers' demonstration' (Figes 1996, p.173), was followed by strikes in many places, in the countryside as well as in industrial centres and on the railways, especially during September and October. The tsar was forced into issuing a manifesto that offered some liberties, constitutional reforms and a legislative Duma or parliament, but 1906 saw him reneging on those promises and wide-ranging persecution and oppression of individuals and groups who had been protagonists in the troubles. From 1910 on there was a second wave of strikes, increasing in number and frequency year by year, except at the start of the 1914–18 war. Early 1917 saw a rapid crescendo of strikes in the towns, now including many women and reinforced by mutinous soldiers, and in the country increasing radicalism among the peasants. All this contributed significantly to the tsar's decision to abdicate. Lenin's promise, after October, to end private ownership of land recognized the peasants' power, rooted in an ancient conviction that the land belonged to those who worked it. These developments are well summarized in Wolf 1971, especially pp.85–7.

2. Zhadova 1988, p.505 and Strigalev and Harten 1993, cat.66, both give 'tempera on canvas' as the medium for this painting. Milner has suggested to me that here and in *The Fishmonger* of the same year (in Zhadova 'gum paint on canvas'; in Strigalev and Harten 'distemper on canvas', cat.67) Tatlin adapted the water-based medium used for painting stage wings and backdrops.

3. I believe that this image was in Malevich's mind, when, in 1915, he painted the *Black Quadrangle*, a curiously clumsily painted near-square black form placed centrally and orthogonally on a square white canvas, which he promoted as the foundation work of suprematism. The icon of *The Saviour Not Made with Hands* (that is, not made by human hands) is spoken of as the foundation instance of icon painting, justifying the practice against the arguments of the iconoclasts. When Malevich was making his first suprematist paintings, Russian soldiers were marching against Germany behind standards bearing images of famous icons, including *The Saviour Not Made with Hands*.

4. In his later years, Larionov tended to adjust the dates of his early work in order to highlight his role as a pioneer of modern art. This has led to careful scrutiny of his dating. Parton 1993 has made a major contribution to this process of verification. A good black-and-white reproduction of the earlier Tatlin portrait is in Milner 1983, p.5; idem, p.39, shows a colour illustration of the second Tatlin portrait, there dated 'c.1911–12'.

5. Larionov invented rayism in 1912–13. Doing so implied impatience with folkloristic primitivism and a desire to engage with something more up to date. Rayism sometimes reveals its nominal subjects and at other times veils them with, or dissolves them

into rays of coloured light proposed by the subject or the artist's instinct. Larionov's rayist manifesto was published as a booklet and more or less reiterated as an article (introduced with lines by Whitman), both in 1913. See Parton 1993, chapters 4 and 7. The manifesto was signed by a number of interested artists, but only Larionov and Goncharova explored rayism with any seriousness. The manifesto claimed it was a synthesis of cubism, futurism and Orphism. Another influence on rayism may have been Leonardo da Vinci. Paul Valéry's essay on da Vinci, written in 1894 and widely read, quoted him on lines and form in nature: 'The air is full of infinite, straight, radiant lines crossing and interweaving without one ever entering the path of another, and they represent for each object the true FORM of its cause'. Shattuck 1984.

6. See Parton 1993, p.127.

7. Tatlin showed work with the Union of Youth in Petersburg from 1911 on, sometimes as a member of Moscow's Donkey's Tail group, led by Larionov. In this manner, he was one of twenty-two exhibitors in the sixth Union show, December 1912–January 1913, eight of them from Moscow. 'Tatlin's eight works again focused on marine subjects with curvilinear forms'; here his self-portait *Sailor* made its debut. See Howard 1992, pp.141 and 148. This exhibition is not listed in Zhadova 1988.

8. For instance, there exist two albums of drawings done in the studio. They include life drawings but also stage designs by Tatlin and other life drawings by, it is now thought, Vesnin. Though dates entered in the album range from 1912 to 1914, Tatlin's life drawings tend to be allocated to the years 1912–13; drawings showing cubist elements (and sometimes described as 'Cubist-Constructive composition') are thought to be of 1913 and probably by Vesnin. It is not impossible that some drawings were done by both artists in open discussion. See Strigalev and Harten 1993, especially cats.125–257c, pp.213–32. At present the attribution of some of the drawings in the albums, or known to have come from these albums, as well as of others, remains uncertain: Tatlin or Vesnin, or, in some instances, Popova.

9. See Toby Clark, 'The "new man's" body: a motif in early Soviet culture', Brown and Taylor 1993, pp.33–50. Clark shows how, especially in its physical aspect, 'the human body became a principal site for utopian speculations' in the 1920s, following the concept of the 'new man' developed by Chernyshevsky and other radical critics in the 1860s.

10. All four Tatlin drawings are reproduced in Zhadova 1988, plates 70–73; see also p.129 for comments on them. Zhadova states that they are the first documentary evidence of contact with Khlebnikov and Mayakovsky. The letters on the cube spell 'MAGI'; this should read 'MAGGI' and refers to the well-known Swiss bouillon cubes 'whose neon signs whirl through Maiakovskii's poem "like constellations"'. See Milner 1983, plates 56 and 26 and pp.54 and 58. Compton 1978 provides publication details of the books on pp.125–7. See also Strigalev and Harten 1993, cat.121 and pp.325–7.

11. See Marks 2003, pp.209–10.

12. See Milner 1983, pp.28–32; quotation from p.28. Tatlin found the execution of his designs so poor that he wanted to dissociate himself from the staging of *Tsar Maximilan*. See the biographical summary for Tatlin in Thessaloniki 2004, p.526.

13. Milner 1983, p.57.

14. The first comment reflects a short quotation from a review of November 1913 used by Strigalev in Barcelona 1995, pp.26–7. The second stems from a review in *Russia's Morning* (*Utro Rossii*), May 1914, found in F.I. Sirkina's essay on 'Tatlin's Theatre', in Zhadova 1988, p.159.

15. Later in his career Tatlin dated this work to 1915–18. Zhadova 1988 echoes this; Punin in 1921 ascribed it to 1910–13 which seems too early stylistically. See Strigalev and Harten 1993, cats.363–87, pp.253–6.

16. Zhadova 1988, p.160 and plates 156–63; the painting, *Ship's Deck*, is reproduced in colour in plate 157 and, smaller, in Strigalev and Harten 1993, plate 73.

17. Milner 1983, pp.34–5.

18. The impact of Robert Delaunay's art and thought on his Russian contemporaries awaits close study. They were certainly aware of him through the championing of his art by the Blaue Reiter exhibitions and the *Blaue Reiter Almanac* in 1911–12. The first Knave of Diamonds exhibition, shown in Moscow in January–February 1912, in part an anti-Larionov manifestation organized primarily by the Burliuks, included work by three Paris avant-garde artists: Picasso, Delaunay and Léger. Georgii Yakulov spent the summer of 1913 with the Delaunays in France, was included in Walden's wide-ranging First German Salon d'Automne in Berlin later the same year, and subsequently lectured on his own Delaunay-influenced thinking at the Petersburg poets' and artists' café, The Stray Dog. In July 1913 The Stray Dog put on an evening dedicated to the art of Robert and Sonia Delaunay: see Steven A. Nash's essay, 'East Meets West: Russian Stage Design and the European Avant-Garde' in Baer 1991, especially p.105. By 1914–15 The Stray Dog's programme was dominated by Mayakovsky and futurism. Marinetti spoke there during his 1914 visit to Petersburg. Some of the futurists' performances, notably a particular Mayakovsky poem declaimed by its author, were designed to upset the well-to-do who came to the café for thrills and had to pay extra to get in. In March 1915 The Stray Dog was closed by the police. See Markov 1969, pp.138–9, 141, 155 and 277–8.

19. The full text, in an alternative translation, is given in Bowlt 1976, pp.102–10. Bowlt suggests that

Rozanova may have written the essay in 1912. It offers a remarkably acute analysis of the newest Russian thinking about art in the age of cubism and futurism, and also of the spiritual speculations, with a base in Oriental mysticism, promulgated by Peter Demianovich Uspensky in Petersburg lectures and books. At its start, Rozanova emphasized that for the modern artist the world is not a mirror but raw material to be seen and touched intuitively: through an 'abstract principle' she names 'calculation' a picture is created from 'constructive processing'. Born in 1886, Rozanova was at the heart of Russian futurism and married the poet Kruchenykh who in 1913 worked on the opera *Victory over the Sun* with Matiushin and Malevich. Bowlt considers that some of Malevich's ideas, as published in 1915–16, echo Rozanova's. She produced some of the most impressive two-dimensional art associated with suprematism in 1916, notably her set of collages for Kruchenykh's book of poems, *Universal War*, published January 1916, as well as three-dimensional pictorial constructions exhibited in the '0.10' exhibition at the end of 1915, among works by Tatlin and others of his circle. In 1918 she worked with Tatlin as a member of the art section of the Ministry of Culture in Petersburg (IZO), but died suddenly that November. A memorial exhibition of her work was presented in Moscow in 1919. 'Everyday life' is precisely what the constructivists and productivists would want to engage with.

20. See John E. Bowlt's essay 'The Construction of Space' in Cologne 1974, pp.9 and 14.
21. Quoted by Lodder from Punin's article of 1923 in *Russian Art*, no.1: Lodder 1983, p.11. In another article, 'Conclusions from Cubism', also of 1923, Punin admitted that his view of cubism and Tatlin's differed fundamentally: Punin saw cubism as an attack upon tradition, whereas for Tatlin cubism was one aspect of a broad search for a new elemental art. See Monas and Prupala 1999, p.84, note 13.
22. See Flam 1973, p.36.
23. Milner 1983, pp.140 and 241, note 9. It was printed in *Art of the Commune* (*Iskusstvo kommuny*), IZO's official journal, issued in 1918.
24. From 1918 on he was part of the IZO, becoming its deputy head and then head during 1919–21. During 1919–20 he was a member of the Petrograd Soviet of Soldier, Peasant and Worker Deputies, and gave lectures on art to workers' groups, published as a book in 1920 (with a cover designed by Malevich). He continued to be exceptionally active until the 1930s and after, when he suffered repeated arrests and exile. For a summary biography of Punin, see Lodder 1983, pp.257–8.
25. M. Rowell, 'Vladimir Tatlin: Form/Faktura', in *October*, Fall 1978, pp.83–108; the words cited are on p.88.
26. Milner 1983, p.59.

27. Quoted in Zhadova 1988, pp.392–3. Zhadova emphasizes that Punin wrote this while the Tower model was on display and there was lively discussion of it, and that the book represents a new type of focused art criticism, concentrating on one work and its significance. He dedicated it 'to the students of the Free State Studios'. (I have simplified the translation a little.)
28. Zhadova 1988, p.243 (translation slightly amended).
29. See Woroszylski 1972, chapter 6.
30. See Yablonskaya 1990, especially pp.100–101 and 158–9. We are told on p.100 that Popova and Udaltsova joined the studio group in the 'Tower' in the autumn of 1912; on p.159 they are said to have done this in the winter of 1913, after their return from Paris. It seems likely that Popova joined Tatlin's studio in late 1912 and that Udaltsova, who may already have been an occasional visitor, became part of the circle a year later. See Sarabianov and Adaskina 1990, p.15.
31. This lost Braque still life is illustrated as a 'relief' in Waldman 1992, plate 46, and in Richardson 1996, p.253, where it is called a 'paper sculpture'. Also more recently in Antliff and Leighton 2001, plate 8; the caption refers to it as a sculpture.
32. Boccioni showed at least eleven sculptures at the Galerie La Boëtie in June 1913. Only three of these remain.
33. Robert and Sonia Delaunay were both born (like Tatlin and Khlebnikov) in 1885. Sonia had pursued her initial art studies in Petersburg, and then studied painting in Karlsruhe, developing that particular interest in colour from which Robert evidently benefited later. She came to Paris in 1905, was briefly married to the German critic Wilhelm Uhde, and in 1910 married Robert. Though Apollinaire was their close friend and champion, their work was better known and more influential in Germany and Russia than in France.
34. Zhadova 1988, p.262. The editor inserted '[1913]' after the dates given by Tatlin. Nothing is known of any other travelling outside Russia apart from Tatlin's journeys as sailor.
35. Ibid., pp.264–5.
36. The 1914 dates are used in the biographical summary in Strigalev and Harten 1993: see p.386. Zhadova 1988 uses both 1913 and 1914 in referring to the visit. Recent publications in many cases still give the earlier date.
37. Le Fauconnier and Metzinger were then developing their own versions of cubism. They showed paintings in Moscow's Jack of Diamonds exhibitions of 1910–12. December 1912 saw the Paris publication of Albert Gleizes and Metzinger's *Du Cubisme*, explaining the movement's aims and methods from the authors' point of view. The book included five illustrations each of the authors' work and of Fernand Léger's, two each of Marcel

Duchamp, Francis Picabia and Marie Laurencin, and a Cézanne, a Picasso, one André Derain and one Juan Gris. No Braque, no Delaunay, no Jacques Villon (Duchamp's elder brother). The text mentions neither Picasso nor Braque, and disputes some of Apollinaire's statements about their art. *Du Cubisme* was soon studied in Russia. Matiushin published translated sections of it in the *Union of Youth* journal (Petersburg, March 1913, no.13), interspersing them with his own comments and with quotations from Uspensky's *Tertium Organum* (Petersburg, 1912), in which the philosopher explored concepts of time and the Fourth Dimension in relation to Oriental mysticism and Theosophy. One of Matiushin's excerpts from Uspensky states: 'The present stage of development presents no more powerful instrument for the recognition of the origins of things than art. The artist must be a clairvoyant; he must see what others do not see. And he must be a Magus, must have the gift of enabling others to see what they by themselves do not see but he sees.' Malevich is known to have been influenced by Uspensky's thought as well as by Theosophy. Tatlin must have been aware of both but does not appear to have been influenced by them. The year 1913 saw also the publication of complete Russian translations of *Du Cubisme*.

38. Strigalev and Harten 1993, p.386.

Chapter 3

1. See Zhadova 1988, pp.240–41.
2. This was the exhibition '0.10 — The Last Futurist Exhibition' in Petrograd, to be discussed below. See Zhadova 1982, chapter 2. Significant more recent publications on Malevich are Crone and Moss 1991, Los Angeles 1990, Milner 1996, Nakov 2002, Drutt 2003 and Nakov 2006.
3. Strigalev and Harten 1993, pp.245–9, associates some of the reliefs catalogued in it with Tatlin's studio exhibition of May 1914: see cats.340–43. The evidence for this is not clear, nor why the *Bottle* relief, widely thought to be the earliest, is not allocated to this first show. It is possible that Tatlin did not display it because of its echo of Picasso; his subsequent reliefs would demonstrate his personal direction. Yet he chose to hang this relief among his stage designs in December 1914.
4. In his paper 'An Excursion Around the 0.10 Exhibition' (Petrova 2001, pp.71–109), Strigalev stresses that 'Tatlin's series of first painterly reliefs should be regarded as one of the most important events in the history of the Russian avant-garde. . . . The artist offered a new method of artistic form-creation, without predetermining the formal-stylistic borders of the new art' (p.90). He described them at the time as 'Works 1913–14'. Professor Strigalev

sees '1913' as a conscious predating on Tatlin's part. But Tatlin may have started making reliefs in response to seeing the Picasso illustrations in November 1913. Moreover, Archipenko started work on his *sculpto-peintures* in 1912, and Tatlin may well have known about these.

5. See Rakitin in the catalogue New York 1992, p.28, and cats.340–45 in Strigalev and Harten 1993. These works are thought to have been shown in Tatlin's studio display and probably also in the March 1915 Petrograd exhibition 'Tramway V. The First Futurist Exhibition'. Tatlin himself organized the 1916 Moscow exhibition 'Store', in which he showed four reliefs of 1913–14, one relief of 1915, and two 'corner counter-reliefs' of 1914–15. To the enormous 1922 Petrograd exhibition 'Survey of New Tendencies in Art' Tatlin sent works ranging from nudes to constructions, presumably to demonstrate his development. See Zhadova 1988, pp.492–3.
6. See Strigalev 1996, p.431.
7. Milner 1983, pp.83–4, suggests that Tatlin may have been stimulated also by Malevich's dramatic use of irrationally juxtaposed images in his paintings of 1913, and by Malevich's 1914 paintings that include collaged papers and real objects. Malevich and Tatlin were close at this time, and linked by their experimental attitude. By the time '0.10' opened they were in conflict.
8. Strigalev and Harten 1993 assembles all the known Tatlin reliefs, etc., under '1914 and after', without discussing their possible dates or sequence: see cat.340 onwards. *Bottle*, cat.346, looks very much like a first essay; the pictorial relief with a projecting triangular plane, cat.348, could well have come next. The others are less 'pictorial'.
9. Punin 1999, p.84.
10. See Parton 1993, p.120 for Eganbyuri's words and pp.46–8 for some discussion of *Glass*; his figure 44 is a black and white reproduction of it. Eganbyuri is derived from the name of Ilya Zdanevich and was used as a pseudonym by him.
11. The Russian word *faktura* relates to a range of characteristics resulting from the creative manipulation of materials. Whereas the French term 'facture' might imply a tasteful or skilful handling of paint (for example), in Russia *faktura* stressed the visible evidence of materials manipulated (without stylistic implications). The term, though not new, took on extra significance in 1912 when David Burliuk proposed that paintings should be classified by the handling of paint. This was in an essay, '*Faktura*', included in the futurist booklet *A Slap in the Face of Public Taste*, edited by the Burliuks and published in 1912. In 1914 the Petrograd group Union of Youth published Vladimir Markov's extensive discussion of *Principles of Creation in the Plastic Arts: Faktura*, in which *faktura* is presented as the basis of all nature's organic creation and thus a

NOTES TO PAGES 38–45

model for human work. Markov was the pen-name of the Lithuanian painter and theorist Voldemar Matvejs (1877–1914), one of the founders of the Union of Youth group. See Jean-Claude Marcadé's essay, 'About the new Relationship to Materials in the work of Tatlin', in Harten 1993, pp.28–36. Marcadé emphasizes Markov's reference to Negro masks as examples of manipulating diverse materials together. Although there is no evidence in Tatlin of direct study of non-European 'primitive' art, he must have been aware of Picasso's response to African and other tribal art as well as of the broader issue of primitivism in Western art since Gauguin. Markov stressed how much the beauty and character of Russian icon painting, as well as tribal art, depended on the use of disparate materials.

12. Milner 1983, pp.82–3.

13. Cited by Cooke 1995, p.16.

14. Milner 1983, pp.92–3. Milner illustrates two old photographs; one of these appears also in the catalogue section of Strigalev and Harten 1993, cat.348. The relief was exhibited in 1915 in 'Tramway V' and in 'The Year 1915', both in Moscow, and then, among about fifteen other works, in Petrograd in '0.10' that December. Tatlin titled it, at one point, 'Selection of Materials: Iron, Plaster, Glass, Tar' (idem). The catalogue for 'The Year 1915' excludes contributions from Tatlin, Malevich, Mayakovsky and Morgunov, presumably because they were thought likely to cause offence. In fact they attracted 'keen critical attention' (Zhadova 1988, p.492). We do not know, therefore, which or how many Tatlins were included. The art historian and critic Yakov Tugendkhold, reviewing the exhibition in July 1915, described a now lost *Counter Relief with Chairleg*, and mentioned that Tatlin marked 'sight lines' on the floor to indicate the best angle at which his work should be seen. This was considered 'scandalous' at the time. See Strigalev and Harten 1993, cat.349.

15. The 'Catalogue of the Second Modern Painting Exhibition of paintings, sculpture, graphics and industrial art' presented by the Moscow Free Art Society in 1913–14, lists two Tatlin exhibits: '246 *Lute Player*' and '247 *Explanatory Drawing*' (Zhadova 1988, p.491). Strigalev and Harten 1993 mentions the latter (cat.236) and associates it with a *Compositional Analysis* in oil shown in the Petrograd Union of Youth exhibition at the same time, otherwise unknown, and asks what this 'explanatory drawing' was to explain if the other work was being shown hundreds of miles away. Strigalev and Harten 1993 also catalogues (cat.238) an 'unknown work' entitled *Kobza* and identifies it with Zhadova's *Lute Player*. This implies a mistranslation: the Russian title *Kobza* specifies an instrument similar to the bandura; the player of a *kobza* would be a *kobzar*. Tatlin made and played such instruments. There is at least a

possibility that he sent to that Moscow exhibition works in various media, including the early pictorial relief (*Glass*) which I see as referring to a musical instrument, and that the *Explanatory Drawing* he sent with it would have served to explicate this novel construction. This would indicate that Tatlin had begun his reliefs in 1913.

16. See Marcadé's essay (see note 10) for a brief description of the physical character of this relief. The dating is not explained, nor is any possible reference outwards mentioned. Strigalev and Harten 1993 includes a good colour illustration of it (plate 75, dated '1914') and summary information in the catalogue note (cat.344) in which it is said that the relief was 'probably' shown in Tatlin's studio show of May 1914, in 'Tramway V' and '0.10', and 'possibly' in the show Tatlin curated in 1916, 'The Store'.

17. See Milner 1983 pp.95–6. Strigalev and Harten 1993 does not ascribe a date: see cat.340. Shchukin bought a Tatlin construction from the 'Tramway V' exhibition at what was said to have been the 'fantastic' price of three thousand roubles. See Rakitin in New York 1992, p.25.

18. See Richardson 1996, pp.172–4.

19. *Bottle and Guitar* is illustrated in Richardson, idem. It was presumably a fairly new work when its photograph was published in *Soirées de Paris*.

20. Reproduced in Milner 1983, plate 94.

21. Isakov's article is in Zhadova 1988, pp.333–5. Zhadova stresses that new Russian art was so generally spurned that avant-garde artists looked for sympathetic critics and journals that would print their reports. One result was that some of these artists functioned also as critics (as also sometimes in the West). Milner 1993 provides an account of Isakov's busy career as teacher, writer and sculptor. He appears to have been particularly close to Tatlin in 1915; see p.184.

22. Milner 1983 accepts one of Tatlin's dates for the painting inscribed 'Staro Basman': 1917 (p.131). Strigalev and Harten 1993 catalogues both 'boards' under '1916' and refers to Tatlin's dating without commenting on it (cats.389 and 390). Regarding the painting inscribed 'Month May', they say that it falls outside the sequence of Tatlin's other work and calls for further research. Milner offers valuable comments on both, pp.131–2 and 134.

23. *Tendenzen der Zwanziger Jahre*, shown in Berlin in 1977, was the fifteenth art and design exhibition presented by the Council of Europe. Tatlin's painting was the only actual Tatlin work shown in it. The exhibition catalogue names it simply *Composition* and accords one of the few colour plates. The exhibition included the 1968 reconstruction of Tatlin's model of the Tower and a 1969 reconstruction of *Letatlin*.

24. These points were made to me by Robin Milner-Gulland in a note of March 2006. See his article, R. Milner-Gulland, 'Eyes and Icons: some verbal-visual

constellations in the work of V. Khlebnikov', in M. Falchikov, etc. (eds), *Words and Images: Essays in Honour of Dennis Ward*, Letchworth, 1989. See especially pp.146–8. The word *May* on this painted board may relate to Khlebnikov's idea of the 'black sails of time' in his manifesto *The Trumpet of the Martians*.

25. This is the title used by Charlotte Douglas for her translation of the first text of Malevich's essay, 'From Cubism to Suprematism in Art, to the New Realism in Painting, to Absolute Creation', written in June 1915, and published for the exhibition that December. See Douglas 1980, pp.108–10. The 1916, rather different, version of the essay is translated in Andersen 1968, pp.19–41.

26. This quotation is from Douglas's translation of Malevich's 1915 text. See the preceding note.

27. See Milner 1996, p.128. In a conference paper entitled 'Malevich, Curator of Malevich' (Petrova 2001, pp.149–54), A. Shatskikh states that Malevich arranged his display during a few hours preceding the opening of '0.10', that placing the *Black Square* like an icon was 'probably an improvised and impulsive action . . . [an] ambivalent action, sacral yet at the same time sacrilegious', and confirms that this was not the first suprematist canvas but was painted over a suprematist composition including blue, red and yellow forms. What the speaker called 'the true "parent" of suprematism' was the tall and complex composition seen in the photograph of Malevich's '0.10' display just below and to the left of the *Black Square* and almost touching it: the 1915 painting now in the Stedelijk Museum in Amsterdam where it is titled simply *Suprematism*. This choice is not backed with evidence. It has long been known that Malevich painted new versions of what he was soon promoting as 'a troika of first figures'. This occurred first when he showed sixty recent paintings at the Knave of Diamonds exhibition in Moscow in November 1916. *Black Square*, *Black Circle* and *Black Cruciform Planes* were there given the first three numbers in the suprematist sequence (idem, p.140). When plans for the Berlin exhibition of modern Russian art were being finalized in 1921, Malevich wrote to David Shterenberg, asking for four of his paintings to be included, the three just mentioned plus a *White Square* (presumably the painting of 1918 now in New York, called *Suprematist Composition: White on White*), and that his contribution be labelled 'Suprematism 1913'. He painted at least two post-1915 versions of the *Black Square*, one of them as part of the basic troika restated in three paintings of 1923, each 106 cm square, intended for showing at the 1924 Venice Biennale, all now in the Russian Museum (illustrated idem, p.130). It is also known that during 1928–30 he altered some of his pre-suprematist pictures, or painted new versions of the same subjects, as well

as, after an interval, a few new suprematist compositions (pp.126–32). The only phase of his paintings to escape this revisionism was that of around 1913–14, when he combined cubo-futurism and irrationalism — associated with *zaum*, the anti-rational word play and word invention then practised in futurist poetry — that is, the paintings assembled in the manner of collage and often including actual collage, which culminated in his *Composition with "Mona Lisa"* and *Woman at the Poster Column*.

28. Anarchism, associated with terrorism and, especially, the assassination of monarchs and their immediate heirs, of presidents and eminent ministers, and of leading Church dignitaries from the 1880s onwards until 1914, was at root a movement predicating that humanity was naturally social and co-operative, and would soon achieve harmony through mutuality. But meanwhile this oppression needed removing, and attacking commanding figures in it was an attainable first step. Books and discussions, in Russia often led by the charismatic Prince Kropotkin, would explain anarchism's deeper purpose. Lenin's beloved brother, the studious and ascetic Alexander Ulyanov, was executed in 1887 for his part in an unsuccessful attempt on the life of Alexander III. Lenin's project was revolution and the establishment of a Communist State. His theoretical work was dedicated to proving that Russia was ready for this. His belief was that other countries, notably those to the west and south of Russia, would follow suit — and so it seemed for some years while the victors of the first world war debated and schemed to create a Europe in which Communism could not thrive. Alexander Bogdanov's science-fiction novel *Red Star* describes an ideal commonwealth formed on Mars on Communist principles; more on this in popular work in chapter 4.

29. Edward Brown points out that cosmism, which attracted others in this period as well as Malevich, was felt to be the opposite of the militant atheism associated with Socialism and revolution. See Brown 1971, p.12.

30. Bucke's book, subtitled *A Study in the Evolution of the Human Mind*, had a particular resonance in Russia. Much of it is devoted to Bucke's account of key exemplars of 'men endowed with the higher consciousness', from the Buddha and Christ on. (There are no women mentioned.) A few were individuals he knew personally, among them Walt Whitman. Bucke claimed to have experienced profound illumination through meeting Whitman, while Whitman credited Bucke, a practising physician, with having saved his life. Every soldier in the Red Army is said to have carried a translation of Whitman's *Leaves of Grass* in his knapsack, together with a copy of Bogdanov's *Red Star*. Several Russian writers of the second symbolist and futurist generation admired Whitman's demotic tone and

optimistic grasp on the world.

31. In 'Art as seen in the Light of Mystery Wisdom', Rudolf Steiner stated that 'in artists' creations we shall meet, as it were, traces of the artists' experiences of the cosmos'. Malevich may not have known this statement when he embarked on suprematism, probably early in 1915, but though Steiner, by then known as the founder of Anthroposophy, published his essay in that year, its basic thought was adumbrated in the Theosophical literature which had previously been part of Steiner's mental base. Moreover, Steiner's books were normally composed of lectures delivered earlier. Railing 1990 quotes Steiner's words on its flyleaf.

32. This is quoted from Blok 1988, p.154.

33. See Dmitri Sarabianov on 'Tatlin's Paintings', Zhadova 1982, pp.46–7 and note 7, and Strigalev and Harten 1993, especially cat.16, p.197.

34. For some account of the critical response, see Zhadova 1982, pp.43–4. Zhadova mentions lectures on suprematism given by Malevich and by Puni in Petrograd on 12 January 1916, which 'fuelled the flames' with their dismissive attitude to all tradition.

35. See note 18 above. Tatlin's exhibits too, and those associated with him in the section of 'Professional Artists', met with abuse from conventionally-minded critics. Professor Strigalev quotes an anonymous reviewer in the *Voice of Rus* newspaper. Listing their names, the writer continues: 'I fear that they will come to a bad end. The verges of human morals hang on the walls of this room, beyond which begin robbery, murder, brigandage and the road to hard labour.' See Strigalev in Petrova 2001, p.92.

36. See Milner 1996, p.120.

37. According to Rodchenko's memoirs, written in 1940, Tatlin and Malevich were in conflict again: 'Malevich came to the opening, and for some reason created a scene with Tatlin. At the time I didn't really understand what happened, just that he removed his work from the exhibition.' Rodchenko 2005, p.78.

38. Milner 1983, p.134, dates it as 1917, and Strigalev and Harten 1993, cat.391, 1916. They reproduce photographs showing the relief at different dates. It has clearly been damaged and then restored, and perhaps lacks some elements. Milner suggests that this work may be the one that Punin referred to in 1919 when he wrote of Tatlin making a relief in response to Khlebnikov's manifesto *The Trumpet of the Martians* (1916). In this the poet speaks of the evolution of government from working in space to working in time: '[We appear] wrapped in a cloak of nothing but victories, and begin to build a union of youth with its sail tied to the axis of TIME', Paul Schmidt (trans.) and Charlotte Douglas (ed.), *Velimir Khlebnikov: The King of Time. Selected Writings of the Russian Futurian*, Harvard University Press, 1985, this edition 1990, pp.126–9. Like Tatlin, Khlebnikov frequently used imagery of the sea and of sailing ships, and also of flight.

39. Cited in Hammer and Lodder 2000, p.15. This important book provides much biographical information. See pp.20–29 and 33–47.

40. For details of Gabo's early sculptures see Nash and Merkert 1985.

41. Hammer and Lodder 2000, pp.47 and 147.

42. Milner 1996, p.121 provides a translation of the lists visible in the photograph, which cover all the Malevich works shown in the room. The titles themselves are curious. Some imply a subject in visible reality, e.g. *Self-Portrait* and *Automobile and Woman*, four titles refer to *Two Dimensions* and four to *Four Dimensions*, some refer to *Painterly* or *Colour Masses*, while twelve works are bracketed under the joint title *Painterly Masses in Movement* and eighteen as *Painterly Masses in a State of Rest*. The *Black Square* is the first item on the list on the left wall; Its Russian title *Chetyreugolnik*, strictly 'four-cornered form', translates as *Quadrangle*.

43. See Milner 1996, pp.124–5 and especially the diagram reproduced as plate 195. It may or may not be significant that the *Black Square* does not have an identifying number by it. Four other paintings visible in the photograph lack these numbers too.

44. Lunacharsky recognized significant differences between himself and Lenin, whom he considered 'a practical man with an enormously clear grasp of tactics, a real political genius'. As for himself, he approached issues 'as a philosopher and, I will say more definitely, as a poet of the revolution'. He wrote that 'art and religion then occupied the centre of my attention, yet not as an aesthete but as a Marxist', needing their 'emotional ethical' counterweight to others' hard rationalism. See Fitzgerald 1970, pp.3–4. Lenin rejected Lunacharsky's valuation of faith in *Materialism and Empiriocriticism*, written in 1908. Its main target was Bogdanov's philosophy; Lunacharsky was mentioned only glancingly but always in mocking terms, though Lenin confessed to Krupskaya, his wife, that he had 'a weakness' for Lunacharsky. 'I am really very fond of him, you know, he is a splendid comrade! . . . His levity is the result of his aestheticism.' See Wolfe 1984, p.566.

45. Kropotkin's book 'made a lasting impression' on Gabo. See Hammer and Lodder 2000, pp.18–19.

46. See Zhadova 1982, p.185. Zhadova emphasizes the topicality of the issue of how the arts were to be reorientated to support the ideals of the new State.

47. See Gassner's essay, 'The Constructivists: Modernism on the Way to Modernization', in New York 1992, pp.298–319. The quotations cited are on pp.302–3.

48. Christina Lodder, 'Lenin's Plan for Monumental Propaganda', in Bown and Taylor 1993, p.20.

49. Campanella's original text, *Civitas Solis*, is available in English in Campanella 1981. The translation and

notes are by D.J. Donno, who also provides an introduction on which my summary draws as well as on the excerpt and commentary in Carey 1999, pp.60–62. Campanella was seen as a precursor of Socialism. In the spring of 1920 Khlebnikov wrote a long poem he called *Ladomir* (world of harmony). It announces the coming of the world state 'Liudostan' (or People Land) whose capital will be a 'City of the Sun'. Cf. Khlebnikov's comments on Andrey Voronikhin's Kazan Cathedral in Nevsky Prospect, Petersburg/Petrograd. See S. Mirsky 1975, p.79, and Markov 1975, p.148.

50. Almost all these names are among nineteen inscribed in 1918 on the granite obelisk erected five years earlier to celebrate three centuries of Romanov rule, close to the outer face of the north wall of Moscow's Kremlin. Marx and Engels head the vertical array. The nineteen (including Campanella) are said to have been chosen by Lenin himself, but drawing up a list of names for his programme for new monuments was left to IZO. As Lodder points out, the list proposes a wide range of cultural heroes: see Bown and Taylor 1993. For detailed information and much else relating to Lenin's Plan for Monumental Propaganda see Drengenberg 1972, especially pp.181–297 and the tables that follow p.284c. For an account of Lenin's plan and what resulted from it see J.E. Bowlt, 'Russian Sculpture and Lenin's Plan of Monumental Propaganda' in Millon and Nochlin 1978, pp.182–93. Bowlt points both to Lunacharsky's enthusiasm for Lenin's project and to Tatlin's and Shterenberg's recognition that Russia lacked the talent to realize it promptly and well.

51. See Zhadova 1988, pp.185–7. This 'memorandum' was an official statement published in the Soviet press. The Moscow Trade Union of Sculptors had contributed to its content, notably the sculptors Boris Korolev and Sergei Konenkov. See also Bowlt's documentary contribution to *Design Issues*, vol.1, no.2, Fall 1984, pp.70–74. Its main matter is a translation of the memorandum of June 1918, signed by Tatlin and Sofia Dymshits-Tolstaia and published that July. Introductory paragraphs quote and outline Lenin's intentions. Bowlt also quotes Punin's essay in *Art of the Commune*, March 1919, on Tatlin's proposed monument: 'Agit-monuments are now being put up in Moscow and Petersburg. In Moscow these "temporary" monuments are cumbersome and awkward, uncultivated, and there is no point in talking about their artistic properties: They are lower than any norm . . . / Tatlin, the wonderful, most vigorous, most sharp-sighted master of our time, completely rejects any artistic value in the monuments being put up at the moment, and is offering us a completely new form of monument, one that seems to be mathematically sound . . . / The form of the monument corresponds

to all the artistic forms discovered in our age . . . the forms of the human body cannot today serve as artistic form, form must be discovered.' Bowlt points out that engineering structures such as water towers, grain silos, etc., had been built since the late 19th century, but that these were seen as functional engineering, whereas Tatlin was proposing a large tower that would be both utilitarian 'and an artistic device'.

52. For an overview of Russian sculpture from the seventeenth century on see Hamilton 1954, especially pp.232–5 and 257. Recent research provides evidence of a tradition of religious sculpture that has pesisted, modestly but not secretly, until modern times. Milner-Gulland 1997 refers briefly to pre-Petrine sculpture in stone and in wood and of modern Russian artists who were becoming aware of some examples of it.

53. Boris and Gleb were the sons of Prince Vladimir who married a sister of the Byzantine emperor, Basil II, brought Orthodox Christianity to Russia and died in 1015. Their half-brother Svyatopolk murdered them both to secure his succession, and they demonstrated Christian fortitude in not offering any resistance. They are amongst the most popular of Russia's saints. Their father, a saint too, is the hero of enduring legends and poems.

54. Konenkov (1874–1971) was one of the few academically trained sculptors to initiate a career before the Revolution and continue it afterwards. He had travelled widely in Europe before being made an academician in 1916. He taught in the Moscow Free State Studios in 1918 and contributed a memorial to Stepan Razin to the Lenin project; it was ready to be set up in Red Square for Mayday 1918. During 1919 he was a member of Moscow's IZO department under Tatlin. See Milner 1993, pp.210–12.

55. Kolli's sketch and a photograph of the monument will be found in Tolstoy 1990, p.60, plates 21 and 22.

56. On the Alexander Column see Hamilton 1954, pp.135 and 216–17. Altman's work is frequently mentioned but is also illustrated in Tolstoy 1990, p.89, plates 46–8; see also pp.90–1, plates 49–53, for the vast decorative and figurative panels with texts Altman designed for the elevations of the Winter Palace and the General Staff Building flanking the square, and the openings between them. Photographs show the column and its additions serving as a focal point for mass events. Idem, pp.70–71 and 81–2, prints Altman's recollections of this work and part of a report on these anniversary celebrations, printed in the journal *The Flame* in 1919. See Jangfeldt 1977, p.40. Natan Altman had studied in Paris and was close to Tatlin. Between the two 1917 revolutions, he was a founding member of the Freedom of Art Association in Petersburg together with Isakov and with such eminent men as Mayakovsky, Meyerhold, Punin and Sergei Prokofiev.

See Milner 1993, pp.39–42.

57. Tatlin's memorandum and his personal letter to Lunacharsky are published in Zhadova 1988, pp.184–8, together with an informative commentary including the difficult circumstances in which Tatlin was pursuing Lenin's plan.

58. Russian avant-garde artists, already in the spring of 1918, were eager to rethink the nature and function of museums and especially to initiate public collections of contemporary art of which the pre-revolutionary museums had taken no notice. Tatlin was much involved in these discussions, alongside Malevich, Altman, Puni and Punin. Punin wanted a limited, focused programme for the new museums: 'Only what is necessary should be taken. It is necessary to create a museum that will teach people to think the way we want them to . . . nothing from the old should penetrate'. Malevich wanted pre-contemporary art to be collected only if it related to 'definite trends in the New Art'. See I. Karasik, 'The Museum of Artistic Culture. The Evolution of an Idea', in Petrova 2001, pp.13–21; the words quoted are on p.14.

59. Experiences of this sort are best encountered in the histories of those who lived through them, for instance the poet Alexander Blok whose diaries and letters provide a remarkable account of the grimness of life during the Civil War years, but express also his faith in the better world promised by the revolutions. Pyman 1980 gives a rich account of the man and his thought.

60. This essay is given in full in Zhadova 1988, pp.237–8. I have slightly adjusted the translation of the sentences quoted here.

61. See Chamberlain 2004, pp.223–9, on the idea of work in Russian thought and its mystical aspects.

62. Proletarian culture was held to be necessarily collectivist, since it expressed the collective experience of industrial labour. Bogdanov wrote in the first issue of the Proletkult journal, *Proletarian Culture* (*Proletarskaya kultura*), July 1918, that it was natural for proletarian poetry to voice 'not the lyric of the personal "I" ' but the lyric of 'comradeship'. In a collection of his essays published in 1924 as *About Proletarian Culture, 1904–1924*, he advocated the idea of the 'collective-creative "we" as the hero and the theme of socialist art and the source of socialist creativity'. Clearly Tatlin was neither alone nor the first to stress the 'creativity of the collective', but his distinction of the role of the 'initiative individual' in a period of innovation and invention as springing from the impulses of the collective is his own. More important, we do not meet thinking of this kind in Malevich's writings. On the other hand, the painter Pavel Filonov (1883–1941) formed a 'school of Analytic Art' and would not sign or sell his works, but had his 'collective' work on projects without revealing anyone's individual authorship.

63. K. Umanskij, an introductory account of Russian modernism in *Das Kunstblatt*, Potsdam 1919, no.3, and 'Tatlinism, or Machine Art' ('Tatlinismus oder die Maschinenkunst'), in *Der Ararat*, Munich January 1920 and February/March 1920.

64. Umanskij 1920, p.4.

65. 'Wanderers' (or 'Itinerants') was the short name used for the Association of Travelling Art Exhibitions, formed in 1871. The Wanderers, who kept aloof from any alliance with the Revolution, continued until 1923 when they were succeeded by a new group of painters, the Association of Artists of Revolutionary Russia (AKhRR), dedicated to producing naturalistic images in praise of Soviet achievements and ideals. The case of Ilya Repin (1844–1930) illustrates the Imperial Academy's ability to adapt to new priorities before it was closed in 1918. Part of his training was at the Academy from 1864 to 1871, when he was awarded the major gold medal for a religious history painting. In 1872 he completed his *Barge Haulers*, a forceful, naturalistic scene of men working like beasts (State Russian Museum). He taught as professor of painting at the Academy from 1894 to 1907 and was its director during 1898–9. See Milner 1993, p.351, and Sarabianov 1990, pp.136–45.

66. Umanskij 1920, pp.19–20.

67. See Andrei Nakov's commentary in London 1983, p.15.

68. See Strigalev and Harten 1993, cat.392. This work is correctly named a counter-relief in that it does not employ a support other than the wall itself. The materials used in it appear to be wood and metal.

69. Bann 1974, pp.70–72 and 75–6. Mention of Tatlin's Monument as located in Moscow is a reference to the second showing of the model, after Petrograd. My sentences on the creation of the First Russian Exhibition in post-war Berlin are indebted to essays by Andréi Nakov and Peter Nisbet in London 1983.

70. Part of this front page is reproduced in East Berlin 1978, p.37.

71. This quotation opens Gough 2005, p.vii.

Chapter 4

1. Zhadova 1988, p.184.

2. See Zhadova 1988, pp.489–503 for her chronological list of 'Tatlin at Russian and Soviet Exhibitions'.

3. See Strigalev and Harten 1993, pp.388–9.

4. Ibid., cats.363–87. See the introductory entry on p.253.

5. The First International Workingmen's Association was set up by Marx and Engels in London, in 1864, to promote Socialism internationally. The Second was formed in Paris in 1889. It sought to establish the eight-hour working day, and appointed 1 May the day for celebrating labour. Though resolutions stated that workers would never again go to war against

each other, propaganda triumphed easily in 1914 and the IWA died. Lenin initiated the Third International in March 1919. The 1919 May Day festival in Petrograd included a *Pageant of the Third International* to which Tatlin may have contributed.

6. See Zhadova 1988, p.138. Punin lists many technical devices, from film projection on the exterior of the building to provision for a wireless station, a telephone exchange and a telegraph office, lifts and other forms of 'mechanized conveyance' within it, to make it 'the centre of the most intense activity'. The building should be in a 'unified form . . . architectural, sculptural and painterly'. He emphasized that engineers and other specialists would have to be involved in realizing the scheme.

7. Already in 1916 Tatlin was being nicknamed 'the builder'. His leap, from being a painter and maker of reliefs to a sculptor-architect proposing a new type of structure that would be the largest building in the world, should not be made matter-of-fact by hindsight. Go-ahead architects had enjoyed special status in nineteenth-century Russia; see S.F. Starr, 'Russian Art and Society 1800–1850' in Stavrou 1983. Some interaction between architecture and the visual arts, developing in Russia as elsewhere from the 1870s on, became part of modernist expectations, most obviously in Germany. Neither in Germany nor in Russia was architecture a protected profession. In Russia, when not left to foreigners, architectural design had been the business of aristocrats; successful architects of lower status might be ennobled, but there was no certification required for anyone designing buildings and seeing them built.

8. Punin in *Art of the Commune*, Petrograd, 9 March 1919, pp.2–3. The major part of this article is given in Swedish and English in T. Andersen, *Vladimir Tatlin*, published as the catalogue to the Tatlin exhibition at the Moderna Museet, Stockholm, 1968, and in German in the same, republished for the exhibition at the Kunstverein, Munich, 1970, pp.56–7 and 48 respectively. A more careful translation, into French, is available in T. Andersen & K. Grigorieva, *Art et poésie russes 1900–1930 – textes choisis*, Paris, Musée National d'Art Moderne, 1979, pp.128–9. I have used this for my summary and quotations.

9. Bogdanov's novel *Red Star*: see Graham & Stites 1984.

10. Hamilton 1954, pp.223 and 256. In chapter xvi of his book *What Is Art?* (1898), Tolstoy contrasts the urge for 'might, greatness, glory' exhibited in the art of all institutional religions with the 'humility, purity, compassion, love' that Christian art should now manifest. See Tolstoy 1969, pp.260–62.

11. See Hamilton, op.cit., note 18, p.288. The title is in French, 'Alexander Vitberg et son projet d'église à Moscou'. The rest of the article is in Russian, except for one paragraph in French which, according to

F. Vitberg, comes from Vasily Kiprianov's book on Russian architecture, published in 1864. (Those sentences are echoed, or pre-echoed, in Herzen 1980, pp.243–4.)

12. Vitberg's pair of Trajan's Columns may derive from the Church of St Charles Borromeo (Karlskirche) in Vienna. Built during 1716–37 to the design of J.B. Fischer von Erlach, it groups together elements from disparate kinds of classical architecture.

13. See Billington 1966, pp.26–37.

14. Quoted from Isaiah Berlin's introduction to Herzen 1980, p.xvi.

15. For Soloviev's thought and influence see Copleston 1986, especially chapter 9. The quotation is on p.229. On Soloviev's teaching that the task of art is 'life-building' and that artists can discover universal harmony, see Groys 1992, pp.18–19.

16. See especially West 1970. For a general account of Russian symbolism, see Pyman 1994. To Ivanov, art was essentially a symbolical form of knowledge: 'Thus true symbolic art approximates to religion, in so far as religion is first and foremost an awareness of the interconnection of everything that exists and the meaning of every kind of life'. This comes from an essay of 1908, republished in 1909, quoted in West. The essay, writes West, 'is, in effect, a short statement of a psychology of creativity'; idem, pp.50–51. The poets Andrei Bely and Alexander Blok emerged from such symbolist views.

17. This is studied in some detail in Read 1979, and is supported and enriched by Pyman 1994.

18. This aspect of Lunacharsky's work and thought is outlined in Read, op. cit., pp.78–85. See also Drengenberg 1972, pp.86–112, and Tumarkin 1983, especially pp.20–23. Herzen had pre-echoed Lunacharsky in the book he wrote after Western Europe's failed revolutions of 1848, *To the Other Shore*, published in 1850: 'The religion of revolution, of a great social transformation – that is the only religion which I bequeath to you'. Similarly, Gorky wrote in June 1905 that 'Only socialism renews life in this world, and it must become the religion of the working man'. See Williams 1986, p.56.

19. For a summary of the positions of 'god-seekers' and 'god-builders', see Wetter 1977, pp.90–91. Lenin wrote to Gorky in 1913: 'God-seeking no more differs from god-building or god-making or god-creating or the like than a yellow devil differs from a blue devil'. Wetter writes: 'Lunacharsky shows no aversion, even, to the employment of traditional Christian symbols: for him the forces of production are the Father, the proletariat the Son, and scientific socialism the Holy Ghost.'

20. Zavalishin 1958, p.153.

21. Steinberg 2002 examines the creative writing that developed among Russian workers from the late nineteenth century on, and its dominant themes and references. What he calls a 'plebeian intelligentsia'

developed, influenced particularly by Tolstoy the aristocrat and by Gorky the working-class author. See especially Steinberg's chapters 6 and 7 on their use of religious imagery and language. The words quoted in praise of Tolstoy are on p.234. In Petrograd a few days before the October Revolution, a great meeting of workers' cultural organizations, trade unions, etc., convened to discuss the new cultural organization *Proletkult*. See Steinberg 2002, especially pp.38–9 and 51.

22. For a brief account of the role of language and symbols in Russia during 1917 see Figes and Kolonitskii 1999, pp.135 and 146 and pp.148–52 for the Bolsheviks' adoption of religious and peasant terms, including references to Christ and to Lenin as being Christ-like.

23. Adopting pen-names was quite common among Russian writers. Andrei Bely's proper name was Boris Bugaev; *bely* means white. Maxim Gorky's proper name was Alexei Peshkov; *gorky* means bitter. Alexander Bogdanov was Aleksandr Malinovsky; *bogdanov* means god-given. On Bogdanov's role in Communist thought and organization, see Sochor 1988, pp.130–57, and Williams 1986, especially pp.34–41.

24. See Graham and Stites 1984. On p.14 Stites quotes a Russian historian of science-fiction, writing in 1970, who judged Bogdanov 'the first writer of Russian science-fiction to combine a well written technological utopia with scientific Marxist views on communism and the idea of social revolution'. Lunacharsky's enthusiastic praise of *Red Star* is cited on p.13.

25. Platon Kerzhentsev, prominent in the PLK movement, wrote a book *On the New Culture*, published in Petrograd in 1921. In it he differentiated studios from other centres: 'Studios break with the principle of authoritarianism and are built on the comradely basis of equality and collective creativity'. Sochor 1988, p.130.

26. See Fitzpatrick 1970, p.100. Fitzpatrick's suggestion that Bogdanov here 'seemed to give some encouragement to proletarian admirers of the constructivists Rodchenko or Tatlin' is a little premature: in 1920 constructivism was not yet a discernible movement and Tatlin's project was known only through Punin's words until that December. Inkhuk's debates about constructed *versus* composed art took place during January–March 1921, and the First Working Group of Constructivists was formed by Rodchenko and others that same March.

27. The Bolsheviks' newspaper *Pravda* received many submissions of workers' writings. Writing continued to be the dominant mode of expression among the workers, but the clubs set up to develop knowledge and cultural awareness also opened up other media, forming choirs, presenting concerts, offering art classes and arranging guided visits to museums. Petersburg led the way, with twenty-one such clubs around 1910 when Moscow had only six and other cities fewer still. In 1913 Moscow put on an exhibition of workers' paintings. By August 1917 Petrograd had sixty workers' clubs. PLK flourished from September 1917 to about 1922, but clubs were also formed outside PLK, usually with Lunacharsky's backing. See Steinberg 2002, chapter 1.

28. At this time the population of Russia's major cities had declined drastically in the face of Civil War, industrial collapse and recurring famine. The working class seemed to be in danger of dissolving as workers returned to their peasant families.

29. For Gastev see Bailes 1977, pp.373–94. The quotation is from Nikolai Aseyev, close to Mayakovsky and one of the creators of the LEF group (Left Arts Front) and its journal *Lef*, discussed here in chapter 8. Bogdanov's disapproval of Taylorism, which he saw as demeaning workers, is discussed by Aseyev and cited in Bailes 1977, pp.379–81. See also Steinberg 2002, especially pp.195–6 and 209–11, and the biographical 'sketch' provided in the appendix on pp.294–7.

30. For Gastev's working experience before the war see Steinberg 2002, pp.163–4; for his vision of workers as superhuman giants see ibid., p.195. Such ideas may well have helped the painter Boris Kustodiev to conceive *The Bolshevik* (1920) as a gigantic striding figure, and could also have fed into Tatlin's conception of his Tower as a vast presence with human characteristics. For discussion of both see my chapter 7, part II.

31. Not only Russia was attracted to Taylorism. On the interest shown in France, notably by Le Corbusier, see McLeod 1983, pp.132–47.

32. Williams 1986, p.170.

33. In 1804 Tsar Alexander I sponsored the publication of Ledoux's treatise *L'Architecture considerée dans le rapport de l'art, des moeurs et de la legislation* and brought one of Ledoux's pupils to Russia. The early nineteenth century saw outstanding achievements in Russian neoclassical architecture, especially in Petersburg. See S. Fredrick Starr's essay, 'Russian Art and Society 1800–1850' in Stavrou 1983, pp.89 and 109, note 4.

34. The name *Arbeitsrat* was chosen to echo the Russian term 'workers' soviet': 'soviet' means 'council' and 'counsel', as does *Rat*.

35. See Lane 1968, p.46.

36. Ibid., p.49. See also the texts brought together in the appendix of Los Angeles 1993, pp.277–322, offering an inclusive account, drawing on sociological and psychological writings of the late nineteenth and early twentieth centuries as well as statements by architects and others of the period, together with many illustrations. These show that the fantastical designs of Taut and his allies were partnered by

designs of a more austerely modernist sort by others who nonetheless shared the aspirational vision of the time.

37. Gropius had already made dramatic use of large steel and metal window areas between brick piers in his Fagus Shoe Last Factory, built 1911–14 in the provincial town of Alfeld an der Leine, pre-echoing his Dessau Bauhaus Buildings of 1926. His transparent staircase became a familiar feature of international modern architecture. Taut's pavilion recently resurfaced in extended form in Norman Foster's building, 30 St Mary Axe, in London. Some of Frank Gehry's designs echo the drawings illustrated in *Frühlicht* in their invincible trust to weightlessness and slightness.

38. This is briefly referred to by Starr 1978, p.78, in a broader discussion of, primarily, German developments in architecture and their impact on Russia after the Revolution. Starr refers particularly to the work of Hans Poelzig, notably his Grosses Schauspielhaus in Berlin, an iron-framed circus building transformed into a vast one-class auditorium for 3,500. It was shaped and lit to suggest a grotto, with an enormous and adjustable stage to accommodate Max Reinhardt's popular productions, and also Taut's *Die Stadtkrone*, both of 1919. Konstantin Melnikov spoke of the latter to Starr in 1967: 'What appealed particularly about Taut's idea was that it had been sketched as the center of a New Jerusalem. Russian architects who had survived the apocalypse of Civil War needed little persuasion to see Moscow as that New Jerusalem.' Milner-Gulland 1997, pp.217–19, touches on the Russian awareness of Jerusalem as a valued reference to Russian founders of towns, monasteries and churches, and particularly on the association of St Basil's, in Red Square, with 'the heavenly city of Jerusalem' (p.212), predecessor of Rome and Constantinople and holier than either. Taut, a friendly observer of the new Russia, had included a picture of Moscow's Kremlin in his book as an instance, among others, of city 'crowns'.

39. See chapter 3, p.18.

40. See Lodder 1983, pp.239–40, and Milner 1993, pp.57–9.

41. For a guide through this complex story, see Khan-Magomedov 1987, especially pp.67–9.

42. See Khan-Magomedov 1986, pp.40–41 and 48–54.

43. See Milner 1996, chapter 7, 'The Architecture of Flight', pp.190–200.

44. The paragraphs that follow have benefited at several points from the book-catalogue, Berlin 1995.

45. Bellamy's writings and the principles developed in them are discussed in Bowman 1958. Bellamy's ideas were welcomed not only by political groups such as the Socialist and Communist movements of the USA and of Europe, but also by forward-looking spiritual associations including the Theosophical

Society, of marked influence in Russia in the first decades of the twentieth century.

46. Federov taught mathematics to the Russian rocket pioneer Konstantin Tsiolkovsky. According to Milner 1883, p.178, Tatlin admired Tsiolkovsky. Lodder, referring to the unpublished memoirs of Anna Begicheva, who knew Tatlin in Kiev during 1925–7, states that Tatlin consulted Tsiolkovsky about man-powered flight and was encouraged by Tsiolkovsky to pursue the project: Lodder 1983, p.215.

47. Russian thought turned frequently to what was called the 'cursed questions' about life and death, and particularly about the present and future of society and of Russia in the world – guardedly until 1917 and less guardedly in the early 1920s. What should individual Russians contribute to their country's development? What does history teach us? What is the future of Europe and what should be Russia's role in it? Many accounts of Russian thought touch on these questions, among them Billington 1966, particularly pp.309–58. See also Herzen's novel about a man with a noble soul and a weak character, published in 1847, entitled *Who Is to Blame?* (in Russian *Kto vinovat?*). The title of Chernyshevsky's novel of 1864 about new ideas and relations between the New Man and the New Woman, *What Is To Be Done?* (in Russian *Chto delat?*), was borrowed by Lenin for a political treatise of 1902, subtitled 'Burning Questions of our Movement'.

48. See Young 1979, p.198. A selection of Fedorov's writings, with an introduction by E. Koutaissoff, is in Fedorov 1990. Read 1979 touches on the theme of death as an aspect of mystical experience before and after 1900, and judges Fedorov to have been the most original thinker of the period to embrace the problem of mortality. See also the section on 'Fyodorov' in Zenkovsky 1953, pp.588–604, and Teskey 1982.

49. The title is often rendered as 'About This!'. *Pro Eto!* is also translated as 'About That!', in Markov 1969 and other places. Milner-Gulland suggests that the latter better indicates the poem's theme of love and sexual longing.

50. Shklovsky 1972, p.174. Shklovsky's breezy account of Mayakovsky was written in 1940, ten years after the poet's death. Feiler quotes Shklovsky: 'he died . . . not of unrequited love, but because he had ceased loving', referring to the poet's love for Lily Brik and for Communism. He 'had lost faith in the cause'.

51. See Starr 1978, chapter x, 'Architecture Against Death: The System of Melnikov's Art', pp.240–58. Starr offers a stimulating survey of Fedorov's influence, including in it Lunacharsky's plays and quoting Mayakovsky's words to Roman Jacobson, in 1920, that he was 'absolutely convinced that there will be no death [and that] the dead will be raised.' In the same year there was a call for open

discussion of the struggle against death, supported by Mikhail Pokrovsky, Lunacharsky's deputy at the ministry, who saw that victory over death would remove the need for religion. The often negative apocalypticism of the symbolists was converted into positive expectation of mankind's regeneration. The embalming of Lenin was an important public contribution. Not only was the deceased leader honoured with the slogan 'Lenin lives!' but he was placed in his glass-covered sarcophagus – for which Melnikov made a design – in expectation of resurrection. Melnikov adapted the design for his Russian pavilion at the 1925 Paris Exposition. See chapter 8.

52. See Paul's First Epistle to the Corinthians, chapter 15, especially verse 21: 'For since by man came death, by man came also the resurrection of the dead'.

53. These are illustrated in Lodder 1983, plate 6.9 and plate 6.8 respectively. Klucis's painting *The Dynamic City*, 1919–20, in colour plate xiv, shows several planes and two major masses clustered around and over a hovering disk. Gustav Klucis (1895–c.1944) was a Latvian trained as a painter in Riga and then in Petersburg, and active as a revolutionary from an early age. From 1918 on he studied in Moscow under Malevich and Antoine Pevsner, and showed in the open-air exhibition mounted by Gabo and Pevsner in 1920. He worked with the Unovis group in Vitebsk and designed constructed kiosks, comparable to Rodchenko's, in 1922. He made photomontage his particular medium and contributed to the journal *Lef* in 1923–5, promoting a close union of artists with Communism. He died in a labour camp. See Lodder 1983, p.246 and Milner 1993, pp.202–5.

54. What Fedorov promised was the New Jerusalem of perfect existence announced in Revelation, when death and all pain have been overcome. Revelation 21: 2–4: 'And I John saw the holy city, new Jerusalem, coming down from God out of heaven, prepared as a bride for her husband. And I heard a great voice out of heaven saying, Behold, the tabernacle of God is with men, and he will dwell with them, and they shall be his people, and God himself shall be with them, and be their God. And God shall wipe away all tears from their eyes: and there shall be no more death, neither sorrow, nor crying, neither shall there be any more pain: for the former things are passed away.'

55. On Platonov and Fedorov, see Teskey 1982, especially chapters 1 and 2 and the quotations on pp.32 and 33, and Starr 1978, p.246, note 17. Starr mentions a journal, published in Moscow in 1908, dedicated to the theme of death and immortality, *New Wine* (*Novoe vino*); idem, p.245, note 14.

56. It seems natural to speak of the Tower's spine – the slanting girder that is its major structural component

– and therefore also of its profile, as in Tatlin's drawing of this elevation. Zhadova 1988 employs the term 'facade', inept here. Tatlin's project was for an all-round edifice. Strigalev and Harten 1993 attributes directional terms such as 'west', 'north-east', 'south-west' to views of the 'facades', but these seem incorrect if we start from the intention to have the Tower point at the Pole Star, i.e. to the north.

57. See Fedorov 1990, pp.123–4.

Chapter 5

1. R. Milner-Gulland translates its Russian name, 'Ivan Velikiy', as 'Big John', adding that the name does not refer to any tsar. See Milner-Gulland 1997, p.218.

2. Ibid., p.221. Additional information has been taken from Berton 1977, pp.108–9.

3. 1 Corinthians, 4:10.

4. Billington 1966, p.68.

5. Joanna Hubbs's study of 'The Feminine Myth in Russian Culture' reports on the Russians' particular regard for the Mother of Christ, and the large number of icons of diverse types representing her. Some of these were credited with miraculous powers. Mary was often identified with Sophia, Divine Wisdom. Hubbs also discusses the Russian Holy Fool, associating his image and role with that of the simpleton of many folktales, the favourite youngest son of his mother, allowed to perform 'unmanly' acts and untouched by patriarchal vanities, but of benefit to his community. With Peter the Great, the capital of Russia was moved from 'Mother Moscow' to a city with a masculine and foreign name, colloquially abbreviated to 'Piter'. Russia was now not a motherland (*rodina*) but a fatherland (*otechestvo*). See Hubbs 1988, pp.103–5, and 201–4. Milner-Gulland 1997, pp.117 and 212–13, states that the Cathedral of St Basil's correct name is Church of the Protecting Veil. That this church came to be named after St Basil represents 'a remarkable case of the popular "appropriation" of the dedication of such a monumental building project' (p.117). See also Milner-Gulland's account of the Holy Fool, pp.116–17.

6. This is mentioned by Wohl 1994, p.302, note 53.

7. See Milner 1983, pp.156, 181–2 and p.243, footnote 7, and also the entry for Yakulov in Milner 1993, pp.464–7.

8. Genesis, 10 and 11. See the discussion in R. Milner-Gulland, 'Tower and Dome: Two Revolutionary Buildings' in *Slavic Review* 1988, no.1.

9. See Godwin 1979. The Tower of Babel is shown in plate 11, p.37. Kircher's search for the unity of all knowledge was of particular interest to the Theosophists: Madam Elena (Helen) Blavatsky discusses his work in the first volume of *Isis Unveiled* (New York 1877). A Theosophical journal,

The Herald of Theosophy (*Vestnik teosofii*) began publication in Russia in 1906. A Russian section of the Theosophical Society was founded in Petersburg in 1908 by Anna Kamenskaia. The journal was condemned in 1911 and Kamenskaia was unsuccessfully tried for blasphemy, and thus attention was drawn to her work. Malevich was interested in Theosophy and probably attended Uspenky's lectures in Petrograd, during February/March 1915 (when he was embarking on his suprematist paintings), dealing with the fourth dimension as a mathematical and a theosophical concept, as well as with Indian mysticism. Malevich's *Black Square* is often associated with Blavatsky's statement that man is the 'mystic square', and sometimes with the Book of Revelation in which the New Jerusalem is described as being 'foursquare, its length is the same as its breadth'. It may be his response to an image describing an earlier beginning, Robert Fludde's black square surrounded by whiteness with the words 'and thus on to infinity' inscribed along each side of the square. Here the square represents *prima materia*, prehistoric chaos, and whiteness infinite space, and comes very close to Malevich's intention. Fludde's images of the creation of the cosmos are in his *Utriusque Cosmi*, 1617, volume 1. I believe that the *Black Square* also evoked, not only for Malevich, the prestigious icon *The Saviour Not Made with Hands*. The original was said to have been Christ's response to a request for an image that might heal King Abgar of Edessa. It is Orthodoxy's equivalent to the 'vernicle' or *sudarium*, the Cloth of St Veronica (meaning 'true icon'), on which the suffering Christ impressed his image. On Theosophy and other spiritual speculations see Williams 1977; Crone and Moos 1991; and, for a broader account, Lipsey 1988. Williams 1977 emphasizes Steiner's belief in death, after-death and resurrection, and Lunacharsky's especial interest in this theme as conveyed in Part Two of Goethe's *Faust*, see pp.104–5.

10. For illustrations and discussion of the ancient Wonders of the World in relation to Tatlin, including Shapiro's statement, see Milner 1983, pp.163–4 and p.244, note 14.

11. These and further details are in Hague and Christie 1975, pp.63–9.

12. For the 'Protestation des artistes', published in *Le Temps* on 14 February 1887, see Harriss 1976, p.20 and Thomson 1985, p.212. On p.11 Harriss reports that an alternative proposition for the 1889 Paris Exposition had been a tower bestriding the Seine, linking the Champ de Mars to the Trocadéro Gardens.

13. Harriss 1976, p.173. On p.223 Harriss quotes Roland Barthes's spirited essay on the Eiffel Tower (1964): the tower 'touches the limits of the irrational . . .[.] In fact, the tower is <u>nothing</u>, it achieves a sort of

absolute zero as a monument . . . it becomes the symbol of Paris, of modernity, of communication, of science, of the nineteenth century, a rocket, stem, derrick, phallus, lightning rod or insect . . .[.] It is impossible to flee from this pure sign, <u>for it means everything</u>.'

14. A seventy-five-foot high statue of The Republic, resembling the Statue of Liberty, was a feature of Chicago's Columbian Exposition in 1893. It was outshone by the world's first ferris wheel. America saw the Eiffel Tower as a challenge to her pre-eminence in engineering. The organizers of the Chicago Exposition asked, from the first, how they might 'out-Eiffel Eiffel'. George W.G. Ferris proposed a large double wheel, resting on huge forks and linked by thirty-six carriages, turning gently and carrying passengers up to 264 feet. The Chicago Exposition was widely noticed in Russia. News of its preparation had drawn attention to the skyscrapers erected in the city after the great fire of 1871. See W.C. Bromfield, 'Russian Perceptions of American Architecture', in Bromfield 1990, p.53, and also Muccigrosso 1993, and Larson 2003, in which a factual account of the exhibition is combined with a murder mystery. Paris's Grande Roue was built for the 1900 Exposition. Britain too felt challenged by the height and popularity of the Eiffel Tower. A bigger tower should be built, at Wembley in the outskirts of London. Eiffel himself was approached to design it but declined. See Barker and Hyde 1982.

15. The *Tower* painting owned by Berlin collector Bernhard Köhler had been shown in the First Exhibition curated by the editors of the *Blaue Reiter* and reproduced in its catalogue. Tatlin could have seen the painting in Berlin; he could also have seen other paintings by Robert and Sonia Delaunay in Walden's offices. At the end of 1912 or early in 1913 Walden published a postcard of a Delaunay Eiffel Tower picture to promote his Delaunay exhibition of January–February 1913. The painting chosen for this was either the Guggenheim's *La Tour rouge* or a horizontal painting, *The Three Windows, the Tower and the Ferris Wheel* (1912), in which Delaunay combined new elements he was exploring with graphic images of the tower in the centre and of the ferris wheel to its right. See Buckberrough 1982, p.357, note 8.

16. Pavel Kuznetsov (1878–1968) was its leader. He was born, had his first art training and became an exhibiting painter in Saratov on the Lower Volga. By 1902 he was associated with The World of Art and its exhibitions. He showed also in Moscow's avant-garde exhibitions until about 1909 when he went East to immerse himself in the life and cultures of Asian Russia. Back in Moscow after the Revolution, he taught at the Free Art Studios and their successors and served on IZO under Tatlin. His best-known painting was the one most remarked on at

the 1907 'The Blue Rose' exhibition, *Blue Fountain* (1905–6), a fantasy of semi-naturalistic but vague figures around a leaping fountain, softly painted in sweet and unlikely colours (Tretyakov Gallery, Moscow). See Sarabianov 1990, pp.242–3. Kuznetsov's engagement with Asian Russia may have been encouraged by Gauguin's example. The Blue Rose group, which continued until 1910, had some of the characteristics of the Nabis of 1890s Paris.

17. A surprising omission from the almanac is the Orthodox icon. One explanation for this may be the prevalence in it of illustrations of Bavarian glass paintings, mostly of religious subjects. Their folk origin may have made these pictures seem more innocently spiritual than the canonically regulated art of the icon.

18. See Butler 1993, pp.334–6, 430–31 and 434.

19. Malevich titled his 1912 painting of a man chopping a log with an axe *Plotnik* (Amsterdam, Stedelijk Museum). The English translation, *Woodcutter*, approximates to one meaning of *plotnik* though Russian has another word specifying 'woodcutter', *drovosek*. Malevich was alert to the socio-political message of his work. Note, for example, the drawings and paintings of 1911–12 in which he shows peasants crossing themselves with two fingers, not three as ordained by Nikon in the seventeenth century. Malevich was here demonstrating his support for the Old Believers' cause. It seems certain that his painting of a *plotnik*, better translated as 'carpenter', is intended as an heroic image of a well-known and admired Russian radical type. (On its reverse is the painting of Old Believers crossing themselves.) Some recent translations give the title of this painting, and of a drawing for it, as *Carpenter*. See A. Shatskikh ('Malevich, Curator of Malevich') and A. Babin ('Albert Gleizes and Jean Metzinger's *Du Cubisme* as Perceived by Russian Artists and Critics') in Petrova 2001, pp.152 and 245. Babin also refers to Charlotte Douglas's discovery of 'the contours of the figure of a carpenter' in one of Malevich's 'white on white' paintings of 1918, adding that 'the symbolic image of the carpenter, cosmic builder and creator of the universe, is completely spectral here'; see p.245 and p.258, note 16.

20. This is suggested by Zygas 1976, pp.15–27.

21. See Ikonnikov 1988, pp.38–9 and 83–5.

22. Chernyshevsky 1982, pp.319–22 and 328. I give a fuller account of Chernyshevsky in chapter 8.

23. Quotations from Dostoevsky's *Notes from Underground* in Dostoevsky 1983. For his response to Chernyshevsky see Frank 1986, pp.289–327.

24. See Dostoevsky 1984, pp.29–31.

25. Vsevolod Garshin's story of 1879, 'Atalea Princeps', speaks of a 'vast greenhouse', made of iron and glass and very beautiful, especially at sunset: 'It is all

aglow then, shot with shifting gleams, like a huge sparkling gem with small-cut facets.' Inside it 'one could see the imprisoned plants.' That is the point: this is a prison; the plants growing in it compete for space and air. The palm tree, the tallest and most beautiful of them all, breaks through the top of the greenhouse . . . and freezes to death. Garshin (1855–1888), from a well-to-do family, fought in the Russo-Turkish War of 1877–8 and subsequently wrote stories of great intensity, many of them allegorical, before committing suicide. See Garshin 1982, pp.129–40. Garshin also wrote about art and corresponded with Kramskoy about his key painting, *Christ in the Wilderness*, suggesting that it represents Christ as a prototype of the modern revolutionary. See Henry 1983. Yevgeny Zamyatin's famous novel *We* (1920; not published in Russia until the 1980s) describes a dystopian city and way of life: 'it's all majestic, beautiful, noble, exalted, crystal-pure, for it guards our unfreedom, that is, our happiness.' Zamyatin (1884–1937) was deeply influenced by Dostoevsky, as well as by Garshin and of course H.G. Wells. See Shane 1968, especially pp.139–44.

26. See Khan Magomedov 1986, pp.116–27.

27. See M. Bliznakov, 'The Realization of Utopia: Western Technology and Soviet Avant-Garde Architecture', in Bromfield 1990, p.160.

28. See Zhadova 1984, plate 196.

29. This is discussed by Tait 1980, pp.189–203. I am grateful to Dr Tait for sending me an offprint. He stresses Lunacharsky's debt to Goethe.

30. This is discussed in Tait 1974, pp.234–51, and Lunacharsky 1923, which includes *Faust and the City*.

31. Sergei Chekhonin (1878–1936) contributed to The World of Art exhibitions before the Revolution and was then appointed to the Petrograd IZO, under Shterenberg, and to the State Porcelain Factory making Soviet images for objects formerly made for the tsar. In 1922 he used Tatlin's 1911 costume design for *Tsar Maximilian*, redrawn by Tatlin for the purpose, to make a *Tsarevich* plate. See Lodder 1983, p.59, with an illustration, and Milner 1983, p.225; for additional information on Chekhonin see Milner 1993, pp.106–8.

32. This quotation is from Tumarkin 1983, p.21.

33. See Zavalishin 1958, p.153.

34. These five are frequently named as those who alone accepted Lunacharsky's invitation. But perhaps there were seven: K. Rudnitsky names also Ryurik Ivniev and Larissa Reisner. See Rudnitsky 1988, p.41.

35. Many intellectuals held back from welcoming the Bolshevik take-over, even those who saw some hope for the future in it. It must have seemed merely reasonable to wait and see. How long would the Soviet state last under the pressures of war, civil war, social division, economic collapse, etc.? What

policies would emerge to control or guide the arts after months of freedom? I take a famous example: Merezhkovsky (1865–1941) and his wife, Gippius, left Russia to settle in Paris in 1919. Neither their influence nor their concern for Russia's cultural life ceased with their emigration. Before and after 1919 Merezhkovsky expressed his view of progress through revolution. For instance, in 1908 he wrote: 'Religion and revolution are not cause and result, but one and the same phenomenon . . .[.] Religion and revolution are not two, but one; religion is also revolution, revolution is also religion.' In 1920 he warned that Europe deceives itself if it thinks 'it is immune to internal shocks while the Third International has such a base as Russia. It deceives itself if it shuts its eyes to the religious essence of the International.' This essay was published in Munich in 1921. See Bedford 1975, pp.136 and 151.

36. Blok's expectation of revolution and his response to October are discussed and illustrated in Pyman 1980, vol.2, chapters 8 and 9.

37. Bengt Jangfeldt discusses the interaction of post-Revolution futurism and Lunacharsky in Jangfeldt 1976, especially chapter 2, pp.30–50.

38. The new realists were reacting against the objective work demanded from them by progressive teaching, but also to the now tired, backward-looking art they saw in the Wanderers' forty-seventh (and penultimate) exhibition in 1922. Formed that year, AKhRR announced 'heroic realism' as its programme. The Association spread rapidly, presented many exhibitions and set up branches around the country, largely in spite of Lunacharsky but with support from bodies such as the army and the trade unions. Their insistence on Russian subjects appealed to the many opposed to the avant-garde's internationalism. Lunacharsky considered their unsophisticated naturalism valueless but could not deny its success with a wide public. By 1928 AKhRR was being attacked for its stylistic backwardness. See Valkenier 1977, especially pp.148–55. Valkenier points out that, in spite of the value attached by revolutionaries such as Lenin to the art of the Wanderers, none of these was listed for celebration as a hero of the Revolution.

39. My summary account of Lunacharsky's views is indebted to several sources, outstanding among them Drengenberg 1972, especially pp.86–112, and Fitzpatrick 1970. Lenin remonstrated with Lunacharsky over art but supported him on most educational issues. Asked why he was still fond of Lunacharsky, Lenin answered: 'And I advise you also to be fond of him. He is drawn to the future with his whole being. That is why there is such joy and laughter in him. And he is ready to give that joy and laughter to everyone.' Ibid., p.1.

40. For example, Gray 1962, p.218 asserts that it was 'to be erected in the centre of Moscow. During 1919 and 1920 [Tatlin] worked on it and built the model in metal and wood with three assistants in his studio in Moscow'. She adds that 'it was not to be an idle symbol — how unsuited to the new economic order if a useless monument should be raised to its glory! No! It was to be dynamic, both in its outward form and inner activity', and quotes Punin's emphasis, in his article of March 1919, on the building's invitation for everyone to move and to be moved. Much the same words are in the posthumous edition of Gray's book, Burleigh-Motley 1986, pp.225–6. In Foster 2004, pp.174–6, a necessarily brief account of the Tower stresses that the constructed monument would be 1. a *modern* monument; 2. 'an entirely *functional, productivist object*'; and that 3. 'like all public monuments, it was conceived as a *symbolic* beacon: it spelled out "dynamism" as the ethos of the Revolution' [my italics]. It could be argued that points 2. and 3. are contradictory: a productivist object could not also be symbolic according to the rules of constructivism. Moreover, whereas the Tower was evidently intended to be a dynamic object, dynamism alone is not in itself a competent symbol.

41. Petrograd had some claim to remain a 'capital of the Revolution'. The descriptive phrase 'window on the West' is derived from a letter of 30 June 1739 from Count Francesco Algarotti to Lord Hervey, promising 'some account of this new city, of this great window lately opened in the North, thro' which Russia looks into Europe'. *Letters from Count Algarotti to Lord Hervey* was published in London in 1769. Alexander Pushkin adapted the phrase in his prologue to *The Bronze Horseman*, written in 1833, published posthumously in 1837.

42. Cited by Figes 1996, p.701.

43. Zamyatin's essay '*Moskva — Peterburg*' was written in Paris in 1933 but not published until June 1963 when it appeared in New York's *New Journal* (*Novy zhurnal*). It is translated in Ginsburg 1970, pp.132–55. Zamyatin comments on recent cultural life in the two cities, including the failure of constructivist architecture to touch the hearts of the people, the urge to return to earlier idioms, and the failure of Lenin's plan for monumental propaganda to produce anything more than feeble statues and busts.

44. Punin 2000, p.123.

45. See Milner-Gulland 1997, p.226. The Russian tradition of commemorating key events by building churches is itself a tradition of creating monuments with an eye to the future.

46. Christina Lodder argues that the combination of red and black used on this pamphlet, often with white as the ground colour, was the avant-garde's 'colour code of the Revolution', citing instances of its use by Malevich, Kolli and Lissitzky during 1918–19. See Lodder, 'Constructivist Colour', Thessaloniki 2005, p.486.

47. Shapiro, one of Tatlin's chief assistants on the 1920 model and subsequently a professional architect, was interviewed by Margit Rowell in 1977. He stressed that they were conscious of making a model out of available materials to give an impression of a vast structure to be made of new materials. See Rowell, 'Vladimir Tatlin: Form/Faktura', in *October*, Fall 1978, pp.97 and 102.

48. Punin 2000, pp.134–5. A translation of Punin's essay, dated July 1920, is given by Zhadova 1988, pp.344–7. Its title names the Tower correctly as ordered by Narkompros: 'Monument for the Third International'. Zhadova adds that the model was not finished until November and that Punin's pamphlet was probably published in December. A more precise French translation is in Andersen and Grigorievna 1979, pp.128–9.

49. For English versions of statements and accounts from Ehrenburg, Viktor Shklovsky, Trotsky, the graphic designer Jan Tschichold (1925) and Lissitzky (1925 and 1930) see Andersen 1968, pp.58–65. Lissitzky in his 1925 text stressed that the Tower would command both an extended space with its open structure and extended time because of its kinetic elements.

50. Public clocks, telling local time, came in as an essential tool of industrialization, to be followed by regional or national time systems. Large public clocks are particularly noticeable on architectural designs made in Russia after 1920.

51. See Milner 1983, pp.172–5. Ehrenburg, the Russian writer who was Lissitzky's co-editor of *Veshch* in 1922–3, published a book of essays in 1922 which he entitled *E pur se muove* (Nevertheless, it does move), the words Galileo supposedly spoke in defiance of the Inquisition's condemnation of his discovery that the earth is not the still centre of the universe. In his book Ehrenburg illustrates Tatlin's Tower from a summary line drawing traced from a photograph of the 1920 model.

52. See Hamilton 1954, pp.202 and 208–9.

53. A reconstruction of the Tower was an important part of the exhibition 'Art in Revolution — Soviet Art and Design since 1917' shown at the Hayward Gallery, London, from 26 February to 18 April 1971. Camilla Gray had proposed the exhibition to the Arts Council of Great Britain and was a key figure in its realization. I was involved in realizing the exhibition to her. Other major contributors were Edward Braun and Lutz Becker; the architect Michael Brawne designed the installation. Two extended visits to the Ministry of Culture in Moscow to negotiate for loans ended in a broad agreement but this was followed by silence from Moscow, enduring until their shipment arrived in London four days before the exhibition was to open. We had meanwhile had to decide on making our own preparations in the West. Moscow had promised us drawings to help us make a reconstruction of the Tower (presumably copies of drawings held by Shapiro) but they never came. Zhadova 1988, p.512, incorrectly asserts that the London reconstruction was based on 'Soviet materials . . . sent by A.A. Strigalev with the permission of the Cultural Ministry of the USSR'.

As director of exhibitions I approached the Moderne Museet in Stockholm in the autumn of 1970, requesting the loan of drawings from their 1968 reconstruction or of the reconstruction itself; both were curtly refused. We thereupon contacted Jeremy Dixon, a former student at the Architectural Association in London, who assembled a construction group — primarily Fenella Dixon, Christopher Cross and Christopher Woodward. Working out of office hours, they researched the contradictory information available and first made a small model of the Tower. Their large model, twelve metres high, was erected on the sculpture court overlooking Waterloo Bridge, an impressive exhibit that also drew attention to the exhibition. The delegates from Moscow, arriving three days before it opened, protested that the Ministry had not intended so prominent a model. I replied that this had never been discussed, and that, lacking all information from Moscow, we had had to go ahead without them. An offer to sell the reconstruction to the Ministry after the exhibition was vetoed from Moscow. A key contribution to our model was made by the engineer Sven Rindl, of Samuely and Partners, who discovered that 'the key to its geometry lay in an invisible truncated inner cone made up of twenty-four lines' which had to be formed to assemble the spirals and then removed. A brief text (from which these quotations are taken), accompanied by reproductions of Tatlin's profile elevation, a few of Rindl's many drawings, photographs of the finished reconstruction's interior, looking up, and of the small model preceding it (with red lines added to show the inner core), are in Latham and Swenarton 2002, pp.30–31. I am grateful to Sir Jeremy Dixon for talking to me about the reconstruction.

54. Milner 1983, p.175.

55. See Geldern 1993, p.196.

56. Ehrenburg, *E pur se muove*, pp.18–20, and (as Elias Ehrenburg) in *Frühlicht*, no.3, Spring 1922. This is the first issue Bruno Taut produced after becoming city architect for Magdeburg; it is more realistic, less visionary, than its predecessors. Ehrenburg illustrated his article with the drawing he used also in *E pur se muove*.

57. Shklovsky: from an article in *Life of Art* (*Zhizn iskusstva*), Moscow, January 1921, p.1. Ehrenburg: from *E pur se muove*, pp.18–20; Trotsky: from *Literature and Revolution*, Moscow, 1924, cited in translation in Andersen 1968, pp.58–62. Quoted out of context, Trotsky's strictures against the Tower,

and against futurism in general, seem harsher than when read as part of his intelligent and remarkably unprejudiced book. I have slightly amended the Shklovsky translation, and fused the Andersen version of Trotsky's paragraphs with those in Trotsky 1975, pp.246–8. For a sympathetic account of Trotsky's book see Taylor 1991, pp.187–97. For Strigalev on the 'expert committee', see Zhadova 1988, p.30. A translation of Sidorov's review, published in 1921, is cited in Roman 1992, p.54.

58. The article appeared in the first issue of *Herald of the Executive Committee of the Moscow Higher Art Studios*, October 1920. A translation is given in V. Rakitin's essay, 'Malevich after Anarchism', in Petrova 2003, pp.27–8. Rakitin comments that the 'idiosyncrasies of artistic journalism' exhibited by this text are typical of the Civil War period, and that Malevich was eager, at this time, to launch suprematism as an integral part of militant Communism. Malevich's attack on Tatlin annoyed Shterenberg so much that he ordered the destruction of that issue of the journal, but some copies appear to have escaped this fate.

59. This is cited by N. Adaskina in 'A Place in History: The Self-Determination of the Russian Avant-Garde of the 1920s', in Petrova 2001, p.197. In June 1922 Petrograd saw a large exhibition surveying 'New Tendencies in Art', organized by Tatlin at the new Museum of Artistic Culture to show a wide range of recent work, including suprematism. Tatlin himself was represented by nudes, a corner counter-relief and *Pink Board*, a monochrome painting. Zhadova mentions this as 'a study in colour and glazing with paint, which was representative of some of the experiments conducted in his studio' (Zhadova 1988, p.493). Tatlin's use of colour has not been fully studied. His use of monochrome recalls work by Malevich and Rodchenko. Punin wrote in *Tatlin. Against Cubism* (1921) that for Tatlin colour was inseparable from materials, in other words, had structural but not necessarily the symbolic value it had in icon painting and for Malevich. Tatlin produced a number of 'boards' or 'planes' for his staging of *Zangezi* in 1923. It is possible that this *Pink Board* is one of them. See Strigalev and Harten 1993, cats 415–74.

60. These words are quoted from G.H. Roman in Roman and Marquardt 1992, pp.50–51.

61. Curtis 1982, p.137. On p.124 Curtis quotes Le Corbusier's words, in *Vers une Architecture* (1923, translated as 'Towards a New Architecture'), on the transcendental nature of architectural forms: 'Architectural abstraction has this about it which is magnificently peculiar to itself, that while it is rooted in hard fact it spiritualizes it.'

62. Both Melnikov's building and Rodchenko's interior will be discussed further in chapter 8.

63. In November 1924 Lunacharsky formed a committee to organize the Soviet section of the Paris exhibition. It is thought that Rodchenko was proposed and backed by Mayakovsky to contribute to the exhibition and to install the Soviet displays in Paris. The committee asked Tatlin to contribute on 29 December, approved showing a model of the Tower on 6 January 1925, and the model itself on 10 February. A small grant was made to Tatlin for its production; the model would remain the artist's property. See Zhadova 1988, pp.159–60.

64. This account, often repeated, has been challenged by Shapiro, who has stated that the small model was made before the large one, earlier in 1920. What was shown in Paris may have been a new version of this. See Strigalev and Harten 1993, p.275. On the other hand, we are told that on 1 February 1925 a new model of the Tower was commissioned from Tatlin as a matter of urgency, and Punin wrote in his diary, one week later, that Tatlin was complaining that nothing was happening — 'Nothing is "moving" anywhere, everything is at a standstill, there is something sinister about time's deathly silence . . . can this really drag on for a decade?' He had 'made a new model of the "tower" ', but was in a 'wild, silly rage, and quite impossible.' A few days earlier, 'he broke some doors at the museum, and again turned furiously on Malevich'. (Punin 2000, p.234.) His request to accompany the model to Paris was not granted. It is not true, though often said, that the model was awarded a prize by the judges of the Paris exposition. It was returned to Petrograd where Tatlin gave it to the Russian Museum. It has not survived.

Chapter 6

1. See Strigalev and Harten 1993, pp.391–2 and Zhadova 1988, pp.447–8.

2. Lodder 1983, p.298, note 30.

3. I am indebted to several studies of Leskov's life and work, including Setschkareff 1959; McLean 1977; and Muckle 1978. Milner-Gulland notes the particular significance for Tatlin of Leskov's story of *Levsha, the left-handed smith of Tula*.

4. A fuller account of Tolstoy's book will be found in chapter 8.

5. Steinberg 2002, p.231. His chapters 6 and 7 deal with religious thought as expressed in the writings of the proletariat, in an atmosphere sometimes of desperation and sometimes of sanguine expectations.

6. Lunacharsky would have known Nikolai Berdyaev's comments on symbolism. See Braun 1988, p.57. Berdyaev's essays of 1900–1906 were published in Petersburg as *Sub specie aeternitatis*. More about him in chapter 7.

7. Bloody Sunday and its repercussions agitated many

writers and artists. Georgii Chulkov, in his reminiscences of Blok, speaks of a meeting of Petersburg writers — 'Everyone was here from Maksim Gorky to Merezhkovsky' — all feeling some responsibility for the event and trying to find some form of public response to it, by making contact with the government, making gestures of protest such as closing the Marinsky Theatre, and possibly rushing out an illegal, because uncensored, newspaper. Revolution was expected any minute. Soldiers were sent to hold the bridges. Blok's stepfather, an officer in the Grenadiers, was called out to take charge of a defensive position. Blok himself went out into the streets to see what was happening. Volleys of gunfire were heard. Bely, arriving from Moscow, went to the Bloks and found them 'in a highly revolutionary state of mind'. See Pyman 1979, pp.182–5.

8. Pavel Filonov (1883–1941) received art training in Petersburg and visited Paris and Rome. He exhibited with the Union of Youth from 1910 on. In 1913 he designed backdrops and costumes for parts of *Vladimir Mayakovsky (A Tragedy)*; there is no visual record of them though they were much noticed. His paintings of the time, and subsequently, are executed meticulously in a highly individualistic manner, presenting modern and quasi-biblical subjects in which gaunt images often appear through a flood of minute representational and abstract forms which he explained as 'units of action'. He is grouped with the Russian futurists, illustrating and drawing the letters for a book of Khlebnikov's poems in 1914, but his images shun futurist methods except in the desire to include experiences of many sorts in large and small paintings that call for detailed execution and study. Filonov taught in Petersburg from 1923, and from 1925 to 1932 ran his own school, the Collective of Masters of Analytical Art. A retrospective exhibition of his art was prepared in 1929 but cancelled at the last moment. A compendious account and representation of his work, and a selection of his writings and those of his contemporaries, is in the catalogue of his exhibition, *Filonov*: see Paris 1990. See also Milner 1993, pp.148–50.

9. Among the many studies of Mayakovsky and his work, I am indebted to the documentary chronicle, Woroszylski 1972, and the searching and insightful introduction to the writings in Brown 1973.

10. These much-quoted lines are from Mayakovsky's poem 'Order of the Day to the Army of the Arts'.

11. For this production Mayakovsky designed a curtain showing images of workers, industrial cities with multi-storey buildings including factories with their smoking chimneys, cars, trains and aeroplanes, all arranged around a radiant central sun which itself is garlanded by a ring of interlocking cogwheels. The flat, jagged forms that make up most of the design

suggest an urban and industrial primitivism that answers the folk-art primitivism of Larionov and his associates yet feels wholly futurist.

12. Geldern 1993, p.43, comments that this production, even more than other theatrical productions of the time, 'exemplified the festivilization of culture that first foreshadowed and then distinguished Bolshevik festivals'.

13. Quotations from Rudnitsky 1988, p.43, and from *Vladimir Mayakovsky: Innovator*, Moscow, p.102. For an account of the two productions, and especially of Malevich's contribution to the first, see Braun 1988, pp.155–9.

14. For the 1921 *Mystery-Bouffe*, its stage set, its largely unenthusiastic reception and for Meyerhold's comments on working closely with Mayakovsky, see Braun 1979, pp.159–62. The new production had a stage designed primarily by Anton Lavinsky, a sculptural environment pushing forward into the auditorium, with a pylon, steps, raised platforms and jagged shapes descending from above, all dominated by a large hemisphere inscribed 'The Earth'. Yuri Annenkov was enthusiastic about this complex construction, at once symbolical and utilitarian as an apparatus for acting: this 'is no "temple" with its great lie of the "mystery" of art, this is the new proletarian art'. See Baer 1991, especially pp.46–7. In 1918 Annenkov had made illustrations for Blok's poem *The Twelve* (see chapter 7, part III). In 1920 he had been the chief designer of the Petrograd pageant re-enacting 'The Storming of the Winter Palace' for the third anniversary of October. More on these in chapters 7 and 6 respectively.

15. Woroszylski 1972, p.264.

16. Lodder 1983, p.271, note 74.

17. Already in 1918, when Kandinsky's *Reminiscences* was published in Moscow, Punin inveighed against his art and personality: 'all his feelings, all his colours are desolate, rootless . . .[.] Down with Kandinsky! Down with him.' This, and more, is quoted by Frank Whitford in his essay in the catalogue of the exhibition 'Kandinsky: Watercolours and other Works on Paper', Royal Academy of Arts, London 1999, p.60.

18. Brown's term: Brown 1973, pp.261–4, discusses Mayakovsky's use of this poetry, which the writer himself claimed to be literature of the highest kind.

19. Stephan 1981, p.7 and p.206, note 15, and p.62 and p.214 note 8. Stephan gives a detailed account of Russian futurism after the Revolution. Repeated reference to it will be made in the paragraphs that follow. Stephan was the first to demonstrate Brik's key role in promoting theoretical imperatives for artists working in the spirit of Marx. His interest in the guilds coincides with Gropius's call for a craft-centred union of artists and designers in the Bauhaus Proclamation of 1919 and in other writings of the same year.

20. Tolstoy stressed the power of the arts to 'infect' people, changing their apprehension of themselves and of the world. His assault on the citadel of culture was so swingeing as to produce counter-reactions, but even those who disagreed with his judgments were often 'infected' by his language. I have more to say about Tolstoy in chapter 8 where the historical background of constructivist theory is outlined. For the Lunacharsky/Slavinsky 'Theses', in a translation preceded by notes and commentary, see Bowlt 1976, pp.182–5.

21. For *About That* see Brown 1973, pp.219–60.

22. Khan-Magomedov 1986 includes many interesting documents and their sources. Lavrentiev 1995 is an illustrated survey of Rodchenko's work in this medium, including photomontages made before 1924, and it includes a brief but illuminating introduction by Alexander Lavrentiev, Rodchenko and Stepanova's grandson.

23. Stephan 1981, pp.85–9; the sentences cited here are on p.87.

24. The editorial board in 1923 consisted of writers and literary critics: Mayakovsky, Brik, Nikolai Chuzhak, Arvatov, Nikolai Aseev, Sergei Tretyakov and Boris Kushner. Khlebnikov, Kruchenykh, Kamensky and Boris Pasternak were among contributors to *Lef*.

25. In *Lef* no.3, 1923; cited by H. Stephan 1981, p.67.

26. Reading Braun 1979 was one of the experiences that led me to consider Tatlin's work in its artistically inter-disciplinary as well as political contexts. Edward Braun had already translated and edited Meyerhold texts: Braun 1969. Much of what is written in the present paragraphs has benefited from these and from Braun 1995. A useful supplement to these is Schmidt 1981, an anthology of texts by those who worked with Meyerhold, as well as by Meyerhold himself.

27. Braun 1969, p.153, p.173 and p.198.

28. Milner 1993, p.122.

29. This quotation is from Braun 1995, p.165, and pp.162–6 for a full account of the production; Braun 1969 includes a Meyerhold article and a report on his contribution to the debate, both of November 1920, pp.170–74.

30. See Milner 1983, p.122.

31. My interest in Khlebnikov in relation to art was initiated by John Milner's dissertation (1980) and his book on Tatlin (Milner 1983). It has been reinforced by, among other publications, Markov 1969 and 1975. Also: Mirsky 1975, Lönnqvist 1977, Stobbe 1982, Cooke 1983 and 1987, Weststeijn 1986.

32. In 1908 there could be no expectation of abstract art, in Russia or elsewhere, but from around 1890 the psychological implications and emotional force of abstract design had been studied in Europe and America in the context of arts and crafts, post-impressionism and art nouveau. *Incantation* may imply a magic spell, a frequent theme in symbolist art and literature.

33. Some of these details are taken from the commentary to 'Incantation by Laughter' and the brief chronology given in Appendix 1 in Kern 1976, pp.267–72. Khlebnikov's play is mentioned in Rudnitsky 1988, pp.11–12. He stresses Khlebnikov's debt to Blok's play of 1906, *The Stranger* [or *Unknown Woman*], which suddenly breaks into 'nonsense and inanity' amid ordinary dialogue but does not attempt Khlebnikov's insistent illogicality.

34. Bogdanov foresaw a merging of global languages. This had already been achieved on his fictional Mars, before even the Socialist revolution was achieved there. See Graham and Stites 1984, p.54.

35. George Grosz, thrilled by news of Tatlin's new 'machine art' in 1920, and a member of the Communist party (until 1923), spent part of 1922 in Russia and returned disenchanted with the great Socialist State. He visited Tatlin and was surprised by his unsophisticated life-style (with chickens, etc.). He described Tatlin as a 'great Fool', probably referring to the Russian tradition of the Holy Fool. See Stockholm 1968, p.86.

36. My references in the preceding paragraphs are, in sequence, to Viktor Shklovsky, *Zoo, Letters Not About Love*, 1923; Tynyanov in Pike 1979; Mandelshtam in Mihailovich 1972; Markov 1975; Lönnqvist 1977; Cooke 1987; idem; Markov 1975, p.19; Cooke 1987; Markov 1975; Mirsky 1975. Milner-Gulland has emphasized that 'for Khlebnikov the whole business of punning, paronomasia, sound-repetition . . ., anagrams, palindromes and so on had a particular urgency and significance as symbolizing or exemplifying the hidden cosmic interconnectedness, the order and balance of the human and natural world that it was his business to lay bare.' See R. Milner-Gulland, 'Eyes and Icons' in M. Falchikov, C. Pike and R. Russell (eds), *Words and Images*, Nottingham, 1989. See also R. Milner-Gulland, 'Khlebnikov's Eye' in C. Kelly and G. Lovell (eds), *Russian Literature, Modernism and the Visual Arts*, Cambridge, 2000.

37. Milner 1983, pp.33 and 203.

38. Ibid., p.120; Zhadova 1988, pp.336–8. R. Milner-Gulland's article is in *Essays in Poetics*, vol.12, no.2, 1987, pp.82–102; his translation is on pp.84–5. In the lecture of 1986 out of which his article was developed, Milner-Gulland included the second of the Danin quotations I cited and went on to suggest that the poem 'seems to be admitting Tatlin to a select circle of initiates, and Tatlin regarded the MS of it as a sort of talisman'. I am grateful to Professor Milner-Gulland for lending me an annotated copy of his lecture, which includes his detailed analysis of the poem. His suggestion that the word translated as 'tin' in its last line also refers to 'life' is new: the Russian word *zhestyanye* carries for Khlebnikov a special 'folk-etymological' sense in that it is linked to

zhist, a variant of the standard word *zhizn* (life). In 1933 Tatlin presented Smirnov with the three volumes of Khlebnikov's collected works available then, placing an inscription into each. These are reproduced in Zhadova 1988, plates 228–30; and translated, p.338. Into volume 1 he wrote: 'Read and study Velimir, a poet of genius, for without true art we shall never build socialism. For my friend from Tatlin'; similar exhortations went into the others. Lodder 1983 refers to 'S. Smirnov'; Milner 1993 has 'N.G. Smirnov' for the same individual, a young artist involved with the First Working Group of Constructivists in 1924 (p.402).

39. Zhadova 1988, p.337. Artur Lure ('Lourié' in the West; 1892–1966) studied at the Petersburg Conservatory but became an atonal composer under the influence of Alexander Skryabin. Commissar for Music during 1918–21, he then left Russia for Germany and Paris where he was close to Igor Stravinsky, adopting a modal idiom derived partly from Orthodox church music. In 1941 he emigrated to the United States.

40. Khlebnikov's ideas for architecture in 'We and Houses' are set out in Lodder 1983, pp.207–8 and 198, notes 17–24.

41. My references are to Cooke, see note 31 above. In sequence: Cooke 1983, p.47; Cooke 1987, p.34; Cooke 1983, pp.153 and 94, note 15; idem, p.274.

42. Pike 1979 quotes Tynyanov, p.151.

43. This paragraph is indebted to G.H. Roman's essay, 'Vladimir Tatlin and *Zangezi*', in *Russian History/Histoire Russe*, vol.8, parts 1–2, 1981, pp.112–13. This reference to Uspensky is the only sign I have come across that Tatlin had any interest in spiritual thought. With Khlebnikov as his mentor, he may well have thought himself in touch with more universal and timeless considerations.

44. Cooke 1983 (see note 1 above), pp.290, 287 and 291.

45. Markov 1975, pp.164–6.

46. Markov 1969, pp.147–63, gives an entertaining account of Marinetti's visit and of Russian responses to Italian futurism before, during and after it.

47. This paragraph, excluding the reference to Hugo Ball, and much of what follows on this theme, is indebted to Lönnqvist 1977.

48. Ades 1978 includes detailed information on the journals published by Dada groups in New York, Zurich, Berlin and Cologne, as well as by the peripatetic Dadaist painter, Picabia. For Rumanian Dada see Sandqvist 2006.

49. For a discussion of revolution and religion after 1917, see Clark and Holquist 1984. In Moscow, Lunacharsky and the symbolist writer Viacheslav Ivanov publicly debated the existence of God. Clark and Holquist 1984, p.123.

50. Idem, pp.124–31.

51. This and other references and quotations are taken from Tolstoy 1990. For a close study of the earlier festivals, in the context both of traditional popular festivals and the government's desire to compete with the religious festivals that still happened every year, see Geldern 1993. Before 1917 public demonstrations were illegal. They became legal with the February Revolution; after October they were sponsored and largely controlled by the government. See Geldern 1993, pp.1–13.

52. Milner 1983, p.143. That summer Tatlin had begun working on Lenin's plan for monumental propaganda, the first Moscow fruits of which were unveiled at the 1918 anniversary of October. So he was here engaging with politically guided art work in two modes: monuments and the ephemeral celebrations.

53. Geldern 1993, pp.96–7, states that Altman 'intended to make [Palace Square] . . . suitable for popular festivals. To begin, the aristocratic associations had to be removed, which he did by creating a carnival atmosphere. . . . What had a year and a half previously been the center of an empire became a bright and splashy carnival'. Tatlin is said to have provided 'colored and dynamic lighting' for this elaboration of the Alexander Column for the October 1918 festival. See Gail Harrison Roman's essay (note 43 above), p.120.

54. See Lodder in Bown and Taylor 1993, p.18.

55. Geldern 1993, especially pp.154–6.

56. Rudnitsky 1988, p.45.

57. Eisenstein made the film *October* in time for the tenth anniversary of the 1927 October Revolution. It climaxes in another re-enactment of the Storming of the Winter Palace, based on Evreinov's. For political reasons, primarily because he included Trotsky as a heroic figure, he had to remake the film and it was not shown until March 1928. See Seton 1952, pp.99–102. See also Geldern 1993, pp.1–2, where Eisenstein's direction is related back to Evreinov's: 'Thousands of Red Guardsmen, led by Lenin, charged across the vast square and seized the destiny that history decreed was theirs. There were more soldiers struggling, more ammunition fired, and probably as many injuries suffered during the theatrical re-creation as during the historical event. A hundred thousand spectators witnessed it from the square. It occurred at the stroke of midnight — a much more dramatic setting than the drizzly, grey, typically dreary Petrograd morn of 1917 — and banks of floodlights illuminated the progress of the battle.'

58. Figes and Kolonitskii 1999 refers repeatedly to the singing of revolutionary songs in demonstrations and during festivals. Since France's 'Marseillaise' was tarnished by association with imperial aggression, a 'workers' version' came into use, with words denouncing inequality; known as the 'Internationale', this was the Bolsheviks' anthem. The 'Varshavianka' was an essentially working class song pointing to the oppression — tyrants, plutocrats, all parasites

living off the working poor — experienced by ordinary people. See especially pp.39–40, 63–4, 111 and 154.

59. See Tolstoy 1990, p.124.

60. Milner 1993, pp.155–6.

61. This suggests the drawings and models Popova and Alexander Vesnin made for a field outside Moscow in celebration of the Third International, but these were made later, for May Day 1921.

62. See Tolstoy 1990, pp.124–6.

63. For references in this paragraph, see Tolstoy 1990, pp.123 and 137.

64. Milner, lecturing on constructivism at the Royal Academy on 15 May 1999; my notes.

65. An excerpt from Séailles's text indicates its flavour: 'His intuitions are directly transmitted to his mind, and his ideas to his heart. The dreams of other men are vague forms, fluctuating fantasies, but his dreaming is a surging of clear thoughts which he masters immediately. His genius has nothing in common with madness; it is health itself, the expression of a powerful spirit, the balanced and happy combination of all human faculties.' This is cited in Ettlinger 1969. Avant-garde artists in Paris were intensely interested in Leonardo's notebooks as well as in his art. See Spate 1979, p.36 and passim. Russian painters — Exter, Popova, Udaltsova and others — were in close touch with some of these Paris artists at exactly this time. The year 1919 was the quarter-centenary of Leonardo's death at Amboise. According to Roger Shattuck, 'no other human being, historical or imaginary, appears to have received so much systematic and such widely disseminated attention from Western culture' as Leonardo around that time: see Shattuck in Philipson 1966, p.374.

66. See Pyman 1994, p.22.

67. Sergei Eisenstein (1898–1948) worked in the Russian theatre as designer and director for Proletkult, made his first designs for films in 1921 and worked with Meyerhold in 1921–2, before becoming the world-famous film director, designer and theorist. Leonardo was his essential guide and model, partly through Freud's study of Leonardo, which caused Eisenstein to sense a deep kinship with him and also to study aspects of Freud's theories, notably about humour, together with anthropology and Bergson's discussions of creativity, time and consciousness. See Seton 1952, *passim.*

68. See Bowlt 1976, p.15 and pp.11–12.

69. Ibid., pp.234–6 and pp.230–31.

70. For *Art and Class* see Bann 1974, pp.43–8; for 'The Proletariat and Leftist Art' see Bowlt 1976, pp.226–30. Also Milner 1983, pp.243–4, note 7 on Arvatov's discussion of Leonardo. In 1922 Tatlin had told Arvatov that he had ceased making 'useless reliefs': ibid., p.246, note 49. In *Art and Class* Arvatov more or less repeated the distinction he had drawn

between expressionist and constructivist abstract art in his article of 1922.

71. An enthusiastic American observer of the early days of aviation, James Gordon Bennett, established an annual prize for the year's fastest flight, an award of $5,000 plus a trophy, a miniature of an aeroplane mounted on a winged and semi-nude figure of a boy launching himself into space: Icarus. Advances in modern flying were here and elsewhere associated with failure even though Daedalus, who made the wings and used them well, was as available for invocation. See Wohl 1994, pp.99 and 122.

72. Cooke 1983, p.208. My selective list of Daedalus's achievements comes mainly from Hammond and Scullard 1979, pp.309–10.

73. For more about this annual ritual see chapter 7, part III.

74. See Harten 1993. My quotations from Professor Bowlt's essay are taken directly from his original text, which he copied to Professor Milner-Gulland.

75. This account of Kharms and his ideas is indebted to Bowlt (see preceding note), and for Tatlin's illustrations for Kharms's book to Bowlt and Zhadova 1988, pp.131–2 and plates 299–312. On the various facets of Kharms' work and ideas, see contributions to N. Cornwell (ed.), *Daniil Kharms and the Poetics of the Absurd*, London: Macmillan, 1991.

Chapter 7

1. Zhadova 1988, p.34, and see chapter 5, part II.

2. See chapter 6, part I.

3. Figes 1996, chapter 14, especially pp.650–82.

4. Reconstructions of the Tower, from that made in Stockholm in 1968 onwards, in almost every case involved some deviations from the model as photographed in 1920–21. Some of these may have been called for by the materials used and by considerations of stability. Others may have resulted from misreadings of the model and the drawings, encouraged by the discrepancies between them.

5. Shklovsky repeatedly says 'spiral', not 'spirals'. This, and his comment that 'the spiral is falling sideways', suggest that he was writing not from study of the model but using reports, notably Punin's 1920 booklet and its illustrations. Tatlin would have been concerned about the relationship of a real Tower to the materials required to construct it, as against those available for the model. As in the case of *Letatlin*, he would have sought up to date advice from experienced specialists in order to bring the project to its full realization.

6. For a fuller account of this project see chapter 5, part I.

7. Punin's pamphlet, written in July 1920, is translated in full in Zhadova 1988, pp.344–7. In 1922, in Vienna, a translation of Punin's article was published by the

artist Lajos Kassák in the journal *MA*, and a photograph of the model in Kassák's and Moholy-Nagy's *Buch neuer Künstler* (Book of New Artists). See Körner 1985, p.71.

8. Milner 1983, p.160.

9. A British book of 1903, by Sir Theodore A. Cook, may have caught Tatlin's attention, directly or indirectly. It is *Spirals in Nature and in Art. A study of spiral formations based on the manuscripts of Leonardo da Vinci, with special reference to the architecture of the open staircase at Blois . . . now for the first time shown to be from his design*. It is the staircase at the heart of the chateau of Chambord that has the form of a double spiral; the 'open staircase at Blois' consists of a single spiral, partly inside and partly outside the wing it serves. Unlike the staircase at Chambord, that at Blois is not normally considered Leonardo's design.

10. Blok: cited in Thomson 1978, p.154, note 2. Herzen in 1842: Blinoff 1961, p.184. Herzen in 1843: Weidle 1952, p.71. Lermontov: Blinoff, ibid. Belinsky: Blinoff, ibid. Gogol: Hellberg-Hirn 2003, p.48.

11. For Petersburg's industrial development see Berman 1983, p.249.

12. These quoted phrases are taken from Bely 1979, pp.3, 9, 10, 12, 22, 27, 40 and 292 respectively. I recommend this version, translated, annotated and introduced by R.A. Maguire and J.E. Malmstad, for the vividness of its text and the value of its introduction. The Russian-American writer Vladimir Nabokov counted *Petersburg* among the 'greatest masterpieces of twentieth century prose'. Rightly so: it is magnificent and unique. Thanks to the annotations, essential to most Western readers, it sheds a rich 'blizzard of associations' (to use Shklovsky's phrase again) on Russian history and culture.

13. Rosenthal 1994 examines Nietzsche's impact on Russian thought, welcomed in a guarded manner among the symbolists, many of whom wished to demonstrate their Christianity, and with enthusiasm among the younger writers and artists eager to accept his invitation to build a new world on the ruins of the old. Only Nietzsche's individualism troubled them as they looked for collective energies and action, but *The Birth of Tragedy* enabled them to see the energies they sensed in futurism, and hoped to inject into revolutionary Russia, as Dionysian. Nietzsche's ideas contributed to the planning and execution of the public festivals. This is one of the themes pursued in Geldern 1993, and touched on here in chapter 6, part II.

14. Zhadova 1988, p.344.

15. This is spelled out in greater detail in Philip Sherrard's essay, 'The Art of the Icon', cited in Temple 1990, pp.120–21.

16. *Ka*, in Richard Sheldon's translation, is given in Kern 1976, pp.159–82; the words quoted are on p.180.

17. Figes 2002, p.312, mentions Gogol's reference to an 'infinite ladder of human perfection', echoing Jacob's ladder.

18. Milner 1983, plate 176 and pp.178–9.

19. In Punin's July, 1920 pamphlet. I quote here Milner's translation, idem, p.180.

20. Zhadova 1988, pp.344–7. A fuller account of Punin's essay is given in chapter 5, part II.

21. For a discussion of collectivism in Bolshevik thought and of its promotion before and after 1917, especially in PLK and the literature it engendered, see Steinberg 2002, chapter 3 and particularly pp.102–6, from which I have taken my quotations.

22. Tatlin's 'The Initiative Individual in the Creativity of the Collective' is cited in full in Zhadova 1988, pp.237–8. The theme of individualism and collective action is voiced repeatedly in Tatlin's writings from this time on, for instance in the statement 'The Work Before Us' issued in 1920 by the small collective that had worked with him on the model of the Tower; more on this in chapter 8.

23. Milner 1983, p.155. Zhadova 1988 refers repeatedly to the Tower's 'facades', as does Strigalev and Hulten 1993. The English version of Zhadova's book at times adds confusion to original wording that tentatively addressed Tatlin's invention. The architectural term 'elevation' is more apt.

24. Ibid. See also p.163 where Milner argues that the Tower suggests a striding figure and relates it to Kustodiev's painting, *The Bolshevik* (1920).

25. See Hamilton and Agee 1967, pp.47–51.

26. Another surviving Boccioni sculpture, sometimes mentioned as providing inspiration for Tatlin's design, is his *Development of a Bottle in Space* (1912–13). In this, an upright bottle seems to open laterally both to reveal internal tensions and show the form's energies in horizontal expansion. It may have encouraged Tatlin to think in terms of a vertical form rising above horizontal extensions of it, as hinted at in Punin's 1919 account of the project. This Boccioni is a sculptural variation on the theme of a familiar still-life motif, prepared in his two-dimensional work.

27. See Milner 1983, p.163, and chapter 5, part I here.

28. For the epic hero as a focal point of the collective, as expressed in proletarian writing, see Steinberg 2002, pp.112–18.

29. Both Chagalls are illustrated in Kamensky 1989, p.340. The earlier image is inscribed 'Forward, forward without pause'. The title of the later painting is there translated as *Onward*. It is in the Tretyakov Museum. In Russian, Chagall's name suggests the Russian for striding, taking great steps.

30. Ivanov's representation of the Baptist owes its general character to the art of Raphael, more particularly to the figure of the protagonist in the cartoon for the *St Paul at Athens* tapestry. St Paul dominates the left half of the composition, addressing a crowd of smaller figures and raising

both his arms in doing so. He stands still, at the top of steps that add to his presence and afford us an unimpeded view of him, whereas Ivanov's Baptist is part of the crowd, yet set apart by his size and pose. These cartoons, made by Raphael and his assistants about 1515 for tapestries for the Sistine Chapel, are in the Victoria and Albert Museum, London; Ivanov may have seen the tapestries in Rome, as well as engravings of them.

31. Ivanov's Baptist is roughly half the height of the painting, the figure of Christ one-seventh.

32. Kramskoy's best-known painting is his *Christ in the Wilderness* (1872; 180 × 210 cm), a conscious sequel to Ivanov's, its subject being Christ's forty days and nights in the desert after his baptism. Kramskoy told Vsevolod Garshin that this image was meant to declare its contemporary relevance: 'There is a moment in the life of every human being . . . when he is totally absorbed by the question whether to turn to the left or to the right', whether or not to dedicate himself to the cause of truth and justice. This grim painting, not easily forgotten, hangs in the same place as Ivanov's, the Tretyakov Museum. Kramskoy's example led to biblical themes being included among the mostly realistic and contemporary subject-matter of the Wanderers. See Sarabianov 1990, pp.122–3, and Milner 1993, p.222.

33. Berlin 1979, one volume of a series reprinting Isaiah Berlin's essays, edited by H. Hardy and A. Kelly; pp.18–19. The lines quoted are from the essay 'Russia and 1848', first published in 1948.

34. The preceding paragraphs, on Ivanov's great painting and its reception, are derived primarily from Barooshian 1987. Punin's words about the painting had alerted me to its importance for Tatlin. John Milner sent me a copy of Barooshian's book in confirmation of this. I owe the reference to Ogarev's obituary to Elizabeth Kridl Valkenier's essay, 'The Intelligentsia and Art', in Stavrou 1983, p.160. J.E. Bowlt's essay,' 'Russian Painting in the Nineteenth Century', in the same book, gives an account of Ivanov and his work, including his 'curious essay' of 1847 on the coming Golden Age: see pp.126–7. P.139, note 41 there refers to Punin's study of Ivanov. Billington 1970 speaks of Ivanov's global temples on pp.343–4.

35. See Geldern 1993, pp.196–200. He writes that memories of 1917 were fading, so that this performance of 'history as it should have been', on the historical spot, sharpened awareness of this key event, chosen like France chose the storming of the Bastille on 14 July 1789.

36. Robin Milner-Gulland describes it: 'The greatest of early summer celebrations [marking] the summer solstice, in Christian terms the eve of St John the Baptist's day (24 June), known as Kupala, metonymically associated with water and hence with a desire for early summer rain, and having also erotic connotations. A memorable re-enactment of Kupala can be seen in Andrey Tarkovsky's famous film *Andrey Rublyov*; there was ritual bathing and great bonfires were lit.' Milner-Gulland also stresses that Orthodox Christianity and Russian folk beliefs achieved a fruitful accommodation with each other. See Milner-Gulland 1993, pp.196–200 and 96–9.

37. The Empress Catherine I, Peter the Great's second wife, died after catching a chill when attending the ceremony out of doors on 6 January 1727.

38. These quotations from *The Festal Menaion*, translated by Mother Mary and Archimandrite Kallistos Ware, London (Faber and Faber), 1969, kindly lent to me by the late Father Sergei Hackel. See pp.56, 321, 354–5, 388–9 and 398.

39. This account is from Massie 1980, p.363; no date or source is given. Suzanne Massie describes also the entertainments offered on the frozen Neva, including the 'ice towers' erected there and at similar sites throughout Russia, and the carnival amusements to be met around them. She points to the flatness of much of Russia, and associates with it this taste for artificial mountains. Especially large and elaborate ones were financed by Moscow and Petersburg, with slides 'wide enough to accommodate as many as thirty sleds at a time'. On pp.366–70 she describes the week-long carnival, beginning about eight weeks before Easter. Enormous ice slides were erected on the Neva, stretching from the Winter Palace to Senate Square. Theatres and puppet booths offered performances in several languages. All business shut down while fun reigned, until the church bells tolled at six on the seventh day and 'everyone went home to prepare for the Great Fast'.

40. See Palmer 1972, p.54.

41. An earlier account of the Blessing of the Waters in Moscow, when Moscow was the capital, speaks of soldiers lining the inside and outside of the Kremlin, and the tsar, 'in his finest regalia', leading a procession out of the Kremlin down to the River Moskva, with court officials, high-ranking military officers and prominent merchants coming behind him. The banks of the river, the roofs of neighbouring houses and the Kremlin walls were covered by throngs of spectators, i.e. worshippers. The tsar was expected to sip the consecrated water, ignoring its contaminated state of which doctors warned him. All men had to be bareheaded throughout the long ceremony; some are believed to have donned wigs. See Grove et al 1913, p.105.

42. See Chamberlain 2006. More on this programmatic exiling of intellectuals in chapter 8.

43. Professor Milner-Gulland points out, in a note of May 2006, that this theme is pre-echoed in Russia's earliest literary work, the *Discourse on the Law and the Grace* written by the Metropolitan Ilarion in the eleventh century, which is resolved by an encomium

addressed to the Christianizer (viz. baptiser) Prince Vladimir and the 'new order' he brought to Russia.

44. See Lowrie 1960, p.133.
45. Berdyaev 1937.
46. See Figes 2002, p.343.
47. Blok's words are quoted from Pyman 1980, pp.253, 243 and 271.
48. A vivid account of the hardships suffered in Petrograd during the months following the Revolution is provided in Lincoln 1999, chapter 1.
49. Ibid., pp.282 and 283.
50. Ibid., p.287; Blok 1982, p.71; Pyman 1980, pp.296–8.
51. Blok 1982 reproduces all the Annenkov illustrations, though the book's small format means an altered relationship of the images to the text and the page. It also includes an introduction by Jack Lindsay, and an 'afterword' by Yuri Molok (pp.72–9) about how *The Twelve* came to be illustrated. Blok had previously had well-known artists making images to accompany his published poems, including Léon Bakst and Nicholas Roerich, both associated with the World of Art. In this case he considered more avant-garde artists, including Petrov-Vodkin. Annenkov was probably his own final choice. Yuri Annenkov (1889–1974), a friend of the publisher S.M. Alyansky, had designed the Alconost logo when the firm began publishing in 1918. He designed a more dramatic one later that year, specifically for *The Twelve*: not the halcyon bird to which 'Alconost' refers but a dramatic, winged, human figure glowing out of a black ground. Annenkov had studied art in Paris and Switzerland during 1911–13 as well as in Petrograd, was well known as an illustrator and caricaturist by 1918 and belonged to an artists' circle around Altman in Petrograd. He drew acute, symbolically loaded portraits of important figures after the Revolution, including Lenin and Lunacharsky and, among the writers, Zamyatin. His illustrations for *The Twelve* include abstract vignettes, little clusters of lines that sometimes recall Kandinsky, but also elaborate figurative images some of which make dramatic use of areas of dense black (Félix Vallotton had been one of his teachers in Paris), while others use line mainly or exclusively, and exploit the transparency of objects that line permits. This is a cubist device and, together with Annenkov's use of 'expressive details', suggests the influence of George Grosz's graphic work, as Milner suggests (Milner 1993, pp.46–7). Annenkov, who also worked for the stage and for films, lived in France and Germany from 1924.
52. Pyman 1980, pp.298–9.
53. Ibid., pp.301–3.
54. Molok in Blok 1982, p.72.
55. See Hayward 1983, pp.123–4. For Ivanov-Razumnik's role in Russian debates about the symbolist inheritance and the new realism he and others called for, see West 1970.

56. Hackel 1980. Sergei Hackel's book is a close, intense study of the poem and its references, sonorities and symbolism. Pyman 1980 devotes most of her chapter 9 to *The Twelve*, its nature and content, and also to some of the responses to it.
57. Hackel 1980, pp.vii–viii; Pyman 1980, pp.289 and 290.
58. See Feinstein 2005, p.71.
59. Pyman 1980, pp.112–13, 113–14, 189, 151, 48.
60. Ibid., p.284.
61. Ibid., p.378. Orlando Figes quotes Zamyatin on how Blok's funeral was attended by hundreds of people, 'all that remained of literary Petersburg', Akhmatova's lines about the burial of 'our pure swan, / Our sun extinguished in torment' and the comment of the then young Nina Berberova that news of Blok's death was felt as a personal bereavement and the loss of the idealism he embodied. See Figes 1996, p.785.
62. Hackel 1980, pp.76–83, 122–43 and 190.
63. See Bowlt and Washington Long 1980. Bowlt's introductory essay on 'Vasilii Kandinsky: The Russian Connection' (pp.1–41) demonstrates how closely Kandinsky was involved in Russian cultural life during his years in Bavaria, both that of his own generation, i.e. the symbolists, and, especially around 1910–13, of the avant-garde. For example, Kandinsky had been in Russia during 1911 but needed to get back to Munich for the opening of the first Blaue Reiter Exhibition, instead of attending the Second All-Russian Congress at the end of the year. Liuba Blok heard Kulbin deliver Kandinsky's text on 30 December, and reported on it enthusiastically to her husband that evening. He may have attended the congress the following day; in any case, he knew Kulbin personally and could well have questioned him about Kandinsky's ideas.

Chapter 8

1. English translations of the article are in Zhadova 1988, p.239 and Andersen 1968, reprinted in Bowlt 1976, p.206. Dated 31 December 1920, it was published the following day in the *Daily Bulletin of the Eighth Congress of Soviets*, Moscow. Hammer and Lodder provide a new translation of its last section in Becker 2001, p.34. Zhadova dates the first exhibition 1916 and locates it in Moscow; the others date it 1915. If it has to be a Moscow exhibition, reference must be to 'The Year 1915'; perhaps Tatlin was also thinking of Petrograd's 'Tramway V, the First Futurist Exhibition'; both were shown in March 1915.
2. Lodder 1983, pp.78–99. See also Bowlt 1976, pp.214–17, for a summary of Gan's career and for excerpts from his book on pp.217–25. A brief account of Inkhuk and its debates is given in

Rudenstine 1981, pp.198–9. Gough 2005 gives a fresh account of Inkhuk's constructivism debates and especially of the role played there by the work and ideas of Karl Ioganson, and of his roles in a steel-rolling works during 1923–6.

3. See chapter 7, p.140.

4. See Lesley Chamberlain's account of this planned assault on Russia's leading intellectuals, and on their individual roles and histories, the character and richness of Russian philosophy and religious thought before the expulsions of 1922, as well as the effect of these exclusions on their country and on the West, in Chamberlain 2006. The words quoted are taken from the introduction, p.2.

5. See Lodder 1983, pp.184–5.

6. See Taraboukine 1972, p.47. On new links between Inkhuk and other organizations, see Lodder 1983, pp.90–93.

7. Soviet Republics were established in Hungary and in Munich (capital of the German State of Bavaria) in the spring of 1919. They hoped to join forces with the Red Army, but were soon overcome by troops sent in from Berlin and Württemberg (adjacent to Bavaria), and by conservative forces in Hungary. The Socialist States existed for only a few weeks or even days: the Bavarian Republic died on 2 May, the Hungarian Republic in July. There followed the exodus from both of intellectuals and artists, including Moholy-Nagy who went to Vienna and then, in 1920, to Berlin, and the sudden growth of the German Communist Party in reaction to the right's victory. Lenin hoped that a Soviet union might form in Central Europe. The Western powers were alarmed by continuous rumours of imminent Communist uprisings in the countries adjacent to Russia and schemed to make these less likely by the dispositions they imposed through the treaty of Versailles in June 1919 and other agreements reached that year.

8. See Lodder 1983, p.94 and endnotes, pp.281–2, nos 101–8.

9. My paragraphs on Chernyshevsky, Dobrolyubov and Pisarev are indebted primarily to Lampert 1965, an illuminating account of crucial aspects of Russian thought that resonated in debates before and after the Revolution. For Dobrolyubov all evil-doing stems from stupidity. Education can establish sound principles, but it will take 'extraordinary circumstances' to make the world abide by them. By these he meant revolution. He challenged Herzen on this point, writing to him in London that 'the axe alone can save us'. Literature must come out of the library onto the streets and embrace truthfulness, its only merit. The great enemy is stagnation. Reviewing Goncharov's novel *Oblomov* (1859), about a well-bred man full of good intentions but incapable of action, Dobrolyubov adopted for him the term 'Superfluous Man', used by Ivan Turgenev for the

title of a book of 1850, and gave it additional force. For Pisarev autocracy corrupts the autocrat. 'Only scoundrels side with the Government — those who have been bought with the money taken from poverty-stricken people by means of fraud and compulsion.' Like Chernyshevsky, Pisarev did most of his writing as a prisoner in Saints Peter and Paul Fortress. Released after four and a half years, he went on working but his mind was faltering as well as his health; his death by drowning was probably suicide. His writings captivated younger readers with their insistence on reason and science. He admired Darwin, finding in the *Origin of Species* confirmation of his materialistic view of life. Life is shaped by the conditions that produce it. Morality is personal preference parading as virtue. While calling for political revolution, Pisarev saw the scientific revolution as the essential means to progress, and education as the way to engage all levels of society in it. Self-evidently a member of the intelligentsia, he hoped for the creation of a 'thinking proletariat'. In his 1865 essay 'The Destruction of Aesthetics', he weighed the arts' contribution to human happiness against the suffering he saw everywhere. The seventeen 'main conclusions' with which Chernyshevsky ended his dissertation of 1855, *The Esthetic Relations of Art to Reality*, are translated in Blinoff 1961, pp.150–52. See also Venturi 1964, pp.129–86, and Berlin 1979, pp.xxiii–iv.

10. Figes 1996, p.734. Figes emphasizes Tolstoy's interest in psychology as an aspect of humanity that needed to be understood and involved in this process of development. My quotations from *What Is Art?* are taken from Tolstoy 1969.

11. See C. Lodder, 'Lenin's Plan for Monumental Propaganda', in Bown/Taylor 1993, p.22, and Fitzpatrick 1970, pp.19–20 and 67–8. Bogdanov had partly welcomed Taylorism in 1913, but warned that it would divide workers into overseers and underlings. He wanted all workers to be involved in the processes of production. He wrote a 'Reply to Gastev' in the PLK journal, *Proletarian Culture*, 1919, nos 11–12 (Sochor 1988, pp.261, note 11, 248–9 and 258–9). Bogdanov's Martian workers in *Red Star* enjoyed variety in their work, guided by a computer that showed where work was needed and where effort might be saved (see Bogdanov 1984, pp.65–8).

12. On Krupskaya's proposals regarding 'thematic complexes' see Fitzpatrick 1970, pp.19–20.

13. Lenin's recommendation of Ermansky's book: see Sochor 1988, p.241, note 41. Lunacharsky voiced his dislike of Taylorism in 'The New Russian Man', in *Idealism and Materialism*, Moscow, 1924; see also Bailes 1978, p.386, note 47.

14. For Gastev's reference to Robinson Crusoe see Sochor 1988, p.259. His discussion of 'mechanized collectivism' is in his article 'On Tendencies in Proletarian Culture' published in *Proletarian Culture*,

1919, nos 9–10; it was answered by Bogdanov in the next issues.

15. The 'Theses of the Art Section of Narkompros and the Central Committee of the Union of Art Workers Concerning Basic Policy in the Field of Art' were published in *Theatre Herald*, Moscow, no. 75, November 1920. See chapter 6, part I. Slavinsky, formerly a conductor at the Moscow Grand Opera, was president of the Union of Art Workers, founded in May 1919: see Bowlt 1976, pp.182–3, and Bowlt's translation, ibid., pp.184–5.

16. The article, in *Art Herald*, no. 1, 1922, is translated in Rosenberg 1984, pp.402–5. In 1921 Arvatov had collaborated with Tatlin in attempting to set up a production laboratory in the New Lessner Factory, Petrograd.

17. My outline account of constructivism and productivism is indebted to Lodder 1983, especially pp.78–108 and pp.225–38, and to her essay 'The Emergence of Constructivism' in Becker 2001, pp.42–71; to Khan-Magomedov 1986, pp.55–115, which combines a scholarly account with quotations from Inkhuk records and other documents; also to Hubertus Gassner's essay, 'The Constructivists: Modernism on the way to Modernization', in New York 1992. Bann 1974 supplies documentation for what other sources refer to, and includes material on the spread in the West of what Bann rightly calls 'the Constructive Idea', up to the 1960s.

18. See Gough 2005, pp.46–50.

19. Gassner notes that in 1919–20 Stepanova emphasized the value of intuition and emotion in art. In October 1920, she still insisted on the transcendent power of the creative impulse. By December 1921, lecturing at Inkhuk, she was clear about the 'new ideology': 'The intellect is our point of departure, taking the place of the "soul" of idealism. / From this it follows that, on the whole, Constructivism is also intellectual production (and not thought alone), incompatible with the spirituality of artistic activity.' There was nothing subconscious now; only 'organized activity'. See New York 1992, p.315.

20. The Stenbergs and Medunetsky studied at the Moscow Stroganov School during 1912–17 and under Yakulov and Tatlin at the Free Art Studios during 1918–20. In 1920 they joined the new Inkhuk, and in January 1922 presented an exhibition of their work at The Poet's Café as 'Constructivists', the first public use of this designation. See Milner 1993, pp.289–90 and 408–9. In 1917 Yakulov had involved Tatlin in decorating the Café Pittoresque.

21. *De Stijl,* no. v/6, has the article in German; Lissitzky-Küppers gives it in English on pp.343–4; the German text expresses Lissitzky's thought more clearly. See Lissitzky-Küppers 1968.

22. Kiaer 2005, in chapter 1, discusses the concept of the 'socialist object' or the 'comradely object' that

the proletariat will be able to create, and, in chapter 2, Tatlin's contribution, as artist and teacher, to the development of everyday objects, especially during 1922–4. *Veshchi veshchi* (meaning Prophecy and objects) was the final line of Khlebnikov's poem *Tatlin.*

23. Chuzhak's open disapproval of Brik (and of Mayakovsky) is discussed in Günther 1973, vol.12, pp.62–75.

24. Gough 2005 sees Ioganson as the most penetrating thinker among the constructivists. She outlines his ideas and their demonstration in the exhibited pieces of 1921 on pp.75–99 and 107–19, and his role in the Prokatchik factory on pp.151–90.

25. Gough 2005 does not comment on this particular construction. That it was adjustable is indicated by the loop of string, seen clearly in a photograph reproduced in the Hungarian arts journal *Egyseg* and in I. Kassak and L. Moholy-Nagy, *Buch neuer Künstler* (both Vienna, 1922). Moholy used the same image and one of the 1921 photographs of the constructivists' display in the Obmokhu exhibition (this exhibit is in the foreground on the extreme left) in *Von Material zu Architektur*, Munich, 1929. Moholy's caption reads: 'equilibrium-construction (when the string is pulled, the structure adopts a different position, as balanced as before)' [my translation].

26. These comments arise from scrutiny of an old photograph reproduced in the bilingual volume *Alexander Rodchenko — Spatial Constructions / Raumkonstruktionen*, edited by Galerie Gmurzynska, Cologne, and published in Ostfildern-Ruit, 2002. The sketch and the construction are reproduced on pp.86 and 87.

27. I have translated the words cited from the 'Constructivists' catalogue in the French version used by Nakov in the catalogue, London 1975, p.66.

28. Lodder 1983 reports on the third Obmokhu exhibition of May 1921 on pp.67–72. Milner 1993 summarizes Ioganson's career on p.183. According to Lodder 1983, pp.244–5, Ioganson probably studied at Riga Art School before coming to Moscow to continue his studies at the Free Art Studios which became the Vkhutemas. Four of his works were included in the 'First Russian Art Show' in 1922–3. One was there titled *Relief*; the others were called *Architectonic Construction.*

29. Lodder 1983, p.22. Later, Rodchenko would call Tatlin a 'typical Russian Holy Fool' on account of his faith in the 'mystique of the material': see Groys 1992, p.24. Rodchenko here put his finger on what may have been a deeply intuitive aspect of the older man's thinking. It is likely that Tatlin sensed in materials — even in industrially originated materials — a natural truth and a right to being which gave them spiritual value. This would partly explain his insistence on organic form and design: nature's and

mankind's creative processes should not be in conflict.

30. Brik and Stepanova, quoted by Gassner in New York 1992, pp.309 and 310.

31. This issue is discussed by Paul Wood in his essay 'The Politics of the Avant-Garde', in New York 1992, pp.1–24, more especially on p.17, and by Gassner, especially p.307.

32. Lissitzky used a double image to represent himself in and after 1924 and named it *konstruktor*. It shows his right hand, loosely holding compasses, combined with a self-portrait photograph, his right eye showing in the palm of his hand, together with graph paper, the letters X, Y and Z inscribed from a stencil, his name in capital letters and his initials in lower case, all apparently on a drawing board and produced by means of multiple exposures. See Tupitsyn 1999, plates 10–16 and catalogue nos 30–35, pp.231–2. Bowlt brings out its considered duality: the precise, objective designer of the age of constructivism, turning his back on pure art, but also the designer-maker with living roots in the crafts. 'Lissitzky was as much astrologist as astronomist and the compasses in his hand may conceal, but they do not cancel, the occult lifeline.' See J.E. Bowlt, 'Manipulating Metaphors: El Lissitzky and the Crafted Hand', in Perloff 2003. Lissitzky's *Tatlin at Work* collage of 1922 is in a similar mode. In 1924 Lissitzky was still in Central Europe, in touch with a variety of modern artists including Arp and Kurt Schwitters (he made multiple-exposure portraits of both the same year). *Tatlin at Work* is a Russian image, forward-looking but linked to tradition; *konstruktor* an international modernist one.

33. In *Veshch* no.3, published in May 1922, Lissitzky attacked the work of Kandinsky as having 'no cohesion, no clarity, no object'. At the end of May the two men would represent opposed views at the Congress of International Progressive Artists in Düsseldorf. Lissitzky's words may have been sharpened by the fact that Kandinsky, too, had arrived in Berlin in late 1921 and had quickly been offered a professorship at the Bauhaus. No doubt Lissitzky had the Bauhaus in his sights and regretted Kandinsky's installation there. Appointing Lissitzky's disciple Moholy-Nagy to the Bauhaus during 1923 suggests that Gropius and others felt that major changes were overdue, but Gropius's older colleagues never thought Moholy 'one of us'. See Bowlt's essay in the catalogue Cologne 1976, p.47.

34. Quotations from Lodder 1983, p.228. Her note 12, p.302, lists *Veshch*'s articles on art and architecture, indicating the languages in which they appear.

35. Quoted from Lodder's essay in Becker 2001, p.50, and Lissitzky-Küppers 1968, p.336. The latter translates the entire text of Lissitzky's lecture, given in Berlin in 1922 and to the Kestner-Gesellschaft in Hanover in 1923 (pp.330–40). The lecture is dated 1922, but there are signs that Lissitzky made some changes before repeating it in 1923. Entitled 'New Russian Art', it surveyed modern art since Cézanne in broad terms and modern Russian art in some detail, especially the art that followed the Revolution. In this he gave pride of place to Tatlin and Malevich, and drew attention to the work of Rodchenko, to the reformed art schools and to new theatre design. He ended by saying that it was now becoming clear that Western Europe, notably Germany and Holland, was engaging with the issues he and his colleagues confronted in Russia.

36. See Lodder's essay in Becker 2001. Bann 1974, pp.58–69, gives a short account of this congress as well as key documents from it. Among the artists (and a few writers) and artists' groups represented at it were several who would have been wholly opposed to anything the International Faction of Constructivists could have proposed. Among these were the Berlin Novembergruppe, Kokoschka and Kandinsky.

37. Two essays in the catalogue of the 'Dada — Constructivism' exhibition at Annely Juda Fine Art provide important initial information on the interaction of Dada and constructivism: Dawn Ades on 'Dada — Constructivism' and Richard Sheppard on 'Kurt Schwitters and Dada': London 1984, pp.33–45 and 46–51 respectively.

38. Bann 1974, pp.5–11, prints Gabo's own translation of the manifesto, first published in 1957. He comments that the manifesto was passed by the State printing and publications department because its title was assumed to refer to traditional realism. Lodder's translation of it, together with notes explaining some of Gabo's references, is in Hammer and Lodder 2000, pp.29–35. Here spacing and type of different weights imitates the style of the manifesto as printed in 1920. See *Gabo on Gabo*, pp.97–106.

39. Khan-Magomedov 1986, p.91.

40. These measurements suggest that Rodchenko may have been using the traditional measurements which Malevich used for his paintings, *arshin* and *vershok*. See Milner 1996, where it is also shown that Tatlin used such measurements during 1911–13 and Rodchenko in and after 1917.

41. According to Khan-Magomedov, these three monochrome paintings were shown in the second part of the exhibition, but according to Alexander Lavrentiev, grandson of Rodchenko and Stepanova, the first part of the exhibition presented paintings and the second part graphic work. See Khan-Magomedov 1968, p.106 and Lavrentiev 1988, pp.56–7. Stepanova's exhibits were of inorganic figure images, composed of linear elements, not abstracted from nature, and executed by various means, ranging from lino-cuts to oil paint on plywood: see pp.42–52.

42. See Milner 1992. Milner's essay is accompanied by a

facsimile of one copy of the exhibition catalogue, with a Popova cover, and gives translations of all the texts in it. For Tatlin's *Pink Painting* see Strigalev and Harten 1993, cat.407a, p.266, where it is said to be one of a series of colour experiments. It was painted on wood; its dimensions are not known.

43. This is illustrated in Lavrentiev 1988, p.57. Close by are reproductions of the figure images Stepanova showed in the exhibition.

44. Details and quotations from Lodder 1983, pp.96–7. Babichev had studied mathematics before turning to painting and sculpture. In 1919 he was listed together with Tatlin and others as leading a course for art teachers, and he taught sculpture in Svomas and then Vkhutemas until 1925. He made projects for the Monumental Propaganda programme. He was prominent in the organization and debates of Inkhuk. In 1926 he joined the AKhRR group and presided over its sculpture section. For summaries of Babichev's life and career see Lodder 1983, pp.239–40 and Milner 1993, pp.57–9.

45. See the programme Tatlin outlined for the Museum in 1923: Zhadova 1988, p.249.

46. Quoted in Lodder 1983, p.113.

47. See Lodder in Becker 2001, especially pp.49–50.

48. Lodder 1983, pp.97–8.

49. Braun 1995, p.189. Lodder 1983, pp.175–6, quotes Popova's own list of the props needed, both longer and more specific ('3 field telephones . . . 2 typewriters') and including a 'film projector, film camera, films, slides, *Kino Pravda* . . .', the last referring to Vertov's *Cinema Truth* newsreels. Braun (ibid., p.179) considers that in several respects what is often referred to as constructivism in the theatre led to an unavoidable compromise with its utilitarian dogma, and quotes Tarabukin, writing in 1931 about Popova's set for *Cuckold*. But Braun adds that 'it proved an ideal platform for a display of biomechanical agility, using the apparatus's ladders, steps, slopes, doors etc.'; see p.180. On p.195 Braun quotes Ivan Aksyonov (poet, translator and authority on drama, working with Meyerhold from 1921 on), writing in 1923: 'So-called "stage constructivism" started with a most impressive programme for the total abolition of aesthetics methods, but . . . now it has degenerated almost to a decorative device, albeit in a new style'.

50. Popova had hesitated to accept this, her first commission for theatre design, being concerned not to 'discredit Constructivism with overly hasty realization'. See Sarabianov and Adaskina 1990, p.250. The story of how Meyerhold turned from the Stenberg brothers to Popova for designs for *Cuckold* is told by the elderly Vladimir Stenberg, from his point of view, in an interview with Alma H. Law published in *Art Journal*, Fall 1981, pp.222–33. It seems that the brothers were not quick and responsive enough to satisfy Meyerhold but

sketched out their idea for a stage apparatus with wheels that would rotate in accord with the feelings of jealousy experienced by the suspecting husband in the story. Popova started from their basic proposal but produced a design in her own style. According to Nakov, the Stenberg's made the timber gantry for *The Earth in Turmoil*. See his catalogue: London 1875.

51. The Popova and Vesnin scheme for Khodinskoe Field is discussed briefly in Braun 1979, pp.169–70; Lodder 1983, pp.50–52; Khan-Magomedov 1986, pp.72–3; and in Sarabianov and Adaskina 1990, pp.249–50, where it is called *The Struggle and Victory of the Soviets*. Khan-Magomedov also illustrates and discusses the Vesnin stage set and Lissitzky's comment on it on pp.97–105.

52. This outline account of LEF and *Lef* comes from Stephan 1981, especially pp.24–56 and 83–5. Brik's article in *Lef* no.1, entitled 'Into Production!', is translated in Sherwood 1972, pp.37–8.

53. Lunacharsky's response is mentioned in Lodder 1983, p.283, note 165.

54. Ilya Ehrenburg (in Germany Elias Ehrenburg) was born, like Lissitzky, in 1890, Ehrenburg into a Jewish middle class family, Lissitzky into a working class one. Ehrenburg began his writing career as a symbolist before becoming a futurist poet. He lived in the West during 1908–17, and left Russia again in 1919. He worked for years in Berlin, as a journalist and novelist. He used a drawing of the Tatlin Tower, derived from one of the photographs of it when shown in Petrograd, as an illustration in his book of essays *E pur se muove*, published in Berlin and Moscow in 1922. Back in Russia, from 1924 on, he wrote successful novels as well as his memoirs. He died in 1967.

55. Four of these illustrations are reproduced in Lissitzky-Küppers 1968, plates 71–4. Sophie Lissitzky-Küppers worked for the Kestner-Gesellschaft in Hanover, which in 1923 published Lissitzky's *Proun* and *Victory over the Sun* portfolios, gave him a major exhibition and invited him to lecture on Russian art. Sophie was the widow of the director of the Kestner-Gesellschaft and had two sons; she and Lissitzky married and, after he finished treatment in Switzerland in 1925, she joined him in Russia where she had a third son. From the start she supported Lissitzky in his multifarious life, especially during his recurring illness from tuberculosis.

56. Milner 1983, pp.169–70, points out that in alchemical imagery compasses 'are associated with Chronos (or Saturn), the personification of time'. Time, as the essential dimension of existence, was Khlebnikov's perennial theme; its patent role in Tatlin's Tower must have struck, even disconcerted, those who saw the model in 1920–21.

57. See Milner 1983, pp.172–3 and plate 171. Milner

emphasizes the difference between the graphic image of Herschel's adjustable structure supporting the telescope and Tatlin's proposals for the kinetic functions of the Tower, and echoes this in connection with a print showing the erecting of the Alexander Column in Petersburg's Palace Square in 1834, plate 172. On the other hand, both structures, for the telescope and for raising the column, assert the Tower's formal duality: a structural skeleton holding solid units.

58. Khlebnikov used mathematics and time as key factors in his thought. He refers repeatedly to the square root of minus one. In mathematics this is an impossible number, invented to facilitate mathematical enquiry; its value is neither more than zero nor less, nor zero itself. In his 1920 poem *Razin*, Khlebnikov uses the root of minus one to refer to the waternymphs who seize 'plus units', i.e. living beings, from the boat on the Volga. Milner quotes an untitled fragment of 1916 in which Khlebnikov proclaims, 'We took the root of minus one [$\sqrt{-1}$] and used him for a table. Our Go-dive-plane was built from glass, thought and iron — it flew, it ran, it dived. . . .'; Milner 1983, p.120. Milner-Gulland has pointed out that, for Khlebnikov, the letter 'L' (Cyrillic), because of its shape, was fancifully related to the mathematical symbol $\sqrt{-1}$. See his essay 'Eyes and Icons, Some visual-verbal "constellations" in the work of Velimir Khlebnikov', in M. Falchikov, Pike and Russell 1989, pp.139–54. Lissitzky himself used the root of minus one in discussing art's ever-changing constitution. In the 1925 essay, 'A. and Pangeometry', where 'A' stands for art, he writes that 'A. is an invention of our spirit, a complex whole, combining the rational with the imaginary, the physical with the mathematical, root 1 [$\sqrt{+1}$] with root −1 [$\sqrt{-1}$].' He considered his position on art and design much closer to Tatlin's than to any constructivist's. See Lissitzky-Küppers 1968, p.348.

59. Lissitzky had developed the Chashnik design before publishing a new drawing of it for a projected book by the Berlin left-wing critic Adolf Behne. See Lissitzky-Küppers 1968, p.51.

60. Presumably the text — probably not the English — was Lissitzky's. In 1924 he wrote an article for Schwitters's journal *Merz*, headed 'Nasci'. It opens: 'We have had ENOUGH of perpetually hearing MACHINE / MACHINE / MACHINE / MACHINE / when it comes to modern art production', 'machine' being repeated on separate lines. It ends: 'In the year 1924 will be found the square root [$\sqrt{00}$] which swings between meaningful (+) and meaningless (−); its name — NASCI'. See Lissitzky-Küppers 1968, p.347. Cf. the mathematical signs in Lissitzky's *Tatlin at Work*. The Latin word *nasci* means 'I am born'. Lissitzky may have been contesting the association of Tatlin with idolization of the machine springing from Umanski's book and the Berlin Dadaists'

echoing it in 1920.

61. The impact of the Russians on Berlin in 1922 is discussed in Lodder 1983, pp.227–38. Lodder lists the three-dimensional exhibits in the First Russian Art Exhibition in note 17, pp.302–3. Gan's attack on Western misconceptions and the role of Lissitzky and Ehrenburg is discussed on p.137.

62. Six out of the set of ten lithographs are reproduced in Lissitzky-Küppers 1968, where plates 52–63 illustrate also the portfolio's cover and associated Lissitzky drawings, including a sketch for 'the machinery'. His title page text is translated on p.348.

63. See Lissitzky-Küppers 1968, p.83.

64. Bann 1974, pp.33–42, prints sections of Gan's book in John E. Bowlt's translation. Some of these and further passages are discussed in Lodder 1983, pp.98–9 and pp.237–8. Lissitzky, in an article of 1926 on 'Our Book', mentions Gan alongside Rodchenko, Popova, Stepanova, etc., as book designers working for the Russian State Publishing House. 'Some of them work in the printing-works itself, along with the compositor and the machine (Gan and several others).' Lissitzky approved of this hands-on approach. *Constructivism* was an early example of such a dynamic display of text.

65. Nikolai Tarabukin studied philosophy and art history, was associated in Petrograd with Punin and, after the Revolution, moved to Moscow where he served Inkhuk as academic secretary. See Gough 2005, p.215, note 2.

66. Henry Ford founded the Ford Motor Company in Detroit in 1903 to produce good quality standardized cars that would bring to anyone on 'a good salary . . . the blessings of hours of pleasure in God's great open spaces'. His Model T tourer, launched in 1908, proved so successful that Ford adopted radical new production methods for it, including, in 1913, the assembly line. This brought him close to, though not wholly dependent on, Taylorism. In 1920s Russia, mass production, Taylorism and Ford's extraordinary success merged in a general enthusiasm for the progress of Capitalism in a country established to be a republic dedicated to equality. See Batchelor 1994, especially pp.19–24, 48 and 98. Ford's book *My Life and Work*, first published in 1922, was instantly translated into twelve foreign languages, including Russian.

67. A French translation of the essay, 'Du chevalet à la machine', by A.B. Nakov and Michael Pétris, with an introduction and notes by Nakov, forms part of Taraboukine 1972, pp.19–84. It is there followed by a translation into French of Tarabukin's 'Towards a theory of painting', published by Moscow PLK in 1923. See also Gough 2005, especially chapter 4.

68. Paris's 1900 international exhibition had included a display of arts and crafts from the old Russia, including a 'Russian Village'. This was 'a reconstruction of the wooden architecture that the

architect Korovin had studied on a trip to the Far North, complete with an ancient *teremok*, or timber tower, and a wooden church, built on site by a team of peasants brought in from Russia. The Parisians were enchanted by these "savage carpenters", with their "unkempt hair and beards, their broad, child-like smiles and primitive methods".' See Figes 2002, p.270. From that time on, goods crafted by Russian peasants flooded into the West, and shops selling these opened on both sides of the Atlantic.

69. Cited in Shvidkovsky 2007, p.364.

70. This short account of Melnikov and his pavilion is indebted to Kopp 1970, pp.60–63, and to Starr 1978, pp.85–103. The words quoted are Starr's, p.100. Starr shows that Melnikov, a devout Orthodox Christian, was deeply affected by Fedorov's belief that science would overcome death, shared by eminent figures in the government as well as by creative individuals such as Mayakovsky. Starr's book ends with a chapter entitled 'Architecture against Death: The System of Melnikov's Art', pp.240–58. He emphasizes Melnikov's interest in German expressionist architecture and ideas, including those developed by Bruno Taut in and after 1919. It would be interesting to examine Melnikov's work in the light of Rudolf Steiner's architecture. Le Corbusier is reported to have said that Melnikov's was 'the only pavilion worth seeing in the whole exhibition'. See Karginov 1979, p.172.

71. See Starr 1978, pp.127–47.

72. Rodchenko 2005, especially pp.160, 163, 164, 166, 169, 176 and 182, i.e. some of the frequent letters he sent to Stepanova in Moscow between 4 April and 1 June 1925. He commented critically on much that he saw, the Salon des Indépendants, non-Russian sections of the Exposition, and various aspects of life in Paris (including the breastless fashionable women). He plainly enjoyed much else, notably the Metro. The Russian section opened late, on 4 June. Rodchenko left Paris by train on 18 June. He had meanwhile bought cameras, etc., for Vertov and for himself, as well as clothes, some of them for Stepanova. He was plainly very busy, almost every day, preparing material for the Russian galleries in the Grand Palais, hanging these often quite plain exhibits as well as supervising the construction, painting, etc., of the workers' club and of Melnikov's pavilion. Rodchenko wrote repeatedly of how much he was missing his wife, and promised to come home as soon as possible, but his departure was postponed several times.

73. See Khan-Magomedov 1986, pp.176–85. The quoted phrase comes from a Russian's report on the Paris exhibition: see note 16, pp.175–8.

74. Zhadova 1988, p.137 and p.152, note 34; also Milner 1983, p.206 and p.247, note 74.

75. Zhadova 1988, pp.250–51.

76. He spelled this out in his 1919 essay 'The Initiative Individual in the Creativity of the Collective'; see chapter 7, p.140.

77. Ibid., p.184.

78. See Strigalev and Harten 1993, cats 410–81, also for the dates of the three performances. Cats 414a–481a refer to painted, textured and patterned boards, with and without inscriptions, which Tatlin produced in preparation for *Zangezi*; also drawings for costumes for a few of the performers (the others wore their ordinary working clothes), a mechanical horse, and a number of hand-painted posters advertising the performances.

79. Milner 1983, pp.197–204 on Tatlin's production of *Zangezi*.

80. According to Strigalev and Harten 1993, p.390, Punin lectured on 27 May on 'Material Culture (Down with Tatlinism)'.

81. Zhadova 1988, pp.248–9. This article was published in *Life of Art* on 8 May 1923, three days before the first performance.

82. Quoted in Milner 1983, p.134; published in *Art of the Commune* for 30 March 1919.

83. Punin's article, in *Life of Art*, no.20, 22 May 1923, is translated in Zhadova 1988, pp.395–6, and followed by a remarkably full commentary on pp.396–400, on which I have drawn for the next paragraph.

84. The connections between the stage Tatlin created for *Zangezi* and his earlier stage designs are discussed by Nicoletta Misler in her contribution to the Tatlin symposium, entitled 'The flying Seaman': see Harten 1993, pp.170–83.

85. Zhadova 1988 stresses that 'Tatlin was the only Soviet artist engaged in designing clothes in the first half of the 1920s to give preference to men's suits'. While Tatlin made a few designs for women's clothes (some were exhibited in 1923), he did give more attention to men's clothing and used himself for measurements and to model them. Kiaer 2005, pp.74–8, discusses Tatlin's designs for men's clothing, emphasizing the contrast between his 'stiff, boxy outfit' (to be made in linen!) and the Western-style men's suits then offered in shops and advertisements, with their many buttons, their waistcoats and nipped-in waists. Eager to promote a progressive view of *byt*, Tatlin drew on his native skills as a craftsman and on his experience as sailor, taking some of his principles from what in sailors' outfits had proved effective as well as economical. See Zhadova 1988, pp.144 and 153, notes 70–72. The forms Tatlin gives to bodies in his designs for clothing are strikingly similar to his drawings for the peasants' costumes in *Ivan Susanin*.

86. In his diary for 1924 Punin reports on a conversation he had with Tatlin, partly about the work the artist was beginning on *Letatlin* (see chapter 9, part I), partly about a suit that Tatlin had designed and got made: 'To me it was simply aesthetically pleasing. . . . It would be significant for Europe if people coming

from Russia arrived in clothes of Tatlin's cut instead of skimpy Parisian jackets. . . . In their shapes, Tatlin's clothes there is something of the shoulders and movements of the archangels of Russian icons about them (of the Holy Trinity, for example).' Punin had written a book about Rublev's *Holy Trinity* icon, and Tatlin had demonstrated his admiration of the painting in his use of curving lines for drawing nudes (see chapter 2). The quotation is taken from S. Monas and J.G. Krupala, *The Diaries of Nikolay Punin 1904–1953*, Austin, 1999, p.129.

87. See Zhadova 1988, plate 243.

88. For the list of new products Tatlin was working on in 1922–3 see Strigalev and Harten 1993, cats 482–97, pp.271–3, and the poster no.498, p.273. Zhadova 1988, plate 243, illustrates the poster, and, in plates 245–51, prototypes and designs for clothing and a stove in the form of drawings and also photographs, in some cases showing Tatlin himself modelling the clothes. The programme of his Section is given there on p.249. Tatlin's designs for a stove appear to have puzzled people, so much so that Punin wrote a long article in its defence, invoking the *Mona Lisa* to stress the aesthetic quality of Tatlin's work: he experiences the same 'inexplicable pleasure' in front of both. He also defended his friend against the charge — quoting the art critic Abram Efros — that Tatlin's abandonment of his artistic work, including the Monument to the Third International, amounted to a dereliction of duty. An artist does not belong to a separate world, and so Tatlin pre-eminently helps us 'to shape and strengthen our mode of life or . . . the way of life of the age that arrived with us'. Ibid., pp.403–7.

89. Zhadova 1988: for Tatlin's essay, 'Art into Technology', pp.310–12; for the contents of his 1932 Moscow exhibition, pp.496–7; for the term 'artist-constructor', p.253.

90. Ibid., plate 186 for the new model, plate 187 for its place in the exhibition. Tatlin's report to the committee is on pp.259–60, where we also learn that the committee was chaired by Lunacharsky and included Shterenberg and Mayakovsky, and that the model 'enjoyed a great success . . . and was awarded a gold medal'. This last point is denied by Strigalev and Harten 1993, cat. 507, p.275. See also Milner 1983, plates 209 and 211.

91. Strigalev and Harten 1993, cat. 508, pp.275–6, illustrates this model and states that it was built by Tatlin's assistants. Another photograph of it, showing more of the procession, is plate 164 in Zhadova 1988, where it is wrongly dated 1926.

92. The exhibition 'Art in Revolution', organized by the Arts Council of Great Britain and shown at London's Hayward Gallery in 1972, included a 'teapot' developed in Vkhutein's Ceramic Faculty under Tatlin and a London reconstruction of what was then referred to as 'a tubular steel chair with rubber moulded seat'. The 'teapot' was lent by Camilla Gray, author of the first substantial English-language book on Russian modernist art and design, Gray 1962. She had proposed the exhibition and was its chief consultant. The 'tubular steel chair' is now known as the 'Viennese Chair', made of bent wood in the manner of the chairs Thonet made in Vienna, and a seat made of sprung wood, covered in cloth. I became convinced that the hand-sized ceramic object was not a teapot but what catalogues have recently called 'a child's drinking vessel' and I am calling a Baby's Bottle. See Gray 1962, plates 197 and 199, or the revised and enlarged edition of Gray's book, Burleigh-Motley 1986, in which these objects are illustrated with the old captions: plates 233–4. Lodder 1983 describes them correctly and illustrates them in her account of 'The organic dimension in Tatlin's product designs', pp.210–17 and plates 7.6–7.10.

93. See Strigalev and Harten 1993, plates 110–12 and cats 568–70, the last showing Tatlin in front of a triple tray of Babies' Bottles. The materials used for the trays are here given as metal covered with wickerwork.

94. See Strigalev and Harten 1993, plates 114 for the original chair and 113 for the Russian reconstruction. These last two numbers are reversed in the commentary given under cats 526 and R526, p.281. The dates there ascribed to the originals are 1930 for the Babies' Bottles and 1929 for the Viennese Chair which is called the *Konsolstuhl* (German for consol or corbel chair). Lodder 1983, plate 7.6 dates the Viennese Chair 1927 (it was illustrated in an article of 1929, see her notes 44 and 45, p.299), and the 'Infants' Drinking Vessels' 1928–9 for the first version and c.1930 for the final version.

95. Tatlin admits the comfort provided by American furniture but emphasizes the multiple materials and much greater expense involved in producing it, as opposed to the furniture he and his students have been working on, made mostly of maple wood of which Russia had a plentiful supply. See Zhadova 1988, pp.266–7.

96. The article has a subtitle: 'Let Us Declare War on Chests of Drawers and Sideboards'. The text is in Zhadova 1988, pp.267–8, where its publication date, in the journal *Rabis* is given as 14 April 1930. Lodder 1983 translates sections of the article on pp.211–12, but dates its publication 1929.

97. Zhadova 1988 prints the whole article and a commentary on pp.310–12. The version published in 1932 omitted two final sentences in which Tatlin named the specialist advisors and student-collaborators who worked with him on *Letatlin*. Lodder emphasizes Tatlin's rejection of 'the mechanical application of technology to art' and also some artists' 'mechanical application of artistic techniques . . . to the larger tasks of design'. See

Lodder 1983, p.212 and p.300, note 52.

98. See Lodder 1983, pp.184–6, for the formation of AKhRR and other new groups emerging committed to realism. AKhRR soon absorbed some of these. Lodder suggests that Picasso's move, around 1917, into neoclassicism and the monumental realism of his figure paintings may have encouraged this reversal of priorities, matched by changes in the work of other leading Parisian modernists such as Braque and Léger. See p.295, note 7. In Germany expressionism was at the same time moving towards realism in what became known as Neue Sachlichkeit (translated as New Objectivity).

99. See Lodder 1983, pp.184–91.

100. See New York 1992, p.315.

101. See the essay 'The Russian Presence in the 1924 Venice Biennale' by Vivian Endicott Barnett, New York 1992, pp.466–73.

102. Zhadova 1988 has three photographs showing the truck and the funeral procession: plates 290–92.

Chapter 9

1. This is mentioned, without reference, in Strigalev and Harten 1993, cats 575–86, p.288, introducing a sequence of individual entries referring to *Letatlin*.

2. See chapter 1, p.2.

3. Siukonen 2001, pp.126–8 and 133–5, quoting Punin's diary for 23 March 1923 and 5 July 1924. I quote some more words from the 1923 entry in note 31 below.

4. The association of the idea of a mass-produceable flying machine with the bicycle is not fortuitous. The chain-driven Safety Bicycle was invented in 1874 and mass-produced from 1885. Wohl 1994, pp.9–10, stresses that the Wright brothers' experience as bicycle manufacturers was the basis of their determination and ability to make machines that would fly.

5. His project is illustrated and explained in F.P. Ingold, *Literature and Aviation*, p.427.

6. Siukonen 2001, pp.126–8 and 133–4.

7. This information and other points are taken from Lutz Becker's essay 'Vladimir Tatlin and the Bicycle of the Air' in Becker 2001, pp.141–57.

8. Siukonen 2001, pp.160–61.

9. Ibid., pp.149–54, 172 and 173. Kornely Zelinsky had been a leading theoretician of the Literary Centre of Constructivists from 1924 on, but by 1930 had denounced them as 'bourgeois'. His article about *Letatlin* of April 1932 quotes Tatlin's belief in organic design as leading both to beauty and to technical success, but dismisses it since it has not yet resulted in a useable machine. Zhadova 1988, p.309, quotes only part of Zelinsky's article. Siukonen makes it clear that Zelinsky was prejudiced against Tatlin, even mocking him for his location in the

Tower of a monastery and describing his workshop there as a 'medieval laboratory'. Tatlin's 'class roots', like Khlebnikov's, were not proletarian.

10. The theme of flight is discussed at several points in Steinberg 2002; see especially pp.98–9, 242–5 and 265–6. Figes refers to a report, launched by 'a practical joker . . . that an old Russian peasant had flown several kilometres on a homemade aeroplane'; this was taken to show the superiority of the Russian people's patriarchal system to anything in the West. See Figes 2002, p.314.

11. Aspects of this new consciousness, the dangers implied in it as well as the dimension it added to daily life, are touched on in Kern 1983, especially p.243.

12. Anna Begicheva's memoirs, quoted by Lodder 1983, p.214.

13. Milner 1983, p.178 and p.244, note 41. On p.248, in note 10, Milner quotes from Tsiolkovsky's book. The people inhabiting the enormous space stations envisaged in the novel, where only a slight gravitational pull is maintained, are described as flying within them by means of 'small wings on the sides of their bodies, rather like fishes' fins which they operate by means of their legs'.

14. Becker in Becker 2001, pp.147–8, citing Begicheva's memoirs.

15. This story is outlined in Wohl 1994, especially pp.145–7 and, with more technological and statistical details, in Kilmarx 1962, pp.4–7. Additional information is taken from F.P. Ingold, op.cit., especially chapters 1 and 2. Russians soon began to produce their own designs, often of a markedly original sort. Sikorski built his first helicopter in 1909 while a Scots engineer, C.J.H. Mackenzie-Kennedy, experimented with a hydroplane at the Imperial River Yacht Club of Petersburg. In 1907 and 1909 the first Russian aircraft factories were set up in Moscow and Petersburg. The year 1914 found Russia better equipped with aircraft than Germany. In 1913 Sikorski had demonstrated his four-engined heavy transport plane. At the outbreak of war the Russian Imperial Air Force owned two.

16. The words quoted here are Steinberg's, to whom this summary paragraph is indebted. See Steinberg 2002. The quotation comes from p.265, but see also pp.98–9, 175–6 and 142–5.

17. It was, of course, the idea not of Icarus but of his father, Daedalus, the legendary artist, inventor and craftsman. Needing to escape from the island of Crete, Daedalus made wings for himself and his son, attaching them with wax. His son, flying too close to the heat of the sun, fell to earth and died. His negative image has been allowed to displace the positive one: Daedalus flew to Sicily where he settled and achieved several major works. Tatlin too referred to Icarus, perhaps because that was (and still is) the expected reference, for example in the

K. Zelinsky interview of 1932 in Zhadova 1988, p.309. Khlebnikov noted the following in or after 1914: '. . . He said that art had to achieve the same status as science and industry, Technology with a capital T. But a thousand years before the invention of the airplane, wasn't there the magic carpet? And the Greek Daedalus two thousand before?' This is quoted from Khlebnikov's notebooks, under the heading 'Things I have studied 1914–22', in Douglas 1987, p.409.

18. See Wohl 1994, pp.146–53 for the story of Kamensky as aviator and writer. The Malevich drawing is illustrated in plate 205, p.167, and in Compton 1978, plate 67, p.99, as well as in the growing Malevich literature.

19. One of Kamensky's visual poems is entitled 'The Mansion of S.I. Shchukin'. It is laid out like a plan of the house to show artists' names and the work to be seen there, sometimes with comments. See Janecek 1984, p.20.

20. This is suggested in Compton 1978, p.83. (Compton 1992 has additional information about Kamensky.) Markov 1969 gives a fuller account of Kamensky's activities as a futurist writer. On his ferro-concrete poems see especially pp.198–9, as well as Janecek 1984, pp.158–9. For Kamensky's assemblage *A Fall from an Aeroplane* see Markov 1969, p.404, note 30. This appears to have been a pioneering piece of anti-aesthetic multimedia art, essentially different from the reliefs Tatlin was making from 1913–14 on, and closer in spirit to the work produced by the Dadaists of Berlin and Cologne in and after 1919.

21. The quotation is from an article by Viacheslav Polonsky in *New World* (*Novy Mir*), June 1930, p.176. From there I took also Mayakovsky's rejecting of nature's charms. See also Mihailovich 1972, p.194.

22. R. Milner-Gulland, introducing a selection of Mayakovsky's poetry in *Soviet Russian Verse*, London, 1964.

23. Terras 1983, p.107.

24. Brown 1973, pp.28, 88 and 361.

25. Cited from Zelinsky's interview with Tatlin, see note 9 above.

26. Nicoletta Misler's lecture 'Der fliegende Matrose' (the flying sailor) is published in Harten 1989, pp.170–83. Misler sees 'dark, cryptic aspects' in Tatlin, and phantoms emerging from his unconscious, pointing especially to the sets for *The Flying Dutchman* and to his awareness of the fate of Icarus. I see no sign of these. The possibility of crashing has to be in every aviator's mind, as of drowning in every sailor's, but I would argue that Tatlin's work, like Khlebnikov's, with rare exceptions (such as *The Flying Dutchman* sets worked on during the war) communicates positive spirits and an optimistic vision of the future.

27. Zhadova 1988 reproduces two of the illustrations used — the cover and a view of the ship Chernomor seen from above (as by a seagull) — and two drawings, of the crew eating and of three men rowing a dinghy through a stormy sea. See plates 294–7. Milner 1983, plates 1 and 227–32, reproduces these and four other drawings. Strigalev and Harten 1993 provides five small illustrations in the catalogue section (cats 534–47), including technical drawings of, for example, different types of sailing ships, thought to be by Tatlin. He derived the cover illustration from a photograph of the ship on which he served in 1904, the Grand-Duchess Maria Nikolaevna. This photograph is reproduced in the catalogue of the Tatlin exhibition presented at the Picasso Museum, Barcelona, in 1995, p.211.

28. I have assembled this quotation from a number of sources, starting from Milner 1983, p.220.

29. See Lönnqvist 1979, p.88. Also Stobbs 1982, p.130, and Mirsky 1975, p.80, quoting Khlebnikov's letter of 18 June 1913 to Matiushin, associating flight with immortality.

30. See Cooke 1987, p.139.

31. Punin 2000, p.213. Tatlin had speculated previously on the role of air travel in daily Russian life. In March 1923 Punin recorded that 'Tatlin was here today. He spoke wonderfully and with great scope about the culture of the future. / Among other things, he spoke about the relationship between the city and the country. . . . Today's type of city is the unstable type produced by a dying era. It doesn't make sense to fill a city with private life. These are places on our earthly globe for workers. Once space has been conquered people won't need to live in them. Instead of having their private life there, they would fly in, say, from the Crimea, to work or for business. In this way, our countryside would preserve its human meaning.' Idem, p.107.

32. Eva Körner quotes from Artseulov's notes of 1977 about how he got involved with *Letatlin*. A superior officer instructed him 'to go to the Novodevichi Convent where an artist called Tatlin is patching together a bird-shaped flying structure. If what he does is really interesting we must help him'. Körner stresses that there was no other country in which airmen would have wanted to enquire into the work of even eminent avant-garde artists. See Körner 1985, vol.31, pp.71–89. Artseulov is quoted on p.71. Körner edited the Hungarian edition of Zhadova 1988, published in Budapest in 1984.

33. See Zhadova 1988, pp.309–10.

34. These details are taken from Zhadova 1988, pp.256 and 311, and Strigalev and Harten 1993, cats 575–86 (introductory entry) and p.393 under '1929–32'.

35. Zhadova 1988, pp.310–11.

36. A short article on Tatlin's thought and work by the artist Alexandra Korsakova, his widow, states that 'one of his masterpieces was a flying structure, a

winged design of such immaculate beauty and technical perfection that the wooden wonder did "fly"'. See Korsakova 1988, p.13. Lodder reports that the son of Russia's Foreign Minister Maxim Litvinov, 'flew the model for a few yards . . . in the autumn of 1933'; Lodder 1983, p.300, note 63. Tatiana Litvinov, Maxim's daughter, doubts this (see below).

37. See note 9 above.

38. Strigalev and Harten 1993: entries for the three *Letatlin*s, cats 575, 576 and 577, p.289. The last of these comments on a *Letatlin* displayed in the Central House of Literature in Moscow in 1977 as part of a wide-ranging Tatlin exhibition. It was there stated that the exhibited 'model' had been reconstructed from parts of the three *Letatlin*s shown in 1932. The editors reject this: first, the object is not a model but the thing itself; secondly, the three machines shown in 1932, being different from each other, could not have supplied interchangeable parts from which to assemble one ornithopter.

39. See Wohl 1994, p.10, and Becker in Becker 2001, p.147 and p.157, note 9. In his book of 1889, published in Russian in 1905, Otto Lilienthal describes bird flight and his experiments and tests of gliders of his own design. In 1909 Tatlin may well have seen a Lilienthal glider in an exhibition of aviation at Moscow's Technical University. Becker refers to an article by A. Rodniykh on the history of ornithopters from Leonardo on, published in Leningrad in 1929: ibid., note 14.

40. Paul Loewenstein, an IT expert living in Palo Alto and a 'triple diamond' glider pilot, as well as a pilot of powered aircraft and of radio-controlled models, was kind enough to examine images of *Letatlin* and to send me his comments on them. Dr Loewenstein concluded that Tatlin's ornithopter would not be operable for lack of vertical stabilizers such as are provided by birds' tails. He also queried whether even athletic individuals would be able to produce enough power and thus sufficient speed. The gap between the two wings of *Letatlin* would greatly increase drag and call for additional power. (From emails exchanged during 2004.)

41. Becker 2001, p.153, citing an article by I. Rakhtanov on '*Letatlin* — An Aerial Bicycle' in the children's magazine *Pioneer*, no.9, 1932, consisting mostly of a lecture Tatlin gave in Moscow on 5 April 1932.

42. See note 9 above.

43. Kemp 1981, pp.122–3 and 256, discusses Leonardo's *uccello* (bird). Leonardo's bird-like design was intended to be a glider with wings articulated to permit a limited amount of flapping. An expert, though brief, account of Leonardo's work on his 'flying machine' is provided in the catalogue of the exhibition 'Leonardo da Vinci, artist, scientist, inventor' shown at the Hayward Gallery, London, in 1989, pp.236–9. Using information from several drawings, a working model was made for this exhibition and is illustrated on p.237. Figs 63 and 65 reproduce drawings, of about 1505, showing Leonardo's thinking about the wings of his machine. The flying man would be prone, using his arms and his legs to tilt and flap the wings via ropes and pulleys. Leonardo was thinking of a machine made mostly of wood, and found no way of overcoming the power-to-weight ratio required to lift it into the air. Like Tatlin's machines, Leonardo's seems to have lacked vertical stabilizers (see note 40 above).

44. These biographical details are taken from Zhadova 1988, p.448, and Strigalev and Harten 1993, pp.395–7.

45. D. Merejkowski, *The Romance of Leonardo da Vinci*, New York, 1931, p.427.

46. Idem, p.522. On Zoroastro, the crippled assistant, see Rosenthal 1986, p.81. The short form of his name, Astro, echoes the Latin for star, *astrum*.

47. Idem, pp.564–6.

48. Butler 1993, p.335.

49. This is quoted in Körner 1985, p.71. I have adjusted the translation very slightly.

50. Quoted in Punin 2000, p.125. Tatlin admired Akhmatova, as did many others, women as well as men. 'Taran' refers to the painter Andrei Taran (1886–1967) who for some months in the early 1920s directed the Petrograd Museum of Artistic Culture and worked with Tatlin as secretary of the Leningrad Union of New Tendencies in Art. Malevich's 'business trip' was his only visit to the West, in 1927, presumably with official permission, taking his big exhibition to Warsaw, Berlin and Amsterdam.

51. From *Apartment No.5*, memoirs of the 1930s, in Punin 2000, pp.25–31.

52. Strigalev and Harten 1993, cat. 947, with a small illustration, and cat. 1148 and plate 156. The drawings are in the State Russian Museum, Petersburg, and in the Central State Archive of Literature and Art, Moscow.

53. Punin, when he was beginning to know Tatlin, was awestruck by the artist. He saw in him a man of action, insistently working with materials of daily life when Malevich was still painting easel pictures. In 1925, when Tatlin was hurriedly making a new model of the Tower for showing in Paris but otherwise impatient at the lack of progress in Russia and his own lack of opportunity to do anything substantial, Punin noted his 'wild and blunt rage'; he even 'pounced on Malevich in a fury'. See Punin 2000, p.234.

54. Photographs of Tatlin, in sequence: Milner 1983, frontispiece; Milner 1983, plate 30, 'about 1912–13', also Zhadova 1988, plate 94, unconvincingly dated 1916; Rudenstine 1981, p.475; Zhadova 1988, frontispiece, as '1930s', also Milner 1983, plate 253,

as '1934'; Zhadova 1988, plate 173, Tatlin and assistants building the Tower model in 1920; Tatlin by himself in front of the model, from the archive of Anna Genrihovna Kaminskaya (daughter of Punin and Akhmatova), here reproduced for the first time; Zhadova 1988, plate 212, Tatlin and friends between performances of *Zangezi*, Petrograd, 1923; Zhadova 1988, plate 318, Tatlin holding one *Letatlin* wing, Moscow, 1932; Milner 1983, plate 149, Tatlin and assistant standing in front of the complete Tower model, Petrograd, 1920 (to his left a tall ladder, and, on the wall, one of his two large elevational drawings).

55. Quoted by Gough 2005, p.61.

56. See Gail Harrison Roman, 'Tatlin's Tower: Revolutionary Symbol and Aesthetic', in Roman/Marquardt 1992, p.47.

57. From Punin, *The Monument to the Third International*, Petersburg, July 1920. I have adjusted the translation given in Zhadova 1988, pp.344–6, incorporating phrases from the translation in R. Fülöp-Miller 1928, pp.144–6.

58. P.I. Novitsky, the director of Vkhutein, proposed Tatlin for this honour. Zhadova 1988, p.448, quotes part of Novitsky's recommendation. He emphasizes Tatlin's role in stimulating Russia's 'great achievements in industrial design since October' and suggests he is 'the greatest exponent of the art of material design', 'world famous' but not used to the full in his own country. He is 'a true master', 'a devoted worker for the proletarian revolution'.

59. See Strigalev and Harten 1993, p.393.

60. Milner offers a close study of the *Corner Counter-Relief* which is generally thought to have been the first in that series and which Tatlin illustrated in the pamphlet printed for the '0.10' exhibition: see Milner 1983, pp.108–11. Analyzing its composition, he emphasizes 'the use of found elements, rigorously organized, despite their irregularity, around a focal point at the heart of the construction from which three axial planes emerge at right-angles, each defined by one of the relief's main elements. . . . A rigid structure results'. Here, he adds, 'construction replaced composition'. Milner notes interesting echoes between this construction and Kandinsky's large *Composition VII* (1913; Moscow, Tretyakov Gallery) which Tatlin will have seen in the Moscow exhibition 'The Year 1915'. In this quickly executed but long-prepared painting, Kandinsky incorporated several of the devices through which he signalled the Apocalypse. In many places his freehand colour forms are visually supported by painted lines, mostly in black.

61. Tatlin himself was too tall, as well as too middle-aged, to pilot *Letatlin*. The photograph of a *Letatlin* skeleton showing him in the pilot's position must have been taken for demonstration purposes. See Zhadova 1988, plate 325, and Milner 1983, plate 239.

62. See www.tatlinstowerandtheworld.net: 'Tatlin's Tower has come to symbolize an impossible project, the Unicorn or Atlantis of the cultural world'; the implication is that the impossible will be proved possible. See also Fiachra Gibbons's report in the *Guardian* Saturday Review, 29 May 1999, on a young artist's convincing attempt at a reconstruction of the Tower model in bamboo, made for the Brighton Fringe Festival, and the Tatlin Tower reconstruction by a Chinese artist shown at Tate Liverpool's exhibition of contemporary Chinese art in 2007.

63. For an outline account of this competition and its results, see Curtis 1982, pp.146–9. Shvidkovsky 2007, p.364, suggests that Le Corbusier's competition-winning project for the great Tsentrosoyuz building in Moscow, was designed in 1928 after his proposal for a great League of Nations building failed to be chosen the previous year. Russians were not able to join the hundreds of other designers who entered this competition since Soviet Russia was not part of the League of Nations. The Russian avant-garde was eager to have Le Corbusier involved in the Moscow project and to be awarded the first prize, and he was well informed on their projects and buildings. Russian collaborators worked with Le Corbusier on the Tsentrosoyuz building while he made several visits to Moscow, but the project was moderated as the years passed, partly with thoughts on cost and partly in view of the increasing regularization of design becoming more dominant from the start of the 1930s. The building was realized after many adjustments to the original design and losing some of the plasticity that should have dramatized the diverse functions of its parts and made visible the arrangements for circulation between them. Finished in 1935, it is thus a more conventional composition, mostly of rectangular units, than Le Corbusier had envisaged, and less in the spirit of Tatlin's dynamic Tower. See Shvidkovsky 2007, pp.354–5.

64. Dziga Vertov (1896–1954) would say that this required close collaboration between his cameraman, Kaufman, his editor, Svilova, and himself as director, his 'Council of Three'. In his best-known film, *The Man with the Movie Camera* (1929), he reminds us of this process by showing it as part of the film, as well as shots of the cinema itself, with an audience watching the screen, proving the entire event a constructed piece of reality. He had developed this process in his earlier news films and documentaries, from 1918 on, claiming that our eyes do not ordinarily see truthfully; it is through 'the viewpoint of the cinematic eye (aided by special cinematic means . . .) you see the full truth'. Eisenstein's fame is closely associated with his use of montage, the constructive assembling of film footage to make an informative and memorable narrative. He wrote about this as his essential process, but he was not its originator.

65. *Forest* is in the collection of the Tretyakov Gallery, Moscow; the lost *Counter-Relief*, tentatively dated 1917, exists in a reconstruction made by Martyn Chalk in wood, paint, steel sheet and carbon, 70 × 38 × 20 cm (London, Annely Juda Fine Art). Contemporary photographs of this *Counter-Relief* exist, including an installation shot of it at the Van Diemen Gallery, Berlin, in October 1922, close to works by Rodchenko, Gabo and Lissitzky. See *inter alia*, the *Counter-Relief* by itself in Strigalev and Harten 1993, cat. 392, p.258, and in London 1983, p.30. See also the installation shot, ibid., p.14. This gives us a glimpse, extreme left, of a Rodchenko slotted construction of 1918, perhaps now in a material more permanent than cardboard. On the wall, to the right of Tatlin's piece, are two Proun paintings by Lissitzky.

66. These exhibitions are listed in Zhadova 1988, pp.496 and 499. On pp.499–500 she refers to the Hayward Gallery's exhibition of early 1971, 'Art in Revolution'. Zhadova states erroneously that its reconstruction of Tatlin's Tower was 'based on surviving blueprints and photographs and detailed information from A.A. Strigalev': in fact, only published photographs of Tatlin's model and of his two drawings were available to us. Also reconstructions of the chair and of *Corner Relief* and *Combined Counter-Relief* are listed here, although the latter two, made by Martyn Chalk, had to be withdrawn from the Hayward exhibition after last-minute protests from Russia at the proposed inclusion of any avant-garde art. The Soviet authorities threatened to withdraw their loans (which had arrived three days before the opening). What they had sent did not greatly enrich the exhibition whereas taking out all the avant-garde art borrowed from Western sources, lacking all information from Russia, meant weakening its essential theme. The Russian representatives' willingness to leave some of their shipment unexhibited as long as the gallery quickly printed a catalogue list of everything they had delivered, suggests that kudos attached to the sending of the exhibits, whether or not they were shown. I still wonder what the effect of showing the exhibition complete with the avant-garde works of art the gallery was forced to exclude would have been. As it was, *The Times* and other papers made more of the exclusions than of the exhibition as presented, in spite of its eye-opening sections of contemporary Russian film, graphic work, theatre and architectural designs and models. Other large and relatively inclusive exhibitions of modern Russian art followed some years later, beginning with 'Paris-Moscow / Moscow-Paris', seen in Paris in 1979 and in Moscow in 1981. The Zhadova 1988 exhibitions list does not include the 1968 Tatlin show mounted by Stockholm and afterwards shown in Munich, though the catalogue compiled for it by Troels Andersen is listed in the 'Selected Bibliography', p.517.

67. See Rudenstine 1981. For Tatlins in the collection see pp.474–83. An introduction by S. Fredrick Starr, an essay on collecting by Costakis and a chronology by J.E. Bowlt make this a valuable publication in itself, but Rudenstine's documentation of each item represented in it makes it one of the essential works on the subject. Costakis and Rudenstine confused Kornely and Alexei Zelinsky in writing that Costakis sought to buy this wing strut from Kornely Zelinsky, and that later, in 1976, Costakis bought it from this Zelinsky's widow. But it was Alexei Zelinsky, a former Tatlin student and then a sculptor of a realistic sort, who assisted Tatlin on *Letatlin*. Zhadova's photograph of the main wing strut (Zhadova 1988, plate 344) is credited to Alexei Zelinsky and the 1950s, and shows it in a studio context of busts and figures of a traditional sort, probably Alexei's own. See Milner 1993, p.476, for biographical information about this Zelinsky (1903–1974). When Alexei Zelinsky studied under Tatlin at the Moscow Vkhutein during 1926–30 he was already a member of the reactionary groups of Moscow artists, OST and AKhRR, and it is interesting to find him working with Tatlin on *Letatlin* and valuing this experience so keenly. For him, at least, Tatlin's work on a bird-like apparatus did not conflict with his personal artistic priorities — after all, Tatlin was working from nature — nor did Tatlin's reputation as an artist who had moved dramatically from impressionistic and then more abstracted but still representational painting to construction and to supposed fatherhood of constructivism.

68. See Syrkina 1988, especially pp.164–79.

69. Zhadova 1988, pp.437–43 and 501 respectively.

70. This is the assembled 'model' disputed by Strigalev and Harten. Two other *Letatlin*s appear to have been lost or destroyed since the early 1930s. See part I of this chapter, and Strigalev and Harten 1993, pp.288–91, especially cat. 577.

71. See Zhadova 1988, pp.437–42.

72. This summary is taken from Strigalev 2000.

73. Strigalev and Harten 1993, cat. 510.

74. The years 1993–4 saw the comprehensive retrospective exhibition of Tatlin's work curated by Anatoli Strigalev and Jürgen Harten and shown in Düsseldorf, Baden-Baden, Moscow and Leningrad between September 1993 and July 1994. It was accompanied by the important catalogue to which reference has frequently been made in these pages as 'Strigalev and Harten 1993'.

Bibliography

Ades 1978 D. Ades, *Dada and Surrealism Reviewed*, exh. cat., London: Arts Council of Great Britain, 1978

Alofsin 2006 A. Alofsin, *When Buildings Speak: Architecture as Language in the Hapsburg Empire and its Aftermath, 1867–1933*, Chicago, IL, and London: Chicago University Press, 2006

Andersen 1968a T. Andersen (ed.), *Essays on Art 1915–1933*, by K.S. Malevich, vol. 1, London: Rapp and Whiting, 1968

Andersen 1968b T. Andersen, *Vladimir Tatlin*, exh. cat., Stockholm: Moderna Museet, 1968, and Munich: Kunstverein, 1970

Andersen and Grigorieva 1979 T. Andersen and K. Grigorieva, *Art et poésie russes 1900–1930 — textes choisis*, Paris: Musée National d'Art Moderne, 1979

Annely Juda 1983 *The First Russian Show*, exh. cat., London: Annely Juda Fine Art Gallery, 1983

Antliff and Leighton 2001 M. Antliff and P. Leighton, *Cubism and Culture*, London: Thames and Hudson, 2001

Antonowa and Merkert 1996 I. Antonowa and J. Merkert, *Berlin-Moskau/Moskau-Berlin 1900–1950*, exh. cat. for exhibition shown in the Martin-Gropius-Bau, Berlin 1995–6 and in the State Pushkin Museum, Moscow, 1996

Armand Hammer Museum 1990 *Kazimir Malevich 1878–1935*, exh. cat., Los Angeles, CA: Armand Hammer Museum of Art and Cultural Centre, 1990

Baehr 1988 S.L. Baehr, 'The "Political Icon" in Seventeenth- and Eighteenth-Century Russia' in *Russian Literary Triquarterly*, no. 21, Ann Arbor, MI: Ardis, 1988, pp.61–79

Baer 1991 N.V.N. Baer, *Theatre in Revolution, Russian Avant-Garde Stage Design 1913–1935*, exh. cat., London: Thames and Hudson, 1991

Bailes 1977 K.E. Bailes, 'Alexei Gastev and the Soviet Controversy over Taylorism, 1918–24', *Soviet Studies*, vol. xxix, no. 3, July 1977, pp.373–94

Bailes 1978 K.E. Bailes, *Technology and Society under Lenin and Stalin, Origins of the Soviet Technical Intelligentsia, 1917–1941*, Princeton, NJ: Princeton University Press, 1978

Bakhtin 1965 M. Bakhtin, *Rabelais and His World*, Bloomington, IN: Indiana University Press, 1965

Bann 1974 S. Bann (ed.), *The Tradition of Constructivism*, London: Thames and Hudson, 1974

Barcelona 1995 *Tatlin*, exh. cat., Barcelona: Picasso Museum, 1995

Barker and Hyde 1982 F. Barker and R. Hyde, *London as It Might Have Been*, London: John Murray, 1982

Barooshian 1987 V.D. Barooshian, *The Art of Liberation: Alexander A. Ivanov*, Lanham and London: University Press of America, 1987

Batchelor 1994 R. Batchelor, *Henry Ford: Mass Production, Modernism and Design*, Manchester: Manchester University Press, 1994

Bauer 2005 Snejanka Bauer, 'Rund ist das Orange — das Gelb hat drei Icken' in *Licht und Farbe in der russischen Avantgarde*, exh. cat., Thessaloniki: State Museum for Contemporary Art — Costakis Collection, 2005, pp.60–71

Becker 2001 L. Becker (ed.), *Construction: Tatlin and After*, Thessaloniki: State Museum of Contemporary Art, Costakis Collection, 2001

Bedford 1975 C.H. Bedford, *The Seeker: D.S. Merezhkovskiy*, Lawrence, KS: University of Kansas Press, 1975

Bellamy 1888 Edward Bellamy, *Looking Backwards 2000–1887*, Boston, MA: Ticknor, 1888

Bely 1979 A. Bely, *Petersburg*, Hassocks: Harvester Press, 1979

Berdyaev 1937 S. Berdyaev, *The Origin of Russian Communism*, London: Bles, 1937

Berlin 1978 *Revolution und Realismus: Revolutionäre Kunst in Deutschland 1917 bis 1933*, exh. cat., Berlin: Altes Museum, 1978

Berlin 1979 I. Berlin, *Russian Thinkers*, Harmondsworth: Penguin Books, 1979

Berman 1983 M. Berman, *All That is Solid Melts into Air*, London: Verso, 1983

Berton 1977 K. Berton, *Moscow, An Architectural History*, London: Studio Vista, 1977

Billington 1966 J.H. Billington, *The Icon and the Axe*, London: Weidenfeld and Nicolson, 1966

Blinoff 1961 M. Blinoff, *Life and Thought in Old Russia*, Philadelphia, PA: Pennsylvania State University Press, 1961

Bliznakov 1990 M. Bliznakov, 'The Realization of Utopia: Western Technology and Soviet Avant-Garde Architecture' in W.C. Bromfield (ed.), *Reshaping Russian Architecture*, Cambridge: Cambridge University Press, 1990

Blok 1982 A. Blok, *The Twelve and the Scythians*, trans. and intro. J. Lindsay, London and West Nyack, NY: Journeyman Press, 1982

Bogdanov 1918 A. Bogdanov, 'Iskusstvo I rabochiy klass' (Art and Working Class), Moscow, 1918

Bogdanov 1924 A. Bogdanov, 'O proletarskoy culture, Sbornik statey, 1904–1924', Moscow–Petrograd, 1924

Bogdanov 1984a A. Bogdanov, 'Red Star', in L.R. Graham and R. Stites (eds), *Alexander Bogdanov: Red Star, the First Bolshevik Utopia*, Bloomington, IN: Indiana University Press, 1984

Bogdanov 1984b A. Bogdanov, 'Engineer Menni', in Graham and Stites 1984 op.cit.

Bogdanov 1984c A. Bogdanov, 'A Martian Stranded on Earth', in Graham and Stites 1984 op.cit.

Bowlt 1974 J.E. Bowlt, 'The Construction of Space', in *Von der Fläche zum Raum, Russland 1916–1924*, exh. cat., Cologne: Galerie Gmurzynska, 1974

Bowlt 1976 J.E. Bowlt (ed. and trans.), *Russian Art of the Avant-Garde, Theory and Criticism 1902–1934*, New York: Viking, 1976

Bowlt 1978 J.E. Bowlt, 'Russian Sculpture and Lenin's Plan of Monumental Propaganda', in H.A. Milton and L. Nochlin (eds), *Art and Architecture in the Service of Politics*, Cambridge, MA: MIT, 1978

Bowlt 1983 J.E. Bowlt, 'Russian Painting in the Nineteenth Century', in T.G. Stavrou (ed.), *Art and Culture in Nineteenth-Century Russia*, Bloomington, IN: Indiana University Press, 1983, pp.113–39

Bowlt 1984 J.E. Bowlt, 'Introduction to V. Tatlin and S. Dymshits-Tolstaia, Memorandum From the Visual Arts Section of the People's Commissariat For Enlightenment to the Soviet People's Commissars: Project for the Organization of Competitions for Monuments to Distinguished Persons (1918)', *Design Issues*, vol. 1, no. 2, Fall 1984, pp.70–74

Bowlt 2003 J.E. Bowlt, 'Manipulating Metaphors: El Lissitzky and the Crafted Hand', in N. Perloff (ed.), *Situating Lissitzky*, Los Angeles, CA: Getty Institute, 2003

Bowlt and Washington Long 1980 J.E. Bowlt and R.-C. Washington Long (eds), *The Life of Vasilii Kandinsky in Russian Art — A Study of 'On the Spiritual in Art'*, Newtonville, MA: Oriental Research Partners, 1980

Bowman 1958 S.A. Bowman, *The Year 2000*, New York: Bookman Associates, 1958

Bown and Taylor 1993 M.C. Bown and B. Taylor (eds), *Art of the Soviets*, Manchester and New York: Manchester University Press, 1993

Braun 1969 E. Braun (ed. and trans.), *Meyerhold on Theatre*, London: Methuen, 1969

Braun 1979 E. Braun, *The Theatre of Meyerhold: Revolution on the Modern Stage*, London: Eyre Methuen, 1979

Braun 1995 E. Braun, *Meyerhold: A Revolution in Theatre*, London: Methuen, 1995

Bromfield 1990 W.C. Bromfield, 'Russian Perceptions of American Architecture' in W.C. Bromfield (ed.), *Reshaping Russian Architecture*, Cambridge: Cambridge University Press, 1990

Brown 1971 E.J. Brown, *The Proletarian Episode in Russian Literature 1928–1932*, New York: Octagon, 1971

Brown 1973 E.J. Brown, *Mayakovsky, a Poet in the Revolution*, Princeton, NJ: Princeton University Press, 1973

Buckberrough 1982 S.A. Buckberrough, *Robert Delaunay: The Discovery of Simultaneity*, Ann Arbor, MI: UMI Research Press, 1982

Butler 1993 R. Butler, *Rodin, the Shape of Genius*, New Haven, CT, and London: Yale University Press, 1993

Campanella 1981 T. Campanella, *The City of the Sun*, Berkeley, CA: University of California Press, 1981

Carey 1999 John Carey (ed.), *The Faber Book of Utopias*, London: Faber and Faber, 1999

Chamberlain 2004 L. Chamberlain, *Motherland: A Philosophical History of Russia*, London: Atlantic Books, 2004

Chamberlain 2006 L. Chamberlain, *The Philosophy Steamer*, London: Atlantic Books, 2006

Chernyevsky 1982 N. Chernyevsky, *What Is To Be Done?* (trans. B.R. Tucker and C. Porter), London: Virago, 1982

Clark 1993 Toby Clark 'The "new man's" body: A motif in Early Soviet Culture', in M.C. Bown and B. Taylor (eds), *Art of the Soviets*, Manchester and New York: Manchester University Press, 1993, pp.33–50

Clark and Holquist 1984 K. Clark and Michael Holquist, *Mikhail Bakhtin*, Cambridge, MA, and London: Harvard University Press, 1984

Cologne 1976 *El Lissitzky*, exh. cat., Cologne: Galerie Gmurzynska, 1976

Compton 1978 Susan P. Compton, *The World Backwards — Russian Futurist Books 1912–16*, London: British Library, 1978

Compton 1992 Susan Compton, *Russian Avant-Garde Books 1917–34*, London: British Library, 1992

Cook 1903 Sir Theodore A. Cook, *Spirals in Nature and in Art: A study of spiral formations based on the manuscripts of Leonardo da Vinci, with special reference to the architecture of the open staircase at Blois in Touraine now for the first time shown to be from his design*, with a preface by Professor E. Ray Lankester, London, 1903

Cooke 1983 R.F. Cooke, *The Poetic World of Velimir Chlebnikov: An Interpretation*, unpublished Ph.D. thesis, University of Sussex, 1983

Cooke 1987 R. Cooke, *Velimir Khlebnikov: A Critical Study*, Cambridge: Cambridge University Press, 1987

Cooke 1995 C. Cooke, *Russian Avant-Garde: Theories of Art, Architecture and the City*, London: Academy Editions, 1995

Coplestone 1986 F.C. Coplestone, *Philosophy in Russia*, Tunbridge Wells: Search Press, 1986

Crone and Moss 1991 R. Crone and D. Moss, *Kazimir Malevich: The Climax of Disclosure*, London: Reaktion Books, 1991

Curtis 1982 W.J.R. Curtis, *Modern Architecture since 1900*, Oxford: Phaidon, 1982

Dostoevsky 1983 F. Dostoevsky, *Notes from Underground and The Double* (trans. J. Coulson), Harmondsworth: Penguin, 1983

Dostoevsky 1984 F. Dostoevsky, *The Diary of a Writer* (trans. Boris Brasol), Haslemere: Ianmead, 1984

Douglas 1980 C. Douglas, *Swans of Other Worlds: Kazimir Malevich and the Origins of Abstraction in Russia*, Ann Arbor, MI: University of Michigan, 1980

Drengenberg 1972 H.-J. Drengenberg, *Die sowjetische Politik auf dem Gebiet der bildenden Kunst von 1917 bis 1934*, Berlin: Osteuropa-Institut an der Freien Universität, 1972

Drutt 2003 Matthew Drutt, *Kazimir Malevich, Suprematism*, exh. cat. for the Malevich exhibition shown in Berlin, New York and Houston, TX, 2003–4, New York: Guggenheim Museum, 2003

Ettlinger 1969 L. Ettlinger, intro. to *The Complete Paintings of Leonardo da Vinci*, London: Weidenfeld, 1969

Fedorov 1990 Nikolai Fedorov, *What Was Man Created for? The Philosophy of the Common Task: Selected Works* (trans. from the Russian and abridged by Elisabeth Kontaissoff and Marilyn Minto), London: Honeyglen, 1990

Feinstein 2005 E.E. Feinstein, *Anna of all the Russians: The Life of Anna Akhmatova*, London: Weidenfeld and Nicolson, 2005

The Festal Menaion (trans. Mother Mary and Archimandrite Kallistos Ware), London: Faber and Faber, 1969

Figes and Kolonitskii 1999 O. Figes and B. Kolonitskii, *Interpreting the Russian Revolution: The Language and Symbols of 1917*, New Haven, CT, and London: Yale University Press, 1999

Figes 1996 O. Figes, *A People's Tragedy: The Russian Revolution 1891–1924*, London: Jonathan Cape, 1996

Figes 2002 O. Figes, *Natasha's Dance: A Cultural History of Russia*, London: Allen Lane, 2002

Fischer von Erlach 1721 J.B. Fischer von Erlach, *Entwurff einer Historischen Architectur*, Vienna, 1721

Fitzgerald 1970 S. Fitzgerald, *The Commissariat of Enlightenment*, Cambridge: Cambridge University Press, 1970

Fitzpatrick 1979 S. Fitzpatrick, *Education and Social Mobility in the Soviet Union, 1921–1934*, Cambridge: Cambridge University Press, 1979

Flam 1973 J.D. Flam, *Matisse on Art*, London: Phaidon, 1973

Foster et al. 2004 Hal Foster et al., *Art Since 1900*, London: Thames and Hudson, 2004

Frank 1986 J. Frank, *Dostoevsky: The Stir of Liberation 1860–1865*, London: Robson, 1986

Fülöp-Miller 1928 R. Fülöp-Miller, *The Mind and Face of Bolshevism*, New York: Knopf, 1928

Galerie Gmurzynska 1974 *Von der Fläche zum Raum, Russland 1916–1924*, exh. cat., Cologne: Galerie Gmurzynska, 1974

Galerie Gmurzynska 2002 *Alexander Rodchenko — Spatial Constructions/Raumkonstruktionen*, exh. cat., Ostfildern-Ruit: Hatje Cantz, 2002

Garshin 1982 V. Garshin, *Stories* (trans. Bernard Esaacs), Moscow: Progress, 1982

Gassner 1992 H. Gassner, 'The Constructivists: Modernism on the Way to Modernization 1915–1932' in New York 1992 q.v., pp.298–319

Godwin 1979 J. Godwin, *Athanasius Kircher — A Renaissance Man and the Quest for Lost Knowledge*, London: Thames and Hudson, 1979

Gough 2005 Maria Gough, *The Artist as Producer: Russian Constructivism in Revolution*, Berkeley, Los Angeles, CA, and London: University of California Press, 2005

Graham and Stites 1984 L.R. Graham and R. Stites (eds), *Alexander Bogdanov: Red Star, the First Bolshevik Utopia*, Bloomington, IN: Indiana University Press, 1984

Gray 1962 Camilla Gray, *The Great Experiment: Russian Art 1863–1922*, London: Thames and Hudson, 1962

Gray 1986 Camilla Gray, *The Great Experiment:*

Russian Art 1863–1922 (ed. Marian Burleigh-Motley), London: Thames and Hudson, 1986

Grove et al. 1913 *Russia Painted by F. de Haenen*, text by H.M. Grove, G. Dobson and H. Stewart, London: A & C Black, 1913

Groys 1992 B. Groys, *The Total Art of Stalinism*, Princeton, NJ: Princeton University Press, 1992

Günther 1973 H. Günther, 'Proletarische und avantgardistische Kunst' in *Ästhetik und Kommunikation*, 1973, vol. 12, pp.62–75

Hackel 1980 S. Hackel, *The Poet and the Revolution: Aleksandr Blok's 'The Twelve'*, Oxford: Clarendon Press, 1980

Hague and Christie 1975 D.B. Hague and R. Christie, *Lighthouses: Their Architecture, History and Archaeology*, Llandysul: Gomer, 1975

Hamilton 1954 G.H. Hamilton, *The Art and Architecture of Russia*, Harmondsworth: Penguin Books, 1954

Hamilton and Agee 1967 G.H. Hamilton and W.C. Agee, *Raymond Duchamp-Villon*, New York: Walker and Co., 1967

Hammer and Lodder 2000 M. Hammer and C. Lodder, *Constructing Modernity — The Art & Career of Naum Gabo*, New Haven, CT, and London: Yale University Press, 2000

Hammer and Lodder 2000 M. Hammer and C. Lodder (eds and trans.), *Gabo on Gabo*, Forest Row: Artists Bookworks, 2000

Hammond and Scullard 1979 N.G.L. Hammond and H.H. Scullard, *The Oxford Classical Dictionary*, Oxford: Clarendon Press, 1979

Harriss 1976 J. Harriss, *The Eiffel Tower, Symbol of an Age*, London: Elek, 1976

Harten 1989 J. Harten (ed.), *Vladimir Tatlin, Leben, Werk, Wirkung. Ein Internationales Symposium*, Cologne: DuMont, 1989

Hayward 1983 M. Hayward, *Writers in Russia 1917–1978*, London: Harvill, 1983

Hellberg-Hirn 2003 E. Hellberg-Hirn, *Imperial Imprints, Post-Soviet St Petersburg*, Jyväskylä: Gummerus Kirjapaino Oy, 2003

Henry 1983 P. Henry, *Vsevolod Garshin: A Hamlet of His Time*, Oxford: Oxford University Press, 1983

Herzen 1980 A. Herzen, *My Past and Thoughts*, Oxford: Oxford University Press, 1980

Howard 1992 J. Howard, *The Union of Youth*, Manchester and New York: Manchester University Press, 1992

Hubbs 1988 J. Hubbs, *Mother Russia*, Bloomington and Indianapolis, IN: Indiana University Press, 1988

Ikonnikov 1988 A. Ikonnikov, *Russian Architecture of the Soviet Period*, Moscow: Raduga, 1988

Ingold 1978 Felix Phillipp Ingold, *Literatur und Aviatik: europäische Flugdichtung 1909; mit einem Exkurs über die Flugidee in der modernen Malerei und Architektur*, Basel: Birkhäuser, 1978

Janacek 1984 G. Janacek, *The Look of Russian Literature*, Princeton, NJ: Princeton University Press, 1984

Jangfeldt 1976 B. Jangfeldt, *Majakovskij and Futurism 1917–1921*, Stockholm: Almqvist and Wiksell, 1976

Kamensky 1989 A. Kamensky, *Chagall: The Russian Years 1907–1921*, London: Thames and Hudson, 1989

Karginov 1979 G. Karginov, *Rodchenko*, London: Thames and Hudson, 1979

Kassàk and Moholy-Nagy 1922, L. Kassàk and L. Moholy-Nagy, *Buch neuer Künstler*, Vienna, 1922. Facsimile published by Müller, Baden, 1991

Kemp 1981 Martin Kemp, *Leonardo da Vinci: The Marvellous Works of Nature and Man*, London: Dent, 1981

Kern 1976 G. Kern, *Velimir Khlebnikov, Snake Train: Poetry and Prose* (intro. by E.J. Brown), Ann Arbor, MI: Ardis, 1976

Kern 1983 S. Kern, *The Culture of Time and Space, 1880–1918*, London: Weidenfeld and Nicolson, 1983

Khan Magomedov 1986a Selim O. Khan-Magomedov, *Alexandr Vesnin and Russian Constructivism*, London: Lund Humphries, 1986

Khan-Magomedov 1986b Selim O. Khan-Magomedov, *Rodchenko — The Complete Work* (ed. Vi Khan-Magomedov), London: Thames and Hudson, 1986

Khlebnikov 1975 *The Longer Poems of Velimir Khlebnikov* (ed. V. Markov), Westport, CT: Greenwood Press, 1975

Kiaer 2005 Christina Kiaer, *Imagine No Possessions: The Socialist Objects of Russian Constructivism*, Cambridge, MA, and London: MIT Press, 2005

Kilmarx 1962 R.A. Kilmarx, *A History of Soviet Air Power*, London: Faber and Faber, 1962

Kolonitskii 1999 B. Kolonitskii, *Interpreting the Russian Revolution*, New Haven, CT, and London: Yale University Press, 1999

Kopp 1970 A. Kopp, *Town and Revolution: Soviet Architecture and City Planning 1971–1935*, London: Thames and Hudson, 1970

Körner 1985 E. Körner, 'Tatlin — Outlines of a Career in the Context of Contemporary Russian Avant-garde Art as Related to East and Western Tendencies',

Acta Historiae Artis Hungarica, vol. 31, Budapest: Akadémiai Kiadó, 1985

Korsakova 1988 A. Korsakova, 'Avant-Garde Tower', *Soviet Weekly*, 16 January 1988

Kostin 1988 A.K. Kostin, *Ekspluatatsionnye rezhimy transportnykh dizelei. Alma-Ata*, Nauka Kazakhskoi SSR, 1988

Lampert 1965 E. Lampert, *Sons Against Fathers: Studies in Russian Radicalism and Revolution*, Oxford: Clarendon Press, 1965

Lane 1968 B.M. Lane, *Architecture and Politics in Germany, 1918–1945*, Cambridge, MA: Harvard University Press, 1968

Langmuir and Lynton 2000 E. Langmuir and N. Lynton, *The Yale Dictionary of Art and Artists*, New Haven, CT, and London: Yale University Press, 2000

Larson 2003 E. Larson, *The Devil in the White City*, London: Doubleday, 2003

Latham and Swenarton 2002 I. Latham and M. Swenarton (eds), *Jeremy Dixon and Edward Jones: Buildings and Projects 1959–2002*, London: Rightangle Publishing, 2002

Lavrentiev 1988 A. Lavrentiev, *Varvara Stepanova: A Constructivist Life*, London: Thames and Hudson, 1988

Lavrentiev 1995 A. Lavrentiev, *Alexander Rodchenko: Photography 1924–1954*, Cologne: Kölemann, 1995

Lincoln 1999 W.B. Lincoln, *Red Victory — A History of the Russian Civil War*, New York: Da Capo, 1999

Lindsay and Vergo 1982 Kenneth C. Lindsay and Peter Vergo (eds), *Kandinsky — Complete Writings on Art*, London: Faber and Faber, 1982

Lipsey 1988 R. Lipsey, *An Art of Our Own: The Spiritual in Twentieth-Century Art*, Boston, MA, and Shaftesbury: Shambhala, 1988

Lissitsky-Küppers 1968 S. Lissitsky-Küppers, *El Lissitzky — Life — Letters — Texts*, London: Thames and Hudson, 1968

Lodder 1993 C. Lodder, 'Lenin's Plan for Monumental Propaganda', in Bown and Taylor 1993 op.cit.

London 1975 *2 Sternberg 2*, exh. cat., London: Annely Juda Fine Art, 1975

London 1983 Commentary by Andrei Nakov, *The First Russian Show*, exh. cat., London: Annely Juda Fine Art, 1983

London 1984 *Dada — Constructivism*, exh. cat., London: Annely Juda Fine Art, 1984

London 1991 *Theatre in Revolution: Russian Avant-Garde Stage Design 1913–1935*, exh. cat., London: Thames and Hudson, 1991

London 1999 *Kandinsky: Watercolours and other Works on Paper*, exh. cat., London: Royal Academy of Arts, 1999

London 2006 *Modernism 1914–1939 — Designing a New World*, exh. cat., London: Victoria and Albert Museum, 2006

Lönnqvist 1979 Barbara Lönnqvist, *Khlebnikov and Carnival: An Analysis of the Poem Poet*, Stockholm: Almqvist and Wiksell International, 1979

Los Angeles 1993 *Expressionist Utopias — Paradise, Metropolis, Architectural Fantasy*, exh. cat., Los Angeles, CA: Los Angeles County Museum of Art, 1993

Lowrie 1960 D.A. Lowrie, *Rebellious Prophet: A Life of Nicolai Berdyaev*, London: Gollancz, 1960

Lunacharski 1923 A.V. Lunacharski, *Three Plays*, London, 1923

Mandelshtam 1972 Osip Mandelshtam and Velimir Khlebnikov in V.C. Mihailovich (ed.), *Modern Slavic Literature: Russian Literature*, vol. 1, New York: Ungar, 1972, p.165

Markov 1969 V. Markov, *Russian Futurism: A History*, London: Macgibbon and Kee, 1969

Markov 1975 V. Markov, *The Longer Poems of Velimir Khlebnikov*, Westport, CT: Greenwood Press, 1975

Marks 2003 S.G. Marks, *How Russia Shaped the Modern World*, Princeton, NJ: Princeton University Press, 2003

Martin, Nicholson and Gabo 1937 J.L. Martin, Ben Nicholson and Naum Gabo, *Circle: International Survey of Art*, London: Faber and Faber, 1937

Massie 1980 S. Massie, *The Land of the Firebird*, New York: Simon and Schuster, 1980

McLean 1977 H. McLean, *Nikolai Leskov: The Man and his Art*, Cambridge, MA, and London: Harvard University Press, 1977

McLeod 1983 M. McLeod, ' "Architecture or Revolution": Taylorism, Technocracy and Social Change' in *Art Journal*, Summer 1983, pp.132–47

Mayakovsky 1976 *Vladimir Mayakovsky: Innovator*, Moscow: Progress Press, 1976

Merejkowski 1931 D. Merejkowski, *The Romance of Leonardo da Vinci*, London: Cassell and Company Limited, 1931

Mihailovich 1972 Vasa D. Mihailovich, *Modern Slavic Literatures, vol. 1, Russian Literature*, New York: Ungar, 1972

Milner 1980 J. Milner, *Russian Constructivism, the First Phase: Tatlin and Rodchenko*, unpublished thesis, Courtauld Institute, 1980

Milner 1983 John Milner, *Vladimir Tatlin and the Russian Avant-garde*, New Haven, CT, and London: Yale University Press, 1983

Milner 1992 J. Milner, *The Exhibition 5 × 5, its Background and Significance*, Budapest: Helikon, 1992

Milner 1993 John Milner, *A Dictionary of Russian and Soviet Artists 1420–1970*, Woodbridge, Suffolk: Antique Collectors' Club, 1993

Milner 1996 J. Milner, *Kazimir Malevich and the Art of Geometry*, London: Yale University Press, 1996

Milner-Gulland 1964 R. Milner-Gulland, *Soviet Russian Verse: An Anthology*, London: Pergamon, 1964

Milner-Gulland 1987 Robin Milner-Gulland, 'Khlebnikov, Tatlin and Khlebnikov's Poem to Tatlin' in *Essays in Poetics*, vol. 12, no. 2, 1987, pp.82–102

Milner-Gulland 1989 R. Milner-Gulland, 'Eyes and Icons: Some Visual-Verbal "constellations" in the Work of Velimir Khlebnikov' in M. Falchikov, C. Pike and R. Russul (eds), *Words and Images: Essays in Honour of Professor (Emeritus) Dennis Ward*, Nottingham: Astra, 1989

Milner-Gulland 1997 R. Milner-Gulland, *The Russians*, Oxford: Blackwell, 1997

Milton and Nochlin 1978 H.A. Milton and L. Nochlin (eds), *Art and Architecture in the Service of Politics*, Cambridge, MA: MIT, 1978

Mirsky 1975 S. Mirsky, *Der Orient im Werk Velimir Chlebnikov*, Munich: Sagner, 1975

Misler 1989 Nicolette Misler, *Der Fliegende Matrose. In Vladimir Tatlin. Leben Werk Wirkung. Ein internationales Symposium*, Köln: DuMont Buchverlag, 1993, pp.170–83

Moholy 1922 L. Moholy-Nagy, *Von Material zu Architektur*, Munich, 1922

Monas and Prupala 1974 S. Monas and J.G. Prupala (eds), *The Diaries of Nikolay Punin 1904–1953*, Austin, TX: University of Texas Press, 1999

Muccigrosso 1993 R. Muccigrosso, *Celebrating the New World: Chicago's Columbian Exposition of 1893*, Chicago, IL: Ivan R. Dee, 1993

Muckle 1978 J. Muckle, *Nikolai Leskov and the 'Spirit of Protestantism'*, Birmingham: Birmingham University Press, 1978

Nakov 1975 A.B. Nakov, *2 Stenberg 2*, exh. cat., London: Annely Juda Fine Art, 1975

Nakov 1983 Andrei B. Nakov in *The First Russian Show*, exh. cat., London: Annely Juda Fine Art Gallery, 1983

Nakov 2002 A. Nakov, *Kazimir Malewicz: Catalogue raisonné*, Paris: Biro, 2002

Nakov 2006 A. Nakov, *Kazimir Malevicz, le peintre russe*, Paris: Thalia, 2006

Nash and Merkert 1985 S.A. Nash and J. Merkert, *Naum Gabo: Sixty Years of Constructivism*, Munich: Prestel, 1985

Nash 1991 Steven A. Nash, 'East Meets West: Russian Stage Design and the European Avant-Garde', in N.V.N Baer, *Theatre in Revolution: Russian Avant-Garden Stage Design 1913–1935*, London: Thames and Hudson, 1991, pp.96–113

New York 1992 *The Great Utopia — The Russian and Soviet Avant-Garde*, exh. cat., New York: Guggenheim Museum, 1992

Nisbet 1983 Peter Nisbet in *The First Russian Show*, exh. cat., London: Annely Juda Fine Art Gallery, 1983

Palmer 1972 Alan Palmer, *Russia in War and Peace*, London: Weidenfeld and Nicolson, 1972

Paris 1972 *Exter*, exh. cat., Paris: Galerie Chauvelin, 1972

Paris 1990 *Filonov*, exh. cat., Paris: Centre Georges Pompidou, 1990

Parton 1993 Anthony Parton, *Mikhail Larionov and the Russian Avant-Garde*, London: Thames and Hudson, 1993

Petrova 2001 Yevgenia Petrova, *The Russian Avant-Garde: Representation and Interpretation*, St Petersburg: Palace Editions, 2001

Petrova 2003 Yevgenia Petrova (ed.), *The Russian Avant-Garde: Personality and School*, St Petersburg: Palace Editions, 2003

Philipson 1966 M. Philipson (ed.), *Leonardo da Vinci: Aspects of the Renaissance Genius*, New York: Braziller, 1966

Pike 1979 Christopher Pike, *The Futurists, the Formalists and the Marxist Critique*, London: Ink Links, 1979

Polonsky 1930 Vyacheslav Polonsky, 'Lenin's Views of Art and Culture', in Max Forrester Eastman, *Artists in Uniform: A Study of Literature and Bureaucratism*, London: Allen and Unwin, 1934

Porthogesi 1968 P. Porthogesi, *Borromini*, London: Thames and Hudson, 1968

Punin 1919 N. Punin, 'Razorvannoe soznanie' (Muddled Consciousness), *Art of the Commune*, no. 18, 26 January 1919

Punin 1920 N. Punin, *Pamyatnik III Internazionala*, Petrograd: Izdanie Otdela Izobratzitelnih Iskusstv, 1920

Punin 2000 N. Punin, *Mir svetel luboviu. Dnevniki. Pisma*, Moscow: Artsit. Rezhisser. Teatr., 2000

Pyman 1980 Avril Pyman, *Life of Aleksandr Blok*, Oxford: Oxford University Press, 1980

Pyman 1994 A. Pyman, *A History of Russian Symbolism*, Cambridge: Cambridge University Press, 1994

Rakitin 1992 Vasilii Rakitin, 'The Artisan and the Prophet: Marginal Notes on Two Artistic Careers',

in New York 1992 q.v., pp.25–37

Rayling 1990 Patricia Rayling, *More About Two Squares*, Forest Row: Artists Bookworks, 1990

Read 1979 C. Read, *Religion, Revolution and the Russian Intelligentsia 1900–1912*, London: Macmillan, 1979

Richardson 1996 J. Richardson, *A Life of Picasso, Volume II, 1907–1917*, London: Jonathan Cape, 1996

Rodchenko 2005 *Aleksandr Rodchenko — Experiments for the Future: Diaries, Essays, Letters and Other Writings*, ed. A.N. Lavrentiev and intro. John E. Bowlt, New York: Museum of Modern Art, 2005

Roman 1981 G.H. Roman, 'Vladimir Tatlin and Zangezi', in *Russian History/Histoire Russe*, vol. 8, parts 1 and 2, pp.112–13

Roman and Marquardt 1992 G.H. Roman and V.H. Marquardt (eds), *The Avant-Garden Frontier: Russia Meets the West*, Gainesville, FL: University Press of Florida, 1992

Rosenberg 1984 W.G. Rosenberg (ed.), *Bolshevik Visions*, Ann Arbor, MI: Ardis, 1984

Rosenthal 1986 B. Rosenthal (ed.), *Nietzsche in Russia*, Princeton, NJ: Princeton University Press, 1986

Rosenthal 1994 B. Rosenthal (ed.), *Nietsche and Soviet Culture*, Cambridge: Cambridge University Press, 1994

Rowell 1978 M. Rowell, 'Vladimir Tatlin: Form/Faktura', in *October*, Winter 1978, pp.83–108

Rudenstine 1981 Angelica Rudenstine, *Art of the Avant-Garde in Russia: Selections from the George Costakis Collection*, exh. cat., New York: Guggenheim Museum, 1981

Rudenstine 1981 A.Z. Rudenstine (ed.), *Russian Avant-Garde Art — The George Costakis Collection*, London: Thames and Hudson, 1981

Rudnitsky 1988 K. Rudnitsky, *Russian & Soviet Theatre: Tradition and Avant-Garde*, London: Thames and Hudson, 1988

Sandquist 2006 R. Sandquist, *Dada East*, Cambridge, MA, and London: MIT, 2006

Sarabianov 1982 D.V. Sarabianov, 'Tatlin's Paintings', in L. Zhadova, *Malevich, Suprematism and Revolution in Russian Art 1910–1930*, London: Thames and Hudson, 1982

Sarabaniov 1990 D.V. Sarabaniov, *Russian Art from Neoclassicism to the Avant-Garde*, London: Thames and Hudson, 1990

Sarabianov and Adaskina 1990 D.V. Sarabianov and N.L. Adaskina, *Popova*, London: Thames and Hudson, 1990

Schmidt 1981 P. Schmidt, *Meyerhold at Work*, Manchester: Carcanet, 1981

Seton 1952 M. Seton, *Sergei M. Eisenstein*, London: Bodley Head, 1952

Setschkareff 1959 V. Setschkareff, *N.S. Leskov. Sein Leben und sein Werk*, Wiesbaden: Harassowitz, 1959

Shane 1968 A.M. Shane, *The Life and Works of Evgenij Zamjatin*, Berkeley and Los Angeles, CA: University of California Press, 1968

Shattuck 1966 V. Shattuck, 'The Tortoise and the Hare: A Study of Valéry, Freud and Leonardo da Vinci', in M. Philipson, *Leonardo da Vinci: Aspects of the Renaissance Genius*, New York: Braziller, 1966

Shattuck 1984 Roger Shattuck, *The Innocent Eye*, New York: Farrar Straus, 1984

Sherwood 1972 Richard Sherwood, 'Documents from Lef', in *Screen*, vol. 12, no. 4, Winter 1971–2, pp.25–58

Shklovsky 1923 Viktor Shklovsky, *Zoo, Letters Not About Love* (Zoo, ili pis'ma ne o ljubvi), Berlin, 1923. English translation Ithaca and London, 1971

Shklovsky 1972 Viktor Shklovsky, *Mayakovksy and his Circle*, trans. and ed. L. Feiler, New York: Dodd, Mead and Co., 1972

Shvidkovsky 2007 O.A. Shvidkovsky, *Russian Architecture and the West*, New Haven and London: Yale University Press, 2007

Syrkina 1988 F.I. Syrkina, 'Tatlin's Theatre', in Zhadova 1988 q.v., pp.503–4

Siukonen 2001 J. Siukonen, *Uplifted Spirits, Earthbound Machines. Studies on Artists and the Dream of Flight, 1900–1935*, Helsinki: Hakapaino Oy, 2001

Sochor 1988 Z. Sochor, *Revolution and Culture, the Lenin-Bogdanov Controversy*, Ithaca and London: Cornell University Press, 1988

Spate 1979 V. Spate, *Orphism*, Oxford: Clarendon Press, 1979

Starr 1978 S.F. Starr, *Melnikov: Solo Architect in a Mass Society*, Princeton NJ: Princeton University Press, 1978

Starr 1983 S.F. Starr, 'Russian Art and Society 1800–1850', in T.G. Stavrou (ed.), *Art and Culture in Nineteenth-Century Russia*, Bloomington: Indiana University Press, 1983

Stavrou 1983 T.G. Stavrou (ed.), *Art and Culture in Nineteenth-Century Russia*, Bloomington: Indiana University Press, 1983

Steinberg 1977 L. Steinberg, *Borromini's San Carlo Alle Quattro Fontane*, New York and London: Garland, 1977

Steinberg 2002 M.D. Steinberg, *Proletarian Imagination: Self, Modernity and the Sacred in Russia, 1910–1925*, Ithaca, NY, and London: Cornell University Press, 2002

Stephan 1981 H. Stephan, *'Lef' and the Left Front of the Arts*, Munich: Sagner, 1981

Stites 2006 Richard Stites, *Serfdom, Society and the Arts in Imperial Russia*, New Haven, CT, and London: Yale University Press, 2006

Stobbe 1982 P. Stobbe, *Utopisches Denken bei V. Chlebnikov*, Munich: Sagner, 1982

Stockholm 1968 *Vladimir Tatlin*, exh. cat. compiled by Troels Andersen, Stockholm: Moderna Museet, 1968

Strigalev 1988 A.A. Strigalev, 'From Painting to the Construction of Matter', in Zhadova 1988 q.v., pp.13–43

Strigalev 1995 A.A. Strigalev, 'El Pintor Vladimir Tatlin (1885–1953)', in Barcelona 1995 q.v., pp.19–63

Strigalev 1996 A.A. Strigalev, 'The "Universities" of the Artist Tatlin' (in Russian), in *Boprovi Iskusstvo*, vol. 9, part 2, Moscow, pp.405–31. Translation by Maria Starkova and Natalie Murray

Strigalev and Harten 1993 Düsseldorf, Städtische Kunsthalle, *Vladimir Tatlin Retrospective*, exh. cat., ed. A. Strigalev and J. Harten, Cologne: Du Mont Buchverlag, 1993

Syrkina 1988 F.I. Syrkina, 'Tatlin's Theatre', in Zhadova 1988 q.v., pp.155–79, 503–4

Tait 1974 A.L. Tait, 'Lunacharsky, the "Poet-Commissar" ', in *Slavonic and East European Review*, vol. LII, no. 127, 1974, pp.234–51

Tait 1980 A.L. Tait, 'Lunacharskii's Russian *Faust*', in *Germano-Slavonica*, vol. III, no. 3, Spring 1980, pp.189–203

Taraboukine 1972 N. Taraboukine, *Le dernier tableau*, Paris: Champ Libre, 1972

Taylor 1991 B. Taylor, *Art and Literature under the Bolsheviks, Volume One: The Crisis of Renewal 1917–1924*, London and Concord, MA: Pluto Press, 1991

Temple 1990 R. Temple, *Icons and the Mystical Origins of Christianity*, Longmead: Element Books, 1990

Terras 1983 V. Terras, *Vladimir Mayakovsky*, Boston, MA: Twayne, 1983

Teskey 1982 A. Teskey, *Platonov and Fyodorov: The Influence of Christian Philosophy on a Soviet Writer*, Amersham: Avebury, 1982

Thessaloniki 2005 *Licht und Farbe in der russischen Avant Garde*, exh. cat., Thessaloniki: State Museum of Contemporary Art — Costakis Collection, 2005

Thomson 1978 B. Thomson, *Lot's Wife and the Venus de Milo*, Cambridge: Cambridge University Press, 1978

Thomson 1985 R. Thomson, *Seurat*, London: Phaidon, 1985

Tolstoy 1930 L. Tolstoy, *What is Art?*, London: Oxford University Press, 1930 and 1969

Tolstoy et al. 1990 V. Tolstoy, I. Bibikova and C. Cooke (eds), *Street Art of the Revolution: Festivals and Celebrations in Russia 1918–33*, London: Thames and Hudson, 1990

Trotsky 1975 L. Trotsky, *Literature and Revolution*, Ann Arbor, MI: University of Michigan Press, 1975

Tumarkin 1983 N. Tumarkin, *Lenin Lives! The Lenin Cult in Soviet Russia*, Cambridge, MA: Harvard University Press, 1983

Tupitsyn and Lissitzky 1999 M. Tupitsyn and El Lissitzky, *Beyond the Abstract Cabinet*, New Haven, CT, and London: Yale University Press, 1999

Tynyanov 1979 Yury Tynyanov, 'About Khlebnikov', in C. Pike, *The Futurists, the Formalists and the Marxist Intrigue*, London: Ink Links, 1979, pp.144–57

Umanskij 1920a K. Umanskij, *Neue Kunst in Russland 1914–19*, Potsdam and Munich: Kiepenheuer, 1920

Umanskij 1920b K. Umanskij, 'Tatlinismus oder die Maschinenkunst' in *Der Ararat*, Potsdam, January and February/March 1920

Utechin 1918 S.V. Utechin, 'Bolsheviks and their Allies after 1917' in *Soviet Studies*, vol. x, no. 2, October 1918

Valkenier 1977 E. Valkenier, *Russian Realist Art*, Ann Arbor, MI: Ardis, 1977

Valkenier 1983 Elizabeth Kridl Valkenier, 'The Intelligentsia and Art', in T.G. Stavrou (ed.), *Art and Culture in Nineteenth-Century Russia*, Bloomington, IN: Indiana University Press, 1983, pp.153–71

Venturi 1964 F. Venturi, *Roots of Revolution*, London: Weidenfeld and Nicolson, 1964

Vitberg 1912 F. Vitberg, 'Alexander Vitberg et son projet d'église à Moscou', in *Starye Gody* (Former Times), February 1912

von Geldern 1993 J. von Geldern, *Bolshevik Festivals, 1917–1920*, Berkeley, Los Angeles, CA, and London: University of California Press, 1993

Waldman 1992 Diane Waldman, *Collage, Assemblage and the Found Object*, London: Phaidon, 1992

Weidle 1952 W. Weidle, *Russia: Absent and Present*, London: Hollis and Carter, 1952

West 1970 J. West, *Russian Symbolism: A Study of Vyacheslav Ivanov and the Russian Symbolist Aesthetic*, London: Methuen, 1970

Weststeijn 1986 W.G. Weststeijn, *Velimir Chlebnikov: Myth and Reality*, Amsterdam: Rodopi, 1986

Wetter 1977 G.A. Wetter, *Dialectical Materialism*, Westport, CT: Greenwood, 1977

Williams 1977 R.C. Williams, *Artists in Revolution*, London: Scolar Press, 1977

Williams 1986 R.C. Williams, *The Other Bolsheviks: Lenin and his Critics, 1904–1914*, Bloomington and Indianapolis, IN: Indiana University Press, 1986

Wohl 1994 Robert Wohl, *A Passion for Wings: Aviation and the Western Imagination 1908–1918*, New Haven, CT, and London: Yale University Press, 1994

Wolf 1971 E.R. Wolf, *Peasant Wars of the Twentieth Century*, London: Faber and Faber, 1971

Wolfe 1984 B.D. Wolfe, *Three Who Made a Revolution*, Harmondsworth: Penguin, 1984

Wood 1992 Paul Wood, 'The Politics of the Avant-Garde', in New York 1992 q.v., pp.1–24

Woroszylski 1972 W. Woroszylski, *The Life of Mayakovsky*, London: Gollancz, 1972

Yablonskaya 1990 M.N. Yablonskaya, *Women Artists of Russia's New Age 1900–1935*, New York: Rizzoli, 1990

Young 1979 G.M. Young Jr, *Nikolai F. Fedorov: An Introduction*, Belmont, MA: Nordland, 1979

Zamyatin 1970 Y. Zamyatin, 'Moskva — Peterburg' in M. Ginsburg (ed. and trans.), *A Soviet Heretic: Essays by Yevgeny Zamyatin*, Chicago, IL, and London: University of Chicago Press, 1970

Zavalishin 1958 V. Zavalishin, *Early Soviet Writers*, New York: Praeger, 1958

Zenkovsky 1953 V.V. Zenkovsky, *A History of Russian Philosophy*, vol. 2, London: Routledge and Kegan Paul, 1953

Zhadova 1982 L. Zhadova, *Malevich, Suprematism and Revolution in Russian Art 1910–1930*, London: Thames and Hudson, 1982

Zhadova 1988 L.A. Zhadova (ed.), *Tatlin*, London: Thames and Hudson, 1988

Zygas 1976 K.P. Zygas, 'Tatlin's Tower Reconsidered', in *Architectural Association Quarterly*, vol. 8, no. 2, London, 1976

Index

Picture acknowledgements

Every effort has been made to credit the photographers and sources of all illustrations in this volume; if there are any errors or omissions, please contact Yale University Press so that corrections can be made to any subsequent edition.

© ADAGP, Paris and DACS, London 2009: 8
© ARS, New York and DACS, London 2009: 47
photograph © The Art Institute of Chicago: 64
The Bridgeman Art Library, London: back jacket illustration, 49, 58, 63
British Library: 13, 14, 15, 69
© DACS 2009: 41, 73
© DACS / Peter Willi / The Bridgeman Art Library: 1
photograph, Editions Nugeron, Paris: 26
The works of Naum Gabo © Nina Williams: 38, 72
photograph, Galerie Jean Chauvelin, Paris: 35
Giraudon / The Bridgeman Art Library: 84

photograph, Roland Halbe / RIBA Library Photographs Collection: 44
photograph, Iraqi Cultural Centre, London: 48
© Succession H Matisse/DACS 2009: 25
© Succession Picasso/DACS 2009: 24
© N. Punin Archive, St Petersburg: title page illustration, frontispiece, 17, 18, 56, 57, 70
© Rodchenko & Stepanova Archive, DACS 2009: 46
photograph, Alexander Rodchenko Archive, Moscow: 71
photography, collection V. A. Rodchenko, Moscow: 60, 61
photograph, Lynn Rosenthal, 1993: 75
Scala, Florence: 74
© 2007, State Russian Museum, St Petersburg: 5, 6, 7, 16, 23
photograph, Joseph Szaszfai: 11
photography, collection Russian State Archive of Literature and Art (RGALI), Moscow: 4, 36, 83
photograph © Anna Zakharova: 55